For Reference

Not to be taken from this room

CENTRAL LIBRARY

FINGER LAKES LIBRARY SYSTEM
ITHACA, N.Y.

OCT 2 2 2003

WOMEN ARTISTS
OF COLOR

WOMEN ARTISTS OF COLOR

A Bio-Critical Sourcebook to 20th Century Artists in the Americas

Edited by
PHOEBE FARRIS

Greenwood Press
Westport, Connecticut • London

Library of Congress Cataloging-in-Publication Data

Women artists of color : a bio-critical sourcebook to 20th century
 artists in the Americas / edited by Phoebe Farris.
 p. cm.
 Includes bibliographical references and index.
 ISBN 0–313–30374–6 (alk. paper)
 1. Minority women artists—America—Biography. I. Farris,
Phoebe, 1952–
N8354.W656 1999
709'.2'39—dc21 98–47134
 [b]

British Library Cataloguing in Publication Data is available.

Library of Congress Catalog Card Number: 98–47134
ISBN: 0–313–30374–6

First published in 1999

Greenwood Press, 88 Post Road West, Westport, CT 06881
An imprint of Greenwood Publishing Group, Inc.
www.greenwood.com

Printed in the United States of America

The paper used in this book complies with the
Permanent Paper Standard issued by the National
Information Standards Organization (Z39.48–1984).

10 9 8 7 6 5 4 3 2 1

Copyright Acknowledgments

This book is dedicated to the memory of African-American artist, Lois Mailou Jones (1905–1998) and Chinese-American artist, Bernice Bing (1936–1998).

CONTENTS

ACKNOWLEDGMENTS

This manuscript was completed while I was on a year's research leave from Purdue University. I am very grateful to Dr. Margaret Rowe, Dean of the School of Liberal Arts, and Professor Dennis Ichiyama, Head of the Department of Visual and Performing Arts, for granting me leave from my teaching duties. I also want to acknowledge the intellectual support and encouragement I received from Dr. Berenice Carroll, Director of Women's Studies; the secretarial and warm personal assistance of Connie Boatwright, Women's Studies secretary; and the long-distance, superb typing, editing, faxing, and emailing support I received from Marcella VanSickle, Division of Art and Design secretary.

The introduction to this book was written while I was a summer 1997 Rockefeller Scholar-in-Residence at the Womanist Studies Consortium at the University of Georgia at Athens. Dr. Barbara McCaskill and Dr. Layli Phillips, codirectors of the Womanist Studies Consortium, were instrumental in clarifying the philosophy of womanism and how it could be incorporated into my text. Appreciation also goes out to my sister colleagues at the consortium—Jo-Ellen Asbury, Olga I. Davis, Nikki Stewart, Catherine Ceniza-Choy, Melinda de Jesús, Dionne Stephens, and Nan Wilson-Tagoe—for their enthusiastic reception of my slide presentations.

The body of the text was written while I was a Visiting Scholar at the Women's Leadership Institute at Mills College in Oakland, California. Special thanks are due to Dr. Edna Mitchell, Director of the Institute; Dr. Moira Roth, Professor of Art History; Patricia Shropshire, Associate Dean of Students; Dr. Melinda Micco, Chair of Ethnic Studies; Dr. Faustina Pereira, Visiting Scholar; and Dr. Brinda Mehta, Chair of French Studies.

While living in northern California the welcoming reception from the local Native American community provided me with a new *family* and an even greater appreciation of our diverse native cultures. From the heart, thank-yous to Melinda Micco (Seminole-Creek), Director of Ethnic Studies at Mills College; Sara

Bates (Cherokee), Native American Studies at San Francisco State University; Janeen Antoine (Lakota), Director of San Francisco's American Indian Contemporary Arts Gallery; Sacheen Littlefeather (Apache), Activist and Nutritional Consultant in San Rafael, California; Theresa Harlan (Pueblo), Native American Studies, University of California at Davis; Jack Forbes (Powhatan), Native American Studies, University of California at Davis; Bo-Jack Blackfeather (Coushatta), Director of Native American Lifetime Achievement Awards; Malinda Maynor (Lumbee), Native American Studies, San Francisco State University; and Elizabeth Parent (Alaska Native), Native American Studies, San Francisco State University.

The ability to conceptualize and form *Women Artists of Color: A Bio-Critical Sourcebook to 20th Century Artists in the Americas* or any other creative endeavor is ultimately made possible by higher powers, called by many names. Thank you, Corn Mother, Tonantzin, Isis, Mother Earth, White Buffalo Woman, Spider Woman, Sky Woman, Ixchel, Nut, and all the female deities silenced by religious patriarchy.

<div align="right">Phoebe Farris</div>

INTRODUCTION

Phoebe Farris

When I begin to read a book, I am always curious about what inspired the author to undertake the project. Many colleagues and friends have asked me why and how I initiated this particular research endeavor. I have to confess that the initial idea was not mine originally. Having just completed editing *Voices of Color: Art and Society in the Americas* (Humanities Press, 1997) and waiting for my complimentary author's copies, I looked forward to a temporary break from writing. But I received a phone call from former Greenwood acquisitions editor Alicia S. Merritt, who, having seen *Voices* at a trade convention, wanted to know if I would be interested in writing a biographical dictionary or bio-critical sourcebook on women of color in contemporary Art in the United States, all of the Americas, or worldwide. Alicia sent me a copy of Greenwood's recent book *Women Film Directors: An International Bio-Critical Dictionary* by Gwendolyn Audrey Foster. I enjoyed the book, I still refer to it for research purposes, and I was impressed by Foster's inclusion of women of color film-makers throughout the book.

The proposal I submitted to Greenwood indicated that I would include four racial/ethnic categories (African American, Asian Pacific American, Latin American, and Native American), acknowledging that these "identifiers" can be problematic at times and undergo political changes (black, Negro, Hispanic, Oriental, and American Indian, to name a few variations). Almost a hundred artists are profiled, with approximately one quarter in each category.

I felt qualified to select and write about African American, Latin American, and Native American women artists, having already researched artists from these backgrounds, having lived in communities with these three racial/ethnic groups since childhood, and having come from a bicultural background (Native American/Powhatan and African American). However, I could not meet Greenwood's deadline unless I had the assistance of other writers. Through consultations with colleagues from around the country, I selected Cynthia A. Sánchez, Executive

Director of the State of New Mexico Capitol Art Foundation (recommended by Professor Miguel Gilbert, University of New Mexico), Nadine Wasserman, Curator of Art at Lawrence University Art Department (recommended by Frida High-Tesfagiorgis, University of Wisconsin at Madison), and Kathryn Kramer, Art History Professor at the State University of New York at Cortland. Often they suggested artists I had not considered, and vice versa, and I am pleased with our mutual decisions. Moira Roth, Art History Professor at Mills College, agreed to contribute an afterword.

My knowledge of Asian Pacific American women artists working prior to the 1980s was limited. The Asian American artists I knew personally were either mid career or emerging, and the book needed to cover the entire twentieth century. Professor Dennis Ichiyama, Head of Purdue's Visual and Performing Arts Department, recommended Professor William W. Lew from the University of Northern Iowa. Owing to personal circumstances beyond his control, Lew was unable to complete the entire chapter. Just a few months prior to production time, Melinda L. de Jesús, Asian American Studies Professor at San Francisco State University, Mary-Ann Milford-Lutzker, Art History Professor at Mills College, Reena Jana, art critic for *Asian Art News*, and Kristine C. Kuramitsu, University of California at Los Angeles graduate student, graciously agreed to complete the chapter with additional entries. Unfortunately, time constraints resulted in a shorter chapter than originally expected; but in no way does this imply a scarcity of dynamic Asian American women artists.

It was difficult to choose which artists to include with the limitation of a hundred artists in an entire century and the inclusion of four racial/ethnic categories. My apologies to any living artists and to the families of any deceased artists not included in this work. Letters were sent to living artists, art museums, and artists organizations, requesting résumés and updated information on permanent acquisitions. This book attempts to provide a representative sample of older and/or deceased artists who helped pave the way for future generations; mature, midcareer mainstream artists with national/international reputations; and younger, emerging artists. The media presented range from traditional painting and sculpture to newer forms such as video, conceptual, and performance art. Women who write, sing, paint, or run for political office are called ''women writers,'' ''women singers,'' ''women painters,'' and ''women politicians.'' This terminology reflects the male bias in society and language. There are no ''male artists,'' only ''artists'' and ''women artists.'' Women artists, writers, and so on, are considered representative of all women, whereas men are perceived to be unique individuals. Man is privileged as the ''norm,'' and woman is the ''other.''[1]

This male ''norm'' is also a white norm. Artists, writers, politicians, and others who are not white (regardless of gender) are labeled ''black artists,'' ''Hispanic writers,'' ''Native American politicians.'' Thus, women of color have double labels. My use of the term *women artists of color* is not of my own volition. It is a term imposed on me by a society that is still racist/sexist and

seeks to categorize me and the artists profiled in this book. Until racism and sexism cease to operate in all aspects of life in the Americas, artists who are not white men will continue to be described by their gender and/or ethnicity and be discussed in books such as this.

The historical circumstances of minority and oppressed groups within the Americas have required the initiation of a period of separatism from the majority culture for self-articulation, knowledge of history and heritage, and awareness of unique culture.[2] When we as women in response to sexism/patriarchy are forced to separate ourselves, create our own spaces, write about each other, then we are labeled "essentialists."

When this project began, I was Purdue University's Interim Women's Studies Director and used the term *feminist* in my teaching and writing. It has always been a problematic term for me because much of its discourse excludes men from any positive dialogue and also from—from the very beginning and unfortunately continuing today—the racism that exists within the women's liberation and feminist movements. Although familiar with Alice Walker's term *woman-ist*—that is, a black feminist or feminist of color committed to the survival and wholeness of an entire people, male and female; not a separatist; one who loves struggle, loves the folk; a womanist is to feminist as purple is to lavender[3]—I didn't use it much working in a predominantly white Women's Studies Program. However, my summer residency at the University of Georgia's Womanist Studies Consortium (sponsored by University of Georgia [UGA's] Institute for African-American Studies and the Rockefeller Foundation), during which I interacted with Filipina Asian American, African (via Ghana and London), Canadian Caribbean, and U.S. African American women scholars, increased my commitment to use the term *womanist* more frequently when discussing women of color who are committed to feminism. Although many of the artists in this book lived prior to the 1970s women's liberation and feminist movements, much of their art practices, lifestyles, and political commitments can be considered "womanist." I choose to use this term as a way of honoring those who have passed on to the spirit world and those who are still with us in the struggle.

This book is a modest attempt to rectify the inequality of information on women artists of color. The early feminist art movement of the 1970s prioritized gender over race or class. But "for women artists of color—despite their concerns with women's issues—ethnicity more than gender has shaped their primary identities and often the content of their art."[4] Women artists of color were active participants in the civil rights movement and later the antiwar/peace movements, student movements, and leftist politics. As cultural workers and political activists, it was a time of cultural affirmation and celebration as well as anger and outrage at injustice.[5]

Expressions of early feminism—between 1968 and 1973—took place alongside events like the assassinations of Dr. Martin Luther King, Jr., and Robert Kennedy, the My Lai Massacre in Vietnam, and the U.S.

invasion of Cambodia. The same period witnessed the incarceration and trials of the Chicago Seven, Huey Newton, and Angela Davis, as well as the Attica prison rebellion; student campus protests around the country and the killings at Kent State; the Native American occupation of Alcatraz Island and the confrontation at Wounded Knee. . . . [P]rotests and meetings were announced by posters. The streets were alive with murals, graffiti and slogans. The demonstrations and strategies of the civil rights and antiwar movements were important models for feminists. For many women, protesting was inseparably fused with their identities as artists, critics, and historians.[6]

Women artists of color have expanded the scope of protest art. Working in a myriad of media and styles, they are researching the fusion of past and current history, of gender and race, deconstructing stereotypical mainstream representations of their identities as women and persons of color.

A motif often used in the art of this period was an upraised arm with the hand clenched in a fist. This symbol of struggle for power can be viewed in the 1968 sculpture of African American artist Elizabeth Catlett, *Homage to My Young Black Sisters*. A cedar wooden sculpture, striking in its monumentality and evoking memories of Mexican pre-Columbian art, it "symbolizes women's participation in the global struggle against the subjugation of women of color, engaging the language of struggle in form, iconography, and iconology."[7]

Chicana artist Yolanda M. López reaffirmed identity stimulated by cultural and individual memories in a series of works that thematize La Virgen de Guadalupe. López's series of the Virgen as her grandmother, mother, and herself (dressed in everyday clothes and working) stimulates thought about feminist/womanist struggles within political and nationalistic struggles. In her 1978 *Portrait of the Artist as the Virgen de Guadalupe*, the figure is a youthful Chicana, running toward the viewer, in stark contrast to the traditional, suffering religious icon. "By embodying La Virgen in real lives of Chicanas, López calls attention to idealized representations of women whom she sees as meriting the kind of passion and honor bestowed upon the Virgen. She commands respect through her self-portrait in her activism to take control of her life and her environment."[8]

Often women artists of color also play dual roles as curators, critics, and art historians. Margo Machida, a New York–based Asian American artist, organized the well-received 1991 symposium "(Re)ORIENTING: Self Representations of Asian American Women through the Visual Arts." Participating artists Tomie Arai, Hung Liu, and Yong Soon Min discussed the clichéd images of Asian women in American popular culture, as opposed to their lived realities, and investigated the positions that gender, race, and ethnicity occupy in Asian American women's self-definitions. Machida critiques Tomie Arai's 1988 print *Laundryman's Daughter* as an "immigrant legacy of all Asian women because it emphasizes the close intergenerational ties between them."[9] She contrasts this to the concept of "white feminist critiques of patriarchy and emphasis on in-

dividual independence, which for many Asians is read as a threat to family unity."[10]

Currently, the Native American woman artist with the most national/international exposure is Jaune Quick-to-See Smith (Salish/Flathead). As an artist, curator, lecturer, and political activist, she is a role model for many Native American artists, male and female. Her multimedia paintings, which incorporate sign language, glyphs, pictograms, and collage, are concerned with issues such as the environment, Native American sovereignty, and civil rights. In Quick-to-See Smith's *The Red Mean: Self Portrait* (1992), the traced outline of the artist's own body is drawn out in imitation of the form of Leonardo da Vinci's *The Golden Mean*. Superimposed over the form of Quick-to-See Smith's body is a large red medicine wheel. She has "conflated an outline specifically of her own racially and sexually marginalized Native American female body with that prototypical and stereotypical icon of perfect human proportions so fundamental to patriarchal western culture, the Vitruvian Man."[11]

Many women artists of color such as Elizabeth Catlett, Faith Ringgold, Betye Saar, Frida Kahlo, Lois Jones, Edmonia Lewis, and Helen Hardin were expressing concerns about the intersections of art, gender, race, and politics in their art—sometimes in subtle understatements—long before these issues became "trendy" and articulated by feminists, postmodernists, and poststructuralists.

According to Shifra Goldman, "The leap from modernism to postmodernism was also that from the concept of the artist as a bohemian to the artist as a social thinker; from the microcosm of the studio to society; from art as unigeneric to interdisciplinary; and most important, from culture as a static self-contained system to a dynamic one encompassing multiple territories of thought and action, semiotics, politics, social anthropology, media, education."[12] I would argue that few artists of color (male and female) had the luxury of being "bohemian" and that artists of color were always "social thinkers."

"The 1980s were dominated by poststructuralism adopted by the visual arts from philosophy, literary criticism, anthropology, and the debate on postmodernism. The 1980s witnessed a politicization of cultural workers, along the lines of the liberating aspects of postermodern theory—what can be called a critique of postmodernism or a postmodern discourse of resistance."[13] Goldman cites the writings of Martha Rosler, Lucy Lippard, Laura Mulvey, Craig Owens, Homi Bhabha, Edward Said, Gayatri Chakravorty Spivak, Trinh T. Minh-ha, Cornel West, Audre Lorde, and bell hooks as helping to shape the theories of postmodernism, poststructuralism, and feminism.

One can ask the question, Why is it necessary in 1999 to publish a book titled *Women Artists of Color: A Bio-Critical Sourcebook to 20th Century Artists in the Americas* if postmodernism, poststructuralism, and feminism have "liberated" academia, art, and society as a whole from the rigid boundaries of race, sex, class, and gender? A brief overview of affirmative action and multiculturalism as they apply to the art world is needed to respond to that question.

Affirmative action policies were enacted in the corporate world, which in-

cludes the art world, and in academia in a temporary period of a liberal reform (as I write, these policies are now being dismantled in universities across the United States) that sought to increase "minority" access to the middle class and to repress more radical "minority" voices such as the Black Panthers, the Brown Berets, and the AIM (American Indian Movement). It was during this initial phase of affirmative action that African American, Latino, Native American, Asian American, and Women's Studies Programs proliferated in academia. During the 1980s affirmative action was watered down to a superficial version of multiculturalism. As the term *multicultural* became more mainstream, its initial purpose as a cultural expression of affirmative action was lost and multiculturalism was co-opted as white educational and cultural institutions sought to make profits by securing grants to host so-called multicultural art exhibits, symposia, and artist/scholar residencies. The definition of "multicultural populations" expanded from minority/people of color to include women (often white), gays/lesbians, and the physically disabled/challenged, among others, when institutions realized that huge profits could be reaped by attaching the term *multicultural* to every conceivable category. This is not to slight the real needs and issues affecting women of all races, gays/lesbians, and the physically challenged—but to point out how capitalism seeks to profit from disadvantaged and marginalized groups.

Into this arena walk artists of color and, for the purposes of this book, specifically women artists of color. Women artists of color have had to walk a thin line between so-called co-optation as they enter the mainstream art world and the middle and upper classes and maintaining their artistic, racial, ethnic, and gender integrity and political commitments. University art departments transmit ideology as well as produce artists. They educate future art critics and art historians, thereby creating the components that feed the art market. Financial rewards and status can be inducements to co-optation, accompanied by a change in the artistic ideology reflected in the art work.[14]

Even more so than artists from the dominant society, artists of color have to face harsh economic realities. The ways in which women artists of color attempt to maintain and creatively express their oppositional stances to racism and sexism vary. Many of them bravely refuse to compromise the quality or content of their work for prestige or financial rewards. Whether working for grassroots arts organizations, creating public murals, or working within the establishment as art educators, museum professionals, among others, the women artists profiled in this book maintained their specific community ties and in some cases involved themselves in national/international coalitions with other peoples of color.

Back to my original question, Why is it necessary to publish this kind of book in 1999? The answer: Racism and sexism are alive and well in the art world. Mainstream art exhibits, criticism, and history are still not fully integrated. If books such as this are seen as "ghettoizing" or "essentializing" women artists of color, then my challenge is for the art establishment to go beyond the tokenism of black art exhibits only in February, Native American

exhibits in November in conjunction with Thanksgiving, and multicultural art chapters at the end of the book (back of the bus).

Before the arrival of Europeans to the Americas, Native Americans from Canada to South America honored the Four Directions expressed in the four sacred colors—white, red, black, and yellow—assigned to the four directions. In most indigenous societies the north is represented by white/Caucasians, the south by red/Native Americans, the east by yellow/Asians, and the west by black/Africans. These directions and colors, often placed on a medicine wheel, also have social, personal, and emotional attributes that vary among indigenous nations. In the spirit of Alice Walker's concept of *womanism*, the contributors to this book, women and one man from different races and ethnic backgrounds, came together to research and write about some of the peoples/colors on the medicine wheel that have been ignored, neglected, or silenced. Womanism activates female energy toward empowerment, not only of women but of communities, foregrounding the unity of community so that group mutuality is not attained at the expense of individual affiliations of race, ethnicity, religion, class, or gender.[15]

We, the authors, look forward to receiving critical commentary regarding our artist choices and suggestions for future research. Information on "emerging" artists of color in the Americas and around the world would also be appreciated. The medicine wheel of knowledge is ever turning.

NOTES

1. Frances Bonner and Lizbeth Goodman, eds., *Imagining Women: Cultural Representations and Gender* (Cambridge, United Kingdom: Polity Press/The Open University, 1992).

2. Shifra M. Goldman, *Dimensions of the Americas: Art and Social Change in Latin America and the United States* (Chicago, Ill.: University of Chicago Press, 1994).

3. Alice Walker, *In Search of Our Mother's Gardens: Womanist Prose* (New York: Harcourt, Brace, 1983).

4. Yolanda M. López and Moira Roth, "Social Protest: Racism and Sexism," in Norma Broude and Mary D. Garrard, eds., *The Power of Feminist Art: The American Movement of the 1970's, History and Impact* (New York: Harry N. Abrams, 1994).

5. Ibid.

6. Ibid., p. 141.

7. Freida High-Tesfagiorgis, "Chiasmus—Art in Politics/Politics in Art: Chicano/a and African American Image, Text, and Activism of the 1960's and 1970's," in Phoebe Farris-Dufrene, ed., *Voices of Color: Art and Society in the Americas* (Atlantic Highlands, N.J.: Humanities Press, 1997), p. 150.

8. Ibid., pp. 154–157.

9. López and Roth, "Social Protest: Racism and Sexism," p. 156.

10. Ibid.

11. Erin Valentino, "Coyote's Ransom: Jaune Quick-to-See Smith and the Language of Appropriation," *Third Text: Third World Perspectives on Contemporary Art and Culture* (Spring 1997), p. 35.

12. Goldman, *Dimensions of the Americas*, p. 17.

13. Ibid., p. 38.

14. Ibid.

15. Barbara McCaskill and Layli Phillips, ''We Are All 'Good Woman!': A Womanist Critique of the Current Feminist Conflict,'' in Nan Bauer Maglin and Donna Perry, eds., *Bad Girls/Good Girls: Women, Sex and Power in the 90's* (New Brunswick, N.J.: Rutgers University Press, 1996).

1

NATIVE AMERICAN WOMEN ARTISTS

Phoebe Farris

Native Americans regard art as an element of life, not as a separate aesthetic expression. In aboriginal societies, public life brings together dancing, poetry, and the plastic and graphic arts, uniting them in a single function: ritual as the all-embracing expression of life. Art is indispensable to ritual, and ritual represents the Native American concept of the whole life process.

Aboriginal philosophy does not separate art from healing or spirituality. Most of the healing disciplines originally came from the religious beliefs and practices of spiritual leaders. Trance, dance, painted drums, and painted shields were central to early shamanism, as they are to the continuing practice of this art and of other forms of Indian spirituality today. In the hundreds of Native American languages, there is no word that comes close to the meaning of the Western word *art*. Art, beauty, and spirituality are intertwined in the Native American routine of living. Native Americans freely use symbols of the spiritual and physical worlds to enrich their daily lives and ceremonies. Symbols are protectors and reminders of the living universe, bridging the gap between the spiritual and physical realms. Symbols are used in ritual performances to portray the power of the cosmos.

Five hundred years after the arrival of Columbus in the "New World," the cultural influences acting on Native American art remain varied and complex. Many aesthetic changes have taken place in the twentieth century as native peoples have participated more fully in the dominant culture and incorporated artistic traditions from the United States, Europe, and other parts of the globe into their own traditions. Native American artists are in the process of developing new definitions of Indian art. Any insistence that Indian art remain "traditional" as a way of preserving culture is a form of cultural discrimination, because cultures are dynamic, not static. Although contemporary Native American culture has lost some of its symbolism and rituals because of cultural change and assimilation, its essence remains. Native American thinking has not

ever separated art from life, what is beautiful from what is functional. Art, beauty, and spirituality are intertwined in the routine of living. The Native American aesthetic has survived colonialism, servitude, racial discrimination, and rapid technological change.

Centuries before European colonizers arrived on Turtle Island (the indigenous name for North America), Native American women were producing art in the form of basketry, pottery, quillwork, weaving, and leather painting. Women dug clay for their pots, gathered reeds for weaving, and tanned skins for painting. Indigenous women developed a sensitivity to colors and textures found in nature and related designs to the space and form on which they were placed. Working communally, Native American women learned their crafts from grandmothers, mothers, and aunts.

Contemporary Native American women artists continue to explore precontact art traditions, styles developed during early colonialism/reservation confinement, and newer, experimental art concepts. Their art often functions as social criticism by using content that expresses alienation from Western culture. Whether the work is abstract in form or more representational, it usually has a social context.

This chapter is an attempt to highlight some of the significant twentieth-century Native American women artists, working in a variety of styles, including the so-called traditional Indian painting associated with the Santa Fe Studio of Dorothy Dunn; the Kiowa movement, a flat, shaded treatment of historic native imagery, represented in the work of Pablita Velarde (Santa Clara Pueblo); as well as contemporary photography, performance art, and filmmaking created by artists such as Jolene Rickard (Tuscarora), Muriel Miguel (Kuna/Rappahannock-Powhatan), Malinda M. Maynor (Lumbee), and others.

The 1960s may be considered the turning point when Native American artists began to break away from the so-called white-influenced (D. Dunn) *traditional* painting style and began to develop and define their own visual, written, and performing arts. Like all other aspects of Indian culture, women were in the forefront of this transition, with Helen Hardin, Pablita Velarde's daughter, being a pioneer in the 1970s. The Institute of American Indian Arts (IAIA), founded in 1962, nurtured many women visual artists such as Karita Coffey (Comanche), Phyllis Fife (Creek), Linda Lomahaftewa (Hopi/Choctaw), Roxanne Swentzell (Santa Clara Pueblo), and poet/musician Joy Harjo (Muskogee Creek).

In the 1990s, beginning with the 1992 quincentenary, women artists were represented in outstanding exhibits such as the *Submuloc Show/Columbus Wohs, We're Still Here, Visions from Native America: Contemporary Art for the Year of the Indigenous Peoples*, and *Three Decades of Contemporary Indian Art at the IAIA*.

This chapter cannot discuss all of the Native American women artists who have impacted the twentieth century—only a small percentage. Contemporary Native American women artists with varying visions such as Emmi Whitehorse (Navajo), Kay WalkingStick (Cherokee), Jane Ash Poitras (Cree), Nora Naranjo-Morse (Santa Clara Pueblo), Gail Tremblay (Onandaga/Micmac), Joanna

Osburn-Big Feather (Cherokee), Hulleah Tsinhnahjinnie (Navajo, Seminole, and Creek), Jean LaMarr (Paiute/Pit River), Judith Lowry (Maidu), Shelley Niro (Mohawk), Rose Powhatan (Pamunkey), Sara Bates (Cherokee), Jaune Quick-to-See Smith (Salish/Flathead), and yours truly, Phoebe Farris (Powhatan), just to mention a few, are dealing with issues such as the environment, genocide, native spirituality, racism, and feminism.

Where does the art of Native American women belong in a so-called pluralistic, postmodern, poststructuralist world? In the various *post-ism* worlds, the concept of identity is undergoing profound changes, as is the concept of high/fine art versus low/popular art. Native American women artists and intellectuals, along with Native American men, are in the process of developing new definitions of Native American art and redefining Native American ethnic heritages. Native American women have always been an integral part of the creative vision and continue to contribute to Indian aesthetics independently, in collaboration with other women, and in tandem with Native American men.

AGARD, NADEMA

Indian name: Winyan Luta Red Woman. *Tribal affiliation*: Lakota/Powhatan/Cherokee. *Born*: 1948. Grew up in New York City. *Education*: B.S. in Art Education, New York University, 1970. Aegina Arts Center, Aegina, Greece, Studies in Fine Arts, Music, and Greek, Summer 1972. M.A. in Art and Education (specialization in painting, drawing, and graphics), Teacher's College, Columbia University, 1973. Metropolitan Museum of Art, New York, The Art Heritage of the Spanish Caribbean: Pre-Columbian to Present, Spring 1979. Universita Cattolica di Milano of Rome, Italy, Studies in Italian Renaissance Art and Architecture, Summer 1989. *Family*: One son. Maternal family in New York and the Pamunkey-Powhatan reservation in Virginia. Paternal Agard relatives on the Standing Rock Reservation in the Dakotas. *Career*: Arts Administrator, Museum of the American Indian, New York, 1981–1987. Various positions (teacher, consultant, mentor) with the New York City Board of Education, 1987–1991. Adjunct Professor, Visual Arts and Native American Studies, Bemidji State University, Minnesota, 1991–1993. Multicultural Consultant and Editor, Scholastic Inc. Publishers, New York, 1994–1995. Repatriation Director for the Standing Rock Sioux Tribe in North Dakota and Archival Development Consultant to Sitting Bull College, 1995–1997. *Awards*: National Endowment for the Arts (NEA) Fellowship, 1987–1988. Scholar-in-Residence at the Phelps

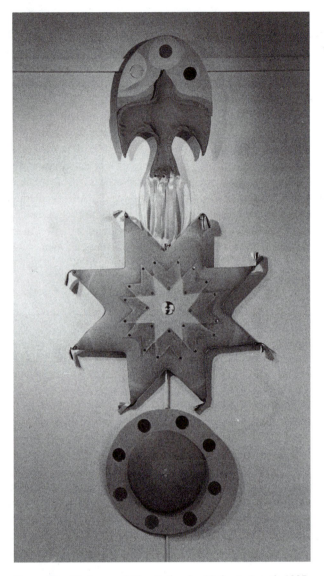

Honor Thy Mother and Thy Father by Nadema Agard, 1997,
mixed-media soft sculpture. Courtesy of artist

Stokes Institute in New York, 1988. Smithsonian Institution American Indian
Museum Studies Scholarship, 1997.

SELECTED EXHIBITIONS

1997 *Frida Kahlo: Modern Portraits of a Modern Icon*, Fraser Gallery,
 Washington, D.C.; *Starblanket Heaven*, Bismarck Art and Galleries

Association, Bismarck, North Dakota (solo traveling show); *Star-blanket Heaven*, George Gustave Heye Center, National Museum of the American Indian, New York (solo traveling show); *Prairie Vision*, American Museum of Natural History, New York; *Piecework: Coast to Coast Quilt Collaboration*, Studio Museum of Harlem, New York

1996 *Native Survival: Response to HIV/AIDS*, Two Rivers Gallery, Minneapolis, Minnesota (traveling exhibit); *Native Survival: Response to HIV/AIDS*, Heard Museum, Phoenix, Arizona; *Native Survival: Response to HIV/AIDS*, Hartwick College, Oneonta, New York

1995 *Native Survival: Response to HIV/AIDS*, Gallery of the American Indian Community House, New York; *Worlds Women On-Line*, United Nations Fourth World Conference on Women in Beijing, China

1994 *Retablos-Latino Icons*, United Community Center Gallery of the Americas, Milwaukee, Wisconsin; *She Is the Four Directions*, Tweed Museum, University of Minnesota, Duluth, Minnesota; *Gathering Medicine*, Coast to Coast Women of Color in the Arts, Art-in-General Gallery, New York

1993 *Visual Arts Faculty*, Talley Gallery of Bemidji State University, Bemidji, Minnesota

1992 *Sacred Door*, Woodland Pattern Gallery, Milwaukee, Wisconsin (solo exhibit); *Manhattan Days—Prairie Daze*, installation and exhibit with Kent Smith, Bemidji Community Art Center, Minnesota

1991 *All Over the Map: Women and Place*, Plains Art Museum, Moorhead, Minnesota

1990 *Ancestors Known and Unknown—Boxworks*, Coast to Coast Women of Color in the Arts, Arts-in-General Gallery, New York

1989 *National Women of Color Artist Book Exhibition*, Coast to Coast, Center for Book Arts, New York

1988 *Riders with No Horse*, C. W. Post College, Brookville, New York

1987 *Riders with No Horse*, Gallery of the American Indian Community House, New York; *Native America: Life, Legend and Art*, Trenton State College, Trenton, New Jersey

1986 *The Artist and the Spiritual Quest*, Women's Caucus for Art Conference, New York; *We Are the Seventh Generation*, Native American Media Corporation traveling exhibit, Atlanta, Georgia; *She Holds Her Own: Transitions and Traditions of Native American Women Artists* (Curator), Greene County Council on the Arts, Catskill, New York

1982 *Native Women Artists*, Gallery of the American Indian Community House, New York; *Native Americans, the Women and Their Art*, New York University Contemporary Art Gallery, New York; *Night of the First Americans*, Atrium Gallery, Kennedy Center, Washington, D.C.

1981 *So the Spirit Flows*, Museum of the American Indian, New York; *At the Edge of the Woodlands*, Native American Center for the Living Arts, Niagara Falls, New York

PUBLICATIONS

Agard, Nadema. "Art as a Medium for Countering Race Stereotypes." *Council on Interracial Books for Children* 2, no. 8 (1980).

Agard, Nadema. "Art as a Vehicle for Empowerment." In Phoebe Farris-Dufrene, ed., *Voices of Color: Art and Society in the Americas*. Atlantic Highlands, N.J.: Humanities Press, 1997. pp. 55–64.

Agard, Nadema. *Selu and Kana' Ti: Cherokee Corn Mother and Lucky Hunter*. New York: Mondo, 1997.

Agard, Nadema, ed. *Southeastern Native Arts Directory*. Bemidji, Minn.: American Indian Studies Department, Bemidji State University, 1993.

Artwork. *Virgin of Guadeloupe Is the Corn Mother*. Published in *World's Women On-Line*, by Muriel Magenta. Institute for Studies in the Arts, Arizona State University, Tempe. http://www.asu.edu/wwol

Artwork published in *Arts International*, by Book Art Press. On CD-ROM and the Internet. Woodstock, N.Y., 1996. http://www.bookart.com

Parker, Janet. "Teachers Who Made a Difference: Nadema Agard-Smith." *Art Beat* 14, no. 5 (May–June 1992).

ARTIST STATEMENT (1994)

In my work as an artist, I create metaphors for the cosmic relationships between the sacred feminine and the sacred masculine. Only in the understanding of how one defines the other can the empowerment of women also empower men. When these sacred feminine images—the doors where one emerges from the spirit world to this material existence—are respected, only then can there be harmony. These are the teachings of our tribal wisdom. The circle and the four directions, or the medicine wheel, is a symbol that inspires my works and installations to express the relationship of male and female in perfect harmony. In *Manhattan Days, Prairie Days*, a large duo installation, the works of the male artist are installed in a circle around the central cross where my works are placed in the four directions. A solo installation of my works, *She Is the Four Directions—Transformational Crosses as Sacred Symbols of Life*, explains the male and female relationship as time and space. Time is male, and the circle, while space, is the directional cross and female. What is matte complements gloss; what is light complements dark; and what is hard contrasts soft. Vertical and phallic hierarchical forms are in balance with horizontal and nonhierarchical yoni forms. Such a balance is inspired by the traditional manner in which a man carves the bowl of the sacred pipe, which represents the female part of the universe, and the woman decorates the stem of the pipe, which represents the male counterpart. In *She Is the Four Directions*, a woman creates the work, and

a man does the installation. This is the balance and the wisdom of the traditional elders.

As a contemporary or modern indigenous woman in the eyes of the Western world, my work appears nontraditional. However, taking a closer look, with a spiritual or heart vision, one will realize the spirit of the work derives much strength from the traditional arts and cosmologies of the native peoples of Mesoamerica, the Southwest, the Plains, the Southeast, the Northeast, and the Great Lakes Woodlands. This eclectic vision is part of my intertribal ancestral reality that draws its roots from the Southeastern Woodlands and the Northern Plains and traces these to one tribal origin of all native peoples of the Western Hemisphere.

BIOGRAPHICAL ESSAY

Nadema Agard is an artist, educator, author, museum professional, repatriation consultant, and most recently, performance artist/comedienne. She uses all of these roles to enhance and proliferate multicultural/Native American art. Adapting to new challenges and new worldviews while still maintaining her indigenous perspectives is one of Nadema's strengths.

Through her visual art, public lectures, and writing, Nadema perpetuates her ideas of art made for reflection and healing rather than art made for power. Her art expresses the belief that visual form is the language of tribal people for most of their sacred teachings. Nadema perceives the arts as a visual vocabulary, serving the artists the way that dictionaries and encyclopedias serve Western literate societies. Viewing her art as a vehicle for her spirituality, Nadema creates works as visual prayers/offerings.

As a syncretist with a Pan-Indian view of native art/religion/culture, Nadema incorporates symbolism from a variety of native cosmologies—the Southwest, the Plains, the Southeast, the Northeast, the Great Lakes Woodlands, and Mesoamerica. In the early 1990s much of Nadema's paintings, transformational boxes, and installations honored the belief systems of Mesoamerica, that is, the syncretism of the Aztec and Catholic religions now practiced by Mexican Indians, Mexican mestizos, and U.S. chicanos. Nadema's *The Virgin of Guadeloupe Is the Corn Mother* (42" × 60" acrylic/canvas mixed media) addressed the image of the Virgin of Guadeloupe as also Tonatzin (Aztec mother of God). The Aztec adaptation to Catholicism ensured the hidden survival of Aztec beliefs. Nadema describes this piece as demonstrating the power of tribal art as a "vehicle for cultural and political resistance and a spiritual grounding for a world that has become unbalanced."

Nadema's newer series produced in the late 1990s, *Starblanket Heaven*, is dedicated to her paternal Agard family on the Standing Rock reservation. The star motif of the art works is based on the star blankets, or morning star quilts. The star, an ancient Lakota symbol, is also sacred to Christians as the star that guided the Wise Men to the infant Jesus. When converting to Catholicism, the

Lakota adapted the star quilts of the missionaries as a way to continue their own religious ceremonies. The traveling exhibit consists of soft sculpture pieces, mixed media, and pastels. The colors used throughout the show relate to the four directions and the four races of humanity; north is white/Caucasian, south is yellow/Asian, east is red/Native American, and west is blue or black/African, as believed by the Lakota peoples. The images and colors in *Starblanket Heaven* also reflect the morning sky of North Dakota, the sunrise across the prairies. This work was completed while Nadema was the Repatriation Director for the Standing Rock Sioux Tribe in North Dakota and had an opportunity to directly experience the Great Plains culture of her father's people. The show served as a bridge from her family on the reservation to her urban Indian family in New York.

In addition to an active exhibition record, Nadema is also widely sought as a lecturer and consultant for organizations such as the American Indian Tribal College Fund, the Museum of Natural History in New York, the United Nations Women's Guild, the National Association of Bilingual Education, and various universities. An artist/scholar with what she calls a *multivision*, Nadema hopes that her work will promote balance and respect for all religions, all races, all cultures, male and female.

BATES, SARA

Tribal affiliation: Cherokee. *Born*: 1944, Muskogee, Oklahoma. *Education*: B.A., Fine Art/Studio and Women's Studies, California State University, Bakersfield, 1987. M.F.A., Sculpture and Painting/Intermedia, University of California, Santa Barbara, 1989. *Family*: Daughter, Daphne Dukate, born 1967. Married Hansel Cancel, 1990. *Career*: Cherokee Nation Artist-in-Residence, Department of Education, Cherokee Nation, Tahlequah, Oklahoma, 1988–1990, summers. Artist-in-Residence, UCLA Artsreach, Los Angeles, California, 1989–1990. Director of Exhibitions and Programs/Curator, American Indian Contemporary Arts, San Francisco, California, 1990–1995. Artist-in-Residence, Headlands Center for the Arts, Sausalito, California, 1992–1993. Instructor, Native American Studies—Contemporary Native American Art, San Francisco State University, California, 1995 to present. Instructor, Contemporary Native American Art, University of California, Berkeley, Extension, 1996. Artist-in-Residence, Florida State University, Tallahassee, Florida, spring 1998. *Awards*: San Francisco Art Commission, Cultural Equity Grants Program: Individual Art-

Honoring by Sara Bates, 1993, 12 feet in diameter, mixed media installation.

ist Grant, 1997. Public Art Program: Market Street Art in Transit/Kiosk Poster Series Project, San Francisco, California, 1997.

SELECTED EXHIBITIONS

1997 *Honoring Our Sacred Earth, The Unexpected West Series*, Eiteljorg
 Museum of American Indian and Western Art, Indianapolis, Indi-
 ana: *Affinities and Influences, "Honoring Series" Installation*, Neu-
 berger Museum of Art, Purchase College, SUNY, Purchase, New
 York

1996 *Beyond the 95th Meridian: Indian Territory 1996, Native Artists
 Group Invitation, "Honoring" Series Installation*, University of
 Tulsa, Tulsa, Oklahoma; *Native Streams, "Honoring" Series Instal-
 lation*, Holter Museum of Art, Helena, Montana (May 1996); *Native
 Streams, "Honoring" Series Installation*, Turman Art Gallery, In-
 diana State University, Terre Haute, Indiana (March 1996); *Native
 Streams, "Honoring" Series Installation*, Jan Cicero Gallery, Chi-
 cago, Illinois (January 1996); *Artist-in-Residence School Program,
 "Honoring" Series Installation*, Eiteljorg Museum of American In-
 dian and Western Art, Indianapolis, Indiana

1995 *"Honoring" Series Installation with 60 Children in Lille*, Lille Art
 Festival, Lille, France; *Experiencing into Art Annual Invitational,*

"Honoring" Series Installation, Crocker Art Museum, Sacramento, California

1994 *The Native American Program "Honoring" Series Installation*, Palazoo delle Esposizioni, Rome, Italy; *In the Spirit of Nature: Coming Home, "Honoring" Series Installation*, San Jose Museum, San Jose, California

1993 *Toi te Aotearoa World Celebration of Indigenous Art and History, "Honoring" Series Installation*, Te Taumata Gallery, Auckland, New Zealand; *Utopian Dialogues, "Honoring" Series Installation*, Los Angeles County Municipal Gallery, California; *A Kindred Spirit, "Honoring" Series Installation*, Bedford Gallery/Regional Center for the Arts, Walnut Creek, California; *Migration of Meaning, "Honoring" Series Installation*, Lehigh Art Galleries, Bethlehem, Pennsylvania (toured Pittsburgh Center for the Arts, Pennsylvania, INTAR Gallery, New York City, and Long Island University, New York)

1992 *Native American Land Issues, "Honoring" Series Installation*, Pro Arts Gallery, Oakland, California

1991 *Spirit as Source*, Bade Museum, Pacific School of Religion, Berkeley, California

1990 *One Woman Exhibition*, San Francisco College of Oriental Medicine, California

1988 *Group Exhibition*, UCEN Gallery, University of California, Santa Barbara, California

1986 *Artist as Shaman*, The Women's Building, Los Angeles, California

SELECTED COLLECTION

Whittier Graphics, Inc., Whittier, California

SELECTED PUBLICATIONS

Bates, Sara. "Essay." In W. Jackson Rushing, ed., *20th Century Native American Art: Essays on History and Criticism*. London: Routledge, 1997.

Bates, Sara. *Indian Humor*. San Francisco: American Indian Contemporary Arts, 1995.

Bates, Sara. *The Spirit of Native America: A Cultural Presentation of the U.S.A.* San Francisco: American Indian Contemporary Arts, 1993.

Bates, Sara, ed. *Dancing Across Time: Images of the Southwest*. San Francisco: American Indian Contemporary Arts, 1995.

Chase, Margaret, ed. *"Honoring Circles."* In *New Art*. New York: Harry N. Abrams, 1997.

Collischan, Judith. *Link of Abstraction and Spiritualism*. Montclair: Montclair Museum of New Jersey, 1997.

Complo, Jennifer. "Sara Bates." In Roger Matuz, ed., *Native North American Artists*. Detroit: St. James Press, 1998. pp. 47–50.

Kissick, John. "The Independent Voice of the Visual Arts." *New Art Examiner* (March 1993).

Nixon, Bruce. "Fixing the Earth: Interview with Sara Bates." *Artweek* (1993).

Robertson, Jean. "Sense of Place." *Surface* 21, no. 4 (Summer 1997).

ARTIST STATEMENT (1996)

These *Honoring* pieces center on the traditional worldview of my tribe, the Cherokee. They represent how I, as one Cherokee, experience this worldview in my everyday life. They are what I hold sacred. This worldview honors our mutual dependency with the natural world. I know this relationship is reciprocal, and it is sacred.

We are all unique and on a different path. To know our path we must follow the way of relationship with all living things if we are to survive and continue as Human Beings. This is the way to live in a good way.

Postmodern science has declared that everything is composed of a subatomic flux of wavelets and particles, chaos and pattern, all boundaries are fluid, possibilities are endless, and the separation many Human Beings feel is an illusion. We are all related—birds, animals, plants, trees, earth, wind, fire, water, and all Human Beings. Every molecule in our bodies participates in this relationship and exhibits beauty. Interconnectedness is reality. Process and participation are everything. Experiential knowledge of the interconnectedness of the natural world is far more than a decorative component to intellectual comprehension of scientific observations. Experiencing this connectedness through subtle awareness can test the conceptual knowledge and move understanding to a place beyond linear concepts.

I connect and honor these fluid relationships by participating in gathering and *Honoring* what I have come to know and value. My images are an expression of that process. What disturbs me sometimes is the dialogue I hear quite often in the art world about everything being socially or culturally produced through discourse. And without this discourse, we can't access each other's work. This is true of some things but not all things. While you may not completely understand the infusion of tribally specific symbols that come from Cherokee Stories, legends, songs, dances, prayers, and architecture, you can understand them as part of the symbolized reality itself. Symbols reveal the accumulation of knowledge and wisdom, regardless of whether the artist is working on the conceptual, realistic, or spiritual level, and there is an acceptance that all these levels exist both independently and simultaneously. I believe you can access the *Honoring* because you are a Human Being and are related to all beauty the Earth exhibits and are connected through every part of your body. This is a natural gift that we as Human Beings have been given.

Language, art, religion, laws, technology, ethics, values, forms of education, and other institutions are all important parts of what constitutes a living community. No matter who we are, we are part of the community. Community is

the natural context of human life and activity; we are all social beings, living in relationship with one another and the natural world.

I hope my efforts to share what I know through expressions of my tradition inspire you to investigate and participate in the sacred relationship we have with the Earth and in some way contribute to our shared understanding of community.

BIOGRAPHICAL ESSAY

To encounter one of Sara Bates's *Honoring* installations is to step into a world that is serene, timeless, contemplative, alive, and global. To talk to Sara Bates about her *Honorings* is to listen to a seer, to be in the presence of a woman connected to her Cherokee traditions and to the twentieth century. To walk around her circular, ground-level installations is akin to walking around a mandala or a medicine wheel—an experience spiritual and aesthetic.

Composed of leaves, seeds, berries, pine cones, sand, flower petals, clay, feathers, and shells, these natural materials are usually laid on the floor in an 8- to 12-foot circular design, with the center in an equal-arm cross, the arms oriented toward the four cardinal directions. Starting from the center, Sara makes concentric and radial patterns, filling the patterns with a variety of colors and textures. The outer perimeters usually have radiating elements such as quills and seashells alternating with triangles of corn, berries, and petals.

Sara gathers her recyclable materials from her travels to other countries, her ancestral home in Oklahoma, her current place of work/residence, San Francisco, and the local environments where she is commissioned to do an *Honoring*. Each *Honoring* only lasts for a few weeks or months and is disassembled, packed into four small boxes, and saved for the next exhibit. Although the *Honorings* she has created over the years have many similarities, each one is a unique experience, requiring prayers and permission from the spirit world to take these objects from nature and transform them.

The symbolism involved in Bates's choices of colors, directions, objects, and so on, center on the Cherokee worldview of the interconnectedness of the natural world and the need for harmony between humans, animals, and nature. But the viewer does not have to be Cherokee or Native American to appreciate, understand, and be moved by these constructions that are both tribally specific and *universal*/global.

In her most recent *Honoring* (at the writing of this book) at the Eiteljorg Museum of American Indian and Western Art, the installation was created as part of an artist-residency program to work with children. In this installation Sara used leaves from the grounds of San Francisco State University to honor students who graduated from the Native American Studies Program, pine cones from a tree in her Oklahoma family home, and dried magnolia from the former Cherokee female seminary in Oklahoma to honor the Cherokee women from that era. The center of the design included a miniature elevated structure, symbolic of a Cherokee family arbor or a clan bed that surrounds the sacred fire.

This author watched as children as young as five or six walked silently around the circle and quietly sat around the perimeter without touching any of the delicate objects.

With her *Honorings*, Sara Bates is able to assist us in *slowing down* and finding a quiet place within ourselves to contemplate what is often taken for granted. We cannot purchase her art or frame it on a wall. We can only possess the experience of its memory.

CHALEE, POP (Merina Lujan)

Tribal affiliation: Taos Pueblo. *Born*: 1906, Castle Gate, Utah. Birth name Merina Lujan. Pop Chalee means "Blue Flower." *Education*: In the 1920s attended Santa Fe Indian School. In the 1930s attended Dorothy Dunn's Studio at the Santa Fe Indian School. *Family*: Her mother was East Indian and her father Taos Pueblo. Married Otis Hopkins; two children, Jack and Betty. Remarried to Edward Lee Ntay, a Navajo businessman. Niece of Mabel Dodge-Luhan, Anglo art patron. *Career*: Muralist commissioned by the Albuquerque International Airport, Roswell and Santa Fe Airports, the Santa Fe Railroad, New Mexico State Capitol Building, Mackinac Island, Michigan, and the General Holmes House in La Cienaga, California. Also worked in radio, for the motion picture industry, and as an art instructor and lecturer. *Awards*: Grand Award, Inter-tribal Indian Ceremonials, Gallup, New Mexico, 1938. Governor's Award for Excellence and Achievement in the Arts, State of New Mexico, 1990. "Horse Trails Show," Museum of Natural History, Albuquerque, New Mexico, third place, 1991. Woman of Distinction Award from the New Mexico Democratic Party, 1992. *Died*: 1993, New Mexico.

SELECTED GROUP EXHIBITIONS

1994	*Watchful Eyes: Native American Women Artists*, Heard Museum, Phoenix, Arizona
1992	Museum of Natural History, Albuquerque, New Mexico
1991–1992	*Shared Visions: Native American Painters and Sculptors in the Twentieth Century*, Heard Museum, Phoenix, Arizona
1991	*Miniatures*, Albuquerque Museum, New Mexico
1990	Academy of Sciences, San Francisco, California
1988	*When the Rainbow Touches Down*, Heard Museum, Phoenix, Arizona

1984–1985	*Indianascher Kunstler* (traveling, Germany), organized by the Philbrook Museum, Tulsa, Oklahoma
1982	*Night of the First Americans*, Kennedy Center for the Performing Arts, Washington, D.C.
1981	*Walk in Beauty*, Santa Fe Festival of the Arts, New Mexico
1978	*100 Years of Native American Painting*, Oklahoma Museum of Art, Oklahoma City, Oklahoma
1975	*Saunders Collection*, Heard Museum, Phoenix, Arizona
1971	*Bimsom Collection of Western Art*, University of Arizona Museum of Art
1965	*Second Annual Invitational Exhibition of American Indian Paintings*, U.S. Department of the Interior, Washington, D.C.
1964	Read Mullan Gallery of Western Art, Phoenix, Arizona
1953	National Gallery, Washington, D.C.
1940	Northwestern University, Chicago, Illinois
1939	Los Angeles Museum, Los Angeles, California; New York World's Fair, New York; Golden Gate Exposition, San Francisco, California
1938	*Inter-Tribal Ceremonial*, Gallup, New Mexico; Chicago Art Institute, Chicago, Illinois
1937	*American Indian Exposition and Congress*, Tulsa, Oklahoma; Museum of Fine Arts, Santa Fe, New Mexico; The Water Color Gallery, Goose Rock Beach, Maine

FILM

1975	*Painting at the Heard*, PBS video. This film represents paintings found at Heard Museum, including Pop Chalee's work.

SELECTED COLLECTIONS

Amerind Foundation, Dragoon, Arizona; Arizona State Museum, University of Arizona, Tucson; Denver Art Museum, Denver, Colorado; Eiteljorg Museum of American Indians and Western Art, Indianapolis, Indiana; Heard Museum, Phoenix, Arizona; Joslyn Art Museum, Omaha, Nebraska; Millicent Rogers Foundation Museum, Taos, New Mexico; Montclair Art Museum, Montclair, New Jersey; Museum of New Mexico, Santa Fe; Philbrook Museum of Art, Tulsa, Oklahoma; School of American Research, Santa Fe, New Mexico; Smithsonian Institution, Washington, D.C.; Southeast Museum of the North American Indian, Marathon, Florida; Southwest Museum, Los Angeles, California; Stanford Fine Arts Museum, Stanford, California; Thomas Gilcrease Institute of American History and Art, Tulsa, Oklahoma; University of Oklahoma, Norman; Wheelwright Museum of the American Indian, Santa Fe, New Mexico

PUBLICATIONS

Archuleta, Margart, and Rennard Strickland. *Shared Visions: Native American Painters and Sculptors in the Twentieth Century*. New York: New Press, 1991.

Broder, Patricia. *American Indian Painting and Sculpture*. New York: Abbeville Press, 1981.

Brody, J. J. *Indian Painters and White Patrons*. Albuquerque: University of New Mexico Press, 1971.

Cesa, Margaret. *The World of Flower Bloom*. Santa Fe, N.M.: Museum of Fine Arts, 1997.

Dunn, Dorothy. *American Indian Painting of the Southwest and Plains Area*. Albuquerque: University of New Mexico Press, 1968.

Gully, Anne, ed. *Watchful Eyes: Native American Women Artists*. Phoenix, Ariz.: Heard Museum, 1994.

Heller, Jules, and Nancy Heller, eds. *North American Women Artists of the Twentieth Century: A Biographical Dictionary*. New York: Garland, 1995.

Hoffman, Gerhard. *Indianascher Kunstler*. Munich, Germany: 1984.

Hoffman, Gerhard, and Gisela Hoffman. "Pop Chalee." In Roger Matuz, ed., *Native North American Artists*. Detroit: St. James Press, 1998. pp. 465–467.

Jacobson, Oscar B. and Jeanne D'Ucel. *American Indian Painters*. Nice, France: 1950.

Silberman, Arthur. *100 Years of Native American Painting*. Oklahoma City: Oklahoma Museum of Art, 1978.

Van Ness Seymour, Tryntje. *When the Rainbow Touches Down*. Seattle and Phoenix: University of Washington Press and the Heard Museum, 1988. Exhbn cat.

BIOGRAPHICAL ESSAY

Pop Chalee (Blue Flower) is of East Indian (mother) and Taos Pueblo (father) heritage. Having lived in both Utah and Taos Pueblo, her creative influences, love of nature, and keen sense of design can be attributed mainly to her Taos Pueblo tribal heritage. But there are also elements of East Indian Asian aesthetics in her work. Other family influences include exposure to Anglo artists through her aunt, Mabel Dodge, an art patron. Pop Chalee's knowledge of the history and culture of other southwestern tribes can be partly attributed to her father's job as John Collier's interpreter throughout the Southwest.

As a 1930s student of Dorothy Dunn at The Studio, located in the Santa Fe Indian School, Pop Chalee was educated in the flat, two-dimensional, so-called traditional style of Native American painting. This flat, shaded treatment of historic native imagery became identified in the public's mind as "real Indian art" and is associated both with the Santa Fe Studio of Dorothy Dunn and the "Kiowa movement," originating in Oklahoma with the institutional support of Bacone College in Muskogee, Oklahoma, and the Philbrook Art Center in Tulsa, Oklahoma.

Operated by the Bureau of Indian Affairs, The Studio was the first school to encourage Native Americans to pursue art as a career. Visited by Walt Disney, students were recruited for jobs in the Disney studio as animators. One of Pop Chalee's 1936 forest scene paintings with stylized deer was purchased by Disney, inspiring him to create the well-known Bambi deer character for his films.

After her 1937 graduation, Pop Chalee and her contemporaries Awa Tsireh,

Joe H. Herrera, Pablita Velarde, Harrison Begay, and Popovi Da were commissioned as muralists for Maisel's Trading Post in Albuquerque, New Mexico. It was through her mural of an imaginary forest scene that Pop Chalee received notoriety. She continued this theme in subsequent murals and in easel paintings.

A dark background, imaginary species of trees, deer as the central figures, families of other animals such as birds, rabbits, squirrels, skunks, and bears, scattered flowers, and personalized color combinations are the standard formulas for Pop Chalee's forests. Although many critics and art historians note the resemblance to painting techniques found in India, Pop Chalee maintains the primary of Taos nature, wildlife, and religion as her strongest influences. A color plate of *The Enchanted Forest* was included in the catalog for the *Night of the First Americans* 1982 exhibit at the Kennedy Center in Washington, D.C.

Pop Chalee's 1940's Albuquerque Airport murals were restored by art conservationists under Pop Chalee's direction and in 1990 were relocated to the Great Hall in the new Albuquerque International Airport. Her Santa Fe Railroad mural *Shalokos* was relocated to the Millicent Rogers Museum in Taos, and several other of her early murals have been restored and placed in newer facilities.

Other subject matter includes scenes of ceremonies, rituals, everyday life, and masks. Pop Chalee also painted a series of mythological horses based on a Taos Pueblo myth of a beautiful white stallion who left a line of famed offspring to lighten the burdens of the Taos Indians. These horses are immortalized in paintings such as *Wild Horses* (31" × 25" watercolor) and *Mythical Horse* (31" × 25" watercolor). With extremely long manes and tails, exaggerated features, and nontraditional colors such as mustards, magentas, turquoises, and lavenders, the effect is very theatrical.

Pop Chalee's flair for the dramatic also expressed itself as a promoter for the film *Annie Get Your Gun* as she toured American cities dressed in white with elaborate Indian jewelry and as an animated lecturer, storyteller, and singer on a Phoenix radio program and for Voice of America. Pop Chalee's beauty and flair were celebrated in the works of other artists such as Paul Coze, Quincy Tohoma, George Blodgett, T. Harmon Parkhurst, Andy Anderson, Louise Crow, Sallie Green, Charles Polowetski, Zahara Schatz, and Will Shuster.

During World War II, Pop Chalee and her first husband, Otis Hopkins, worked at Los Alamos for the secret Manhattan Project. She was awarded a War Department citation for her efforts in helping end the war through her work with the children of the Project's employees. Pop Chalee also taught rehabilitation art classes for soldiers at Anthro Lab, Bruns Hospital. Her second husband, Edward Lee Natay, was a Navajo medicine man, singer, and radio celebrity who toured with her on the Santa Fe Railroad to promote MGM's *Annie Get Your Gun*.

Pop Chalee lived life to the fullest, active as an artist all of her life and never letting her age interfere with her creative pursuits. She left a legacy through her numerous exhibits, murals, and works in public and private collections.

FARRIS, PHOEBE

Tribal affiliation: Powhatan-Renape. *Born*: 1952, Washington, D.C. *Education*: B.A. in Fine Arts, City College of City University, New York, 1975. M.P.S. in Art Therapy, Pratt Institute, New York, 1977. Ph.D. in Art Education, University of Maryland, College Park, 1988. *Family*: Daughter of Phoebe Mills Lyles, antiques collector and real estate investor. Mother of Sienna Farris, public relations consultant for arts and media organizations. Member of an extended family of 28 arts professionals, including her aunt, painter Georgia Mills Jessup. *Career*: Art Therapist, Special Education Department, Washington, D.C. Public Schools, 1978–1989. Assistant Professor at Purdue University, 1989–1995. Associate Professor of Visual and Performing Arts/Women's Studies, Purdue University, 1995–present. Independent consultant for Native American and multicultural institutions. Private art therapy practice. *Awards*: National Endowment for the Humanities, Newberry Library Scholar, summer 1990. Purdue Research Foundation International Travel Grant (Cuba), 1991 and 1993. Midwestern Universities Consortium International Travel Grant (Brazil), spring 1992. Fulbright Grant American Republics Research Program (Mexico), summer 1992. National Art Education Association Multiethnic Faculty Fellowship, spring 1993. Rockefeller Humanities Fellowship, University of Georgia Womanist Studies, Visiting Scholar, summer 1997. Women's Leadership Institute, Mills College, Oakland, California, Visiting Scholar, fall 1997.

SELECTED EXHIBITIONS

1999–2000	*Women Artists of Color in the Americas*, Dowd Fine Arts Center, SUNY, Cortland, New York (co-curator)
1997	*Voices of Color*, Union Gallery, Purdue University, West Lafayette, Indiana (co-curator); *Illusions, Mirages, and the Mind's Eye*, Stewart Center Gallery, Purdue University
1995	*Women Artists of Color* (video), National Women's Caucus for Art, Fourth United Nations World Conference on Women, People's Republic of China
1994	*Synthetic Union*, Greater Lafayette Museum of Art, Lafayette, Indiana (co-curator)
1990–1994	*Visual and Performing Arts Faculty Exhibits*, Stewart Center Gallery, Purdue University
1990	*Washington-Moscow Exchange*, Tretyakov State Gallery, Moscow,

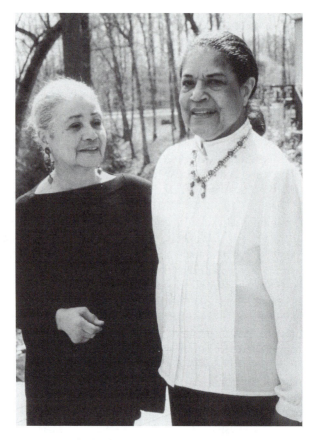

Beatrice and Phoebe Mills (Powhatan) by Phoebe Farris, 1994.

	Russia: *Women's Caucus for Art*, Soho New York Viewing Room Gallery, New York
1987	*Three Washington Photographers*, Market Five Gallery, Washington, D.C.; *Women's Caucus for Art*, Castillo Gallery, New York
1986	*Women's Caucus for Art*, Aaron Davis Hall, City College, New York
1984	*W. D. Printmakers*, Art Barn Gallery, Rock Creek Park, Washington, D.C.
1983	*Emerging Artists*, Lansburgh's Cultural Arts Center, Washington, D.C.
1982	*Family Re-Union*, Market Five Gallery, Washington, D.C.
1981	*W. D. Printmakers*, NOA Gallery, Washington, D.C.

SELECTED PUBLICATIONS

Directory of People of Color in the Visual Arts. College Art Association, New York, 1994. Directory listing.

Dufrene, P. "Art as Technology: The Arts of Africa, Oceania, Native America, Southern California." *Art Therapy* 8, no. 1 (1991), pp. 29–31.

Dufrene, P. "Art Therapy in Mexico from a Mexican Perspective: Five Viewpoints." *Art Therapy* 10, no. 3 (1993), pp. 39–43.

Dufrene, P. "A Comparison of the Traditional Education of Native American Healers with the Education of American Art Therapists." *Art Therapy* 8, no. 1 (1991), pp. 17–24.

Dufrene, P. "Contemporary Powhatan Art and Culture: Its Link with Tradition and Implications for the Future." In *Papers of the 22nd Algonquian Conference*. Ottawa, Canada: Carleton University Press, 1991. pp. 125–136.

Dufrene, P. "Encuentro Latinoamericano sobre enseñanza artistica." *INSEA News* 1 (1994), p. 15.

Dufrene, P. "Exploring Native American Symbolism." *Journal of Multicultural and Cross-cultural Research in Art Education* 8, no. 1 (1990), pp. 38–50.

Dufrene, P. "Report on Art Therapy in Brazil." *INSEA News* 2–3 (1992), p. 18.

Dufrene, P. "Through Our Own Eyes: Popular Art and Modern History." *Studies in Art Education* 31, no. 4 (1990), pp. 253–255.

Dufrene, P. "Utilizing the Arts for Healing from a Native American Perspective: Implications for Creative Arts Therapies." *Canadian Journal of Native Studies* 10, no. 1 (1990), pp. 121–131.

Dufrene, P. "A Visit with Elizabeth Catlett." *Art Education* 47, no. 1 (1994), pp. 68–72.

Dufrene, P., and V. D. Coleman. "Art Therapy with Native American Clients: Ethnical and Professional Issues." *Art Therapy* 11, no. 3 (1994), pp. 191–193.

Farris, P. "Decoding Visual Politics: A Review of Art on My Mind: Visual Politics and English Is Broken Here: Notes on Cultural Fusion in the Americas." *Art Journal* 55, no. 3 (1996), pp. 91–93.

Farris-Dufrene, P. "Art, Visual (to 1960)." In *Encyclopedia of North American Indians*. Boston: Houghton Mifflin Company, 1996. pp. 45–50.

Farris-Dufrene, P. ed. *Voices of Color: Art and Society in the Americas*. Atlantic Highlands, N.J.: Humanities Press, 1997.

Farris-Dufrene, P., and V. Coleman. *Art Therapy and Psychotherapy: Blending Two Therapeutic Approaches*. Washington, D.C.: Taylor & Francis, 1996.

Southeastern Native Arts Directory. Bemidji State University, Bemidji, Minn., 1993. Directory listing.

Women of Color Slide Registry. Women's Caucus for Art, 1995. Directory listing.

ARTIST STATEMENT (1998)

The dominant images of Native Americans, past and present, tend to focus on two geographical/culture areas, the Plains and the Southwest. These images become fixed in the American media as "typical" physical cultural characteristics. Native American images east of the Mississippi River are often ignored.

These concerns have led me to use photography as a means of documenting various aspects of Native American culture found in the eastern United States and in the Caribbean. I am especially interested in those nations on the Atlantic Coast who had early contact with Europeans, Africans, and "free people of color" (a broad category usually including, for lack of better terms, mulattoes

or racially mixed nonwhites) and absorbed aspects of those outside cultures while still maintaining a firm Native American identity.

My research interests have also included travels to the Caribbean where the Taino and Carib cultures/people have supposedly "disappeared" or been totally absorbed into the Spanish and African cultures. Travel experiences to racially mixed, culturally diverse indigenous communities help expand the evolving Native American aesthetic. Interaction with eastern nations such as the Lumbee, Shinnecock, Narragansett, Houma, Haliwa-Saponi, Piscataway, Lenni-Lenape, Pequot, and the Powhatan Confederacy, which are usually ignored in literature on contemporary Native American art, can help in the revitalization of those cultures. Straight documentary photography of these people and their culture as they exist in contemporary society is the best way that I can use my art to reaffirm a native heritage that Euro-Americans claim is "extinct" or just a "remnant" culture. Although many of us were forced to give up our traditional languages and spiritual belief systems, our cultures still thrive through the arts, land bases in state-recognized reservations, and participation in Pan-Indian events.

My current photo/research project involves using photographs of family members found in the Smithsonian Native American Photography Archives and juxtaposing them with photos of living relatives into a multimedia collage format. These relatives were photographed on the Pamunkey Reservation in the early 1900s by anthropologists researching Southeastern American Indians. This project also involves photodocumentation of grave sites on the Pamunkey Reservation.

The ability to conceptualize my photo series or any other creative endeavor is ultimately made possible by a higher power, called by many names. Thank you, Corn Mother, Tonantzin, Mother Earth, White Buffalo Woman, Spider Woman, Sky Woman, and Great Spirit.

BIOGRAPHICAL ESSAY

Phoebe Farris is an Associate Professor of Art and Design/Women's Studies at Purdue University in West Lafayette, Indiana, where she teaches courses in gender and multiculturalism, feminist art criticism, art education, art therapy, and art and design; serves on doctoral dissertation committees; and conducts research on multicultural/gender issues in art. Farris has published extensively in national/international journals and presented lectures/workshops at national/international conferences.

As a recipient of a Fulbright Grant to Mexico, a Global Initiative Faculty Grant/MUCIA (Midwestern Universities Consortium International Association) to Brazil, the Purdue Research Foundation Travel Grant to Cuba (twice), and Art and Design departmental funding to Canada, Farris has established an international reputation in art disciplines and gained considerable expertise in grant proposal writing.

She is the founder and faculty adviser of Purdue's Native American Student Association and involved in local, national, and international indigenous issues. Other organizations that Farris is involved in are the College Art Association, Women's Caucus of Art, the Native American Art Studies Association, and the Wordcraft Circle of Native Writers.

Since the late 1980s most of Phoebe's art exhibits and slide presentations deal with her documentation of contemporary Native American culture east of the Mississippi River and in the Caribbean. She has traveled to powwows and other cultural events, interacting with relatives, friends, and the public at the Rankokus Powhatan-Renape Reservation in New Jersey, the Pamunkey and Mattaponi Reservations in Virginia, the Chickahominy Tribal Cultural Center in Virginia, the Haliwa-Saponi Cultural Center in North Carolina, Pembroke State University in North Carolina (founded and operated by the Lumbee tribe until taken over by the state), the Shinnecock Reservation in Long Island, New York, the Piscataway campground in Maryland, and the Houma Cultural Center in Louisiana.

Her photographs at these events with people dressed in both powwow regalia and everyday clothing reveal the diversity prevalent among eastern tribes, with some contemporary Native Americans resembling their early ancestors, others showing the results of intermixture with other races. The regalia that Phoebe photographs shows a blend of the Plains Indian Pan-Indian styles and more tribally specific clothing such as the turkey feather headdresses worn by Powhatan chiefs that stand straight up rather than fan out like Plains Indian eagle headdresses.

Also, as part of this series, is photo documentation of reconstructed colonial Native American villages on the Pamunkey Reservation in Virginia and the Rankokus Powhatan-Renape Reservation in New Jersey. Photographs show the various stages of building traditional homes with willow branches, tree barks, and shrubbery. These houses resemble Iroquois long houses in architectural style but were built smaller to accommodate a single family. Photographs of the largest grouping, in a wooded setting in New Jersey, have a timeless quality, with only the color photography to remind the viewer that they are contemporary images.

Phoebe has also photographed people of native ancestry in Puerto Rico, Cuba, Mexico, and Jamaica. Not recognizing externally imposed national boundaries, she refers to all of the Americas as "Indian Country."

Phoebe has been inspired in her research by fellow Powhatan intellectual Dr. Jack D. Forbes, professor emeritus of Native American Studies at the University of California at Davis. According to Forbes a major task for scholars involved in Native American studies is to clarify the repeopling of the Americas, that is, the population recovery that followed the declines of the sixteenth century. Particularly along the eastern United States and to a lesser extent in the Southwest are mixed populations arising from interracial relationships between Africans, Europeans, and Native Americans. By the late nineteenth century, many North American, Latin American, and Caribbean native groups had absorbed varying amounts of African ancestry from New England to the entire rim of Central and

Dr. Jack Forbes (Powhatan/Lenni-Lenape) by Phoebe Farris.

South America.[1] After 500 years of intermixture, the ancestry and cultural influences of contemporary Native Americans is very complex. The resulting art and culture are more varied than the usual emphasis on the European/Native American encounters. Phoebe feels that the study of Native American art and artists should more accurately portray some of the more multidimensional aspects of Native American heritage.

Phoebe credits her success in academia and the art world to strong family ties and cultural influences. She was born in a segregated Washington, D.C., and grew up in an extended multicultural/multiracial family that challenged the existing racial laws and identity "choices." At the age of seven she and her mother moved to a less segregated New York but spent summers and holiday vacations with relatives in Virginia, Washington, D.C., and Maryland.

Approximately 28 or more of Phoebe's relatives have careers in the arts and mass media including Pamunkey painter Georgia Mills Jessup, who is represented in the permanent collection of the National Museum of Women in the Arts, and David Mills, Emmy nominee and scriptwriter for *N.Y.P.D.* and *E.R.* Phoebe and her family's artistic expression is influenced by their Powhatan-Pamunkey heritage, intermarriages with other nationalities (Caribbean and Asian), and their collections of Pamunkey pottery, Japanese Raku pottery, and Oriental rugs. Farris states, "We were multicultural before it became a commodified fad and politically correct."

Future challenges for Phoebe include taking a break from her scholarly writing to devote more time to her creative pursuits, perhaps returning to painting and printmaking. A permanent challenge is coping with the external and internal racism faced by mixed-blood Native American artists with similar backgrounds

1996, black and white diptych photo.

who wish to explore their ethnic complexity in their artwork. Phoebe reaches into the past and also out to future generations, taking responsibility for using the arts to call attention to and preserve ATTAN AKAMIK.

Note

1. J. D. Forbes, *Africans & Native Americans* (Urbana-Champaign: University of Illinois Press, 1988).

HARDIN, HELEN

Indian name: Tsa-Sah-Wee-Eh. *Tribal affiliation*: Santa Clara Pueblo. *Born*: 1943, Albuquerque, New Mexico. A month after her birth at the Santa Clara Pueblo Reservation, a naming ceremony was held, and she was given the name Tsa-Sah-Wee-Eh (Little Standing Spruce). *Education*: Attended a Catholic High School; spent the summer of her junior year in the Southwest Indian Art Project for Native American students at the University of Arizona, 1960. University of New Mexico, 1961–1962. *Family*: Daughter of artist Pablita Velarde. Daughter Margarete born, 1964. Married Cradoc Bagshow, 1973. *Career*: Commissioned

paintings and lectures for the Enchanted Mesa Gallery, Albuquerque, New Mexico, 1960s through early 1970s. Worked independently as a studio artist from the mid-1970s until her death. *Awards*: Honors at the Santa Fe Indian Market, Scottsdale National Arts Exhibition, the Heard Museum in Phoenix, Arizona, and the Philbrook Art Center in Tulsa, Oklahoma. *Died*: 1984, New Mexico.

SELECTED EXHIBITIONS

1994	*Passing on the Spirit: Helen Hardin*, Institute of American Indian Art, Santa Fe, New Mexico (solo exhibit)
1991–1994	Silver Sun Gallery, Santa Fe, New Mexico
1991	*Shared Visions: Native American Painters and Sculptors in the 20th Century*, Heard Museum, Phoenix, Arizona (traveling through 1992)
1989	*Paint, Bronze, and Stone*, Mitchell Indian Museum, Kendall College, Evanston, Illinois; Wheelwright Museum, Santa Fe, New Mexico
1984	*Indianischer Kunstler*, organized by Philbrook Museum of Art, Tulsa, Oklahoma (traveling in Germany through 1985); Institute of American Indian Art, Santa Fe, New Mexico (solo exhibit)
1983	Western Images Gallery, Chester, New Jersey
1982	National Museum of Natural History, Smithsonian Institution, Washington, D.C.
1981	*Salon d' Automne*, Grand Palais, Paris, France; Squash Blossom Gallery, Aspen, Colorado
1980	*American Indian Women's Spring Art Festival*, Indian Pueblo Cultural Center, Albuquerque, New Mexico; California State University at Long Beach (solo exhibit)
1979	*National Women in the Arts Show*, Springfield, Illinois; *Native American Paintings*, Mid-America Arts Alliance Project, Joslyn Art Museum, Omaha, Nebraska
1978	Forrest Fenn Gallery, Santa Fe, New Mexico (solo exhibit)
1977	Philbrook Art Center, Tulsa, Oklahoma; Kansas State University, Manhattan, Kansas
1975	Ashton Gallery, Scottsdale, Arizona
1974	Heard Museum, Phoenix, Arizona
1971	U.S. Embassy, Bogotá, Colombia (solo exhibit)
1968	U.S. Embassy, Bogotá, Colombia (solo exhibit)
1964	Enchanted Mesa Gallery, Albuquerque, New Mexico (solo exhibit)
1962	Coronado Monument, Albuquerque, New Mexico (solo exhibit)

COLLECTIONS

Heard Museum, Phoenix, Arizona; Indian Arts & Crafts Board, U.S. Department of the Interior, Washington, D.C.; Loyola Marymount College of Law, Los Angeles, CA; Millicent Rogers Museum, Taos, New Mexico; Museum of New Mexico, Santa Fe; South-

west Museum, Los Angeles, CA; University of Oklahoma Museum of Art, Norman; Wheelwright Museum of the American Indian, Santa Fe, New Mexico.

PUBLICATIONS

American Indian Artists I. Public Broadcasting System, 1974. Documentary.

Briggs, Walter. "Helen Hardin: Tsa-Sah-Wee-Eh Does Her Thing." *New Mexico Magazine* (March–April 1970).

Farris, Phoebe. "Helen Hardin. In Roger Matuz, ed., *Native North American Artists.* Detroit: St. James Press, 1998. pp. 211–213.

Farris Culley, Lou Ann. "Allegory and Metaphor in the Art of Helen Hardin." *Helicon Nine* (Fall 1981).

Farris Culley, Lou Ann. "Helen Hardin: A Retrospective." *American Indian Art Magazine* (Summer 1979).

Hood, Gary Allen. "Helen Hardin." *Native Peoples* (Summer 1994).

Lacouture, Sheila. "Artist Helen Hardin Exhibit at CMM." *Bernardsville New Jersey News*, October 7, 1982.

Scott, Jay. *Changing Woman: The Life and Art of Helen Hardin.* Flagstaff, Ariz.: Northland, 1989.

Shane, Karen. "Helen Hardin (1943–1984): Casting Her Own Shadow." *Southwest Art* (June 1985).

ARTIST STATEMENT (1976)

I think the reason I don't fear death is because I know that I'll always be here through my paintings. I have a lifetime, no matter how long or how short, to do it in, and I want to be good at what I'm doing. I want to make it complete. It's the reward of living and the reward I have to give to those who survive me. It's the only thing I can give that's really me.

BIOGRAPHICAL ESSAY

Hardin successfully combined the imagery, composition, and color common among traditional Indian painters with a geometric abstraction of shapes, colors, and composition. The influence of her mother, the artist Pablita Velarde, was a constant in her life. Hardin attributed her sense of detail to her mother's teachings and Hardin's early work was influenced by the cultural heritage displayed in Pablita Velarde's work. But Hardin's work also had an inventiveness, confidence, and uniqueness. Not wanting to be labeled a traditional Indian painter, she went beyond tradition. Hardin resisted the realism of her forebears and produced paintings in which geometric details became the prominent elements.

Hardin's mastery of abstraction proved that she could do something different. The transition in her art from realism to abstraction occurred after a 1968 visit to her father in Bogotá, Colombia. In an exhibition at the U.S. embassy, where she sold 27 paintings, Hardin received recognition as an individual artist, separate from her mother's fame. Her change to abstraction was also the result of

being introduced to drafting tools, such as compasses, protractors, and plastic curves. Geometry gave her linear structure and a method of investigating light, space, and color.

In 1975 Hardin was the only woman artist in a Public Broadcasting System (PBS) film series about Native American artists. By 1976 her role as a leader in contemporary Native American art was being recognized. Her work grew in depth and complexity. The influence of anthropology began to permeate her art as she studied the ancient designs of the Hohokam, Mogollon, Anasazi, and Mimbres cultures (300 B.C.–A.D. 1300). Hardin wanted to personalize the impersonal inventory of ancient Native American iconography and to detribalize and demystify it. Hardin worked on her Kachina series through the 1970s and into the 1980s. Considering Kachinas (intermediaries responsible for rain, corn, and fecundity) to be her spiritual forebears, Hardin painted them as Cloud People. With her *Woman* series in 1980, the connection between Kachinas, humanity, and herself as individual is clarified.

The painting *Metamorphis* (1981) represents a definitive example of Hardin's art in the early 1980s. It is a masklike face, bisected and composed of airbrushed rectangles and symbolic material derived from Kachina masks worn during sacred ceremonies conducted by Hopi Indians in Arizona. Saw-toothed structures and geometric designs are adapted from prehistoric pottery, and the figures' hairstyles resemble those common among Hopi, Pueblo, and Navajo peoples. This painting, like all of Hardin's work, consists of many varnished layers of acrylic paint applied with atomizers, brushes, pens, and sponges. Hardin's art merged archaeology and tribalism with the contemporary and personal and sought a return to ancient realms by modern means. Hardin called *Metamorphis* a self-portrait.

In the early 1980s, Hardin also experimented with printmaking, specifically etching. In 1980 she produced four prints, *Fireside Prayers, Bountiful Mother, The Healers*, and *Messenger of the Sun.*

Fireside Prayers portrays robed figures gathered in a smoky semicircle; *The Healers* depicts fetish bears with healing properties; *Messenger of the Sun* is an exploration of the eagle; and *Bountiful Mother* is a dramatic figure dressed in a white robe parted across pale blue corn kernels that make up the body. *Changing Woman* (1981) is considered one of her most ambitious etchings—a self-portrait of the artist as a young woman and ageless Kachina. Hardin also reproduced the image in a painting with brighter hues, *Changing Woman* (1981).

Hardin embarked on a series of paintings with themes relating to women: These include *Medicine Woman* (1981), *Listening Woman* (1982), *Winter Woman* (1982), and *Creative Woman* (1982). According to Hardin, her female imagery represents woman's intellectual, emotional, and sensitive characteristics, as opposed to the physical traits most often evident in images of women by male artists.

In 1981 Hardin was diagnosed with cancer. Although suffering from the disease, she continued when possible to paint, and at her death in 1984 she left

uncompleted her final work, *Last Dance of the Mimbres*. A posthumous exhibit was held in 1984 at the Institute of American Indian Arts Museum in Santa Fe, New Mexico.

LaMarr, Jean

Tribal affiliation: Pit River/Paiute. *Born*: 1945, Susanville, California. *Education*: San Jose City College, 1969–1973. University of California, Berkeley, 1973–1976. Kala Institute, Berkeley, California, 1976–1986. University of Oregon and Oguni, Japan, 1991. *Career*: College of Marin, San Francisco State University, California College of Arts and Crafts, 1986–1990. Art instructor at San Francisco Art Institute, University of Oregon, and California Correctional Center, 1986–1994. Director, Native American Graphic Workshop, Susanville, California, 1986–1994. Institute of American Indian Arts, 1987–1992. International guest printmaker, Poly-Technical Institute, Whanganui, New Zealand, 1993. *Awards*: Maple Creek Willies Scholarship, 1973–1976. Brandywine Workshop fellowship, 1988. Honors at Heard Museum Guild Indian Fair and Market, American Indian Festival of the Arts, La Grande, Oregon, and California Indian Days.

EXHIBITIONS

1995	*Violently Volatile, Selected Mixed Media Works, 1974–1995*, C. N. Gorman Museum, University of California, Davis
1981	Great Plains Indian Museum, Browning, Montana
1977	Trading Post Gallery, Berkeley, California
1976	Marin Civic Center Gallery, San Rafael, California
1975	C. N. Gorman Museum, University of California, Davis

SELECTED GROUP EXHIBITIONS

1994–1998	*Spirit of Native America, South and Central America*, American Indian Contemporary Arts, San Francisco (touring Mexico, Chile, Argentina, Colombia, Brazil, Venezuela, Dominican Republic)
1994–1997	*Indian Humor*, American Indian Contemporary Arts, San Francisco, California, Yerba Buena Gardens, San Francisco, California (touring throughout the United States)
1995	*Legacies: Contemporary Art by Native American Women*, Castle Gallery, New Rochelle, New York; *Weaving Contemporary Ceremony I*

and II, American Indian Contemporary Arts, San Francisco, California

1994 *Native People, Sacred Lands*, San Francisco Art Institute, California; *Forms of Address*, San Francisco Art Institute, California

1992 *Four Directions: Women Honor Native Land*, ProArts Gallery, Oakland, California; *500 Years of Resistance through Women's Eyes*, Mission Cultural Center, San Francisco, California; *Alcove Show*, New Mexico Museum of Fine Art, Santa Fe, New Mexico; *With the Breath of Our Ancestors*, Los Angeles Municipal Art Gallery, California; *Centered Margins: Contemporary Art of the Americas*, Bowling Green University, Ohio

1991–1996 *Shared Visions: Native American Painters and Sculptors in the 20th Century*, Heard Museum, Phoenix, Arizona (traveling)

1991–1994 *Our Land/Ourselves: American Indian Contemporary Arts*, University Art Gallery, SUNY at Albany, New York (traveling)

1991–1992 *Counter Colon-ialismo*, Centro Cultural de la Raza, San Diego, California, Mas Artspace, Phoenix, Arizona, Dinnerware Artist Cooperative, Tucson, Arizona, Diverse Works, Houston, Texas; *Adeest'ii-Signs of Contradictions*, Center of Contemporary Art, Santa Fe, New Mexico; *Hosting Our Ancestors*, Richmond Art Center, Richmond, California

1990 *Submuloc, In Response to the Columbus Wohs*, Evergreen State University, Olympia, Washington, University of Oregon, Eugene, Oregon

1988–1990 *Committed to Print: Social and Political Themes in Recent American Printed Art*, Museum of Modern Art, New York

1985–1986 *Extension of Tradition, Contemporary Northern California Native American Art in Cultural Perspective*, Crocker Art Museum, Sacramento, California, and Palm Springs Desert Museum, California

1987 *We the People*, Artists Space, New York

1984 *Intergrafika 84*, Berlin, Germany

1983 *Cultural Resistance Artist of the Bay Area*, Lafena Cultural Center, Berkeley, California

1981–1986 *Art and Culture of the American Labor Movement*, Staadliche Kunsthalle, Berlin, Stadtische Galerie Schloss, Oberhausen, Germany, Stockholm Museum, Sweden, Frankfurt Museum, Germany, Kassel Museum, Germany, Chicago Historical Society Museum, Chicago, Illinois, D. Q. University, The International Indian Arts Festival, Davis, California, American Indian Community House Gallery, New York (touring)

1980 *Das Andere Amerika*, Germany, France, and Italy (touring)

1978 *Circle of Tradition and Vision*, Artist Embassy, San Francisco, California

| 1976 | *New Horizons in American Indian Art*, Southwest Museum, Los Angeles, California |
| 1975 | *Knowledge through Vision and Tradition*, Marin County Civic Center, San Rafael, California; *Governor's Show*, State Capitol Building, Sacramento, California; *International Women's Exhibit*, Artist Embassy, San Francisco, California |

COLLECTIONS

Heard Museum, Phoenix, Arizona; Institute of American Indian Arts, Santa Fe, New Mexico

PUBLICATIONS

Amerson, L. Price. *Confluences of Tradition and Change*. Davis: University of California Press, 1981.

Archuleta, Margaret, and Rennard Strickland. *Shared Visions: Native American Painters and Sculptors in the 20th Century*. New York: New Press, 1991.

Bildender, Verband. *Intergrafik*. Germany: Kunstler der Deutschen Demokratischen Republik, 1990.

Cahan, S., ed. *Contemporary Art and Multicultural Education*. New York: Routledge, 1996.

Dubin, Margaret. "Jean LaMarr." In Roger Matuz, ed., *Native North American Artists*. Detroit: St. James Press, 1998. pp. 295–298.

Gully, Anne, ed. *Watchful Eyes: Native American Women Artists*. Phoenix, Ariz.: Heard Museum, 1994.

Hill, Rick. *Creativity Is Our Tradition*. Santa Fe, N.M.: Institute of American Indian Arts, 1992.

Lippard, Lucy. *Mixed Blessing*. New York: Pantheon Books, 1990.

Myths of Primitivism, Perspectives on Art. New York: Hiller, 1989.

Penney, David, and George C. Longfish. *Native American Art*. Hong Kong: Hugh Lauter Levin, Assoc., 1994.

Roberts, Carla, ed. *The Submuloc Show/Columbus Wohs*. Phoenix, Ariz.: Atlatl Inc., 1992.

Roth, Moira, and Yolanda Lopez. "Social Protest: Racism and Sexism." In Norma Broude and Mary D. Garrard, eds., *The Power of Feminist Art*. New York: Harry N. Abrams, 1994.

Wye, Deborah. *Committed to Print*. New York: MOMA, 1988.

ARTIST STATEMENT (1996)[1]

My personal experience is directly responsible for the statements in my work. My art deals with cultural survival within my community. The largest part of my work is directed to the non-Indian audience in order to generate awareness and concern for the Earth and our future generations' survival. This communication also addresses indigenous rights as well as the native woman's experience, thereby bringing the art back to the personal. My art makes possible visual experiences that communicate between the Indian world and the non-Indian world. This visual communication blends philosophy, worldview, and stereo-

types of Indians, all presented in contrast to often-held preconceptions of my community.

Note

1. From S. Cahan, ed., *Contemporary Art and Multicultural Education* (New York: Routledge, 1996), p. 133.

BIOGRAPHICAL ESSAY

Jean LaMarr is a widely recognized printmaker, painter, installation artist, and political activist who addresses issues affecting the environment, women's rights, Native American sovereignty, and urban Indians. Her work is exhibited in mainstream national/international galleries and museums, Native American galleries and museums, and local grassroots institutions that reach the atypical art viewing public. LaMarr's greatest exposure is from her graphics, which have a wide political and aesthetic appeal.

LaMarr cites the influence of two of her uncles who were artists as an early childhood inspiration to pursue art as a career. Her uncles entertained her by making comic strips that featured the Indian trickster Coyote. Another inspiration was the landscape of her *rancheria* (a California reservation) in Susanville, California. Situated in a valley surrounded by high mountains, the purple sunset would later influence LaMarr's exploration of purple tones in her printmaking and painting.

At San Jose City College and the University of California, Berkeley, LaMarr specialized in printmaking, studying lithographing, color etching, and monoprinting. After graduating from the University of Berkeley, LaMarr studied printmaking and papermaking at the Kala Institute in Berkeley, color-etching at the University of Oregon, and Japanese papermaking in Oguni, Japan. While expanding her knowledge of various printmaking techniques, LaMarr also taught classes on Native American art and printmaking at several California colleges, the Institute of American Indian Arts in Santa Fe, New Mexico, workshops in New Zealand and Siberia, and the Native American Graphic Workshop at her *rancheria* in Susanville, California.

Many of LaMarr's print series are now well known in both the Indian and non-Indian art community. Her 1989 *Cover Girl* series was inspired by a photograph titled *Squaw*, taken by a nineteenth-century government photographer. Like many other Indian "models" of that era, paid by the government, the women posed topless in a somewhat pornographic pose. LaMarr's series restores dignity to those Indian women, coerced to participate in their own sexual exploitation. LaMarr's cover girl women are surrounded by pottery, baskets, and beautiful cloth. Their shapes represent the reality of a woman's body, rather than an idealized myth. Another homage to Indian women is the photo-etching *Lena, 1922 and Now*. Like the *Cover Girl* series, *Lena* was also inspired by a

photograph, this one of Lena Joaquin photographed in 1922 by a University of California, Berkeley, anthropologist as an object of scientific research. LaMarr depicts the aging process of Lena, the last child of a respected Paiute leader in northern California, with grace and dignity. The beauty LaMarr portrays in the older woman's face challenges the idea that attractiveness is only for the young.

A pressing issue for LaMarr is environmental and nuclear destruction of sacred Indian lands. *They're Going to Dump It Where?* (1984, monoprint, 18" × 24") deals with Indian resistance to nuclear dumping on lands used for spiritual ceremonies. An Indian woman dressed in contemporary clothing is wearing large sunglasses that reflect the Diablo Canyon Nuclear Power Plant. LaMarr used an invitation to participate in the San Francisco Art Institute's annual exhibition as a forum to expand on environmental/nuclear destruction in a larger context. Her 1994 installation *Native People, Sacred Lands* (acrylic, handmade paper on canvas, cedar tree limbs, wood, scrap metal, feathers, glitter, plexiglass, and light, 138" × 306" × 342") is an exploration of the significance of sacred sites for Native Americans and how these sites in California and the Great Basin are being destroyed. Other well-known works on this theme are *Sacred Places Where We Pray*, a mixed-media piece dealing with human destruction caused by missiles, and *Lighting Up*, in which women are portrayed in a spiritual ceremony to counteract the effects of jet fighter planes used for military testing in California and Nevada.

In lectures, interviews, and catalog publications, LaMarr stresses the importance of reaching a wide audience, thus her preference for printmaking as a medium and her commitment to teaching. Her first public works involved designing flyers and posters for tribal events when she was a teenager. Since then she has viewed art as a means to disperse information and as a tool for education. Her prints and her current mural work address the cultural survival of her Pit River/Paiute community.

LaMarr also views humor as a tool for awareness, education, and survival skill. In the touring *Indian Humor* exhibit and catalog, LaMarr also describes humor as a way to ease the pain from racism. One of LaMarr's pieces from that exhibit is *Ms. Coyote* (11" × 12" × 9", mixed-media mask), a contemporary trickster reinterpreted as a hip, sexy, female persona. Trickster characters are used to humorously exemplify life's follies and set standards for correct tribal behavior. LaMarr's contemporary female trickster offers an alternative view of this character. LaMarr states, "The two-sided expression represents a dichotomy of opposites, which the mask may also be covering. Layers of meaning can be evoked by the viewer and will have different meanings. . . . All are valid and reflect the 'trickster' in all humankind." LaMarr is opposed to the type of humor that demeans her people in sporting events such as the Atlanta Braves and their "Tomahawk Chop" but acknowledges constructive, positive humor as an Indian tradition that educates the people. "Using this element in my art has become my weapon and my salice to convey my message."

With a wide variety of media—printmaking, murals, installations, beadwork,

painting, and mixed media—LaMarr does accomplish her goal of reaching a large, diverse audience. Her art is accessible without sacrificing aesthetic and technical standards. Although she has traveled and exhibited throughout the United States and abroad, LaMarr prefers to live on her *rancheria* in Susanville, California, directing the Native American Graphic Workshop. Although actively involved as a consultant for various arts projects, Indian education, and the Smithsonian Institution's new National Museum of the American Indian, LaMarr always returns home to the sacred lands of her people—her priority commitment.

LITTLE TURTLE, CARM

Tribal affiliation: Apache, Tarahumara. *Born*: 1952, Santa Maria, California. *Education*: Navajo Community College, registered nurse, 1978. Also studied photography at the University of New Mexico, Albuquerque, 1978–1979, and at the College of the Redwoods, Eureka, California, in 1980. *Family*: Married to Navajo artist Ed Singer. Both parents (Apache, Tarahumara, Mexican) were artists, and Carm Little Turtle was also raised by a Japanese uncle. *Career*: Operating room nurse, 1978–present. Producer/photographer, Shenandoah Films, Arcata, California, 1980–1983. Artist model.

SELECTED EXHIBITIONS

1996
Strong Hearts: Native American Visions and Voices, Smithsonian Institution, Washington, D.C.; *I Stand in the Center of the Good*, American Indian Community House Gallery, New York

1995
Image and Self in Contemporary Native American Photoart, Hood Museum, Dartmouth College, Hanover, New Hampshire; *After the Ceremony*, Old Town Gallery, Flagstaff, Arizona

1994
Best of the Southwest, Old Town Gallery, Flagstaff, Arizona; *Watchful Eyes: Native American Women Artists*, Heard Museum, Phoenix, Arizona; *Traditions of Looking*, Institute of American Indian Art Museum, Santa Fe, New Mexico; *Praising the Spirit*, Local 803 Gallery/Group for Photographic Intentions, Tucson, Arizona; *Negatives and Positives*, Street Level Gallery, Glasgow, Scotland; *The Spirit of the Southwest 93*, Democratic Party Convention, Washington, D.C.; *Silver into Gold*, Ansel Adams Center for Photography, San Francisco, California; *Defining Our Realities: Native American Women Photographers*, Sacred Circle Gallery, Seattle, Washington

Bailerina y Tierra by Carm Little Turtle, 1989, black and white sepia with oils.

1992 *Message Carriers*, Photographic Resource Center, Boston University,
 Boston, Massachusetts; *Representatives: Women Photographers from
 Permanent Collection*, Center for Creative Photography, University
 of Arizona, Tucson, Arizona; *We the Human Beings*, The College of
 Wooster Art Museum, Wooster, Ohio; *Six Yeux, Three Women Pho-
 tographers*, La Cigale, Taos, New Mexico

1991 *Counter Colon-ialismo*, Centro Cultural de la Raza, San Diego, Cal-
 ifornia; *America*, The Center for Contemporary Art, Sacramento, Cal-
 ifornia; *Visions of Dineh*, Old Town Gallery, Flagstaff, Arizona; *Our
 Land Ourselves*, University Art Gallery, State University of New
 York, Albany, New York; *Reflections in Time: One Woman Show*,
 American Indian Contemporary Arts, San Francisco, California

1990 *Ed Singer and Carm Little Turtle: Contemporary Art*, Old Town
 Gallery, Flagstaff, Arizona; *Language of the Lens*, Heard Museum,
 Phoenix, Arizona; *Compensating Imbalances: Native American Pho-
 tography*, C. N. Gorman Gallery, University of California, Davis,
 California; *Ancestors Known and Unknown*, Coast to Coast, National
 Women Artists of Color, Art in General Gallery, New York

1989 *Personal Preferences: First Generation Native Photographers*,
 American Indian Contemporary Arts Gallery, San Francisco, Cali-
 fornia

1988 *Visual Poems*, Jackson Photo Gallery, Flagstaff, Arizona

1987 *Women of Sweet Grass, Cedar, and Sage*, Wheelwright Museum,
 Santa Fe, New Mexico

1985	*The Photograph and the American Indian*, Library of Western Arts Americana, Princeton University, New Jersey
1984	*24 Native American Photographers*, American Indian Community House Gallery, New York; *Contemporary Native American Photographers*, Southern Plains Indian Museum, Anadarko, Oklahoma
1983	*Indian Artists of the 80's*, Sacred Circle Gallery, Seattle, Washington
1982	*Native Americans Now*, American Indian Museum, Santa Rosa, California
1981	*Solo Exhibit*, Humbolt State University Library, Arcata, California; *Inter-Tribal Group Show*, Tsuri Rancheria, Trinidad, California

SELECTED COLLECTIONS

The Center for Creative Photography, University of Arizona, Tucson; The Heard Museum, Phoenix; Southern Plains Indian Museum, Anadarko; Southwest Museum, Los Angeles; Western Arts Americana Library, Princeton University, New Jersey

SELECTED PUBLICATIONS

Abbott, Lawrence. "Carm Little Turtle." In Roger Matuz, ed., *Native North American Artists*. Detroit: St. James Press, 1998. pp. 312–315.

Abbott, Lawrence. *I Stand in the Center of the Good: Interviews with Contemporary Native American Artists*. Lincoln: University of Nebraska Press, 1994.

"Carm Little Turtle Photo Finish." *Southwest Art Magazine* (April 1991), p. 120.

First Americans. New York: Random House, 1993.

Neumaier, Diane. *Reframings: New American Feminist Photographies*. Philadelphia: Temple University Press, 1995.

Our Land/Ourselves: American Indian Contemporary Artists. Albany, N.Y.: University Art Gallery, SUNY, 1990.

The Photograph and the American Indian. Princeton, N.J.: Princeton University Press, 1994.

Skoda, Jennifer R. "Image and Self in Contemporary Native American Photoart: An Exhibition at the Hood Museum of Art." *American Indian Art Magazine* 21, no. 2 (1996), pp. 48–57.

"Strong Hearts: Native American Vision and Voices." *Aperture Magazine*, no. 139 (1995).

We, the Human Beings: 27 Contemporary Native American Artists. Wooster, Ohio: College of Wooster Art Museum, 1992.

ARTIST STATEMENT (1997)

My mother always painted and proved to be a major influence on my work. My earliest memories are of paints and the painted surface. My own attempts to blur the boundaries between photography and painting are a result of that influence. I concern myself with all the elements of design to make an interesting image, while at the same time hopefully succeeding in conveying a strong statement. I like to leave these statements open-ended in order to encourage a con-

tinuing dialogue with the viewer. My statements are tinged with political overtones, a result of being both a person of color and a woman. Being of mixed Pan-American ancestry, I have been in the midst of many influences and have absorbed them and used them. I have been in Mexico many times, but I don't consider it foreign. Borders are arbitrarily drawn boundaries by the United States government. Form and colors are also design elements arbitrarily drawn by the dominant culture, but one can instead use the forms and colors that the specific ethnic culture chooses as its own. I try to derail the viewer's sense of perception by the implication of a three-dimensional surface and movement by my choice of colors. Using object as metaphor, photography can provide a window to the human spirit, the need to communicate, and the importance of humor in that quest.

BIOGRAPHICAL ESSAY

Carm Little Turtle's work has many layers of meaning. Like a metaphor, the images and titles evolve with the passage of the viewer's time. Staging models and props, either in the studio or on location, multiple, sequential images are born. She creates nontraditional portraiture and nontraditional landscapes. The essence of the person is captured, either through the actual image of the person or through props and possessions only, with the absence of the person represented. Unlike traditional painted or photographed landscapes, in Carm's work the human presence is still evident, if not with bodies then with relics such as abandoned cars.

Many of Carm's photographs use humor to comment on the male-female dynamics in personal relationships. The *Earthman* series is her most popular and widely shown theme on that topic. In these hand-painted sepia-toned photographs, Little Turtle, her husband, artist Ed Singer, and other relatives are actors/characters in a variety of staged scenes.

In *Earthman Thinking About Dancing with Woman from Another Tribe* (1991, painted black and white photo), Earthman, symbolic of any man, is seated with his back turned away from the woman, his face cupped in his hand, elbow resting on his knee. He is looking downwards or out onto the landscape, deep in thought and ignoring the sexy, voluptuous woman standing next to him. The woman's body is cropped to the waist. The viewer sees a red parasol, covering her stomach, and a pair of legs covered in skin-tight, leopard-spotted dance leotards/pants. Her spike-heeled shoes stand precariously on the edge of a cliff, in a rocky southwestern landscape. The artist seems to be saying that regardless of how sexy/attractive women try to make themselves, men often think of other women instead of appreciating their own partners. *She Was Used to Abiding by Her Own Decisions* (1989, black and white sepia with oil paint), the woman's profile is partially hidden by a pink and white striped parasol, and the man's face is completely obscured by a hat. While the woman is looking away, her

partner ties the laces of her shoes together, thus attempting to hinder the women's mobility and independence.

Strongly interested in women's rights in marriage and reproduction, Little Turtle uses her photography to visually explore one-on-one relationships between men and women, feeling that the way people relate to the opposite sex on a personal level carries over into politics. The ongoing male/female issue is also conveyed through the symbolism of feet/shoes. In *Cowboy Boots con Pintura* (1990, hand-color photo), a standing figure is cropped to the waist, leaning against a wall. At first glance the viewer may assume that the person is a male because of the pants (jeans) and the rugged work shoes. But with today's androgynous, unisex fashions, the figure could also be female. On the floor are five pairs of cowboy boots, some with brightly colored designs, in vivid red and turquoise. The boots could belong to a man or woman. Is androgynous, unisex clothing a modern symbol for equality between the sexes? *Bailerina y Tierra* (1989, black and white sepia with oils) is one of Carm's more *delicate* images. Once again, the figure is cropped, this time to the knees. A woman's shapely, bare legs/feet touch the landscape (tierra) in a graceful, dancing pose. Lavender-colored fringe seems to glide over her legs. Without showing the entire body or total nudity, a sensuousness is deeply felt.

In addition to her dramatically staged photoart, Carm also shoots street photography, images she encounters and captures. Usually using natural light, she works with a Minolta 55-mm lens, fast film, and infrared. Paint is used to make the images come forward or recede by employing warm or cool colors.

Although Little Turtle does feel that her work involves itself with feminist issues, her perspective is as a humanitarian first. Her work represents both the female and male gaze, going beyond genitalia to the broader issues facing humanity. As an operating room nurse, Carm has "seen the spirit shrunken, depleted, almost devoid of life, then reborn through support, compassion and love."

LOMAHAFTEWA, LINDA

Tribal affiliation: Hopi and Choctaw. *Born*: 1947, Phoenix, Arizona. *Education*: Associate Degree, Institute of American Indian Arts, Santa Fe, New Mexico. B.F.A., San Francisco Art Institute, 1970. M.F.A., San Francisco Art Institute, 1971. *Family*: She is the daughter of Clifford Lomahaftewa, a Kachina doll carver and member of a drum/singing group, and Mary Lomahaftewa, a quilter and beadworker. Her brother Dan is a painter/printmaker, and her sister Gloria

is a curator at the Heard Museum. *Career*: Assistant Professor of Native American Art, California State College, Sonoma, 1971–1973. Professor of Painting and Drawing in the Native American Studies Department, University of California, Berkeley, 1974–1976. Professor of Painting, Drawing and 2-D Design at the Institute of American Indian Arts, 1976–present. Brandywine Workshop, Philadelphia, Pennsylvania, 1988; Wheelwright Museum of the American Indian, 1989–1992; McDougal Art Gallery, New Zealand, Yavapi Art Institute, Prescott, Arizona, Heard Museum, 1993; Visiting Artist at Southwestern Association for Indian Arts, 1993–96; Rotorua Aotearoa, New Zealand, 1995; *Awards*: Poster artist, Heard Museum Indian Fair and Market, 1994 and 1997. Invited Key Note speaker at the 8th Annual Oscar Howe Memorial Lecture, Northern Plains Tribal Arts Project, 1996. Best of Division, Mixed Media, 39th Annual Heard Museum Indian Fair and Market, Phoenix, Arizona, 1997.

SELECTED EXHIBITIONS

1997	*Native American Invitational*, Gilcrease Museum, Tulsa, Oklahoma; *2nd Annual Masters of Santa Fe Indian Market Exhibition*, sponsored by Southwestern Association for Indian Arts–Santa Fe Community College, Santa Fe, New Mexico; *We Are Many, We Are One*, University Art Gallery, University of Wisconsin, LaCrosse; *New Art from Native America*, Center Gallery, Elaine Bangone Center, Bucknell University, Lewisburg, Pennsylvania
1996–1998	*River Deep, Mountain High*, international traveling exhibit produced by Highland Council Culture and Leisure Studies and funded by the Scottish Arts Council–Inverness Museum and Art Gallery, Scotland; venues throughout Scotland and Europe
1996	*The Masters of Santa Fe Indian Market Exhibition*, sponsored by Southeastern Association for Indian Arts–Santa Fe Community College, Santa Fe, New Mexico; *I Stand in the Center of the Good*, group exhibit in conjunction with publication of book by Lawrence Abbot, American Indian Community House, New York City; *Second IAIA Alumni Triennial*, Institute of American Indian Arts Museum, Santa Fe, New Mexico
1995–1998	*Indian Humor*, traveling exhibit produced by American Indian Contemporary Arts, San Francisco, 12 venues including: Autry Museum of Western Heritage, Los Angeles, California, University of Minnesota Weisman Art Museum, Minneapolis, Minnesota, and the National Museum of the American Indian, New York City
1995	*Spirit of the Pueblo People*, East West Center, Honolulu, Hawaii; *Legacy: Native American Women Artists*, Castle Gallery, College of New Rochelle, New Rochelle, New York; *IAIA Faculty Triennial Exhibition*, Institute of American Indian Arts Museum, Santa Fe, New Mexico; *Native American and Native Artists of the South Pacific Islands*, Hei Tiki Gallery, Rotorura District Council Chambers, Rotorura, New Zealand

1994	*The Book as Art*, Institute of American Indian Arts Museum, Santa Fe, New Mexico; *The Spirit of Native America*, international traveling exhibit produced by American Indian Contemporary Arts, San Francisco, six venues in Latin America and Lille, France
1993	*Bridges and Boundaries*, Peiper-Regraf Gallery, Frankfurt, Germany; *First IAIA Alumni Triennial*, Institute of American Indian Arts Museum, Santa Fe, New Mexico
1992	*Lomahaftewa: Looking for Beauty in the Future*, two-person exhibition, Galleria Posada, Sacramento, California; *Transformed Traditions: Exhibition of Contemporary American Indian Art*, Santa Rosa Junior College, Santa Rosa, California
1991–1996	*Shared Visions: Native American Painters and Sculptors in the Twentieth Century*, international traveling exhibit sponsored by the Heard Museum, Phoenix, Arizona, national and international venues including: Gilcrease Museum, Tulsa, Oklahoma, National Museum of the American Indian, Smithsonian Institution, New York City, and McDougal Gallery, New Zealand; *Our Land/Ourselves: American Indian Contemporary Artists*, traveling exhibition produced by State University of New York-Albany, venues included University Galleries throughout the United States
1990	*Contemporary Printmaking in New Mexico: A Native American Perspective*, sponsored by The Governor's Gallery, Santa Fe, New Mexico–The Stables Art Center, Taos, New Mexico; *Direction of the Sun*, two-person exhibition, American Indian Community House Gallery, New York City; *We Are Part of the Earth: Contemporary Works on Paper: Eleven Native American Artists*, Centro Cultural de la Raza, San Diego, California; *Contemporary Printmaking in New Mexico: A Native American Perspective*, Governor's Gallery, Santa Fe, New Mexico
1989	*Native Proof: Contemporary American Indian Printmakers*, American Indian Contemporary Arts, San Francisco, California; *As in Her Vision*, American Indian Contemporary Arts, San Francisco, California
1988	*Progressions of Impressions*, The Heard Museum, Phoenix, Arizona
1987	*Harmony and Rhythm in Balance*, INdo-Hispano/Nuevo Mexicano, San Antonio, Texas
1985	*Second Biennial Invitational*, The Heard Museum, Phoenix, Arizona; Solo Exhibition, American Indian Contemporary Arts, San Francisco, California; *Women of Sweetgrass, Cedar and Sage* (traveling), American Indian Community House Gallery, New York

COLLECTIONS

American Indian Historical Society, San Francisco, California; Center for the Arts of Indian America, Washington, D.C.; City of Phoenix, Sharing Ancestral Creations: Native American Art Collection; The Heard Museum, Phoenix, Arizona; Institute of American

Indian Arts Museum, Santa Fe, New Mexico; The Millicent Rogers Museum, Taos, New Mexico; Native American Center for the Living Arts, Niagara Falls, New York; United States Department of the Interior, Indian Arts and Crafts Board, Washington, D.C.; University of Lethbridge, Native American Studies Department, Alberta, Canada; The Wheelwright Museum of the American Indian, Santa Fe, New Mexico.

SELECTED PUBLICATIONS

Abbot, Lawrence. *I Stand in the Center of the Good: Interviews with Contemporary Native American Artists.* Lincoln: University of Nebraska Press, 1994. pp. 149–159.

Archuleta, Margaret, and Rennard Strickland. *Shared Visions: Native American Painters and Sculptors in the Twentieth Century.* Phoenix: Heard Museum, 1991. pp. 56, 94. Exhbn cat.

Breunig, Robert, and Erin Younger. ''The Second Biennial Native American Fine Arts Invitational.'' *American Indian Arts Magazine* 11 (Spring 1986), p. 61.

Durbin, Margaret. ''Linda Lomahaftewa.'' In Roger Matuz, ed., *Native North American Artists.* Detroit: St. James Press, 1998. pp. 324–327.

Indian Humor. San Francisco: American Indian Contemporary Arts, 1995. pp. 60–61. Exhbn cat.

Penn, W. S., ed. *The Telling of the World: Native American Stories and Art.* New York: Steward, Tabori, & Chang, 1996. pp. 76, 107, 111, 132, 234.

Quick-to-See Smith, Juane, et al. *Our Land/Ourselves: American Indian Contemporary Artists.* Albany: State University of New York Art Gallery, 1990. Exhbn cat.

ARTIST STATEMENT (1997)[1]

When I paint, I share my culture. My paintings tell stories about Hopi. Hopi means praying, having respect for everything, believing that everything has a purpose. It means asking for good things to happen for everyone. My imagery of shapes and colors comes from ceremonies and the landscape. I associate a special power, respect, and sacredness with these colors and shapes. My recurring images of Hopi symbols arise from a source deep within me.

My father says, ''Whatever you work on, pray for it to come out well.'' My paintings represent individual prayers. While concentrating on a line, shape, or color, I think it's like a prayer, remembering what my father told me. I have this prayer when I'm working—not only for myself but for all people.

Note

1. From the catalog for *Native Indigenous American Women Invitational* (Tulsa, Okla.: Gilcrease, 1997), exhbn cat.

BIOGRAPHICAL ESSAY

A well-respected painter and printmaker, Linda Lomahaftewa incorporates Hopi symbols of water, sun, stars, lightning, clouds, and deities into modern

abstract landscapes such as *New Mexico Sunset* (1978), *Parrot Migration* (1992), and *Red Buffalo Path II* (1997). In addition to incorporating Hopi symbolism into her art, Lomahaftewa's complex designs are also reminders of patchwork quilts—a Choctaw tradition.

Lomahaftewa is also noted for her strong commitment to teaching, especially to Native American art students. As an academic she has had a profound effect on students at the Institute of American Indian Arts (IAIA) in Santa Fe, where she teaches painting, drawing, and 2-D design in the Foundations Department. An alumni of IAIA, Linda was a peer of noted students/artists T. C. Cannon and Alfred Young Man. Linda has also shared her expertise in studio techniques and Native American art history as a lecturer/visiting artist in the United States, Europe, and New Zealand.

New Mexico Sunset (1978, acrylic on canvas, 130 × 104 cm) is included in the *Contemporary Major Artists: 1960's–1991* section of Archuleta and Strickland's *Shared Visions: Native American Painters and Sculptors in the Twentieth Century*. One of a series of abstract landscapes, its bold, flat colors give the simultaneous effect of receding and protruding. Shades of red, pink, lavender, purple, yellow, green, and blue function as a rainbow and the sun's rays, emerging from the mountainous landscape of more purples, reds, and shades of brown. A dark blue sky with stars is also reflected in a body of water below the land. Lomahaftewa ignores the Western tradition of using cool colors to recede and warm colors as foreground. Notions of top and bottom are also blurred as the sky and water resemble each other.

In recent years Linda has been more involved in printmaking, especially monotypes. A 1997 monotype, *Red Buffalo Path II*, included in the Gilcrease Invitational, has a softer quality than some of her earlier work. The background includes painterly strokes of blue swirls and red circles stretched across the length of the paper (an elongated rectangle). The red buffalo, brown deer, and blue hunter figure float in space, their shapes reminiscent of Plains Ledger drawings, petroglyph designs, and rock art figures encountered in South Africa and Australia. Brown triangles/mountains are firmly centered. The animal/human figures appear prehistoric, whereas the background could easily be interpreted as abstract expressionist. It is the ability to blend the new and the old that is prevalent in Lomahaftewa's art.

MARTÍNEZ, MARIA

Tribal affiliation: San Ildefonso Pueblo. *Born*: 1886, San Ildefonso Pueblo. *Education*: Learned pottery making from her maternal aunt. *Family*: Married Julian

Martínez (also an artist) in 1904. Four sons, one of whom (Popovi) continues the family's art traditions. *Career*: Potter, pottery-making workshops, ceremonial dancer. *Awards*: Special Recognition Award and Bronze Medal for *Indian Achievement*, Chicago World's Fair, 1934. The Craftsmanship Medal, American Institute of Architects, 1954. Jane Adams Award for Distinguished Service, Rockford College, Santa Fe, 1959. Presidential Citation, American Ceramic Society, 1968. Symbol of Man Award, Minnesota Museum of Art, 1969. Honorary Doctorate of Fine Arts, New Mexico State University, 1971. Governor's Award, New Mexico Art Commission, 1974. Honorary Member of the Council, National Council on Education for the Ceramic Arts, 1976. Honorary Doctorate from Columbia College and the Presbyterian Hospital Foundation Award for Excellence, 1997. *Died*: 1980.

SELECTED GROUP EXHIBITIONS

1996	*Drawn from Memory: James T. Bialac Collection of Native American Art*, Heard Museum, Phoenix, Arizona
1991–1996	*Shared Visions: Native American Painters and Sculptors in the Twentieth Century*, Heard Museum, Phoenix, Arizona
1990	*American Indian Artists in the Avery Collection and the McNay Permanent Collection*, Koogler McNay Art Museum, San Antonio, Texas
1988	*When the Rainbow Touches Down*, Heard Museum, Phoenix, Arizona (traveling)
1984–1985	*Indianascher Kunstler* (traveling, Germany), organized by the Philbrook Museum, Tulsa, Oklahoma
1978	Renwick Gallery, National College of Fine Arts, Washington, D.C.
1967	*Three Generations Show* (Maria, Popovi DA, and Tony Da), U.S. Department of Interior, Washington, D.C., and Institute of American Indian Arts, Santa Fe, New Mexico
1958–1961	European tour sponsored by the University of Oklahoma, Norman
1955–1956	European tour sponsored by the University of Oklahoma, Norman
1953	University of Colorado, Boulder
1939	San Francisco World's Fair, Golden Gate International Exhibition, California
1937	*American Indian Exposition and Congress*, Tulsa, Oklahoma
1934	*Century of Progress*, Chicago World's Fair, Illinois
1931–1933	*Exposition of Tribal Arts*, organized by the College Art Association (traveling)
1928	Fair Park Gallery, Dallas, Texas
1927	Corona Mundi International Art Center, New York
1919–1920	Museum of New Mexico, Santa Fe
1914	*Panama-California Exposition*, San Diego World's Fair, California
1904	*Louisiana Purchase Exposition*, St. Louis World's Fair, Missouri

COLLECTIONS

American Museum of Natural History, New York; Amerind Foundation, Dargoon, Arizona; Amon Carter Museum of Art, Fort Worth, Texas; Arizona State Museum, University of Arizona, Tucson; Cincinnati Art Museum, Ohio; Cleveland Museum of Art, Ohio; Columbus Gallery of Fine Arts, Ohio; Dartmouth College Collection, Hanover, New Hampshire; Denver Art Museum, Colorado; Joslyn Art Museum, Omaha, Nebraska; Koogler McNay Art Museum, San Antonio, Texas; Millicent Rogers Foundation Museum, Taos, New Mexico; Museum of Art, University of Oklahoma, Norman; Museum of New Mexico, Santa Fe; Museum of Northern Arizona, Flagstaff; Museum of the American Indian, New York; School of American Research, Santa Fe, New Mexico; Smithsonian Institution, Washington, D.C.; Southwest Museum, Los Angeles, California; Thomas Gilcrease Institute of American History and Art, Tulsa, Oklahoma; University of Pennsylvania Museum, Philadelphia; Wheelwright Museum of the American Indian, Santa Fe, New Mexico

PUBLICATIONS

Bernstein, Bruce. "Maria Martínez." In Roger Matuz, ed., *Native North American Artists*. Detroit: St. James Press, 1998. pp. 359–362.

Cohen, Lee M., ed. *Art of Clay: Timeless Pottery of the Southwest*. Santa Fe: Clear Light Publications, 1993.

Dillingham, Rick. *Seven Families in Pueblo Pottery*. Albuquerque: University of New Mexico Press, 1974.

Jacka, Jerry, and Lois Jacka. *Native American Art and Its Evolution*. Flagstaff, Ariz.: Northland Press, 1988.

Marriott, Alice. *Maria: The Potter of San Ildefonso*. Norman: University of Oklahoma Press, 1948.

McGreevy, Susan B. *Maria: The Legend, the Legacy*. Santa Fe, N.M.: Sunstone Press, 1982.

Monthan, Guy, and Doris Monthan. *Art and Indian Individualists*. Flagstaff, Ariz.: Northland Press, 1975.

Peterson, Susan. *The Living Tradition of Maria Martínez*. Tokyo, Japan, and New York: Kodan Sha America, 1977.

Peterson, Susan. *Maria Martínez: Five Generations of Potters*. Washington, D.C.: Smithsonian Institution Press, 1978.

Spivey, Richard L. *Maria*. Flagstaff, Ariz.: Northland Press, 1979.

Van Ness Seymour, Tryntje. *When the Rainbow Touches Down*. Phoenix, Ariz.: Heard Museum, 1987. Seattle: University of Washington Press, 1987.

Williams, Jean Sherrod, ed. *American Indian Artists in the Avery Collection and the McNay Permanent Collection*. San Antonio: 1990.

BIOGRAPHICAL ESSAY

Maria Martínez, born in 1886 on the San Ildefonso Pueblo, was an internationally known Pueblo potter. The Martínez family members have experimented more widely with ceramic styles and techniques than any other known group of potters. Around the turn of the century, they also perfected the polychrome-on-

cream-slipped style that Maria had learned from her maternal aunt. She, along with her husband, Julian Martínez, developed the now-famous polished matte black on blackware style of ceramic pottery that was originally produced by the ancient peoples of the Santa Fe area. Although this style has changed considerably since its inception in the 1920s, through the addition of stone inlay, carving, duotone, oxidation, reduction firing, and color reversal designs, still, the basic style remains the mainstay of San Ildefonso pottery making.

Maria began to make pottery around the age of 10, by observing her aunt. During her life, Maria Martínez created pots for over 70 years. Through her, over five generations of the Martínez family have made, and continue to make, pottery. When she married Julian, they formed a team by working together. She would hand build (coil) the pottery, while Julian would create and paint the designs on the surface of the pottery. Between 1910 and 1915, many Southwestern Indian women created and shaped ceramic pottery, and their husbands decorated them. This team effort reduced the amount of time needed to finish a piece so it could be sold commercially.

In 1909, the School of American Research in Santa Fe encouraged Martínez to reproduce pottery excavated at the Pajarito Plateau. Martínez used the broken shards found at the Tewa and ancient burial mounds to reconstruct a replica of the original pot. Maria Martínez and her husband experimented with smoldering and smoking the pottery until the desired blackware was produced in 1910. The first pots were plain and unsigned. In 1918, the first decorated blackware was painted by Julian Martínez. These first pots had matte backgrounds with polished *avanya* designs that are horned water serpents. Designs were burnished over the background. Later motifs and symbols that resembled prehistoric and contemporary Zuni, Zia, and Acoma pottery traditions were applied to Maria Martínez's pottery. Soon the pots became more refined, highly polished, and blacker than the shards found at the excavation site. The quality of line, form, and symmetry was exceptional, considering the fact that all of the pottery was made by hand and without the use of a potter's wheel. Many of the pots have repeating geometric shapes and patterns within an intricate and symmetrical composition.

Following Julian's death in 1943, Maria continued producing undecorated pottery. Her daughter-in-law began to assist her, contributing a new vitality to the decorating system developed by Julian. During this time, meticulously crafted, classically harmonious plates were perfected. The earlier Art Deco style gave way to pristine symmetry, balance, and forms often associated with Greek Attic Ware. Maria's son Popovi also worked with her. Educated, he approached art scientifically, concerned about the properties of clay, pigments, and firing techniques. His experimentation allowed him and Maria to develop varieties of firing atmospheres that created sienna and duotone surface finishes. Maria also employed relatives to assist in stages of the pottery making, eventually expanding it into a full-scale cottage industry.

Maria Martínez is credited with creating commercially successful, Pan-Puebloan designs with burnished surface treatment of great technical quality and

beauty. Although she eventually achieved international fame, Maria dismissed the temptations of the limelight, preferring to live her entire life in her San Ildefonso village. She donated a large percentage of her earnings to her community, sponsoring traditional ceremonies and social functions. She is one of those rare artists who is warmly remembered by both her local, indigenous community and the world at large.

MAYNOR, MALINDA M.

Tribal affiliation: Lumbee. *Born*: North Carolina's Lumbee Indian community, Robeson County. *Education*: A.B., cum laude, History and Literature, Harvard University, 1995. M.A., Documentary Film and Video, Stanford University, 1997. *Career*: Research Assistant, Midnight Films, 1992–1993. Intern at the Smithsonian Institution's National Museum of the American Indian, Film & Video Center, New York, summer 1996. Consultant for The Learning Company, summer 1997. Lecturer in American Indian Studies, San Francisco State University, 1997–present. *Awards*: Smithsonian Institution Research Fellowship, National Museum of American History, and Director's Citation, 1993. Black Maria Film and Video Competition, 1994. National Endowment for the Humanities (NEH) Younger Scholar Grant, 1994. Best Indian-Produced Short Documentary, Red Earth Film Festival, Oklahoma City, 1997. Best Short Documentary, South by Southwest Film Festival, Austin, Texas, 1997.

SELECTED FILMOGRAPHY

1997	*Sacred Land Film Project*, La Honda, California. Associate Producer. Manage all phases of a documentary concerning threats to Native American sacred sites by government and industrial interests. Duties include research, outreach to Native subjects, and production scheduling. *Sounds of Faith*, Hi/8/Color/15 minutes. Producer/Director/Editor. A portrait of a Lumbee Indian family of singers and how their unique brand of traditional gospel music steers them through the modern world. Screened at the San Francisco American Indian Film Festival
1996	*25th Annual Stanford Powwow*, Hi/8/Color/60 minutes. Videographer. Directed by Yvonne Yazzie. An observational depiction of the Stanford University American Indian Organization's Powwow. *Real Indian*, 16mm/Color/7 minutes. Producer/Director/Editor. A personal film examining Native American racial stereotypes and their effect on the producer/director's cultural identity. Distributed by Women

Make Movies, New York, New York. Screened at the Sundance Film Festival, the National Museum of the American Indian, and the Boston Women's Film Festival

FESTIVAL APPEARANCES

1997 Women of Color Film and Video Festival, Santa Cruz, California; Women in the Director's Chair Film Festival, Chicago, Illinois; Two Rivers Native Film and Video Festival, Minneapolis, Minnesota; South by Southwest Film Festival, Austin, Texas; Sundance Film Festival, Park City, Utah; Red Earth Film and Video Festival, Oklahoma City, Oklahoma; Nordic Glory '97, Finland; Charlotte Film and Video Festival, Charlotte, North Carolina; American Indian Film Festival, San Francisco, California; Cine Estudiantil '97, San Diego, California; Boston Women's Film Festival, Boston, Massachusetts

1996 American Indian Film Festival, San Francisco, California

SELECTED PUBLICATIONS

Brayboy, Connie. "Sounds of Faith." *Carolina Indian Voice* (April 17, 1997).
Brunson, Matt. "Carolina Connections." *Creative Loafing/CLT* (April 26, 1997).
Rado, Mark Anthony. "Native Filmmaker's Work Shown at Sundance Film Festival." *Circle Quarterly Arts Review* 8, no. 2 (February 1997).
22nd Annual American Indian Film Festival Catalog. San Francisco: City of San Francisco Governmental Agencies. 1997.

ARTIST STATEMENT (1998)

I want to move people into my space, my definition of who we are as native people. For us, it is about a sense of place—home. I think being Indian is more than one thing, such as tradition, or having a connection to language. I think it involves being a whole person—having a desire to help, heal, and care for your family, friends, and neighbors. The connection is home.

BIOGRAPHICAL ESSAY

Malinda M. Maynor was born in North Carolina's Lumbee Indian community and grew up in Durham. She was the first Lumbee female to attend Harvard University, where she graduated cum laude in American History and Literature. It was at Harvard that she gained experience writing and researching documentaries for independent producer Paul Stekler and the Smithsonian Institution's American Indian Program, with Rayna Green. She then decided to study filmmaking full-time and entered Stanford University's Documentary Film and Video Program, where she earned a master's degree in June 1997.

Her first film, *Real Indian,* has been screened at, among other venues, the Sundance Film Festival and the Smithsonian's National Museum of the Amer-

ican Indian and won the best short documentary award at the 1997 South by Southwest Film Festival. It has garnered much praise and sparked serious discussion about the meaning of Native American identity. It is distributed by Women Make Movies, the country's leading distributor of films by and about women.

Malinda's next project was a 15-minute video entitled *Sounds of Faith*, which is concerned with Lumbee Indian gospel music. It premiered at the 1997 American Indian Film Festival and the 1998 Sundance Film Festival.

In addition to her filmmaking experience, Maynor received a grant from the National Endowment for the Humanities to write a research paper on nineteenth-century Lumbee history that focused on violence and race relations in Robeson County, North Carolina. She also received a Smithsonian Institution Research Fellowship to research and write a film treatment on the history of the Cherokee Baptist Church. Currently, Malinda is Associate Producer on Christopher McLeod's *Sacred Land Film Project*, teaching in American Indian Studies at San Francisco State University, and developing a multimedia project on Lumbee spirituality.

In a *Quarterly Arts Review* interview, Maynor openly discusses some of her apprehensive feelings about previewing her film *Real Indian* to a Native filmmaking audience and discusses identity issues affecting her and other Lumbees—apprehensive feelings that inspired her to create the film. Theories about the origin of the Lumbees include that they are descendants of the intermixture between North Carolina Algonquian tribes and sixteenth-century English colonists on Roanoke Island, descendants of an eastern Siouan tribe, the Cheraws, or an amalgamation of both Siouan and Algonquian tribes. Because of their early mixture with European colonists (British and Scottish), assimilation lifestyle, loss of indigenous language and religion, and lack of a federal or state reservation, Lumbees do not fit society's stereotypes for Native Americans. Historically, Lumbees have had problems being recognized as Indians by non-Indians and even other Indians. In addition, some Lumbee Indian families have African American ancestry dating from intermixture during colonial times. All of these identity issues are explored in a lighthearted, personal look at film footage of Malinda's family's home movies and photos, other Lumbee families, and historic Lumbee photographs. *Real Indian* makes the audience question their perceptions of Native Americans as well as the meaning of their own identities.

Sounds of Faith is in some ways a continuation of the themes addressed in *Real Indian*. It takes a personal look at the vibrant gospel music tradition of the Lumbees and gives the audience a unique view of the issues confronting an Indian community trying to pass its musical and spiritual traditions to younger generations. Visiting Southern Baptist Church services, powwows, and family holiday gatherings, the filmmaker shows the audience an important transitional moment in the life of her community. Viewers are privy to the internal conflicts that cause Lumbees to adopt Plains Indian regalia to look more "authentic," the questions younger Lumbees have about indigenous beliefs/practices such as

the Great Spirit and Lakota rituals versus Christianity (can the two be blended?), and self-esteem issues about appearance for Lumbees who do not have long, straight hair.

Through her films, Malinda stresses the fact that the Lumbees' very existence and their insistence on being defined as American Indians challenge native stereotypes that have been perpetuated by the dominant culture and other Native Americans. The *Quarterly Arts Review* critiques *Real Indian* as a "raw, frank confession from a woman who has struggled to define her heritage, and a challenge to others to appreciate that definition." In an interview in *Carolina Indian Voice* about *Sounds of Faith*, Malinda acknowledges that Lumbees are different in some aspects from reservation Indians, "but those differences don't make us any less Indian. There is a uniqueness about our people that is not found any place else. I would like to be able to express that uniqueness on video." In *Real Indian, Sounds of Faith*, and future films, Malinda Maynor can share that uniqueness and expand the definitions of native identity.

McKAY, MABEL

Tribal affiliations: Pomo/Wintu/Patwin. *Born*: 1907, Nice, Lake County, California. *Family*: Married to Charlie McKay. One son, Marshall. Maternal relatives were all basket weavers in the indigenous California styles. *Career*: Basket weaver, lecturer in basket weaving and California Indian culture, medicine woman, factory worker. *Died*: 1993, California.

SELECTED GROUP EXHIBITIONS

1996	*The Fine Art of California Indian Basketry*, Crocker Art Museum, Sacramento, California
1979	Pacific Western Traders, Folsom, California
1930	California State Indian Museum, Sacramento, California

COLLECTIONS

California State Indian Museum, Sacramento; Collection of Marchal McKay; Heard Museum, Phoenix, Arizona; Pacific Western Traders, Folsom, California; Smithsonian Institution, Washington, D.C.; State of California, Department of Parks and Recreation

PUBLICATIONS

Bernstein, Bruce. "Mabel McKay." *American Indian Art Magazine* (Winter 1995).
Bibby, Brian. *The Fine Art of California Indian Basketry*. Sacramento: Crocker Art Museum, 1996.

Frederickson, Vera Mae. "Big Times/Little Times." *News from Native California* (July–
 August 1989).
Hill, Dorothy. *Mabel McKay and Bertha Mitchell.* California State University, Chico,
 1974. Film.
Sarris, Greg. *Mabel McKay: Weaving the Dream.* Berkeley: University of California
 Press, 1995.
Sarris, Greg. "On the Road to Lolsel: Conversations with Mabel McKay." *News from
 Native California* (September–October 1988).
Schaaf, Gregory. "Mabel McKay." In Roger Matuz, ed., *Native North American Artists.*
 Detroit: St. James Press, 1998. pp. 369–370.

BIOGRAPHICAL ESSAY

Mabel McKay was a multitalented woman who played many roles in life—
basket maker, Dream doctor, university lecturer, factory worker, prophet, wife,
and mother—roles performed mainly to benefit the indigenous peoples of Cal-
ifornia. As a world renowned Pomo basket maker with permanent collections
in the Smithsonian Institution, the last Dreamer and sucking doctor among the
Pomos, and the last living member of the Long Valley Cache Creek Pomo tribe,
Mabel McKay's contributions to Pomo and Wintu culture have left a legacy for
the indigenous peoples she represented and the non-Indian populations who
thought California Indian culture ended with the Gold Rush.

Born in 1907 in rural California, north of San Francisco, Mabel McKay was
a sickly child raised by her grandmother. As a young child Mabel experienced
prophetic dreams and lessons about life from a spirit that would later guide her
in basket making and healing. Mabel's grandmother's brother started the Dream
religion called Bole Maru or Bole Hesi, and her great-grandmother saved their
tribe from starvation by selling her baskets to white people. With spiritual guid-
ance and a family background that included basketry and traditional healing,
Mabel started weaving at six years old, handling willow rods, sedge roots, and
redbud bark, creating anthill and quail designs without seeing the patterns in
advance.

The processes involved in basket making included splitting and peeling sedge
roots, peeling and coiling redbud bark, using willows picked at certain times of
the year in order for the baskets to be watertight, soaking the sedge roots in
water to make them pliable, and weaving them around the willow rod, opening
a space for each new stitch with a steel awl. Mabel wove in redbud for the
colored designs, seeing a pattern form in her mind as she coiled. Her feather
baskets were made from the yellow feathers of the meadowlark, metallic green
feathers from the necks of mallard ducks, and orange breast feathers from robins.
Some of her miniature baskets were as small as an eraser head, requiring a
magnifying glass to observe the intricate designs made from tiny strips of redbud
bark. Mabel also made larger baskets, some for cooking.

Mabel followed certain rules or taboos when basket making—tribal rules and

those dictated by her spirit guide. According to her traditions, baskets are living entities, not just pretty objects to look at, and each basket has a particular purpose. Miniature baskets were used for health and protection and larger ones for pragmatic purposes such as cooking and food storage. Basket making was taboo when drinking alcohol or menstruating because menstruating women were honored and exempt from cooking and other household chores. Mabel's basket making was intertwined with her healing, with each patient receiving a personal basket and/or instruction in basket making. While weaving three hours a day and healing people, Mabel continued working as a seasonal fruit picker, washerwoman, and factory worker.

As Mabel McKay became known throughout northern California for her basket making and healing among the Pomo and Wintu peoples, white anthropologists, art collectors, and basket specialists began to approach her, offering high prices for her services. But Mabel never changed her traditional procedures to meet consumer requests, ignoring some requests for baskets and making some customers wait years before receiving a basket. In 1929 at the age of 22 she exhibited at the California State Fair in Sacramento. Speaking four languages—Lolsel Cache Creek Pomo, Sulphur Bank Pomo, Southwestern Wintun, and English—Mabel became a lecturer on California Native American culture and basket making demonstrator for college students, professors, and the general public in Davis, Sacramento, Santa Rosa, and Santa Cruz. During the 1950s and 1960s the lecturing helped supplement the family income and she, her Wintu husband Charles McKay, and their adopted son Marshall (her sister's son) led a modest, comfortable life after years of hard struggle.

In 1975 Mabel retired from her 20-year job at the cannery and became even more involved in lecturing about California Native American culture at museums and universities. California governor Jerry Brown appointed her to the first California Indian Heritage Commission. She became active in an environmental protest against construction of the Warm Springs Dam on Dry Creek, a traditional place for digging sedge roots. Due to severe arthritis her weaving was limited to one hour a day, and her healing to singing and praying over patients. By this time Mabel McKay was an honored elder, the last spiritual adviser for her tribe, and the last speaker of the Lolsel Cache Creek Pomo language.

Mabel McKay never considered herself an artist and attributed all of her talents to her spirit guide. In her biography *Mabel McKay: Weaving the Dream*, she states, ''It's no such a thing art. It's spirit. Only the spirit trained me. I only follow my dream. That's how I learn.'' The spirit called Mabel McKay on May 31, 1993. She is buried in the Kashaya Pomo cemetery.

NARANJO-MORSE, NORA

Tribal affiliation: Santa Clara Pueblo. *Born*: 1953, Española, New Mexico. *Education*: Silversmithing Program, Institute of American Indian Arts, Santa Fe, New Mexico, 1991. *Career*: Independent artist from the 1980s to the present. Artist-in-residence, Santa Fe Indian School, 1982. Pottery instructor in Denmark and Germany, 1984. Poetry readings, 1986–1995. *Awards*: Third place, single figure clay sculpture, Indian Market, 1979. Second place, single figure clay sculpture, Indian Market, 1980. First place, contemporary clay forms, Annual Pottery Show, Denver, Colorado, 1981. Fellowship from South Western Association on Indian Affairs, 1982. First place, contemporary clay forms, Annual Pottery Show, Denver, Colorado, 1982. Second place, clay sculptures, Indian Market, 1982. First place, clay scenes, Indian Market, 1983. Fellowship from the School of American Indian Research, 1989.

EXHIBITIONS

1994	*What Was Taken . . . What We Sell*, Institute of American Indian Arts, Santa Fe, New Mexico
1993	*One Woman Exhibition*, American Indian Contemporary Arts, San Francisco, California
1992	*One Woman Exhibition*, Maxwell Museum, Albuquerque, New Mexico
1988	*One Woman Show*, Museum of Northern Arizona, Flagstaff, Arizona
1987	*One Woman Exhibition*, Many Goats Gallery, Tucson, Arizona

SELECTED GROUP EXHIBITIONS

1994	*Sisters of the Earth*, Bush Barn Art Center's A. N. Bush Gallery, Salem, Oregon; *Indian Humor*, American Indian Contemporary Arts, San Francisco, California
1991	*Group Showing of Miniatures*, Albuquerque Museum, New Mexico; *Separate Vision*, National Museum of Natural History, Smithsonian Institution, Washington, D.C.
1990	*Two Person Show*, The Four Winds Gallery, Pittsburgh, Pennsylvania
1988	*Earth, Hands, and Life*, Heard Museum, Phoenix, Arizona
1985–1986	*Two Person Show*, Squash Blossom, Vail, Colorado
1984	*Group Showing*, Adobe Wall Gallery, Houston, Texas
1983	*Two Person Show*, Many Goats Gallery, Tucson, Arizona
1980	*Rising Stars*, Gallery 10, Scottsdale, Arizona

COLLECTIONS

Albuquerque Museum, Albuquerque, New Mexico; Heard Museum, Phoenix, Arizona; Museum of Northern Arizona, Flagstaff, Arizona; Smithsonian Institution, Washington, D.C.

SELECTED PUBLICATIONS

Abbott, Lawrence. *I Stand in the Center of the Good: Interviews with Contemporary Native American Artists*. Lincoln: University of Nebraska Press, 1994.

Bryan, Susan. "Nora Naranjo-Morse: Pearlene Plays Poker at the Pueblo." *Phoenix Home and Garden* (April 1988).

Ceremony of Brotherhood: Anthology of Native American and Hispanic Writers and Artists. Albuquerque: University of New Mexico Press, 1981. Poems published.

Eaton, Linda. "The Only One Who Knows: A Separate Vision." *American Indian Art* 14, no. 3 (Summer 1989).

Fireweed: Native Women Speaking Out. Ontario: Ontario Arts Council, 1986. Poems published.

A Gathering of Spirits: Writings and Art of Native American Women. Ontario: Sinister Women Press, 1982. Poems published.

Naranjo-Morse, Nora. *Kaa Povi's First Clay Gathering*. Boston, Mass.: Modern Curriculum Press, Inc., in association with The Children's Boston Museum.

Naranjo-Morse, Nora. *Mud Woman: Poems from the Clay*. Tucson: University of Arizona Press, 1992.

Pardue, Diana, and Kathryn Coe. "Earth Symbols." *Native Peoples* 2, no. 2 (Winter 1989).

Peterson, Ashley. "Nora Naranjo-Morse: Working with Enchantment." *Artists of the Sun: Official Indian Market Program*, August 20, 1981.

Seven Families in Pueblo Pottery. Albuquerque: University of New Mexico Press and the Maxwell Museum of Anthropology, 1974.

Sun Tracks American Indian Literary Magazine 3, no. 2 (Spring 1979). Poems published.

Trimble, Stephen. "Brown Earth and Laughter: The Clay People of Nora Naranjo-Morse." *American Indian Art* 21, no. 4 (Autumn 1987).

Trimble, Stephen. *Talking with Clay: The Art of Pueblo Pottery*. Santa Fe, N.M.: School of American Research Press, 1987.

Vigil, Jennifer. "Nora Naranjo-Morse." In Roger Matuz, ed., *Native North American Artists*. Detroit: St. James Press, 1998. pp. 408–409.

ARTIST STATEMENT (1992)[1]

Plant, animal and human life cycles, nurtured and guarded, are held equally in a larger vessel called earth. The symmetry of earth's vessel depends on our respect for earth's balance and our caretaking of these cycles. Gathering this knowledge as I do clay, I am impressed by the spiritual strength of these lessons. This cultural rooting encourages me when I explore my own creative vein. I am excited and challenged by simple lines, new shapes, and textures. I weave my experiences as a modern pueblo woman into this fiber of clay work, centuries old.

My work does not generally conform to standards set by the present Indian

art market. I exercise my creative license in a menagerie of characters that travel through time, inspired by culture and personal experiences.

In the Tewa language, there is no word for art. There is, however, the concept for an artful life, filled with inspiration and fueled by labor and thoughtful approach.

Note

1. From Nora Naranjo-Morse, *Mud Woman: Poems from the Clay* (Tucson: University of Arizona Press, 1992), p. 15.

BIOGRAPHICAL ESSAY

Nora Naranjo-Morse is strongly centered in her world on the Santa Clara Pueblo Reservation in northern New Mexico. Coming from a long line of Pueblo potters, Nora learned her craft at an early age, gathering clay with her mother from the hillsides and mountain roads in New Mexico, using traditional Pueblo methods to prepare and coil the clay. During the late 1970s she began working as a ceramic artist, developing her own styles, which break away from traditional Pueblo vessel shaping. Incorporating modern aesthetic influences with her Pueblo traditions, Nora combines metals, wood, stones, and plastics with clay to invent new forms that symbolize the struggle to achieve balance between the Pueblo Indian world and the outside, dominant culture.

At times, Nora textures wood to look like clay, colors clay with coffee to make it look like richly stained wood, or immerses formed clay in water, air-drying it quickly to achieve an ancient look. She creates a wide variety of figures, some based on traditional images such as fetishes and clowns, others very contemporary, like her famous Pearlene. Poetry is often an important aspect of Nora's clay figures, sometimes inspiring her to create certain characters and situations in clay. In some instances, the figures become the impetus for a poem.

Mud Woman is both a character in clay that represents Nora and the title of her book of poems. *Mud Woman's First Encounter with the World of Money and Business* (1987) is a standing, plump figure holding a *kosa* (ceremonial clown) in each hand, traditional objects for sale to a non-Indian consumer culture. The piece symbolizes Nora's first attempts to sell her art and the internal conflicts she experienced in selling her culture to outsiders who were not aware of the deeper significance of the *kosas*. In interviews and lectures, Nora discusses the commercialization of Pueblo culture and how "fast money" and consumer greed and demand are affecting the integrity of Pueblo art.

The center of what Mud Woman knew to be real was shifting with each moment in the gallery.[1]

A very different Mud Woman is *Water Jar on Mud Woman's Head*. This is a very elegant figure with an erect posture, turquoise earrings, a red beaded necklace, and upraised arms poised to help maintain the balance of the water

jar on her head. The subtly abstracted facial features are serene, dignified, a woman of the Pueblo world before the crass commercialization depicted in the other Mud Woman sculpture.

Pearlene is Nora's most popular figure, appearing in *Pearlene's Roots, Pearlene Teaching Her Cousins Poker*, and other series. Pearlene is a contemporary Pueblo woman who "tells it like it is" with a humorous, assertive, sexy bravado. Pearlene became so popular that a businessman offered to mass produce the image in plastic. Refusing to have her art commodified, despite the potential lucrativeness, Nora ceased production of the Pearlene figures.

Although a thoroughly modern woman through education and travel, Nora still feels bound to the Pueblo earth and the Pueblo worldview. She wants the public to be aware of her heritage through her art. In addition to tribal influences, Nora's work is informed by her curiosity and awe of everyday occurrences— the variety of shapes and colors in all peoples, the stages in her personal life, children in all their emotions, the strangeness of urban life, and ordinary people she encounters in public.

Nora's recent works are more politically charged, focusing on current issues affecting Native Americans. Through large-scale installations, mixed media, and her poetry she is headed in new directions in which clay is not always the dominant focus. But the humor and the irony are ever present.

Note

1. From Nora Naranjo-Morse, *Mud Woman: Poems from the Clay* (Tucson: University of Arizona Press, 1992), p. 35.

NIRO, SHELLEY

Tribal Affiliation: Mohawk. *Born*: 1954, Niagara Falls, New York. *Education*: Durham College, Oshawa, Ontario, Graphics Program, 1978. Ontario College of Art & Design, H.F.A., 1990. Summer graduate courses at the Banff School of Fine Arts. *Career*: Part-time faculty at the University of Western Ontario. *Awards*: First Projects Grant and Photographer's Exhibition Assistant Grant, Ontario Arts Council. Two Rivers Film and Video Festival, Minneapolis, Minnesota. Walking in Beauty Award, for *It Starts with a Whisper*, 1992.

EXHIBITIONS

1994 *Senses of Self*, London Regional Art and Historical Museums, London, Ontario

1992 *This Land Is Mime*, Ufundi Gallery, Ottawa, Canada; *Mohawks in
 Beehives and Other Works*, Mercer Union, Toronto, Canada

SELECTED GROUP EXHIBITIONS

1995 *Alter* Native: *Contemporary Photo Compositions*, McMichael Cana-
 dian Art Collection, Kleinburg, Ontario; *Image and Self: In Contem-
 porary Native American Photoart*, Hood Museum of Art, Dartmouth
 College, Hanover, New Hampshire; *The Female Imaginary*, Agens
 Etherington Art Center, Kingston, Ontario

1994 *From Icebergs to Ice Tea*, Thunder Bay Art Center, Ontario

1993 *Cultural Contrasts*, Stamford Museum and Nature Center, Stamford,
 Connecticut; *Defining Our Realities: Native American Women Pho-
 tographers*, Sacred Circle Gallery, Seattle, Washington

FILMS

1997 *Overweight with Crooked Teeth*, live Short, video, 5 minutes, Shelley
 Niro, director

1992 *It Starts with a Whisper*, with Anna Gronau

COLLECTIONS

Canada Council Art Bank, Ottawa; Canadian Museum of Civilization, Hull, Quebec;
City of North Bay; Indian and Northern Affairs, Indian Art Bank; Laurentian Art Centre,
Sudbury; Woodland Cultural Center, Brantford, Ontario

PUBLICATIONS

Harlan, Theresa. ''As in Her Vision: Native American Women Photographers.'' In Diane
 Neumaier, ed., *Reframings: New American Feminist Photographies*. Philadelphia:
 Temple University Press, 1995. pp. 114–124.
Harlan, Theresa. *Watchful Eyes: Native American Women Artists*. Phoenix, Ariz.: Heard
 Museum, 1994.
Hill, Lynn A. *Alter* Native: *Contemporary Photo Compositions*. Kleinburg, Ontario:
 McMichael Canadian Art Collection, 1995.
Hoone, Jeffrey. *Shelley Niro*. Syracuse: Light Work Gallery, 1994. Available from http:/
 /sumweb.syr.edu/summon2/com_dark/public/web/niro.html
Ryan, Allan. ''I Enjoy Being a Mohawk Girl: The Cool and Comic Character of Shel-
 ley Niro's Photography.'' *American Indian Art Magazine* 20, no. 1 (Winter 1994).
Shelley Niro: Senses of Self. London, Ontario: London Regional Art and Historical Mu-
 seum, 1994. Exhbn cat.
Skoda, Jenifer. ''Image and Self: In Contemporary Native American Photoart.'' *American
 Indian Art Magazine* 21, no. 2 (Spring 1996).
Tharp, Paula E. Shooting Constructed Realities: The Self-Defining Art of Native Amer-
 ican Women Photographers. Master's thesis, University of Oklahoma, 1997.
Vigil, Jennifer. ''Shelley Niro.'' In Roger Matuz, ed., *Native North American Artists*.
 Detroit: St. James Press, 1998. pp. 414–415.

BIOGRAPHICAL ESSAY

Niro, photographer, painter, and filmmaker, was raised on the Six Nations Reserve near Brantford, Ontario, Canada. She is most noted for photographs of herself and female family members that use humor to challenge stereotypes of Native American women. Based on her personal experiences as a Mohawk woman, Niro casts herself, her sisters, and mother in contemporary situations such as on their Canadian reserve or in downtown Brantford, Ontario.

Niro uses photomontage, hand tints, and sepia tones in her photographs, often working in diptych or triptych format. Exhibiting since the mid-1980s—first in Canada and now including the United States—Niro achieved notoriety with *The Rebel* (1987), *Red Heels Hard* (1991), *Mohawks in Beehives* (1992), and the *This Land Is Mime* series (1992). Shelley Niro is often compared to the artist Cindy Sherman because they both use costumes/props and play themselves in different roles. However, a major difference is that Shelley never fully disguises herself. She wants the viewer to recognize her in her many manifestations.

In the sepia-toned triptych *This Land Is Mime*, Niro dresses as the Statue of Liberty, a playboy, Marilyn Monroe, and Elvis. In one image, dressed in the black clothes, painted face, and white gloves of the mime, Niro reminds the native viewer of their similarities with the mime—a character who has to be silent as he/she entertains. Native voices are often silenced, but their bodies and cultures are used for entertainment in sports mascots and consumer advertising.

From the same series, the *500 Year Itch* features Niro as Marilyn Monroe dressed in a white halter dress and blond wig, standing over an electric fan. Instead of a 7-year itch like the character in the Hollywood film, Niro is humorously reminding viewers of the 500-year itch native peoples have been feeling since contact. The photo is also a commentary on how many women, including Native American women, want to match the idealized sex symbols portrayed by actresses like Marilyn Monroe—images that have no resemblance to most women's faces or bodies.

The Rebel (1987), in which Niro's middle-aged, slightly plump mother poses stretched across the top of a car trunk, is a playful commentary on how sexuality is used to sell cars to consumers. The photograph challenges viewers on two fronts. First, her mother is not the thin, Anglo model preferred by the advertising agencies. Second, and perhaps most important, the photo challenges the stereotype of the middle-aged Indian woman as poor, depressed, and victimized. Niro's mother is laughing, hamming it up with the photographer.

Also noted as a filmmaker, Niro won the Walking in Beauty Award for her 1992 production *It Starts with a Whisper*. Her most recent film, *Overweight with Crooked Teeth* (live short, video, 5 minutes), premiered at the 1997, 22nd Annual American Indian Film Festival in San Francisco, California. Directed by Shelley, it is based on a poem by Michael Doxater in which the poet himself plays the principal roles of Sitting Bull and Chief Joseph.

Images of Native American women created by non-Indians usually reinforce

stereotypes of "Indian Princess" or "Earth Mother." Shelley Niro is part of an expanding group of Indian women artists who refute these stereotypes by creating images that show a broader range of contemporary Native American women's experiences. Using herself and family members, Niro photographs humorous, playful scenes of Indian women without the required beads, feathers, and buckskin dresses.

PEÑA, TONITA

Indian name: Quah Ah. *Tribal affiliation*: San Ildefonso Pueblo. *Born*: 1893, San Ildefonso Pueblo. *Education*: St. Catherine's Indian School, Santa Fe. San Ildefonso Public Day School. Trained in pottery at home by her aunt, Martina Vigil. *Family*: She was born with the name Maria Antonia Peña, but was also called Quah Ah (White Coral Beads) and Tonita Vigil Peña. Her father was Natividad Peña, and her mother was Ascencion Vigil. After her mother's death in 1905, Tonita was raised by her aunt, Martina Vigil of Cochita, who was a potter. Peña's half brother was the artist Romando Vigil. Peña's third husband, Epitacio Arquero, was governor of their pueblo. One of her children, Joe Herrera, became a well-known progressive artist who broke with the Studio style imagery. *Career*: Painter and art instructor at the Santa Fe Indian School and the Albuquerque Indian School; muralist. *Died*: 1949, New Mexico.

SELECTED GROUP EXHIBITIONS

1994	*Watchful Eyes: Native American Women Artists*, Heard Museum, Phoenix, Arizona
1991–1992	*Shared Visions: Native American Painters and Sculptors in the Twentieth Century*, Heard Museum (traveling)
1988	*When the Rainbow Touches Down*, Heard Museum (traveling)
1984–1985	*Indianascher Kunstler*, organized by the Philbrook Museum, Tulsa, Oklahoma (toured Germany)
1980	*Native American Painting*, sponsored by Mid-American Arts Alliance (traveling)
1955–1956	*European Tour of Contemporary American Indian Painting*, U.S. Information Agency
1937	*American Indian Exposition and Congress*, Tulsa, Oklahoma
1931–1933	*Exposition of Indian Tribal Arts*, sponsored by The College Art Association (traveling)

COLLECTIONS

American Museum of Natural History, New York; Center for Great Plains Studies, University of Nebraska, Lincoln; Cincinnati Art Museum, Ohio; Cleveland Museum of Art, Ohio; Columbus Gallery of Fine Arts, Ohio; Corcoran Gallery of Art, Washington, D.C.; Cranbrook Institute of Science, Bloomfield, Michigan; Dartmouth College Collection, Hanover, New Hampshire; Denver Art Museum, Colorado; Heard Museum, Phoenix, Arizona; Millicent Rogers Foundation Museum, Taos, New Mexico; Museum of New Mexico, Santa Fe; Museum of Northern Arizona, Flagstaff; Museum of the American Indian, Heye Foundation; National Museum of American Art, Washington, D.C.; Philbrook Art Center, Tulsa, Oklahoma; Phoebe Hearst Museum, University of California, Berkeley; Roswell Museum and Art Center, Roswell, New Mexico; School of American Research, Santa Fe, New Mexico; Smithsonian Institution, Washington, D.C.; Thomas Gilcrease Institute of American History and Art, Tulsa, Oklahoma; University of Oklahoma, Norman

PUBLICATIONS

Archuleta, Margaret, and Rennard Strickland. *Shared Visions: Native American Painters and Sculptors in the Twentieth Century*. New York: New Press, 1991.

Brody, J. J. *Indian Painters and White Patrons*. Albuquerque: University of New Mexico Press, 1971.

Dunn, Dorothy. *American Indian Painting of the Southwest and Plains Areas*. Albuquerque: University of New Mexico Press, 1968.

Gray, Samuel L. *Tonita Peña*. Albuquerque: Avanyu, 1990.

Heller, James, and Nancy Heller, eds. *North American Women Artists of the Twentieth Century*. New York: Garland Publishing, 1995.

Jantzer-White, Marilee. ''Tonita Peña (Quah Ah) Pueblo Painter: Asserting Identity through Continuity and Change.'' *American Indian Quarterly* 18, no. 3 (Summer 1994).

Rogers, Lisa. ''Tonita Peña.'' In Roger Matuz, ed., *Native North American Artists*. Detroit: St. James Press, 1998. pp. 445–447.

Silberman, Arthur. *100 Years of Native American Painting*. Oklahoma City: Oklahoma Museum of Art, 1978.

Sloan, John, and Oliver La Farge. *Introduction to American Indian Art*. New York: Exposition of Indian Tribal Arts, 1931.

Van Ness Seymour, Tryntje. *When the Rainbow Touches Down*. Seattle: University of Washington Press, 1988.

BIOGRAPHICAL ESSAY

Tonita Peña was an art colleague of the first group of Southwest easel painters, including Awa Tsireh, Fred Kabotie, Oqwa Pi, Velino Shije, Romando Vigil, and Crescencio Martinez. She was also the first Native American woman to make a career from easel painting, paving the ground for other women artists such as Pablita Velarde and Pop Chalee.

Her paintings often focused on women's roles in the pueblo and were noted

for their meticulous attention to detail, lively sense of movement, and individualized facial expressions. *Woman Weaving and Supervising Kiln* is an example of this meticulous attention to minute detail with each pottery piece painted with intricate detail to traditional pueblo designs and clothing styles accurately rendered. It was Peña's way of visually documenting a lifestyle threatened by federal government intrusion.

Peña's artistic expression was first nurtured at home where she learned pottery skills from her aunt and uncle, Martina Vigil and Florentino Montoya. Living in the San Ildefonso Pueblo and in Cochita, Peña was exposed to the traditional creativity of ceremonial dancing, singing, weaving, embroidery, and decorated utilitarian objects.

As a young child Peña began watercolor painting at the San Ildefonso Pueblo Public Day School under the direction of her teacher, Esther B. Hoyt. After her mother's death she lived with her aunt in Cochita and attended St. Catherine's Indian School in Santa Fe. While she was still a student at St. Catherine's, Dr. Edgar Lee Hewitt of the Museum of New Mexico and School of American Research and Kenneth Chapman of the Laboratory of Anthropology in Santa Fe encouraged her artistic efforts and became Peña's first art patrons.

In 1933 Peña was commissioned to paint murals for the Society of Independent Artists and the Chicago World's Fair. During the 1930s Peña also worked as a Works Progress Administration (WPA) artist, painting murals for the Santa Fe Indian School and was involved with other Pueblo artists in copying the Pajarito murals before restoration. Occasionally Peña also worked as an art teacher at the Santa Fe Indian School and the Albuquerque Indian School, encouraging other potential Native American artists—particularly Pablita Velarde, who always cites Tonita Peña as a major influence.

Peña's easel paintings have been exhibited in major shows throughout the United States and Europe and are in numerous public/private collections. Her paintings are almost exclusively in watercolor, centering around ceremonial dances such as the Green Corn Dance and the Eagle Dance. Contemporary viewers of her paintings can experience her tribe's traditional tempo through the way Peña portrayed their uses of sashes, flying feathers, moving feet, and consecrated expressions. Peña managed to have a successful art career while raising six children, burying two husbands, and assuming the responsibilities of a pueblo governor's (her third husband) wife. Peña entered the spirit world in 1949, but her legacy continues through the work of her son, Joe Herrera, a pioneer in modern abstract Indian painting.

PITT, LILLIAN

Indian name: Wa'-K-a-mu. *Tribal affiliation*: Warm Springs Yakima Wasco. *Born*: 1943, Warm Springs, Oregon. *Education*: Associates of Arts, Mental Health/Human Services, Mt. Hood Community College, Oregon, 1981. Also studied Raku pottery, Japanese papermaking, and bronze and willow techniques. *Family*: Raised by her parents on the Warm Springs Reservation in Oregon. *Career*: Self-employed artist since 1981. *Awards*: Purchase Award, Metropolitan Arts Commission, Portland, Oregon, 1986. Oregon Governor's Award for the Arts, 1990.

SELECTED EXHIBITIONS

1997	*In Search of Self*, Ft. Lewis College Art Gallery, Durango, Colorado
1996	*Native American Tradition/Contemporary Responses*, Society for Contemporary Crafts, Pittsburgh, Pennsylvania; *Forest Spirits*, Quintana Gallery, Portland, Oregon; Detroit Gallery, Detroit, Michigan
1995	*Plateau-Spirits*, Quintana Gallery, Portland, Oregon; Memorial Union Gallery, University of California, Davis
1994	*Plateau Spirits: Works by Lillian Pitt*, Institute of American Indian Studies, Washington, Connecticut; *Honoring Our Ancestors*, Quintana Gallery, Portland, Oregon
1993	Governor's Office, Salem, Oregon
1992	*Out of the Earth*, Salishan Lodge, Gleneden Beach, Oregon
1991	Spirit Square Art Center, Charlotte, North Carolina; Galleria Posada, Sacramento, California

SELECTED GROUP EXHIBITIONS

1996	*Native American Art Exhibit*, Parkland College, Champaign, Illinois; *Art of the People*, Sunbird Gallery, Bend, Oregon
1995	*Oregon Biennial*, Portland Art Museum, Oregon; Tacoma Art Museum, Tacoma, Washington; *Te Atinga*, International Exhibit, Rotorua, New Zealand; *Setting the Stage: A Contemporary View of the West*, Eiteljorg Museum of American Indian Art, Indianapolis, Indiana; *Indian Humor*, American Indian Contemporary Arts, San Francisco, California
1994	*Artists Who Are Indian*, Denver Art Museum, Colorado; *Watchful Eyes: Native American Women Artists*, Heard Museum, Phoenix, Ar-

izona; *Works of Three Native American Women*, Adobe East Gallery, Summit, New Jersey; *Feats of Clay*, Lincoln Arts Center, Lincoln, California

1993 *Northwest Native American and First Nations People's Art*, Western Washington University, Bellingham, Washington; *Spirits Keep Whistling Us Home*, Sacred Circle Gallery, Seattle, Washington; *Contemporary Art Work*, Te Taumata, Auckland, New Zealand; *Tribal Member's Show*, Museum at Warm Springs, Warm Springs, Oregon; *Crosscut*, Portland Art Museum, Oregon

1991 *Wood Spirits*, Galleria Mesa, Mesa, Arizona; *Ancient Images from the Columbia River Gorge*, Maryhill Museum, Goldendale, Washington

1986 *Women of Sweetgrass, Cedar & Sage*, American Indian Community House, New York (touring United States and Canada)

1984 *No Beads No Trinkets*, Palais de Nations, Geneva, Switzerland

SELECTED COLLECTIONS

City of Hillsboro, Justice Center, Hillsboro, Oregon; City of Lake Oswego, Oregon; Heard Museum, Phoenix, Arizona; Indian Arts and Crafts Board, Washington, D.C.; Nieman Marcus, Minneapolis, Minnesota; R. C. Gorman, Taos, New Mexico; Sapporo City Hall, Sapporo, Japan; Seattle Arts Commission, Percent for Art, Seattle, Washington; Washington State Arts Commission, Art in Public Places, City of Oguni, Japan; Yakima Cultural Heritage Museum, Yakima, Oregon

SELECTED PUBLICATIONS

Bates, Sara. *Indian Humor.* San Francisco: American Indian Contemporary Arts, 1995.
Giles, Vesta. ''Lillian Pitt.'' In Roger Matuz, ed., *Native North American Artists*. Detroit: St. James Press, 1998. pp. 452–455.
Green, Rayna. *Women in American Indian Society.* New York: Chelsea House.
Jeffri, Joan, ed. *The Craft Person Speaks: Artists in Varied Media Discuss Their Crafts.* Westport, Conn.: Greenwood Press.
Rubenstein, Charlotte Streifer. *American Women Sculptors.* Boston: G. K. Hall.
Schlick, Mary. *Columbia River Basketry: Gift of the Ancestors, Gift of the Earth.* Seattle: University of Washington Press, 1994.
Wright, Robin K., ed. *A Time of Gathering: Native Heritage in Washington State.* Seattle: University of Washington Press, 1992.

ARTIST STATEMENT (1997)

When hand building my masks, I think of the rich history of the Columbia River Gorge, the people, the legends and stories, the animals, salmon, and all its lifegiving properties. It inspires me to give homage to it all throughout the clay process. I treasure each piece that survives the bronze casting process and the high-fired Japanese Raku and Korean Anagama processes. It becomes more

special when it is shared with the general public because it represents my ancestry, my origins, and my sense of gratitude of who I am.

BIOGRAPHICAL ESSAY

Lillian Pitt's ancestors lived on the Columbia River Gorge area for over 10,000 years. Her father's people lived on the Washington side of the river and her mother's people on the Oregon side. During the mid-1800s the government moved the Washington Wasco, Wishxam, and Wanapum Indians to Yakima, then switched their names to *Yakima*. The Oregon side Wasco, Wyam, Tenino, Tygh, and Watlalas were moved to Warm Springs, Oregon, where they were then called the *Warm Springs* tribe. Pitt lived with her parents on the Warm Springs Reservation the first 12 years of her life, after which they moved to nearby Madras.

Her masks and her recent sculptural installations are inspired by the rich history of the Columbia River Gorge, its people, oral history, and nature. Through her art, Pitt interprets legends told to her by her great-grandparents, legends of the Stick Indian of the Forest, Coyote the Trickster, and Tsagagllal the woman chief. She is also inspired by ancestral petroglyphs along the Columbia River.

Pitt started her career relatively late in life and almost by accident. While pursuing a degree in mental health/human services she took a ceramics class as an elective, and as she states, "It was love at first touch!" Due to back problems, Lillian Pitt was unable to sit at the potter's wheel and thus became involved in hand building and the Raku process. After making seven Raku fired masks she summoned the courage to show her work to famous Indian artist R. C. Gorman and a local gallery owner. Gorman purchased two of her masks and helped promote her work. Since then Pitt has been an independent artist, creating masks, mask pins, and now larger-scale multimedia works.

Raku is a low firing method in which the heat, fire, smoke, and glazes give a quality that is without absolute prediction or control. In the 30-foot climbing Anagama kiln, the fire burns continually for 56 hours, depositing ash, flame marks, and subtle color on the exposed clay surfaces. Only 50 percent of the pieces usually survive the 2,500 degrees Fahrenheit heat. After firing, materials such as feathers, buckskin, shells, and beads are added to embellish the masks. Pitt chooses some of the surviving pieces for special bronze editions, involving a 16-week bronze casting process. Pitt chooses clay pieces that she feels are worthy enough to be duplicated many times, pieces that evoke positive feelings in her.

Lillian's *Stick Indians* are well known and exhibited/sold as both large masks and smaller mask pins, measuring only 2" × 1.5". Her *Yakima Stick Indian* (9" × 8" × 2" Raku) depicts a legendary mountain spirit of the forest who is believed to rescue good people lost in the forest and to lead bad ones to misfortune. The face is divided into three geometric shapes separated by bold zigzag

lines. Shades of purple/lavender, off-white, and rose cover the surface. Large eyes peer at the viewer, and feathers frame the top of the head. The mask has a "universal" quality, reminding one of indigenous tribal masks found in Oceania, Asia, Africa, as well as the Americas.

Less haunting than the *Stick Indians* and the *Wasco and Wannapambhe Who Watches* masks is the playful, myth-shape shifter series that Pitt exhibited at the *Indian Humor* show, San Francisco, 1995. With titles like *Menopausal Mute, Migraine Madness*, and *Tendonitis Terrors*, these 9-inch Raku/Mixed figures reveal a different side of Pitt's personality.

Although Pitt's imagery is inspired by her Yakima ancestry, clay is a nontraditional medium for Northwest mask making. Pitt has broken the centuries old tradition of Northwest (Tlingit, Haida, Inuit) wood carved masks to embrace the Asian clay techniques of Raku and Anagama. Pitt has also traveled to New Zealand and been inspired by the indigenous Maori aesthetic. Some of her more recent work involves freestanding sculpture and installation pieces. However, the mask still remains as essential element in the newer work. As Lillian Pitt states: "I am involved at all times with the nature of my clay, which is often my boss. I love these spirits and am never alone."

POITRAS, JANE ASH

Tribal affiliation: Cree. *Born*: 1951, Fort Chipewyan, Alberta, Canada. *Education*: B.S., microbiology, University of Alberta, Edmonton, Canada, 1977. B.F.A., Columbia University, New York, 1983. M.F.A., Columbia University, New York, 1985. *Family*: Orphaned at age six and raised in a foster home. As an adult, through finding her mother's death certificate, reunited with her Cree relatives. *Career*: Industrial microbiologist, sessional instructor at the University of Alberta, Canada, lecturer, writer, and philosopher. *Awards*: Lady Rodney Scholarship, 1972. Graphex Purchase Award, 1978. Bursaries from Indian & Northern Affairs, 1981–1985.

EXHIBITIONS

1995	Hamburg Art Academy, Hamburg, Germany; New Zones Gallery of Contemporary Art, Calgary, Alberta
1994	Robertson Gallery, Ottawa, Ontario
1993–1994	Leo Kamen Gallery, Toronto, Ontario
1993	Thunder Bay Art Gallery, Thunder Bay, Ontario

1992	*Americas*, Andalusian Pavilion at Expo '92, Seville, Spain; *Recycled Blackboards*, Leo Kamen Gallery, Toronto, Ontario
1991	*Peyote Visions*, Woltjen/Udell, New York, and Vancouver, British Columbia; *Dream Vision*, Elaine Horwitch Galleries, Phoenix, Arizona, Scottsdale, Arizona, Santa Fe, New Mexico
1990	*Power Shields*, New York; West End Gallery, Edmonton, Alberta
1989	*Indigenous Blackboards*, Woltjen/Udell, New York
1988	*Fort Chip Breakfast Club*, Fort Chipewyan, Alberta
1987	*Sweat Lodge Etchings*, Museum of Anthropology, University of British Columbia, Vancouver
1986	*Print and Collages*, Brignall Gallery, Toronto, Ontario
1985	Robert Vanderleelie Gallery, Edmonton, Alberta

SELECTED GROUP EXHIBITIONS

1997	*Transitions: Contemporary Canadian Indian and Inuit Art*, Indian and Northern Affairs Canada, Department of Foreign Affairs and International Trade, Paris, France
1995	*Basket, Bead and Quill Forum*, Thunder Bay Art Gallery, Thunder Bay, Ontario
1994–1995	*Women and Paint*, Mendell Art Gallery, Saskatoon, Saskatchewan
1994	*Together—Alone*, New Zones Gallery of Contemporary Art, Calgary, Alberta
1993	Kamloops Art Gallery, Kamloops, British Columbia
1992	*Indigena*, Museum of Civilization, Hull, Quebec; *Americas*, Monasterio de Santa Clara, Moguer (Huelva), Spain; *New Territories . . . 350/500 Years After*, Antelier Vision Planetaire, Montreal, Quebec
1991–1992	*Changes: A Spiritual Renaissance* (traveling)
1990	*Eleven Stories: Mixed Media Work by Eleven Native American Artists*, Sacred Circle Gallery of American Indian Art, Seattle, Washington (traveling); *Seeing Red*, Agnes Etherington Art Centre, Queens University, Kingston, Ontario; *Ritual and Magic*, Winnipeg Art Gallery, Winnipeg, Manitoba; *Carriers of the Fire*, American Indian Community House, New York
1989	*Revelation of Inner Strengths*, Beaver House Gallery, Edmonton, Alberta; *The Mainstream Move*, Nova Gallery, Calgary, Alberta; *In the Shadow of the Sun*, Canadian Museum of Civilization, Hull, Quebec; *Beyond History*, Vancouver Art Gallery, Vancouver, British Columbia; *The 4th Biennial Native American Fine Arts Invitational*, Heard Museum, Phoenix, Arizona
1988	*Modern Echoes of Ancient Dreams*, Arts Court, Ottawa, Ontario; *Zeitgenossische Kunst der Indianer und Eskimo in Kanata*, Canadian Museum of Civilization, Hull, Quebec, opened in Dortmund, Germany, toured Canada

1987 *Los Angeles Celebration of Canadian Contemporary Native Art*,
 Southwest Museum of Los Angeles, California

1986–1987 *Stardusters*, Thunder Bay Art Gallery, Thunder Bay, Ontario (trav-
 eling)

1986 *New Beginnings*, Native Small Business Summit, Toronto, Ontario

1985 *Keepers of Our Culture*, Woodland Indian Cultural Centre, Brantford,
 Ontario

1984 *Izbagranfic '84*, Museo de Art Contemporeano, Ibiza, Spain; *Inter-
 national Independent Exhibition of Prints*, Prefectural Gallery, Kana-
 gawa, Japan; *Cabo Frio International Print Biennial*, Cabo Frio,
 Brazil

1982 *UCLA Third National Print Exhibition*, Los Angeles, California;
 Universiade '83, Kaleidoscope Native Art Exhibit, Edmonton, Al-
 berta; Shadows Gallery Group, Edmonton, Alberta

1981 Canadian Galleries, Edmonton, Alberta

COLLECTIONS

Alberta Art Foundation, Edmonton; Alberta Indian Arts & Crafts Society Collection,
Edmonton; Art Gallery of Ontario, Toronto; Brooklyn Museum, New York; Canada
Council Art Bank, Ottawa, Ontario; Canadian Museum of Civilization, Hull, Quebec;
City of Edmonton, Alberta; Columbia University, New York; Edmonton Art Gallery,
Alberta; Department of Indian and Northern Affairs Canada, Ottawa, Ontario; McMichael
Art Gallery, Kleinburg, Ontario; Peace Hills Trust, Edmonton, Alberta; Peguis Indian
Band, Winnipeg, Manitoba; Thunder Bay Art Gallery Collection, Thunder Bay, Ontario;
University of Alberta; Winnipeg Art Gallery, Winnipeg, Manitoba; Woodland Indian
Cultural Centre, Brantford, Ontario; Yale University, New Haven, Connecticut

PUBLICATIONS

Archuleta, Margaret. *The 4th Biennial Native American Fine Arts Invitational*. Phoenix,
 Ariz.: Heard Museum, 1989.
Duffek, Karen, and Tom Hill. *Beyond History*. Vancouver, British Columbia: Vancouver
 Art Gallery, 1989.
Dwyer, Victor. "Reflections on Nationhood." *Mcleans*, July 1, 1995.
Mackay, Gillian. "Lady Oracle." *Canadian Art* (Fall 1994).
Mark, Laura. "Jane Ash Poitras." *Artforum* 33 (January 1995).
McMaster, Gerald, and Lee-Ann Martin. "Indigena: Perspectives of Indigenous Peoples
 on Five Hundred Years." *American Indian Art Magazine* (Autumn 1992).
Poitras, Jane Ash. "The Essential Spirituality of North American Indigenous Cultures."
 In Gerald McMaster and Lee-Ann Martin, eds., *Indigena: Contemporary Native
 Perspectives in Canadian Art*. Vancouver, Canada: Douglas & McIntyre, 1992.
"The Synchronic Spirit: An Interview with Jane Ash Poitras." *Border Crossings* (Sep-
 tember 1992).
Vigil, Jennifer. "Jane Ash Poitras." In Roger Matuz, ed., *Native North American Artists*.
 Detroit: St. James Press, 1998. pp. 460–462.

BIOGRAPHICAL ESSAY

Jane Ash Poitras was born in Fort Chipewyan, Alberta, and relocated to Edmonton at the age of six when her mother died. Living in a nonnative foster home, Jane lost touch with her Cree heritage. As an adult she sought out her Cree relatives and became reimmersed in her native identity and Native American history and culture in general.

Although a successful microbiologist, Jane embarked on an education in the fine arts as a way to further explore her Native American identity. Jane completed a B.F.A. and M.F.A. in printmaking and went on to pursue a successful career as an artist.

Jane's interest in her own Cree heritage and the history and culture of other First Nations peoples is the prime focus of her printmaking, mixed-media collages, lectures, and writing. She views her work as a vehicle for educating the nonnative population and as a source of pride and self-esteem for First Nations people.

Jane's narrative imagery incorporates Cree iconography with text and imagery referencing Western exploitation of indigenous peoples, symbols from other North American traditional cultures, especially those of the Plains and the Southwest, contemporary mass media symbols, and modern/contemporary art styles/ movements, particularly Mark Rothko's paintings, Robert Rauschenberg's collages, and the constructivist Kurt Schwitters. When working with the collage format, Jane uses vivid paint, newspaper clippings, and historical information.

A Sacred Prayer for a Sacred Island (1991, three-panel mixed media on canvas) explores the issue of spirituality from a native perspective and its connection to a land base rather than a permanent structure such as a church. The dominant colors are black, red, white, and yellow—sacred colors for many tribes. Crosses painted red, black, and white are prehistoric religious symbols, not Christian crosses. Words like *medicine* and *shaman* refer to native equivalents of the Western concepts of faith, healing, priest, and minister. Photographs of traditional holy people, painted animal symbols, a printed sign reading "Sacred Ground Beyond This Point," and a long printed text criticizing the Bureau of Indian Affairs and Euro-American insensitivity to indigenous religious beliefs are just some of the striking images Jane employs to evoke prayer.

Jane also explores the issue of spirituality in her writings. In an essay titled "The Essential Spirituality of North American Indigenous Cultures," Jane critiques the Canadian suppression of indigenous spiritual practices, including drumming, and the devastating impact this has had on First Nations peoples. Empowerment and transformation are discussed in terms of reasserting the spiritual guidance of traditional leaders.

In keeping with Jane's focus on empowerment through spirituality, *Buffalo Rebirth* (18-color seriglyph) is a tribute to the 1994 birth of the white buffalo in Wisconsin. Indian prophecy predicted that the birth of a white buffalo would

signal the beginning of a positive new era for Native Americans, and this recent birth has attracted pilgrimages to Wisconsin. Behind the white buffalo skull is a black tipi shape with spirit figures at the corners, the phrases "Medicine Medicine," "Sacred Buffalo Came," and "Sage and cedar were offered" bordering the images, and a bright reddish-purple frame locking in the entire scene. Jane describes this image as emanating from her dreams and visions. Proceeds from the sale of Jane's edition of 99 were given to Artists for Kids Trust, a scholarship fund for Canadian students.

Real power is about finding our own spiritual guidance and helping others find theirs; it is about admitting our own limitations and ignorance so that spiritual power and wisdom can work through us; it is about empowerment and transformation.[1]

Note

1. Jane Ash Poitras, "The Essential Spirituality of North American Indigenous Cultures," in Gerald McMaster and Lee-Ann Martin, eds., *Indigena: Contemporary Native Perspectives in Canadian Art* (Vancouver, Canada: Douglas & McIntyre, 1992), p. 167.

POWHATAN, ROSE

Tribal affiliation: Pamunkey. *Born*: 1948, Washington, D.C. *Education*: B.F.A., Painting/Art History, Howard University, Washington, D.C. M.A., Art Education/Art History, Howard University, Washington, D.C. Graduate studies in Humanities, History, and Education, Catholic University, Washington, D.C., University of the District of Columbia, and University of London, United Kingdom. *Family*: Daughter of Pamunkey artist Georgia Mills Jessup, whose work is included in the permanent collection of the National Museum of Women in the Arts, Washington, D.C. Married to Jamaican/Taino artist Michael Auld. Mother of three sons, Ian, Alexei, and Kiros. *Career*: Codirector and founder of Opus 2 Gallery, a multicultural and artist-run gallery, 1973–1977. Cofounder and director of A&B Associates, an educational publications agency, 1973–1977. Teacher/Curriculum Writer/Department Chair of Humanities and Fine Arts at Eastern High School, Washington, D.C., 1973–present. *Awards*: Kiwanis Teacher of the Year, 1981. Appointed Commissioner to the Maryland Commission on Indian Affairs. ATLATL Second Circle Board Southeastern Represen-

Totems to Powhatan by Rose Powhatan, 1988, fire-engraved wood.

tative. Cafritz Foundation Educator's Fellowship. D.C. League of Women Voters Outstanding Educator Award. Fulbright Teacher Exchange, London. John F. Kennedy Center for the Performing Arts Community Board. METRO-Art Tri-State Public Art Commission. Washington, D.C., Historical Society Educational Advisory Board.

SELECTED EXHIBITIONS

1996	*A View from Baltimore to Washington*, Fine Arts Gallery, University of Maryland, Baltimore Campus
1995–1996	*Lois Jones and Her Students*, Washington, D.C., and Boston, Massachusetts
1993	Chickahominy Tribal Cultural Center, Charles City, Virginia; Virginia Museum of Natural History, Martinsville, Virginia; Urban League Show, D.C. Convention Center, Washington, D.C.
1992	Arts on the Square Gallery, Richmond, Virginia; Last Stop Gallery, Richmond, Virginia; New Visions at Linden Row Gallery, Richmond, Virginia; *The Submuloc Show/Columbus Wohs*, ATLATL Columbus Quincentennial, Washington, D.C.; On the Hill Gallery, Yorktown, Virginia; *Breath of Life*, Women's Art Caucus Annual Exhibition, Starfields of Astraea, Washington, D.C.
1990	*Attan Akamik*, Washington, D.C.; Wolf Trap Farm Park, Vienna, Virginia; Jamestown Settlement, Jamestown, Virginia
1988	METROART, Vienna, Virginia
1985	Krane Gallery, New York, New York; Gallery 409, Baltimore, Maryland
1984	Fondo del Sol Visual Arts Museum, Washington, D.C.
1983	International Art Exposition, Washington, D.C.; *Caribbean/American Independence Show*, Washington, D.C.; Galeria Intl, Centro de Arte, Washington, D.C.
1982	Indianapolis Museum of Art, Indianapolis, Indiana; Blackburn Center Gallery, Howard University, Washington, D.C.
1981	The Art Gallery, University of Maryland, College Park, Maryland; Gibbes Art Gallery, Charleston, South Carolina; Montgomery Museum of Fine Arts, Montgomery, Alabama; Joslyn Art Museum of Fine Arts, Omaha, Nebraska; Center of the Visual Arts Gallery, Illinois State University, Normal, Illinois; Romare Beardon Gallery, Atlanta, Georgia; *South of and Better Than Texas*, Washington, D.C.
1980	Bronx Museum Gallery, Bronx, New York; United Nations Building, New York, New York; Pyramid Gallery, Detroit, Michigan; LaMont Zeno Gallery, Chicago, Illinois
1979	WDVM, Washington, D.C.; U.S. Department of Commerce, Washington, D.C.; *Family Reunion*, Market Five Gallery, Washington, D.C.

1978	*In Celebration of Caribbean Unity*, Washington, D.C.; Caribbean American Intercultural Organization, Washington, D.C.; Paul Robeson International Art Gallery, Washington, D.C.; Department of Housing and Urban Development, Washington, D.C.
1977	Martin Luther King Jr. Library Gallery, Washington, D.C.; M Ban Art Gallery, Washington, D.C.
1976	Afro-American Bicentennial Corporation, Washington, D.C.
1975	*Contemporary Women Artists*, Washington, D.C.
1974	Opus 2 Galleries, Washington, D.C.; Acts of Art Gallery, New York, New York; *Caribbean Perspectives*, Washington, D.C.
1973	Presidential Building, Board of Education, Washington, D.C.
1972	BFA Thesis Show, Washington, D.C.
1970–1971	James A. Porter Gallery, Washington, D.C.
1969	Anacostia Museum, Smithsonian Institution, Washington, D.C.
1968	Seven Miles Kingston, Jamaica, West Indies
1967	Department of Recreation, Washington, D.C.
1964–1972	Howard University Galleries, Washington, D.C.

SELECTED PUBLICATIONS

Connell, Susan. "The World According to Georgia." *Columbia Magazine*, Spring 1989, pp. 48–52.

Dorsey, John. "Artists Express Themselves by Carving in Wood." *The Baltimore Sun*, May 16, 1996.

Farris-Dufene, Phoebe. "Reaching In and Taking Out: Native American Women Artists in a Different Feminism." In Phoebe Farris-Dufrene, ed., *Voices of Color: Art and Society in the Americas*. Atlantic Highlands, N.J.: Humanities Press, 1997. pp. 11–19.

Powhatan, Rose. "Painting, Murals, Printmaking and Installations." In Nadema Agard, ed., *Southeastern Native Arts Directory*. Bemidji, Minn., Bemidji State University Press, 1993. p. 159.

ARTIST STATEMENT (1997)

Color has always fascinated me. I crave color. I dream in colors so bright that I sometimes have to shield my eyes from the sheer intensity of the beautiful colors I experience in my dreams. Recently, I have become more traditional in my creative expression. I find myself working in natural media that my ancestors may have used centuries ago. When I fire-engraved narrative imagery on the shafts of my totem poles, I called on the energies of my ancestor Keziah Powhatan, the Fire Woman Warrior, who burned down the Fairfax County, Virginia, Courthouse that was being built on land that was stolen from her through the injustice of colonialism. Her blessing gave me a satisfaction that surpassed any *easel art* experience that I may have had from a more academic art experience.

One of the meanings of my name *Powhatan* is "one who dreams." It suits me. I have been blessed with the ability to receive dreams and visions that have guided me all my life. I am a God-centered person. I start each day with prayers of thanksgiving to my Creator for the gift of life and my heartfelt respect for the responsibility of fulfilling my mission to honor my people through the work of my life's energies. Spirituality is the foundation upon which my entire being is anchored. Spirituality is my breath of life.

I was born into a family of artists. At last count, at least 28 members of my family were noted for having made a living from the literary, performing, and/or visual arts. My mother (Georgia Mills Jessup) is an artist whose work is included in the permanent collection of the National Museum of Women in the Arts (Washington, D.C.). Her high personal standards for discipline in creativity have inspired me immensely in my life's work. My family and tribe recognize my being an artist as part of the natural order of things. I was born to be an artist. It was the tradition in my tribe for women to create beautiful functional objects. Art/objects that are uplifting to the spirit are extensions of that tradition. As a woman, I have enjoyed the experience of companionship with a man, carrying three babies, giving birth to them (ouch), nurturing them, being a daughter, sister, mother, friend, lover, and mentor. My work is an extension of my life, and my life is full. I am proud to be descended from strong women, like my ancestor, the Fire Woman Warrior. The strong women in my family have served as inspiration to both the women and men they've given birth to. Their spirits live on in us in our resolve to continue the legacy of our cultural inheritance.

Diego Rivera, the Mexican muralist, has always been a very special artistic influence on my life's work. His respect for indigenous American culture is very evident in his choice of subject matter and the reverence with which he depicts the true Mexican spirit of the people. His pride in his Indian ancestry sustained me during the turbulent civil rights era of the 1960s. Since Virginia Indians had a tendency to lean toward a more insular viewpoint exclusive of worldwide indigenous peoples' concerns, I was proud when, in 1969–1971, Indians of All Tribes occupied Alcatraz Island in San Francisco Bay. Their actions rekindled my belief in the endurance of the warrior spirit of my people. In 1978, I participated in the Longest Walk, which was symbolic of forced marches of Indians. My participation in that event was mandated by a vision I received of buffaloes chasing me down the streets of Washington, D.C. My life as an artist/activist was given deeper meaning through a mission that demanded a commitment to consciously do more for my people.

Negative experiences that I've had in my life due to discrimination and physical assaults upon my person both here and abroad have strengthened my resolve to speak the truth about the Native American experience through my art and my deeds. I've had to contend with *document genocide* being practiced against me in being ethnically misrepresented in some publications by historians with an agenda that includes destroying all documented evidence of Eastern Algon-

quin presence in contemporary history. We are referred to in the past tense, as in "are now extinct" or "once inhabited." In my travels, I've found that indigenous people around the world have had the same experience. We must be vigilant in asserting our presence. As an artist/activist I try to represent the Pamunkey Indian Nation as a viable, productive member of society.

BIOGRAPHICAL ESSAY

Rose A. Powhatan is an enrolled member of the Pamunkey Indian Nation, a historic tribe in the mid-Atlantic region. The Pamunkey were once the leading tribe in the Powhatan Confederacy, which included Virginia, Washington, D.C., and parts of Maryland and North Carolina. The Pamunkey Reservation in King William County, Virginia, is the oldest reservation in the United States. Rose Powhatan earned both her undergraduate and graduate degrees in art education and art history from Howard University in Washington, D.C.

Rose's life is a kaleidoscope of professional activity. She has created critically acclaimed art installations, murals, totem poles (a traditional art form in the mid-Atlantic region), stage craft, costumes, a series of educational posters, and written plays. Her work as an art educator has included teaching practically all the studio arts in the past 23 years. Powhatan's curriculum writing has included materials written as part of the District of Columbia Public Schools Multicultural Initiative, which focused on the integration of Native American knowledge into mainstream subject areas.

Rose's aesthetic concerns vary in regard to the specific use of medium and methodology in her artwork, but thematically, there is a constant thread that runs throughout her life's work—respect for indigenous culture and commitment to presenting the Pamunkey Tribe and the Powhatan Confederacy in a positive, reverent, uplifting mode of visual arts expression. Rose uses a narrative approach to her subject matter, as a visual artist and storyteller. Rose uses the narrative approach to speak about her people because she feels that Eastern Algonquin tribes have not been given full respect in being included as part of the picture in *Indian Country*, USA. The stereotype of Indian, as in Southwestern Indian, *only* has become deeply imbedded in the subconscious of America's cultural inheritance. Rose makes use of traditional Eastern Woodlands indigenous design and design concepts in her work. The authenticity of her work demands involvement in research to document the legitimacy of cultural retentions. There is a decided sense of place inherent in Rose's work—a self-explanatory art that establishes who she is, where she is from, and what she is about.

A work that is definitely about a sense of place is *Totems to Powhatan*, a 1988 installation that Rose and her husband, artist Michael Auld, created as a METROART commission. The series of wood totem figures standing in a circle were exhibited for one year at the Vienna metro station. The carved heads on the totem poles represent various Powhatan Confederacy chiefs, and the black

and red engraved designs portray significant Powhatan symbols such as Powhatan's mantle, deer, Pamunkey-Powhatan picture writing, and circles representing the original tribes of the Confederacy.

Rose chose the Vienna metro station because that area was a former trade center for Powhatan tribes. Three of the chiefs (Miles, Adkins, and Custalow) from the current Powhatan Confederacy blessed the installation during the opening ceremony.

Concern with international indigenous peoples' issues outside of the Native American experience is also reflected in Rose's art. One of her 1980s silk screen prints, *So We Too . . . Resettlement Compounds—Attan Akamik, South Africa, Palestine*, depicts the problems all indigenous people of color confront when dealing with European exploitation of their lands and natural resources. Colors used in the print are the four sacred Native American colors—red, black, yellow, and white—representing the four directions and the four races of humanity. An eagle sweeps diagonally across the black and yellow background as traditional African, Palestinian, and Native American homes are swept in flames. Geometric symbols of the three ethnic groups dominate the lower border.

In lectures discussing her work, Rose stated, ''There is essentially no difference between a North American Indian reservation, South African bantustan, or Palestinian resettlement camp—all are isolated, desolate places of forced habitation for indigenous people. Being made a stranger in your homeland is more demoralizing than being made a stranger in a strange land. I use my work as a means to educate and communicate positive indigenous cultural values in hopes of encouraging those who will come behind me to continue the mission to make a stand in honoring their ancestors and let the world know that *We Are Still Here*.''

Rose is engaged in research focusing on the retention of indigenous culture in the Americas, the Caribbean, and the Pacific. She has found a commonality of cultural expression between Australian Aborigines, New Zealand Maoris, Dominican Caribs, and North American indigenous peoples that transcends national boundaries. According to Rose, the 1646 treaty made between the King of England and the Virginia Powhatans resembles the New Zealand Maori treaty. The Virginia totem pole tradition is mirrored in the Maori carved post tradition. The body tattoo design that Rose uses in her art is a prominent cultural expression for the Maori.

For Rose, respect for traditional cultural values is the tie that she sees binding all indigenous peoples together in their art. Exhibiting locally, nationally, and internationally, there is diversity in style, media, and intent of purpose in Rose Powhatan's work as she adapts to the changing locations of her painting.

QUICK-TO-SEE SMITH, JAUNE

Tribal affiliation: Salish/Cree/Shoshone. *Born*: 1940, St. Ignatius, Indian Mission Flathead Reservation, Montana. *Education*: B.A., Art Education, Framingham State College, Massachusetts, 1976. M.A., Art, University of New Mexico, 1980. *Family*: Daughter of Arthur Albert Smith, horse trader and rodeo rider, who was born in the Métis colony in Pincher Creek, Alberta, Canada. *Career*: Since the mid-1970s, independent artist, curator, activist, lecturer, and commissioned artist. *Curatorial activities: Contemporary Native American Art* (Ken Philips Gallery, Denver, Colorado), 1980. *Women of Sweetgrass, Cedar and Sage* (traveling), 1985. *The Submuloc Show/Columbus Wohs* (traveling), 1990. *Our Land/Ourselves: American Indian Contemporary Artists* (University Art Gallery, SUNY–Albany), 1990. *We, the Human Beings: 27 Contemporary Native American Artists* (College of Wooster Art Museum, Ohio), 1992. *Positives and Negatives: Native American Photographers* (European traveling exhibit), 1995. *Awards*: Purchase Award, The Academy of Arts and Letters, New York, 1987. Western States Art Foundation Fellowship, 1988. Honorary Professor, Beaumont Chair, Washington University, St. Louis, Missouri, 1989. The Association of American Cultures, Arts Service Award, 1990. Honorary Doctorate, Minneapolis College of Art and Design, Minnesota, 1992. Fourth International Biennial, Painting Award, Cuenca, Ecuador, South America, 1994. Wallace Stegnar Award, Center of the American West, University of Colorado, Boulder; SITE Santa Fe Award, Santa Fe, New Mexico, 1995. Joan Mitchell Award for Painting, 1996. Women's Caucus for Art, Outstanding Achievement in the Visual Arts, 1997.

SELECTED EXHIBITIONS

1996 *Subversiona/Affirmations: Jaune Quick-to-See Smith, a Survey*, Jersey City Museum, Jersey City, New Jersey (travel tour, catalog)

1995 *Talking Pictures*, Steinbaum Krauss Gallery, New York, New York; *Jaune Quick-to-See Smith: Recent Works*, Wabash College Art Museum, Crawfordsville, Indiana; University of Wyoming Art Museum, Laramie, Wyoming

1994 *Jaune Quick-to-See Smith*, Jan Cicero Gallery, Chicago, Illinois; LewAllen Gallery, Santa Fe, New Mexico; Santa Fe Institute of Fine Arts, Santa Fe, New Mexico

1993 *Jaune Quick-to-See Smith*, Chrysler Museum, Norfolk, Virginia, Par-

ameters Series (travel); Smith College Museum of Art, Northampton, Massachusetts (brochure); Sweet Briar College, Sweet Briar, Virginia; *Jaune Quick-to-See Smith*, LewAllen Gallery, Santa Fe, New Mexico

1992 *The Quincentenary Non-Celebration*, Steinbaum Krauss Gallery, New York, New York; *Jaune Quick-to-See Smith*, LewAllen Gallery, Santa Fe, New Mexico

1991 *Jaune Quick-to-See Smith: Works on Paper*, LewAllen Gallery, Santa Fe, New Mexico; Anne Reed Gallery, Sun Valley, Idaho

1990 *New Paintings by Jaune Quick-to-See Smith: A View of Western Lands*, Bernice Steinbaum Gallery, New York, New York; Lawrence Arts Center, Lawrence, Kansas; *Jaune Quick-to-See Smith, New Works: Chief Seattle Series*, LewAllen/Butler Gallery, Santa Fe, New Mexico

1989 *Centric 37: Jaune Quick-to-See Smith*, University Art Museum, California State University, Long Beach, California; Cambridge Multi-Cultural Center, Cambridge, Massachusetts; *Jaune Quick-to-See Smith*, LewAllen/Butler Gallery, Santa Fe, New Mexico; Marilyn Butler Gallery, Scottsdale, Arizona

1988 Marilyn Butler Gallery, Santa Fe, New Mexico

1987 *Jaune Quick-to-See Smith: New Paintings*, Bernice Steinbaum Gallery, New York, New York; *Jaune Quick-to-See Smith*, Marilyn Butler Gallery, Santa Fe, New Mexico

1986 *Horses Make a Landscape Look More Beautiful*, Bernice Steinbaum Gallery, New York, New York; *Jaune Quick-to-See Smith: Speaking Two Languages*, Yellowstone Art Center, Billings, Montana (brochure); The Candy Store, Folsom, California

1985 *Jaune Quick-to-See Smith*, Bernice Steinbaum Gallery, New York, New York; Marilyn Butler Gallery, Santa Fe, New Mexico; Peter Stremmel Gallery, Reno, Nevada

SELECTED GROUP EXHIBITIONS

1996 *American Kaleidoscope: Themes and Perspectives in Recent Art*, National Museum of American Art, Smithsonian Institution, Washington, D.C. (catalog); *Brücken und Abgrenzungen: Zeitgenössiche indianische Kunst (Bridges and Boundaries: Spiritual Indian Art)*, Taunus-Sparkasse, Kronberg, Germany; *Sniper's Nest* (Collection of Lucy Lippard), curated by Bard College, Hudson, New York (traveling exhibition); *A Candle in the Wilderness: Selections from the Permanent Collection*, Richard F. Brush Art Gallery, St. Lawrence University, Canton, New York; *Movements: Contemporary Native American Art*, Allegheny College, Penelec Gallery, Meadville, Pennsylvania; *Ecology and Printmaking*, University of Wyoming, Art Mobile Program, Laramie, Wyoming; *I Stand in the Center of Good*, The American Indian Community House Gallery/Museum, New

York, New York; *Objects of Personal Significance*, Exhibits USA and Eastern Illinois University, Charleston, Illinois (traveling nationally through 1999, catalog); *New York/New Mexico: New Prints*, Horwitch LewAllen Gallery, Santa Fe, New Mexico; *Native Streams*, Jan Cicero Gallery, Chicago, Illinois (traveling exhibition, catalog)

1995 *Summer Group Exhibition*, Steinbaum Krauss Gallery, New York, New York; *The 75th Anniversary of the U.S. Dept. of Labor's Women's Bureau*, Marty Anderson Design, Washington, D.C. (traveling exhibition, poster); *Volume I: Book Arts by Native American Artists*, American Indian Community House Gallery/Museum, New York, New York (traveling exhibition); *X-Sightings*, Anderson Gallery, Buffalo, New York; *Contemporary Native American Prints*, Goshen College Art Gallery, Goshen, Indiana; *Current Identities: IV Biennial International de Pintura 94–95* (traveling exhibition through South America, catalog); *Justice/Injustice: Art against Death*, Puffin Room, New York, New York; *Indian Country Revisited and Coyote Made Me Do It*, Peiper-Riegraf Gallery, Frankfurt, Germany; *Art at the Edge: Social Turf*, High Museum of Art, Atlanta, Georgia (brochure); *Old Glory, New Story: Flagging of the 21st Century*, Capp Street Project, San Francisco, California; *Across Backgrounds and Traditions*, University Art Gallery, Central Michigan University, Mount Pleasant, Michigan; *Heroes and Heroines: From Myth to Reality*, New Jersey Center for Visual Arts, Summit, New Jersey; *Contemporary American Indian Art*, The Joe Feddersen Collection, Prichard Art Gallery, University of Idaho, Moscow, Idaho; *The Stephane Janssen Collection of Contemporary American and European Art: In Memory of R. Michael Johns*, Fred Jones, Jr., Museum of Art, The University of Oklahoma, Norman, Oklahoma (traveling exhibition, catalog); *Into the Nineties: Prints from the Tamarind Institute*, Weatherspoon Art Gallery, University of North Carolina, Greensboro, North Carolina (traveling exhibition); *Indian Humor*, organized by the American Indian Contemporary Arts, San Francisco, California (traveling exhibition); *Contemporary Native American Prints*, Goshen College Art Gallery, Goshen College, Goshen, Indiana; *Bridges and Boundaries: Brücken und Abgrenzungen*, Peiper-Riegraf Gallery, Frankfurt, Germany; *SITE*, Santa Fe, New Mexico; *Prints from the Lawrence Lithography Workshop*, Strecker Gallery, Manhattan, Kansas; *Collection of Lawrence Lithography Print Workshop*, Malin Gallery, K. S. Coalition, Kansas City, Missouri

1994 *Memories of Childhood . . . So We're Not the Cleavers or the Brady Bunch*, Steinbaum Krauss Gallery, New York, New York (traveling exhibition, catalog); *AD*VANCES*, Museum of Modern Art, Art Advisory Service for General Electric, New York, New York; *From the Earth X*, American Indian Contemporary Arts, San Francisco, California; *Reuse/Refuse*, Honolulu Academy of Arts, Honolulu, Hawaii (catalog); *Artistas Contemporaneo de Nuevo Mexico*, University of Guadalajara, Guadalajara, Mexico; *Cultural Signs in Contemporary*

Native American Art, Herbert F. Johnson Museum, Cornell University, Ithaca, New York (catalog); *Multiplicity: A New Cultural Strategy*, University of British Columbia, Museum of Anthropology, Vancouver, British Columbia; *West Art and the Law*, West Publishing Corporation, Eagan, New Mexico (traveling exhibition, catalog); *Toi te Ao, an Aotearoa World Celebration of Indigenous Art & History*, Te Taumata Gallery, Auckland, New Zealand (catalog); *The Spirit of Native America*, organized by the American Indian Contemporary Art, San Francisco, California (traveling exhibition to Mexico, South America, Central America, and the United States, 1993–1996, catalog); *Contemporary Native American Artists: Reflections on Their Past*, Susquehanna Art Museum, Harrisburg, Pennsylvania (catalog); *Plural America: Singular Journey*, Farmington Art Guild, Farmington, Connecticut; *Celebrating Diversity: Contemporary Expressions by Native American Artists*, The Rotunda Gallery, Montclair, New Jersey; *Animal Stories*, Goddard Riverside Community Center, New York, New York (catalog); *Voices on Paper: A Multicultural Exhibit*, Concordia College, Moorhead, Minnesota; *Of Dancing Frogs and Altarwings: Animal Allegories in Contemporary Art*, John Michael Kohler Arts Center, Sheboygan, Wisconsin; *Salon de Barbie: A Multi-Media Exhibition*, The Kitchen, New York, New York, and Guild Hall, East Hampton, New York; *Weltpremiere: Remember the Earth Whose Skin You Are*, Kunsthalle, Bonn, Germany; *Art in Your Own Backyard*, Yellowstone Art Center, Billings, Montana

1993 *Current Identities: Recent Paintings in the United States*, organized by Aljira: A Center for Contemporary Art, Newark, New Jersey (traveling exhibition including venues in Panama, Honduras, Salvador, Costa Rica, Ecuador, Columbia, Uruguay, Venezuela, Paraguay, and Dominican Republic, running through 1996, catalog, Fresno Art Museum, Fresno, California); *From the Earth IX*, American Indian Contemporary Arts, San Francisco, California; *Indian Territories: 20th Century American Artists Dismantle 19th Century Euro-American Myths*, Rene Fotouhi Fine Art, East Hampton, New York; *Into the Forefront: American Indian Art in the 20th Century*, Denver Art Museum, Denver, Colorado; *For the Seventh Generation: Native Americans Counter the Quincentenary*, Columbus, New York, and Art In General, New York, New York (traveling exhibition, catalog); *Art and Environment: Imagine Celebrates Earth Day*, National Arts Club, New York, New York; *Indianer Nordamerikas, Kunst und Mythos*, Peiper-Riegraf Gallery, Frankfurt, Germany (catalog); *Women's Arts, Women's Lives, Women's Issues*, Tweed Gallery, City Hall, New York, New York; *Narratives of Loss: The Displaced Body*, University of Wisconsin, Milwaukee, Wisconsin (catalog); *Multicultural Americana*, Downtown Gallery, Florida Community College at Jacksonville, Jacksonville, Florida; *Magnifico*, Festival of the Arts, Albuquerque, New Mexico; *A Kindred Spirit*, Regional Center for the

Arts, Walnut Creek, California; *Spirits Keep Whistling Us Home*, Sacred Circle Gallery of American Indian Art, Seattle, Washington

1992 *Floored Art*, Steinbaum Krauss Gallery, New York, New York (traveling exhibition, catalog); *The Edge of Childhood*, Heckscher Museum, Huntington, New York (catalog); *Without Boundaries*, Steensland Art Museum, St. Olaf College, Minnesota; *Shared Visions: Native American Sculptors and Painters in the Twentieth Century*, Heard Museum, Phoenix, Arizona (traveling exhibition, catalog); *Counter Colon-ialismo*, traveling exhibition including Centro Cultural Tijuana, Mexico, and Centro Cultural de la Raza, San Diego, California (catalog); *Unbroken Threads: A Quincentennial Exhibition*, The Albuquerque Museum, New Mexico; *44th Annual Purchase Exhibition*, American Academy and Institute of Arts and Letters, New York, New York, purchased by the Hassam, Speicher, Betts and Symons Purchase Fund, New York, New York; *Decolonializing the Mind*, Center of Contemporary Art, Seattle, Washington; *Skin, Sand, Paint, Metal: A Visual Exploration of Cross Cultural Encounters in North America*, Center Gallery, Bucknell University, Lewisburg, Pennsylvania; *In Plural America: Contemporary Journeys, Voices and Identities*, Hudson River Museum, Yonkers, New York (catalog); *Indigenous: Indian Identity Revision*, Niagara County Community College, Sanborn, New York; *One World*, in conjunction with the Earth Summit, Kassel, Germany; *Six Directions*, Galerie Calumet, Heidelberg, Germany; *New Art of the West*, The Third Eiteljorg Invitational, Eiteljorg Museum, Indianapolis, Indiana; *Wind and Glacier Voices: The Native American Film & Media Celebration*, Walter Reade Cinema Gallery, Lincoln Center, New York, New York (poster); *Visions of the People: A Pictorial History of Plains Indian Life*, Minneapolis Institute of Arts, Minneapolis, Minnesota; *Contemporary Uses of Wax & Encaustic*, Palo Alto Cultural Center, Palo Alto, California; *Social Figuration*, San Diego State University Art Gallery, San Diego, California; *Columbus Drowning*, Rochdale Art Gallery, Rochdale, England; *For the Seventh Generation: Native American Artists Counter the Quincentenary*, Chenango County Council of the Arts Gallery, Norwich, New York, and Golden Artist Colors Gallery, Columbus, New York (traveling exhibition, catalog); *Three Directions: Three American Indian Artists*, Hampden Gallery, University of Massachusetts, Massachusetts; *Multiples, Who We Are: Autobiographies in Art*, Washington State Arts Commission's Art in Public Places Program, Olympia, Washington

1991 *Figuration*, The Museum of Modern Art, Art Advisory Service for Pfizer Corporation, New York, New York; *Presswork: The Art of Women Printmakers*, Lang Communications Collection (traveling exhibition, catalog); *Light on the Subject*, American Indian Contemporary Arts, San Francisco, California; *Encuentro: Invasion of the Americas and the Making of the Mestizo*, Artes de Mexico, Venice, California (catalog); *Myth and Magic in the Americas*, Museo de Arte

Contemporáneo de Monterrey, Monterrey, Mexico (catalog); *Other Voices: Mediating between the Ethnic Traditions and the Modernist Mainstream*, The Baxter Gallery, Portland Museum of Art, Portland, Maine (brochure); *The Sacred Bear in Two Worlds*, Missoula Museum of the Arts, Missoula, Montana; *20th Anniversary Visiting Artists Exhibit*, University of Colorado, Boulder, Colorado; *Gallery Choice*, Contemporary Women Artists, Santa Fe Community College, New Mexico; *Broadening the Collection*, Roland Gibson Gallery, Potsdam College of the State University of New York, Potsdam, New York; *Big Sky/Bold Wind*, Montana Collection of the Yellowstone Art Center, Boulder, Colorado; *Show of Strength*, MADRE Benefit Show, Anne Plumb Gallery, New York, New York; *The Enabling Spirit*, Michael Naranjo and Significant New Mexico Artists, Very Special Arts Gallery, Washington, D.C.; *Without Boundaries: Contemporary Native American Art*, Jan Cicero Gallery, Chicago, Illinois; Okanta, A-Space, Toronto, Ontario, Canada; Anne Reed Gallery, Sun Valley, Idaho

1990 *Menagerie*, Museum of Modern Art, New York, New York; *The New West*, Bernice Steinbaum Gallery, New York, New York; *The Decade Show*, The New Museum of Contemporary Art, The Studio Museum in Harlem, Museum of Contemporary Hispanic Art, New York, New York (catalog); *A Celebration of Women in the Arts*, Tucson Museum of Art, Tucson, Arizona; *Traditional and Spirit*, Maryhill Museum of Art, Goldendale, Washington; *Illustrious Alumni*, Johnson Gallery, University of New Mexico, Albuquerque, New Mexico (catalog); Richard Brush Art Gallery, St. Lawrence University, Canton, New York; Phyllis Rothman Gallery, Fairleigh Dickinson University, Madison, New Jersey; *Soho in Oswego: New York Art 1990*, Tyler Art Gallery, Oswego SUNY, Oswego, New York; *The Matter at Hand: Contemporary Drawings*, University of Wisconsin at Milwaukee, Fine Arts Gallery, Milwaukee, Wisconsin (catalog); *Coast to Coast—The Box Show*, Art in General, New York, New York (traveling exhibition); *Visual Twists in Miniature*, Marilyn Butler Fine Art, Scottsdale, Arizona

1989 *Selections from the Bernice Steinbaum Gallery*, New York, Axis Twenty, Atlanta, Georgia; *Coast to Coast: Women of Color National Artist's Book Project*, Center for the Book Arts, New York, New York; *Bridges and Boundaries*, Newhouse Center for Contemporary Art, Staten Island, New York; *The Natural Image: Nature as Image in Contemporary Art*, Stamford Museum and Nature Center, Stamford, Connecticut; *100 Drawings by Women*, Hillwood Art Gallery, Long Island University, New York, New York, United States Information Agency (traveling exhibition, catalog); *41st Annual Academy-Institute Purchase Exhibition*, American Academy and Institute of Arts and Letters, purchased by the Hassam, Speicher, Betts and Symons Purchase Fund, New York, New York; *Zeitgenossiche Indianische Kunst II*, Dorothee Peiper-Riegraf Gallery, Frankfurt, Ger-

many; *Beyond Survival: Old Frontiers/New Visions*, Ceres Gallery, New York, New York

1988 *Committed to Print*, Museum of Modern Art, New York, New York; *Figuration*, The Museum of Modern Art, Art Advisory Service of General Electric, New York, New York; *Alice, and Look Who Else, Through the Looking Glass*, Bernice Steinbaum Gallery, New York, New York (traveling exhibition, catalog); *Cultural Currents*, San Diego Museum of Art, San Diego, California; *American Herstory: Women and the U.S. Constitution*, The Atlanta College of Art Gallery, Atlanta, Georgia; *Cultural Diversity in American Art*, California State University at Stanislaus, Turlock, California; *Earth and Sky*, Anne Reed Gallery, Sun Valley, Idaho

1987 *Art in Fashion, Fashion in Art*, Bernice Steinbaum Gallery, New York, New York (traveling exhibition, brochure); *Home*, curated by Faith Ringgold, Goddard Riverside Community Center, New York, New York; *Motion and Arrested Motion: Contemporary Figurative Drawing*, Chrysler Museum, Norfolk, Virginia; *Montana Collects Montana* (traveling exhibition, catalog); *The Soaring Spirit*, Morris Museum, Morristown, New Jersey; *Contemporary Native American Artists*, Fort Wayne Museum of Art, Fort Wayne, Indiana; *Connections Project/Conexus*, collaborative exhibition between women artists from Brazil and the United States, Museum of Contemporary Hispanic Art, New York, New York, Tamarind European Tour, lecturer for U.S. Information Agency, Poland; *Recent Aquisitions*, Albuquerque Museum, Albuquerque, New Mexico; *New Acquisitions*, Museum of Fine Art, Santa Fe, New Mexico; *39th Annual Purchase Exhibition*, American Academy and Institute of Arts and Letters, purchased by Hassam and Speicher Purchase Fund, New York, New York; Marilyn Butler Gallery, Santa Fe, New Mexico; D.E.L. Galleries, Taos, New Mexico

1986 *Views across America*, Museum of Modern Art, Art Advisory Service of Gannett Corporation and Pfizer Corporation Headquarters, New York, New York; *Native American Art: Our Contemporary Visions*, Museum of Art, Sierra, Nevada; *American Women in Art: Works on Paper—An American Album*, Nairobi, Kenya, and University of Northern Iowa, Cedar Falls, Iowa; *New Mexico Selections—86*, College of Santa Fe, New Mexico; *AdoRnmenTs*, Bernice Steinbaum Gallery, New York, New York (traveling exhibition, catalog); *Let's Play House*, curated by Miriam Schapiro, Bernice Steinbaum Gallery, New York, New York; *Tamarind Impressions—Recent Lithographs: A Cultural Presentation of the United States* (traveling European exhibition, catalog); *Connections Project/Conexus*, Museum of Contemporary Hispanic Art, New York, New York; *Whoa! Contemporary Art of the Southwest*, Tampa Museum of Art, Tampa, Florida (brochure); *The Doll Show*, Hillwood Gallery, Long Island, New York (catalog); *American Indian Art*, Hippodrome Gallery, Long Beach, California; *In Homage to Ana Mendieto*, Zeus-Trabia Gallery,

New York, New York; *Visible/Invisible*, Palo Alto Cultural Center, Palo Alto, California; *Personal Symbols, Two-Person Exhibition with George Longfish*, Northern Iowa Gallery of Art, Cedar Falls Iowa and University of Nebraska, Lincoln, Nebraska

1985 *Women of the American West*, Bruce Museum, Greenwich, Connecticut; *Western Art Classic*, Art Center of Minnesota, Minneapolis, Minnesota (catalog); *Cowboys and Indians*, Common Ground, Boca Raton Museum of Art, Boca Raton, Florida, and Loch Haven Art Center, Orlando, Florida (catalog); *New Ideas from Old Traditions*, Yellowstone Art Center, Billings, Montana; *Visage Transcended: Contemporary Native American Masks*, American Indian Contemporary Arts Gallery, San Francisco, California; *Four Native American Painters*, Wooster Art Museum, Wooster, Ohio; *Contemporary Visions of New Mexico*, Sangre de Cristo Arts and Conference Center, Pueblo, Colorado; *Twenty-five Years of Printmaking at Tamarind*, University of New Mexico Art Museum, Albuquerque, New Mexico (catalog); *Signale*, sponsored by Galerie Akmak, Germany (traveling exhibition, catalog); *Women of Sweetgrass, Cedar and Sage: Contemporary American Art by Native American Women*, AICH (American Indian Community House), New York, New York (traveling exhibition, catalog)

SELECTED PUBLIC COMMISSIONS

1996 West Seattle Aiki Beach Trail, Team, memorial markers and art installations

1993 National Museum of the American Indians, Smithsonian Institution, Washington, D.C., artist on design team

1992 Northwind Fishing Weir Project, collaboration with Duwamish Tribe, King County Arts Commission, Seattle, Washington

1991 Yerba Buena Park, Sculpture Garden, Moscone Center, San Francisco, California; Cultural Museum, Flathead Reservation, Montana, designed floor; New Denver Airport, terrazzo floor, Main Terminal; Wastewater Treatment Plant, series of installations for public tour, Phoenix, Arizona

1990 Washington State Arts Commission, Public Schools Art Program

1989 Salt River Utilities Headquarters, Phoenix, Arizona

1985 The Palms Hotel, Phoenix, Arizona

1983 Phelps Dodge Corporation Headquarters, Phoenix, Arizona

SELECTED COLLECTIONS

Albuquerque Museum, Albuquerque, New Mexico; American Medical Association, Chicago, Illinois; Art Museum Framingham State College, Framingham, Massachusetts; AT&T Corporate Art Collection; Atlantic Richfield, Los Angeles, California; Bank of New Mexico, Albuquerque, New Mexico; Bell Atlantic Headquarters, Virginia; Birmingham Museum of Art, Birmingham, Alabama; Bruce Museum, Greenwich, Con-

necticut; Bureau of Indian Affairs, Washington, D.C.; The Chrysler Museum, Norfolk, Virginia; Continental Bank, Chicago, Illinois; Cornell University, Ithaca, New York; Dain Bosworth Inc., Minneapolis, Minnesota; The Denver Art Museum, Denver, Colorado; Eastern New Mexico State University, New Mexico; Fine Arts Museum, Santa Fe, New Mexico; General Mills, Inc., Minneapolis, Minnesota; The Hallmark Art Collection, Hallmark Cards, Inc., Kansas City, Kansas; Heard Museum, Phoenix, Arizona; Home Box Office Productions, New York, New York; Iowa State University, Ames, Iowa; Jersey City Museum, Jersey City, New Jersey; Memorial Art Museum, Rochester, New York; Midland Federal Savings, Denver, Colorado; Minneapolis Art Institute, Minneapolis, Minnesota; Montclair Art Museum, Montclair, New Jersey; Mount Holyoke Art Museum, Mount Holyoke, Massachusetts; The Museum of Mankind, Vienna, Austria; Museum of Modern Art, New York, New York; Museum of New Mexico, New Mexico; The National Museum of American Art, Washington, D.C.; National Museum of Women in the Arts, Washington, D.C.; Nebraska 1% for Arts Program, Lincoln, Nebraska; Newark Art Museum, Newark, New Jersey; Phelps Dodge, Phoenix, Arizona; Philip Morris Companies, Inc., New York, New York; Phillips Petroleum Company, New York, New York; Roswell Museum and Art Center, Roswell, New Mexico; Smith College Museum of Art, Northampton, Massachusetts; Southern Plains Indian Museum, Anadrako, Oklahoma; The Stamford Museum, Stamford, Connecticut; Steinberg Museum, St. Louis, Missouri; St. Jude Medical, Inc., Minneapolis, Minnesota; St. Paul Companies, Minneapolis, Minnesota; Sweet Briar College, Sweet Briar, Virginia; The Thomas Gilcrease Museum, Tulsa, Oklahoma; University of California, Davis Nelson Gallery, California; University of Colorado, Boulder, Colorado; University of North Dakota Museum, Grand Forks, North Dakota; University of Northern Iowa, Cedar Falls, Iowa; University of Oklahoma Museum of Art, Norman, Oklahoma; University of Regina, Canada; Valley National Bank, Phoenix, Arizona; Washington State 1% for Arts Program, Seattle, Washington; Wells Fargo Bank, Los Angeles, California

SELECTED PUBLICATIONS

Abbott, Lawrence. *I Stand in the Center of the Good: Interviews with Contemporary Native American Artists*. Lincoln: University of Nebraska Press, 1994. pp. 209–231.

American Journey: Women in America. Woodbridge, Conn.: Primary Source Media, 1995. CD–ROM.

Anreus, Alejandro, Joy Harjo, Lucy Lippard, and Gail Tremblay, essayists for catalog. *Subversions/Affirmations: Jaune Quick-to-See Smith*. Jersey City, N.J.: Jersey City Art Museum, 1996.

Archuleta, Margaret, and Rennard Strickland. *Shared Visions: Native American Painters and Sculptors in the Twentieth Century*. New York: New Press, 1991.

Borum, Jennifer P. "Jaune Quick-to-See Smith: Steinbaum Krauss Gallery." *Artforum* (January 1993).

Broder, Patricia Janis. *The American West: The Modern Vision*. New York: Graphic Society; Boston: Little, Brown, 1984.

Cline, Lynn Hunter. "A Celebration of Tamarind Institute Artist." *Pasatiempo*, February 2, 1996.

The Decade Show: Frameworks of Identity in the 1980s. New York: Studio Museum in Harlem, Museum of Contemporary Hispanic Art, and New Museum of Contemporary Art, 1990.

Hill, Richard. "The Gray Canyon Artists." *Turtle Quarterly* 2 (Spring–Summer 1980).

Lippard, Lucy. *Mixed Blessings: New Art in a Multicultural America.* New York: Pantheon Books, 1990.

Mathiew, Victor. "X-Sightings." *Art Voice*, June 21–July 4, 1995.

Nemiroff, Diana, Robert Houle, and Charlotte Townsend-Gault. *Land, Spirit, Power: First Nations at the National Gallery of Canada.* Ottawa: National Gallery of Canada, 1992.

Penney, David W., and George C. Longfish. *Native American Art.* Hong Kong: Hugh Lauter Levin Assoc., 1994.

Quick-to-See Smith, Jaune. "Family Album." In Lucy Lippard, ed., *Partial Recall: Photographs of Native North Americans.* New York: New Press, 1992. pp. 59–63.

Quick-to-See Smith, Jaune. *"Women of Sweetgrass, Cedar and Sage."* *Women's Students Quarterly* 15, nos. 1–2 (Spring–Summer 1987), pp. 35–41.

Quick-to-See Smith, Jaune, et al. *Give Back.* Vancouver, British Columbia, Canada: Gallerie Publications, 1992. pp. 61–72.

Quick-to-See Smith, Jaune, et al. *Our Land/Ourselves.* Albany, N.Y.: SUNY University Art Gallery, 1990.

Quick-to-See Smith, Jaune, et al. *The Submulock Show/Columbus Wohs.* Phoenix, Ariz.: Atlatl, 1992.

Quick-to-See Smith, Jaune, et al. *We, The Human Beings: 27 Contemporary Native American Artists.* Wooster, Ohio: College of Wooster Art Museum, 1992.

Roberts, Lisa. "Jaune Quick-to-See Smith." In Roger Matuz, ed., *Native North American Artists.* Detroit: St. James Press, 1998. pp. 525–528.

Wade, Edwin, ed. *The Arts of the North American Indian: Native Traditions in Evolution.* New York: Hudson Hill Press, 1986.

Wade, Edwin, and Rennard Strickland. *Magic Images: Contemporary Native American Art.* Norman: University of Oklahoma Press, 1981.

BIOGRAPHICAL ESSAY

As an artist, curator, lecturer, and political activist, Jaune Quick-to-See Smith is a role model for many Native American artists and for all artists with a consciousness. Her multimedia paintings, which incorporate sign language, glyphs, pictograms, and collage, are concerned with issues such as the environment, Native American sovereignty, racism, and sexism. Her public art commissions in which she collaborates with other artists address the same issues, focusing on regionally specific concerns. Jaune sees herself as someone who brings together diverse issues and concerns of contemporary Indian life and modern life in general. Her works are philosophical statements that are designed to make people think.

Design, color, line, and other art elements are used by Quick-to-See Smith to portray present-day realities as well as what is spiritual and beyond the material world perceived by Western culture. Abstract and narrative, the symbols found in her art such as teepees, horses, headdresses, sweet grass, indigenous plants, the human figure, and petroglyphs, tell stories about Native American life in

general and her own personal stories. Many of these images are collected from the reservations she lived on as a child—the Flathead Indian Reservation in Montana where she was born, the Hupa Reservation in California, and the Nisqually Reservation in Washington. Her inhabited landscapes show powerful movement within a geometric space, combining styles as diverse as nineteenth-century Plains Indian art ledgerbooks, modern abstract expressionism, and cubism from the geometry found in native cultures.

As member of Greenpeace, the environmental group, Jaune's artwork focuses strongly on environmental issues because she feels the earth's destruction is one of the—if not *the*—most pressing global concerns. She has taken a stand on using art materials that pollute the environment, take excessive storage space, and are costly to ship. One of her environmental series is based on the Salish/ Flathead history of making parfleches (a rawhide suitcase folded like an envelope to carry food, clothing, etc.) Called *The Nomad Art Manifesto*, it consists of 15" × 15" folded squares in different combinations that carry messages about the environment and Indian life. They are made from rag paper (no trees) and biodegradable materials such as Sumi watercolors, charcoal, rice paper, and rice glue.

The Nomad Art Manifesto

Nomad Art is made with biodegradable materials.

Nomad Art can be recycled.

Nomad Art can be folded and sent as a small parcel.

Nomad Art can be stored on a bookshelf, which saves space.

Nomad Art does not need to be framed.

Nomad Art is convenient for countries which may be disbanding or reforming.

Nomad Art is for the new diaspora age.

The 1997–1998 *Subversions/Affirmations* survey exhibit and catalog that originated at the Jersey City Museum and traveled to other venues was the first show to look at the roots and development of Jaune Quick-to-See Smith's art. Through essays, an interview, and her powerful art, the public could trace Jaune's earliest childhood artistic influences, observe her work from the 1980s and 1990s, and also become educated about her public art commissions.

In Quick-to-See Smith's family, her female ancestors and her father were all involved in trading as a family unit. Speaking Salish, Shoshone, and Kootenai, her father was raised traditional and earned his living as a horse trader and rodeo rider. Raised primarily by her father, with intermittent stints in foster homes, Smith and her siblings worked as childhood field hands with migrant workers, lived in 50 places including three reservations, and learned horse training from their father. Not having children's toys, she drew in the dirt with a stick, relishing opportunities to draw and paint when attending school.

With money saved from working as a field hand, Jaune ordered the Famous Artists School correspondence course, completing workbook assignments. After high school graduation, Jaune attended Olympic Junior College in 1958 and attended college part-time for 22 years as a divorced single mother, earning a B.A. in Art Education from Framingham State College in 1980 and an M.A. in Art from the University of New Mexico in 1980.

While in graduate school, Quick-to-See Smith was already an established artist, having her first solo show in 1978. Her influences were modern Indian artists Oscar Howe and Fritz Scholder, cave paintings, art of the Americas, Folk Art, Klee, Pollock, Rothko, Still, and Pop Art. Jaune's late 1970s work became more obviously political, and she emerged as a leading figure in the Pan-Indian art movement, working with Peter Jemison, George Longfish, Jolene Rickared, Emmi Whitehorse, and others. Jaune founded artists collectives (Coup Marks on the Flathead Reservation and Gray Canyon in Albuquerque), curated, networked with Indian artists nationwide, and gave slide presentations that always included examples from other Indian artists. By the early 1980s Jaune was represented by galleries in New York, Scottsdale, Arizona, and Santa Fe, New Mexico. In the late 1980s Jaune embarked on a new aspect of her career— public art commissions in which she collaborated with other artists, engineers, architects, and the local population.

Some of Quick-to-See Smith's 1980s and 1990s commission projects include designing a terrazzo tile floor piece at the new Denver International Airport, creating a series of 50 computer-generated pictograms that trace Colorado's history, and designing rainbow steps/directional patterns that help guide flight passengers; collaborating with Indian artist James Luna to create a sitting and meditation piece at Yerba Buena Park in San Francisco; assisting with the Northwind Fishing Weir Project (in collaboration with the Duwamish Tribe in Seattle) that will include an intricate traditional fish wheel, a cedar canoe and rack on a river site, and a proposed longhouse; working as a consultant on the design for the Flathead Cultural Museum; and designing a floor for her tribe's Squelixu People's Center that is based on traditional beadwork designs. Also in the 1990s Jaune curated three nationally touring contemporary Native American art exhibits: *Our Land/Ourselves: American Indian Contemporary Artists*; *We, the Human Beings*; and *The Submuloc (Columbus spelled backwards) Show/Columbus Wohs (show spelled backwards)*.

Relishing her solitude and need for privacy, Jaune still works on individual pieces in her studio. In Jaune's *The Red Mean: Self Portrait* (1992, oil, mixed media, and collage on canvas, 90" × 60", diptych), the traced outline of the artist's own body is drawn out in imitation of the form of Leonardo da Vinci's *The Golden Mean*. Superimposed over the form of Smith's body is a large red medicine wheel. On the body's upper torso are the words "Made in the U.S.A.," and a tribal number acknowledging the Native American female body as racially and sexually marginalized conflates her outline with that of the Vitruvian man—

symbolic of the stereotypical icon of perfect human proportions in patriarchal Western culture.

Challenging misconceptions about indigenous culture, Jaune Quick-to-See Smith uses her art, lectures, and writing to educate the dominant culture and to reeducate native peoples. In her essay in the anthology *Give Back*, Jaune Quick-to-See Smith urges Indian artists and scholars to conduct research firsthand in the field, not just in the library or archives; to write for a broader audience, not just academia; to mentor students; to become a bridge between the Indian community, other ethnic communities, and the mainstream; and to think of themselves as catalysts whose art and writing "will touch one—then two—then more."

RICKARD, JOLENE

Tribal affiliation: Tuscarora. *Born*: 1956, Niagara Falls, New York. *Education*: London College of Printing, 1976. B.F.A., Rochester Institute of Technology, 1978. Ph.D., M.A., SUNY at Buffalo, 1996. *Career*: Exhibiting photographer, 1983–present. Assistant Professor, SUNY at Buffalo, 1992–present. New York University Trisch Photography Institute, 1994–1997. Lecturer, Getty Center for Art and Art History, 1996. *Awards*: SUNY–Buffalo-Schomberg Fellowship, Light Work Residency, 1992. New York State Council on the Arts/Pyramid Art Center Grant, 1993. Indigenous Women's Network Delegate, Italy, 1996. Julian Park Faculty Award, 1997. Rockefeller Research Grant, 1997.

SELECTED EXHIBITIONS

1996	National Museum of the American Indian Swiss Institute
1995	Albert-Knox Gallery, New York
1993	Menshel Gallery (solo); Heard Museum, Phoenix, Arizona
1992	COCA
1990	*Our Land/Ourselves: American Indian Contemporary Artists*, University Art Gallery, University at Albany, New York (traveling show); *Language of the Lens*, Heard Museum, Phoenix, Arizona
1988	*Compensating Differences*, American Indian Contemporary Arts, San Francisco, California
1987	Exit Art; *The Silver Drum: Five Native Photographers*, Native In-

dian–Inuit Photographers Association, Hamilton, Ontario, and Forest City Gallery, London, Ontario

1986 *We Are Always Turning Around on Purpose*, State University of New York, Old Westbury, Long Island, New York

1985–1987 *Photographing Ourselves: Contemporary Native American Photography*, Southern Plains Indian Museum, Oklahoma, and ATLATL, Phoenix, Arizona

SELECTED PUBLICATIONS

Harlan, Theresa. "As in Her Vision: Native American Women Photographers." In Diane Neumaier, ed., *Reframings: New American Feminist Photographies*. Philadelphia: Temple University Press, 1995. pp. 114–124.

Lippard, Lucy. *Mixed Blessings: New Art in a Multicultural America*. New York: Pantheon, 1990.

Penney, David W., and George C. Longfish. *Native American Art*. Hong Kong: Hugh Lauter Levin, Assoc., 1994.

Rickard, Jolene. "Cew Ete Haw I Tih: The Bird That Carries Language Back to Another." In Lucy R. Lippard, ed., *Partial Recall*. New York: New Press, 1992. pp. 105–111.

Rickard, Jolene. *Indigenous Art as Visual History*. New York: Routledge, 1997.

Rickard, Jolene. "Jolene Rickard." In S. Cahan, ed., *Contemporary Art and Multicultural Education*. New York: Routledge, 1996.

Rickard, Jolene. "Sovereignty: A Line in the Sand." *Aperture* (August 1995).

ARTIST STATEMENT (1997)[1]

As a historian of Native American art and an installation artist, I continue to be committed to policies of inclusion and diversity. Questions surrounding post and/or neocoloniality are at the core of my writing, curating, and photographic work. As an advocate, I concentrate on collaborations between African, Chicano, Asian, and Native American artists and historians. As an educator, I have developed curricula addressing media and arts literacy in an intracultural global, visual space. As an experienced lobbyist at the government level and at the U.N., I am prepared to speak on behalf of the arts. I maintain that the arts signal the intellectual and emotional condition of contemporary society and therefore play a critical role in our future.

Note

1. Rickard, Jolene, "Personal Statement," *College Art Association News* (Fall 1997).

BIOGRAPHICAL ESSAY

Jolene Rickard functions as a photographer, professor, curator, lecturer, and author, using all these roles to advocate for the preservation and continuance of

traditional and contemporary Native American art and culture. Some of the cultural organizations she has been involved in to help promote Native American art and the arts in general are CAA (College Art Association), IWN (Indigenous Women's Network), NEA (National Endowment for the Arts), Atlatl Inc., AICH (American Indian Community House), NYSCA (New York State Council on the Arts), and the Ostego Institute for Native American Art History, of which she is a founding board member.

In 1987 Jolene moved back to her reservation in upstate New York, while at the peak of her career as a television art director and graphic designer. She reintegrated herself into the spiritual and political activities of her Turtle Clan and the wider Tuscarora reservation life. Jolene's art became more connected to her specific tribal identity and also embraced issues common to all indigenous peoples.

Through her writings and her photography, Jolene emphasizes the matrilineal aspects of Tuscaroran/Iroquoian identity. As a member of the Turtle Clan through birth and descent from her mother, she will inherit landownership and material possessions matrilineally. In the Tuscarora as in other tribes of the Iroquois Nation, clan mothers play important roles in political decisions. Jolene perceives her photography as a statement about securing the roles of women in native communities as a source of strength for the future. Originally from North Carolina, the Tuscarora migrated north and were adopted by the Iroquois, incorporating Iroquoian cosmology into their belief systems. Jolene describes her photographic work as "a path for me to put the threads in place that were once Tuscarora."

3 Sisters (1989, black and white photo and color xerox) has an image of Jolene's face sandwiched between images of corn, beans, and squash (the traditional three sisters in all agricultural native groups). Jolene's sleeping face in the center becomes one of the sisters, becomes one of the precontact female agricultural deities that blessed the people with good crops, becomes a contemporary continuation of an ancestral woman figure central to agricultural indigenous communities.

Another image that Rickard is well known for is *I See Red in the 90's* (1992, Ekta color and black and white silver prints, 33" × 42"), created in protest of the Columbus quincentenary. In the title, "seeing red" can be interpreted as symbolizing Native Americans and/or the commonly used expression to denote anger. The six-panel image is composed of three rows: at the top, clouds, sky, and fowl; in the middle, close-ups of heavily textured tree barks including a serious-looking self-portrait in front of one of the trees; and the bottom, a billowing Hudson Bay blanket. Jolene describes the disease-filled Hudson Bay blanket as "a metaphor for all of the threats against the Indian way." The multiphoto image is also Jolene's contemporary interpretation of the Tuscarora creation story of Sky Woman falling on the backs of fowl, entertaining the world to give life and taking her place in eternity as Grandmother Moon.

In her autobiographical essay in *Contemporary Art and Multicultural Edu-*

cation, Jolene discusses her work as a reflection and interruption, an art made with an Indian audience in mind that "can help people find the questions and look for answers." She also addresses a broader audience that is interested in indigenous people. Jolene's essay expresses the necessity of envisioning a future in order to have one and creating art that makes Indian people think about their options.

As a historian, Jolene researches tribal and family photographs, incorporating images from the past to create a contemporary reality. *Photomontage* (1992) is a collage made from a 1940s photograph of three Tuscarora women (two of whom are relatives) selling crafts created for the tourist market at the New York State Fair. Although tourist art is criticized as "inauthentic" by the "experts," Jolene informs viewers that tourist items are reminders of a group's spiritual, economic, and cultural survival. Jolene's photocollage changed the original scale relationship between her great-grandmother and her beadwork, enlarging the beadwork's importance. She asks questions about what is really negotiated in the trading of money for crafts and answers that "what is really being purchased is a momentary release from the crimes of the past."

Jolene states that her concerns in photography are to use her images to reflect the Indian agenda and to put her thoughts into the visual arts where they can be felt and communicated. She uses daily experiences in the continuum of Tuscarora life to visually explore indigenous survival as it continues to evolve and adapt to outside cultures while still maintaining its original essence.

SPIDERWOMAN THEATER COMPANY
Lisa Mayo, Gloria Miguel, and
Muriel Miguel

Tribal affiliation: Kuna/Rappahannock-Powhatan.

MAYO, LISA

Born: New York City. *Education*: Mayo is a classically trained mezzo-soprano who has studied privately with Uta Hagen, Robert Lewis, and Walt Witcover. She studied at the New York School of Music, with Tina Packer and Kristin Linkklater at Shakespeare and Company, and with Charles Nelson Riley for musical comedy. She has also studied languages. *Family*: Daughter of a

Spiderwoman Theater Company (from left to right, Lisa Mayo, Gloria Miguel and Muriel Miguel). Courtesy of Martha Swope Associates/William Gibson and Liz Dunn, Production/Management

Rappahannock-Powhatan mother, originally from Virginia, and a Kuna father, originally from the San Blas Islands near Panama and Colombia. Both parents were actors in snake oil shows that performed all over New York State. The eldest sister in the trio. *Career*: A founding member of two Native American performing arts groups, Spiderwoman Theater and Off the Beaten Path, with whom she has toured worldwide. In 1990 she taught theater crafts and acting to young people as part of the Minnesota Native American AIDS Task Force. In 1991 Mayo directed the Native American Actor's Showcase at the American Indian Community House, where she serves on the board of directors. *Awards*: Recipient of a Creative Arts Public Service (CAPS) Fellowship, 1981. Recipient of a grant from the New York State Council on the Arts for the development of *The Pause That Refreshes*, a piece she created and directed, 1985. Recipient of a Rockefeller Multi-Arts Production Grant for the development of *Daughters from the Stars: Nis Bundor*, 1994.

ARTIST STATEMENT (1996)[1]

I think our saving grace is that we are comediennes. Even though our main message is a very heavy one, we are funny and entertaining. The issues that we

decide upon are generally what you would call political, things that are happening with native people in this country. We are not supposed to be here now if the people who came here had their way. So you just think about that and you see how it is political. But finding the funny part of that is a way of survival. I think healing is the main thrust of what we do. In almost all our work, there is a theme of survival. It's not only survival for us but also for the future. We're concerned for future generations, and as we get older, we're passing on our information to younger native people and young people in our own families who have decided to take theater as a profession. That's part of survival, too.

Note

1. From Larry Abbott, "Spiderwoman Theater." *Indian Artist* (Spring 1996), p. 37.

MIGUEL, GLORIA

Born: New York City. *Education*: Studied drama at Oberlin College in Ohio (classical and experimental theater and clowning). *Family*: The middle sister of the trio. Mother of one daughter and one grandson. Her daughter's play *Princess Pocahontas and the Blue Spots* was produced in New York in 1991. *Career*: A founding member of Spiderwoman Theater. Has worked extensively in film and television; toured the United States in *Grandma*, a one-woman show; toured Canada as Pelajia Patchnose in the original Native Earth production of Tomson Highway's *The Rez Sisters*; and performed as Coyote/Ritalinc in *Jessica*, a Northern Light Production in Edmonton, Canada. Drama consultant for the Minnesota American Indian Youth AIDS Task Force to develop a play about AIDS. Drama teacher at a Brooklyn, New York, YMCA when not touring. *Awards*: Nominated for a Sterling Award for outstanding supporting actress. Recipient of a Rockefeller Multi-Arts Production grant for the development of *Daughter from the Stars: Nis Bundor, 1994.*

ARTIST STATEMENT (1996)[1]

All the material I use is from my native background, even though I was trained in both classical and experimental theater, as well as in clowning. I've always used and can never get away from my heritage, and I've always felt Indian. Every step of the way I use my Indianness in my work. But we have the skills and techniques to tackle other subjects. I've traveled to Central America, throughout the United States, and up to Canada. If we are going to survive as Indian people, we have to know more about each other and accept each other. I put down all my thoughts and write from a storyteller's point of view. We realize that there has to be someone to take our place. It would be nice to have

our children take over. I can see myself acting on the stage until I am 80 years old, at least.

Note

1. From Lary Abbott, "Spiderwoman Theater," *Indian Artist* (Spring 1996), p. 37.

MIGUEL, MURIEL

Born: New York City. *Education*: Studied Indian dancing as a child at 9 years old in a group that became the Thunderbird American Indian Dancers, which is now 30 years old. Studied acting with her parents and siblings. Studied and performed with Joe Chaikin at the Open Theatre. *Family*: Youngest sister in the trio. Has one daughter and one granddaughter. *Career*: A founding member and director of Spiderwoman Theater and Off the Beaten Path. With Spiderwoman, she directed and appeared in *Women in Violence*; *Three Up, Three Down*; *Winnetou's Snake Oil Show from Wigwam City*; *Rever-ber-berations*; and *Power Pipes*. Her own erotic one-woman show *Hot and Soft* premiered in New York in 1992 at the American Indian Community House. In 1992 she cocreated and directed *Blood Speaks*, featuring Coatlicue/Las Colorado. Taught drama at Bard College for four years; taught summers at the Native Theatre School in Ontario, Canada.

ARTIST STATEMENT (1996)[1]

I hate it when the message gets didactic. I also feel that I could never be in a piece where we all held hands and walked off into the sunset. That's not realistic to me, either. I tried to develop other ways of seeing things, taking the absurd and going so far into it that you almost pull it inside out and you come up with something else. I guess that's the way my mind runs. I'm interested in finding the universal line. I'm interested in working with lots of different people and also in doing one-woman shows. I'd like to start a Native Theatre space someplace and have the control ourselves of what we do and how we do it.

Note

1. From Larry Abbott, "Spiderwoman Theater," *Indian Artist* (Spring 1996), p. 37.

SELECTED PLAYS, PERFORMANCES, AND WORKSHOPS

Blood Speaks; Daughters from the Stars: Nis Bundor; Hot and Soft; Jessica; One Voice; The Pause That Refreshes; Plastic Shamanism: New Age Feminism and Native Spirituality; Power Pipes; Rever-ber-berations; The Rez Sisters; Son of Ayash; Storyweaving:

Storytelling, Oral Tradition, and Collective Creation; Storyweaving: Turning Personal Stories into Political Performance; Sun, Moon, and Feather; Survival Strategies: Living in the Arts; Three Up, Three Down; Trail of the Otter; Voices from the Criss-Cross Bridge; Winnetou's Snake Oil Show from Wigwam City; Women in Violence

THEATRE LOCATIONS SINCE 1975

American Indian Community House, New York, New York; Maryland International Theatre Festival, Baltimore; La MaMa E.T.C., New York, New York; Festival de Nancy, France; Brussels, Belgium; Frankfurt, Munich, Berlin, Germany; Turin, Modena, Lucca, Pisa, Verona, Italy; Lausanne, Switzerland; Helsinki and Tampere, Finland; London and Cardiff, England; San Diego, and Santa Monica, California; Seattle, Washington; York College, Vancouver, British Columbia; Brooklyn Academy of Music, New York, New York; Colby College, Waterbury, Maine; Buffalo and Oswego, New York; Cambridge, Massachusetts; Rutgers University, New Brunswick, New Jersey; North and South Dakota; Hartford, Connecticut; Panama, Central America; St. Louis, Missouri; Aspen and Telluride, Colorado; Pullman, Washington; Atlanta, Georgia; Raleigh-Durham, North Carolina; Ithaca, New York; Cedar Falls, Iowa; Lincoln, Nebraska; University of Illinois, Champaign-Urbana; Purdue University, West Lafayette, Indiana; NOW Convention, Philadelphia, Pennsylvania; The Public Theatre, New York, New York; Theatre for the New City, New York, New York; Festival de Rennes, France; Amsterdam and Rotterdam, Holland; Fredricksberg, Germany; Rome, Florence, Livorno, Italy; Copenhagen, Denmark; Vienna, Austria; Edinburgh, Scotland; San Francisco, California; Portland, Oregon; Minneapolis, Minnesota; Philadelphia, Pennsylvania; Hamilton, Albany, Syracuse, New York; Toronto and Ottawa, Canada; Pittsburgh, Pennsylvania; Long Island, New York; Anchorage, Alaska; New Orleans, Louisiana; Helena and Boseman, Montana; Santa Fe and Taos, New Mexico; Adelaide, Australia; Milwaukee, Wisconsin; Shepherdstown, West Virginia; San Antonio, Texas; Rochester, New York; Kansas City, Missouri; Beijing, China; Tulsa, Oklahoma; Oxford, Ohio

PUBLICATIONS

Abbott, Larry. "Spiderwoman Theater." *Indian Artist* (Spring 1996), 32–37.

Clark, Laura Beth. *High Performance* (Spring 1992).

Coulbourn, John. *The Toronto Sun* (Toronto, Canada), 1993.

Davies, Christopher V. *New York City Tribune*, 1987.

de Barros, Paul. *Seattle Times* (Seattle, Washington), 1990.

Downtown (New York City), 1989.

Dunn, Liz. *Spiderwoman Public Relations Packet*. New York: Dunn Production Management, 1997.

Friedlander, Mira. *The Toronto Star* (Toronto, Canada), 1993.

Harjo, Susan Shown. "Arts, Contemporary (Since 1960)." In Frederick E. Hoxie, ed., *Encyclopedia of North American Indians*. New York: Houghton Mifflin, 1996. pp. 50–56.

Isaac, Dan. *Chelsea Clinton News* (New York City), 1987.

Jacobs, Leonard. *Theatre Week* (New York City), 1990.

Kaufman, Sarah. *The Washington Post* (Washington, D.C.), 1993.

Lloyd, Tim. *The Advertiser* (Adelaide, Australia), 1989.

Mayo, Lisa. "Meeting My Past." *Indian Artist* (Spring 1997), p. 80.

Perkins, Kathy A., and Roberta Uno. *Contemporary Plays by Women of Color*. New York: Routledge, 1996. pp. 297–298.

Stone, Laurie. *The Village Voice* (New York City), 1990.

BIOGRAPHICAL ESSAY

Spiderwoman Theater, founded in 1976 by sisters Lisa Mayo, Gloria Miguel, and Muriel Miguel is the oldest continually running women's theater company in North America. Their name comes from the Hopi deity Spiderwoman, who taught her people how to weave. Lisa, Gloria, and Muriel describe their method of working as *storyweaving*, in which they create designs and weave stories using words and movement, creating an overlap of interconnected stories in which fantasy, power, reality, and humor are intertwined. It is an alternative approach to creative writing and acting that emphasizes collectivity, empowerment, and storytelling.

Comedy, ritual, satire, and improvisation are their media for social change. Movement and narrative translate the imagery of their dreams and their lived experiences as Native American women (Kuna/Rappahannock). Their powerful performances address issues of race, ethnicity, sexuality, and community, attempting to dispel stereotypes about Native Americans and about women. Depending on the production, the style can be somewhat traditional with scenery, props, lighting, and so on, or it can be a plain, no-frills, guerrillalike agitprop street theater.

All three sisters began acting, singing, and dancing as children in snake oil shows with their parents. When Lisa, Gloria, and Muriel were growing up in the 1930s, 1940s, and 1950s, snake oil shows were often the only avenue for aspiring Indian actors. The shows involved dressing in Plains-style regalia, demonstrating Indian magical cures (snake oil), and entertaining tourists by fulfilling white stereotypes of Native Americans. Growing up as the only Indian family in a Brooklyn Italian neighborhood, it was a means of financial support. Their father and his brothers came to New York from the San Blas Islands in the Caribbean by working on ships and settled in New York. Their mother's family originally lived in a Rappahannock community in Virginia. Their childhood was a blend of both Native American cultures and the New York urban experience.

Their play *Sun, Moon, and Feather* explores what it was like for three Native American girls growing up in an Italian neighborhood in Brooklyn during the 1940s. It explores their feelings of being disenfranchised and lonely and exposes their anger and rage. Time jumps back and forth as they perform as children and as adults, reflecting on their childhood. It incorporates old family movies from their Italian neighborhood, their summer home on the beach, their snake oil shows, and film sections made by their uncle of their father's homeland, the San Blas Islands off the coast of Panama. The title *Sun, Moon, and Feather* is a partial translation of their respective Indian names.

A recent piece, *Daughters from the Stars: Nis Bundor*, created and performed

by Lisa Mayo and Gloria Miguel, explores the ancestral roots of their Native Kuna (San Blas Islands in Panama) and Rappahannock (Virginia Powhatan) heritage. Inspired by a trip the two sisters made to Kuna Yala on the San Blas Islands to meet their father's people, including an older half brother, the structure for the piece comes from the Kuna legend of the five sisters who descend to Earth from the stars when a mother tries to stop her son from getting married. Interrupting the marriage would interrupt the life cycle. The sisters descend to Earth to ensure the progression of life and to protect the circle/chain of birth-life-death. Beginning with this Kuna myth, the piece progresses to engage in themes about heritage, ancestry, responsibility to preserve culture and family life, the connections between North American tribes and indigenous peoples in Central/South America, and how healing and wholeness can be achieved by having the flexibility to pass through borders of time and space. A strong component of the piece is the use of Kuna songs and language, which is a new experience for many North American native peoples. Lisa and Gloria also stress that *Daughters from the Stars: Nis Bundor* hopes not only to connect the different tribes of native nations but also to reach out to all races, encouraging them to examine where they have come from and how they will pass on the culture and history of their family to the following generations.

Although enjoying her role as the director of Spiderwoman, Muriel also likes to do one-woman shows. Her erotic one-woman performance *Hot and Soft* was first produced off-Broadway in 1994. Its themes of lesbianism, coming out, and the Native American concept of the *Two-Spirit* person are popular among gay/lesbian groups and frequently performed at Women's Studies events.

Whether working individually or together, Lisa, Gloria, and Muriel entertain and humor their audiences while simultaneously exploring contemporary topics in a historical context. They perform on stage and in community/outreach residencies with children of all ages, adults, and college students with varying degrees of theater training. Performing on reservations, in mainstream America, and in other countries, Spiderwoman has helped Native Americans of all nations to have more respect for their culture and enlightened, entertained, and educated a diverse public.

SWENTZELL, ROXANNE

Tribal affiliation: Santa Clara Pueblo. *Born*: 1962, Taos, New Mexico. *Education*: The Institute of American Indian Arts, 1978–1980. Portland Museum Art School, Portland, Oregon, 1980–1981. Private lessons with her uncle, blind

sculptor Michael Naranjo. *Family*: Roxanne is from the Naranjo family, which is well known for potters and sculptors—Rose Naranjo, Michael Naranjo, and Nora Naranjo-Morse. Her mother Rina is a potter and a Pueblo architect. *Career*: Self-employed artist. Artist-in-residence, Santa Fe Indian School, 1979. Artist-in-residence, Santa Clara Elementary School and the Tesuque Elementary School in New Mexico, 1981–1982. *Awards*: Eight awards for sculpture and pottery at the annual Indian Market, Santa Fe, 1986. Indian Market Creative Excellence in Sculpture, 1994.

SELECTED EXHIBITIONS

1998 Fort Mason, San Francisco, California (solo exhibit)

1993 Allan Houser Art Park, Institute of American Indian Arts Museum, Santa Fe, New Mexico; Museum of the Blackhawk, Danville, California; *Maintaining Cultural Roots: Personal Expressions by Women*, Tempe Arts Center and Sculpture Garden, Tempe, Arizona

1992 Four Winds Gallery, Pittsburgh, Pennsylvania

1991 *Shared Visions: Native American Painting and Sculpture of the Twentieth Century*, Heard Museum, Phoenix, Arizona

1990 Fort Mason, San Francisco, California (solo exhibit)

1988 *Four Generations: Group Exhibition*, C. N. Gorman Museum, University of California, Davis; *Earth, Hand, Life: Southwestern Ceramic Figures*, Heard Museum, Phoenix, Arizona

PUBLICATIONS

Abbott, Lawrence. "Roxanne Swentzell." *Indian Artist* (Fall 1997), pp. 20–25.
Archuleta, Margaret, and Rennard Strickland. *Shared Visions: Native American Painters and Sculptors in the Twentieth Century*. New York: New Press, 1991.
Gillespie, Nancy. "Indian Market Supplement." *The New Mexican* (August 1988).
Penney, David W., and George C. Longfish. *Native American Art*. Hong Kong: Hugh Lauter Levin Assoc., 1994.
Schaaf, Gregory. "Roxanne Swentzell." In Roger Matuz, ed., *Native North American Artists*. Detroit: St. James Press, 1998. pp. 548–549.

ARTIST STATEMENT (1997)[1]

What I like to get across to people is a way of seeing the world. That is the Pueblo philosophy that I was taught—the way of seeing the connectedness we have with everything around us and being in touch with ourselves on both the spiritual level and in the physical sense. More and more, I see people out of touch with the physical environment around them. I think that's a key thing to what I try to express. I think the Pueblo view of life can help the rest of the world, but I don't make my work just for Indian people; I want to reach all kinds of people.

Note

1. From Lawrence Abbott, "Roxanne Swentzell," *Indian Artist* (Fall 1997), p. 23.

BIOGRAPHICAL ESSAY

Roxanne began experimenting with clay as a young child, surrounded by family members who were potters and sculptors. Because of her art precociousness, Roxanne was given special permission to attend the Institute of American Indian Arts (IAIA) before graduating from high school. After leaving IAIA, she studied pottery, sculpture, painting, drawing, and glass blowing at the Portland Museum of Art. But clay is her first love, and she has been sculpting in clay and supporting herself through her art since the age of 17.

Swentzell achieved national and international notoriety with her 1988 *The Emergence of the Clowns* (42" × 36" × 36"), which toured the United States, Canada, and New Zealand as part of the Heard Museum exhibition *Shared Visions: Native American Painters and Sculptors in the 20th Century*. The piece is based on the myth of the *kosharis*—Pueblo clowns—that came from the underworld up to the world that we inhabit now. The four *kosharis* in the sculpture grouping represent the four directions that the clowns took the people in different parts of the world. The figures are unsettling in their realism. With a mischievous look in their humanlike eyes, the striped clay figures crawl and stretch across the surface. Swentzell states, "I want to show a consciousness and awareness that was happening, so there are different stages of their awakening. The figures could be four people or one person in four stages."

Other ceramic sculptures that are similar in style and include figures that seem to be part human and part mythic are *Sitting Woman* (1992, 20" × 18" × 17"), *Tse-Ping* (1990, 30" × 36" × 36"), *Despairing Clown* (1991, 26" × 12" × 12"), and *Yes He Loves Me* (1992, 21" × 12" × 12"). Although some of the figures have the same mischievous look as the *kosharis* in *The Emergence, Despairing Clown* is hauntingly serious in demeanor. With head bent and arms lifted, the clown peels back a layer of striped skin on the left arm as a layer of striped skin is already peeling or shedding on the stomach. Many questions could be asked about the figure's movement. Is the mythic clown shedding skin so that a new identity as a present-day human can emerge? Is the *koshari* immune to the physical pain of humans?

Swentzell hand builds her pieces with coil construction. It takes approximately a week to complete one figure, using very strong clays that can support the arms. Some of her figures are painted; some are left in their natural coloring. Swentzell uses an electric kiln, which places some limits on the sizes of her pieces. She describes the clay as having a character of its own that shrinks and moves around.

In 1997 Roxanne was commissioned by the city of Santa Fe to do a large outdoor park sculpture on land donated to the Rape Crisis Center. It is made of

cement and has a woman-centered theme focusing on motherhood and women's warmth that can reassure those who have been hurt. In the Pueblo tradition the mother is the central figure for caring. Swentzell feels that the male and female aspects are more balanced in Pueblo societies, that female strengths tend to be ignored in Western society. To compensate for that Western imbalance, Swentzell is reinforcing the female aspect in her commissioned outdoor sculpture and in many of her other current projects.

In her *Indian Artist* interview with Lawrence Abbott, Roxanne discussed the changes that have occurred in her art over a period of years, mentioning that her art is a reflection of events going on in her life and different issues that arise. "I think that as I grew as a person, the issues that I was dealing with became clarified. My art helps me. I think it's a part of my healing."

TREMBLAY, GAIL

Tribal affiliation: Onandaga/Micmac. *Born*: 1945, Buffalo, New York. *Education*: B.A., Drama, University of New Hampshire, 1967. M.F.A., Creative Writing, University of Oregon, 1969. *Family*: Her father was the town doctor. Tremblay became an artist because she was influenced by the creative output of her grandfather and great aunts. *Career*: Adjunct Professor in Creative Writing/Humanities at the University of Nebraska, Omaha, 1977–1981. On the faculty at Evergreen State College in Washington, teaching interdisciplinary courses in Native American Studies, creative writing, and art, 1981–present. Tremblay has also worked in prisons, summer camps, alternative schools, and children's theater companies.

SELECTED EXHIBITIONS

1997 *Native American Group Exhibit*, University of Wisconsin, La Crosse; *Beijing and Beyond*, Women's Caucus for Art, United Nations, New York; *Calyx Cover Girls*, Interstate Firehouse Cultural Center, Portland, Oregon; *The Empty Fish Trap Installation*, Bush Barn Art Center, Salem, Oregon

1996 *Women of Color in Art*, Federal Reserve Bank Gallery, Boston, Massachusetts; *The Empty Fish Trap Installation*, Sacred Circles Gallery, Seattle, Washington

1995 *Women's Caucus for Art Exhibit*, Non-Governmental Organization Forum, United Nations Fourth World Conference on Women, Huairou, China; *Sculpture, '95*, Sacred Circles Gallery at Daybreak Star Indian Cultural Center, Seattle, Washington; *Women of Color Artists:*

Power in Transition, Carver Cultural Center, San Antonio, Texas; *Agents of Change: New Views by Northwest Women*, Washington State Convention and Trade Center, Seattle, Washington; *In the Shadow of the Eagle*, Castellani Art Museum at Niagara University, New York; *Watchful Eyes: Native American Women Artists*, Heard Museum, Phoenix, Arizona

1994 *Native America: Reflecting Contemporary Realities*, Warm Springs Museum, Oregon; *Indian Humor*, American Indian Contemporary Art Gallery, San Francisco, California; *Gathering Medicine Show*, Art-in-General Gallery, New York; *Greetings from 93 for 94*, Steinbaum-Krauss Gallery, New York

1993 *Northwest Native American and First Nations Art*, Western Gallery at Western Washington State University, Bellingham, Washington; *Rhythms of Visions: 15 Contemporary Native American Artists*, Renshaw Gallery, Linfield College, Linfield, Oregon

1992 *For the Seventh Generation: Native American Artists Counter the Quincentenary, Columbus, New York*, touring exhibit, Arts Council Gallery, Norwich, New York, Golden Arts Colors Gallery, Columbus, New York, Buffalo Seminary, Buffalo, New York, Colgate University, New York, and Art-in-General Gallery, New York; *5th Biennial Native American Fine Arts Invitational*, Heard Museum, Phoenix, Arizona

1991 *Submuloc Show*, Evergreen State College, Olympia, Washington; *Definitive American Quilt Exhibit*, Steinbaum Krauss Gallery, New York

1990 *Never Been Shown*, Bumbershoot Festival of the Arts, Seattle, Washington; *Ancestors Known and Unknown: Box Works*, Coast to Coast: National Women Artists of Color, Art-in-General Gallery, New York

1989 *Masks: Cultural and Contemporary*, Afro-American Historical and Cultural Museum, Philadelphia, Pennsylvania; *Contemporary Native American Art*, Howard University Art Gallery, Washington, D.C.

1988 *Gail Tremblay: Fiber, Metal, Wood*, Museum of the Plains Indian, Browning, Montana (solo exhibit)

1986 *Women of Sweetgrass, Cedar, and Sage*, Portland Art Museum, Portland, Oregon, American Indian Community House Gallery, New York, C. N. Gorman Museum, University of California, Davis, California, and the Wheelwright Museum, Santa Fe, New Mexico (touring exhibit)

SELECTED PUBLICATIONS

Archuleta, Margaret. *5th Biennial Native American Fine Arts Invitational Catalog*. Phoenix, Ariz.: Heard Museum, 1992.

Penney, David W., and George C. Longfish. *Native American Art*. Hong Kong: Hugh Lauter Levin Assoc., 1994. Color illustration, p. 304.

Tremblay, Gail. [Artist statement.] In Sara Bates, *Indian Humor*. San Francisco: American Indian Contemporary Arts, 1995.

Tremblay, Gail. "Constructing Images, Constructing Reality: American Indian Photography and Representation." *Views* (Winter 1993).

Tremblay, Gail. [Five poems]. In Duane Niatum, ed., *Anthology of 20th Century Native American Poetry.* New York: Harper & Row, 1988.

Tremblay, Gail. [Four poems]. *Raven Chronicles*, vol. 6, no. 1 (Fall 1996).

Tremblay, Gail. "Indian Singing in 20th Century America." *CALYX Journal* (January 1990).

Tremblay, Gail. "Reflections on 'Mattie Looks for Steve Birko.' " In Lucy Lippard, ed., *Partial Recall: Essays on Native North Americans.* New York: New Press, 1992. pp. 113–119.

Tremblay, Gail. "Sisters." In Joy Harjo, ed., *Reinventing the Enemy's Language: Contemporary Native Women's Writing of North America.* New York: W. W. Norton, 1997. pp. 169–171.

Tremblay, Gail. "The Weaving of Elizabeth Walker: A Personal Exploration of Women's Lives Using the Apron as Metaphor." *CALYX Journal* 14, no. 2 (Winter 1992–1993).

ARTIST STATEMENT (1997)

Lots of folks have influenced me but most of all the stories, ideas, and values I learned from my relatives and my passion for combining diverse materials in my artwork, like people combined diverse materials in traditional work to create rich, varied, and sensuous objects—clothes with ribbon and beadwork trimmed with silver brooches, wooden masks with horsehair and tin plates around the eyes, leather clothes with porcupine quill and moose hair embroidery; I wanted to bring a sensuous variety of materials into my contemporary art making like artists in the old days did. Sometimes I reference traditional stories or history in my work; sometimes I talk about various contemporary issues. Like most Hau-de-no-sau-nee women, I have always believed and insisted that women should be powerful. We were all raised that Sky Woman Fell to Earth, and it all started there. Spiritual connection to the circle of things that supports life in the creation is the most important force in anything I do. I'm always struggling to keep spiritual ideas alive in my life and in my work. How else can one aspire to be a *real* human being?

BIOGRAPHICAL ESSAY

Gail Tremblay is most noted for working in fiber art, mixed-media weaving, and more recently installations. Her tapestries, wall hangings, coiled weaves, masks, baskets, mixed-media weaving, and human doll figures/installations are made with metal, wood, husks, grass, leather, bark, and porcupine quills. These traditional materials require hours of cleaning, pounding, splitting, sorting, dyeing, drying, soaking, filing, sanding, and polishing.

In addition to incorporating traditional Iroquoian aesthetics and techniques into her work, Tremblay also uses universally taught techniques in European,

Euro-American, and Asian art. She appreciates art from a variety of cultures and combines techniques from around the world. Gail has traveled to England to research the collection of Hau-de-no-sau-nee art in the Victoria and Albert Museum. She has also collaborated with artists in Mexico and interacted with Chinese women artists at the NGO Forum of the United Nations Women's Conference.

Like many Native American artists, there is often an element of humor in Tremblay's work. For the San Francisco American Indian Contemporary Arts Indian Humor show, Tremblay constructed a three-figure installation titled *In Search of the Ultimate Roach Joke* (1994, 17" × 16" × 5", mixed media). One figure, an Indian dressed in dance regalia, including a hair roach, is labeled: *I got to the powwow around five: took my suitcase and started to put on my outfit and roach* . . . The center figure, dressed in casual clothes, has a roach (insect) at the feet. The end figure, dressed in a hippie-style fringe vest, is labeled: *Hey man, did you say you found a roach?* (a reference to a marijuana cigarette butt). Tremblay describes the piece as dealing with semantics and levels of understanding. Very few non-Indians know that a porcupine hair headdress is called a *roach*. It is Tremblay's way of poking fun at the lack of familiarity with indigenous cultural concepts.

A very different work is *Forming Star* (1990, mixed media, 49" × 41"). A wall hanging of silver and gold metallic yarn, aluminum, and brass, it is both very delicate and strong/bold. Tremblay describes it as a "meditation on the birth and death of stars." Executed for the 5th Biennial at the Heard Museum, it is a comment on the draining of Earth.

In addition to her fine arts career, Gail is a widely published poet who has received several awards and is well known on the poetry reading circuit. Coming from an oral tradition, the spoken word is as inspiring to Tremblay's creativity as the visual world.

Currently living and teaching in the Northwest, Gail interviewed elders, ceremonial leaders, and scientists at the Northwest Indian Fish Commission to make the installation *The Empty Fish Trap* (1996). The piece makes reference to the current salmon fishing crisis affecting indigenous people in the Northwest. Tremblay's art refers to a wide variety of native issues, not just ones relating to her own people. In her visual art and in her literature, she is intertribal and global.

TSINHNAHJINNIE, HULLEAH

Tribal affiliation: Seminole/Creek/Navajo. *Born*: 1954, Phoenix, Arizona. *Education*: Acrosanti, Cordes Junction, Arizona, 1975. Haystack Mountain School of Arts, Deer Isle, Maine, 1977. Institute of American Indian Arts, Santa Fe, New Mexico, 1975–1978. B.F.A., California College of Arts and Crafts, Oakland, California, 1981. *Family*: Daughter of Andrew Van Tsinhnahjinnie, renowned Navajo painter. *Career*: Professional graphic designer and photographer since 1980. Instructor at various institutions such as the Institute of American Indian Arts, the San Francisco Art Institute, University of California, Davis, and the California College of Arts and Crafts. *Awards*: Rockefeller Scholar-in-Residence/University of California, Davis Institute for Indigenous Research in the Americas, 1997.

EXHIBITIONS

1997 *Women of Hope: Portraits of Indigenous Women*, 1199 Union Gallery, New York

1994 *Photographic Memoirs of an Aboriginal Savant*, Multimedia Sacred Circle Gallery, Seattle, Washington; C. N. Gorman Museum, University of California, Davis

1993 *Nobody's Pet Indian*, San Francisco Art Institute

SELECTED GROUP EXHIBITIONS

1998 ProArts Gallery, Oakland, California

1997 *Art of the Americas: Identity Crisis*, M. H. de Young Memorial Museum, San Francisco, California

1994 *Watchful Eyes*, Heard Museum, Phoenix, Arizona; *This Path We Travel*, National Museum of the American Indian, New York

1992 *Message Carriers*, Photographic Resource Center, Boston University, Massachusetts; *International Istanbul Biennial*, Istanbul Municipality Nejat F. Eczacibasi Art Museum, Halic, Turkey; *Ancestral Memories: A Tribute to Native Survival*, Falkirk Cultural Center, San Rafael, California

1991 *Counter Colon-ialismo*, Centro Cultural de la Raza, San Diego, California; *Shared Visions*, Heard Museum, Phoenix, Arizona

1990 *Language of the Lens: Contemporary Native Photographers*, Heard Museum, Phoenix, Arizona; *Talking Drum, Connected Vision: Native*

American Artists Addressing Affinities with the Indigenous People of South Africa, Salad Bar Gallery, Oakland, California; *Native Photographers*, Stewart Indian School Museum, Reno, Nevada

1986 *The Photograph and the American Indian*, Princeton University Library, Princeton, New Jersey

1977 *Indian Art Today: Traditional and Contemporary*, Albuquerque Fine Arts Museum, New Mexico

SELECTED PUBLICATIONS

Archuleta, Margaret, and Rennard Strickland. *Shared Visions: Native American Painters and Sculptors in the 20th Century*. New York: New Press, 1991.

Ballerini, Julia. "Postcolonial Legacies Artworks." In Diane Neumaier, ed., *Reframings: New American Feminist Photographies*. Philadelphia: Temple University Press, 1995. pp. 146–159.

Fitzsimons, Casey. "Cultural Confrontations." *Artweek* 22 (November 21, 1991).

Harlan, Theresa. "As in Her Vision: Native American Women Photographers." In Diane Neumaier, ed., *Reframings: New American Feminist Photographies*. Philadelphia: Temple University Press, 1995. pp. 114–124.

Harlan, Theresa. "A Curator's Perspective: Native Photographers Creating a Visual Native American History." *Exposure* 29, no. 1 (Fall 1993).

Jenkins, Steven. "A Conversation with Hulleah Tsinhnahjinnie." *Artweek* 24 (May 6, 1993).

Lippard, Lucy. *Mixed Blessings: New Art in a Multicultural America*. New York: Pantheon Books, 1990.

McWillie, Judith. "The Migrations of Meaning." *Visions Art Quarterly* (Fall 1989).

Penney, David, and George Longfish. *Native American Art*. Hong Kong: Hugh Lauter Levin Associates, 1994.

Rapko, John. "Sovereignties." *Artweek* 24 (May 6, 1993).

Rickard, Jolene. "Sovereignty: A Line in the Sand." *Aperture*, no. 139 (Summer 1995).

Skoda, Jennifer. "Image and Self in Contemporary Native American Photoart." *American Indian Art Magazine* 21, no. 2 (Spring 1996).

Tremblay, Gail. "Reflections on 'Mattie Looks for Steve Biko': A Photograph by Hulleah Tsinhnahjinnie." In Lucy Lippard, ed., *Partial Recall: Photographs of Native North Americans*. New York: New Press, 1992.

Tsinhnahjinnie, Hulleah. "Compensating Imbalances." *Exposure* 29, no. 1 (Fall 1993).

Tsinhnahjinnie, Hulleah. *This Path We Travel: Celebrations of Contemporary Native American Creativity*. Washington, D.C.: Smithsonian Institution, 1994.

Vigil, Jennifer. "Hulleah Tsinhnahjinnie." In Roger Matuz, ed., *Native North American Artists*. Detroit: St. James Press, 1998. pp. 584–586.

BIOGRAPHICAL ESSAY

Hulleah's photographs, photocollages/montages, and installations are reflective of a postmodern art world that attempts to portray the human condition in the context of culture, time, and place. In her work, Hulleah alters images, creating layers of metaphors and allusions that center Native Americans as sub-

jects in today's global world. Through layering and rephotographing old images, placing them in a newer context, Hulleah challenges stereotypes of the "Vanishing Indian"—making room for the "Urban Indian."

Hulleah's 1980s series *Metropolitan Indian* dealt with the invisibility of urban Indians, often unrecognized by the general public unless dressed in traditional regalia. In one of the photographs from that series, a Native American woman in Plains buckskin is mounted on a horse on a California hill, overlooking the freeway. In another image Jean Antoine, the director of San Francisco's American Indian Contemporary Arts gallery, is posed next to a motorcycle wearing a white buckskin dress. It is a new way of portraying landscapes and Native Americans. Instead of "Vanishing Indians," Hulleah informs the viewer about the "Vanishing Landscape" and the roles of Native Americans in the overdeveloped urban America.

Never one to shy away from controversy, Hulleah Tsinhnahjinnie is one of the main artists addressing the issue of Public Law (PL) 101–644 passed in 1990 by Congress. The law was originally composed to protect tribal arts and crafts from Indian imposters/wannabees and requires people selling their art as Indian artists to have a tribal enrollment number or a Bureau of Indian Affairs (BIA) Certificate of Indian Blood. But as a result of assimilation tactics such as the Indian Removal Act, the Dawes Act, boarding schools, urban relocation, and adoption, thousands of Indians do not have tribal enrollment numbers, and Indian artists affected by those governmental policies face federal fines if they exhibit as Indian artists without governmental documentation. In a series of self-portraits titled *Creative Native*, Hulleah addresses PL 101–644 in a series of mugshots of herself with adhesive numbers across her mouth. In the triptych titled "Would I have been a member of the Nighthawk Society or the Snake Society or would I have been a half-breed leading the whites to the full-bloods?" Hulleah's tribal enrollment number covers her forehead. The series is Hulleah's critique of an Indian internalized racism that is dependent on the BIA for Indian "authenticity."

During 1993 Hulleah engaged in a series—*My Heroes Have Always Been Native*—that involved images of inspirational men/women. The 8" × 10" black and white photos were mounted on a wooden board that was then painted to extend the photograph's frame. In *Talking about Aunt Lucy*, Hulleah's maternal aunts are sitting in chairs, engrossed in conversation with their backs facing the viewer. It is a tribute to her aunt's heroism as a child when she led a group of lost children from the Trail of Tears back to their families. Hulleah's manipulation of family photographs places Native Americans in the broader context of their tribal histories.

The television as manipulator of mass media misinformation, particularly as it applies to Native Americans, is critiqued through a series of photographs in which images of contemporary Native Americans are placed inside a television screen or emerging from the screen. In *Mattie Looks for Stephen Biko, Return of the Native, Vanna Brown, Azteca Style*, and *Oklahoma, the Unedited Version*,

photographs of Indians dressed in traditional regalia but located in contemporary settings such as a car seat or a San Francisco subway challenge the stereotypes of where Native Americans are located in space and time.

Like many artists, Hulleah is inspired by family influences. Her father, Andrew Van Tsinhnahjinnie, is a renowned Navajo painter whose representational works are in collections at the Smithsonian Institution and in Natural History museums throughout the Southwest. As a child Hulleah traveled with her father, helping him set up displays at trading posts, craft centers, and roadside camps. Those experiences reinforce her commitment to also engage in community arts through posters and educational aids that convey messages to a broader audience that may not be engaged in the "fine arts." Whether working as a community artist, photographer, graphic designer, curator, lecturer, or writer, Hulleah is always reminding her audience that Native America is a contemporary reality.

VELARDE, PABLITA

Indian name: Tse Tsan (Golden Dawn). *Tribal affiliation*: Santa Clara Pueblo. *Born*: 1918, Santa Clara Pueblo, New Mexico. *Education*: St. Catherine's Indian School, Santa Fe, Santa Fe Indian School, 1932–1936, where she studied painting with Dorothy Dunn at the Studio. Also inspired to paint by Indian woman artist Tonita Peña. *Family*: Divorced from Herbert Hardin in the 1960s. Two children, Herbert II and artist Helen Hardin, who died in 1984. *Career*: Artist-in-residence at Bandelier National Monument. Muralist for the Works Progress Administration (WPA). Muralist for the Museum of Fine Arts, Santa Fe, New Mexico. Lecturer, teacher, book illustrator, and author. *Awards*: Palmes d'Academiques from the French government, 1954. Waite-Phillips trophy from the Philbrook Art Center, 1968. Several first-place awards including All American Indian Days, Sheridan, Wyoming; Trail of Tears Show, Cherokee National Museum, Tahlequah, Oklahoma; Inter-Tribal Indian Ceremonies, Gallup, New Mexico (four times); and Indian Market, Santa Fe (seven times). Most recently the Lifetime Achievement in Art from the Native American Art Studies Association, 1997.

EXHIBITIONS

1996	Desert Museum, Palm Springs, California
1995	Museum of New Mexico, Santa Fe
1993	*Woman's Work: The Art of Pablita Velarde*, Wheelwright Museum of the American Indian, Santa Fe, New Mexico

SELECTED GROUP EXHIBITIONS

1991–1992	*Shared Visions: Native American Painters and Sculptors of the 20th Century*, Heard Museum, Phoenix, Arizona (traveling)
1990–1991	*One with the Earth*, Institute of American Indian Arts and Alaska Culture Arts and Development (traveling)
1990	Koogler McNay Art Museum, San Antonio, Texas
1987	Cherokee National Museum, Tahlequah, Oklahoma
1986	*When the Rainbow Touches Down*, Heard Museum, Phoenix, Arizona (traveling)
1984–1985	*Indianischer Kunstler*, organized by the Philbrook (traveling), West Germany
1981–1983	*Native American Painting*, organized by Amarillo Art Center, Amarillo, Texas (traveling)
1981	*Walk in Beauty: A National Invitational Native Art Show*, Santa Fe Festival of the Arts, New Mexico
1980	*American Indian Woman's Spring Art Festival*, Indian Pueblo Center, Albuquerque, New Mexico; *Native American Art at the Philbrook*, Tulsa, Oklahoma
1979–1980	*Native American Paintings*, Mid-America Arts Alliance Project, Joslyn Art Museum, Omaha, Nebraska (traveling)
1978	*100 Years of Native American Art*, Oklahoma Museum of Art, Oklahoma
1963	*Contemporary American Indian Art*, U.S. Department of State, Washington, D.C. (traveling)
1958–1961	University of Oklahoma European Tours (traveling)
1947–1965	*American Indian Paintings from the Permanent Collection*, Philbrook Art Museum, Tulsa (traveling)
1934	Chicago Century of Progress, Chicago, Illinois
1931–1933	*Exposition of Indian Tribal Arts*, College Art Association (traveling)

COLLECTIONS

Amerind Foundation, Dragoon, Arizona; Denver Art Museum, Colorado; Heard Museum, Phoenix, Arizona; Joslyn Art Museum, Omaha, Nebraska; Kiva Museum of the Koshare Indian, Boy Scouts of America, La Junta, Colorado; Logan Museum of Anthropology, Beloit, Wisconsin; Museum of New Mexico, Santa Fe; Museum of Northern Arizona, Flagstaff; National Museum of the American Indian, Smithsonian Institution, Washington, D.C.; Oklahoma University Fred Jones, Jr., Museum of Art, Oklahoma City; Philbrook Museum of Art, Tulsa, Oklahoma; Roswell Museum and Art Center, Roswell, New Mexico; San Diego Museum of Man, California; Southwest Museum, Los Angeles, California; Thomas Gilcrease Institute of American History and Art, Tulsa, Oklahoma; United Pueblo Agency, Albuquerque, New Mexico; University of California, Berkeley; Wheelwright Museum of the American Indian, Santa Fe

PUBLICATIONS

Archuleta, Margaret, and Rennard Strickland. *Shared Visions: Native American Painters and Sculptors in the Twentieth Century*. New York: New Press, 1991.

Culley, LouAnn. "Helen Hardin: A Retrospective." *American Indian Art Magazine* (Summer 1977).

Dunn, Dorothy. *American Indian Painting of the Southwest and Plains Areas*. Albuquerque: University of New Mexico, 1968.

Hyer, Sally. *Woman's Work: The Art of Pablita Velarde*. Santa Fe, N.M.: Wheelwright Museum of the American Indian, 1993.

Nelson, Mary Carroll. *Pablita Velarde*. Minneapolis: Dillon Press, 1971.

Nelson, Mary Carroll. "Pablita Velarde," *American Indian Art Magazine* (Spring 1978).

Pablita Velarde: An Artist and Her People. National Park Service, 1984. Film.

Roberts, Lisa. "Pablita Velarde." In Roger Matuz, ed., *Native North American Artists*. Detroit: St. James Press, 1998. pp. 601–603.

Scott, Jay. *Changing Woman: The Life and Art of Helen Hardin*. Flagstaff, Ariz.: Northland Press, 1989.

Silberman, Arthur. *100 Years of Native American Painting*. Oklahoma City: Oklahoma Museum of Art, 1978.

Van Ness Seymour, Tryntje. *When the Rainbow Touches Down*. Seattle and London: University of Washington Press, 1988. Heard Museum exhbn cat.

Velarde, Pablita. *Old Father, the Storyteller*, Globe, Ariz.: D. S. King, 1960.

Wade, Edwin L., ed. *The Arts of the North American Indian: Native Traditions in Evolution*. New York: Hudson Hills Press, in association with Philbrook Art Center, Tulsa, Okla., 1986.

Witzling, Mara R., ed. *Voicing Our Visions: Writings by Women Artists*. New York: Universe Publ., 1991. pp. 319–332.

BIOGRAPHICAL ESSAY

Pablita Velarde, painter and mother of Native American artist Helen Hardin, was born on the Santa Clara Pueblo in New Mexico in 1918. Although Velarde's Indian name is Tse Tan, which means *Golden Dawn*, she was required to give up her native name when she attended a Catholic boarding school. She was given the Spanish name of Pablita. When she was a teen, she enrolled in the Studio of the Santa Fe Indian School of New Mexico. Her paintings have gained recognition for their importance in documenting the lifestyles of Pueblo men and women. Velarde was influenced by Dorothy Dunn, an art teacher from Chicago who opened a painting studio at the Santa Fe Indian School in 1932. For the next five years, she developed the Santa Fe Studio Style, or Studio style, which was a unique painting movement that focused on Native American values and concepts. The Studio style was similar to the Oklahoma style of painting in that flat colors and distinct lines are used throughout the composition. Paintings depict traditional Indian life and events. Other Native American artists who trained under the instruction of Dunn besides Velarde included Pueblo artists

Jose Vincente Agujlar, Vincente Mirabel, Juan Medina, and Navajo artists Harrison Begay, Quincy Tahoma, and Stanley Mitchell. Velarde also studied under Tonita Peña (1893–1949), the first recognized Indian woman painter. Art produced under the Oklahoma and Studio styles is considered *traditional* Indian painting. Dorothy Dunn did not encourage her students to become mainstream artists. She tried to maintain the Indian as *separate but equal* and encouraged the exploitation of what she defined as native tradition. Dunn suggested tribal elements that she considered *authentic*. Pablita Velarde was one of Dunn's earliest pupils and exposed to this 1930s liberal paternalism.

While in the eighth grade, Velarde's paintings were exhibited in Chicago. She continued to develop at the Studio until her graduation in 1936. Pablita Velarde became the first person in her family to get a high school diploma. She returned to the pueblo as a day school instructor and was commissioned to paint the facade of a downtown department store. Velarde was also hired as an artist-in-residence for the Bandelier National Monument to paint scenes from daily Pueblo life. She painted murals and watercolors for the Works Progress Administration, and along with other WPA artists, her work was exhibited in New Mexico and Washington, D.C. Mural projects painted during the 1950s depicted Pueblo life and subjects and also used colors and shapes found in Navajo sandpaintings.

Pablita Velarde also painted a science mural titled *Biology, Botany*. The purpose of the science mural series was to show that many elemental concepts of art and science are neither old nor new but eternal and commonly shared. Velarde's mural *Botany* shows the sequence of plant life from the mosses, ferns, and palms to modern forms such as yucca, giant cactus, Indian paintbrush, and aspen.

Pablita completed two mural projects in the late 1950s. The first depicted Pueblo subjects, naturalistically in oil, and was executed in the Foote Cafeteria, Houston, Texas. The second mural featured a long, horizontal panel of Navajo sandpainting adaptations in earth colors and was executed in the lobby of the Western Skies Hotel, Albuquerque, New Mexico. Velarde's modernization of Navajo sandpaintings was accomplished by grinding natural pigments to powder, liquefying them in a glue base, and applying them to a board with a brush. It is a time-consuming procedure because each layer of powder has to dry fully before another can join it.

In 1960, Pablita published a book of stories and paintings, *Old Father, the Storyteller*. The stories focus on the migration of Indian peoples as passed down through oral history. The painting of the storyteller is considered one of her best. The storyteller is depicted sitting in the village square at night with Pueblo children seated around him, boys on one side, girls on the other, listening in awe. Above his head in an arc shape are the constellations whose meaning the storyteller explains to the children. The background is filled with mythic beings, plant life, and communal housing. Although widely received by the non-Indian

public and contributing greatly to Velarde's national recognition, this book was criticized by tribal officials for going against tradition by writing down oral legends.

Pablita's name remains first among those of Santa Clara painters and is well recognized wherever Indian painting is known. Her career has undergone a steady development from her formative works in 1932 to the present. At first emphasizing the genre of her native village, Pablita's paintings have extended to include various art patterns from other pueblos as well as from the Navajo area and prehistoric southwestern sites. Casein, tempera, oil, and her own mixtures of local earth colors are her media. Native earths are her principal medium for fresco secco. Her abstract motifs are adapted from ceramic designs and prehistoric mural figures. Another avenue for Pablita is Tewa mythology and legend, which she has extensively interpreted in tempera paint.

Velarde's distinct style of painting has been compared to traditional American Folk painting. Her densely clustered figures, animals, fields, and architectural features appear to be frozen in an instant of time. Their visual texture suggests the artist's quest to detail the life and attitude of her people and community.

WALKINGSTICK, KAY

Tribal affiliation: Cherokee. *Born*: 1935, Syracuse, New York. *Education*: B.F.A., Beaver College, Glenside, Pennsylvania, 1959. M.F.A., Pratt Institute, New York, 1975. *Family*: WalkingStick is the mother of two children and a grandmother. *Career*: Painting Instructor, Edward Williams College of Fairleigh Dickinson University, New Jersey, 1970–1973. Lecturer in Twentieth-Century Art, Painting, and Drawing, Upsala College, East Orange, New Jersey, 1975–1979. Painting and Drawing Instructor, Art Center of Northern New Jersey, 1978–1985. Artist-in-Residence, Fort Lewis College, Durango, Colorado, 1984. Artist-in-Residence, Ohio State University, 1985. Painting Instructor, Montclair Art Museum, Montclair, New Jersey, 1986–1988. Assistant Professor of Art, Cornell University, 1988–1990. Assistant Professor of Art, SUNY, Stony Brook, 1990–1992. Associate Professor of Art, Cornell University, Ithaca, New York, 1992–present. Artist-in-Residence, Heard Museum, Phoenix, Arizona, 1995. *Awards*: Residency, McDowell Artist's Colony, 1970, 1971. Residency, Yaddo Artist's Colony, 1976. National Endowment for the Arts, 1983–1984. New Jersey State Council on the Arts, 1985–1986. New York Foundation for the Arts, 1992. Residency, Rockefeller Conference & Study Center, Bellagio, Italy, 1992.

Joan Mitchell Foundation Award in Painting, 1995–1996. Honoree, Women's Caucus for Art, 1996.

SELECTED EXHIBITIONS

1995 Atlantic Center for the Arts, Works on Paper, New Smyrna Beach, Florida

1994 June Kelly Gallery, New York, New York

1993 Galerie Calumet, Heidelberg, Germany; Flushing Council on the Arts, Flushing, Queens, New York; Hartell Gallery, Cornell University, Ithaca, New York

1992 Morris Museum, Morristown, New Jersey; *Works on Paper*, Jersey City Museum, Jersey City, New Jersey

1991 Elaine Horwitch Gallery, Scottsdale, Arizona; *Kay WalkingStick: 1974–1990*, Hillwood Art Museum of Long Island University, C. W. Post Campus, Brookville, New York; Heard Museum, Phoenix, Arizona; Hartwick College Gallery, Hartwick College, Oneonta, New York

1990 M-13 Gallery, New York, New York; Rathborne Gallery, Junior College of Albany, Albany, New York

1989 Union College, Cranford, New Jersey

1988 Wenger Gallery, Los Angeles, California

1987 M-13 Gallery, New York, New York

1986 Galleria Maray, Englewood, New Jersey

1985 Beaver College, Spruance Art Gallery, Glenside, Pennsylvania; Ohio State University, Hopkins Hall Gallery, Columbus, Ohio (visiting artist exhibit); Carl N. Gorman Museum, University of California, Davis, California (a two-person exhibit)

1984 Fort Lewis College, Fine Arts Gallery, Durango, Colorado; Bertha Urdang Gallery, New York, New York; Wenger Gallery at the Fine Arts Building, San Diego, California

1981 *Painting on Paper*, Bertha Urdang Gallery, New York, New York

1979 Wenger Gallery, San Diego, California

1978 Bertha Urdang Gallery, New York, New York

1976 Soho Center for the Visual Arts, New York, New York

1975 New Jersey State Museum, Trenton, New Jersey (a two-person exhibit)

1969 Cannabis Gallery, New York, New York

SELECTED GROUP EXHIBITIONS

1997 *The New York Experience*, Institute of American Indian Arts Museum, Santa Fe, New Mexico; *Native Abstraction: Modern Forms, Ancient Ideas*, Museum of Indian Arts and Culture, Santa Fe, New

Mexico; *We Are Many, We Are One*, University of Wisconsin, La Crosse, Wisconsin (to travel one year to various universities)

1996 *Native Papers: Joe Feddersen, James Lavadoor, Kay WalkingStick, Phil Young*, University of Missouri, St. Louis, Missouri; *Changing Horizons: Landscape on the Eve of the Millennium*, Katonah Museum of Art, Katonah, New York; *Cherokee, the Fire Takers*, Cherokee National Museum, Tahlequah, Oklahoma; *Honorees of W.C.A. 1996*, Rose Art Museum at Brandeis University, Boston, Massachusetts; *Retreat and Renewal: Painting and Sculpture by MacDowell Art Colonists*, Currier Gallery of Art, Manchester, New Hampshire (to travel to the Wichita Art Museum, Wichita, Kansas, and the National Academy of Design, New York City, New York, 1997–1998)

1995 *Indian Humor*, American Indian Contemporary Arts, San Francisco, California (to travel two years); *Legacies: Native American Women Artists*, Castle Gallery, College of New Rochelle, New Rochelle, New York

1994–1995 *Strategies of Narration*, Cairo Biennial (U.S. exhibit, December–January, to travel to Africa until 1997, Cairo, Egypt)

1993–1994 *Multiplicity: A New Cultural Strategy*, University of British Columbia, Museum of Anthropology (December 14–May 1994, Vancouver, British Columbia, Canada)

1993 *93 Artists Greetings for '94*, Bernice Steinbaum Gallery, New York, New York

1992 *We the Human Beings*, Wooster College Art Museum, Wooster, Ohio; *Land, Spirit, Power*, National Gallery of Canada, Ottawa, Canada; *Decolonizing the Mind*, Center on Contemporary Art, Seattle, Washington; *Six Directions*, Calumet Galerie, Heidelberg, Germany; *Bob Blackburn's Printmaking Workshop: Artists of Color*, Hillwood Art Museum, Brookville, New York (travel in United States 1992 and 1993; to travel with the United States Information Agency (USIA) in Africa in 1994–1995)

1991 *Presswork, the Art of Women Printmakers*, National Museum of Women in the Arts, Washington, D.C.; *Light on the Subject, the Environment*, American Indian Contemporary Arts Gallery, San Francisco, California; *The Submuloc Show, in Response to the Columbus Wohs*, Evergreen State College, Olympia, Washington; *Our Land/ Ourselves, American Indian Contemporary Artists*, University Art Gallery, SUNY, Albany, Albany, New York (to travel in the United States for three years); *Shared Visions, Native American Painters and Sculptors of the 20th Century*, Heard Museum, Phoenix, Arizona

1990 *The Decade Show, Framework of Identity in the 1980's*, The New Museum, a three-museum show including The Studio Museum, Museum of Contemporary Hispanic Art, and the New Museum, New York, New York

1989	*100 Women Artists' Drawings*, United States Information Agency (traveled in South America)
1988	*Autobiography: In Her Own Image*, Intar Gallery, curated by Howardena Pindell, New York, New York
1987	*We the People*, Artists Space, curated by Jimmie Durham and Jean Fisher, New York, New York; *Soaring Spirit: Contemporary Native American Arts*, Morris Museum, Morristown, New Jersey
1986	Native Business Summit Foundation of Canada, Toronto, Canada
1985	*AdoRomenTs*, Bernice Steinbaum Gallery, New York, New York; *Second Biennial Invitational*, Heard Museum, Phoenix, Arizona; *Women of Sweetgrass, Cedar, and Sage*, Gallery of the American Indian Community House, New York, New York
1984	*Signals*, Gallery Akmak, Berlin, West Germany; *New Jersey Curators Choice*, Robeson Gallery, Rutgers University, Newark, New Jersey
1983	*Contemporary Native American Art*, Oklahoma State University, Gardner Art Gallery, Stillwater, Oklahoma
1982	*Tribute to Bertha Urdang*, Israel Museum, Jerusalem, Israel
1981	*Invitational 1981*, Jersey City Museum, Jersey City, New Jersey
1980	*Marking Black*, Bronx Museum, Bronx, New York; *Four Native American Women*, Southern Plains Indian Museum, Anadarko, Oklahoma
1975	*Works on Paper*, Brooklyn Museum, WIA Exhibition, Brooklyn, New York

SELECTED COLLECTIONS

Albright-Knox Museum, Buffalo, New York; Bailey-Howe Library of the University of Vermont, Burlington, VT; Cherokee Heritage Foundation, Tahlequah, Oklahoma; City University of New York, Shepard Hall, New York, New York; City University of New York, Steinman Hall, New York, New York; Davidson College, Davidson, North Carolina; Heard Museum, Phoenix, Arizona (four works); Israel Museum, Jerusalem, Israel; Johnson Museum, Cornell University, Ithaca, New York; Kresge Museum of Michigan State University, East Lansing, MI; La Jolla Museum of Contemporary Art, La Jolla, California (two works); Metropolitan Museum of Art, New York, New York; National Gallery of Canada, Ottawa, Canada; Newark Museum, Newark, New Jersey (two works)

SELECTED PUBLICATIONS

Abbott, Lawrence. *I Stand in the Center of the Good: Interviews with Contemporary Native American Artists*. Lincoln: University of Nebraska Press, 1994.

Archuleta, Margaret. ''Swimming Upstream: Diversity in Native American Art at the End of the 20th Century.'' In *Native Streams*. Chicago: Jan Cicero Gallery, 1996. pp. 4–7.

Baldwin, Victoria. ''Beside and Beyond the Mainstream.'' *Artweek*, November 2, 1985.

Braff, Phyllis. "Myths of the American Indian and Significant Photographs." *New York Times*, August 8, 1993.

Castle, Ted. "Review." *Art in America* (February 1984).

Cheney, Liana, Alicia Faxon, and Kathleen Russo. *Self-Portraits by Women Painters*. London: Scholar Press, 1998.

Durham, Jimmie. "A Central Margin." In Lindon Craighead, ed., *The Decade Show*. New York: MOCHA, Studio Museum in Harlem, and the New Museum, 1990.

Floyd, Phyllis, ed., *Selections from the Kresge Art Museum Collection VI: Recent Contemporary Acquisitions*. East Lansing: Michigan State University Press, 1997.

Gouma-Peterson, Thalia, Jaune Quick-to-See Smith, and Elizabeth Woody, *We, the Human Beings: 27 Contemporary Native American Artists*. Wooster, Ohio: College of Wooster Art Museum, 1992.

Heller, Jules, and Nancy G. Heller, eds., *North American Women Artists of the Twentieth Century*. New York: Garland, 1995.

Ittner, John. "Review." *New York Post*, March 28, 1980.

Janson, H. R. *History of Art*. New York: Prentice-Hall & Abrams, 1995.

Jemison, Noah. *Bob Blackburn's Printmaking Workshop: Artists of Color*. New York: Printmaking Workshop, 1992.

Jones, Kellie. "Kay WalkingStick." *The Village Voice* (New York), May 16, 1989.

Lippard, Lucy R. *Mixed Blessings: New Art in a Multicultural America*. New York: Pantheon Books, 1990.

Morgan, Anne Barclay. "Kay WalkingStick." *Art Papers* 19 (November–December 1995), pp. 12–15.

Parr, Debra. "Native Paper." *New Art Examiner* (May 1997), p. 58.

Penn, William S. *The Telling of the World: Native American Legends and Stories*. New York: Stewart, Tabori, and Chang, 1997.

Penney, David. *Native American Art*. Southport, Conn.: Hugh Lauter Levin Assoc., 1994.

Penney, David W. *Native American Art Masterpieces*. Southport, Conn.: Hugh Lauter Levin Assoc., 1996.

Perlman, Meg. "Review." *ART News* (1983).

Pindell, Howardina, Moira Roth, and Judith Wilson. *Autobiography, In Her Own Image*. New York: INTAR, Latin American Gallery, 1988.

Raynor, Vivien. "Landscapes That Call for Saving Nature." *New York Times*, August 25, 1996.

Raynor, Vivien. "Review." *New York Times*, June 19, 1981.

Remer, Abby. *Discovering Native American Art*. Worcester, Mass.: Davis, 1997.

Roberts, Lisa. "Kay WalkingStick." In Roger Matuz, ed., *Native North American Artists*. Detroit: St. James Press, 1998. pp. 610–613.

Valentino, Erin. "Mistaken Identity: Between Death and Pleasure in the Art of Kay WalkingStick." *Third Text* (Spring 1994), pp. 61–73.

Vine, Richard. *Art in America* (January 1995), p. 106.

WalkingStick, Kay. "Democracy, Inc., Kay WalkingStick on Indian Law." *Artforum International* (November 1991), pp. 20–21.

WalkingStick, Kay. Foreword. In *Bob Blackburn's Printmaking Workshop: Artists of Color*. New York: Printmaking Workshop, 1992. Exhbn cat.

WalkingStick, Kay. "Like a Longfish Out of Water." *Northeast Indian Quarterly* 6, no. 3 (1989).

WalkingStick, Kay. "Recent Native American Art." *College Art Association Journal* (Fall 1992), pp. 15–17.

WalkingStick, Kay. "Seeking the Spiritual." In W. Jackson Rushing, ed., *20th Century Native American Art: Essays on History and Criticism*. London: Routledge, 1998.

WalkingStick, Kay. "Woodworker." In *"HAGA (Third Son)" Truman Lowe*. Indianapolis: Eiteljorg Museum of American Indian and Western Art, 1994. pp. 32–38. Exhbn cat.

Welish, Marjorie. "Review." *Art in America* (September–October 1978).

Wiedmann, Christoph. "Somenstanz und Blutrausch." In *Suddeutche Zeitung*. West Germany: Feuilleton Domerstag, 1987.

Women of Color in Art—Unit IV—Native American Slide Resource Series. Sarasota, Fla.: Universal Slide Company; New York: Women's Caucus for Art, 1997.

Zimmer, William. "Light and Heat from American Indian Women." *New York Times*, September 24, 1995.

ARTIST STATEMENT (1997)

In the spring of 1996 I went to Rome for six months, and during that time my work was transformed. I worked in gouache on gessoed paper—then sprayed it so that the texture of the work had a glow from both the gesso and the acrylic varnish. I used both the landscape of Italy and that of the American Southwest and then combined the landscapes with figures I saw in Italy—on pots, a bronze in Pompeii, all those Renaissance paintings—as well as the Kokopelli figure from the petroglyphs of the United States. I also simply made up figures—played with them—took them apart and rearranged them. I made stencils of the figures to simplify and "iconicize" them. The prior year I had realized that the landscapes that I was painting were stand-ins for my own body and that the spiritual reading of the works related primarily to my own corporeal (and incorporeal) self—my own spiritual experience. I had years before realized that the diptych format that I favored represented, in part, the internal need to unite different traditions into one unified self and that the exterior forms that I used—abstract shapes and landscape—were simple metaphors for the unification of the disparate. Once these ideas were clear, the step to working with the human figure, especially one that is simplified through repetition or other means, became consistent with the conception of the pieces.

Last summer I once again went to Italy for a brief visit and drove through the Italian Alps where I made sketches for large drawings that I made in my home studio. Many of these drawings are in charcoal on paper, some repeat the gouache and stencil method of the previous year, and some are a mixture of media, but all include the human figure with landscape. Italian light has entered the work; my palette has altered, as has the imagery. I want to bring the paintings closer in feeling to the works on paper and to move away from the strict diptych format. My working method is to photograph and sketch from nature, make explicit drawings in black and white or color, then make paintings that are reduced from the ideas in the drawings.

I identify myself as an artist of Native American heritage. There have been periods in my painting career in which this part of myself and the history of native people has been paramount in the content of the work. I am still that person, but I am also part of the Western art tradition—and that tradition has always functioned in the formal aspects of my painting. The primary subject has always been concerned with my relationship to the divine, but these newer works—influenced and enriched by my Italian experience—seem to add ecstasy, both spiritual and physical, to that content.

BIOGRAPHICAL ESSAY

Kay WalkingStick has achieved national and international success through her art as well as her thought-provoking writings and lectures on contemporary Native American art. A prolific painter since the mid-1970s, WalkingStick's notoriety emerged during the 1980s when she began painting abstract, surreal landscapes on a diptych format. WalkingStick's use of diptych panels for her paintings is connected to the way she perceives life and art. For her, it is important that the two portions are connected yet still have some mystery surrounding their relationship. These two portions are often portrayed as opposite concepts in which one panel becomes a continuation of the other.

In addition to paint, her surfaces contain dirt, metal shavings, pottery shards, small rocks, and wax that is cut and gouged to reveal the layers below the surface. In the 1990s Kay introduced copper in her work to represent the economic urges underlying the rape of the earth. Often using her hands as well as a paint brush, painting becomes a very physical process for WalkingStick because of the labor involved in redrawing and repainting until layers of graphite and paint are created.

Kay sees her art as communicating with what is spiritual and beyond the physical world. Like some of her diptychs, her work unifies the two sides of living in an Indian and non-Indian world. She grew up in Syracuse, New York, with her older siblings and her white mother. Coming from a family of artists, she was the first woman artist in the family. WalkingStick's older siblings had more exposure to Native American culture because their formative years were spent in Oklahoma with both their mother and their Cherokee father, who could speak and write the Cherokee language. Kay's father died while she was a child, and Kay compensated for not growing up in a native atmosphere by researching Native American history, incorporating aspects into her paintings. In many ways the diptych form represents WalkingStick's biraciality, and she refers to it as two sides singing in concert, each unique yet united.

In most of the landscapes, one side is more realistic with recognizable mountains, water, and terrain, whereas the other is more abstract or geometric with allusions to a more imaginary landscape. Kay has described these distinctions as two types of memory, "momentary and particular, permanent and non-specific . . . a dialogue with the spiritual that transcends our bittersweet daily

lives.'' In an interview with Lawrence Abbott, WalkingStick said, ''Any kind of art, whether it's visual, verbal, musical, or kinesthetic, should have layers of meaning that even the artist is not aware of.''

Where Are the Generations? (1991, copper, acrylic, wax, oil on canvas, 28" × 50") is haunting landscape that has many layers and is both concrete/specific and metaphysical. The right side of the canvas is a rugged, mountainous, desert landscape with a southwestern feeling. The background/sky is dark and gives the appearance of evening, but the foreground is pale and seems to have light shining on it. The landscape could be the environment for southwestern Indians or territory conquered by European colonists during their westward expansion, depending on one's interpretation. On the left panel a small receding circle is centered on the canvas, enveloped by blue and black paint strokes that come toward the viewer. The circle is a landscape with ominous cloud formations on the horizon and murky waters. Within the cloud formations and almost hidden is printed: ''In 1492 we were 20 million. Now we are 2 million. Where are the children? Where are the generations? Never born.'' The forceful paint strokes surrounding the circle extend to the edges of the canvas. Flecks of red are scattered among the black strokes. It is as if the observer is looking through a viewfinder at a faraway scene. Having both modern, formal qualities as well as an indigenous political message, this painting, like many of WalkingStick's works, reflects her Western trained art background and her native sensibility.

Increasingly, WalkingStick is being recognized as an art critic and lecturer that can espouse on issues relating to contemporary Native American art, multicultural art, identity politics, and postmodernism. She has collaborated with art historian W. Jackson Rushing as a guest editor for a 1992 *Art Journal* issue devoted to Native American art and in his 1998 book *20th Century Native American Art: Essays on History and Criticism.* In her writings Kay critiques multicultural/ethnic/minority art exhibits that mainly benefit the grant-seeking sponsors from the dominant culture—sponsors that focus more on the ethnicity of the artist than the work. She is critical of museums/galleries that exclude artists of color from mainstream exhibits and also concerned about ''the lack of serious critical discussion of Native American art outside of its relationship to ethnographic or tribal art and artifacts.'' Kay writes about contemporary Native American artists that have been educated in twentieth-century modernism but are also sensitive to their indigenous heritage, reflecting this duality in their work. Although there is not a single Native American aesthetic sensibility, one common thread that she has observed and written about is the concern for the environment in much of today's Indian art. This is a critical issue uniting Indian artists from many tribes.

Kay WalkingStick is embarking in a new direction, as exemplified in her ''Artist Statement.'' Inspired by research and painting experiences in Italy, her work has been transformed to include the merging of the Italian and American Southwest landscapes. For the first time her paintings now incorporate the

human figure—the Kokopelli figure from petroglyphs in the United States, images from Renaissance paintings, forms influenced by bronze sculptures in Pompeii, and figures from her imagination. WalkingStick is moving away from her strict diptych format that is so popularly received and helped push her to the forefront of contemporary artists—Indian and non-Indian. It will be interesting to see how her new work is received. WalkingStick's risk taking and sense of adventure and exploration at the height of her career deserve serious critical analysis.

WALLACE, DENISE

Tribal affiliation: Sugpiaq (Pacific Eskimo). *Born*: 1957, Seattle, Washington. *Education*: A.A., Fine Arts, Institute of American Indian Arts, Santa Fe, New Mexico, 1981. *Family*: Married to Sam Wallace, collaborating designer and business partner. Mother of two children. *Career*: Owner and operator of DW Studio, Inc., in Santa Fe, New Mexico. *Awards*: Jewelry design awards from the Heard Museum, the Eight Northern Pueblos, and the Southwestern Association of Indian artists. First Award, a Best of Class (Jewelry), and Best of Division Award, Santa Fe Indian Market, 1984.

EXHIBITIONS

1996	*Denise & Samuel Wallace: Ten Year Retrospective Exhibition*, Graythorne Gallery, Santa Fe, New Mexico
1992	*Crossroads of Continents*, Canadian Museum of Civilization, Hull, Quebec, Canada
1991	*Northern Images*, Southwest Museum, Los Angeles, California
1990	*Secret of Transformation*, American Museum of Natural History, New York, and the Gene Autry Museum, Los Angeles, California
1989	Anchorage Museum of History and Art, Alaska

SELECTED GROUP EXHIBITIONS

1996–1997	*Gift of the Spirit*, Peabody Essex Museum, Salem, Massachusetts; *Native American Traditions/Contemporary Responses*, Society for Contemporary Crafts, Pittsburgh, Pennsylvania
1994–1995	*This Path We Travel*, National Museum of the American Indian, New York

1993	*Voices and Visions*, University of California Museums at Blackhawk, Danville, California
1989	*Native Art to Wear*, Heard Museum, Phoenix, Arizona
1988	*Sun, Moon, and Stone*, Southwest Museum, Los Angeles, California
1987–1996	*Visions of Alaska*, DW Studio, Inc., Santa Fe, New Mexico

COLLECTIONS

Anchorage Museum of History and Art, Alaska Institute of American Indian Arts, Santa Fe, New Mexico; Wheelwright Museum of the American Indian, Santa Fe, New Mexico

PUBLICATIONS

Benesh, Carolyn L. E. "Spirits and Souls: Denise and Samuel Wallace." *Ornament* 15, no. 2 (1991).

Berlo, Janet Catherine. "Denise Wallace." In Roger Matuz, ed., *Native North American Artists*. Detroit: St. James Press, 1998. pp. 613–615.

Denise & Samuel Wallace: Ten Year Retrospective Exhibition. Santa Fe, N.M.: Graythorne Gallery, 1996. Exhbn cat.

Dunitz, Robin J. "Wearable Sculpture: Denise Wallace's Versatile Metalsmithing." *Southwest Art* (November 1988).

"Layered with Significance." *Lapidary Journal* (September 1992).

Mittler, Gene, ed. *Art in Focus*. New York: Macmillan, 1994.

Teters, Charlene. "Denise Wallace." *Indian Artist* (Summer 1997), pp. 22–27.

This Path We Travel. Washington, D.C.: National Museum of the American Indian, Smithsonian Institution, 1994. Exhbn cat.

BIOGRAPHICAL ESSAY

Denise Wallace is of Sugpiaq/Aleut tribal heritage on her mother's side. Her Alaskan native ancestry and close connections to her maternal grandmother have been major influences in her native-inspired jewelry designs. Denise's use of indigenous Alaskan motifs in her award-winning jewelry has helped to expand the public's appreciation of northern aesthetics.

Prior to attending the Institute of American Indian Arts (IAIA), Denise had studied lapidary work and silversmithing in Seattle. She credits her husband for awakening her interest in stones and inspiring her to pursue a career in jewelry making. Denise further strengthened her technical skills at the IAIA and credits fellow students for most of her training there. After graduation from IAIA Denise and her husband, Sam Wallace, who is also a designer, opened DW Studio, Inc., in Santa Fe and have been successfully collaborating ever since.

Denise creates intricate interactive pieces using gold, silver, carved and incised walrus ivory fossil, and semiprecious stones. Her pieces have doors, latches, and removable parts that can be worn separately or as a total unit. Engineering skills are involved in creating Denise's movable jewelry that people can physically interact with instead of just observing.

Killer Whale Belt (1982), her first interactive accessory design, won several awards at the Santa Fe Indian Market. For Denise, the killer whale is an animal that she strongly identifies with as part of her ancestral memory. The belt is designed so that every other piece has a theme cut out in it with overlay work depicting scenes from Alaskan life. During this time Denise also created a series of masks, one of which opened up. This early experimentation helped perfect Denise's engineering skills in interactive art objects.

Another interactive belt, *Crossroads of the Continents* (1989, sterling silver, 14-karat gold, fossilized walrus tusk, semiprecious stones), was inspired by the Smithsonian exhibition *Crossroads of the Continents: Cultures of Alaska and Siberia*, which featured works by indigenous people of that area from the mid-1800s. Intricately designed Siberian and Alaskan motifs are featured on the 4" × 2" human and animal figures along the length of the belt.

Recent works include the 1997 *Yup'ik Dancer Series* with movable masks (sterling silver, 14-karat gold, fossilized walrus tusk, semiprecious stones, sugilite, chrysopase). Technologically complex pieces like the belts and these newer pieces require a large studio staff to help with the fabrication. In the DW Studio Denise and her husband work collaboratively, with her creating most of the designs, Sam doing the lapidary work, and their staff assistants involved with the fabrication. Their children are now also involved in the silversmithing and lapidary work.

In her 1997 *Indian Artist* interview, Denise describes her pieces as telling a story and her buyers as storytellers. She feels that her wearable art is more personal than a painting or sculpture and enjoys the responses people experience wearing her interactive shapes. Denise states that her art is her way of saying something positive about Native American people and culture.

WHITEHORSE, EMMI

Tribal affiliation: Navajo. *Born*: 1956, Crownpoint, New Mexico. *Education*: Attended a government boarding school for Navajo girls. B.A., painting, University of New Mexico, 1980. M.A., printmaking with a minor in art history, University of New Mexico, 1982. *Family*: Spent most of her childhood raised by her grandmother on the Navajo Reservation. *Career*: Studio artist in Bridgeport, Connecticut, 1982–1987. Studio artist in Santa Fe, New Mexico, 1987–present.

SELECTED EXHIBITIONS

1997 *Sola*, Tucson Museum of Art, Tucson, Arizona

1996	Bentley Gallery, Scottsdale, Arizona
1995	L'Homme Art, Antwerp, Belgium; The Hartje Gallery, Frankfurt, Germany; Jan Maiden Contemporary Art, Columbus, Ohio
1994	Horwitch Lew Allen Gallery, Santa Fe, New Mexico; Lew Allen Gallery, Santa Fe, New Mexico
1993	The Hartje Gallery, Frankfurt, Germany; The Millicent Rogers Museum, Taos, New Mexico; Lew Allen Gallery, Santa Fe, New Mexico; Bentley/Tomlinson Gallery, Scottsdale, Arizona
1992	Lew Allen Gallery, Santa Fe, New Mexico; Jan Cicero Gallery, Chicago; Illinois; Will Thompson Gallery, Telluride, Colorado; The Lowe Gallery, Atlanta, Georgia
1991	*Neeznaa*, The Wheelwright Museum, Santa Fe, New Mexico; Karin Iserhagen Galerie, Basel, Switzerland; Lew Allen Gallery, Santa Fe, New Mexico; Hartje Gallery, Frankfurt, Germany
1990	Hartje Gallery, Frankfurt, Germany; Lew Allen/Butler Fine Art, Santa Fe, New Mexico; Thomas Riley Gallery, Chicago, Illinois
1989	Marilyn Butler Fine Art, Scottsdale, Arizona
1988	Yuma Art Center, Yuma, Arizona
1987	A.I.C.A. Gallery, San Francisco, California
1985	A.I.C.A. Gallery, San Francisco, California
1984	Akmak Gallery, West Berlin, Germany; Art Resources, Denver, Colorado; Galleriea del Cavallino, Venice, Italy
1982	Sun Valley Center for Arts & Humanities, Sun Valley, Idaho

SELECTED GROUP EXHIBITIONS

1997	*Something Cool*, Jan Cicero Gallery, Chicago, Illinois
1995	Westfalisches Museum, Münster, Germany
1994	American Academy of Arts and Letters Purchase Exhibit, New York
1993	The Millicent Rogers Museum, Taos, New Mexico
1992	New Mexico State University, Las Cruces
1991	*Presswork, the Art of Women Printmakers*, National Museum of Women in the Arts, Washington, D.C. (traveling)
1990	*Primavera*, Tucson Museum of Art, Arizona; Centro Cultura de la Raza, Balboa Park, San Diego
1989	*6 from Santa Fe*, Gibbes Museum of Art, Charleston, South Carolina; Miller Gallery, Palm Desert, California
1988	Ann Reed Gallery, Sun Valley, Idaho; *Mask*, Old Pueblo Museum, Tucson, Arizona
1987	Fort Wayne Museum of Art, Indiana; Read Stremmel Gallery, San Antonio, Texas
1986	Stemmel Galleries, Reno, Nevada
1985	*Visage Transcended*, The American Indian Contemporary Arts Gal-

lery, San Francisco, California (traveling mask show); *Eight Artists*, The Southwest Museum, Los Angeles, California; *Women of Sweetgrass, Sage, and Cedar*, The A.I.C.H. Gallery, New York (traveling); *Women of the American West*, Bruce Museum, Greenwich, Connecticut; *Artists under Thirty*, The Silvermine Guild, New Canaan, Connecticut

1984 *She Holds Her Own*, The Green County Council on the Arts, Catskill, New York; *Contemporary Native American Art Exhibition*, Oklahoma State University, Stillwater; Marilyn Butler Fine Art, Santa Fe, New Mexico; Marilyn Butler Fine Art, Scottsdale, Arizona

1983 *The Southwest Scene*, The Brentwood Gallery, St. Louis, Missouri; *Native Artists of the Eighties*, The Sacred Circle Gallery, Seattle, Washington

1982 *Modern Native American Abstraction*, The Philadelphia Art Alliance Gallery, Pennsylvania (traveling); *Works on Paper*, Santa Fe Festival of the Arts, Santa Fe, New Mexico; The Aspen Institute at Baca, Crestone, Colorado; *Taos to Tucson*, The Foundations Gallery, New York; *Native Women Artists*, The A.I.C.H. Gallery, New York

1981 *Confluences of Configuration and Change* (traveling); R. L. Nelson Gallery, University of California, Davis; Museum of the Southwest, Midland, Texas; The A.I.C.H. Gallery, New York; The Brunnier Gallery, Iowa State University, Sioux City, Iowa; Heard Museum, Phoenix, Arizona; *Works on Paper*, University of New Mexico, Albuquerque (traveling)

1980 The University of North Dakota, Grand Forks; The Southern Plains Museum, Anadarko, Oklahoma; The Sioux Land Heritage Museum, Sioux Falls, South Dakota; The Galleria del Cavalina, Venice, Italy; The Wheelwright Museum, Santa Fe, New Mexico

1979 Gallery Upstairs, Berkeley, California; Downtown Center for the Arts, Albuquerque, New Mexico; University of New Mexico, Albuquerque

SELECTED COLLECTIONS

Albuquerque Museum, New Mexico; American Embassy, Rabat, Morocco; American Embassy, Tokyo, Japan; Arizona State University, Tempe, Arizona; Art Bank/Art in Embassies, U.S. Department of State, Washington, D.C.; Gutenberg Buchergilde, Frankfurt, Germany; The Heard Museum, Phoenix, Arizona; Joslyn Art Museum, Omaha, Nebraska; Mountain Bell, Denver, Colorado; Museum of Fine Arts, Santa Fe, New Mexico; State Capital Collection, State of New Mexico, Santa Fe; St. Louis Museum, Missouri; University of Arizona Museum of Art, Tucson; Wheelwright Museum, Santa Fe, New Mexico

SELECTED PUBLICATIONS

Abbott, Lawrence. *I Stand in the Center of the Good: Interviews with Contemporary Native American Artists*. Lincoln: University of Nebraska Press, 1994.

Cicero, Jan, and Craig McDaniel. *Native Streams: Contemporary Native American Art.* Chicago: Jan Cicero Gallery; Terre Haute: Indiana State University, 1996.

Farris, Phoebe. "Emmi Whitehorse." In Roger Matuz, ed., *Native North American Artists.* Detroit: St. James Press, 1998. pp. 622–625.

Highwater, Jamake. "Noble Savages and Wild Indians." *New Arts Journal* (January 1980).

Hoffman, Gerhard. "Frames of Reference: Native American Art in the Context of Modern and Post Modern Art." *Artspace Magazine* (Spring 1987).

Lippard, Lucy. *Mixed Blessings: New York in a Multicultural America.* New York: Pantheon Books, 1991.

Lippard, Lucy. *Neezháá Emmi Whitehorse: Ten Years.* Santa Fe: Wheelwright Museum of the American Indian, 1990.

Lippard, Lucy. *Shima: The Paintings of Emmi Whitehorse, Wheelwright Museum Catalog.* Santa Fe, N. Mex.: Wheelwright Museum of the American Indian, 1991.

Melkoinian, Neery. "Emmi Whitehorse." *Arts Magazine* (1991).

Momaday, N. Scott. "Abshied von der edlen Rothaut." *GEO Magazine* (U.S.A. Southwest Special) (April 1989).

Peterson, W. *Emmi Whitehorse: Changing Woman.* Santa Fe: Lew Allen/Butler Fine Art Gallery, 1990.

Traugot, Joseph. "Emmi Whitehorse, Kin'nah,zin." *Artspace Magazine* (Summer 1982).

ARTIST STATEMENT (1997)

My work deals with recreating worlds remembered. It is never ending because I am constantly redesigning, replacing, rebuilding it with personal images and concepts, always trying to bridge the future with the old—a compromise between the tradition and futurity.

My idea material comes from the land, the environment in which I grew up. Also, each family member contributes to my imagery.

My choice of colors is not random but arbitrary and personal. My color usage often comes from colors my Grandmother uses in her weavings and also as a way of paying homage to her. She tends to be very abstract—sometimes using optical illusions but always balancing these with a delicacy of design.

I want to make use of these abstractions that I remembered, using it aesthetically to help create my work. This way, I'm closer to building that bridge between not only the new and the old but also the two cultures in which I live. My hope is that my abstractions will help to change the regional art that is so stereotyped as *Indian Art* and be more readily accepted.

BIOGRAPHICAL ESSAY

Whitehorse's art integrates her Navajo background with abstract shapes, forms, and color. Memories of her grandmother's weaving and shepherding and her own experiences at boarding school play an important part in the creation of her paintings. Many of the objects depicted are based on Navajo culture, such

as arches that represent Navajo wedding baskets and comb/fork shapes that represent weaving objects that tighten yarn. Whitehorse paints with colors inspired by her native southwestern landscape. A sense of nature and geometry comes from her grandmother's weaving. Many of the shapes and objects provide symbolic and mythical meaning for the artist. Whitehorse's paintings give a sense of space where various shapes appear to be moving and floating. Early paintings include figures that are more geometric and pointed, often resembling the early petroglyphs found carved into the rock walls and canyons of the Southwest.

Other forms found in her paintings came from her father's branding iron and the gouges in wooden gates that record her family's sheep herds. Leaves, hands, feathers, plants, hooks, fish, houses, and silhouettes of human forms seem to represent the importance of personal identity and nature.

In later works these figures and shapes become more curved and with more open areas. Delicate lines are found throughout the paintings' surfaces. Some lines are curvy, others cross each other, and some make separate shapes. Many of Whitehorse's paintings are expressed through various shades and tints of the primary colors. Other paintings are created with background shades and tints of analogous colors.

Whitehorse's work is often compared to that of the European artist Paul Klee because of her free-association imagery/fantasy and her individualistic approach to pictographic forms. Like Klee, Whitehorse uses shifting color planes and small pieces of paper collage. On the other hand, critics such as Lucy Lippard feel that Whitehorse's compositional elements may be inspired by the Native American concept of balancing the four directions rather than the Western focus on top and bottom, as well as from Navajo sandpainting, which also influenced abstract-expressionist artists like Jackson Pollock.

As her painting career began in the early 1980s, Whitehorse drew on her personal experiences and abstracted them. Her *Kin' Nan' Zin'* (*Standing Ruins*) series included geometric forms, prismatic planes, and atmospheric color that evoked childhood memories of the vast spaces on the Navajo Reservation, the luminous sky, red earth, her grandmother's weaving, sheep, and ancient Anasazi sites. Some of the later works in the 1980s that incorporated an indigenous identity were less abstract and included objects such as houses, stick-figures, leaves, horns, bowls, bells, flowers, and ladders. This approach is evident in the 1988 *Chaos in the Visitor's Dream*.

The female form is also evident in many of Whitehorse's paintings. The figures have been interpreted as goddesses or deities. The form is usually an incomplete torso with vase-shaped contours. Whitehorse refers to this figure as *White Shell Woman*, a mythic being in Navajo legends. Other silhouetted female forms are evident in Whitehorse's paintings, including bell-shaped women in full-length dresses. Although some critics associate them with *Changing Woman*, the central and most revered being in the Navajo cosmology, Whitehorse attributes a different source for her inspiration. According to Whitehorse,

the white figure in a long dress depicts the type of so-called ideal woman, a fairytale princess, popular with young girls during Whitehorse's childhood years in a boarding school. Young Indian girls, caught in a conflict between traditional and white cultural expectations of women, often aspired to the somewhat un-attainable goals of being a Miss America or high school prom queen. It should be noted that the Navajo culture is matrilineal, and female energy is considered active, vital, creative, and productive. *Changing Woman* represents regeneration, rejuvenation, and renewal.

Two worldviews are ever present in Emmi Whitehorse's art. There is the abstract, formalist world of balanced shapes and colors familiar to those who appreciate or espouse art for art's sake. And there is also the spiritual Navajo worldview that incorporates art into all aspects of life. Whitehorse could be described as a modernist concerned with the picture plane but one who is in-spired by the ancient surfaces of the southwest landscape. Like the land itself, her work is both layered and open, full of light, and active.

In the catalog accompanying her 1996 group exhibit *Native Streams: Con-temporary Native American Art*, Whitehorse describes her pictorial exploration of the land and everything related to it. She mentions her interest in unseen energy, the microcosms underneath one's feet, the growth that occurs in dark, damp places, and the magnification of nature in her work. In *Union II* (1992, 51" × 78", oil/chalk/paper, canvas), Whitehorse employs visual symbols that are ambiguous and meant to be both illuminating and obscure. Memory, light, color, visual symbology, and perhaps most of all, memory, "which comes back in bits and pieces," are the factors the artist mentions as aiding her artistic intentions.

2

LATIN AMERICAN WOMEN ARTISTS

Cynthia A. Sánchez

Latina[1] artists have played a significant role in the development of the visual arts in Latin America and the United States throughout this century. Valuable contributions by artists such as Tarsila do Amaral, Frida Kahlo, Ana Mendieta, Kathy Vargas, Pola López, María Mercedes, Amalia Mesa-Bains, Carmen Lomas Garza, Coco Fusco, and Mayé Torres include the fusion of indigenous and regional aesthetics with international styles, the documentation of the sociopolitical and historical life of their times, and most important, the articulation of personal principles and narratives in their art.

Many of these artists share a history of a colonization period in the sixteenth to eighteenth centuries influenced by Spain, Portugal, and other parts of central Europe. Many emerged as nineteenth-century mestiza artists in a Westernized culture entering the twentieth century with diverse cultural and personal experience. Theirs is a hybrid experience that has informed their artistic expression and political context. The recognized need to establish cultural and individual identity is imminent and manifests in the work of these women, as they actively engage in the process of reconstructing new identities.

Linked and uniquely distinguished by language, history, native traditions, and geographic and socioeconomic influences, Latina artists share a common context: securing a sense of self and belonging in a transcultural society. Although their works vary aesthetically and stylistically, their prevailing influences, intents, and issues are similar. Together they create their own history of art, creating a body of diverse work that transcends gender, class, ethnicity, and culture. It is difficult to speak of a distinctly unique Latin American style or movement as strains of various European avant-garde movements have infiltrated most artistic traditions in the Americas.

The history of contemporary art in Latin America has shaped many Latina artists working in the Americas. Although primarily dominated by men, many influential women artists did have an impact historically. In the 1920s the Mex-

ican agrarian revolution was a crucial political event that had tremendous impact on modern art in Latin America. The works of Mexican muralists—Diego Rivera, David Alfaro Siqueiros, and José Clemente Orozco—reflect both political indoctrination and personal inclination. Painters Frida Kahlo and María Izquierdo contributed with their highly personalized narratives incorporating Surrealist trends. In 1922 Brazilian painters Anita Malfatti and Tarsila do Amaral worked with avant-garde writers Oswalde de Andrade, Paulo Menotti del Picchia, and Mário de Andrade (Grupo dos Cinco) to revolutionize modernist traditions in Brazil. Around the same time in 1925, the Chilean avant-garde group Montparnasse also sought to revolutionize artistic standards, and in Buenos Aires conflicts between writers from Florida and Boedo initiated new artistic trends. The 1920s and 1930s showed an increase in alliances between writers and the plastic arts. Avant-garde groups advocated poetry, manifestos, and literary magazines. This in turn affected many artists. Amelia Peláez was promoted in the Cuban magazine *Revista de Avance*, and Chilean artist Catalina Parra was influenced by her father Nicanor Parra's poetry.

In the nineteenth century, artistic standards and representations in Latin America were revolutionized and conditioned by political unrest, social circumstances, avant-garde groups, the search for a national identity, tenuous cultural boundaries, struggles of independence, the colonization of pre-Hispanic peoples, the influx of blacks from Africa, the infiltration of European traditions, crossbreeding, and racial integration.

Many artists—for example, Tarsila do Amaral, Amelia Peláez, Frida Kahlo, Catalina Parra, Rufino Tamayo, and Joaquín Torres-Garcia—studied in their native countries as well as abroad, bringing in trends from Paris, France, Rome, Italy, Frankfurt, Germany, and New York City into Latin America. Mexico, Argentina, and Venezuela had influences from European traditions, whereas São Paulo had no contact with works of the School of Paris until Tarsila do Amaral (1886–1973) began her frequent visits to the studio of André Lhote. Carlos Mérida, in 1907, first saw a modern painting in a tailor's shop owned by one of Picasso's friends. This incident and Wilfred Lam's visit to Picasso's studio in 1930 would prove to be significant, fruitful influences on these Latin American pioneers of modern art.

However, few European traditions took hold in Latin American art, except for Surrealism. In Mexico, in particular, many Surrealists felt at home—Antonin Artaud and André Breton. In the 1930s and during World War II, painters Remedios Varos from Spain and Leonora Carrington from England also gravitated to Mexico. This promoted a stream of Surrealism that would be nurtured, traditionally and natively, by such artists as José Guadalupe Posada, Frida Kahlo, Julio Ruelas, María Izquierdo, and Francisco Toledo. Surrealism in Latin America was very different from the European tradition, as it merged with native mythologies, magical beliefs, and the diverse cultural traditions of each country, embracing a multiplicity of experience.

The following provides a representative selection of Latina artists to reflect

significant artistic innovations and contributions to the history of contemporary Latina art. There are many Latina artists whose work is significant in the cultural milieu of the twentieth century not included here, like Remedios Varos, Leonora Carrington, Lygia Clark, Maria Brito-Avellana, Celia Alvarez Muñoz, Laura Aguilar, María Enríquez de Allen, Judy Baca, and Tina Fuentes, to name only a few. The following, however, will provide a representative sampling of Latinas, geographically, chronologically, and ethnically.

The depth and diversity of these artists' works attest to the varied influences and atmospheres the artists have engaged in cross-culturally in their lives and studies and reveals a shared spirit in their art. Tarsila do Amaral's and Tilsa Tsuchiya's phantasmagoric paintings celebrate the wondrous beauty and sacredness of their indigenous roots in Brazil and Peru, fusing modernist Surrealistic tendencies with nativist traditions. Similarly, Pola López, Carmen Lomas Garza, and Myrna Báez document and commemorate vanishing traditions, landscapes, and people of their native regions.

Kathy Vargas's and Delilah Montoya's photo montages are petitions, offerings, and prayers carefully arranged into symbols and images for cultural, political, and spiritual transformation. The larger-than-life social documentaries of Beatriz Mejia-Krumbein have an affinity with Catalina Parra's collages of torn materials and fragmented texts critiquing sociopolitical travesties. María Mercedes's bold emblematic figures and their poetic gestures are representations of the self-journeying through life, encountering tumultuous, harmonious relationships in the quest of identity and destiny. Similarly, Imna Arroyo's women are presented as voyagers on a symbolic journey to self. Like Mexico's Kahlo, Cuba's Mendieta created work that was autobiographical, erotic, and body conscious. Both artists shared great psychological anguish, established ties to the earth as an extension of being, made reference to blood as a metaphor in women's lives (Frida to birth, miscarriage, and death; Ana to rape and menstruation), and both died tragically at a young age. Both artists incorporated folk traditions of their native lands; Frida was influenced by pre-Columbian imagery and folk Catholicism, Ana, the rituals of Afro-Cuban Santería. Kahlo and Mendieta each established their own distinctly personal expressions using different mediums and forging native tradition with personal and political context but united in their experience of the glorification, pain, and mystery of womanhood.

NOTE

1. *Latina* is becoming a more accepted inclusive term accounting for those who come from a specific geographical or regional area where the Spanish and Portuguese legacy is dominant but not exclusive. This includes Amerindian and African cultures. The term *Hispanic* excludes racial and cultural differences linking all to Spain and ignoring diverse indigenous cultural heritage, homogenizing what are heterogeneous populations diverse in language, customs, and class. Any term, however, is problematic and lumps diverse cultures together, making Cubans, Brazilians, Puerto Ricans, New Mexicans, Mex-

icans, Hispanics, Colombians, Peruvians, and Chicanos indistinguishable. Ethnic identity is constantly being reinvented and reinterpreted. *Nationality* refers to origin in a particular nation or geographic region. The designation *New Mexican* is used to refer to those born in the geographic area New Mexico. New Mexico has retained a distinctive cultural heritage that includes Hispanic, Mexican, Native American, and European traditions while still a part of the United States.

AMARAL, TARSILA DO

Nationality: Brazilian. *Born*: 1886, Capivari, São Paulo. *Education*: Do Amaral began formal art studies in 1916 with academic realists in São Paulo. She studied at the Académie Julien from 1920 to 1922. Her work was first exhibited at the Salon des Artistes Francais. After her participation in the Modern Art Week in São Paulo, she returned to Paris to study Modernism and Cubism with André Lhote, Albert Gleizes, and Fernand Léger. *Family*: Do Amaral was the daughter of a wealthy rancher in Brazil. *Career*: Do Amaral participated in the formation of the Modern Art Week manifesto declaring a new era of expression in the arts in Brazil. She collaborated with painter Anita Malfatti and writers Oswald de Andrade, Mário de Andrade, and Paulo Menotti del Picchia, who together formed the Grupo dos Cinco. She continued to work closely with Oswald de Andrade and poet Blaise Cendrars. She helped initiate the Anthropofagy movement, which used metaphors relating to cannibalism to assert Brazil's independence from European traditions. In the 1920s, do Amaral painted in a style that fused African and indigenous influences with European elements. Her subject matter included cityscapes, industrial scenes, and ethnic imagery. In 1931 she traveled to Russia, where her images shifted to Soviet social realism. Her work was exhibited in Moscow at the Museum of Modern Western Art. *Died*: 1973, São Paulo.

SELECTED EXHIBITIONS

1995 *Latin American Women Artists, 1915–1995*, Milwaukee Art Museum, Wisconsin; Phoenix Art Museum, Arizona; Denver Art Museum, Colorado; National Museum of Women in the Arts, Washington, D.C.

1993 *Latin American Artists of the Twentieth Century*, Museum of Modern Art, New York

1987 *Art of the Fantastic*, Indianapolis Museum of Modern Art, Indiana

1969 *Tarsila—Fifty Years of Painting*, Museum of Modern Art, Rio de Janeiro, Brazil

1960	Venice Biennial, represented Brazil
1950	*Retrospective*, Museum of Art, São Paulo
1931	Museum of Modern Western Art, Moscow

SELECTED COLLECTIONS

Gilberto Chateaubriand/Museu de Arte Moderna do Rio de Janeiro, Brazil; Jean Boghici, Rio de Janeiro, Brazil; Luis Antonio Nabuco de Almeida Braga, Rio de Janeiro, Brazil

PUBLICATIONS

Amaral, Aracy. *Desenhos de Tarsila*. São Paulo: Editora Cultrix, 1971.

Amaral, Aracy. *Tarsila: Sua obra e sue tempo*. 2 vols. São Paulo: Editore Perspectiva S.A., 1975.

Bartella Gotlib, Nadia. *Tarsila do Amaral: A musa radiante*. São Paulo: Editora Brasiliense, 1983.

Bercht, Fatima. "Tarsila do Amaral." In *Latin American Artists of the Twentieth Century*. New York: Museum of Modern Art, 1992. pp. 52–59. Exhbn cat.

de Andrade, Mário, et al. *Revista académica: Homenagem a Tarsila*. Rio de Janeiro: 1940.

de Andrade, Oswald. "L'effort intellectual du Brasil contemporain." *Revue de l'Amérique Latine* 20 (1993), pp. 197–207.

de Andrade, Oswald. "Manifesto Antrofolago." *Revista de Antropofagía* 1 (1928), pp. 184–187.

de Andrade, Oswald. "Manifesto of Paul-Brasil Poetry." *Latin American Literary Review* 14 (1986), pp. 184–187.

de Campos, Augustos. *Revista de Antropofagía*. São Paulo: Cia Lithographica Ypirigina, 1976.

IBM do Brasil. *Tarsila: Obras 1920/1930*. São Paulo: 1982.

Marcondes, Maros A. *Tarsila*. São Paulo: Arte Editora/Circulo do Livro, 1986.

Sturges, Hollister. "Tarsila do Amaral, 1886–1973." In *Art of the Fantastic: Latin America, 1920–1987*. Indianapolis, Ind.: Indianapolis Museum of Art, 1987. pp. 66–75. Exhbn cat.

Zilio, Carlos. *Aquarela do Brasil. A questão da identidade na arte brasileira: A obra de Tarsila, di Cavalcanti e Portinari, 1922–1945*. Rio de Janeiro: Edicao Funarte, 1982.

BIOGRAPHICAL ESSAY

Along with Anita Malfatti, Tarsila do Amaral participated in the *Semana de Arte Moderna* in São Paulo in 1922 and together with avant-garde artists and writers Oswald de Andrade, Mário de Andrade, and Paulo Menotti del Picchia formed a group of five called Grupo dos Cinco. Strong collaborative ties developed between Tarsila do Amaral, Oswald de Andrade, Mário de Andrade, and their work. In 1923, do Amaral exhibited *A Negra*, a painting that inspired Oswald de Andrade's Pau-Brasil Poetry Manifesto, 1924, and the work of French poet Blaise Cendrars. She was then invited to illustrate Cendrars's col-

lection of poems *Feuilles de route*. Oswald de Andrade used do Amaral's images to tropicalize the urban landscape. *A Negra* also generated two other important paintings by do Amaral, *Abaporú* (1928) and *Antropofagí* (*Anthropophagy*) (1928), which form an evolving triptych that coincided with the changes in the literary avant-garde.

Tarsila painted with the intense colors she admired in her native folk decoration, festivals, and landscapes—pure blues and greens against violet roses, reds, and vivid yellows. These brilliant hues inform a series of paintings inspired by her native subjects—the favela (hillside shantytowns in Rio de Janeiro), the carnival, and the marketplace. In these paintings, dark-skinned figures, domestic animals, tropical flora, and humble cottages are reduced to simple shapes with clear, precise outlines and a smooth surface. In *Lagoa Santa* (1925), Tarsila transforms the already exotic shapes of tropical vegetation into something fantastic. A strange cluster of tree trunks is depicted as phallic stalks sprouting from the earth. In other landscapes her mushroom-shaped trees, cacti, and leafy plants are bloated, swollen, oversized, and laden with the energy and life-juices of the tropics.

Her paintings from 1924 to 1927 are known as her Pau-Brasil period. During this time, she focused on essentials. Anamorphic figures, hillsides, fruits, cubes, massive plants, and towers are some of do Amaral's visual repertory in her fusion of Art Deco with Légeresque Cubism. *Abaporú*, a painting she presented to her partner Oswald as a birthday gift, depicts a naked man whose giant size is greater than nature, and trees are plantlike. The image is reduced to its basic elements: man, earth, sun, sky, foot, and hand. Similarly *Urutu* (1928) depicts a giant, anthropomorphic egg-shaped sphere with a limblike tentacle clinging to a vertical object. Once again, Tarsila reduces the image to its essential components.

It was in Paris that Tarsila came to know the works of Jean Arp, Joan Miró, Yves Tanguy, and other Surrealists who also employed biomorphic forms or imaginary environments that probed the irrational world of dreams. Do Amaral's symbolic landscapes of the late 1920s intensified, eroticized, and poeticized the natural world and have been termed "tropical Surrealism." She and painters like Tilsa Tsuchiya are central figures in the development of the modernist tradition, particularly an indigenous-based Surrealism, in Latin America in the 1930s.

ARROYO, IMNA

Nationality: Puerto Rican. *Born*: 1951, Guayama, Puerto Rico. *Education*: Arroyo attended the Universidad Católica de Santa Maria in Puerto Rico as a high school student on an honors program in 1966. After graduation, Arroyo and her family moved to San Juan, where she enrolled at the Escuela de Artes Plasticas in 1967 and studied with such artists as Frank Cerbonie, Rafael Tufiño, Luis Hernandez Cruz, and Susana Herero. She left Escuela de Artes Plasticas in the spring of 1967 and returned in 1972. Arroyo moved to New York in 1973, after her mother's death. She graduated from Pratt Institute in 1977 with a B.F.A. and was accepted in the printmaking department at Yale University's School of Art. There she studied with Gabor Peterdi, Winefred Lutz, Greta Campbell, Samia Halaby, and Elizabeth Murray. After Yale, she continued her printmaking with Krishna Reddy at New York University. Arroyo worked with master printmaker Lynne Allen in 1987 at the Tamarind Institute in Albuquerque, New Mexico. In 1994 at a workshop of traditional Japanese woodcut techniques, Arroyo worked with Francisco Pátlan at the Universidad de Guanajuato in Mexico. *Family*: Arroyo comes from a family of teachers and artisans. Her paternal grandmother was one of the first black teachers to be certified in Puerto Rico in 1898. Arroyo is one of two daughters. She and her sister moved to the United States with their parents in 1952, only to return to Puerto Rico in 1957. She married Tito Efrain Mattei and had two daughters, Isis and Swahili. She left her husband, and after her mother's death in 1973, she moved to New York. She later remarried and has a son. *Career*: Along with a full-time career as an artist, Arroyo has also been actively involved in the National Women's Caucus for Art, New England Artists Trust, and Commission of Cultural Affairs of New Haven. In 1992 she was the chair of the printmaking department at Rhode Island School of Design and the cofounder of the Color Network. Arroyo has taught art and printmaking at Eastern Connecticut State University, Rhode Island School of Design, Gateway Community College in New Haven, and San Juan College in Farmington, New Mexico. In 1995 Arroyo participated in the Fourth United Nations Conference on Women and NGO Forum in Beijing, China. *Awards*: Ford Foundation Teaching Grant, Yale University, 1977. Artist Project Grant from Connecticut Commission on the Arts, 1980. Commissioner, Commission of Cultural Affairs of New Haven, and Women in Leadership Honoree, 1986–1992. Merit Award, South Central Community College, 1987. Professional Development Award, AAUP Eastern Connecticut State University, 1994.

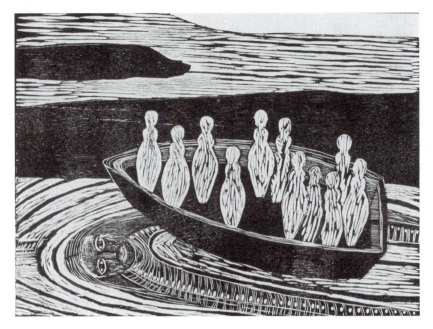

Voyage I by Imna Arroyo, 1995, wood block print 24" × 32". Courtesy of Imna Arroyo

EXHIBITIONS

1995	*Time, Movement and Symbolism/Survey of Works by Imna Arroyo 1968–1995*, Charter Oak Cultural Center, Hartford, Connecticut; *Ancestors/Deities—Deidades/Ancestros*, Akus Gallery, Eastern Connecticut State University, Willimantic, Connecticut
1993	*Water Media and Ceramics by Imna Arroyo*, Every Day Books Cafe, Alternative Gallery, Willimantic, Connecticut; *Acuarelas*, Museo de la Independencia, Dolores Hidalgo, Guanajuato, Mexico
1992–1993	*Imna Arroyo at CCSU*, University Wide-Gallery, Central Connecticut State University, New Britain, Connecticut
1992	*Passages by Imna Arroyo*, AS220 Gallery, Providence, Rhode Island
1991	*Imna Arroyo Recent Works*, South Central Community College Library Gallery, New Haven, Connecticut
1990	*Imna Arroyo Recent Works: Exchange Professor from South Central Community College*, San Juan College Gallery, Farmington, New Mexico; *Imna Arroyo: Moving Through the Spiral*, Whalley Framing Gallery, New Haven, Connecticut
1989	*La Malla (The Net)*, Merchants Bank, City Spirit Artists, New Haven, Connecticut; *Imna Arroyo: Out of Darkness*, Trinity College Austin Art Center, Hartford, Connecticut

1987	*Containment: Images of Women towards Liberation*, Elihue Burritt Library, Central Connecticut State College, New Britain, Connecticut
1986	*Imna Arroyo*, Cityarts Gallery, Department of Cultural Affairs, City of New Haven, Connecticut; *On Interaction: Video Performance and Sculptural Installation*, Casa Cultural Julia de Burgos, New Haven, Connecticut
1985	*Aqui Entre Nosotras/Among Ourselves*, The Small Space Gallery, Arts Council of Greater New Haven, Connecticut; *Noche Latina*, University of Connecticut, West Hartford, Connecticut
1984	*Muestra de Pintura de Imna Arroyo*, Rincon Taino, New York, New York; *Imna Arroyo: Recent Works*, Connecticut Artists Showcase, Connecticut Commission on the Arts, Hartford, Connecticut
1983	*Imna Arroyo: Works on Paper, Paintings and Prints*, Housatonic Museum of Art, Bridgeport, Connecticut; *Imna Arroyo: Monoprints from Now and Then*, New Haven Credit Union Community Gallery, New Haven, Connecticut; *Imna Arroyo*, New Haven Foundation, New Haven, Connecticut
1981	*Imna Arroyo/Works on Paper*, African American Cultural Center, Yale University, New Haven, Connecticut
1980	*Imna Arroyo/Works on Paper*, Macy's Community Gallery, New Haven, Connecticut
1979	*Prints and Drawings*, Despierta Boricua Puerto Rican Cultural House, Yale University, New Haven, Connecticut; *First One Person Show*, Galleria Tito, New York

RECENT GROUP EXHIBITIONS

1995	*Artistas del Mundo en Tlaxcala-Mexico*, 14th General Assembly and Congress of the International Association of Art/UNESCO, Tlaxcala, Mexico; *Tell Me a Story Exhibition—Personal Narratives from the Women's Caucus for Art Delegation*, United Nations Fourth World Conference on Women, Beijing, China; *Printmaker's Network '95*, Housatonic Museum of Art, Housatonic Community College, Bridgeport, Connecticut; *Faculty Art Exhibition: Connecticut State University System*, Samuel S. T. Chen Fine Arts Center Gallery, Maloney Hall, Central Connecticut State University, New Britain; *Ain't I a Woman? Women of the African Diaspora*, Artspace, New Haven, Connecticut
1994	*Mujer Madre*, Galleria La Sirena, Guanajuato, Mexico; *Women of the Americas*, Arts Alliance of Haverstraw Multicultural Gallery, Village of Haverstraw, New York; *Sharing Spaces*, Le Mieux Gallery, New Orleans, Louisiana; *Unabridged: Print Portfolio*, Quinebaug Valley Community-Technical College, Danielson, Connecticut; *Unabridged: Print Portfolio*, Washington Art Association, Depot, Connecticut; *Unabridged: Print Portfolio*, Fairfield University, Fairfield, Connecticut

1993 *Evolution of the Print: Varied Techniques of the Fine Art of Print-making Featuring Works of 18 Members of the Printmakers Network of Greater New England*, Bradley International Airport: Connecticut Commission on the Arts Showcase, Windsor Locks, Connecticut; *They Earn(ed) Their Keep: The Struggles and Successes of American Women Artists*, The Discovery Museum, Bridgeport, Connecticut; *Messages from Home*, Fruehwirth Design, San Diego, California; *Fragments of Life*, Arts Alliance of Haverstraw Multicultural Gallery, Village of Haverstraw, New York; *Faculty Art Show*, Akus Gallery, Eastern Connecticut State University, Willimantic, Connecticut; *Images*, Wave Gallery, New Haven, Connecticut; *One Voice: Call & Response*, In* Sights Gallery, Seattle, Washington

1992 *Crosscultural Explorations*, Atlanta College Art Gallery, Atlanta, Georgia; *Faculty Showcase*, Akus Gallery, Eastern Connecticut State University, Willimantic, Connecticut; *El Impacto de dos Mundos/ The Impact of Two Worlds*, Artspace, New Haven, Connecticut; *A Voice of Peace and Reason: An Exhibition of Art in Celebration of the Human Spirit*, Pennsylvania State University, University Park, Pennsylvania; *Epidemic and Crisis: 12 Caribbean Artists in an Exhibit Focusing on AIDS*, Art Works Gallery, Hartford, Connecticut; *Curator's Choice: New Works in Connecticut*, John Eli Slade House, New Haven, Connecticut; *Latin American Artists in Connecticut*, Mattatuck Museum, Waterbury, Connecticut; *Multicultural Threads: An Exhibition of Contemporary Arts*, The Art Guild, Farmington, Connecticut; *Women in the Arts*, Moira Fitsimmons Arons Art Gallery, Hamden Hall Country Day School, Hamden, Connecticut; *Connecticut Printmakers*, Connecticut Commission on the Arts, Hartford, Connecticut; *Spirit of the Figure/Espiritu de la Figura*, Aetna Gallery, Hartford, Connecticut

1991 *Essence of Life*, Stamford Community Art Council, Connecticut; *Contemporary Caribbean Artists/Artistas Contemporaneos del Caribe*, Creative Arts Workshop, New Haven, Connecticut; *The Awakening/El Despertar*, The Discovery Museum, Bridgeport, Connecticut

1990 *TSE BIT'A'l: The Rock with Wings, Movement of Adobe, Peace, Harmony, and Well-Being*, Farmington Museum, Farmington, New Mexico; *Coming of Age: Connecticut Women and Their Choices*, Torrington Historical Society, Torrington, Connecticut; *Coming of Age: Connecticut Women and Their Choices*, New Haven Colony Historical Society, New Haven, Connecticut; *Coming of Age: Connecticut Women and Their Choices*, Windham Textile Museum, Windham, Connecticut; *Coming of Age: Connecticut Women and Their Choices*, Norwalk Historical Commission, Norwalk, Connecticut; *Connecticut Artists in Connecticut*, Connecticut Commission on the Arts Showcase, Legislative Office Building, Hartford, Connecticut

COLLECTIONS

African American Cultural Center, Yale University, New Haven, Connecticut; Arjo Wiggins USA Inc., New York, New York; Arjo Wiggins USA Inc., Paris, France; Bank of

New Haven (Former Merchants Bank), New Haven, Connecticut; Farmington Museum, Farmington, New Mexico; Housatonic Museum, Housatonic Community College, Bridgeport, Connecticut; Mount Holyoke College, South Hadley, Massachusetts; Museo de las Americas, Leon, Nicaragua; Museum of Modern Art Library/Franklin Furnace Art Book Collection, New York, New York; New Haven Foundation, New Haven, Connecticut; Private Press Collection, Watson Library, Trinity College, Hartford, Connecticut; Schomberg Collection of American Art, Schomberg Center for Research and Black Culture, New York, New York; Yale Art Gallery, New Haven, Connecticut

SELECTED PUBLICATIONS

Arroyo, Imna. "An Educator Is Inspired by Ancient Ceramic Traditions—My Experience as an Artist in Residence at the C.E.C.A.T.I. NO. 60, Researching Talavera Ceramic in Dolores Hidalgo, Mexico." *The Studio Potters Net Worth/National News Letter* (March 1994).
Arroyo, Imna. "New Mexico and New Haven: Two Different Lands, My Experience as an Exchange Faculty at San Juan College." *New Haven Arts* (Arts Council of Greater New Haven) (1992).
Arroyo, Imna. "WCA/NGO Representation in the United Nations." *National Women Caucus for Arts News Letter* (January 1995).
"Critica y Arte." *El Taller Literario, Revista de Literatura* 1, no. 3 (Fall–Winter 1989).
Ritual and Dissent: A Journal of Black Arts and Letters 1, no. 1 (Summer 1983).

ARTIST STATEMENT (1997)

Since 1982, I have been exploring the theme of "Energia de Mujeres—Women's Energy" in my work. As a painter and printmaker who works with clay, I make use of functional objects such as commercial clay vases that I reinterpret and reassemble into female vessels. My search for imagery reflects my physical and spiritual world.

My source for inspiration is my experience of women. These experiences are reflected in my world of visions. It is a world nurtured by personal and collective references to my culture and ancestry bound to my Neolithic past as well as my indigenous and African Caribbean heritage.

The symbolism in my work includes nets, caves, spirals, and water. The energy of "Woman" is represented in cocoon or conical forms. The concept of the "island" is used to establish a place or point of origin. The boat is a metaphor for my voyage to self-discovery.

Through my family lineage, I have discovered my connectedness, worth, and meaning. It is precisely for these reasons that I want to honor my deceased mother, Ana Idalia Cora, my maternal grandmother, Ramona Bolorin, and my paternal grandmother, Modesta Moret, as well as my father, my children, and my husband.

BIOGRAPHICAL ESSAY

Nets, caves, boats, vessels, cocoons, spirals, figures of women, islands, and water permeate Imna Arroyo's inner landscapes. The printmaker, painter, and

mixed-media artist describes her work as a rite of passage. It is a process through which she restores her history in an attempt to reconstruct identity for the present and future. Her identification of woman as womb, generator of life, and sustenance is nurtured by her own personal relationships with the women of her life—her deceased mother, Ana Idalia Cora; her maternal grandmother, Ramona Bolorin; her paternal grandmother, Modesta Moret; and countless others. Arroyo typically concerns herself with women's issues, and her repertory of female symbols and images is expansive, ranging from painted mythical and ancestral portraits of goddesses to the groups of journeying women shrouded in anonymity of her installations and woodcuts.

Arroyo's most recent series *Time, Movement and Symbolism/Ancestors and Deities* includes works from 1968 to 1995. This series focuses on self-discovery, reclaiming ancestral heritage, and securing cultural identity through image making. *Isla de Mujeres (Island of Women)* (1995) is a mixed-media piece of a grouping of cylindrical ceramic vessels on an island surrounded by candles and water. Clay figured vases are assembled on a fiberglass boat in *Mi Barca (My Boat)* (1995). Arroyo's women are embarking on a journey to a distant shore like the women in her woodblock *Voyage* series. The women, the island, and the boat are all references to Arroyo's personal voyage to self-discovery, self-representation, and a deepened sense of origin and destiny.

Arroyo attributes her explorations of movement and space in drawing and painting to her dance experience and the influence of the calligraphic gestures of Japanese and Chinese prints and paintings. Her exhibition *Moving Through the Spiral*, completed in 1990, was inspired by her visits to Mexico and New Mexico. In this series of paintings, lithography, etchings, and ceramics, she explores her relationship with nature as a living, spiritual entity.

Coming Out of Darkness is a series of etchings that feature Arroyo's conical motif of shrouded women moving in and out of darkness. Similar to Arroyo's lithographs and woodcuts, these prints reveal groups of women, stoic and silent, like watch towers or pilgrims of a sacred land. They move in and out of light gracefully, passing on knowledge, sharing stories, contemplating ancient mysteries, or consoling each other in grief.

Arroyo's self-portraits are also significant and recall those of Frida Kahlo's. In *Coming of Age*, Arroyo paints herself inside the form of a Yucatan flower. Her silenced women move before her in magenta robes, in the painting as well as three dimensionally on a shelf extending from the edge of the canvas. Arroyo's three-dimensional ceramic forms like *Blue Spiral, Virgin Spiral*, and *Birthing* seem to embody the timelessness of nature, the wisdom of ancestors and goddesses, and the simple beauty of the female form.

A dominant theme in all of Arroyo's various mediums is the exploration of the energy, power, and mystery of the woman. She uses personal and collective references to reinterpret and reassemble female iconography. Arroyo's vessel is a metaphor for creation, identification, and transformation. The woman, as a sacred symbol and image, is omnipresent in Arroyo's art and life. The woman,

she explains, "is rooted in the landscape, in my dreams, and in my surroundings. She is my grandmother, my mother, and my daughter. She is magical."

BÁEZ, MYRNA

Nationality: Puerto Rican. *Born*: 1931, Santurce, Puerto Rico. She currently lives in Hato Rey. *Education*: Báez initially studied the sciences at the University of Puerto Rico in 1951, then took up art studies at the Academia de San Fernando, Madrid, Spain, in 1957. She initially went to Spain to study medicine at the age of 16 and instead discovered art. She studied printmaking at the Taller de Artes Gráficas, Instituto de Cultura Puertorriqueño in 1960. She continued her study of printmaking techniques at Pratt Institute, New York, from 1969 to 1970. *Family*: Báez is the daughter of Enrique Báez, an engineer, and América González, an elementary school teacher. *Career*: Báez was one of the few women of her generation to make a career as a professional artist and the first to have a solo exhibition at the Institute of Puerto Rican Culture in 1962. Along with her artistic career, Báez has held a lifelong commitment to Puerto Rico's independence. Her roles as an activist, artist, and teacher are inseparable. She taught at the Academia de Bellas Artes in Madrid for six years. She was an active member of the artists' group Mujeres Artistas de Puerto Rico in 1983. She has exhibited in Spain, the United States, Puerto Rico, Cuba, Ecuador, and Venezuela. *Awards*: In 1970 she was honored at the Pratt Graphic Center Exhibition, New York. Báez was 1 of 35 women artists invited to exhibit in the Women's Pavillion de la Feria Internacional in 1984. In 1983 she was recognized for her artistic efforts in the *Semana de la Mujer* in New York. In 1986 Báez was invited to Cuba for the inauguration of the Museo Haydée Santamaría in Havana and was invited by Taller Puertorriqueño to exhibit in Philadelphia at the Galería Francisco Oller-Campeche. In the same year, she was awarded third place in painting at the First Biennial of Painting in Ecuador. In 1987 she was invited to exhibit in New York's El Museo del Barrio's *Puerto Rican Painting: Between Past and Present*.

EXHIBITIONS

1992 *Pinturas. Exposición en Botello de Plaza las Americas*, Hato Rey, Puerto Rico

1989 *Exposición de Myrna Báez, Semana de la Mujer*, Recinto Universitario de Mayaguez, Puerto Rico; *Tres Decadas Gráficas de Myrna Báez*, Semana Cultural de Puerto Rico en Costa Rica; Galería Na-

cional de Arte Contemporáneo, San José, Costa Rica; *Gráfica de los '80*, Biblioteca Madre Maria Teresa Guevara, Universidad del Sagrado Corazon, Santurce, Puerto Rico

1988 *Tres Decadas Gráficas de Myrna Báez Exposición-homenaje*, VIII Bienal de San Juan del Instituto de Cultura Puertorriqueña, Museo de Bellas Artes, San Juan, Puerto Rico; *Gráficas de Myrna Báez*, Museo de Arte y Casa de Estudio Alfredo Ramirez de Arellano y Rosell, San German, Puerto Rico

1987 *Myrna Báez*, Taller Puertorriqueño, Philadelphia, Pennsylvania

1985 *Pintura y Gráfica de Myrna Báez*, Instituto de Cultura Puertorriqueño, Philadelphia, Pennsylvania

1982 *Diez Años de Pintura y Gráfica de Myrna Báez*, Museo del Barrio, New York/Museum of Fine Arts, Springfield, Massachusetts/Chase

 Manhattan Bank, Hato Rey, Puerto Rico; *Gráfica Contemporánea: Myrna Báez y Antonio Martorell*, Villa Igea, Locarno, Suiza

1981 *Aguafuertes de Myrna Báez*, Galería Botello, Hato Rey, Puerto Rico

1980 *Exhibición de Pinturas*, Estudio de la Artista, Hato Rey, Puerto Rico

1976 *Pinturas de Myrna Báez*, Museo de la Universidad de Puerto Rico, Rio Piedras, Galería G, Caracas, Venezuela

1974 *Myrna Báez, Pinturas y Cerámicas*, Galería Santiago, San Juan, Puerto Rico

1968 *Grabados de Myrna Báez*, Galería Colibri, San Juan, Puerto Rico; *Grabados de Myrna Báez*, Instituto Panameño de Arte, Panama

1962 *Dibujos, Grabados y Pinturas de Myrna Báez*, Instituto de Cultura Puertorriqueño, San Juan, Puerto Rico

GROUP EXHIBITIONS

1993 *Muestra de Arte Puertorriqueño, Quinientos Años del Descubrimiento de Puerto Rico Arsenal de Puntilla*, Instituto de Cultura Puertorriqueña, San Juan, Puerto Rico

1992 *45 Años de Expresión Gráfica Puertorriqueña*, Museo de Arte Contemporáneo, Santurce, Puerto Rico; *Puerto Rico*, Pabellon Nacional de Puerto Rico en la Exposición Universal de Sevilla, Spain; *La Tercera Raiz: La Presencia Africana en Puerto Rico*, Instituto de Cultura Puertorriqueña, Arnsela de la Puntilla, San Juan, Puerto Rico; *Encuentro: Once Galerías en el Banco de Desarrollo Económico para Puerto Rico*, Hato Rey, Puerto Rico (representing a la Galería Botello)

1991 *Colección de Arte Puertorriqueño*, Compañia de Turismo, San Juan, Puerto Rico

1990 *New Art from Puerto Rico*, Museum of Fine Arts, Springfield, Massachusetts/Museo de 1992 Arte de Ponce, Puerto Rico

1990 *Mujeres Artisticas de Puerto Rico*, Voluntariado de las Casas Reales,

Santo Domingo, Republica Dominicana; *Figuración y Fabulación, 75 Años de Pintura Latinoamericana*, Museo de Bellas Artes, Caracas, Venezuela; *New Art from Puerto Rico*, Museum of Fine Arts, Springfield, Massachusetts

1989 XVIII Bienal de Arte Gráfico de Grabados de Ljubljana, Ljubljana, Yugoslavia

1988 *El Espiritu Latinoamericana: Arte y Artistas en los Estados Unidos, 1920–1970*, Museo del Bronx, New York, Museo de Arte de El Paso, Texas, Museo de Arte de San Diego, California, Instituto de Cultura Puertorriqueña, Puerto Rico, Centro para las Artes, Vero Beach, Florida

1987 *I Bienal Internacional de Pintura*, Museo de Arte Moderno, Cuenca, Ecuador; *Puerto Rican Painting: Between Past and Present*, Museum of Modern Latin America, Washington, D.C., The Squibb Gallery, Princeton, New Jersey, El Museo del Barrio, New York, Museo de la Universidad de Puerto Rico, Rio Piedras, Puerto Rico; *XIX Bienal de São Paulo*, São Paulo, Brazil

1986 *Presencia Femenina Latinoamericana*, Galería Epoca, Santiago, Chile

1985 *Obra Unica sobre Paper*, Instituto de Cultura Puertorriqueña, Arsenal de la Puntilla, San Juan, Puerto Rico

1984–1986 *I y II Bienal de La Habana*, Museo Nacional de Bellas Artes, La Habana, Cuba

1984 Women's Pavillion, Louisiana State Fair, Louisiana

1983 *Premio Cristobal Colon de Pintura de Union de Ciudades Capitales Latinoamericanas*, Centro Cultura del Conde Duque, Ayuntamiento de Madrid, Spain

PUBLICATIONS

Bloch, Peter. *Painting and Sculpture of the Puerto Ricans*. New York: Plus Ultra Educational Publishers, 1978.
The Latin American Spirit: Art and Artists in the United States, 1920–1970. New York: Abrams, 1988.

BIOGRAPHICAL ESSAY

Both in painting and in graphics, Báez engages in a process of experimentation of formal elements. She combines this with a highly personal style. After having rejected art that was merely illustration, she began to explore issues relating to modern industrialized Puerto Rico. In an early painting, *In the Bar*, she portrays the isolation, alienation, and solitude experienced by members of Puerto Rico's changing society. In her later works she expands these kinds of concerns, renewing the tradition of art as social critique. It became evident that art for Báez was a social as well as aesthetic commitment. She understood early

in life that as an artist she was highly accountable to the society in which she lives.

Báez remembers as a young girl her introduction by the Spanish painter Juan Genoves to a way of life for artists. She recalls those years as a young artist in Spain: "Artists then were still committed to art and to society. Today's commitment is to the (art) market . . . that changes the type of art produced." Coinciding with her artistic vocation has been her devotion to the independence of Puerto Rico. Báez's powerful bond with her native land—its places and spaces—is central to her work.

It is in her paintings and prints that she explores a sense of place and of belonging or not belonging. This sense of place, interior or exterior, is captured and framed. Although Báez is an established painter, she is known primarily as a printmaker. The Puerto Rican landscape has been a constant motif in her work. The works simultaneously celebrate the land's beauty and provoke concern for its destruction. Báez believes that people are shaped by their native landscapes, which they internalize and carry with them wherever they go.

In *Daybreak (Alborada)* (1988), she describes the gentle hills of Barrazas at dusk. A bright green rectangle, softly etched over the landscape, breaks the hazy calm of the afternoon. Perhaps the rectangle represents a thought, a memory, a dream, or the artist's presence. In *Respite (Pausa)* (1989), Báez surrounds the sitter with luminous layers of vistas to create a dreamlike, equivocal space, a state of mind, or an inner world where exterior and interior spaces overlap and merge. Many of her large-scale paintings of the last decade explore this kind of layered, luminous space. These spaces are sometimes desolate, sometimes inhabited.

She has captured Puerto Rico's interior daily life in works like *Doña Julia's Vanity* (1986) that expose everyday personal objects and spaces. She paints the vanity table as if it were a sacred altar. One can feel Doña Julia's presence through her absence from her personal space. Like in many of her paintings, there is a sense of nostalgia and grief. They are examples of Báez's undying tribute to the vanishing world of Puerto Rico's traditions, the land, the people, and the spaces they inhabit.

BENITES ARRIOLA, JULIA

Nationality: Mexican/Mescalero Apache. *Born*: 1952, Tucson, Arizona. *Education*: After finishing high school, Benites Arriola studied music on a full scholarship at the University of Arizona, Tucson. Not ready to pursue an academic

Merry Widow by Julia Benites Arriola, 1995, copper, silver, mixed media, 29" × 32". Courtesy of Julia Benites Arriola

career, she joined the navy and then spent some years working in high-technology manufacturing companies, building a variety of things, including missiles. She received a B.F.A. (1992) and an M.F.A. (1996) from the University of Arizona. *Family*: Benites Arriola is a native of southern Arizona. Her family has lived in the Southwest for many generations. Her cultural roots are in the Hispanic, Mescalero Apache, and Mayo Indians of the northern Sonoran in Mexico. Her father was in the military, and Benites Arriola spent her early years living apart from her native culture, immersed in schools and communities of the mainstream culture. These diverse experiences have informed her work. *Awards*: Benites Arriola received the Rutgers Purchase Award at the 1994 Works on Paper Exhibition and a Museum Purchase Award from the Hoyt Institute of Fine Art. She also was the recipient of a Graduate Fellowship from the University of Arizona in 1994.

SELECTED EXHIBITIONS

1997 *Arizona Biennial*, Tucson Museum of Art, Tucson, Arizona; *Cuentos del Barrio: Borders & Bodies*, Tucson Pima Art Council, Tucson, Arizona; *Eros: Group Exhibition*, Guadalupe Fine Art Gallery, Santa Fe, New Mexico

1996 *Nuestra Señora II: Contemporary Visions of Our Lady of Guadalupe*, Guadalupe Fine Art Gallery, Santa Fe, New Mexico; *Hoyt National Art Show*, Hoyt Institute of Fine Art, New Castle, Pennsylvania; *Impacto Cultural IV: Hispanic Sculptors of Arizona*, University of Arizona Museum of Art, Tucson, Arizona

1995 *North American Sculpture Exhibition*, Foothills Art Center, Golden, Colorado; *Down & Under*, José Galvez Gallery, Tucson, Arizona

1994 *P.A.C.T. for Life-Life thru Art: A Benefit for People Living with HIV and AIDS*, Temple of Music and Art, Tucson, Arizona; *Impacto Cultural III: Mujeres a Traves de la Frontera/Women across the Border*, University of Arizona Museum of Art, Tucson, Arizona; *Rutgers National "Work On/Of Paper*," Stedman Art Gallery, Rutgers University, Camden, New Jersey

1993 *National Exhibition Focusing on Breast Cancer, Art & Science: Memories, Milestones & Miracles*, Bowers Museum of Cultural Art, Santa Ana, California; *The Fifth Biennial Seven State Juried Exhibition*, Dinnerware Artists' Cooperative Gallery, Tucson, Arizona

COMMISSIONS

1994 Freestanding five- and one-half-foot sculpture made of copper and welded rebar—piece was commissioned by Mr. Leigh Stivers and is located at 2804 E. Elm, Tucson, Arizona; copper relief, which is installed on an adobe wall at 3901 N. Vine, Tucson, Arizona—piece was commissioned by Dr. Dena Baumgartner

COLLECTIONS

Hoyt Institute of Fine Art, New Castle, Pennsylvania; Stedman Art Gallery, Rutgers University, Camden, New Jersey

PUBLICATIONS

Hertel, Carl. "Nuestra Señora II: Contemporary Images of Our Lady of Guadalupe." *Sandoval Arts* (1997).
Tobin, Richard. "Eros in Art-Group Shows." *The Magazine* (1997).

ARTIST STATEMENT (1997)

The works in general explore the interplay between cultural symbols. My mixed heritage has blessed me with wonderful imagery that is constantly floating around in my mind, just waiting to be brought into the physical. There is a

constant exploring of tensions and connections between multicultural symbols and ideas that are on my mind as well as in my work.

The materials employed in my work are copper (I am totally seduced by this metal), wood, silver (metalsmith background), clay, and found objects.

Most of my ideas and imagery come to me late at night, at the place just before falling asleep, and they remain with me when I wake up in the morning. I quickly write them down for safekeeping. As I think of the ideas during the day, the appropriate medium will come into mind.

When I was in grade school, my teachers told me that I would never succeed at anything because I was too much of a daydreamer. For most of my life, I thought that this was a negative trait, but now I know better. Being a daydreamer is a gift and is quite entertaining, too!

BIOGRAPHICAL ESSAY

Julia Benites Arriola remembers that when she was a girl in grade school, her teachers told her that she would not succeed at anything because she was a daydreamer. It is precisely her ability to daydream that has enabled her to create her images of copper, silver, wood, clay, and mixed media. Most of her ideas and imagery come to her late at night, in the intangible moments segueing into sleep.

For Benites Arriola the imagery will dictate the medium. She works with content inherent in the materials themselves, often incorporating found objects and fruit. In *The Serpent Beguiled Me, and I Did Eat* (1996), Benites Arriola installed 600 apples in the Joseph Gross Gallery in Tucson, with pieces of her copper and silver underwear garments, and scattered texts from the Bible. The apples were piled over the texts, and the garments were exhibited on top of the overturned apple baskets. Female reproductive organs are etched into one of the pairs of copper boxer shorts. A red blinking cord umbilically connects the two shorts. The installation complete with baskets of rotting apple bites refers to the heritage of the biblical loss of innocence experienced by Adam and Eve in the Garden of Eden with the forbidden fruit.

Wit and satire permeate the works of Benites Arriola. Her series of copper and mixed-media women's lingerie evokes the medieval time of chastity belts for women. Modern-day undergarments are turned into shields of armor or an-cient artifacts from a distant time. Arriola replaces the soft, frivolous laces and silks with the harness of metal, creating an inaccessibility to such garments and their ability to enhance the objectification and feminization of women. Her *Merry Widow* (1995) is a copper and mixed-media corset tacked up like an old army belt, busted rifle, or retired saddle, no longer in use. Another is *Merry Widow's Kiss* (1997), in which a merry widow corset is torn and draped in metal. A black widow spider has woven her web on the edge of the lace. These garments have obviously not been worn for years. Arriola's experience building military equipment in the navy has no doubt informed this series.

Arriola also completed a series of crosses in 1997. They are made of wood and are marked with arrangements of found objects, milagros, and trinkets. The *Warrior Crosses* are a series of crosses that pay homage to various cultural warriors, like Joan of Arc and Native Americans. *Soldier of Fortune* is a camouflage painted cross with heart milagros tied onto the horizontal section. At the center of the cross is a photograph of a woman in a bikini, a soldier's pinup.

The satirical nature of Arriola's works suggests their political underpinnings and their critique or commentary on social issues. A very intriguing piece is *Lupe Tagged* (1996), in which Arriola constructs a Virgin of Guadalupe of the twentieth century, living in a trailer, wrapped in her star-spangled robe, and hiding in her bathtub to avoid gang drive-by shootings in her neighborhood.

FUSCO, COCO

Nationality: Cuban American. *Born*: 1952, New York City. *Education*: As a young adult she studied in Paris, where she learned to speak French. Most of her academic life was spent in the United States. *Family*: Fusco is the daughter of a Cuban who immigrated to the United States in 1954 and was deported in 1959. Her mother hid from the Immigration and Naturalization Service until after her birth. She returned to Cuba with infant Fusco, and within a few weeks, because of Fusco's U.S. citizenship, they returned to New York City. In the decade that followed, her mother's sisters, brother, parents, nieces, and nephews all emigrated. At an early age Fusco was teaching English to her cousins and translating for older relatives. Like most immigrant children, she found herself sliding between languages and cultures. *Career*: Fusco began traveling to Cuba in the early 1980s. As her interest in the political climate of Cuba increased, she began to write about it. Fusco has traveled extensively to such places as London, Havana, San Francisco, Merida, Paris, San Antonio, Chicago, Berlin, Montreal, Miami, Santiago, Denver, Barcelona, San Juan, Mexico City, Toronto, Managua, Porto Alegre, and Brooklyn. Fusco has lectured in Cologne, Spain, Cuba, and Mexico City. She currently lives in New York. Fusco has collaborated with artist and writer Guillermo Gómez-Peña on many performances, installations, and texts since the late 1980s. She publishes regularly in the *Village Voice* and *The Nation*, among others.

PERFORMANCES/INSTALLATIONS/TEXTS/SCRIPTS

1995 *English Is Broken Here, Notes on Cultural Fusion in the Americas*, publication, New Press, New York

1993	*The Couple in the Cage, a Guatinaui Odyssey*, video documentary
1993	*El Aztec High-Tech and La Miss Discovery*, from *The New World (B)order*, performance, Dance Theatre Workshop, New York
1993	*La Pinta Dos*, radio broadcast, from *The Year of the White Bear*, aired on National Public Radio in 1992–1993, commissioned by Los Angeles Festival and the Territory of Art
1992	Published an article in the *Village Voice*, about Ninart's show in Mexico City
1992	*Two Undiscovered Aborigines*, performance/installation, Columbus Plaza, Madrid, Covent Garden, London, Smithsonian Institute, Washington, D.C., Australia Museum, Sydney, Field Museum of Natural History, Chicago, opening of the 1993 Whitney Biennial, New York
1991	Published article about an exhibition of art from Cuba in the United States, *The Nation*
1990	*Norte: Sur*, performance-radio script, aired on National Public Radio, commissioned by the Festival 2000, San Francisco;
	El Aztec High-Tech and La Authentic Santera, from *Norte: Sur* (performance)
1987	Documentary for Havana Film Festival (second screening banned)
1986	First radio program about Cuban film airs on a community radio station, New York

PUBLICATIONS

"Art & National Identity: A Critic's Symposium." *Art in America* 79 (September 1991), p. 80.

Avgikos, Jim. "Kill All White People." *Artforum* 31 (1993), pp. 10–11.

Gablik, Suzi. "Breaking Out of the Imperialist Cage." *New Art Examiner* 21 (1993), pp. 36–39.

Garfield, Donald. "Culture in a Cage." *Museum News* 72 (1993), pp. 17–18.

Hernandez, Eloy J. "Art History's Anxiety Attack" (analysis of the October article "Visual Culture Questionnaire" from D. Crimp and C. Fusco). *Afterimage* 24 (1997), pp. 6–7.

Portfolio. (Statements by Hispanic American female artists). *Heresies* 7, no. 3 (1993), pp. 20–28.

Sherlock, Maureen P. "The Year of the White Bear." *Art Papers* 18 (1994), pp. 31–37.

BIOGRAPHICAL ESSAY

Even as a child Coco Fusco maneuvered herself between languages and cultures with ease. Growing up among foreigners, she was accustomed to living "with the presence of an imaginary country" in her home, a home that spoke to her in a different language, with different stories, prayers. It sounded, tasted, and smelled different from the world beyond the front door. Her experience as

a cultural translator began when she was a child, living with immigrant relatives in New York. She taught them English and translated their Spanish.

Fusco grew up in between cultures, languages, and ideologies. It was only after she began to travel back to Cuba in the 1980s that she began to realize that her diverse cultural experience had shaped and defined her, determining her life beyond her control. At this time she began to understand herself as a child of diaspora, of the Cold War, of the Black Caribbean, of the civil rights movement, of Cuba, and of the United States. She knows what it is like to be caught between worlds and how to maneuver oneself through them.

Fusco's work as an interdisciplinary artist, cultural critic, curator, and writer are all explorations of the gaps, conflicts, and boundaries between cultures and the possibilities of media and art of revealing hidden realities. The process of cultures meeting, clashing, and mixing has become central to her art and writing. Informed by her own diverse cultural experience, she writes about the work of many artists of color. Her works expose limited perceptions and ideologies that are rooted in the conquest and colonization of the Americas in an attempt to transform the vision of America and its many cultures. Fusco believes that by rekindling histories from marginalized communities, rewriting alternative stories, gathering collective memories, and reconstructing identities, power sites of cultural resistance can be accessed and activated.

English Is Broken Here, Notes on Cultural Fusion in the Americas (1995) is Fusco's latest collection of essays and texts dealing with the diasporic experience, cultural politics of identity and appropriation, intercultural performance, and writing on the works of Andres Serrano, Lorna Simpson, Ana Mendieta, Catalina Parra, and Guillermo Gómez-Peña. Her writing about art, performance, representation, cultural assimilation, identity, and cultural making continue to inform and inspire artists, writers, scholars, and critics.

Fusco met writer/artist Guillermo Gómez-Peña in 1988 at a conference at New York's Dance Theatre Workshop. He was a member of the Border Art Workshop/Taller de Arte Fronterizo, a San Diego–based art collective. Several conversations later, independent writer/curator Fusco and artist/writer Gómez-Peña began collaborating on a variety of projects that include performances, installations, scripts, texts, and experimental radio broadcasting. Their work together involves an ongoing dialogue about Latinos of the North, South, East, and West. Fusco explains their role in the work: ''As artists of color in the United States, whatever our aesthetic or political inclinations, Guillermo Gómez-Peña and I carry our bodies as markers of difference and reminders of the endlessly recycled colonial fantasies on which Western culture thrived.''

In their cage performance project *Two Undiscovered Aborigines*, (1992–1993), Fusco and Gómez-Peña cage themselves. The piece centers on the invention of fictional identities and the presentation of themselves as ''savages'' from an undiscovered island untouched by Western culture. By exhibiting themselves as curiosities, they intend to parody the practice of ethnographic display and, through performance, critique dominant ideologies of ownership, represen-

tation, and cultural property. They lived in a cage (for two or three days in each location) as savages from an imaginary island in the Gulf of Mexico, speaking their own made-up language and dressed in costumes. Gómez-Peña, the male specimen, wore a feather headdress, sunglasses, an Azteca-like costume, and cowboy boots. For a dollar he would tell stories in his native language. Fusco was also elaborately costumed, her face painted, and also wearing sunglasses. She would dance to rap music upon request. At each of the various performance sites there were guards who interpreted their actions and speech for the public, fed them, and even took them to the bathroom on leashes.

The trilogy *The New World (B)order*, a performance, *The Year of the White Bear*, an exhibition, and *The Couple in the Cage*, a video, is a process of describing the condition of society at the end of the century with its major issues of multiracial conflicts and national identity crisis. Fusco and Gómez-Peña's work is political in the realm of culture but does not stop being art because of its explicit critique of culture. In terms of political activism and exploring the relationships of power, their work operates in this realm of culture because culture is the place where the symbolic, the imaginary, and language can be manipulated and altered. Changing what things mean is crucial for social transformation, as Fusco reminds us: "If you want to transform the way people behave in the world one of the things you have to work on is how they see it. Their view is often mediated by languages—visual, iconic, and verbal."

Fusco's writing and performance are precisely about changing the way people see the world, offering alternative views and encouraging ongoing dialogues of the politics of making culture, images, and selves. She profoundly summarizes the crux of these politics: "History, collective experience, and memory are important. We do have a self, to an extent constructed by systems but also informed by our pasts, and what each individual does is different from what anybody else would do. Agency, or the ability to take the power to become an agent for change, lies in that specificity. I don't buy this notion that we are all victimized and hypnotized by simulation."

HERNÁNDEZ, ESTER

Nationality: Mexican American. *Born*: Dinuba, California. *Education*: Graduated from the University of California, Berkeley. *Family*: Hernández is of Yaqui-Mexican ancestry. She comes from a family of farmworkers. This experience continues to inform her work. She is a resident of Oakland, California. *Career*: Hernández has been an artist-in-residence several times for the California Arts

Council. She has worked on numerous mural projects. She has also lectured extensively on women artists and taught in elementary schools, at senior citizen centers, and for the disabled. Hernández is currently involved in community service programs for the disabled and elderly. *Awards*: In 1976 Hernández was awarded an Artist-in-Residence position by the California Arts Council. She also received the first annual Bay Guardian GOLDie Award, a lifetime credential as an Art Specialist from California Community College, and was the first one-woman show to be held at the Galería de la Raza.

EXHIBITIONS

1987	*Day of the Dead Exhibition*, La Bodega, Oakland, California
1986	*Artistas Indigenas Exhibit II*, La Peña Cultural Center, Austin, Texas
1985	*International Women's Day*, Battersea Arts Gallery, London, England

BIOGRAPHICAL ESSAY

Three of Ester Hernández's well-known images demonstrate the efficacy of her political and cultural critiques of established ideologies and images: *La Virgen de Guadalupe Defendiendo Los Derechos de Los Xicanos (The Virgin of Guadalupe Defending the Rights of Chicanos)* (1974) is an etching depicting the Virgin of Guadalupe as a karate fighter; *Libertad* (1975) portrays the Statue of Liberty as a Mayan stele; and *Sun Mad* (1981) is a color serigraph of a revised logo for Sun-Maid Raisins.

Hernández is an ex-farmworker whose experience informs her paintings, prints, and murals. She made the *Sun Mad* print as a reaction of shock after discovering that the water in her hometown, Dinuba, California, which is the center of raisin-growing territory, had been contaminated by pesticides for 25 to 30 years.

A great amount of Hernández's work is centered on representations of the women of her farmworkers' community, which are complex explorations of the Latina feminine. As a child of farmworkers in California, Hernández grew up in an atmosphere of natural beauty, mixed cultural traditions, and social activism. Her family has been actively involved in the struggle for the rights of farmworkers since the 1930s.

Hernández moved to the Bay Area in the 1970s to study Chicano Studies at Laney College and Visual Arts at the University of California, Berkeley. She became actively involved in Las Mujeres Muralistas, San Francisco's first Latina mural collective. Although she worked as a muralist and a painter, she considers herself primarily a printmaker.

Hernández's intent, through her prints, is to reinterpret and recontextualize traditional images of the feminine through social critique. Her focus is primarily on images of "la mujer Chicana," and she explores issues of empowerment and injustice based on her own experience. Her undying commitment to social

change and to community service is evident in her work with the elderly, the disabled, and the farmworkers of her community. Hernández believes that the role of the artist to initiate change can be fulfilled in other venues besides image making. She continues to teach, lecture, and serve in elementary schools, at senior citizen centers, and at San Francisco's Creativity Explored, a disabled adults' center.

IZQUIERDO, MARÍA

Nationality: Mexican. *Born*: 1906, Jalisco, Guadalajara. *Education*: Izquierdo began her studies at the School of Plastic Arts in Mexico City in 1928 to study painting and sculpture. Diego Rivera was the school's director at the time, and he arranged her first solo exhibition in 1929. She established a relationship with Rufino Tamayo, who clearly influenced her later works. *Family*: Izquierdo was born in a small town. She was married at the age of 14, and she had three children. In 1923 she separated from her husband and moved to Mexico City, where she participated in the city's artistic life. *Career*: Izquierdo exhibited her work for the first time in 1929 at the Galería de Arte Moderno in Mexico City. In her early works she concentrated on painting portraits and still lifes. Later in her career her repertoire included circus scenes, landscapes with enigmatic still-life arrangements, and small allegorical compositions. In 1930 she was the first Mexican woman to have a solo exhibition in New York. Izquierdo promoted the advancement of women, and in 1935 she organized an exhibition of revolutionary posters by women artists. Although a stroke in 1955 left her partially paralyzed, she continued to paint and write. Her extensive exhibition history includes one-woman exhibitions in Mexico, New York, and Paris. *Died*: 1955, Mexico City.

SELECTED EXHIBITIONS

1995	*Latin American Women Artists, 1915–1995*, Milwaukee Art Museum, Wisconsin, Phoenix Art Museum, Arizona, Denver Art Museum, Colorado, National Museum of Women in the Arts, Washington, D.C.
1993	*Latin American Artists of the Twentieth Century*, Museum of Modern Art, New York
1989	*The Modern Era, 1820–1980*, Hayward Gallery, London
1988	*One-Woman Exhibition*, Centro Cultural/Arte Contemporáneo, Mexico City

1979	*One-Woman Exhibition*, Palace of Fine Arts, Mexico City
1956	*One-Woman Exhibition*, Galería de Arte Moderno, Mexico City
1951	*Art Mexican, Musée d'Art Moderne de la Ville de Paris*, Paris, France
1940	*Golden Gate International Exposition*, San Francisco
1930	*Twenty Centuries of Mexican Art*, Museum of Modern Art, New York
1929	First Exhibition, Galería de Arte Moderno, Mexico City

SELECTED COLLECTIONS

Carolyn Farb, Houston; Galería de Arte Mexicano/Alejandra Yturbe/Mariana Pérez Amor, Mexico City

PUBLICATIONS

Andrade, Lourdes, et al. *María Izquierdo*. Mexico City: Centro Cultural/Arte Contemporáneo, 1988. Exhbn cat.

Artaud, Antonin. "La pintura de María Izquierdo." *Revista de revista* (1936).

Artaud, Antonin. "Mexico y el espiritu femenino: María Izquierdo." *Revista de la Universidad de Mexico 22* 6 (1968), p. 2.

Debroise, Oliver. *Figuras en el trópico, plástica mexicana, 1920–1940*. Barcelona: Océano, 1983.

Ferrer, Elizabeth. "María Izquierdo." In *Latin American Artists of the Twentieth Century*. New York: Museum of Modern Art, 1992. pp. 116–121. Exhbn cat.

Michelena, Margarita, et al. *María Izquierdo*. Jalisco, Guadalajara: Departamento de Bellas Artes, Gobierno de Jalisco, 1985. Exhbn cat.

Monsiváis, Carlos, et al. *María Izquierdo*. Mexico City: Casa de Bolsa Cremi, 1986. Exhbn cat.

Museo de Monterrey. *María Izquierdo*. Monterrey: Casa de Bolsa Cremi, 1977. Exhbn cat.

Tibol, Raquel. "María Izquierdo." *Latin American Art* 1, no. 1 (Spring 1989), pp. 23–25.

Tibol, Raquel. *María Izquierdo y su obra*. Mexico City: Museo de Arte Moderno, 1971. Exhbn cat.

BIOGRAPHICAL ESSAY

Using bold forms and earth tones, María Izquierdo painted images that fused pre-Columbian elements with those of modernist tendencies. Like her contemporaries Frida Kahlo, Amelia Peláez, and Tarsila do Amaral, she combines her own native cultural diversities with European traditions to create her own style of painting. It was in 1923, when Izquierdo moved to Mexico City, that her artistic life began to flourish. Both Izquierdo and Kahlo employed elements derived from techniques and subjects characteristic of the Open Air Schools in Mexico City, but because each developed highly personalized styles, they were not categorized as Mexican School painters. They both painted still lifes, incorporating elements of nature and the landscape.

Izquierdo's art demonstrates the influence of Surrealism in the juxtaposition of objects that she depicted in many paintings. In her early works, she concentrated on painting portraits and still lifes. Later in her career she expanded her repertoire to include still lifes set in landscapes, circus scenes, and small allegorical compositions. María's depictions of altars to commemorate deceased relatives and friends on the Day of the Dead celebration describe the rich Mexican traditions and customs that survive to the present day. In her 1943 oil painting *Altar de Dolores (Good Friday Altar)*, Izquierdo paints an offering of fruits and candles to the Virgin of Sorrows. The draped lace curtains on each side of the Virgin's image recall the curtains of a stage and embue a theatrical and rituallike atmosphere. Izquierdo painted in a simplified style that was very characteristic of her work.

In 1930, Izquierdo was the first Mexican woman artist to have a solo exhibition in New York. Relatively few women at this time in Mexico had broken into the emerging Mexican art world. A world dominated by men, Izquierdo was one of those few. Carlos Mérida writes this about María Izquierdo in his 1937 book *Modern Mexican Artists*: "It is not frequent that one finds a Mexican woman making a profession of painting and above all successfully." In a society in which the activities of the woman were assigned solely to wifely and motherly duties, Izquierdo established a new precedent for other women.

Not only through her art but in other ways she promoted the advancement of women. In 1935 she organized a group of women making posters for a traveling exhibition of revolutionary posters by women from the Artes Plásticas, Departamiento de Bellas Artes in Mexico City. In 1936 Antonin Artaud published an account of her work in *Excélsior* in Mexico City. She was included in the Museum of Modern Art exhibition *Twenty Centuries of Mexican Art* in New York in 1940.

Izquierdo was partially paralyzed by a stroke in 1950. Her tenacity, like that of Frida Kahlo, compelled her to paint and write until her death.

KAHLO, FRIDA

Nationality: Mexican. *Born*: 1907, Coyoacán, Mexico. Named Magdalena Carmen Frida Kahlo y Calderón. *Education*: In 1922 she attended the National Preparatory School in Mexico City. In 1925 she had an apprenticeship with Fernando Fernández, a commercial printer and friend of her father Guillermo. *Family*: Parents were Matilde Calderón y González, a devout Catholic mestiza, and Guillermo Kahlo, a photographer and German Jew of Austro-Hungarian

descent. As a small girl of six years she contracted polio. On September 17, 1925, Frida Kahlo was severely injured in a streetcar accident. She married muralist Diego Rivera on August 21, 1929, and lived in Cuernavaca, Mexico. In 1934 Rivera had an affair with Frida's sister, Christina Kahlo, and beginning in 1935, Frida had an affair with Ignacio Aguirre and then with Isamu Noguchi. She divorced Rivera in 1939. They remarried in 1940. Her father, Guillermo Kahlo, died in 1941. *Career*: Kahlo painted her first self-portrait in 1926, *Self-Portrait Wearing a Velvet Dress*. She joined the Young Communist League in 1927. In 1930 she traveled to San Francisco with Rivera and met Imogen Cunningham, Dr. Leo Eloesser, and Edward Weston. She painted major works such as *Henry Ford Hospital, Self-Portrait on the Border between Mexico and the United States*, and *My Birth*. In the same year she had a miscarriage at three and a half months of pregnancy. She spent 13 days in the Henry Ford Hospital, then returned to Mexico. She lived in New York for ten months in 1933 and then once again returned to Mexico with Rivera. Kahlo and Rivera were active in the Communist movement, and in 1937 Leon Trotsky and his wife moved into Kahlo's Blue House in Coyoacán. In 1938 she met André Breton in Mexico. She then traveled to New York, where she had an affair with Nickolas Muray. In 1939 she sailed to Paris, where she stayed with the Bretons. While there, Marcel Duchamp arranged an exhibition of her paintings. Kahlo continued to paint from 1935 to 1954, major paintings such as: *A Few Small Nips* (1935), *My Nurse and I* (1937), *Fruit of the Earth* (1938), *Two Fridas* (1939), *Self-Portrait with Thorn Necklace and Hummingbird, The Wounded Deer (The Little Deer)* (1946), and *Marxism Will Heal the Sick* (1954). Kahlo exhibited extensively in Paris, New York, and Mexico. *Awards*: Kahlo was selected as 1 of 25 founding members of the Seminario de Cultura Mexicana, Ministry of Education, in 1941. She was appointed as a painting professor to the Education Ministry's School of Painting and Sculpture in 1943, and in 1946 she was awarded the National Prize of Arts and Sciences by the Education Ministry. *Died*: 1954, Coyoacán, Mexico at her family home. It became the Frida Kahlo Museum in 1958.

SELECTED EXHIBITIONS

1995 *Latin American Women Artists 1915–1995*, Milwaukee Art Museum, Wisconsin, Phoenix Art Museum, Arizona, Denver Art Museum, Colorado, National Museum for Women in the Arts, Washington, D.C.

1953 *One-Person Exhibition*, Lola Alvarez Bravo's Galería de Arte Contemporáneo, Mexico City

1943 *31 Women*, Peggy Guggenheim's of this Century Gallery, New York

1942 *Twentieth Century Portraits*, Museum of Modern Art, New York

1941 *Modern Mexican Painters*, Institute of Contemporary Arts, Boston, Massachusetts

1940	*International Surrealism Exhibition*, Galeria de Arte Mexicano, Contemporary Mexican Painting and Graphic Art, Palace of Fine Art, Golden Gate International Exhibition, San Francisco, 20 Centuries of Mexican Art, Museum of Modern Art, New York
1939	*Mexique*, Galerie Renon & Colle, Paris
1938	*Masters of Popular Painting: Modern Primitives of Europe and America*, Museum of Modern Art, New York; *Exhibition of Paintings*, Julien Levy Gallery, New York, André Breton writes catalog preface
1937	*Group Exhibition*, Galeria de Arte of the Department of Social Action, National Autonomous University of Mexico
1931	*Exhibition of Frida Kahlo and Diego Rivera*, Sixth Annual Exhibition of the San Francisco Society of Women Artists, California Palace of the Legion of Honor, San Francisco, California

SELECTED COLLECTIONS

Albright-Knox Art Gallery, Buffalo, New York; Madison Art Center, Wisconsin; Museum of Modern Art, New York; National Museum of Women in the Arts, Washington, D.C.; Phoenix Art Museum, Arizona

PUBLICATIONS

Bergman-Carton, Janis. "Like an Artist."*Art in America* (January 1993), pp. 35–39.

Borsa, Joan. "Frida Kahlo: Marginalization and the Critical Female Subject." *Third Text* 12 (Autumn 1990), pp. 21–40.

Breton, André. "Frida Kahlo de Rivera." In *Frida Kahlo (Frida Rivera)*. New York: Julien Levy Gallery, 1938. Exhbn cat.

Chadwick, Whitney. *Women Artists and the Surrealist Movement*. Boston: Little, Brown, 1985.

de Lappe, Pele. "The Intense Duality of Frida Kahlo."*The People's World* (November 1977), p. 10.

del Conde, Teresa. *Frida Kahlo: La pintora y el mito*. Mexico City: Instituto de Investigaciones Estéticas/Universidad Nacional Autónoma de México, 1992.

García, Rupert. *Frida Kahlo: A Bibliography*. Berkeley: Chicano Studies Library Publications Unit, University of California, 1983.

Gómez Arias, Alejandro, et al. *Frida Kahlo: Exposición homenaje*. Mexico City: Sala Nacional, Palacio de Bellas Artes, 1977. Exhbn cat.

Grimberg, Salomon. *Frida Kahlo*. Dallas, Tex.: Meadows Museum, Southern Methodist University, 1989. Exhbn cat.

Herrera, Hayden. "Beauty to His Beast: Frida Kahlo & Diego Rivera." In Whitney Chadwick and Isabelle de Courtivron, eds., *Significant Others: Creativity & Intimate Partnership*. London: Thames and Hudson, 1993. pp. 118–135.

Herrera, Hayden. *Frida: A Biography of Frida Kahlo*. New York: Harper and Row, 1983.

Herrera, Hayden. *Frida Kahlo*. Chicago: Museum of Contemporary Art, 1978. Exhbn cat.

Herrera, Hayden. *Frida Kahlo: The Paintings*. New York: HarperCollins, 1991.

Kozloff, Joyce. "Frida Kahlo."*Women's Studies* 6 (1978), pp. 43–59.

Merewether, Charles, and T. del Conde. *The Art of Frida Kahlo*. Adelaide: Art Gallery of South Australia and the Adelaide Festival of the Arts, 1990. Exhbn cat.

Mulvey, Laura, and Peter Wollen. *Frida Kahlo and Tina Modotti*. London: Whitechapel Art Gallery, 1982.

Museum of Fine Arts. *The World of Frida Kahlo*. Houston: Author, 1993.

Orenstein, Gloria. "Frida Kahlo."*Latin American Art* 4, no. 3 (December 1991), pp. 31–34.

Orenstein, Gloria. "Frida Kahlo: Crónica, testimonios, y aproximaciones." Mexico City: *Ediciones de Cultura Popular*, 1977.

Orenstein, Gloria. "Frida Kahlo: Painting for Miracles." *Feminist Art Journal* (Fall 1973), pp. 7–9.

Orenstein, Gloria. "Frida Kahlo: Una vida abierta." Mexico City: *Editorial Oasis*, 1983.

Rivera, Diego, with Gladys March. *My Art, My Life: An Autobiography*. New York: Citadel, 1960.

Sullivan, Edward J. "Frida Kahlo in New York." *Arts Magazine* 57, no. 7 (March 1983), pp. 90–92.

Tully, Judd. "The Kahlo Cult." *Artnews* (April 1994), pp. 126–133.

Wolfe, Bertram D. *The Fabulous Life of Diego Rivera*. New York: Stein and Day, 1963.

Zamora, Marta. "Frida Kahlo: The Brush of Anguish" (trans. and ed. by Marilyn Solde-Smith). *San Francisco Chronicle*, 1990.

BIOGRAPHICAL ESSAY

Frida Kahlo's paintings are reflections of her innermost feelings and thoughts about her life: her childhood during the Mexican Revolution, a tragic bus accident that left her crippled and unable to bear children, her tormented marriage to muralist Diego Rivera, her intermittent love affairs with some of the most influential men of the twentieth century, her involvement in the Communist Party, and her undying fascination with the indigenous Mexican culture. Perhaps her most revered works are her self-portraits, which stand out like surreal pages of her diary, painted with aesthetic elegance and fervent passion.

Throughout her life, Kahlo used the self-portrait as a means to illustrate her state of mind, her suffering, her physical as well as emotional pain, and her joyous moments. Kahlo's self-portraits are the performative records and the visual documentation of her personal experiences of pain. A chronology of her life can be followed through her images of herself. Many of Kahlo's portraits are dramatically staged scenes of her constructed selves at various but significant moments in her life.

A severe accident as a teenager in 1925 left Kahlo in permanent pain. This tragedy cruelly shaped Kahlo's life and art. Along with a fractured spine, a shattered pelvis, and a crushed foot, she also lost her motherhood. Operations, miscarriages, and abortions filled her life until her death in 1954. During the times that she was bedridden, in excruciating pain, and incapacitated, she continued to use painting as a means to reconstruct her self and her body. It was

through the act of painting that Kahlo attempted to retrieve hope and power over her broken body and spirit.

In *My Birth* (1932), Kahlo stages her own birth. Depicted in this scene is a woman lying on a bed, her head covered with a white sheet and legs spread open, giving birth to a full-grown Frida. She reveals her bloody head emerging from the vaginal opening, staining the stark white sheets covering the bed. Over the bed is a *retablo* (picture of a saint) of Mater Dolorosa (Mother of Sorrows), pierced with daggers and shedding tears for her lost son and perhaps for Frida as well. This portrait contains three parts of Kahlo's self: the birthing mother she could never be, the sorrowful Virgin Mother, and the newborn Frida. In the same year *Henry Ford Hospital* depicts one of Kahlo's life-threatening miscarriages. She paints her little, contorted, bleeding body on a massive hospital bed. The bed is outside in a vacant lot within a cityscape. In the middle of the bed is the fetus she lost, in a puddle of blood. Surrounding her are carefully arranged objects—a crushed flower, an embryo of a child, a pelvic bone, and medical instruments—all attached to her by a red vein.

Besides the revelation of a wounded, broken self in painful dramas, Kahlo also portrays a more stately, public self in *Self-Portrait as a Tehuana* (1943). She is depicted as a Tehuana, a woman from the matriarchal society in Tehuantepec, Mexico. In this bustlike portrait, Kahlo is wearing the traditional wedding dress of Tehuantepec. She reveals the stoic, proud, and heroic Frida. The elaborate headdress and veil of lace and satin cover her head and frame her beautiful face. With Rivera as her "third eye," she looks out invincibly.

Kahlo's suffering self, her tortured relationship with her body, her tumultuous marriage to the unfaithful Rivera, and her obsession with her own image gave rise to over 55 self-portraits, which was almost one third of her oeuvre. Kahlo never presents her body according to conventional notions of the female body in art. Her paintings gave visibility and validity to subject matter and events that had seldom been represented and acknowledged as legitimate subjects for art.

One of her most unsettling, enigmatic paintings is her portrayal of herself as a deer in *The Wounded Deer (The Little Deer)* (1946). A little deer with Frida Kahlo's face and a body wounded with nine arrows stands helplessly in the middle of a clearing in a forest. A year later, in 1947, Kahlo painted *Self-Portrait with Loose Hair*, in which she appears strong but fraught with sadness and grief. Her hair is loosely hanging down to her shoulders as she stands firmly, in her red Mexican dress, against a lava rock from which a succulent plant sprouts. On the bottom of the painting there is an inscription in Spanish that reads: "I Frida Kahlo, painted myself from a mirror image. I am 37 years old and it is the month of July in 1947. In Coyoacán, Mexico, the place where I was born."

Kahlo's paintings are her repeated attempts to document and materialize her experience, to make it visible and credible. She lucidly describes this attempt to make her experience real through portraiture: "My subjects have always been

my sensations, my states of mind and the profound reactions that life has been producing in me. I have frequently objectified all this in figures of myself, which were the most sincere and real thing that I could do in order to express what I felt inside and outside myself.''

LOMAS GARZA, CARMEN

Nationality: Mexican. *Born*: 1948, Kingsville, Texas. She now lives in San Francisco. *Education*: Garza received an M.E. from Juarez-Lincoln/Antioch Graduate School in 1973 and an M.A. in 1980 from San Francisco State University. She attended Washington State, Pullman (1975–1976). *Family*: Garza's mother's family lived in Texas for many generations, working as ranch hands or cowboys (*vaqueros*) and on the railroad. One of her maternal great-grandfathers was a chuck-wagon cook on the famous King Ranch. Her father was born ''in the crossing,'' in Nuevo Laredo, just before his parents crossed the Rio Grande in flight from the hardships of the Mexican Revolution. Garza's parents met in Kingsville, where her father was employed as a sheet-metal worker at the naval air station. After raising five children, of whom Carmen is the second, her mother began working as a florist. Garza recalls that both her grandmother and mother were artistically inclined. Her grandmother produced crochet and embroidery works and paper flowers; her mother was a self-taught painter who specialized in handmade playing cards for *lotería*, a Mexican game similar to bingo. Inspired in part by their example, Garza decided as a teenager to become a professional artist, and her family supported her art endeavors. Garza grew up in Kingsville, Texas, a small community not far from the border with Mexico. *Career*: In college, Lomas Garza became involved in the Chicano movement, an effort for political reform for Mexican Americans and others of Latino ancestry. She worked at Galería de la Raza, San Francisco, between 1976 and 1981 as an administrative assistant and curator. She had two-person exhibitions at the Mexican Museum, San Francisco (1977); at the Frank C. Smith Fine Arts Center, Texas Arts and Industries University (1978); and at the Museum of Modern Art, San Francisco (1980).

SELECTED EXHIBITIONS

1996	*Cuadros de Recuerdos de una Artista Chicana (Paintings of Memories of a Chicana Artist)*, Steinbaum Krauss Gallery, New York City
1995	Whitney Museum of American Art at Philip Morris, New York, New York (brochure); Hirshhorn Museum and Sculpture Garden, Smith-

sonian Institution, Washington, D.C. (brochure); *Los Primos del Rio Abajo*, Millicent Rogers Museum, Taos, New Mexico

1994 *Día de los Muertos/Ofrenda para Antonio Lomas*, Honolulu Academy of Art, Honolulu, Hawaii

1993 *Carmen Lomas Garza/Works*, Terrain Gallery, San Francisco, California

1992 *Día de los Muertos Ofrenda para Tenoctitlan y Doña Marina (La Malinche)*, Smith College Museum of Art, Northampton, Massachusetts (brochure)

1991 *The Old and the New*, Galería Sin Fronteras, Austin, Texas; *Pedacito de mi Corazon (A Piece of My Heart)*, Laguna Gloria Art Museum, Austin, Texas (exhibition traveled to El Paso Museum of Art, El Paso, Texas; Texas A&I University, Kingsville, Texas; Lubbock Fine Arts Center, Lubbock, Texas; Mexican Fine Arts Center Museum, Chicago, Illinois; Laband Art Gallery, Loyola Marymount University, Los Angeles, California; The Oakland Museum, Oakland, California (catalog); *Tradition and Investigation*, Galeria Nueva (with Roberto Delgado), Los Angeles, California (brochure)

1990 Dexter Hall Gallery, California Polytechnic State University, San Luis Obispo, California; *Imagenes Familiares*, Bank of America, San Francisco, Los Angeles, and Modesto, California

SELECTED GROUP EXHIBITIONS

1996 *Labor of Love*, The New Museum of Contemporary Art, New York City, New York (catalog); *Legacy/Legado*, Old State House, Hartford, Connecticut, Luis Cancel, guest curator

1995 *Fables, Fantasies and Everyday Things: Children's Books by Artists*, Whitney Museum of American Art at Champion, Stamford, Connecticut; Paintings and More: A Chicana Perspective, Art Space Gallery, Fresno College, California; Multicultural Children's Literature, San Francisco International Airport, San Francisco, California; *Landscapes/Cityscapes*, M. H. de Young Memorial Museum, The Fine Arts of San Francisco, California; *Día de Los Muertos*, The Oakland Museum, Oakland, California; *A Defiant Legacy 1970–1995*, Galería de la Raza/Studio 24, San Francisco, California

1994 *Sor Juana Inés de la Cruz Festival: A Tribute to Mexican Women*, Mexican Fine Arts Center Museum, Chicago, Illinois; *Under One Sky: Opening Young Minds with Books*, Bedford Gallery, Regional Center for the Arts, Walnut Creek, California

1993 *Hispanic Perspective*, Patricia Stewart Gallery, Napa, California; In Out of the Cold, Center for the Arts at Yerba Buena Gardens, San Francisco, California (catalog); *Art of the Other Mexico*, Mexican Fine Arts Center Museum, Chicago, Illinois (exhibition traveled to Museo de Arte Moderno, Mexico City; Museo Regional de Oaxaca, Mexico; Cecut-Centro Cultural Tijuana, Baja California, Mexico;

Palm Springs Desert Museum, Palm Springs, California; Museo del Barrio, New York City, Center for the Arts, San Francisco, California) (catalog); *El Sabor, From Tradition to Innovation*, Galería de la Raza/Studio 24, San Francisco, California; *La Frontera/The Border: Art about the Mexico/United States Border Experience*, Centro Cultural de la Raza and the Museum of Contemporary Art, San Diego, California (exhibition traveled to Centro Cultural, Tijuana, Baja California, Mexico; Tacoma Art Museum, Tacoma, Washington; Scottsdale Center for the Arts, Scottsdale, Arizona; Neuberger Museum, State University of New York at Purchase; San Jose Museum of Art, San Jose, California) (catalog); *Chicano Art*, Jesse Alonso Gallery, Tucson, Arizona

1992 *The Chicano Codices*, The Mexican Museum, San Francisco, California (exhibition traveled to Foothills Art Center, Golden, Colorado; California State University–Northridge Art Gallery, Northridge, California; La Plaza de la Raza, Los Angeles, California; Centro Cultural de la Raza, San Diego, California; El Centro de la Raza, Seattle, Washington) (catalog); *C.A.R.A., Chicano Art: Resistance and Affirmation*, National Museum of American Art, Smithsonian Institution, Washington, D.C. (traveling exhibition); *Master Prints from the Rutgers Center for Innovative Printmaking, The First 5 Years*, gallery at Bristol-Myers Squibb, Princeton, New Jersey; *Hospitality House, 7th Annual Art Auction*, Stephen Wirtz Gallery, San Francisco, California; *Lo Mejor de lo Nuestro*, La Peña, Austin, Texas; *Latino Art Show*, Concannon Vineyard, Livermore, California; *Directions in Bay Area Printmaking: 3 Decades*, Palo Alto Cultural Center, Palo Alto, California (catalog)

1991 *Her Story*, The Oakland Museum, Oakland, California (catalog); *Behind the Scenes: The Collaborative Process*, BACA, Berkeley Art Center Association, Berkeley, California (brochure); *Art as a Healing Force*, Bolinas Museum, Bolinas, California (catalog); *Tejanos*, The University of Texas at San Antonio Art Gallery, San Antonio, Texas (catalog); *Los Artistas Chicanos de Valle de Tejas: Narradores de Mitos y Tradiciones*, Centro Cultural, Tijuana, Baja California, Mexico (traveling exhibition) (catalog); *Mujeres, La Peña*, Austin, Texas; *Presswork, the Art of Women Printmakers*, Lang Communications and the National Museum of Women in the Arts, Washington, D.C. (traveling exhibition) (catalog); *Crossing Over/Changing Places*, The Print Club, Philadelphia, Pennsylvania (traveling exhibition) (catalog)

1990 *C.A.R.A., Chicano Art: Resistance and Affirmation, 1965–1985*, Wright Art Gallery, University of California, Los Angeles (traveling exhibition, including National Museum of American Art, Smithsonian Institution, 1992, poster and invitation at National Museum of American Art, Washington, D.C.) (catalog); *Printed in America*, Walters Hall Gallery, Art Center, Douglass College Campus, Rutgers State University of New Jersey; *15 Pintores, 3 Escultores Tejanos Artistas Mexicano-Norte Americanos*, Instituto Nacional de Bellas

Artes, Museo de Arte Alvar y Carmen T. de Carrillo Gil, Mexico, D.F. (catalog); *Visible Truths: Traditional Sources within the Chicano Esthetic*, Galería Posada, Sacramento, California; *Body/Culture: Chicano Figuration*, University Art Gallery, Sonoma State University, Rohnert Park, California (traveling exhibition) (catalog); *Days of Saints and Souls, a Celebration of the Days of the Dead*, De Pree Art Center, Hope College, Holland, Michigan

COLLECTIONS

Dain Bosworth Company, Minnesota; El Paso Museum of Art, El Paso, Texas; Federal Reserve Bank of Dallas, Texas; Fresno Unified School District, Fresno, California; Galería de la Raza/Studio 24, San Francisco, California; Hirshhorn Museum and Sculpture Garden, Smithsonian Institution, Washington, D.C.; The Jane Voorhees Zimmerli Art Museum, Rutgers University, New Brunswick, New Jersey; Kaiser Permanente Art Program, Denver, Colorado; Lang Communications, New York, New York; McAllen International Museum, McAllen, Texas; McAllen Memorial Library, McAllen, Texas; Mexican American Library Project, University of Texas Library, Austin, Texas; Mexican Fine Arts Center Museum, Chicago, Illinois; The Mexican Museum, San Francisco, California; Mills College Art Gallery, Oakland, California; National Museum of American Art, Smithsonian Institution, Washington, D.C.; The Oakland Museum, Oakland, California; San Francisco Art Commission, City and County of San Francisco, California; Shields Library, University of California, Davis, California; Smith College Museum of Art, Northampton, Massachusetts; St. Paul Companies, Minneapolis, Minnesota; Texas Women's University, Denton, Texas; Tucson Museum of Art, Tucson, Arizona

PUBLICATIONS

Alba, Victoria. "Artists with a Mission." *San Francisco Examiner*, May 20, 1990.

Andrade, Sally J. "Painting a Different Picture" (letter to the editor). *Washington Post*, December 17, 1995, pp. G7–G9.

Artforum, December 1995. (*Labor of Love* exhibition announcement)

"Arts and Leisure Guide." *New York Times*, January 14, 1996. (*Labor of Love* announcement, with detail of Nopalitos Para Ti).

Brown, Betty. "Carmen Lomas Garza." *Art Scene* 12, no. 3 (November 1992), pp. 15, 16, 33.

Brown, Betty Ann. "A Community's Self-Portrait." *New Art Examiner* (December 1990), pp. 20–24.

Brown, Mike. " 'Pedacito' Exhibit Enjoyable Experience" (letter to the editor). *El Paso Herald Post*, February 4, 1992.

Cardenas, Gilberto, and Amelia Malagamba. *Los Artistas Chicanos del Valle de Tejas: Narradores de Mitos y Tradiciones*. Tijuana: Centro Cultural Tijuana, 1991. Exhbn cat.

"Carmen Lomas Garza: Pedacito de mi Corazon." *Laguna Gloria Art Museum Newsletter*, November–December 1991, front page.

Cotter, Holland. "Carmen Lomas Garza" (review). *New York Times*, July 18, 1995, p. C21.

Crohn, Jennifer. "What's the Alternative?" *The East Bay Guardian* (March 1991), p. 41.

Davis, Jim. "Memories of Home: Art by Kingsville Native Reflects Chicano Life in South Texas." *Corpus Christi Caller-Times*, November 8, 1991, pp. E6, E7.

El Tiempo Latino (Washington, D.C.). November 10, 1995, p. 7. (photograph *Self Portrait*, 1980)

El Tiempo Latino (Washington, D.C.). November 17, 1995. (exhibition announcement)

Farley-Villalobos, Robbie. "Artist's Political Struggle Opens Museum," *El Paso Herald-Post*, December 19, 1991, p. 3.

Farley-Villalobos, Robbie. "Museum President Embarrassed: 'Personal' Survey Shows Public Doesn't Like Current Exhibit," *El Paso Herald-Post*, January 25, 1992, front page.

Filler, Marion. "Art Shows Put Latinos on Exhibit." *Daily Record*, January 27, 1996.

Fonseca, Marcela Sanchez. "Color y composición en la obra de Carmen Lomas Garza." *El Tiempo Latino* (Washington, D.C.), January 19, 1996, p. B1.

Guevara, Aurora. "Artist Shows Off Considerable Talents" (letter to the editor). *El Paso Herald-Post*, February 4, 1992.

Hess, Elizabeth. "Needles and Pins." *Village Voice*, February 6, 1996. (exhibition review of group show *Labor of Love*; Garza not mentioned)

Heyman, Therese. *Her Story: Narrative Art by Contemporary California Artists*. Oakland, Calif.: Oakland Museum, 1991. Cat.

"Hirshhorn inaugura muestra de artiste Chicana." *La Nación*, November 17, 1995. (exhibition announcement with photograph)

Hurley, Anne. "Galería de la Raza Turns 20." *San Francisco Bay Guardian*, August 29, 1990, p. 47.

Jones Joyce. "All in the Family" (review). *Washington Post*, December 8, 1995.

Ken Oda's Art Newsletter. December 1995, p. 20.

Kutner, Janet. "Art with Roots." *Dallas Morning News* (Dallas, Tex.), February 17, 1990, pp. 1C–2C.

Levy, Rebecca. "Ofrenda del Corazon," *Austin Chronicle*, November 1, 1991.

Lewis, Valerie. "A Celebration of Family" (review). *San Francisco Chronicle*, July 29, 1990, p. 9.

Lippard, Lucy R. *Mixed Blessings—New Art in a Multicultural America*. New York: Pantheon Books, 1990.

Marcus, Hal. "Individuals Must Judge Art for Themselves" (letter to the editor). *El Paso Herald-Post*, February 4, 1992.

Marquis, Ann-Louise. *Carmen Lomas Garza*. Washington, D.C.: Hirshhorn Museum and Sculpture Garden, 1995. Exhbn brochure.

Marquis, Ann-Louise. "Carmen Lomas Garza: Hirshhorn Exhibition Features Work by Mexican American Artist." *Smithsonian* (Fall–Winter 1995), pp. 1–2.

"The Marvelous, The Real (Lo Real Maravilloso)." *Mexican Museum Newsletter* (San Francisco, Calif.) (Fall–Winter 1987–1988).

Matthews, Lydia. "Stories History Didn't Tell Us." *Artweek*, February 14, 1991, pp. 1, 15–17.

Meek, Sharon. "Making Memories, Monitos Style." *School Arts* (April 1995), pp. 25–26.

Mejias-Rentas, Antonio. "Arts & Entertainment." *Hispanic Link Weekly Report* (Washington, D.C.), November 13, 1995.

Mesa-Bains, Amalia. Essay in *Body/Culture: Chicano Figuration*. Rohnert Park, Calif.: Sonoma State University, 1990. Exhbn cat.

Mesa-Bains, Amalia. Essay in *C.A.R.A. Chicano Art: Resistance and Affirmation*. Los

Angeles: Wight Art Gallery, University of California, Los Angeles, 1991. Exhbn cat.

Mesa-Bains, Amalia. *Homenaje a Tenochtitlan: An Installation for the Day of the Dead by Carmen Lomas Garza*. Northampton, Mass.: Smith College Museum of Art. 1992. Exhbn cat.

Museums (New York). Spring 1996. (exhibition review of group show *Labor of Love*; Garza not mentioned)

Museums (New York). Winter 1995–1996. (*Labor of Love* announcement)

Nelson, Robert. "Art Museum Finds Lots of New Friends." *El Paso Times*, February 9, 1992, sec. B. *New York Observer*. January 20, 1996.

Oleson, J. R. "Lomas Garza Tells Own Stories." *Austin American-Statesman*, November 9, 1991, p. 13.

Quirarte, Jacinto. *15 Pintores, 3 Escultores Tejanos Artistes Mexicano-Norteamericanos*. Mexico, D.F.: Instituto Nacional de Bellas Artes, Museo de Arte Alvar y Carmen T. de Carrillo Gil, 1990. Exhbn cat.

Richard, Paul. "Tejana Nostalgia." *Washington Post*, December 3, 1995.

Santiago, Chiori. "The Mexican Museum." *Latin American Art* 2, no. 4 (Fall 1990), pp. 95–98.

Shaw-Eagle, Joanna. "Rich Heritage Fills Joyful Pictures from Childhood." *The Sunday Times/The Washington Times*, December 17, 1995, sec. D.

Smith, Roberta. "Fine Art and Outsiders: Attacking the Barriers." *New York Times*, February 6, 1996. (exhibition review of group show *Labor of Love*; Garza not mentioned)

Smithsonian. Vol. 26, no. 9 (December 1995), p. 34. (exhibition announcement)

Snow, Shauna. "Deep in the Heart of Chicano Art." *Los Angeles Times*, November 7, 1992, pp. F6, F7.

Soto, Gary. *A Summer Life*. Hanover: University Press of New England, 1990. (jacket cover)

Strickland, Carol. "A Labor of Love Focuses on the Artist's Heart as Well as Hands." *Christian Science Monitor*, February 12, 1996. (exhibition review of group show *Labor of Love*; Garza not mentioned)

Szilagyi, Pete. "Art from the Heart: Carmen Lomas Garza's Work Depicts Childhood Memories." *Austin American-Statesman*, October 26, 1991, p. 13.

Tucker, Marcia. *A Labor of Love*. New York: New Museum of Contemporary Art, 1996. Cat.

Van Proyen, Mark. "To Touch Both Soul and Body." *Artweek*, April 11, 1991, pp. 11–12.

Velasco II, Robert. "Complex Latino Experience" (letter to the editor). *Washington Post*, December 13, 1995.

Village Voice. January 28, 1996. (*Labor of Love* exhibition announcement)

Village Voice. February 6, 1996. (announcement for lecture *Tied to Tradition* in conjunction with *Labor of Love* exhibition)

Washington Hispanic (Washington, Maryland, Virginia). November 17, 1995. (exhibition announcement)

Wasserman, Abby. "The Art of Narrative." *Museum of California Magazine* 15, no. 1 (Winter 1991), pp. 24–28.

Woodard, Josef. "Not So Naive After All." *Artweek*, April 14, 1991, pp. 9–10.

Zamudio Taylor, Victor. *Carmen Lomas Garza*. New York: Whitney Museum of American Art at Philip Morris, 1995. Exhbn cat.

ARTIST STATEMENT (1997)

At the age of 13 I decided to become a visual artist and pursue every opportunity to advance my knowledge of art in institutions of higher education. The Chicano movement of the late 1960s inspired the dedication of my creativity to the depiction of special and everyday events in the lives of Mexican Americans based on my memories and experiences in south Texas. I saw the need to create images that would elicit recognition and appreciation among Mexican Americans, both adults and children, while at the same time serve as a source of education for others not familiar with our culture. The process of creating these images has been a salve for the wounds of discrimination in the public schools of my youth. It has been my objective since 1969 to make paintings, prints, installations for Day of the Dead, and paper and metal cutouts that instill pride in our cultural and historical contributions to American society.

BIOGRAPHICAL ESSAY

Most of Carmen Lomas Garza's images are derived from recollections of her childhood in south Texas. For over 20 years she has chronicled the celebrations, family stories, shared memories, everyday rituals, and healing ceremonies of her cultural community of Kingsville, Texas, in the 1950s and 1960s. Relatives and friends are depicted as remembered in such everyday activities and celebrations as tamale making, wedding day blessings, birthday barbecues, her grandfather gardening, *limpiezas* (cleanings), and *ferias* (fairs). Her family's history is rich with stories of her Spanish, Mexican, and American ancestors. Her father's family moved to Texas as a result of the Mexican Revolution, and her mother's family included *vaqueros* (Mexican American cowboys), railroad workers, and a chuck-wagon cook.

Lomas Garza's visual recollections are like pages in a family album, recording and documenting important events and the magic moments of everyday living. Her visual records are grounded in oral traditions—stories, myths, and *chisme* (gossip). Her *monitos* (doll-like figures) as well as her insistence on narrative are inspired by the tradition of popular votive and folk painting still prevalent in Latin America, Mexico, Texas, and New Mexico artistic traditions. Her particular figuration creates a visual language centered on storytelling.

In *Para la Sena (For Dinner)* (1986), the preparation of the family meal is vividly documented and becomes a ritualized drama of the killing of chickens for dinner. Feathers are flying, and mother and father are active participants while the children look on, sipping their dripping *raspados* (ice cones). The magnification of detail conjures up diverse narrative possibilities and interpretation. Similar devices operate in *El Milagro (The Miracle)* (1987), which de-

picts the apparition of the Virgin of Guadalupe on a water tank. Families gather out of faith, devotion, and curiosity to see the miraculous outline of the Virgin. Bleeding snakes and floral gifts are presented as offerings to the Patroness. Lomas Garza depicts herself as a child wearing a blue and white dress. The scene evokes a sense of wonder and mystery, a sense of the marvelous in the real.

Lomas Garza recounts her memory that inspired *El Milagro*: ''There was a rumor going around the colonia that the Virgin of Guadalupe had appeared on a water tank in a ranchito not too far from town. So when we all got home from school and work my parents took us in the truck on a search for the ranchito. Some of us could see the Virgin in the water stains, others did not believe. Many people had been there all day praying and trying to make out the image of the Virgin. Instead of bothering the family of the ranchito some people had gone out into the fields to relieve themselves which alarmed the family. The rattlesnakes were a warning to people to be very careful when walking in the fields.''

Lomas Garza uses memory as a tool and a guiding impulse for transforming ordinary, everyday episodes into poetic recollections. She transposes images and scenes from her past, combining cultural documentation with invention, fact with fiction. Her seemingly peaceful, magical, harmonious pages of life often have a disquieting quality underneath their celebratory surfaces. Her exaggerations and simplifications have emotionally charged implications that oscillate between wonderment, excitement, and serenity to a subtle, chilling uneasiness. Her innerscapes fuse the imaginary with the palpable. The killing of a chicken, a birthday celebration, or a virginal apparition is no longer ordinary but hauntingly whimsical. Lomas Garza explains the deeper significance of unveiling the marvelous real. ''If you see my heart and humanity through my art, then hopefully you will not exclude me from rightfully participating in this society . . . and now I give you a little piece of my heart in my art.''

LÓPEZ, POLA

Nationality: New Mexican. *Born*: 1954, Las Vegas, New Mexico. *Education*: López is a self-taught artist. Mediums include oil and acrylic on canvas, gouache, encaustic, and monoprints. *Family*: Her father is a poet. López is divorced and has two children, Jazmin and Catana. *Career*: As well as a full-time artist, López is a self-employed businesswoman. From 1978 to 1987 she owned and operated La Galería de Colores, a studio, gallery, and art store in Las Vegas,

New Mexico. From 1988 to 1995 she owned and operated Taos Studio Connection, an art store. She has done illustrations for books, magazines, and posters, including color illustrations for *La Musica del Sol* (Houghton Mifflin) and writer Jim Sagel's book *Mas Que No Love It*. *Awards*: In 1984 she received a Fellowship Grant from the Rio Grande Institute, Albuquerque, New Mexico. The Hispano Chamber of Commerce awarded her for Community Service in the Arts in 1985. She won Best of Show at the Hispanic Invitational, Millicent Rogers Museum, Taos. In 1995 López received a Printmaking Fellowship from the Tamarind Institute, Albuquerque, New Mexico.

EXHIBITIONS

1995 *Hispano Artists*, Fine Arts Museum, Albuquerque, New Mexico; *Fall Arts Festival Invitational*, Taos, New Mexico; *Crafting Devotions*, Gene Autry Museum, Los Angeles, California

1994 *Artistas Contemporáneos de Nuevo Mejico*, Guadalajara, Mexico; *Hispanic Art*, Stables Gallery, Taos Art Association, Taos, New Mexico; Hispanic Contemporary Market, Santa Fe, New Mexico; *Las Mujeres de la Tierra del Sol*, photo exhibited and panel participant, Center for Southwest Research, University of New Mexico, Albuquerque, New Mexico

1993 *Imágenes de la Fe*, Taos Inn, Taos, New Mexico; *Voyeur: A Show of the Erotic*, Goebel Gallery, Taos, New Mexico; De Colores Gallery, Taos, New Mexico (three-person show); Spring Arts Celebration, Taos, New Mexico; *Nuestras Mujeres*, Maxwell Museum, University of New Mexico, Albuquerque, New Mexico; *New Mexico State Fair Hispanic Exhibit*, Albuquerque, New Mexico

1992 *Aztlán '92*, Gallery at the Rep, Santa Fe, New Mexico

1991 *Live from Taos*, Design Center, Taos, Russel Senate Rotunda, Washington, D.C., Buffalo Gallery, Alexandria, Virginia (traveling exhibit); *Mundo Mestizo*, Millicent Rogers Museum, Taos, New Mexico (two-person exhibit); *Selections '90*, College of Santa Fe, Fine Arts Gallery, Santa Fe, New Mexico; *Perspectives in Cultural Identity*, Centinel Bank, Taos, New Mexico (one-woman show)

1990 *Governor's Gallery Keynote Exhibit*, Albuquerque Fine Arts Gallery, New Mexico State Fair; *Contemporary Hispanic Art in Northern New Mexico*, Stables Gallery, Taos Art Association, Taos, New Mexico

1988 *Spanish Arts Fair Exhibit*, Martinez Hacienda, Taos, New Mexico; *Hispanic Expressions of New Mexico*, Governor's Gallery State Capital, Santa Fe, New Mexico

1987 *Frieda y Diego: Una Pareja*, Mi Raza Arts Consortium, Prairie Avenue Gallery, Chicago, Illinois

1986 Woman's Juried Exhibit, New Mexico Highlands University, Las Vegas, New Mexico

1985 *Indo-Hispaño/Nuevo Mejicano*, Ghost Ranch, Albuquerque, New

Mexico; *La Feria Artesana*, Convention Center, Albuquerque, New Mexico; *Vistas Artísticas*, United World College, Montezuma, New Mexico

1984 Artistas Indígenas, *"Full Moon Harvest,"* Dougherty Arts Center, Austin, Texas; *A Spirit Shared*, Fine Arts Museum, Santa Fe, New Mexico

1983 *Chicana Voices and Visions*, Social and Public Art Resources Center, Venice, California; *Canción*, La Galería de Colores, Las Vegas, New Mexico

1982 Armand Hammer United World College Opening Exhibit, Montezuma, New Mexico; *Motivos Sinceros*, Guadalupe Foundation, Santa Fe, New Mexico

1981 Native American/Hispanic Festival, Institute of American Indian Arts, Santa Fe, New Mexico

1979 *La Cofradía*, Museum of Fine Arts, Santa Fe, New Mexico

1975 Fine Arts Exhibit, New Mexico State Fair, Albuquerque, New Mexico (juried)

COLLECTIONS

Millicent Rogers Museum, Taos, New Mexico; Santuario de Guadalupe, Santa Fe, New Mexico; Various private collections in New York, Colorado, California, Texas, Florida, Oklahoma, Kentucky, New Mexico, and Puerto Rico

PUBLICATIONS

"Artist Profile." *New Mexico Magazine* (May 1992).
Cover story. *Albuquerque Journal* (July 1991).
The Desert Is No Lady. Chicago, Ill.: British Broadcasting Co. and Brigham Young SBG Reading Program, Ligature, 1995. Documentary film.
Gourmet Magazine. November 1992.
Museum News Magazine. November–December 1993.
"Nuestras Mujeres Hispañas of New Mexico: Their Images and Lives, 1582–1992." *El Norte Publication*, 1992.

ARTIST STATEMENT (1997)

The time comes
When you whistle a tune that is strange
And the heart cares not where it was born
Never to repeat it again, not even once
Knowing it is but the reflection of your soul.

This excerpt from a poem written by my father best conveys poetically how I feel about my creative work. At times I feel that my work is a reflection of

my soul, the sole expression of my spirit, and at other instances, I feel that it is the physical reflection of this world on me.

As a native New Mexican now residing in Taos, I seek to capture the spiritual essence as it is embodied in physical terms of life. As an indigenous female surrounded by the bounds of a mixed cultural identity rich in tradition, my images relay the distinct flavor of this region but are universal in relevance.

If I accentuate the simple and positive aspects of life, it is in these things that I see the most beauty. Nothing is deliberate in my painting technique, as I am a self-taught artist and I remain true to my inspiration that springs from the heart.

Spiritual survival as it is interwoven with the menial tasks of everyday existence, the mudding of a wall, the sharing of native foods at the dinner table, the icons of our religious heritage, our families, and our simple way of life create a balance and a sustenance upon which rests the magic of this land, *La Tierra Encantada*, and it's people that have been my inspiration.

BIOGRAPHICAL ESSAY

The festivities, grandeur, and celebration of everyday life emanate from Pola López's brilliantly painted canvases. Ordinary people of rural New Mexico, their cherished foods, objects, images, activities, and traditions she presents with a density that reveal their deeper meaning. *El Sabor* and *Ven, Sientate a Comer (Come, Sit, and Eat)* both present savory displays of traditional foods on dinner tables, celebrating the everyday feasts of native dishes—tamales, beans, chile, *calabacitas, posole*, tortillas, and empanaditas. In *Las Enjarradoras (The Mud Plasterers)*, she commemorates women's active participation in the construction and restoration of adobe structures, particularly churches, in the communities of rural New Mexico.

López uses the symbols of her ancestral faith, folk Catholicism, and combines them with secular themes to explore their duality. A recurring image and evocative metaphor in her paintings is the Virgin of Guadalupe. It is this particular version of the Virgin that the artist is constantly revising. López explains that the Virgin of Guadalupe's urgent message to the world is a warning of current environmental conditions. The Virgin, according to the artist, "is the cosmic Earth Mother reminding us to unite to save the planet." *All One People* is a floral tapestry that envelops the Virgin of Guadalupe and a flag showing the earth from outer space. This painted altar of flowers, cactus, and candles is crowned by a winged heart.

Ever since her childhood in rural New Mexico, López has been immersed in traditional community activities, rituals, and stories embedded in the strata of New Mexico's indigenous culture. She began painting as a young girl who fell in love with paint and color after accidentally spilling jars of paint during a kindergarten art class. Her medium repertoire has expanded considerably ever since and now includes encaustic, mixed media, oil, acrylics, gouache, pen and

ink, and lithography. Her father's poetry was also an inspiration to the young López. As a self-taught painter, she relies on her experience, beliefs, and faith as educational and aesthetic materials for her life's work.

Themes in the work vary from representations of everyday life to critiques of dominant culture. *Who Wins This Game?* explores ethnic stereotypes in an effort to transcend them. López makes a game board of words and images surrounding dominant culture's labeling and categorization of Latino experience, at the same time exposing the richness and diversity of that cultural heritage. A game of tic-tac-toe is implied, with the winner undetermined.

The people, land, and culture of her native New Mexico continue to fuel the work of López. Her images embody the spirit and enchantment of her home, her faith, her experience—all richly rooted in the land that bore her. When she is compared to the late Georgia O'Keeffe, who also used such symbols as flowers and crucifixes to celebrate the sacredness of the New Mexico landscape, López de Jaramillo wittingly remarks: "We have the same backyard."

LÓPEZ, YOLANDA M.

Nationality: Mexican American. *Born*: 1942, San Diego, California. She has been a permanent resident of San Francisco since 1979. *Education*: López attended the College of Marin in 1964 and San Francisco State University from 1966 to 1969. In 1975 she completed a B.A. in painting and drawing from San Diego State University. She received an M.F.A. from the University of California, San Diego, in 1978. *Family*: López's grandparents fled Mexico to the United States in 1918. Her grandparents were born in Mexico. Her grandfather, Senobio Franco, worked as a tailor and was born in Guadalajara to an entrepreneurial family of small shopkeepers. Her grandmother, Victoria Fuentes, was a housewife and was born in Mexico City to a family of flower vendors. Yolanda is the oldest of three daughters from her mother's first marriage at the age of 22. Her mother was divorced before the third girl was born. They lived with her maternal grandmother and grandfather and uncles until López was 11 years old, when her mother married for the second time. López's mother supported the family as a seamstress for 30 years. She was raised in Logan Heights and moved to the Bay Area shortly after her high school graduation. In 1968 she became part of the San Francisco State University Third World Strike. She worked as a community artist in the Mission District with a group called Los Siete de la Raza. She lives and works in San Francisco with her son. *Career*: López has taught at University of California, Berkeley, 1981, 1982, 1992, 1994;

Mills College, 1989, 1995; California College of Arts and Crafts, 1989, 1996;
San Francisco State University, 1990, 1991, 1994; Stanford University, 1997;
University of California, Santa Cruz, 1997; and San Francisco Unified School
District. López has also been a California Art Council Artist-in-Residence.
Awards: In 1993 she was honored with a Chicanas in the Arts Award from the
National Association for Chicano Studies. In 1996–1997 López was given a San
Francisco Arts Commission Cultural Equity Grant for Individual Artist Com-
mission. She was awarded a Eureka Fellowship Grant from the Fleishhacker
Foundation in San Francisco for 1996–1998. In 1997 López received a grant
from the Pollock-Krasner Foundation, New York; and a Rutgers Dialogue Grant,
Mason School of the Arts, New Jersey.

SELECTED EXHIBITIONS

1986–1993 *Cactus Hearts/Barbed Wire Dreams: Media, Myths, and Mexicans*,
 MACLA Center for Latino Arts, San Jose, California; Galería de la
 Raza, San Francisco, California; Galería Posada, Sacramento, Cali-
 fornia

1979 *Recent Paintings: Yolanda M. Lopez*, San Diego State University Art
 Department, San Diego, California

1978 *Works: Yolanda M. Lopez 1975–1978*, Mandeville Center for the
 Arts, University of California, San Diego, and El Centro Cultural de
 la Raza, San Diego, California

1976 *Tres Mujeres: Three Generations*, Galería Campesina, La Brocha del
 Valle, Fresno, California

1975 *One Woman Show*, The Community Center, Chicano Federation Inc.,
 San Diego, California

RECENT GROUP EXHIBITIONS

1997 *The Eureka Fellowship Awards Exhibit*, San Jose Museum of Art,
 San Jose, California; *Art of the Americas: Identity Crisis*, M. H. de
 Young Memorial Museum, San Francisco, California

1996–1997 *The Madonna: Four Centuries of Divine Imagery*, William King Re-
 gional Arts Center, Virginia Museum of Fine Arts, Abingdon, Vir-
 ginia

1996 *Sexual Politics: Judy Chicago's Dinner Party in Feminist Art His-
 tory*, Armand Hammer Museum of Art and Cultural Center, UCLA,
 Los Angeles, California; *Cancer Support Community Exhibit*, Latino
 Outreach Project, Galería Museo, San Francisco, California

1995 *10 × 10: Ten Women/Ten Prints*, Berkeley Art Center, Berkeley,
 California

1994 *Xicano Ricorso: A Thirty Year Retrospect from Aztlán*, Museum of
 Modern Art, New York; *Fierce Tongues: Women of Fire*, Highways,
 Santa Monica, California

1993–1994 *La Frontera/The Border: Art about the Mexico/United States Border*

Experience, Museum of Contemporary Art, San Diego, California (traveling exhibition)

1992–1993 *Counter Weight/Alienation, Assimilation, Resistance: Artists Who Investigate the Tension between Group Identification and Self-Representation and Who Counter Socially Constructed Ideas about Race, Gender, Ethnicity, Culture, and Sexuality*, Santa Barbara Contemporary Arts Forum, Santa Barbara, California

1992 *Tele Mundo: Karen Atkinson, Yolanda López, Iñigo Manglana-Ovalle, Celia Alvarez Muñoz, Jorge Pardo, Danny Tisdale*, Terrain Gallery, San Francisco, California; *Journeys: The Bus Shelter Project, Intersection for the Arts*, various locations, San Francisco, California

1990–1993 *CARA: Chicano Art—Resistance and Affirmation*, Wright Art Gallery, UCLA, Los Angeles, National Museum of American Art, Smithsonian Institution, Washington, D.C., San Francisco Museum of Modern Art, The Bronx Museum, New York

1990 *The Decade Show: Dreamworks of Identity in the 1980s*, The New Museum of Contemporary Art, Museum of Contemporary Hispanic Art, The Studio Museum in Harlem, New York; *Sacred Forces: Contemporary and Historical Perspectives*, Yolanda López, Ana Mendieta, Mayumi Oda, Nancy Spero, San Jose State University Art Gallery, San Jose, California

SELECTED VIDEO SHOWINGS

1987–1988 *Terrorizing the Code: Recent U.S. Video*, The Australian Video Festival, The Center for Photography, Sidney; The University Gallery, Tasmania; The Center for Contemporary Art, Melbourne

1987 *Sin Fronteras*, Society of Photographic Educators (SPE) National Conference and Women's Caucus Invitation Video Exhibition, San Diego, California; *Passages: A Survey of California Women Artists, 1945 to Present & The Lively Arts: Video and Performance, Part III*, Fresno State University, Fresno, California

1986 *Mapping One Place onto Another*, SF Art Commission Gallery, San Francisco, California; *Women, Culture & Public Media*, Hunter College, New York City

PUBLICATIONS

Lippard, Lucy. *Mixed Blessings, New Art in a Multicultural America*. New York: Pantheon Books, 1980.

López, Yolanda, with Moira Roth. "Social Protest: Racism and Sexism." In Norma Broude and Mary D. Garrard, eds., *The Power of Feminist Art: The American Movement of the 1970s, History and Impact*. New York: Harry N. Abrams, 1995.

Mano a Mano, Abstracción/Figuración, 16 Pintores Mexicano-Americanos y Latino-Americanos del area de la Bahía de San Francisco. Santa Cruz: Art Museum of Santa Cruz County and University of California, 1988.

ARTIST STATEMENT (1997)

Making art for me is the way I practice being a good citizen. Who do I make art for? Well, of course, every piece I make I do for myself, because it interests me. Beyond that, I make art for other Chicanos, especially those I know, California Chicanos. It is with them I share the jokes in my work, our common anger and rage, our sense of what is kind and compassionate in a world fraught with irony and injustice. Art is important. The artist is the person in society who dreams out loud.

BIOGRAPHICAL ESSAY

Yolanda López's work documents the years of struggle by the Latino community, particularly her own. She has been an activist for farmworkers' rights, labor unions, and immigration rights in California. Making art, according to López, is the way she practices being a good citizen. For her, it is also a way to dream out loud, to express rage and compassion. She sees her artistic function as that of provocateur. Her intent has remained the same for over a decade: to challenge and critique representations of Mexicans, particularly images generated by popular culture and the media, and to heighten consciousness and access information for political and social change via new images.

New images are precisely what López offers in her 1978 Virgin of Guadalupe portrait series, in which she portrays herself, her mother, and her grandmother as the Virgin of Guadalupe. López critiques this potent mother icon, the archetype of the ideal woman/mother originating in Mexican culture. She prompts the reinterpretation of a culturally constructed idealization of woman that is unrealistic for women. She offers instead new role models of ordinary women who are real and accessible. Her Guadalupes are attempts to empower women by glorifying and honoring the activities of working-class women of all ages, occupations, and personalities.

Although López's images of Guadalupe have provided liberation and hope for many women, they have also offended many church officials who consider them sacrilegious depictions of the Holy Mother. López's Guadalupes, however, celebrate the Holy Mother in each of us, as well as challenge authoritarian, patriarchal constructions, images, and ideologies.

Throughout the years the content of López's work has not changed, but her mediums have. She began as a painter, but her work in the last ten years has expanded into installation, video, and slide presentations. In the 1980s she began to collect images—ads in magazines, newspapers, photographs of other artists' work—anything with representations of Mexicans or Chicanos. López began to explore the stereotypes and misrepresentations of Mexicans in magazines, on storefronts, on food containers, in cartoons, in movies, and as toys. Her video *When You Think of Mexico: Images of Mexicans in the Media* (1986) explores issues of identity, representation, assimilation, and cultural change, citing stereo-

types of Mexicans in the media like the Frito Bandito, the Mexican with an oversized sombrero taking a siesta, and the Mexican woman always portrayed with long hair pulled back, hoop earrings, and wearing a peasant blouse.

Out of her concern for images, especially derogatory ones, came her series *Cactus Hearts/Barbed Wire Dreams: Media, Myths, and Mexicans*, which began with an installation of collected objects, and *Things I Never Told My Son About Being Mexican*, which was part of a major traveling exhibition and was exhibited in the New Museum of Contemporary Art in New York. In these as in other works, López attacks popular culture. Her current project, *Women's Work Is Never Done*, includes a series of prints, as well as the installation *The Nanny*, and explores the invisibility of immigrant women as domestic workers. The first image is her response to Proposition 187, the California initiative that would have cut public services to illegal immigrants and their children. Another image features a portrait of Dolores Huerta, who cofounded United Farm Workers, with images of women harvesting broccoli.

Even though López's work reaches a variety of audiences, she does intend for it to target the Latino audiences. She hopes that her images will provoke them to rethink certain issues and create awareness and dialogue concerning the misrepresentation of Latinos in many public images. López's work has been influenced by the Chicano movement of the 1970s and the civil rights movement of the 1980s. She believes that artists, as image makers, have the opportunity to reinterpret old images and generate new ones. For López, even a plastic toy her son got at Walgreen's called "Taco Terror" is a political statement and another example of popular culture's stereotypic representation of Mexican Americans.

MALFATTI, ANITA

Nationality: Brazilian. *Born*: 1896, São Paulo. *Education*: Malfatti studied at Mackenzie College, São Paulo from 1904 to 1906. She continued her studies at the Imperial Academy of Fine Arts in Berlin with Fritz Burger and Expressionist Lovis Corinth. While in Europe she was exposed to the trends of modern painting. When World War II broke out, she returned to Brazil. Malfatti subsequently traveled to New York, where she attended the Art Students' League and the Independent School of Art. She also studied with Homer Boss of the Fifteen Group and became acquainted with Marcel Duchamp. *Family*: Malfatti was the daughter of an Italian engineer. Her mother was of German descent. *Career*: Malfatti's early paintings were influenced by Cubism and Expressionism. After

her stay in New York, Malfatti returned to São Paulo, where she had her first solo exhibition at the Líbero Badaró in 1917. This exhibition received a negative review by an influential critic and created a scandal. In 1922 she participated in the historic *Modern Art Week*, during which visual artists, performers, and writers declared their break from traditional forms of art in Brazil. In the same year she joined with Brazilian artist Tarsila do Amaral and avant-garde writers to form Grupo dos Cinco. After traveling and living in Europe for six years, Malfatti returned to Brazil in 1928. *Awards*: Malfatti became president of the Syndicate of Plastic Arts in the 1940s. *Died*: 1964, São Paulo.

SELECTED EXHIBITIONS

1995	*Latin American Women Artists, 1915–1995*, Milwaukee Art Museum, Wisconsin; Phoenix Art Museum, Arizona; Denver Art Museum, Colorado; National Museum of Women in the Arts, Washington, D.C.
1977	Posthumous Retrospective, Museum of Contemporary Art, São Paulo
1952	Modern Art Week Exhibition, São Paulo
1949	*Retrospective*, Museum of Art, São Paulo
1917	Solo Exhibition, Líbero Badaró, São Paulo

SELECTED COLLECTIONS

Gilberto Chateaubriand/Museu de Arte Moderna do Rio de Janeiro, Brazil; Julio Capobianco, São Paulo, Brazil; Luis Antonio Nabuco de Almeida Braga, Rio de Janeiro, Brazil; Sergio Fadel, Rio de Janeiro, Brazil

PUBLICATIONS

Amaral, Aracy. "Anita Malfatti: 50 anos depois (1977)." In *Arte e meio artístico: Entre a feijoada e o x- burguer*. São Paulo: Nobel, 1983. pp. 14–20.
Amaral, Aracy. *Artes plásticas na Semana de 22*. São Paulo: Perspectiva, 1972.
Anita Malfatti. São Paulo: Museu de Arte Contemporánea da Universidade de São Paulo, 1977. Exhbn cat.
"Anita Malfatti." *O Estado de S. Paulo*, May 29, 1914.
Centro Cultural Banco do Brasil. *EMBEMAS DO CORPO O Nue Na Arte Moderna Brasileira*. Rio de Janeiro: Author, 1991.
"Exposiçao de pintura (Registro de arte)." *Correio Paulistanao*, May 25, 1914.
Mendes de Almeida, Paulo. *De Anita ao museu*. São Paulo: Perspectiva, 1976.
Rossetti Batista, Marta. *Anita Malfatti no tempo e no espaço*. São Paulo: IBM/Brasil, 1985.
da Silva Brito, Mario. "O estopim do Modernismo." In *Historia do modernismo brasileiro—l Antecedentes da Semana de Arte Moderna*. Rio de Janeiro: Civilizaçao Brasileira, 1978. p. 40.

BIOGRAPHICAL ESSAY

Anita Malfatti is referred to as the first Brazilian woman artist of the twentieth century. She first exhibited her paintings in São Paulo in 1917 at Líbero Badaró.

This exhibition created a scandal. A negative review from an influential critic affected her profoundly. She actively participated in the historic *Semana de Arte Moderna* in 1922, a week-long cultural initiative organized by artists and writers in São Paulo. This event was the impetus for a Modernist movement for Brazilian artists and writers in an attempt to free themselves from restrictive European influences. That same year she joined with Tarsila do Amaral and several important writers to form the group Grupo dos Cinco. Her portrait *Retrato de Mário de Andrade* (1921–1922) depicts the avant-garde writer of the group. After her participation in the modernist revolution of the 1920s, Malfatti left Brazil to travel in Europe for six years. She returned in 1928.

Malfatti's early works were influenced by Cubism and Expressionism. She was inspired by the work of Expressionist Lovis Corinth, and her stay in Europe exposed her to a variety of modernist traditions. She painted in Brazil, Europe, and New York.

Together with painter Tarsila do Amaral, Malfatti created the foundation of the early modernist Latina tradition in Brazil.

MEJIA-KRUMBEIN, BEATRIZ

Nationality: Colombian. *Born*: 1945, Medellin, Colombia. *Education*: Mejia-Krumbein studied art in the United States, Germany, and Mexico. She received an M.F.A. from James Madison University, Harrisonburg, Virginia. She also studied ceramics and painting at Montemorelos University in Mexico. Pre-Columbian and Mayan art, Social Realism, and the Mexican muralists were of particular interest to Mejia-Krumbein. In Salzburg, Austria, and Geneva, Switzerland, she participated in Orff Schulwerk and Dalcroze methodology workshops and studied musicology at Hamburg University in Germany. While in Germany, she was influenced by German Expressionism and the work of Kaethe Kolltwitz and Emil Nolde. *Family*: Mejia-Krumbein grew up in Colombia, South America, in a culture steeped in the Catholic religion combined with native Indian mythology. During her college years, she experienced a crucial turning point in her life, breaking with traditions long honored by her family: She changed her religious beliefs, married a foreigner, and left her country permanently to live in Germany, Mexico, and the United States. *Career*: Mejia-Krumbein is currently an Associate Professor of Art in the Department of Art, La Sierra University, in Riverside, California, where she teaches painting. Her most recent exhibition of current work for the Faculty Show at La Sierra University includes a 28-page art book of women. She has exhibited extensively in

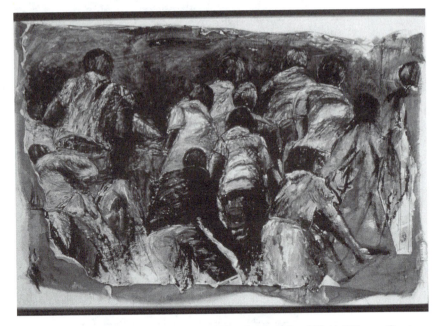

Stampede by Beatriz Mejia-Krumbein, 1995, mixed media, 182 × 284 cm. Courtesy of Beatriz Mejia-Krumbein

Germany, Mexico, and the United States. She worked as a teaching assistant at James Madison University from 1994 to 1996. She was featured in a Public Broadcasting Service film for the Shenandoah Valley, Virginia, in 1996 and a 16mm film in 1981 in Germany. *Awards*: In 1988 she received the second-place award in the First National Bank, Cleburne 20th Annual Art Exhibition. In 1993, she was awarded the New Market Arts and Crafts Scholarship. In 1997 the National Museum of the Woman in the Arts in Washington, D.C., selected one of her pieces to be exhibited in the Library and Research Center.

EXHIBITIONS

1996	*M.F.A. Degree Exhibit*, Sawhill Gallery, James Madison University, Virginia
1994	Colombian Consulate, Washington, D.C.
1993	Art Works Gallery, James Madison University Students Gallery, Virginia
1992	Atlantic Union College Art Gallery, South Lancaster, Massachusetts
1991	South Western Art Gallery, Coral Gables, Florida
1986	*Homenaje a mi Pueblo*, Casa de la Cultura, Monterrey, Nuevo León, Mexico

1984	Instituto Mexicano-Norteamericano de Relaciones Culturales, Monterrey, Mexico
1982	Ibero-Club, Bonn, Germany
1981	Germany-Iberoamerican Society, Frankfurt, Germany
1980	Pellerschloss, Nurenberg, Germany
1979	*Faces of Latin American Children*, Darmstadt, Germany

GROUP EXHIBITIONS

1997	The National Museum of the Woman in the Arts, Washington, D.C., selected the piece *Album—Children* to be exhibited in the Library and Research Center
1996	Kline Campus Center Gallery, Bridgewater College, Bridgewater, Virginia; Franklin Gallery, Harrisonburg, Virginia; Art on Site, Harrisonburg, Virginia
1995	*Graduate Students Show*, James Madison University, Harrisonburg, Virginia; *Show Case*, Warren Center, James Madison University, Harrisonburg, Virginia
1994	*Graduate Students Show*, James Madison University, Harrisonburg, Virginia; *Colombian Cultural Week*, Organization of American States, Washington, D.C.
1990	*Art for Easter Seals*, Carolina Gallery, Coral Gables, Florida
1988	*International Competition*, Asociación de Críticos y Comentaristas de Arte, Miami, Florida; *First National Bank 20th Art Show*, Cleburn, Texas
1987	*Resumen Plastico de Nuevo León*, Monterrey, Mexico; *Watercolor in Nuevo León*, Monterrey, Mexico
1985	Galleries BRUNELL, S.A., Monterrey, Mexico

PRIVATE COLLECTIONS

ADRA, Adventist Relief Agency, Maryland; Andrews University, Department of Modern Languages, Missouri; Beth Biermann, Frankfurt, Germany; Brigadier General Guillermo Leon Diettes, Colombia; Kurt-Dieter Dohman, Ph.D., Darmstadt, Germany; S. Engelman, Darmstadt, Germany; Robert Folkenberg, Seattle, Washington; Joanne Veal Gabbin, Franklin Gallery, Harrisonburg, Virginia; German-Iberoamerican Society, Frankfurt, Germany; Egon and Christa Gerth, Berlin, Germany; Yolanda Patricia Gomez, Bosley, Maryland; Alfredo Haag and Maria Haag, Frankfurt, Germany; Instituto Mexicano-Norteamericano de Relaciones Culturales, Monterrey; John Maas and Aura Maas, Chicago, Illinois; Mexico Patrimonia Artístico Nuevo León, Monterrey Casa de la Cultura de Nuevo León, Mexico; Peter Meyburg, Ph.D., and Louisa Meyburg, Muelheim, Germany; C. Panic, M.D., Frankfurt, Germany; Roger Plata and Shirley Plata, California; Uníon Colombo-Venezolana, Medellin, Colombia; Hans-Georg Wehner, Darmstadt, Germany

PUBLICATIONS

"El Arte de Beatrix Krumbein es un encuentro con Latinoamerica" (Beatrix Krumbein's art is a meeting with Latin America). *El Norte* (Monterrey, Mexico), 1986.

"Arte. La Obra de Beatrix." *Revista Escuela de Cadetes "General Santander"* (Santa Fe de Bogotá, Colombia), no. 67 (1995).

"Artista Colombiana expone Oleo y Batik" (Colombian artist exhibits oil and batik). *El Diario de Monterrey* (Mexico), 1984.

Beatrix Manifiesta Sentir de un Pueblo (Beatrix expresses the feelings of a nation). Monterrey, Mexico, 1986.

"Beatrix Mejia en Medellin." *El Colombiano*, 1983.

"Beatrix Mejia y el Arte del Batik en Montemorelos" (Beatrix Mejia and the art of batik at Montemorelos). In *Dinamica Universitaria, Organo informativo y cultural*. Nuevo León, Mexico: Universidad de Montemorelos, 1984.

"Bewegte Formen" (Forms in motion) Sprechender Ausdruck (Saying expression). *General Anzeiger* (Bonn, Germany), 1982.

"Cargador de Agua" (Water carrier). *Dinamica Universitaria*, no. 62 (1986). (cover)

"Colombiana muestra oleos y batiks en obra" (Colombian shows oils and batiks). *El Diario de Monterrey* (Mexico), 1984.

"Expone artista colombiana oleo y batik hoy en el IMNRC." (Colombian artist exhibits oil and batik today in the IMNRC). *Tribuna de Monterrey* (Monterrey, Mexico), 1984, sec. C, p. 3.

"Homenaje a mi Pueblo, Muestra que expuso Beatrix Mejia" (Homage to my people. A sample exhibit by Beatrix Mejia). *ABC Culturales* (Monterrey, Mexico), 1986.

"Kraftvolle Exotic" (Powerful exotic). *Nurenberger Anzeiger*, 1981.

"Presenting Art in 3D. Painting Where Imagination Plays." *Daily News Record, Skyline* (Harrisonburg, Vir.), 1993.

"Ungewohnliche Impressionen aus einen sehr fernen Land" (Unusual impressions from a very distant country). *Frankfurter Nachrichten*, 1981.

ARTIST STATEMENT (1997)

I view the purpose of my art as a reflection on my life, as a social and spiritual function. I love to observe human behavior and try to question and understand it. I want to share thoughts and experiences and motivate the viewer to interact with my work.

I need to explore my surroundings by touching, feeling, and transforming. I see the world as my studio, where I manipulate materials, change objects, and transform them. I try to show overlooked and concealed qualities of objects, putting them in an unusual and unexpected context, creating tension between things we know intellectually and things we know through our senses.

I start to use daily found objects to create two- and three-dimensional collages and constructions. I try to challenge its possibilities and potential; however, I consider my art primarily as an exploration of my inner self, projecting social issues. I am adopting collage as one of my preferred media, and I see my own life like a collage or collection of roles: as mother, wife, teacher, student, and

citizen. As I transform my art, I transform myself in order to be able to play these roles within different circumstances.

My urgency in approaching the subject of violence is rooted in my belief that as soon as we are born we become emotional, if not physical, victims of its grip. Staring in the face of the problem helps us to realize that we do not need ugly scars on our skin, or bruises on our body, to feel its marks. Only after we recognize the universality of the problem will we be able to help build a support group, a single global community.

BIOGRAPHICAL ESSAY

Beatriz Mejia-Krumbein startles the viewer with her intense reflections of isolation, fragmentation, violence, and prejudice as profound political statements about the ills of society. These statements are made through texture, through the use of black and white, and especially through scale. Her pieces, many 6' × 4' or larger, are composed of torn paper, newsprint pasted onto large pieces of burlap with gesso and paint. Scale is crucial to the work. It emphasizes the great magnitude and urgency of the issues and problems Mejia-Krumbein examines through image making.

The presence of a larger-than-life attacker or victim enhances feelings of vulnerability and victimization. In *Aftermath*, which is almost 6 feet high and 27 feet long, figures are grouped together—standing, waiting, crouching, recuperating, contemplating, and anguishing over some kind of tragedy, disaster, or accident. Similarly in *Stampede* (70" × 110"), it is the vulnerable backs of a group of people that are seen as they flee terrified like a herd of animals.

Mejia-Krumbein's early artistic influences like her childhood environment and the narrative styles of storytellers motivated her often dramatic scenes of details and gestures. The crude visual journalism and verbal information distributed during the years of the ''violent period'' in Colombia awakened her interest in figurative Expressionism as well as history. Living in different cultural environments prompted her to access materials that would allow her to interpret different political and social issues.

German Expressionists as well as Spanish artist Francisco Goya played an important role in the development of her art. Goya's fresh, spontaneous, and immediate technique allowed him to portray injustice, war, and human relationships. His Black Paintings inspired Mejia-Krumbein to fully appreciate the drama of human experience through the use of black and white, the graphic expression of line, the relationship of dark and light, and the use of contrast to emphasize form.

The whole process of creation for each piece is significant for Mejia-Krumbein. The physical action of covering the burlap with torn paper refers directly to her own sense of fragmentation as a foreigner in many countries. According to the artist, the process of putting things together by mending or patching resembles a healing process related to a sense of connection, restora-

tion, community, and solidarity. The physical violence of her brush strokes and attack of the wholeness of her surfaces are a metaphor for a realized lack of resistance by most people and their compliancy and blind obedience to dominant traditions and systems.

Mejia-Krumbein chooses to work in black and white because aesthetically it presents a clarity and severity in form that is necessary for the interaction of light and shadow and the emergence of her figures. Color is not necessary for her interpretation of themes she associates with dirt, darkness, and drama. Her paintings' torn, raw edges and their magnification of scale are references to issues of social significance that often times go untreated or ignored. Mejia-Krumbein explains: ''Many times we close our eyes to deny its existence, or to diminish its significance, but it is important for me to denounce such problems through the size of my paintings, making it very difficult to overlook them.''

MENDIETA, ANA

Nationality: Cuban. *Born*: 1948, Havana, Cuba. *Education*: Mendieta attended the University of Iowa, where she received a B.A. in 1969 and an M.A. in painting in 1972. She then enrolled in the university's multimedia and video program and abandoned painting. Her focus became the relationship between her body, the earth, and art. She was also influenced by Third World feminism and Santería, the religion of Latin Afro-Americans. *Family*: In 1961, after Castro took over Cuba, Mendieta and her sister Raquelín were sent to the United States. They spent their adolescent years in Iowa. After moving to New York in the late 1970s, she met minimal sculptor Carl Andre, who she later married. *Career*: Mendieta began her *Silueta* series of earth/body sculptures in the 1970s in Mexico, followed by a series in Iowa. In 1978 she moved to New York but was able to return to her homeland twice to complete works there. She carved her *Rupestrian* sculptures in the caves of Escaleras de Jaruco. She worked as an artist until her tragic death in New York in 1985. *Awards*: Mendieta received a fellowship from the American Academy in Rome in 1983. It was there that she began to make indoor sculptures out of molded earth and sand. *Died*: 1985, New York.

SELECTED EXHIBITIONS

1995 *Latin American Women Artists, 1915–1995*, Milwaukee Art Museum,
 Wisconsin; Phoenix Art Museum, Arizona; Denver Art Museum,

Colorado; National Museum of Women in the Arts, Washington, D.C.

1993 *Latin American Artists of the Twentieth Century*, Museum of Modern Art, New York

Mendieta's work has also been exhibited at the Museum of Contemporary Hispanic Art, The New Museum of Contemporary Art, and The Studio Museum in Harlem, all in New York.

SELECTED COLLECTIONS

Rosa and Carlos de la Cruz, Key Biscayne, Florida; Galerie Lelong, New York; Marlene Gerwin, Milwaukee; Hirshhorn Museum and Sculpture Garden, Smithsonian Institute, Washington, D.C.

PUBLICATIONS

Brenson, Michael. "Art: Works by Ana Mendieta in a Retrospective Exhibition." *New York Times*, November 27, 1987, p. C30.

Camhi, Leslie. "Ana Mendieta at Galerie Lelong." *Art in America* 80 (September 1992), p. 127.

Clearwater, Bonnie, ed. *Ana Mendieta: A Book of Works*. Miami: Grassfield Press, 1993.

Fusco, Coco. "Traces of Ana Mendieta." *Polyester* 4 (Winter 1993), pp. 52–61.

Hess, Elizabeth. "Out of Body." *The Village Voice*, December 8, 1987, p. 119.

The Institute of Contemporary Art. *Corazón Sangrante/The Bleeding Heart*. Boston: Author, 1991.

Jacob, Mary Jane. *Ana Mendieta: The "Silueta" Series, 1973–1980*. New York: Galerie Lelong, 1991. Exhbn cat.

Lippard, Lucy. *Overlay, Contemporary Art and the Art of Prehistory*. New York: Pantheon Books, 1983.

Mosquera, Gerardo. "Ana Mendieta: Esculturas Rupestres." *Arcito* 7, no. 28 (1981), pp. 54–56.

Museum of Contemporary Hispanic Art. *Ana Mendieta—Earth: Latin America's Visions/La Tierra: Visiones de America Latina*. New York: 1989.

New Museum of Contemporary Art. *Ana Mendieta: A Retrospective*. New York: Author, 1987.

Rich, B. Ruby. "The Screaming Silence." *The Village Voice*, September 16–23, 1986, pp. 23–24.

Río, Petra Barreras del, and J. Perreault. *Ana Mendieta: A Retrospective*. New York: New Museum of Contemporary Art, 1988. Exhbn cat.

Spero, Nancy. "Tracing Ana Mendieta." *Artform* (April 1992), pp. 75–77.

Wilson, Judith. "Ana Mendieta Plants." *The Village Voice*, August 19, 1980, p. 90.

ARTIST STATEMENT (1973)[1]

It was during my childhood in Cuba that I first became fascinated by primitive art and cultures. It seems as if these cultures are provided with an inner knowledge, a closeness to natural sources. And it is this knowledge which gives reality

to the images they have created. This sense of magic, knowledge and power found in primitive art has influenced my personal attitude toward art-making. For the past twelve years I have been working out in nature, exploring the relationship between myself, the earth and art. I have thrown myself into the very elements that produced me, using the earth as my canvas and my soul as my tools.

Note

1. Copyright estate of Ana Mendieta. Courtesy of Galerie Lelong, New York.

BIOGRAPHICAL ESSAY

As an adolescent Mendieta was exiled from her native Cuba. She was torn from her home, family, land, and culture and sent to the United States (to the Midwest) in 1960 by a Cuban Catholic Campaign. Not long after her arrival to this foreign place, she realized that because of the violent disruption and tumultuous nature of her past, her life could go in two extreme directions: she could be a criminal or an artist.

Mendieta's art begins as a process of self-healing and restoration of identity. She abandoned painting in 1970 and almost immediately returned to the earth as a constant medium, a secure template in her work. She began to use her own body in performance and body-earth works. Perhaps this was a way for her to reintegrate her divided, ruptured self, a kind of symbolic return to her native land. In response to her profoundly sensuous relationship to nature and her indelible marks on the earth, Mendieta states: "I am overwhelmed by the feeling of having been cast from the womb (nature). My art is the way I re-establish the bonds that unite me to the universe."

Mendieta incorporated earth, water, fire, blood, and air as metaphors. In *Sweating Blood* (1973), blood mixed with paint slowly dripped over her face. In other pieces blood was smeared over her partially nude body in response to the rape and murder of a young woman in her community. Fire was used to light up large silhouettes of Mendieta's body, perhaps reminiscent of the burning of traditional Judas figures in Mexico, which she visited in 1971.

In 1978 Ana Mendieta moved to New York, where she made her first contacts with the feminist movement and was introduced to the established tradition of the use of the artist's body as a medium, particularly in performance and installation. She established close ties with many New York Latin American artists and married minimalist Carl Andre.

Burned images of her body or hand into wood, earth, paper, grass, or rocks were found throughout her work. Her burned handprint appeared on the title page of the book *Rites and Rituals of Initiation*. Her negative body image scooped or burned into the earth became visible in 1977 and after. It was important that Mendieta leave her mark, literally and bodily, on nature and culture.

Perhaps it was her own symbolic ritual in an urgent attempt to be visible, present, and remembered. In her *Tree of Life* and *Fetish Series*, Mendieta modeled body forms in relief and covered herself in mud and straw as a living sculpture.

What is ironic, however, is that the very form of her work was transient and impermanent. The works themselves vanished or disintegrated into nature. Documentation of the process to preserve some pictorial material was important. Some of Mendieta's works are documented with photographs, films, and video and now serve as significant records of her work.

Mendieta's first return to Cuba was in 1980. She was reunited with her family and passionately explored and embraced her native land and its young artists. She made a second trip in 1981 when she created her *Rupestrian Sculpture Series*. These earth sculptures were carved and painted in the soft limestone caves at the Escaleras de Jaruca and were dedicated to the ancient earth goddesses, incorporating Taíno Indian mythology and terminology. Mendieta's goddesses recalled the ancient Caribbean or pre-Columbian petroglyphs of fertility deities.

Following Mendieta's tragic death[1] in 1985 at the age of 36, James and Bonnie Clearwater, with the help of Mendieta's sister Raquelín, collected her drawings of the *Pre-Hispanic Myths of Antilles* and her photo etchings of the *Rupestrian Sculptures* into a book, *Ana Mendieta: A Book of Works* (1993).

Note

1. Ana Mendieta fell from her apartment window to her death. Her husband was a suspect, but later was acquitted of homicide charges. He insists that she committed suicide; however, her friends and other artists debate the issue.

MERCEDES, MARÍA

Nationality: Puerto Rican. *Born*: 1967, Santurce, Puerto Rico. *Education*: Mercedes received a B.F.A. from the School of Visual Arts, New York, in 1991 and an M.F.A. from Yale University, School of Art, in 1993. *Family*: Mercedes came to New York when she was a year old with her father, who was studying psychology at New York University, and her mother, who was studying English literature at Fordham University. She grew up on the upper west side of Manhattan, where her parents still live. Mercedes is the oldest of three children. *Career*: Mercedes lives in Brooklyn and works in New York City. She has worked with Lynda Benglis, Jackie Winsor, Paul Waldman, and Mel Bochner.

Mercedes also assisted the late Donald Judd and, most recently, Jeff Koons on his forthcoming project. Her work has been shown in New York, New Haven, Santa Fe, and Argentina. *Awards*: Mercedes was a recipient of a Van Lier Fellowship and has been awarded teaching positions at Yale University, School of Art, Studio in the Schools Association, and in other public and private organizations in New York.

EXHIBITIONS

1997	Universidad de Tucumán, Argentina; Meredith Kelly Latin American Fine Art, Santa Fe, New Mexico
1996	Gallery 121, New York, New York; A.I.R. Studio Space, New York, New York; Abrons Art Center Gallery, New York, New York
1993	Yale University Art Gallery, New Haven, Connecticut; Yale Cabaret, New Haven, Connecticut
1992	A. C. Project Room, New York, New York
1991	Visual Arts Gallery, New York, New York

ARTIST STATEMENT (1997)

The abstract drawings and paintings that comprise *La Santa Fe del Heroe/ The Holy Faith of the Hero* reflect the soul of my work. My work comes out of the terror, the rage, the need to communicate and connect across the void created by the limitations of worldly differences. When I paint, I transcend the labels of my gender, my ethnicity, my profession, and my lifestyle. Suddenly, I am no longer a single soul battling alone, but, rather, I am the divine thread that also runs through me.

Society's attempt to organize, categorize, and literalize has failed. Language cannot express meaning, and naming something does not make that thing fixed. Painting is a purer form of communication as it works on a symbolic and therefore spiritual level. My paintings are like tarot cards, each loaded with meanings that adapt to the shape of the viewer's experience. Together, the sum of meanings will take the viewer from the simple to the complex and back, evoking an almost religious understanding of the relationship of the child in the family, the individual (outsider) in society, and the artist in the world. It evokes the journey of the life-struggle via collective symbols and neomythology to connect the individual soul to the soul of the universe.

The images are fierce and resigned, violent and serene, raw and refined. There is an ancient energy of primal apocalypse that resounds in the muscular movement of the oil over the lead. The extreme variations in the paint's density on the canvas add to the complexity of the emblem. The images are evocative rather than literal and are intended to touch each viewer individually. The work obeys the will that is both within me and beyond me.

The work is about the responsibility of being strong, the trials in which

strength is tested, and the moments of transformation in which doubt through sacrifice becomes faith. This abstract struggle of devotion to the spiritual brings me to a place of questioning conviction and the fervent resignation that rushes me and my work to a divine place of truth.

BIOGRAPHICAL ESSAY

María Mercedes's paintings are more like drawings. Sensuous, lush, passionate strokes dominate space, embodying Mercedes's terror, rage, and urgency to communicate and connect across what she describes as "the void created by the limitations of worldly differences." In the process of painting, she is able to transcend cultural labels of gender, ethnicity, profession, and lifestyle. Her series *La Santa Fe del Heroe (The Holy Faith of the Hero)* (1997) reflects "the soul" of her work. Images in this series are fierce and resigned, violent and serene, raw and refined. *Madre del Heroe* (1997) portrays two emblematic figures—a mother and a child—umbilically connected and evoking a harmonious and nurturing relationship. In contrast, *Facing the Bull* (1997) presents two emblematic figures bound together with fury, rage, and ambivalence.

Mercedes explores a kind of primal religiosity, the relationship of the child in the family, the individual in society, and the artist in the world. *The Hero Surveys Herself* (1997) portrays again a relationship between two figures, only this time it is self reflecting on self. The hero contemplates her own self-image. She uses collective, abstract symbols and neomythology to connect what she calls "the soul of the individual to the soul of the universe."

Mercedes believes that painting is a purer form of communication because it allows her to work on a strictly symbolic and spiritual level. She is able to strip away all other unnecessary information and get right to the core of her subject to expose important truths. Although the sensuous qualities of ink and oil on paper and canvas are accentuated, it is the deeper meaning of her luscious marks that are significant. Mercedes views her paintings as tarot cards, each loaded with meanings that are adaptable to each individual viewer, enabling him or her to transition from the simple to the complex and back again. Her painted strokes are attempts to work out moments of struggle and contemplate those of serenity. They caress the sometimes delicate and other times harsh moments of self in relation to self, family, others, and the world, courageously revealing the pain, rage, agony, fear, and ecstasy of each moment.

According to Mercedes, painting is a healing process; it is transformative. She refers to her work, creative process, and artistic intent as spiritual enlightenment: "My work is about the responsibility of being strong, the trials in which strength is tested, and the moments of transformation in which doubt through sacrifice becomes faith. This abstract struggle of devotion to the spiritual brings me to a place of questioning conviction and fervent resignation that rushes me and my work to a divine place of truth."

MESA-BAINS, AMALIA

Nationality: Mexican American. *Born*: 1943, Santa Clara, California. She lives and works in Seaside and San Francisco, California. *Education*: Mesa-Bains received a B.A. in 1966 from San Jose State College and an M.A. in 1971 from San Francisco State University. She also received an M.A. (1981) and Ph.D. (1983) in psychology from the Wright Institute in Berkeley. *Career*: Mesa-Bains is an independent artist and cultural critic. She is the author of scholarly articles and a nationally known lecturer on Latina art. Throughout her cross-disciplinary career, she has worked to define a Chicana and Latina aesthetic in the United States and in Latin America. She has pioneered the documentation and interpretation of long-neglected Chicana traditions in Mexican American art, both through her cultural activism and through her own altar installations. As educator and community advocate she has served the San Francisco Unified School District, the San Francisco Arts Commission, and the Board of Directors for both the Galería de la Raza and the Center for the Arts and Yerba Buena Gardens. Currently, she is the Director of the Visual and Public Art Institute, California State University at Monterey Bay. She curated such exhibitions as *Artists Talk Back: Visual Conversations with El Museo, Part I*, El Museo del Barrio, New York, New York; *Other Mexico: Sources and Meaning*, traveling exhibition, Mexican Fine Arts Center, Chicago, Illinois; *Ceremony of Spirit*, traveling exhibition, Mexican Museum, San Francisco, California; and *Body/Culture: Chicano Figuration*, Sonoma State College, Sonoma, California. *Awards*: Mesa-Bains was awarded special achievement awards from the Association of American Cultures, the Association of Hispanic Artists, and the San Francisco State University Alumni. She is also a recipient of a distinguished MacArthur Fellowship, 1992. She served as a consultant for the Texas State Council on the Arts and the Arizona Commission on the Arts and is a former Commissioner of Arts for the City of San Francisco.

EXHIBITIONS

1997	*Venus Envy, Chapter III: Cihuatlampa, the Place of the Giant Women*, Steinbaum Krauss Gallery, New York, New York
1995	*Fragments of a Chicana Art History*, Steinbaum Krauss Gallery, New York, New York
1994	*Venus Envy, Chapter Two: The Harem and Other Enclosures*, Williams College Museum of Art, Williamstown, Massachusetts

1990	*(Re)(Un)(Dis) Covering America: A Counter Quincentenary Celebration*, M.A.R.S.: Movimiento Artístico del Rio Salado Artspace, Phoenix, Arizona (catalog)
1987	*Grotto of the Virgins*, INTAR Gallery, New York, New York

RECENT GROUP EXHIBITIONS

1997	*The Shoe Show*, Bedford Gallery, Dean Lesher Regional Center for the Arts, Walnut Creek, California
1996	*Objects of Personal Significance*, Exhibits USA and Eastern Illinois University, Charleston, Illinois (national tour through 1999); *Homenaje a Dolores del Rio/Legacy (Legado): A Latino Bicentennial Reflection*, The Old State House, Hartford, Connecticut; *"Grotto of the Virgins" Family in Focus: Cultural Diversity and the Family*, The Noyes Museum, Oceanville, New Jersey
1995	*"Venus Envy Chapter Two: The Harem and Other Enclosures: The Library of Sor Juana Inez de la Cruz," Going for Baroque*, presented in collaboration with The Contemporary, Baltimore, Maryland, and the Walters Art Gallery, Baltimore, Maryland; *"Vanity from Venus Envy Chapter One or the First Holy Communion Moments before the End Installation" Is It Art?*, Exhibition Management Inc., Cleveland Heights, Ohio (traveling exhibition through 1997); *"The Castas Closet" Division of Labor: "Women's Work" in Contemporary Art*, The Bronx Museum of the Arts, Bronx, New York, and The Museum of Contemporary Art, Los Angeles, California; *"The Circle of Spirits," Distant Relations: An Exhibition on Identity among Mexican, Irish, and Chicano Artists and Writers*, traveling exhibition through 1997 in Mexico, the United States, Ireland, and Britain; *Summer Group Exhibition*, Steinbaum Krauss Gallery, New York, New York; *"Museum of Fatima," Artists Talk Back: Visual Conversations with El Museo, Part III Reaffirming Spirituality*, El Museo del Barrio, New York; *"Emblem of the Decade: Borders," Reinventing the Emblem*, Yale University Art Gallery, Yale University, New Haven, Connecticut; *"Venus Envy Chapter One Portrait Poster" Women of Hope: Latinas Abriendo Camino*, Bread and Roses, Gallery 1199, New York *"Grandmaw Is That You?" Women's Caucus for Art Honorees Exhibition*, San Antonio Museum of Art, San Antonio, Texas; *"Scapular of the Spirit" and "Scapular of the Land," Post-Colonial California*, San Francisco State University Art Department Gallery, San Francisco, California
1994	*"Grandmother Is That You?" States of Loss: Migration, Displacement, Colonialism, and Power*, Jersey City Museum, Jersey City, New Jersey
1993	*"Venus Envy Chapter One or the First Holy Communion Moments before the End," Amalia Mesa-Bains and Maren Hassinger*, The Whitney Museum of American Art at Philip Morris, New York; *"Vanitas: Evidence, Ruin and Regeneration," Revelaciónes/Revela-*

tions: Hispanic Art of Evanescence, Herbert F. Johnson Museum of Art, Cornell University, Ithaca, New York; *Sin Frontera: Chicano Arts from the Border States of the U.S.*, Corner House, Greater Manchester Arts Center Limited, Manchester, England; *"Queen of the Waters, Mother of the Land of the Dead: Homanaje to Tonatzin/ Guadalupe,"* *Ante America*, The Queens Museum of Art, Queens, New York, and Center for the Arts, Yerba Buena Gardens, San Francisco, California

1992 *"Emblems of the Decade: Borders," La Reconquista: A Post Columbian New World Exhibition*, 3rd International Biennial, Istanbul, Turkey; *"Queen of the Waters, Mother of the Land of the Dead: Homenaje to Tonatzin/Guadalupe,"* *Ante America*, Biblioteca Luis Angel Arango, Bogotá, Colombia

1991 *"Emblems of the Decade: Body + Time = Life/Death," The Interrupted Life*, The New Museum, New York; *"Curiositas: The Cabinet," Encuentro: Invasion of the Americas and the Making of the Mestizo*, Artes de Mexico, SPARC: Social and Public Art Resource Center, Venice, California

1990 *"Dolores Del Rio Altar," CARA: Chicano Art Resistance & Affirmation*, traveling exhibition, California, Arizona, Texas, New York; *"Emblems of the Decade: Borders & Numbers," The Decade Show*, Studio Museum of Harlem, New York

PUBLICATIONS

Amalia Mesa-Bains. New York: INTAR Latin American Gallery, 1987. Exhbn cat.

Amalia Mesa-Bains and Maren Hassinger. New York: The Whitney Museum of American Art at Philip Morris, 1993. Exhbn cat.

Ante America. Queens, N.Y.: The Queens Museum of Art, 1993. Exhbn cat.

Artists Talk Back: Visual Conversations with El Museo, Part III Reaffirming Spirituality. New York: El Museo del Barrio, 1995. Exhbn cat.

Benedict, Stephen. *Public Money & the Muse, Essays on Government Funding for the Arts*, 1991.

Contemporary Hispanic Shrines. Reading, Pa.: Freedman Gallery, Albright College, 1985–1989. Exhbn cats.

The Decade Show, Frameworks of Identity in the 1980's. New York: Museum of Contemporary Hispanic Art, The New Museum of Contemporary Art, The Studio Museum of Harlem, 1990. Exhbn cat.

Design Principles and Problems. Reproduction of the image *An Ofrenda for Dolores del Rio*. Harcourt Brace College Publishers, 1995.

Distant Relations, a Dialogue between Chicano, Irish and Mexican Artists. Camden: IKON Gallery, Camden Arts Centre, The Irish Museum of Modern Art, 1996. Exhbn cat.

Division of Labor: "Women's Work" in Contemporary Art. Bronx, N.Y.: The Bronx Museum of the Arts, 1995. Exhbn cat.

Exhibits Catalog of Traveling Exhibition, 1994–1995. Kansas, Mo.: A National Division of Mid-America Alliance, 1995. Exhbn cat.

Forty Years of California Assemblage. Los Angeles: Wright Art Gallery, UCLA, 1989. Exhbn cat.

Going for Baroque, 18 Contemporary Artists Fascinated with the Baroque and Rococo. Baltimore, Md.: The Contemporary at the Walters, 1995. Exhbn cat.

Herzberg, Julie. *Re-Membering Identity: Vision of Connections.* New York, 1990.

Image: International Chicano Poetry Journal. Vol. 3 (Summer/Winter 1988). Arte Chicano Issue.

The Interrupted Life. New York: The New Museum, 1992. Exhbn cat.

Is It Art? Cleveland Heights, Ohio: Exhibition Management Inc. 1995. Exhbn cat.

"Lady-Unique-Inclination-of-the-Night." *Cycle* 6 (Autumn 1983), pp. 83–84.

Les Demons des Anges, 16 Artistes Chicanos Autour de Los Angeles. Barcelona, Spain: Departamento de Cultura de la Generalitat de Cataluñya, 1989. Exhbn cat.

Lippard, Lucy R. *Mixed Blessings, New Art in Multi-Cultural America.* New York: Pantheon-Random House, 1990.

Made in Aztlan. Mexico City: Centro Cultural de la Raza Fifteenth Anniversary, Philip Brookman and Guillermo Gomez-Peña, 1981. Exhbn cat.

MIRA! Toronto: The Canadian Club Hispanic Art Tour III, 1988–1989. Exhbn cat.

New Langton Arts. Catalogue of Programs, Monument and Memorial, 1988.

Other Gods: Containers of Belief. 1986. Exhbn cat.

Reinventing the Emblem. New Haven, Conn.: Yale University Art Gallery, Yale University, 1995. Exhbn cat.

A Retrospective of the Work of Pepon Osorio: "Con To" Los Hierros. New York: El Museo del Barrio, 1991. Exhbn cat.

(Re)(Un)(Dis) Covering America: A Counter Quincentenary Celebration. Phoenix, Ariz. M.A.R.S.: Movimiento Artístico del Rio Salado Artspace, 1990. Exhbn cat.

Revelaciónes/Revelations: Hispanic Art of Evanescence. Ithaca, N.Y.: Herbert F. Johnson Museum of Art, Cornell University, 1993. Exhbn cat.

ARTIST STATEMENT (1996)[1]

The development of my work has been rooted in the practice and consciousness of my community. Through the traditions of the home altar and the celebrations of the Day of the Dead, I have created a hybrid form of ephemeral installation. Both of these traditions of popular culture represent aspects of a redemptive and resilient struggle to maintain family history and cultural continuity in the face of colonial domination. My work has been inspired by these popular processes of critical intervention.

A ceremonial aesthetic has grown from this process of critical invention that characterizes my work. Through the use of *bricolage* miniaturization, the use of domestic objects, Catholic imagery, natural and organic ephemera, mirrors, and dispersal, I have pursued a personal and collective narrative of Chicano/Mexicano history. The adoption of this form and process for more than twenty years has produced a politicizing spirituality that has served my community and given meaning to my life.

In my own work, a feminine *Rasquachismo* or *Domesticana*, as I call it, is a

driving force in creating a critical space that is simultaneously contestatory and passionately affirming of our histories as women and our situation of struggle.

Note

1. This is an excerpt from the catalog for the exhibition *Distant Relations: A dialogue between Chicano, Irish and Mexican Artists* (Camden: IKON Gallery, Camden Arts Centre, The Irish Museum of Modern Art, 1996).

BIOGRAPHICAL ESSAY

For the past two decades, Amalia Mesa-Bains has examined ritual space as a site of the production and constriction of feminine identity. Her installations and altars reinvent constructions of gender and ethnic identity. She arranges fragments of personal history, images, and objects of cultural and political reference and redefines historical configurations of what it means to be a woman of color maneuvering between cultures.

Halls of Mirrors was a preliminary piece for the *Venus Envy Series*. Mesa-Bains lined two side walls of the room with mirrors, some of which bore ghost-like images of women in familiar roles—doting mother, reclining Venus, and cultural heroines such as Sor Juana Inés de la Cruz, a Spanish nun who lived in Mexico and defined the repressive dictates of the Church by continuing to pursue her studies and write poetry. Underneath the mirrors run a succession of ink rubbings made from photocopies of traditional representations of women with a handwritten commentary by the artist.

In her current mixed-media installation *Venus Envy, Chapter III: Cihuatlampa, the Place of the Giant Women* (1997), at Steinbaum Krauss Gallery in New York, Amalia Mesa-Bains creates an environment, a metaphor to explore her own experience of being a large woman, too large for society, metaphorically speaking. This installation is a critique of the restrictions of women in a patriarchal society. In *Cihuatlampa*, these giant women live beyond the roles that men traditionally assign them. It is the place of the untamed spirit, a place of counterpoint, a mythical and spiritual place where Mesa-Bains can explore memory, sexuality, and gender materially. *Venus Envy, Chapter III* includes a variety of works—mixed-media installations, sculpture, and Iris monoprints on canvas. *Cihuateotl* is a voluptuous woman of Cihuatlampa, reclining sensuously on the gallery floor. Another installation, *The Amazona's Mirror*, is an oversized handheld mirror (over seven feet high) to be used by a giant woman.

In autobiographical works like *Museum of Memory* and *Boudoir Chapel*, Mesa-Bains politicizes the personal, incorporating memorabilia and intimate, personal objects and items. *Boudoir Chapel* is a vanity table and chair dramatically framed by a baroque sweep of drapery. A rosary, perfume bottles, glitter, and dried flowers are combined with objects with wide-ranging cultural references. On an adjacent wall votive images and objects were assembled with

images by contemporary Chicana artists. It is this kind of layering of the secular and sacred with the public and private that ignites Mesa-Bains's critical and conceptual approach to retrieving and rewriting history through textual and material excavation and reconstruction.

Mesa-Bains is the pioneer of the genre of the altar as a form of installation. Through the home altar, *nichos*, and *retablos*, she dedicated the first phase of her artistic trajectory to create installations of didactic nature as a quest for self-definition and identity. Mesa-Bains deconstructs a feminine and Chicana past and present denied by dominant culture. Her earlier altar/installations were dedicated to landmark dates (Cinco de Mayo, Día de Los Muertos), figures of historic heroines (Santa Teresa de Avila, Sor Juana Inés de La Cruz, Frida Kahlo, Dolores Del Río, Rita Cancino Hayworth), and deceased family members.

MONTOYA, DELILAH

Nationality: Mexican American. *Born*: 1955, Fort Worth, Texas. *Education*: Montoya received an Associate Degree in Photography in 1978 from Metropolitan Technical College, Omaha, Nebraska. Montoya also received a B.F.A. (1984), an M.A. (1990), and an M.F.A. (1994) in printmaking from the University of New Mexico, Albuquerque. *Career*: As well as being a full-time artist, Montoya has taught printmaking for Working Class Storytellers, Albuquerque, 1990; monoprinting, University of New Mexico, Albuquerque, 1992; photography at the Institute of American Indian Art, Santa Fe, 1994; and art history at California State University, Los Angeles, 1995. Montoya has also lectured about her work at Stanford University, San Francisco Museum of Modern Art, and UCLA. She has juried exhibitions in New Mexico, California, and Nevada, and conducted printmaking workshops. *Awards*: In 1992 and 1996, she was awarded a Purchase Award for *Close to the Border*, University Art Gallery, Las Cruces, New Mexico. In 1994 Montoya won first place in the *Latina/Indigena Women's Art Exhibit*, Guadalupe Cultural Art Center, San Antonio. Montoya also received a Sacred Heart Research Grant, Southwest Hispanic Research Institute, Albuquerque; a College Arts Association Professional Development Fellowship, New York (1993); and an Under-represented Graduate Fellowship, Albuquerque (1994).

SELECTED EXHIBITIONS

1996 *Chambers of Enchantment*, CEPA Gallery, Buffalo, New York; *Day of the Dead 1996*, Mexican Fine Arts Center Museum, Chicago, Il-

linois; *Reencuentros/Reencounters*, Center for the Visual Arts, Denver, Colorado; *El Corazón Sagrado/Sacred Heart*, Daniel Saxon Gallery, West Hollywood, California; *Refiguring Nature: Women in the Landscape*, SF Camera Work, San Francisco, California; *From the West*, Mexican Museum, San Francisco, California; *Intersecting Identities*, USC Fisher Gallery, Los Angeles, California

1995 *Corazón Sagrado/Sacred Heart*, Intersection for the Arts, San Francisco, California

1994 *El Corazón Sagrado*, University of Alabama, Tuscaloosa, Alabama; Guadalajara International Book Fair, Guadalajara, Mexico; *Corazón Sagrado/Sacred Heart*, Cafe Gallery, Albuquerque, New Mexico; *Las Comadres: Visionaries Chicanas*, Sangre de Cristo Arts & Conference Center, Pueblo, Colorado; *America's Cultural Diversity: CAJE 94*, COCA, University City, Missouri; *American Voices, Latino/Hispanic/Chicano Photography in the U.S.*, Fotofest, Houston, Texas

1993–1994 *Magnífico: Albuquerque Festival of the Arts*, Albuquerque Convention Center, Albuquerque, New Mexico; *Fiesta Artística de Colores Art Exhibition*, Albuquerque Convention Center, Albuquerque, New Mexico

1993 The Friends of Photography Auction 1993, Ansel Adams Center, San Francisco, California

1992 *Close to the Border*, Biennial Juried Exhibition, University Art Gallery, Las Cruces, New Mexico; *Aztlan 92*, Gallery at the Rep, Santa Fe, New Mexico; *Printmakers 1992*, SPARC Gallery, Venice, California; *Los Guardianes: Land, Spirit, and Culture: The Alcove Show*, Museum of Fine Arts, Museum of New Mexico, Santa Fe, New Mexico

1991 *Focus on Printmaking*, COCA Gallery, St. Louis, Missouri

1989 *Sin Fronteras*, Gallery of Contemporary Art, Colorado Springs, Colorado; *Self Help Graphics*, Otra Vez Gallery, Los Angeles, California

1988–1994 *Annual Juried Latina/Indigena Women's Art Exhibit*, Guadalupe Cultural Arts Center, San Antonio, Texas; Hispanic Contemporary Market, Santa Fe, New Mexico

1988 *Hecho a Mano*, GCAC Gallery, San Antonio, Texas; *Chicano Aesthetics*, Rasquachismo Mars Artspace, Phoenix, Arizona

1982 Museo de Barrio, Austin, Texas, Mexico City, Mexico

SELECTED COLLECTIONS

Armand Hammer, Los Angeles, California; The Bronx Museum, Bronx, New York; Houston Museum of Fine Art, Houston, Texas; Los Angeles County Museum of Art, Los Angeles, California; Mexican Museum, San Francisco, California; Museum of Fine Arts, Santa Fe, New Mexico; Smithsonian Institute, Washington, D.C.; Stanford University Libraries, Stanford, California; UCLA Wight Gallery, Los Angeles, California

SELECTED PUBLICATIONS

Alurista. *Et Tu . . . Raza?* Tempe, Arizona: Bilingual Press, 1996.
"Rio." Albuquerque Journal (March 10, 1994).
Robert J. Hirsch. *Exploring Color Photography.* New York: McGraw-Hill, 1996.

ARTIST STATEMENT (1997)

Of primary importance is my view of art as a serious and responsible vehicle for exploring issues of Chicana ideology. In my own evolving ideology, I question my identity as a Chicana in occupied America and articulate the experience of a minority woman. I work to understand the depth of my spiritual, political, emotional, and cultural icons, realizing that in exploring the topography of my conceptual homeland, Aztlan, I am searching for the configurations of my own vision.

My approach to art makes use of documentary methods. With each project, I study the discourse by examining the issues. The projects I produced are *Inca Street*, a photo journal of Denver's west side; *La Gente*, a slide presentation of the Mexican Nebraskan; *Crickets in My Mind*, an artist book in collaboration with Cecilio Garcia Camarillo, a Chicano poet; *Saints and Sinners*, a photo installation exploring the nature of the Hermanidad (a penitential brotherhood); *Codex Delilah, Six Deer a Journey from Mechica to Chicana; From the West: Shooting the Tourist*; and *El Corazón Sagrado/Sacred Heart*.

El Corazón Sagrado/The Sacred Heart is a collection of collotypes that portrays Albuquerque's Chicano community. The images explore the manifestation of the Sacred Heart as a cultural icon. This symbol is a spiritual icon that is embedded in the religious fabric of my culture. Basing my research on my own Mestizo perspective, I have concluded that this Baroque religious symbol expressed shared cultural religious patterns that connote a syncretic relationship between European Catholicism and Aztec philosophy.

When the Aztec Indians, for example, fashioned the bleeding heart on the Franciscans' coat of arms, they included their own stylized circular glyphs. For the Indians these glyphs represented the blood flowing from the sacrificial victims. Consequently, this representation could no longer exclusively be considered the heart of Christ in the sense previously intended by the European monks. Likewise, because of the new Christian definitions, the glyphed bleeding heart was not simply the sacrificial heart the Indians were being taught to forget. The Baroque Sacred Heart in the Americas is an icon that resulted from an encounter. It is not purely Indian in content and never completely European in its form. Rather, it is a hybrid of two diverse cultures that clashed and bonded at a particular historic moment and created the foundation for religious syncretism.

My approach to the Sacred Heart was to involve the community in a contemporary manifestation of the heart as a cultural icon. As a photographic printmaker, I photographed members of the Chicano community with an 8 × 10

view camera. The portraits were shot in a constructed space and reproduced as collotypes. The constructed space was the result of a collaboration with Chicano youth (aerosol artists) who spray-painted images on the studio walls. These murals were used as backdrops for the portraits.

The installation *Saints and Sinners* is an investigation of Chicano spiritualism. This investigation is part of a study to define a personal and collective identity. Spiritualism, a binding force of the Chicano homeland, is crucial to maintaining the mental boundaries of Aztlan. The study deals with iconography used by the Hermanidad for the transmutation of sin to absolution. The exhibit expresses the universal themes of life, death, and salvation.

The glass jar series, a component of *Saints and Sinners*, refers to the alchemist's method of transmutation. The alchemist places a material together with a catalyst in order to change it into a superior material. The jar symbolizes the corporeal, and the materials placed inside, the soul. Like a being, each jar is unique and possesses the potential for transformation. The exterior environment in which the jars float represents the land as altar space. Just as the cathedral provided a spiritual uplift for Western man, the land is the uplift for the Indigenous American. The exterior landscapes echo the interior ambiance of the jar.

Within the framework of a feminist vision, *Codex Delilah, Six Deer a Journey from Mechica to Chicana* approaches the Spanish/Indian encounter from a *mestizaje* perspective. As a Chicana, I am conscious of how the historical contributions of women have been undermined or completely ignored. This project attempts to correct that injustice by rethinking the traditional interpretation of the European/Native encounter. The narrative of this artist book is viewed from the perspective of Six Deer, a fictional Mayatec young girl from the Tutupepec region near present-day Mexico City. From her home to the nuclear weapons laboratories in New Mexico, the codex details Six Deer's journey toward enlightenment.

As she journeys "pal norte," toward Aztlan (the spiritual home of her ancestors), Six Deer also travels forward in time, meeting well-known women of the Chicano folklore tradition. Each of these characters informs her of the long and negative historical processes that were initiated by the European encounter. For example, Six Deer meets La Llorona, a manifestation of Cortez's mistress Malinche, who describes the effect of the conquest on her people. As Six Deer travels through time and space, she learns and simultaneously reveals to us our historical identity and how for our people survival has meant learning to live within a multicultural heritage and ambiance.

From the West: Shooting the Tourist, my most recent body of work, attempts to redirect documentary photography from the "objective" vision of modernity by documenting its search for the "West" through tourist attractions. The notion is to return the documentary gaze.

Shooting the Tourist, commissioned by the Mexican Museum for the traveling exhibition *From the West*, consists of seven artist books constructed into accordion-fold postcards and one photomural. The mural depicts a tourist line

waiting to ride on Thunder Mountain at Frontier Land in Disneyland. The series of postcards documents various tourist activities.

At present, my conceptions are rendered through printing processes that together form a photographic printing technique. This composite skill is the result of experimentation with printmaking, computer technology, and photography. This process allows me to inject my own conceptual expression into the photo image.

BIOGRAPHICAL ESSAY

Delilah Montoya views her art as a serious and viable vehicle for exploring issues of Chicana ideology. Her approach to art makes use of documentary methods. Some of her documentary series include the following: *Inca Street* is a photo journal of Denver's west side; *La Gente* is a slide presentation of the Mexican Nebraskan; *Crickets in My Mind* is an artist book in collaboration with Cecilio Garcia Camarillo, a Chicano poet; *Saints and Sinners* is a photo installation exploring the nature of the Hermanidad (a Franciscan penitential brotherhood); *Codex Delilah, Six Deer a Journey from Mechica to Chicana*; and *From the West: Shooting the Tourist. El Corazón Sagrado/Sacred Heart* is a collection of collotypes that portray Albuquerque's Chicano. The images explore the manifestation of the Sacred Heart as a Chicano cultural icon, embedded in religious tradition. Montoya has researched the Sacred Heart image in European Catholicism and Aztec philosophy. The Aztec Indians, for example, fashioned the bleeding heart on the Franciscans' coat of arms. It is a hybrid symbol of diverse cultures. Montoya involved the community by photographing members with an 8 × 10 view camera. This series sprang from a historical investigation of the symbol and evolved into a collaboration with young aerosol artists. In order to depict the Sacred Heart as a sacred icon she involved the community in the works development. The murals printed by local aerosol artists on her studio walls were utilized as backdrops for portraits she composed. This collaborative experience not only gave the young artists a safe space to work but equally inspired the artist as well.

The installation *Saints and Sinners* is an investigation of Chicano spiritualism and the transformation of sin to absolution, expression cycles of life, death, and salvation. Montoya's jar series is part of this installation and makes reference to the alchemist's method of transmutation by placing a material with a catalyst to change its properties. The jar symbolizes the corporal, and the materials inside, the soul, and each jar possesses the potential for transformation. Each jar has an interior landscape that acts as altars for a request made. *(Glass Jar with Rosary Beads)—The Blessing* is a cibachrome print, the image of the glass jar superimposed on a color photograph of a landscape. Inside the jar is a rosary and a black and white image of a girl at her First Communion. This print makes reference to the preservation of spirituality in organized tradition as well as in the primordial energy of the land, hoping for a transmutation of a new spiritu-

ality. *(Glass Jar with Child)—Who Wants My Baby* is a print of an image of a baby enclosed in a jar whose image is placed in the interior space of a run-down vacant house. Abandonment and desertion are implied. Montoya's prints are two-dimensional altars upon which social ills are raised up as petitions for change, transformation, and spiritual enlightenment.

PARRA, CATALINA

Nationality: Chilean. *Born*: 1940, Santiago, Chile. *Education*: Parra attended high school in Chile. She is a self-taught artist. Her experience as a formal artist began in Germany when she was 28 years old. *Family*: Parra comes from a family of artists, poets, and musicians. Her father, Nicanor Parra, is a well-known Chilean poet whose works draw on aphorisms and other vernacular expressions. Her aunt Violeta Parra led the revival of indigenous music in Chile, and her songs became anthems of the Latin American New Song movement of the 1970s, fusing troubadour and folk traditions with politically charged lyrics. The poetry of her father and the music of her aunt have no doubt influenced Parra's visual arrangements of words and phrases with images. Parra was married in 1958 and had three children by 1962. *Career*: Parra's art career began in Germany, where she lived from 1968 to 1972. She moved into the art communities there with her German-born art critic husband Ronald Kay. She became familiar with the photomontage technique developed by the Berlin Dada movement. She was especially influenced by the British Pop artists exhibition *Information*, which inspired her to create a series of collages. Parra has an extensive teaching career in conjunction with her art making. She is currently teaching at the New Museum of Contemporary Art, New York. She also taught at the New Museum from 1991 to 1996; at El Museo del Barrio, New York, in 1990 and 1994; at Sommer Akademie, Palderborn, Germany, in 1995; and at the State University of New York, Purchase, in 1991. She was also an Artist-in-Residence at Civitella Ranieri, Umbertide, Italy, in 1995; at BANFF Center for the Arts, Canada, in 1993 and 1994; and at El Museo del Barrio, New York, in 1990. Parra has given public talks and lectures in New York, Washington, D.C., Santa Fe, Canada, Chile, and France. *Awards*: Parra received a Guggenheim Fellowship in 1980. Parra has exhibited extensively on three continents and has an upcoming exhibition in 1998 at the Museo de Bellas Artes in Caracas and an upcoming one-woman exhibition in 2000 at the Jersey City Museum.

EXHIBITIONS

1998 Jersey City Museum, New Jersey, New York (catalog)

1997	Meredith Kelly Art Gallery, Santa Fe, New Mexico
1992	Lehman College Art Gallery, New York, New York (catalog); Museo de Arte Contemporáneo, Santiago, Chile (catalog)
1991	Museo des Arts, Sainte Foy, France; Exposition Mediatheque Municipale, Libourne, France; INTAR Gallery, New York, New York (catalog)
1990	Galerie Zographia, Bordeaux, France (catalog)
1987	Terne Gallery, New York (catalog)
1983	Ivonne Seguy Gallery, New York (catalog)
1981	Museum of Modern Art (MoMA), New York
1977	Galería Epoca, Santiago, Chile (catalog)
1971	Gallerie Press, Konstanz, Germany

SELECTED GROUP EXHIBITIONS

1997	*Across Borders*, A Space, Toronto, Canada
1996	*Across Borders*, Peterborough, Ontario, Canada
1995	*Latin American Women Artists 1915–1995*, Milwaukee Arts Museum, Milwaukee, Wisconsin (traveling show in the United States)
1994	*Rejoining the Spiritual: The Land in Contemporary Latin American Art*, Maryland Institute College of Art, Baltimore, Maryland
1993	*Engaged Cultures*, traveling show in the United States; *States of Loss*, Jersey City Museum, New Jersey
1992	*Empreintes de Distance*, (L'Exil) Articule, Montreal, Canada; *Marking Time Marking Place 1492–1992*, Galería de la Raza/Studio 24, San Francisco, California; *Installations*, Dowd Fine Arts Gallery, State University of New York, College at Cortland (catalog); *Remerica! America 1492–1992*, The Bertha and Karl Leubsdorf Art Gallery at Hunter College, New York; *Troubled Waters*, Rockland Center for the Arts, New York; *Rediscoveries: The Mythmakers*, Jamaica Arts Center, Jamaica, New York
1990	The Decade Show: Frameworks of Identity in the 80s (catalog) The New Museum of Contemporary Art, New York (catalog); *Installations: Current Directions*, Museum of Contemporary Hispanic Art (MoCHA), New York; *Coastal Exchange III*, Main Gallery, Richmond, Virginia (catalog); *Dream Machinations in America*, Minor Injury, New York
1989	*Women and Art*, Boricua College, New York; *Urban Narrative/Evil Empires*, Center for Contemporary Art, Newark, New Jersey; *Beyond Survival: Old Frontiers—New Visions*, New York Fine Arts Institute, New York; *Running Out of Time*, Gallery 128, Riverton Street, New York
1988	*MIRA!*, The Canadian Club Hispanic Art Tour III; *Works on Paper*, Arch Gallery, New York; *Art of the Refugee Experience*, Euphrat Gallery, Cupertino, California; *The Debt*, Exit Art, New York

1987	*From the Other Side*, Terne Gallery, New York; *Un Hiver D'Ang-oisse*, Articule Gallery, Montreal, Canada; *Messages to the Public*, Spectacolor Lightboard, One Times Square. The Public Art Fund, Inc., New York; *Connections*, Museum of Contemporary Hispanic Art (MoCHA), New York
1986	*In the Tropics*, The Bronx Council in the Arts, New York; *Segunda Bienal de la Habana*, Habana, Cuba
1985	*Collaborations*, Alternative Museum, New York; *Artists Books*, Franklin Furnace, New York
1984	*Latin American Visual Thinking*, Art Awareness Gallery, Lexington, New York; *Ten Latin American Artists Working in New York*, International House, New York; *Women and Politics*, INTAR Gallery, New York; *Reconstruction Project*, Artist Space, New York; *Artist Call: Rape/Intervention*, Ivonne Seguy Gallery, New York
1983	*Contemporary Latin American Artists*, Chrysler Museum, Norfolk, Virginia; *Hispanic Achievements in the Arts*, Equitable Gallery, New York; *Traditions and Modern Configurations*, AAA Art, New York, ''Textos Inferno'' Galería Venezuela, New York; *Multiples: Latin American Artists*, Franklin Furnace, New York; *Latin American Women Artists Living in New York*, Central Hall Gallery, New York
1982	*Beyond Aesthetics*, Henry Street Settlement, New York; *Common Sensibilities*, Central Hall Gallery, New York; *Ritual and Rhythm*, The Kenkeleba House Gallery, New York; *Women of Americas*, Center for Inter-American Relations, New York
1981	*Monologues, Ten Artists from South America*, Henry Street, Settlement, New York
1979	*Bienal de Buenos Aires*, CAYC, Buenos Aires, Argentina; *Encuentro de Arte Joven*, Instituto Cultural de las Condes, Santiago, Chile
1978	*Tercera Bienal de Valparaiso*, Valparaiso, Chile; *Triennial of India*, New Delhi, India; *III American Biennial of Graphic Arts*, Cali, Colombia
1972	*Internationale Kunstmesse Art 3*, Basel, Switzerland
1971	*Internationale Kunst und Informationsmesse*, Köln, Germany

COLLECTIONS

Archer M. Huntington Gallery, University of Texas, Austin; Museo El Barrio, New York; Museum of Art, Rhode Island School of Design, Providence; Museum of Modern Art, New York; New School for Social Research, New York

PUBLICATIONS

Advincula, Carlos. ''Catalina Parra en Lehman.'' *La Causa* (New York), 1992.
Aranguiz, Carolina. ''El Otro Diario de Catalina Parra.'' *La Nación* (Santiago, Chile), 1992.

Art in America. "1991 in Review." *Guide to Galleries-Museums Artists, 92–93*. New York: Author, 1991.

"Artistic and Cultural Identity in the Western Hemisphere." *American Visions*, 1994.

Bindis, Ricardo. "El Arte de Catalina Parra." *La Tercera* (Santiago, Chile), 1992.

Christ, Ronald, Dennis Dollens. *Nomadic Design*. New York: 1993.

Eltit, Diamela. *La Transparencia de la Mirada*. Santiago, Chile, 1990.

"En Agosto, Retrospectiva de Catalina Parra." *La Segunda* (Santiago, Chile), 1992.

Feijoo, Katia. *Catalina Parra, Une Conscience Politique*. Bordeaux, France, 1990.

Fusco, Coco. *English Is Broken Here: Notes on Cultural Fusion in the Americas*. New York: New Press, 1995.

Gajardo, Alejandra. "La Retrospectiva de Una Parra." *La Epoca* (Santiago, Chile), 1992.

Herreria, Michel. "Catalina Parra, un art de dire." *Artension* (Bordeaux, France), 1990.

Herzberg, Julie. *Re-Membering Identity: Vision of Connections*. New York, 1990.

Hess, Elizabeth. "Breaking and Entering: The Decade Show." *Village Voice* (New York), 1990.

Lippard, Lucy. *Mixed Blessings: New Art in a Multicultural America*. New York: Pantheon-Random House, 1990.

Lockpez, Inverna. *Village Voice Art Special*, 1990.

Montero, Beatriz. "Con Lenguaje Nuevo." *El Mercurio* (Santiago, Chile), 1992.

Morgan, Robert C. *Arts Magazine* (New York), 1990.

"Otra Parra en el Museo." *Hoy* (Santiago, Chile), 1992.

Raven, Arlene. "A Stitch in Time," *Village Voice* (New York), 1992.

Ryan, Dinah. "Coastal Exchange III." *Art Papers* (Virginia), 1990.

Sommer, Waldemar. "Catalina Parra Ha Vuelto." *El Mercurio* (Santiago, Chile), 1992.

Torres, Ximena. "Nicanor y Catalina: De tal Parra tal astilla." *Revista Paula* (Santiago, Chile), 1990.

Valdes, Cecilia. "Hago Mi Propio Periodico." *El Mercurio* (Santiago, Chile), 1992.

Valenzuela, Samuel. "Catalina Parra en Museo de Arte Contemporáneo." *Las Ultimas Noticias* (Santiago, Chile), 1992.

ARTIST STATEMENT (1997)

I have been working with international social and ecological issues for the last 30 years: During the 1970s I focused on the political situation in Chile, where I had grown up and lived at the time; since 1980, in the United States where I live now, I have focused on global issues that affect all human beings.

I make use of media and photographs, texts from various sources, and ordinary materials from daily life—all loaded with their own iconography. Tearing and fragmenting these materials, I then sew and tape them together, communicating my attitude and feelings toward the issues, not only in my choice of commonplace, ephemeral materials but also in the ways I reassemble them. I do not preach. I ask questions. I ask the viewer to ask questions.

BIOGRAPHICAL ESSAY

Catalina Parra possesses an acute sensibility of the illusory qualities of mass media and culture. Her works expose the transparency and superficiality of in-

formational materials and the illusions of security and hegemony. She explores issues of displacement, fragmentation, and disillusion, which are central to her own experience as a migrant artist. New York has been Parra's home since 1980. Making art allows her to root her diversified self firmly in a North American present, as a social critic and visionary. She considers herself a "scrambled mixture . . . and a citizen of the world society," as well as "part of New York with all its chaos."

In mass media there is a constant bombardment of images and words. Parra's work fuses selected media images and words in response to that bombardment and as a critique of cultural ideologies and circumstances. Over the last decade, Parra's hand-sewn, symbolically charged materials—gauze, plastic bags, newspaper and magazine images, maps, texts, and animal hides—have evolved from metaphors about repression into contemporary commentaries on the suppressed, subliminal significance of the mainstream media in the United States and its effect on popular perception. Her collages are critical interpretations of social, political, and ecological conditions.

In 1968 Parra went to Germany where she dedicated time to her work and was influenced by Pop artists. Germany's political history was of particular interest for Parra—the politics of the 1920s, the Hitler period, the social and artistic consciousness of the late 1960s, and the work of Joseph Beuys. She had a job at an ad agency, and it was this experience that prompted her to begin cutting disparate materials and piecing them together.

In 1972 Parra returned to Chile, only to find it in a state of chaos and violent political unrest. She felt like an outsider. It was at this time that she began to collect materials like plastic bags, animal skins, wood, wire, cloth, stamps, newspaper clippings, and tickets to use as art materials. These materials embodied the violence of her homeland, and she incorporated them with discernment, literally stitching together images and words, tearing, ripping, taping, and patching in attempts to piece together the brokenness, the ruptured reality she experienced. She used barbed wire to express the cruelty and destruction she saw in Chile. Her work represented the dead and disappeared. Adhesive tape became a metaphor for wounds and animal skins referred to the dead. Sewing became a metaphor for censorship silenced through the stitches.

Parra focused on political issues in Chile, but in the States, particularly in New York and New Mexico, her work centers on social and ecological issues. When Catalina Parra came to New Mexico, its landscape recalled her own native Chilean landscape—the dry, desert terrain, the skies, mountains, and arroyos. Parra's visits to New Mexico made her remember the Chile of her childhood. Growing up in a desert region provoked her heightened awareness of water— its usage, preservation, and value. Her work often incorporates handmade paper to emphasize the necessity for water to make paper to begin a work, a necessity often taken for granted. Parra did a series of work in New Mexico called *Clouds, Mountains, Water*, dealing specifically with water issues in a desert region.

From her New Mexico series, Niagara Falls and New Mexico skies are pieced together to bring water from Niagara to Santa Fe during a drought. Her collages

reflect the unrest, imbalance, paradoxes, and injustices of the world she sees. She combines charged iconography, usually selected from mass culture, with other carefully selected materials to create tension that provokes the viewer to really read and see the content layered in her messages.

In a recent installation in Lexington, New York, Parra exposes the environmental atrocities of the New York beaches shut down due to contamination from the dumping of excessive amounts of medical wastes. This installation incorporates sculptures made from bread loaves, dead fish in plastic bags, and animal skins. ''What are we doing to the environment?'' the work seems to beckon, as art materials rot in space and time. Water pollution and scarcity affect all people.

Parra's aesthetic intent intersects with her political commitment, like her stance against Pinochet's dictatorship in Chile, the U.S. intervention in Nicaragua and Iran, and her position against poverty, hunger, and pollution. These issues are paramount in Parra's surfaces of cut, ripped, layered, and stitched images and words that embody a duplicity of seeing and reading. Her objective is to communicate the content of the work to the viewer using reinterpreted and rearranged mass media materials as tactics of reversal to suture a new vision of hope in a desperate time.

PELÁEZ, AMELIA

Nationality: Cuban. *Born*: 1896, Yaguajay, Cuba. *Education*: Peláez entered the Academia San Alejandro in Havana in 1916. She went to New York in 1924, where she studied briefly at the Art Students' League with George C. Bridgeman. She then returned to Havana. In 1927 she moved to Paris to attend drawing, painting, and art history classes. From 1927 to 1934 she traveled through Europe on a Cuban government scholarship before returning to Cuba. She attended classes Grande Chaumière in the history of art at the Ecolé des Beaux Arts and Ecolé du Louvre. She traveled to Madrid to study Velázquez at Prado and to see Gothic architecture in Belgium, Holland, and Germany. *Career*: Peláez was a pioneer in fusing Modernist tendencies like Cubism and Modigliani's influences with early twentieth-century Cuban art. In the history of Cuban art she has paralleled her male contemporaries, Wilfredo Lam and René Portocarrero. Her work was first exhibited in Paris in 1933. *Died*: 1968, Havana.

SELECTED EXHIBITIONS

1995 *Latin American Women Artists, 1915–1995*, Milwaukee Art Museum, Wisconsin, Phoenix Art Museum, Arizona, Denver Art Museum,

	Colorado, National Museum of Women in the Arts, Washington, D.C.
1988	*Amelia Peláez, 1896–1968, A Retrospective*, Cuban Museum of Art and Culture, Miami, Florida
1959	*The United States Collects Latin American Art*, Art Institute, Chicago, Illinois
1956, 1957	Pan American Union, Washington, D.C.; American Federation of the Arts, Washington, D.C.
1952	Pan American Union, Washington, D.C.; Institute of Contemporary Art, Boston, Massachusetts
1947	Pan American Union, Washington, D.C.; Institute of Modern Art, Boston, Massachusetts
1946	Pan American Union, Washington, D.C.
1945	San Francisco Museum of Modern Art, San Francisco, California
1944	Museum of Modern Art, New York
1943	Museum of Modern Art, New York
1942	San Francisco Museum of Modern Art, San Francisco, California
1941	Solo Exhibition, Galería Norte, New York
1939	*Latin American Exhibition of Fine Arts*, Riverside Museum, New York
1933	First Exhibition, Galerie Zak, Paris

SELECTED COLLECTIONS

Art Museum of the Americas, Organization of American States, Washington, D.C.; Cuban Foundation Collection, Museum of Arts and Sciences, Daytona Beach, Florida; Collection of Carolyn Farb, Houston, Texas; Museum of Modern Art, New York; Museum of Modern Art of Latin America, Washington, D.C.

PUBLICATIONS

Alonso, Alejandro G. *Amelia Peláez*. Havana: Edit. Letras Cubanas, 1990.

Altmann, Robert. "Ornamento y naturaleza muerta en Amelia Peláez. *Orígenes* (Winter 1945).

Baigts, Juan. "Amelia Peláez, Gran Dama de la Pintura." *Excelsior*, October 7, 1979.

Barr, Alfred H., Jr. "Modern Cuban Painters." *Museum of Modern Art Bulletin 5* 9 (April 1944).

Blanc, Giulio V. "Amelia Peláez: The Artist as Woman." *Art Nexus* 51 (August 1992), pp. 214–216.

Casal, Julian del. *Poesias completas*. Havana: Ministerio de Educación, 1945.

Consejo Nacional de Cultura. *Amelia Peláez*. Havana: Author, 1968.

Cuban Museum of Art and Culture. *Amelia Peláez: 1868–1968—A Retrospective/Una Retrospectiva*. Miami: Author, 1988.

Damian, Carol. "Amelia Peláez." *Latin American Art 3* 2 (Spring 1991), pp. 27–29.

Gamboa, Fernando. *La Gran Pintora Cubana Amelia Peláez*. Mexico City: Museo de Arte Moderno, 1979. Exhbn cat.

Gómez Sicre, José. *Pintura Cubana de Hoy*. Havana: Maria Luisa Gómez Mena, 1944.

González, Beatriz. "Amelia Peláez y la Cultura Cubana." *Re-Vista 5* 2 (1980).

Mañach, Jorge. "Amelia Peláez o el absolutismo plástico." *Revista de La Habana 13* 3, no. 2 (September 1943), pp. 32–38.

Museo del Pueblo/Museo de Arte Carrillo Gil. *Amelia Peláez, Fulgor de las Islas*. Guanajuato/San Angel, 1991.

Poglotti, Graziella. "Amelia Peláez." *La Gaceta de Cuba 64*, no. 6 (April–May 1968), pp. 8–9.

Rigol, Jorge, et al. *Amelia Peláez*. Havana: Museo Nacional, 1968. Exhbn cat.

Rodriguez, Bélgica. "Apuntes sobre Amelia Peláez y el arte latinoamericano." *Plástica 18* 1, no. 10 (March 1988), pp. 64–75.

Zea de Uribe, Gloria. *Amelia Peláez*. Havana: Comisión Nacional Cubana de la UNESCO, 1973.

BIOGRAPHICAL ESSAY

Amelia Peláez is to the history of twentieth-century Cuban art what Anita Malfatti and Tarsila do Amaral were to the history of contemporary Brazilian art: a pioneer who helped bring her Cuba and Latin American art into the twentieth century. Her stature in the history of Cuban art is considered parallel to that of her contemporaries Wilfredo Lam and René Portocarrero. She incorporated elements of modernism, particularly Cubism and Modigliani into her work, which influenced other artists of her time. Peláez did, however, develop her own more personal and introspective sensibility. Her interpretations of the gardens and wrought-iron grillwork that surrounded her Havana villa provide a uniquely constructed view of the colorful flora and baroque colonial architecture of Cuba.

Beginning in 1939 she exhibited in group exhibitions in the United States, including the *Latin American Exhibition of Fine and Applied Art* at the Riverside Museum in New York. In 1941 she had her only individual exhibition while she was alive at the Galería Norte in New York. It is important to note that at this time (1930s), most Mexican artists were heavily influenced by the sociopolitical ideas and images advocated by the great muralists. Cuban artists, like Peláez, were more concerned with the development of figurative images that did not carry any particular ideology. What was of primary concern for Cuban artists at this time was the freedom of a more formalistic visual expression. They were motivated by the freedom inspired by the variety of artistic styles in the early twentieth century.

Peláez's paintings have a baroque nature that reflects the exuberant Caribbean environment of her native land. Her painting is replete with allusions to that land. The intricate networks that lace together her colors recall the cane-bottomed chairs of the Caribbean, Victorian fan lights, and patterned curtains. Peláez had a great impact on other Cuban artists with her distinctive style. She developed structured compositions in which the elements are sometimes aggressively decorative. *Marpacífico (Hibiscus)* (1943) demonstrates this intricate network style, decorative elements, and a patterned, flattened space. *Naturaleza*

Muerta (Still Life) (1955) is another example of her bold outlined shapes creating an almost calculated, systematic composition. Bold colors, abstracted outlined shapes, condensed spaces, and detailed patterning recall those found in the paintings of Matisse and Stuart Davis.

PORTER, LILIANA ALICIA

Nationality: Argentinean. *Born*: 1941, Buenos Aires, Argentina. *Education*: Porter graduated from the National School of Fine Arts in Argentina in 1963. She also studied at the Universidad Iberoamericana in Mexico City in 1958, and in 1959 she exhibited individually for the first time at the Galería Proteo also in Mexico City. In 1961 she returned to Buenos Aires to study at the Escuela Nacional de Bellas Artes. In 1964 she moved to New York, where she continues to live and work. *Family*: Porter came to the United States in 1964 and naturalized in 1982. Her parents were Julio and Margarita (Galetar) Porter. She married Luis Camnitzer in 1965 and divorced him in 1978. She remarried in 1980 to Alan B. Wiener and then divorced him in 1991. *Career*: She cofounded the New York Graphic Workshop in 1965 with Camnitzer. She was an adjunct lecturer at SUNY College, Old Westbury, New York, from 1974 to 1977. She was a codirector and instructor at Studio Camnitzer-Porter in Lucca, Italy, for summer workshops in 1975, 1976, and 1977. From 1979 to 1987 Porter was a codirector of Studio Porter-Wiener in New York City. Porter was an Associate Professor of Art at Queens College, New York, in 1991. *Awards*: In 1978 she was the first-prize recipient for the Argentian Art 78, Museum of Fine Arts, Buenos Aires. The New York Foundation for the Arts granted her a fellowship in 1985, and she received a Guggenheim Fellowship in 1980. In 1986 she was awarded first prize in the VII Latin American Print Biennial, San Juan, Puerto Rico; and in the Grand Prix XI International Print Biennial, Cracow, Poland. Porter is represented by Steinbaum-Krauss Gallery in New York City.

EXHIBITIONS

1993	*Retrospective Exhibit*, Archer Huntington Art Gallery, University of Texas, Austin; Steinberg-Krauss Gallery, New York City
1992	Bronx Museum of Art, New York City
1991	Museo Nacional de Artes Plásticas, Montevideo, Uruguay; Centro de Recepciónes del Gobierno, San Juan, Puerto Rico
1990	Syracuse University, New York; Fundación San Telmo, Buenos Aires, Argentina

1988	The Space, Boston, Massachusetts
1987	Galería Taller, Museo de Arte Moderno, Cali, Colombia
1986	Galería Luigi Marrozzini, San Juan, Puerto Rico
1985	Dolan Maxwell Gallery, Philadelphia, Pennsylvania; University of Alberta, Edmonton, Alberta, Canada
1984	Museo de Arte Contemporáneo, Panama City, Panama
1983	Galerie Jolliet, Montreal, Quebec, Canada
1982–1984	Barbara Toll Fine Arts, New York City
1980	Center of Inter American Relations, New York City; Galería Arte Nuevo, Buenos Aires, Argentina
1978	Museum of Modern Art, Cali, Colombia
1977–1978	Galería Artemultiple, Buenos Aires, Argentina
1977	Galería Arte Comunale, Adro, Brescia, Italy; Hundred Acres Gallery, New York City
1968–1990	Retrospective Exhibit, Syracuse University, Syracuse, New York

GROUP EXHIBITIONS

1993	MOMA, New York City
1987	Museum of Contemporary Spanish Art, New York City
1986	Galería Epocha, Santiago, Chile; Centro Wilfredo Lam, Havana, Cuba
1983	Musee d'Art Contemporain, Montreal, Quebec, Canada; Queens College, Flushing, New York; Museum of Modern Art, San Francisco, California
1982	Bronx Museum of Fine Arts, Bronx, New York
1980	Alternative Museum, New York City, New York
1979	Ben Shahn Gallery, New Jersey; Everson Museum, Syracuse, New York; Washington World Gallery; Roosevelt Art Museum and Gallery, Nassau County, New York
1978	Center for Interamerican Relations, New York City, New York; Chateau de L'Hermitage, Brussels, Belgium; Museum of Fine Arts, Buenos Aires, Argentina; Alternative Center for International Arts, New York City, New York

COLLECTIONS

La Biblioteque Nationale, Paris, France; Metropolitan Museum of Art, New York City; Museo de Arte Moderno, Cali, Colombia; Museo de Bellas Artes, Caracas, Venezuela; Museo del Grabado, Buenos Aires, Argentina; Museo Universitario, Mexico City, Mexico; Museum of Modern Art, New York City; Museum of Philadelphia; New York Public Library, New York City; RCA Corporation, New York City; Recipient 1st Prize Argentinian Art 78

PUBLICATIONS

Contacts/Proofs. Jersey City, N.J.: Jersey City Museum, 1993.

Cuperman, Pedro. "About Metaphors: The Art of Liliana Porter." In *Liliana Porter*. Syracuse: World Gallery, Syracuse University, 1990.

El desdoblamiento, el simulacro y el reflejo. Buenos Aires: Instituto de Cooperación Iberoamericana, 1994.

Floored Art. New York: Steinbaum Krauss Gallery, 1992.

Goldman, Shifra. "Presencias y ausencias: Liliana Porter en Nueva York 1964." In *Liliana Porter: Selección de obras 1968–1990*. Buenos Aires: Fundación San Telmo, 1990.

Gonzalez, Miguel. *Liliana Porter*. La Tertulia, Calib: Museo de Arte Moderno, 1983. Exhbn cat.

Humphrey Gallery. *Books, Books and Books*. New York, 1991.

Kalenberg, Angel. *Liliana Porter: Selección de obras, 1968–1990*. Buenos Aires: Fundación San Telmo, 1990.

Le Sud est notre Nord: Identité et modernité de L'Amérique Latine ou XX Siècle. Paris: Hotel des Arts, 1992.

Liliana Porter. Bogotá: Museo de Arte Moderno, 1974.

Liliana Porter/Luis Benedit. Madrid: Ruth Bencazar Galería de Arte, 1988.

Liliana Porter. Greensboro: Weatherspoon Art Gallery, The University of North Carolina, 1991.

Nelson, Florencia Bazzano. "Porter y Borges: Una revelación inminente." In *Liliana Porter: Selección de obras 1968–1990*. Buenos Aires: Fundación San Telmo, 1990.

Obra Gráfica: 1964–1990. San Juan, Puerto Rico: Centro de Recepciónes del Gobierno, 1991.

Ramirez, Mari Carmen, and C. Merewether. *Liliana Porter: Fragments of the Journey*. New York: Bronx Museum of the Arts, 1992. Exhbn cat.

Reclaiming History. New York: El Museo del Barrio, 1994.

Show of Strength. New York: Anne Plumb Gallery, 1991.

Stringer, John. *Liliana Porter*. New York: Center for Inter-American Relations, 1980. Exhbn cat.

Urbach, Marina. "Liliana Porter—Steinbaum Krauss Gallery." *Art Nexus* 56 (September–December 1993), pp. 144, 212–213.

Windhausen, Rodolfo. "Voyages through Absence and Presence." *Americas* 44 4 (1992), pp. 22–27.

BIOGRAPHICAL ESSAY

In 1969 Porter participated in *Experiencias 69*, at the Instituto Torcuato Di Tella in Buenos Aires, by painting the shadows of individuals on the wall, like absent spectators. It was then that she first encountered one of the central issues her work continues to explore: the opposition between reality and illusion. She uses photography, photo-engraving, and photo-silkscreen to illustrate the interplay between signs and their objects.

In 1972 Porter did an installation in Milan with real strings that hung from

fictitious nails photo-engraved onto the wall. She then drew lines in space that were tied to real nails in the floor. A year later she was invited to do a similar installation at the Museum of Modern Art in New York. In 1975 she completed her *Magritte* series, of which *The 16th of September* is a part. This is a photo-engraving with aquatint that reworks Surrealist Rene Magritte's 1957 painting of the same title. Porter replaces Magritte's naturalistic tree with a photo-engraving of her own hand. A stark white crescent moon marks the center of the palm.

Porter's work analyzes representational codes and their relationship to modes of perception. In a series of works from 1977, *Untitled*, *The Journey*, and *Phrase*, pencil lines, inkblots, and soot embody the minimal elements of a hermetic sign language, a verbal vision, a visual alphabet. As a printmaker, the process of drawing has naturally manifested in Porter's works. Her drawing transcends its ordinary function and is transformed into codified language. In *Correction V* (1991), a painting and assemblage on canvas, Porter lays out the process of construction and representation of a still life, incorporating references to instruments that allow the artist to correct, alter, and adjust drawings, like red pencil and crayon. A red lipstick rests on a real shelf. In *Correction V*, Porter exposes the illusion, tears apart the metonymy, showing the assumptions upon which perceptions and conventions of art are shaped. She sometimes employs academic drawing in opposition to experimental modes to enhance the relationship between the real and the illusory. It is in her analytical vision that she explores the relational value of words and the suggestive power of metaphor.

Porter's work has a direct relationship to literature and in particular the writing of Jorge Luis Borges and Lewis Carroll, with their use of paradox. Porter, like Borges, explores parallel realities, the invention of verisimilitudes, fantasies, and illusion. Her painting/collage *The Unending Story* (1980) incorporates Borgesian conventions of time and space and the relation of self-referential to dialogistic elements in art. The altered appearances and scale distortions of objects carefully arranged on the canvas recall the work of Lewis Carroll.

RODRIGUEZ, ANITA

Nationality: New Mexican. *Born*: 1941, Taos, New Mexico. *Education*: Rodriguez was surrounded by art and artists before school age in Taos. She spent time with Taos artists Victor Higgins and Julius Charles Berninghaus. When she was 16, she went to Mexico City to study the work of Frida Kahlo and Diego Rivera. Other artistic training at the University of New Mexico and Col-

orado College did not lead her to the studio until years later. As a child she traveled with her father on Sundays, in his 1941 Studebaker, to rural villages of New Mexico. These experiences have inspired her work as a painter. She learned about *yerbas nativas* (native herbs) and how to castrate sheep. She also learned about adobe architecture and building, a tradition in New Mexico. She left New Mexico and returned in 1965 to retrace her earlier journeys with her father to villages like Peñasco and Chamisal to learn the traditions of the *viejas* (old women). It was these women who built and maintained the villages. *Family*: Rodriguez is the daughter of Alfredo ''Skeezie'' Rodriguez, who was a druggist, and artist Grace Graham King. Her paternal grandfather was from Parral, Mexico. *Career*: Rodriguez built the house that she now lives in, in Taos. For 25 years she worked as a general contractor and adobe builder. In 1984, at the age of 47, she returned to painting full-time. In addition to painting and building, Rodriguez also writes stories. She is currently working on a novel. She finds that all three mediums, writing, painting, and construction, are related processes and enhance each other. *Awards*: Rodriguez was written about in *Ms. Magazine*, was featured on the *Today Show*, and received the Wonder Woman Award from Warner Communications.

SELECTED EXHIBITIONS

1996	*De Colores*, Mission Cultural Center for Latino Arts, San Francisco, California; *New Art of the West*, Eiteljorg Museum, Indianapolis, Indiana
1995	*Día de la Raza*, Albuquerque Museum of Art, Science and History, Albuquerque, New Mexico; *Exotic and Erotic Show*, Spirit-Runner Gallery, Taos, New Mexico; *Taos Invites Taos Show*, Rio Grande Hall, Civic Center, Taos, New Mexico; *One-Woman Show*, Handsel Gallery, Santa Fe, New Mexico; *Spanish Market*, Santa Fe, New Mexico; *Fiesta Artística*, Albuquerque Convention Center, Albuquerque, New Mexico
1994	*Artistas Contemporáneos de Nuevo Mexico*, Mayor of Guadalajara's Gallery, Guadalajara, Mexico; *Día de los Muertos*, Orange County Center for Contemporary Art, Santa Ana, California (Second Prize)
1993	*Four Person Show*, Millicent Rogers Museum, Taos, New Mexico
1992	*Visions of Hope, Threads of Vision*, Dougherty Art Center, Austin, Texas; *Día de Los Muertos Show*, La Luz de Jesús Gallery, Los Angeles, California; *The Crypto-Jews of New Mexico*, Handsel Gallery, Santa Fe, New Mexico; *Día de Los Muertos*, Mexican Museum of Fine Arts Center, Chicago, Illinois; *Fast-forward, an Alternative Art Show*, Firestone Building, Santa Fe, New Mexico; *Governor's Gallery Show*, Capital Building, Santa Fe, New Mexico; *Quincentennial Show*, Stables Art Center, Taos, New Mexico; *Eighth Annual Juried Latina Artists Show*, Guadalupe Cultural Arts Center, San Antonio, Texas

| 1991 | *Noche, One-Woman Show*, Ateleier Gallery, Taos, New Mexico; *One-Woman Show*, Dejavu Gallery, Taos, New Mexico |
| 1990 | *Hispanic Art—Contemporary and Traditional*, Santa Fe Center for the Arts, Santa Fe, New Mexico; *Tom Noble, Jim Wagner, Anita Rodriguez*, Dejavu Gallery, Taos, New Mexico; *Taos Hispanic Arts Council Show*, Millicent Rogers Museum, Taos, New Mexico |

COLLECTIONS

Albuquerque Museum of Art, History and Science, Albuquerque, New Mexico; Centennial Bank, Taos, New Mexico

ARTIST STATEMENT (1997)

The Spanish Conquest gave birth to a phenomenon the planet will not witness again. A new people and culture were born, woven out of a genetic and cultural diversity that encompasses all the gene pools and traditions of the Spanish, European, Muslim, and Jewish worlds.

Spain was the crossroads between Europe and Africa, and next door the Portuguese had opened to the Orient. She was the most culturally diverse and multiethnic country in the Western world, and she had created a Golden Age out of her diversity.

But that ended with the ascendancy of Christianity in 1491 and the "discovery" of America. The diaspora of Sephardic Jewry and the conquest of the Americas were simultaneous. Three days before Columbus sailed, Ferdinand and Isabella signed the edict ending more than eight centuries of Jewish, Muslim, and Christian coexistence on Spanish soil. Onto the indigenous tree of ancient American Indian civilizations were grafted the far-flung shoots of Spanish diversity.

My paintings are rooted in that world and inspired by its art, dances, ceremony, customs, and oral traditions. I paint stories in the visual vernacular of Hispanic New Mexico. The image of death comes from Penitente religious art; the shapes of *reredos* (altar screens), *retablos* (paintings on wood), and *nichos* (niches with doors) all come from New Mexican religious art and Mexican folk art (my paternal grandfather came from Parral, Mexico). As for the stories, that New Mexico was full of stories. In stories, I was born to a groaning table.

Certainly one of the most compelling of them all is that of the Conversos. It fascinated me. I was awed by the faith and tenacity of a people who kept their traditions in secret for so long while living in tiny villages where everybody knows everything. Things I had never understood or thought about suddenly took on new meaning. In 1991 I began painting the *Crypto-Jew* series.

A secret one's ancestors have kept for centuries accumulates a tremendous tendency to remain secret, even when its meaning has long been forgotten. Where the evidence has been deliberately destroyed and even oral tradition is reticent, everything ends up meaning several things, and scholars and historians

confront ambivalence and generate controversy. Perhaps all the truth will never be known.

But storytellers and painters reach the truth by different routes and tell it in a different idiom. It may well be that in the end the most authentic story of the New Mexican crypto-Jew, or *anusim*, will be told in the language of art and the voice of the storyteller.

Nichos with doors and *reredos* with movable panels are a perfect form with which to convey the multifaceted conflict and confluence of Jewish and Catholic holidays, the contradictions and multiple meanings of custom, and the atmosphere of secrecy. The *nichos* become like little theaters, the story becomes drama, and in the act of opening the doors, the viewer reveals the secret and becomes involved, a participant committed to believing the story. I hope my paintings will mirror what is perhaps the *tikkun* of a single people whose diversity is so generously beautiful.

BIOGRAPHICAL ESSAY

Anita Rodriguez's use of skeletons in her paintings is an affirmation of life, not death. Her fluorescent pink and green *calaveras* (skeletons) are dancing flamencos, boogeying to jukebox music, making love, eating, or generally celebrating the joys of living. Her figures are usually surrounded by elaborate and baroquely ornate settings of blazing orange and fuschia flowers that are a hybrid version of the Iris and Mexican paper flowers. Her use of skeletons stems out of a 6,000-year tradition of skeletons in American art. The *calavera* is a rich symbol of fertility and renewal. Rodriguez's paintings are not morbid images of death but are instead tantalizing and seductive scenes of life.

She Danced in a Secret Garden of Earthly Delights (1997) is an altarlike shrine that features a flamenco dancer in one of Rodriguez's fantastic spaces that is at once a botanical paradise and an interior dance or theater space. The dancer is honorably presented as if she were a saint on an altar screen or *retablo*. An array of floral bouquets crown the image in the arched doorwaylike space derived from traditional religious paintings in New Mexico. The frame is a vibrant floral ceramic piece by Santa Fe ceramist/sculptor George Alexander. A continuation of floral and votive offerings are gathered at the foot of the altar. The piece combines a *nicho*'s spatial depth with the flatness of an altar screen. This layering of space is common in Rodriguez's paintings, as well as the fusion of traditional elements with a flare of Baroque and fantasy.

Her paintings are inspired by dances, ceremony, customs, and oral traditions. Rodriguez paints stories in the visual vernacular of traditional New Mexico. The image of death comes from Penitente religious art. The shapes of *reredos* (altar screens), *retablos* (paintings on wood), and *nichos* (niches with doors) are derived from New Mexican religious art and Mexican folk art. Recent works have incorporated Jewish imagery, as Rodriguez explores her crypto-Jewish roots. She began painting a series in 1991. One *nicho, Las Posadas*, tells a story of

crypto-Jews. Hidden away inside the *nicho*, skeletons are lighting a menorah in preparation for a Hanukkah ceremony. Outside, others are celebrating a New Mexico Christmas.

Rodriguez's business card reads "Enjarradora," a woman who specializes in adobe architecture and building. Her years as an *enjarradora* have shaped her sensibility constructing both interior and exterior spaces, rooms, doors, and *nichos*. This keen sensibility is visibly evident in her paintings. Her paintings, like her structures, are attempts to capture and enclose the viewer in a new space. Rodriguez paints the illusions of space with rooms inside of rooms. She also creates three-dimensional spaces with *nichos* and wooden cabinets with painted interiors and exteriors.

For Rodriguez, *nichos* with doors and *reredos* with movable panels are a perfect form with which to convey the multifaceted conflict and confluence of Jewish and Catholic holidays, the contradictions and multiple meanings of custom, and the atmosphere of secrecy. The *nichos* become like little theaters. The story becomes drama. And in the act of opening the doors, the viewer reveals the secret and becomes actively involved and committed to believing the story, if only for a fleeting moment. Rodriguez paints with the voice of a storyteller, exposing the electric colors and diversity of a culture abounding in stories, rituals, myths, and dramas.

TORRES, MAYÉ

Nationality: New Mexican. *Born*: 1966, Taos, New Mexico. *Education*: Torres attended the University of New Mexico from 1978 to 1980 and Humboldt State University in Arcata, California, for one year in 1980. She received a B.F.A. from the University of New Mexico, Albuquerque, in 1982. Her studies in college focused on both art and science. Torres was an apprentice for artist Larry Bell of Taos from 1983 to 1986, for sculptor Ted Egri of Taos in 1983, and for painter John Wenger of Albuquerque also in 1983. *Family*: Torres was born in Taos, New Mexico, and was raised in Albuquerque. At the age of nine she moved with her family to El Salvador for two and a half years. They then moved to Quito, Ecuador. They returned to Taos, where Torres completed high school. She was heavily influenced by her parents and the art environment of Taos as a child. Her father used to be a painter, and her mother sewed. Her grandparents had an extensive art collection that influenced Torres as a child. This collection included works by Hans Paap, Patrocinio Barela, and Cliff Harmon. She lives in Taos with her husband and three sons. *Career*: Torres has exhibited in the

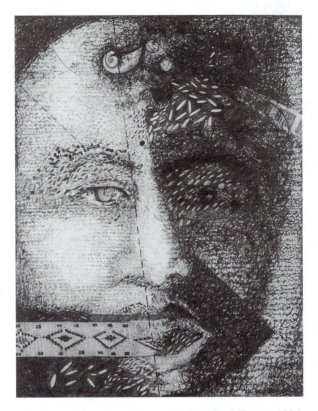

Weaving Wisdom from Depression by Mayé Torres, 1996,
drawing, 36" × 28". Courtesy of Pat Pollard Taos

New Mexico Spanish Market in Santa Fe since 1980 and regularly throughout
the state. *Awards*: In 1991 she was awarded a grant from the New Mexico Arts
Division for a One-Percent for the Arts project. She was the featured artist for
the *Patrick Finn Show* in Taos in 1992. In 1993 and 1994 Torres was named
Who's Who among Hispanic Americans.

SELECTED EXHIBITIONS

1997 *Taos Inn-vitational*, Taos Inn, Taos, New Mexico; New Directions
 Gallery, Taos, New Mexico; *Spanish Market*, Santa Fe, New Mexico;
 Taos Invites Taos, Taos, New Mexico

1996 *One-Person Window Exhibit*, New Directions Gallery, Taos, New
 Mexico; *Mayé Torres and Alejandra Almuelle: Two-Person Show*,
 Guadalupe Cultural Arts Center, Visual Arts Annex, San Antonio,
 Texas; *Window Exhibit*, Deborah Hudgins Fine Art, Santa Fe, New
 Mexico; *Contemporary Hispanic Market*, Santa Fe, New Mexico;
 Ranchos Trading Post Cafe Exhibit, Taos, New Mexico; *Toy Show*,

Gallery Elena, Taos, New Mexico; *Arte Contemporáneo por Hispanos*, Gallery Plaza Real, Santa Fe, New Mexico

1995 *Monothon '95*, College of Santa Fe Fine Arts Gallery, Santa Fe, New Mexico; *Fiesta Artística*, Albuquerque Convention Center, Albuquerque, New Mexico; *Sculpture and Photography Show*, Taos Art Association, Taos, New Mexico; *Hung on Seco Walls*, Good Friday, Artlab, Arroyo Seco, New Mexico; *An Artistic Taste of Taos*, Longview Art Museum, Longview, Texas (traveling to Wichita Falls Art Museum and Art Center); *Energy Lines (A progression of faces through drawings and sculpture)*, New Directions Gallery, Taos, New Mexico (one-person show); *Contemporary Hispanic Market*, Santa Fe, New Mexico; *Little Bomb, Big Bomb*, Artlab, Arroyo Seco, New Mexico; *Taos Invites Taos*, Taos Convention Center, Taos, New Mexico

1994 *Monothon Exhibition*, College of Santa Fe, Santa Fe, New Mexico; *Fiesta Artística*, Albuquerque Convention Center, Albuquerque, New Mexico; *Contemporary Hispanic Market*, Santa Fe, New Mexico; *Right to Write*, Opening Scene Gallery, Taos, New Mexico; *Flor y Canto*, Martinez Hacienda, Taos, New Mexico; *Artistas Contemporáneos de Nuevo Mexico*, Guadalajara-New Mexico Task Force, Guadalajara, Mexico

1993 *Voyeur: A Show of the Erotic*, Rod Goebel Gallery, Taos, New Mexico; *Taos Moderns in Carlsbad*, Carlsbad Museum and Art Center, Carlsbad, New Mexico; *Spring Arts Celebration*, Taos Civic Center, Taos, New Mexico; *Contemporary Hispanic Market*, Santa Fe, New Mexico; *First Annual Sawmill Art Show*, Historic Duran Home, Albuquerque, New Mexico; *One-Person Window Exhibit*, New Directions Gallery, Taos, New Mexico; *Meet-the-Artist*, Historic Taos Inn show, Taos, New Mexico

1992 *Arts Celebration Show*, Taos Civic Center, Taos, New Mexico; *Small Works Juried Show*, Barbershop Gallery, Taos, New Mexico; *Rio Grande del Norte Sculpture Show*, Stables Art Center, Taos, New Mexico; Taos Art Association, Taos, New Mexico; *Taos Moderns*, Stables Art Center, Taos, New Mexico; *Last of the Wild, Wild West*, New Directions Gallery, Taos, New Mexico (one-person exhibition); *Quincentenary Show*, Taos Hispanic Arts Council, Stables Art Gallery, Taos, New Mexico

1991 *Taos Invites Taos*, Taos Civic Center, Taos, New Mexico; *Day Dreams from Taos*, Treebeard's, Houston, Texas; *Spring Arts Show*, Design Center of New Mexico, Taos, New Mexico; *La Cofradia*, Millicent Rogers Museum, Taos, New Mexico; *John Vasconcellos Invites Mayé and Friends*, Santa Clara, California

1990 *Consider the Child*, Centinel Bank, Taos, New Mexico; *Taos Hispanic Arts Council Show*, Millicent Rogers Museum, Taos, New Mexico; *Printmaking in New Mexico: A Survey*, The Governor's Gallery on the Road, Branigan Cultural Center, Las Cruces, New

Mexico; *Relativity*, New Directions Gallery, Taos, New Mexico (one-person exhibition); *Taos Artists against Apartheid*, Milagro Gallery, Taos, New Mexico; *Contemporary Hispanic Art in Northern New Mexico*, Stables Art Center, Taos, New Mexico; *Enlightenment of the Human Spirit, One-Person Show*, Centinel Bank of Taos, New Mexico; *Paperworks*, Stables Art Center, Taos, New Mexico

1989 *Black and White Show*, Armory for the Arts, Santa Fe, New Mexico; *Indo-Hispano/Nuevo Mexicano Primavera/Renewal*, Guadalupe Cultural Arts Center, San Antonio, Texas; *Spring Arts Celebration Show*, Taos, New Mexico; *La Hispana*, Bottger Mansion, Albuquerque, New Mexico; *Taos Today Show*, Taos Civic Center, Taos, New Mexico; *Taos Invites Taos*, El Cielo Grande, Taos, New Mexico; *American Hieroglyph Show*, Stewart's Fine Art, Taos, New Mexico

1988 *Hispanic Expressions of New Mexico*, Governor's Gallery, Santa Fe, New Mexico; *Mayé Torres, One-Person Show*, Centinel Bank, Taos, New Mexico; *Inaugural Group Show*, New Directions Gallery, Taos, New Mexico; *Eros*, Armory for the Arts, Santa Fe, New Mexico

COLLECTIONS

Art Commission, Mary Medina Building, Taos, New Mexico; AT&T Collection, Denver, Colorado, corporate collection; B. Veiz Furth/Bay, Berlin, Germany; Dr. R. M. Butler, Lubbock, Texas; C. Fahlander, Uppsala, Sweden; Kiyo Higashi, Los Angeles, California; John A. Noble Foundation, Maryland; Ed Luck, Palo Alto, California; Mary Medina Building, Human Services, Taos, New Mexico—1% for Art; Governor & Mrs. Mitchell, Arlington, Virginia; Mr. & Mrs. S. Spiegel, San Antonio, Texas; J. Vasconcellos, Santa Clara, California

ARTIST STATEMENT (1997)

The job of the artist is to express that which is seen but not noticed by most. It is a language that allows me to cross barriers. It is a discipline that allows me to test boundaries and break rules. Through the process of art, I am searching for a visual synthesis of our existence that includes science, spirituality, and art. A form of visual unified theory.

When I work, I think about how the medium relates to the workings of the universe. The drawings become superstrings and the interaction of quantum energy. The lines eventually evolve to form. Then they become deep, dark voids of space. I relinquish control, and the imagery seems to evolve on its own. I "speak" with a variety of mediums: clay, drawing, painting, wax, metals, casting, whatever seems to be at hand. Each medium informs the other. I often solve a problem in drawing with wax. Sometimes I combine materials, and sometimes they work better alone.

Art is really about transformation—taking a medium in one form and transforming it into an object, a visual poem, for a million thoughts by those who

eventually view the art. It is a birthing of an idea from thought form into physical form. A metamorphosis. Ultimately, the process of art is a tool that allows me to interact with life and dance with thought. It allows me to tap into the deepest parts of awareness, an existential exercise.

BIOGRAPHICAL ESSAY

The name *Mayé*, a variation of the East Indian name *Maya*, translates as "vision" or "illusion" and is an appropriate name for a multimedia artist who has created bodies of work that transcend ordinary temporal and spatial orientations. Her works draw on her fascination with religion, mythology, astrology, and science. Torres's interest in science, the work of Albert Einstein and Stephen Hawking, in particular, have influenced her art. She considers her studio a kind of art laboratory where she can experiment with ideas in visual forms.

In her most recent exhibition titled *Energy Lines* (1996), Torres explores an array of emotions in drawings and sculptures of faces and figures. Torres reconstructs the planetary arrangement of Earth, Venus, Uranus, and Saturn and reinvents the planets as mythological figures of fear, hope, introspection, and vision. These works, however, have less to do with portraiture and more to do with capturing psychological states of being and translating them into line and form. Escherlike graphite drawings of faces and figures that emerge from densely layered marks and lines are paired with three-dimensional mythological figures like Venus, Zeus, and Neptune encased in wrought-iron structures suspended from the ceiling.

Torres's installation is a personalized solar system complete with orbital paths. This solar system of images and objects is an organized format of her search for her place in the grand scheme of things. Through her careful arrangement and interpretation of the planets, she hopes to construct a universe within which she can locate herself, her position, her purpose.

The Heavy Hand of War represents Mars as a man with an extremely enlarged hand and a pinhead. *Constant Mind Talk* represents Mercury and reveals a density of thought as messages, visual data, and symbols crowding in his mind. Her figures seem to be working through contradictions. *The Cosmic Jester*, Uranus, is portrayed as the harbinger of new ideas, whereas her poignant representations of Saturn in *The Sage of Years* and *Weaving Wisdom from Depression* personify depression as well as wisdom and introspection. These works delicately fuse technology with emotion.

In her solar system, Earth is represented sculpturally in *The Emergence of Earth and Moon* (1996), in which two figures, a woman and a man, Adam and Eve, are almost suspended in an apparatus of iron. The figures are ambiguous and almost androgynous. It is difficult to determine if the woman or the man is representing the Earth or Moon. Torres has thoughtfully pondered the relationships of the human being with an ominous universe. She has her thoughts about our existence between these two spaces—earth and the heavens—and our re-

lationship to them. ''People once lived very much in sync with the earth and stars. We watched the skies closely to know when to plant, when to harvest—for all sorts of things. Now we live somewhere in between them—and never think too much of either.''

Torres's planetary visions offer both darkness and hope. She believes that we are at a critical point in history and that we must heighten awareness of the individual's relationship with others, society, the environment, and the universe. Only then, she believes, can we make informed, critical decisions about the present and future. Sometimes creating an illusion or vision of balance, harmony, or even chaos can be beneficial in organizing thought. For Torres, keeping a strong vision and having the ability to express that particular vision are key to artistic, social, and personal transformation.

Torres began to draw and paint at an early age and ever since then was inquisitive about her role in the nature of things. She has concluded over the years that her development as a human, a woman, a mother, and an artist has to do with allowing her thoughts to manifest in her art. Her relationship, not only with her native New Mexico, her family, and her diverse cultural experience but, more important, with the entire universe, has become a probing issue for Torres. Her works passionately explore and express the larger, vast domain of experience with concrete line and form.

Her ability to express freely is not one she takes for granted. *Forming/Writers Wings* was inspired by Torres's two-year stay in El Salvador, where she witnessed the suppression of free speech. Torres explains: ''Most of the people were illiterate, but the poets spoke and people passed out visual fliers. You have to have wings to speak out. People were murdered because of their outspoken views.'' Torres's experiences in Latin America have no doubt contributed to her unique style and fervent expression.

TSUCHIYA, TILSA

Nationality: Peruvian. *Born*: 1932, Lima, Peru. *Education*: Tsuchiya studied at the School of Fine Arts in Lima from 1954 to 1959. Among her teachers were muralist Carlos Quizpez Asín, realist painter Manuel Zapata Orihuela, and abstract painter Ricardo Grau. She completed the program with honors and a gold medal. This instruction provided Tilsa with a diverse range of thematic influences—social realism, indigenismo, and abstraction. She combined these themes with aspects of an aesthetic sensibility inherited from her Japanese father. In 1960 Tsuchiya traveled to Paris, where she studied at the Sorbonne and attended

classes at the Ecolé des Beaux Arts. In 1964 she returned to Peru with her young son. *Family*: Tsuchiya's father, Yoshigoro Tsuchiya, was a doctor who was born in Chiba, Japan. He moved to Peru to practice his profession. In Peru he met her mother, María Luisa Castillo, in the town of Supe in northern Peru. When her parents married, her father was twice her mother's age. Tilsa was one of eight children. She learned to draw from her brother Wilfredo, who became a doctor. *Career*: After her return from Paris in 1964, Tsuchiya continued to paint in Peru for most of her life. Her paintings and drawings have been exhibited throughout Peru, in Paris, France; Washington, D.C.; Medelín, Colombia; Havana, Cuba; Amsterdam, Netherlands; Quito, Ecuador; London, England; and Caracas, Venezuela. *Died*: 1984, Lima.

SELECTED EXHIBITIONS

1995	*Latin American Women Artists, 1915–1995*, Milwaukee Art Museum, Wisconsin, Phoenix Art Museum, Arizona, Denver Art Museum, Colorado, National Museum of Women in the Arts, Washington, D.C.
1979	Represented Peru, XV São Paulo Bienal, São Paulo, Brazil

SELECTED COLLECTIONS

Rafael Lemor, Peru; Dr. José Antonio Schiaffino, Lima, Peru

PUBLICATIONS

ARSA. "Tilsa: Desde la otra orilla." *El Comercio*, December 20, 1981, suplemento Diario.

Bernuy Guerrero, Jorge. "El Mundo Mítico de Tilsa Tsuchiya." *La Prensa*, July 8, 1980.

Day, Holliday T., and H. Sturges. "Tilsa Tsuchiya: 1932–1984." *Art of the Fantastic: Latin America, 1920–1987*. Indianapolis, Ind.: Indianapolis Museum of Art, 1987. pp. 128–133. Exhbn cat.

Galería de Arte Enrique Camino Brento. *Tilsa*. Lima, Peru: Author, 1980.

Gálvez, Elvira de. "Tilsa: Un mito en la pintura." *El Comercio*, September 30, 1984, suplemento Diario.

Moll, Eduardo. *Tilsa Tsuchiya 1929–1984*. Lima, Peru: Editorial Navarrete, 1991.

Monteverde Morzán, Guido. "La Gran Tilsa Tsuchiya." *Revista Gente*, February 24, 1976.

Rodriguez Saavedra, Carlos. "Tilsa Tsuchiya." In Holliday T. Day and H. Sturges, eds., *Art of the Fantastic: Latin America, 1920–1987*. Indianapolis, Ind.: Indianapolis Museum of Art, 1987. pp. 256–257. Exhbn cat.

Rodriguez Saavedra, Carlos. *Tilsa—XV Bienal de São Paulo*. Lima, Peru: Instituto Nacional de Cultura. Exhbn cat.

Seymour. "Los mitos de Tilsa." *El Comercio*, November 4, 1976, suplemento Diario.

"Tilsa y su arte: Una gran muestra de una gran artista." *El Comercio*, June 3, 1984.

Tsuchiya, Tilsa. "Diez años después Tilsa en el fondo del mar, debajo de la tierra. Lo que le dejo a Arturo Curcuera." *Revista*, October 17, 1994, Homenaje, cultural, pp. 47–51.

Wuffarden, Jorge Eduardo. *Tilsa Tsuchiya*. Lima, Peru: Editorial Ausonia, 1981.

BIOGRAPHICAL ESSAY

The fantastic images of Tilsa Tsuchiya were drawn from her imagination and have parallels to Quechuan legends and their deep psychological layers. The stone figures in her paintings make reference to *huaca*, a sacred object or place in Quechuan mythology. This mythology still plays as important a role today as it did in the time of the Incas. Many of her paintings are based on Peruvian Indian myths. The 1976 series *Myth of the Bird and Stones* includes images of a single armless woman perched on a tree or mountain top, combining aspects of Surrealism and the artist's own mythic culture.

Tristan e Isolde (Tristan and Isolde) (1974–1975) depicts this mythological couple as half animal, half human. They are crouched and facing each other. Tristan has the horns of a ram, and Isolde, the ears of a rabbitlike creature. Both are armless. Her figures are armless because she believes that it is the whole being that loves rather than just its parts or limbs. In *Machu Picchu* (1974), another armless creature is perched between Machu Picchu's twin peaks. These ancient places and their mystic power haunt not only the Incas but modern poets like Chile's Pablo Neruda and artists like Tsuchiya.

Tsuchiya's use of fantasy disengages the viewer from concrete earthly elements and reinvents the world, populating it with the same inhabitants that are refigured and altered into imaginary and mythic species and creations: woman-totem, fish-tree, bird-mountain, man-stone. Her images appear like visions of the Day of Creation of the World when forms are originating, merging, and settling. Her images are sensuous, erotic, and terrifying.

Tsuchiya's work is influenced by the Quechua legends about people who turn into stone, magical rocks, and trees, and animals that bring luck or misfortune. Like Tarsila do Amaral who fuses Surrealism with her Native Brazilian subjects, Tsuchiya combines Surrealism with her indigenous Peruvian mythologies. Despite her subject matter, Tsuchiya's method of painting is not Indian in concept. Although heads and faces often resemble Inca masks, and the proportions of the figures with enlarged, massive legs recall Indian ceramic painting, her color schemes, modeling, and atmospheric rendering of mist and clouds derive from either European or Chinese sources.

In pictorial terms, Tsuchiya's paintings utilize the unreality of space, the lack of visual clues to guide the eye in a rational way, the transparent atmospheric surroundings, and the indeterminate inhabitants to create her marvelously haunting and vast cosmos of unknown, mystical lands. Her works provide chilling visions into the unseen psychic, symbolic, and mythic realms of dreams.

VARGAS, KATHY

Nationality: Mexican American. *Born*: 1950, San Antonio, Texas. She has been a lifelong resident of east side San Antonio. *Education*: In 1972 Vargas enrolled in her first photography class, taught by Tom Wright, a rock-and-roll photographer. She received a B.F.A. in 1981 and an M.F.A. in photography in 1984. *Family*: Vargas's uncle was a photographer from Laredo, and his work influenced her as a child. At the age of seven she developed proficiency at coloring the eyes and lips of her uncle's portraits. Fifteen years later she began making her own photographs. *Career*: Along with being a full-time artist, Vargas is the Director of the Visual Arts Program for the Guadalupe Cultural Arts Center, San Antonio. Before that she taught photography at Healy Murphy Learning Center and was an art critic and writer for the *San Antonio Light*. Vargas has also worked as a freelance photographer and as an animator. In 1994, as a curator, she worked with Charles Biasiny Rivera, Robert Buitron, and Ricardo Viera on the touring exhibition *American Voices, Contemporary United States Latino Photography*. She also curated *Intimate Lives*, an exhibition of Latino artists, for women and their work, in Austin. Vargas serves on the board of Art Matters, Inc., and the Texas Photographic Society. *Awards*: In 1994 she received a Fellowship from Light Work, New York, and an Individual Artist Grant, Department of Art and Cultural Affairs, City of San Antonio. She was awarded Residency, Pace-Roberts Foundation in 1995. Also in 1995 she received a Mid-America Arts Alliance Grant. In 1997 she was awarded Residency, Pace-Roberts Foundation for Contemporary Art, San Antonio and London Studio.

EXHIBITIONS

1997	*State of Grace: Angels for the Living/Prayers for the Dead*, ArtPace, San Antonio, Texas; *Mosaics Series*, Dallas Visual Arts Center, Dallas, Texas
1996	*Miracle Lives*, Galería Alejandro Gallo, Guadalajara, Mexico, Kiam Building, FotoFest 96, Houston, Texas; Ida Green Gallery, Austin College, Sherman, Texas
1995	*Speaking in Thorns*, Options Gallery, Odessa College, Odessa, Texas
1994	Lynn Goode Gallery, Houston, Texas; Jump Start Performance Space, San Antonio, Texas
1993	*Images of Loss and Hope*, Houston Center for Photography, Houston,

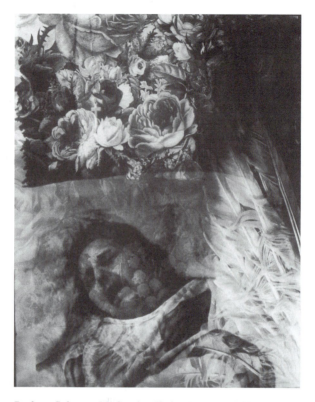

Broken Column: Mother by Kathy Vargas, 1997, detail of
hand colored photo, 24" × 20". Courtesy of Kathy Vargas ©
Kathy Vargas

	Texas, Galveston Arts Center, Galveston, Texas; Galería Posada, Sacramento, California
1992	Jansen-Perez Gallery, San Antonio, Texas
1991	Louisiana State University, Shreveport, Louisiana; University of Texas at El Paso, El Paso, Texas
1990	Frances Wolfson Art Gallery, Miami Dade Community College, Miami, Florida (catalog)
1989	Pinnacle Gallery, Dallas, Texas; Saint Mary's Hall, San Antonio, Texas
1988	Universitat Erlangen-Nurnberg, Erlangen, West Germany (retrospective); San Angelo Museum of Fine Art, San Angelo, Texas
1987	Biblioteca Simón Bolívar, Centro de Enseñanza pare Extranjeros, Universidad Nacional Autónoma de Mexico, Mexico D.F.
1986	Galería Fotocamera, Grosseto, Italy

1985 Women's Center, University of California–Santa Barbara, Santa Bar-
 bara, California; Guadalupe Cultural Arts Center, San Antonio, Texas

1984 Galería Sala Uno, Rome, Italy; Galería Juan Martin, Mexico D.F.;
 Amerika Haus, Stuttgart, Germany; Charlton Gallery, San Antonio,
 Texas

RECENT GROUP EXHIBITIONS

1997 *Secrets and Revelations: Shamans, Saints & Sinners*, The Carver Gal-
 lery, San Antonio, Texas; *Hopeworks: Trabajos de Esperanza*, The
 Esperanza Peace & Justice Center, San Antonio, Texas; *Uncommon
 Sense* (collaborative work with Mel Chin and the GALA Committee
 on Mel Chin's *In the Name of the Place* project), The Museum of
 Contemporary Art/The Geffen Contemporary at MOCA, Los Ange-
 les, California

1996 *Hospice: A Photographic Inquiry*, Corcoran Gallery of Art, Wash-
 ington, D.C. (also traveling to Wexner Center for the Arts, The Ohio
 State University, Columbus, Ohio, 1996; Chicago Cultural Center,
 Chicago, Illinois, 1996; The Morris Museum, New Jersey, 1997; San
 Diego Museum of Art, San Diego, California, 1997; Telfair Academy
 of Arts and Sciences, Savannah, Georgia, 1997; Norton Gallery and
 School of Art, West Palm Beach, Florida, 1997; Marjorie Barrick
 Museum of Natural History, University of Nevada, Las Vegas, Ne-
 vada, 1998; Phoenix Art Museum, Phoenix, Arizona, 1998; David
 Winton Bell Gallery, Brown University, Providence, Rhode Island,
 1998; International Center for Photography, New York, New York,
 1998; New Orleans Museum of Art, New Orleans, Louisiana, 1999;
 Frederick R. Weisman Art Museum, University of Minnesota, Min-
 neapolis, Minnesota, 2000; Portland Art Museum, Portland, Oregon,
 dates TBA); *Photography in the 1990s*, Wright State University Art
 Galleries Creative Arts Center, Dayton, Ohio; *De mujer a mujer: A
 Celebration of Latinas by Latina Artists*, Austin Museum of Art/
 Laguna Gloria, Austin, Texas; *Darkness & Silence: The Photo-
 graphic Works of Kate Breakey, Kent Rush, and Kathy Vargas*,
 Southwest Texas State University, San Marcos, Texas; Photography
 Exhibit, Slover McCutcheon Gallery, Houston, Texas; *Beds, Graves
 and Other Places to Lie Down*, The Bath House Cultural Center,
 Dallas, Texas; *Mujeres Moviendo el Mundo*, La Peña, Austin, Texas;
 PhotoView, Longview Art Museum, Longview, Texas; *Día de los
 Muertos*, Centro Cultural Aztlan, San Antonio, Texas

1995 *The Pleasure Principle*, CEPA Gallery, Buffalo. New York; *Sniper's
 Nest: Art That Has Lived with Lucy R. Lippard*, Center for Curatorial
 Studies, Bard College, Annandale-on-Hudson, New York; *From the
 West, Chicano Narrative Photography*, The Mexican Museum, San
 Francisco, California; *Camera/Canvas*, Kilgore College Fine Arts
 Gallery, Kilgore, Texas, curated by John Hillier; *Planos Liricos*,
 UNAM San Antonio, San Antonio, Texas; *Día de los Muertos, Of-*

rendas en dos Culturas, La Peña/Las Manitas, Austin, Texas; *Arte Cosmicao*, Esperanza Peace and Justice Center, San Antonio, Texas; *Celebración*, Fine Arts Center, Lubbock, Texas; *Art Alumni Exhibition*, University of Texas at San Antonio Art Gallery, San Antonio, Texas; *El Corazón*, Bath House Cultural Center, Dallas, Texas; *17th Annual Lubbock Arts Festival*, Lubbock, Texas; *Regeneración*, Centro Cultural Aztlán, San Antonio, Texas; *Cruces de la Vida*, Bath House Cultural Center, Dallas, Texas

1994 *American Photography: A History in Pictures*, San Antonio Museum of Art, San Antonio, Texas; *Contemporary Women Photographers*, The Museum of Fine Arts, Houston, Houston, Texas; *Images Fixed by Light*, Jansen Perez Gallery, San Antonio, Texas; *Colaborateur/ Resistance [Blue Star 9]*, Blue Star Art Space, San Antonio, Texas; *Las Comadres: Visionarias Chicanas*, Sangre de Cristo Arts & Conference Center, Pueblo, Colorado; *Artistas en America*, La Peña, Austin, Texas; *Cultural Hispanic Regionalism*, The Center for Hispanic Arts, Corpus Christi, Texas; *El Corazón*, Bath House Cultural Center, Dallas, Texas

1993 *Target: South Texas—Depth of Field*, Art Museum of South Texas, Corpus Christi, Texas; *Texas Focus: Recent Photographic Acquisitions from the Mundy and Willour Collections*, The Museum of Fine Arts, Houston, Houston, Texas; *Works on Paper: Alumni Exhibit*, San Antonio College, San Antonio, Texas; *Chicanolandia*, MARS Art Space, Phoenix, Arizona, Los Alamos Historical Society, Los Alamos, New Mexico, Peoria Arts Commission, Peoria, Illinois, Mohave Community College, Kingman, Arizona, MACLA San Jose Center for Latino Arts, San Jose, California, Mary Porter Sesnon Art Gallery, Porter College, University of California at Santa Cruz, Santa Cruz, California; *Texas Artists*, Patricia Stewart Gallery, St. Helena, California; *Women as Voyeurs*, Cruzitas Galería, San Antonio, Texas; *International Women's Day Exhibit*, La Peña, Austin, Texas; *CARA, Then & Now*, Jansen Perez Gallery, San Antonio, Texas, Incarnate Word College, San Antonio, Texas; *Día de los Muertos*, La Peña, Austin, Texas

1992 *From Media to Metaphor: Art about AIDS*, Emerson Gallery, Hamilton College, Clinton, New York (1992), Center on Contemporary Art, Seattle, Washington (1992), Sharidan Art Gallery, Kutztown University, Kutztown, Pennsylvania (1992), Musee d'art Contemporain de Montreal, Montreal, Quebec, Canada (1993), Bass Museum of Art, Miami Beach, Florida (1993), McKissick Museum, University of South Carolina, Columbia, South Carolina (1993), Fine Art Gallery, Indiana University, Bloomington, Indiana (1993), Klausner Gallery, Santa Barbara Contemporary Arts Forum, Santa Barbara, California (1993), The Grey Art Gallery and Study Center, New York University, New York, New York (1994) (catalog); *20th Anniversary of the Visiting Artist Program*, CU Art Galleries, University of Colorado at Boulder, Boulder, Colorado; *Baja Tejas: South Texas Art-*

ists—Works on Paper, Instituto Cultural Peruano Norte Americano, Lima, Peru; *Chicano Art—Seis Autores Tejanos*, Atenco Municipal de Cultura, Guadalajara, Spain, Meadows Museum, Dallas, Texas (catalog); *5 Artistas Chicanos*, Instituto Mexicano Norteamericano de Relaciónes Culturales de Nuevo León, A.C., Monterrey, Mexico; *The Chicano Codices: Encountering Art of the Americas*, The Mexican Museum, San Francisco, California (1992), Foothills Arts Center, Golden, Colorado (1993), El Centro de la Raza, Seattle, Washington (1994), University Art Gallery at California State University Northridge, Northridge, California (1993), Plaza de la Raza, Los Angeles, California (1993), Centro Cultural de la Raza, San Diego, California (1994) (catalog); *20th Anniversary Exhibition*, The Art Center, Waco, Texas; *El Día de Los Muertos*, Los Angeles Photography Center, Los Angeles, California; *America, 500 Años Después*, La Peña, Austin, Texas; *On Death/La Muerte*, Bridge Center for Contemporary Art, El Paso, Texas; *Worldviews in Collision*, Our Lady of the Lake University, San Antonio, Texas; *Igual Pero Diferente*, El Paso Art Museum, El Paso, Texas, Jansen Perez Gallery, San Antonio, Texas; *Lo Mejor de lo Nuestro*, La Peña and the Dougherty Art Center, Austin, Texas; *Three Year Review*, D-Art Visual Art Center, Dallas, Texas; *Mujer: Palabras y Visiónes*, La Peña, Austin, Texas

1991 *Alma, Corazón y Vida*, Circolo della Rosa, Rome, Italy (catalog); *Contemporary Hispanic Women Artists of Texas*, The Art Center, Waco, Texas, Sealy Gallery, Galveston, Texas, Laguna Gloria Art Museum, Austin, Texas, Midtown Art Center, Houston, Texas, Del Rio Council on the Arts, Del Rio, Texas (catalog); *Death Warmed Over*, Center for Research in Contemporary Art, University of Texas at Arlington, Arlington, Texas; *Deliberating a Vision: Hispanic Perspectives*, Union Art Gallery, University of Wisconsin, Milwaukee, Wisconsin; *Ojo Vivo/The Living Eye: Contemporary Chicano Photography*, Los Angeles Photography Center, Los Angeles, California; *Healing Hands*, Lubbock Fine Arts Center, Lubbock, Texas, D-Art, Dallas, Texas (catalog); *Bridging Borders*, Laredo Junior College, Laredo, Texas, curated by Terry Ybañez; *Freedom of Choice*, Esperanza Peace & Justice Center, San Antonio, Texas; *Día de los Muertos*, La Peña, Austin, Texas, Bath House Cultural Center, Dallas, Texas

1990 *Mixing It Up*, University of Colorado, Boulder, Colorado; *Emulsionally Involved*, Images Gallery, Cincinnati, Ohio; *Created Histories*, Fine Arts Gallery, Texas Tech University, Lubbock, Texas; *Texas Dialogue: El Paso/San Antonio*, Blue Star Art Space, San Antonio, Texas, The Bridge Center for Contemporary Art, El Paso, Texas; *Chicano Art: Resistance and Affirmation (CARA)*, Wight Gallery, University of California at Los Angeles, Los Angeles, California, Denver Art Museum, Denver, Colorado, Albuquerque Museum, Albuquerque, New Mexico, San Francisco Museum of Modern Art, San Francisco, California, Tucson Museum of Art, Tucson, Arizona, Na-

tional Museum of American Art, Washington, D.C., El Paso Art Museum, El Paso, Texas, Bronx Museum, Bronx, New York, San Antonio Museum of Art, San Antonio, Texas; *Post-Chicano Generation in Art: Breaking Boundaries*, MARS Art Space, Phoenix, Arizona

COLLECTIONS

Art Museum of South Texas, Corpus Christi, Texas; Arts Council of San Antonio, San Antonio, Texas; Bank of San Antonio, San Antonio, Texas; Casa de las Americas, Habana, Cuba; Center for Chicano Studies, University of California, Santa Barbara, California; Centro de Enseñanza para Extranjeros, Universidad Nacional Autónoma de Mexico, Mexico D.F.; Consejo Mexicano de Fotografia, Mexico City, Mexico D.F.; Corcoran Gallery of Art, Washington, D.C.; Joe Diaz, San Antonio, Texas; En Foco, New York, New York; Federal Reserve Bank, Dallas, Texas; FFACTS (AIDS) Clinic, San Antonio, Texas; Fuddrucker's Inc., San Antonio, Texas; Hill Country Arts Foundation, Ingram, Texas; Library, University of California, Santa Barbara, California; Lightwork, Syracuse, New York; Lucy R. Lippard, New York, New York; Mexican Museum, San Francisco, California; Museum of Fine Arts, Houston, Texas; The Object Library at the Art Center, Waco, Texas; San Antonio Museum of Art, San Antonio, Texas; South Texas Blood & Tissue Center, San Antonio, Texas; Southwestern Bell, Houston, Texas; Texas Lutheran College, Seguin, Texas; University of Colorado, Boulder, Colorado; University of Texas Humanities Research Center, Austin, Texas; Women's Center, University of California, Santa Barbara, California

PUBLICATIONS

Alma, Corazón y Vida. Rome, Italy: Circulo della Rosa, 1991.
Antología Retrospectiva del Cuento Chicano. Mexico City, Mexico: Consejo Nacional de Población, 1988.
AVAA 1985 Citation Exhibition. Austin, Tex.: Austin Visual Arts Association, 1985.
The Chicano Codices: Encountering Art of the America. San Francisco, Calif.: Mexican Museum, 1992.
Chicano Art: Resistance and Affirmation (CARA). Los Angeles, Calif.: Wight Art Gallery, UCLA, 1991.
Contemporary Art for San Antonio—The Blue Star Exhibition. San Antonio, Tex.: Blue Star Art Space, 1986.
Contemporary Hispanic Women Artists of Texas. Waco, Tex.: Waco Art Center, 1991.
From Media to Metaphor: Art about AIDS. New York: Independent Curators Inc., 1992.
From the West, Chicano Narrative Photography. San Francisco, Calif.: Mexican Museum, 1995.
Healing Hands. Lubbock, Tex.: Lubbock Fine Arts Center, 1991.
Hecho en Latinoamerica II. Mexico City, Mexico: Consojo Mexicano de Fotografía, 1981.
Hirsch, Robert. *Exploring Color Photography*. 3rd ed. Brown & Benchmark Publishers, 1996. p. 238.
Hospice: A Photographic Inquiry. Washington, D.C.: Corcoran Gallery of Art, 1996.
In Search of the Pleasure Principal. Buffalo, N.Y.: CEPA Gallery, 1995.
The Intermedia Quilt. San Antonio, Tex.: Artists' Alliance, 1983.
Kathy Vargas: Priests Series and Oración: Valentine's Day/Day of the Dead Series.

Miami, Fla: Frances Wolfson Art Gallery, Miami-Dade Community College, 1990. Exhbn.

Lazzari, Margaret R. *The Practical Handbook for the Emerging Artist.* New York: Harcourt Brace, 1995. pp. 195–198.

Lippard, Lucy. *Mixed Blessings: New Art in a Multicultural America.* New York: Pantheon Books, 1990. pp. 84–85.

Lippard, Lucy. *The Pink Glass Swan.* New York: New Press, 1995. p. 206.

Mid-America Arts Alliance/National Endowment for the Arts Regional Visual Arts Fellowships. 1994. 1995. 1996. Kansas City, Mo.: Mid-America Arts Alliance, 1997.

The Myth of the Bride. San Antonio, Tex.: Women's Caucus for Art, 1984.

No Bluebonnets. No Yellow Roses—Essays on Texas Women in the Arts. New York: Midmarch Arts Press, 1988. p. 96.

The Presence of the Sublime. San Antonio, Tex.: San Antonio Museum of Art, 1988.

Target: South Texas—Depth of Field. Corpus Christi, Tex.: Art Museum of South Texas, 1993.

Third Coast Review: A Look at Art in Texas. Aspen, Colo.: Aspen Art Museum, 1987.

Upton/Upton Photography. 2nd ed. Boston: Little, Brown, 1981. (juried selection of work; Marie Cosindas, Jim Hughes, Ansel Adams, jurors)

Villegas, Juan, ed. *Actas Irvine—92.* Irvine, Calif.: Asociación Internacional de Hispanistas and the University of California Irvine, 1994. (cover)

ARTIST STATEMENT (1997)

Most of my work has been about the complementary dualities of life and death. Set in this context, death is not morbid but simply a part of the cycle of life; dying is the completion of living, and vice versa. Being aware of death makes life more intense. That's the way I learned to see it from within my Mexican American culture, from the time I was a child. I work with complements. It is important for me to formally depict the starkness of death within the complement of beauty. So I make hand-colored images to get you to look into something you might not want to see. People come to look at the soft colors and find out that there's a little death waiting inside; or they come to look at the harshness of death and find life waiting for them in the seduction of the colors.

BIOGRAPHICAL ESSAY

Kathy Vargas's photographic images are overlays of content and image, a fusion of her childhood experiences, pre-Columbian myths, folk Catholicism, and the Magic Realism of Latin America. Many of her images are hand-colored, double-exposure photographs, but since 1986 she has also worked in installation, creating environments and using three-dimensional objects with her photographic images.

Vargas moved from commercial photography to more personal work that included photographs of her family and friends. She began a documentary proj-

ect on yard shrines, on San Antonio's east side, that led to her research of religious shrines throughout Mexico and to her rereading of the literature of Latin American Magic Realism, in particular the writing of Garcia Marquez. The possibility and probability of magic as an underpinning of reality became a concern for Vargas, and her work began a conscious layering of different realities, images, and objects. She reignited ancient pre-Columbian symbols from the shrines and incorporated them in various contexts. She focused on symbols that made reference to continuity, resurrection, and remembrances like hearts and crosses.

Vargas uses double-exposure and hand-coloring techniques to create dense tableaus of color and symbols, layering time, meaning, and realities. The cycle of life, death, and resurrection is repeated in her visual documentation of grief, suffering, fear, and hope. Portions of *milagros*, skeletons, and flowers are offered as testimonies of hope for miracles for friends who have died and suffered. Many of Vargas's images are made as tributes and prayers for specific people who have died from AIDS, some inspired by music, and others are created as celebrations of the cyclic nature of life and death, as each folds into the other in her montages.

The viewer is invited to see the beauty of death and pain underneath her soft layers of image. Vargas's *Broken Column: Mother* (1996–1997) consists of six photographs arranged together to form a cross. Forming the top of the cross is the image of a mother lying in bed, sick or dying. The middle, vertical section of the cross exposes the woman's broken spinal column in magnified, x-rayed images. The vertical bottom of the cross is completed with an image of the mother's legs and feet as she lies in bed. The mother's arms and hands across the bed's edges form the horizontal section of the cross. The reality and tragedy of physical and emotional suffering are recontextualized and softened into a montage of beautiful images and graceful illusions. *Broken Column: Mother* was exhibited in Vargas's larger installation, *State of Grace: Angels for the Living/Prayers for the Dead*.

In her series *Sites and Accompanying Prayers* (1992), Vargas creates two-dimensional sites of death and prayer for friends who have died. *Site and Accompanying Prayers #7* is half of a diptych made in memory of a friend who died after a long, painful illness. The nails symbolize his pain, the *milagro* the hoped-for miracle. The subtle cross behind the heart *milagro* alludes to Christ-like suffering and to resurrection. Similarly, in another series, *Oración, Valentine's Day/Day of the Dead* (1990–1991), Vargas commemorates Mexican folk art collector Ted Warmbold, who died of AIDS. A skeletal hand, perhaps his own, reaches out for the *milagro* hearts that had actually been sent to Warmbold's wife before his death.

The duality of life experience is present in many of her works. Vargas ritualizes the ordinary, reinterprets the experience of death and grief, and glorifies the human spirit. Her layering of time and space allows the illusory and the actual to penetrate each other and create new visions of hope. Her images are

assembled, altered, and adjusted in her studio. Feathers, *milagros*, thorns, lace, flowers, nails, and x-rays become metaphors for belief, beings, emotions, and desires. Her reflective and introspective tributes to human experience give us a glimpse of the magic of living and dying.

VATER, REGINA

Nationality: Brazilian. *Born*: 1943, Rio de Janeiro, Brazil. *Education*: In Brazil her first art teachers were Frank Schaeffer and Ibere Camargo. Vater studied drawing and painting in Rio de Janeiro between 1962 and 1966. She studied architecture at the Universidade Federal do Rio de Janeiro in 1964. In 1973 she moved to New York. She studied silkscreening at Pratt Institute in 1974 and video at the Downtown Video Community Center in 1982. *Family*: Vater's father is a well-respected doctor in Brazil, and two of her great-grandparents were recognized poets and physicians. Vater moved to Austin, Texas, in 1985 with her husband, who was invited to teach at the University of Texas. *Career*: In the 1960s, besides working as a freelance graphic artist, Vater worked as a cultural journalist for Educational Television in Rio de Janeiro, for Radio Maua, and for newspapers and magazines. In 1976 she met and interviewed Joseph Beuys, who has been a great inspiration in her work and her teaching. In the same year she also met John Cage, who supported her residency in the United States, which she was granted as an artist in 1982. In 1973 she met Helio Oiticica in New York and Lygia Clark in Paris and in 1975 met Augusto de Campos in Brazil. Vater has taught courses in popular visual culture and visual thinking. She has exhibited extensively in Brazil, New York, France, England, Spain, Italy, West Germany, Sweden, and Argentina. She has been a guest curator for several exhibitions. *Awards*: In 1972 she was awarded the most important prize for art in Brazil, a $12,000 travel grant that took her to New York in 1973. In 1984 she received a certificate of merit in video from the American Film Institute in Los Angeles. She has received travel grants from Arts International and the National Endowment for the Arts. Vater has visual poems (mostly objects and artists books) in the Ruth and Marvin Sackner Archives for Visual Poetry, Florida, the most important collection of this kind in the United States.

EXHIBITIONS

1997 *Curandarte*, Women and Their Work Gallery, Austin, Texas; *Voices and Visions*, Mexic-Arte Museum, Austin, Texas

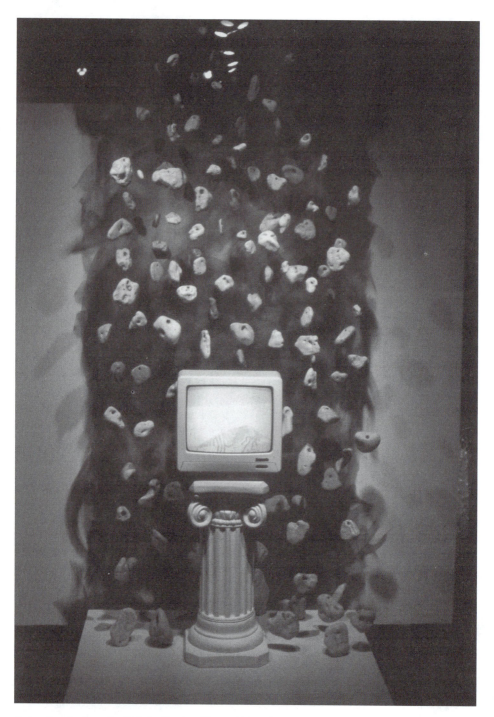

Swimming Against the Tide by Regina Vater, 1997, video installation, 5' × 7" × 3.5". Courtesy of Regina Vater

1995	SESC Paulista Gallery, São Paulo, Brazil; IBEU Gallery Copacabana, Rio de Janeiro, Brazil; IBEU Gallery Madureira, Rio de Janeiro, Brazil
1993	Carrington & Gallagher Gallery, San Antonio, Texas; Southeast Museum of Photography, Daytona Beach, Florida
1992	*Comigo Ninguem Pode—Celebration for a Cultural Spring in Brazil with Performance by José Celso Martinez Correia*, Teatro Oficina, São Paulo, Brazil; Galería Paulo Figueiredo, São Paulo, Brazil; Solar Grandjean Du Montigny, Rio de Janeiro, Brazil; Artist's Window (video installation) at the Donnell Library, Center, New York

SELECTED GROUP EXHIBITIONS

1996	*Ceremony of the Spirit*, Studio Museum, Harlem, New York; *Latino American Book Arts*, Mexic-Arte Museum, Austin, Texas
1995	*Ceremony of the Spirit*, Laguna Gloria Museum, Austin, Texas; *Um Abraco Verde*, participacao especial com Bill Lundberg SESC Itaquera, São Paulo, Brazil; *Terra Brasilia*, Espaco Cultural 508 Sul, Brasília, Brazil; *The Native American Day*, Museum of the Indian, Brasília, Brazil
1994	Dallas International Video Festival, Dallas, Texas; *Rethinking la Malinche*, Mexic-Arte, Austin, Texas; *São Paulo International Video Festival*, SESC, São Paulo, Brazil; Arte Poe Gráfica, Gibiteca Espaco Cultural, São Paulo, Brazil; Fundacao Cultural, IBAC, Brasília, Brazil; *Rejoining the Spiritual: The Land in Contemporary Latin American Art*, Maryland Institute, College of Art, Baltimore, Maryland; *Outside from Within: Paper as Sculpture*, Rosenwald Woulf Gallery at The University of the Arts, Philadelphia, Pennsylvania
1993	*Ceremony of the Spirit*, Mexican Museum, San Francisco, California; *Intimate Lives*, Women and Their Work Gallery, Austin, Texas (traveling show); *Ultramodern—Art of Contemporary Brasil*, National Museum of Women in the Arts, Washington, D.C.
1992	*Completing the Circle: Artist's Book on the Environment*, Minnesota Center for Book Arts, Minneapolis, Minnesota (traveling show); *Linguagem dos Minerais*, Galería Miriam Mamber, São Paulo, Brazil; *Vozes da Diaspora—A Show on the Brazilian Black Heritage*, Pinacoteca do Estado, São Paulo, Brazil; *Installations*, Mexi-Arte Museum, Austin, Texas; *Show America, The Bride of the Sun*, Koninklijk National Royal Museum, Antwerp, Belgium
1991	*Latin American Drawings Today*, Museum of Art, San Diego, California; *Counter-Colonialism*, Centro Cultural de La Raza, San Diego, California; *The Revered Earth*, Blue Star Art Space, San Antonio, Texas; Dinnerware Artist Cooperative, Tucson, Arizona; Nexus Contemporary Art Center, Atlanta, Georgia
1990	*Trance Medial Show*, Franklin Federal Plaza Alternative Space, Austin, Texas; Regina Vater and Bill Lundberg, Bridge Contemporary Arts Center, El Paso, Texas; *Outcry: Austin Artists Respond to AIDS*,

Atrium Gallery, St. Edwards University Documental Show of Brazilian Visual and Experimental Poetry at the X Brazilian Congress of Literary Criticism & Literary Theory and IX International Seminar of Semiotics and Literature, Federal University of Paraiba, Campina Grande, Brazil; *Poetics of Presence*, SMU Gallery, Southeastern Massachusetts University, Massachusetts; *The Revered Earth*, The Contemporary Arts Museum, Houston, Texas; Pratt Institute, Brooklyn, New York; *Transcontinental*, Ikon Gallery, Birmingham, England, Corner House, Manchester, England; Symposium on Oswald de Andrade, Portuguese Department, University of Texas at Austin, Austin, Texas

BIENNIALS

1988	Texas Triennial, Contemporary Arts Museum, Houston, Texas
1981	Cinema de Artista, International Biennial of São Paulo, Brazil
1979	Trienal Latinoamericana del Grabado, Buenos Aires, Argentina
1976	Venice Biennial, Venice, Italy
1975	National Biennial of São Paulo, Brazil
1969	International Biennial of São Paulo, Brazil
1968	Lima Biennial, Lima, Peru
1967	Biennale des Jeunes, Paris, France; International Biennial of São Paulo, Brazil
1966	Bienal da Bahia, Salvador, Bahia, Brazil

COLLECTIONS

Steve Anthony, New York, New York; Raquel Babenco, São Paulo, Brazil; Benson Latin American Collection, University of Texas at Austin; Bibliotheque Nationale, Paris, France; Gilberto Chateaubriand, Rio de Janeiro, Brazil; Barbara Ducan, New York, New York; Franklin Furnace, New York, New York; Fundacao Alvares Penteado, São Paulo, Brazil; Penny Gallagher, San Antonio, Texas; Governor's Palace in Belo Horizonte, Minas Gerais, Brazil; Juan Haffers, New York, New York; Marvin and Ruth Sackner Visual Poetry Archives, Miami, Florida; Jose Mindlin, São Paulo, Brazil; Museum of Contemporary Art, São Paulo, Brazil; Museum of Modern Art of Niteroi, Rio de Janeiro, Brazil; Museu Nacional de Bellas Artes, Rio de Janeiro, Brazil; San Antonio Museum of Art, Texas; Luiz Villares, São Paulo, Brazil

ARTIST STATEMENT (1997)

My work has to do with ideas, with poetry, and with a shamanistic approach to art. For me, any artwork, even in an unconscious way, is a form of reaching out to the creative and regenerative forces of the universe: as a votive device, as a healing ritual or a ceremony of cleansing, which, by the way, has no desire to be of a sugar-coated substance. This aspect of my work is usually expressed by connections that my art makes with archaic sacred traditions—mainly African

and Native American. The sacredness of nature, human bondage, and human pertinence/relation to nature are better preserved in these cosmologies. These factors made their mythologies an important source of inspiration for my attempt with my art, to revive in the public a notion of sacred space tied to the natural world.

Very often, I use technology, mainly video. But I don't want to handle it as a smoke screen to hide my lack of interest in the internal journeys of life or minimize the social connections that are implicit in every work of art. My approach to technology is an alchemist approach. For me, to experiment with art doesn't mean just to produce technical tricks. What is important is not the form that I can achieve with such or such a technique but what the process of creating that form can do to me and to some extent to the social environment around me.

My formative years of art practice were spent in Brazil. From them I bring to my art making an approach to aesthetics very close to "Arte Povera." Already in the mid-1960s, in Brazil, artists such as Lygia Clark and Helio Oiticia, who were close friends of mine, were practicing what they called "The Aesthetics of Precariousness"—a procedure of art invention using nonconventional materials that drew inspiration from popular Brazilian creative expression, with an attempt to achieve significance and a feeling of wealth using materials affordable to their precarious economy.

Because of these factors described above, my huge interest in poetry, and various other philosophical questions I keep asking myself, I feel that the readings of my work should be done not in a literal or a narrative way but through the peeling of a system of layers of conceptual and visual contents that try to establish back-and-forth metaphorical and poetic interrelations in an attempt to mitigate or fight back some symptoms of a degenerative attention disorder and loss of depth, which I feel are jeopardizing our capacity to nurture a healthier and more intelligent sensibility.

BIOGRAPHICAL ESSAY

Making art, as well as experiencing it, according to Regina Vater, is a healing process and has a strong connection to the sacred. Her work is informed by her diverse cultural experience in Brazil, a hybridization of European, African, and Amerindian traditions. Her interest in the archaic traditions of Africa and Native America is rooted in her belief that these particular traditions are sophisticated and refer directly to the sacred forces of nature. Vater describes her role and interaction in reference to these traditions: "Because the metaphysical and shamanistic practices of both indigenous and African traditions are intrinsically connected with the sacredness and the energies of nature . . . as an active gardener, I, myself, experienced the healing powers of these cosmic energies. It is natural that in the making of my art, I bring the organic and the natural world

with me. And they are used in my art not just for its metaphors and aesthetics but for its energy fields as well.''

When describing her multimedia environments, Vater uses terms like *visual poetry, technology of the sacred, metaphysical, natural world*, and *ecology*. Photography, film, and language are elements that comprise these works. One of Vater's intentions is to reclaim hope and reach deep, archaic levels of understanding. Nature is the subject of many of Vater's installations and environments. Since her first installation in 1970, she has explored metaphysical concepts, cosmology, and ecology. Visual poetry is an important tradition in Brazil, and Vater participated in several shows featuring works of this kind on Brazil. In 1976 she represented Brazil at the Venice Biennial, and her work was based on a visual poem by Augusto de Campos, one of Brazil's inventors of Concrete Poetry.

Natural materials and objects and video are incorporated into carefully constructed, poetic settings that explore environmental, metaphysical, and spiritual issues. Vater's video installation *Swimming against the Tide* (1997) consists of a series of stones of different sizes hanging over a white television monitor placed on a white Greek column. The television screen shows a video of an Amazonian fish swimming vertically. The video is tinted the same tonality of light blue violet that is sponged-painted on the background wall. The irony of the fish swimming in the enclosed space of the television, the ornamentation of the television with an ionic Greek column, and stones suspended in air provoke ecological concerns. Another work, *Verve* (1997), is a ground installation inspired by African and Navaho ground paintings and Tibetan sandpaintings. Vater uses corn, rice, and black beans (the basic staples of the indigenous Americas) to create a large spiral combined with the image of the Jaguar's eye, an important mystical symbol of Afro-Brazilian healing.

Vater has continued this tradition of visual poetry in her work since her first installation in 1970. *Magi (O)cean* was an altar for the black madonna, the patroness of Brazil, Nossa Senhora da Aparecida, who in African tradition is known as Oxumare, the rainbow snake, the goddess of hope. The piece was made on Joatinga Beach in Rio de Janeiro. It was a sand structure covered by organic wastes from the sea—seaweed, driftwood, shells, stones—and included industrial garbage like plastic bottles. For almost 30 years, Vater has revived the spiritual energies of nature and initiated a deeper understanding of our relationship to those energies as a vital source of healing and enlightenment. Her art and her teaching are testimony to her sacred commitment, role, and intent as an artist: ''I believe that art can help to mature and heal individuals and society. I believe in the contemporary artist as the new shaman, the seer, the one who rescues the voices of the inner side through his/her images. And through this process he/she helps to light the path to spiritual growth for society or individuals by helping to open their eyes to the recognition of both their own possibilities and failures.''

3

AFRICAN AMERICAN WOMEN ARTISTS

Phoebe Farris, Kathryn Kramer, and Nadine Wasserman

There is no doubt that artists of color, both male and female, historically have been excluded or marginalized by art history textbooks and art world institutions. The recent prevailing climate of multiculturalism has done much to revise the canonical devotion to white male artists at the expense of all others, especially women of color. Yet precisely because of their historical exclusion from the mainstream, the mere inclusion of African American women artists in greater numbers by publications and by exhibitions is insufficient for their proper appreciation. Their work must be considered in terms of race and gender not only because such issues occasioned their exclusion in the first place but also because they themselves focus their work as well as their roles as artists around these societal topics. Many label themselves as ''Afrofemcentric''—that is, their art and their lives are devoted to representing black women. Most write critically about their own and fellow black women artists' work. Most devote a great deal of their professional practices to art education, especially on behalf of the African American community. Many have founded galleries, art centers, archives, and major museums on behalf of African and African American arts. Almost a century's worth of this kind of advocacy is resulting at last in major monographs, solo retrospectives, and group exhibitions, and many of the artists who are included in this chapter have now received ''canonical status.''

However, canonization is meaningless if the significant public relations work that has taken place so effectively at the margins is now disregarded in favor of merely featuring the biographies and works of a collection of individual artists. The artists who are profiled in this volume have created new cultural spaces of representation for themselves and others through efforts that emphasize collectivity over autonomous art production, and a critical examination of these consolidated efforts and their spaces should also be part of the canon. If the full story of the creation and promotion of art by African American women is excluded from mainstream presentations, emerging African American women art-

ists therefore may moderate their practice of dealing unashamedly with issues particular to their identities. While their progenitors may enjoy discussion and perhaps a full-color reproduction in the latest art history surveys, their hard work will nonetheless be wasted if the canon is not expanded to include the presentation of an informed, critical process that resulted in its new, inclusive environment.

Much of the work of contemporary artists, then, must continue to identify the significance of the intersections of race, gender, and class in their lives, to reclaim their own subjectivity, and to celebrate their cultural heritage. In counteracting stereotypes and preconceived notions about black womanhood, these young artists will demonstrate the ongoing need to promote an understanding of the complexities of their experiences, to confirm that there is no monolithic black female experience. It is essential that these artists and their critics persist in producing material that presents the pertinent information and promotes the critical debate necessary not only for expanding the canon but also for changing its fundamental structure.

AMOS, EMMA

Born: 1938, Atlanta, Georgia. *Education*: B.A., Antioch College, Yellow Springs, Ohio, 1959. London Central School of Art, 1960. Masters in Art, New York University, 1966. Slade School of Art, London, (attended) 1960. *Family*: Parents Miles and India Amos owned a drugstore on Atlanta's West Side where she grew up with her brother Larry. In 1965 she married Bobby Levine. They have a son, Nicholas, and daughter, India. *Career*: Teaches textile design at the Newark School of Fine and Industrial Art. Co-hosts crafts show on WGBH, Boston. Professor of Art, Mason Gross School of Art, Rutgers University. Writes and produces *Artists Helping Artists* video through Rutgers University Research Council Grant, 1986. *Awards*: National Endowment for the Arts Fellowship, 1983. Artist-in-Residence, Skowhegan School of Painting and Sculpture, Maine, 1986. New York Foundation for the Arts Fellowship, 1989. New York City Board of Education Public Art Commission, 1991. Rockefeller Foundation Fellowship, Bellagio, Italy, 1993.

EXHIBITIONS

1994	*New Work*, Art in General, New York, New York
1993	*Emma Amos: Paintings and Prints 1982–92*, The College of Wooster Art Museum, Wooster, Ohio (traveling show)

1992	*Odyssey*, The Pump House Gallery, City of Hartford, Bushnell Park Foundation, Connecticut, Clarion University, Clarion, Pennsylvania
1991	*The Falling Series*, The Bronx Museum, New York, New York; *Recent Paintings*, The McIntosh Gallery, Atlanta, Georgia
1990	*The Wild Blue Yonder Series*, The Newark Museum, New Jersey; *Paintings from the Wild Blue Yonder Series*, Zimmerman/Saturn Gallery, Nashville, Tennessee
1989	Zimmerman/Saturn Gallery, Nashville, Tennessee; *The Water Series*, Ingrid Cusson Gallery, New York, New York, Clemson University Gallery, Genoa, Italy; *Paintings*, Douglass College Women Artists Series, Rutgers University, New Brunswick, New Jersey
1988	*The Water Series*, Isobel Neal Gallery, Chicago, Illinois; *Meet the Artist Series: Emma Amos*, Jersey City Museum, New Jersey; *Works on Paper*, Shifflett Gallery, Los Angeles, California
1987	*The Water Series*, Parker/Bratton Gallery, New York, New York
1986	Galleri Oscar, Stockholm, Sweden
1983	Jazzonia Galleries, Detroit, Michigan, and Cleveland, Ohio
1980	Gallery 62, National Urban League, New York, New York
1979	*Paintings and Prints*, The Art Salon, New York, New York
1974	*Prints*, Davis Fine Arts Gallery, West Virginia State College, Institute, West Virginia
1960	New Arts Gallery, Atlanta, Georgia; *Prints*, Alexander Gallery, Atlanta, Georgia

SELECTED GROUP EXHIBITIONS

1996	*Bearing Witness: Contemporary Work by African American Women Artists*, Spelman College, Atlanta, Georgia
1993	*At the Heart of Change: Women Artists Explore Color and Culture*, Kennesaw State College Library Art Gallery, Kennesaw, Georgia; *My/Self: Your/Other*, Castle Gallery, College of New Rochelle, New York
1992	*Expanding the Circle*, The Gallery at Bristol-Myers Squibb, Princeton, New Jersey; *Dream Singers, Story Tellers: An African-American Presence*, Fukui Fine Arts Museum, Japan, New Jersey State Museum, Trenton, New Jersey
1991	*Diversity and Strength: Six Contemporary Black Artists*, Kennesaw State College Library Art Gallery, Kennesaw, Georgia; *African American Works on Paper*, New Visions Gallery, Atlanta, Georgia (traveling show); *Presswork: The Art of Women Printmakers*, Lang Communications Corporate Collection (traveling show)
1990	*The Decade Show*, Museum of Contemporary Hispanic Art, New York, New York; *Black Women in the Arts*, Montclair State College Gallery, Montclair, New Jersey

1989	*Selections: Six Contemporary African American Artists*, Williams College Museum, Williamstown, Massachusetts; *Homefront*, DIA Foundation, New York, New York; *Lines of Vision: Drawings by Contemporary Women*, Hillwood Art Gallery, Long Island University, Brookville, New York, and U.S. Information Agency (traveling show); *Directions: African American Artists Now*, Lyman Allyn Museum, New London, Connecticut
1988	*Autobiography: In Her Own Image*, INTAR Gallery, New York (traveling show); *Committed to Print*, Museum of Modern Art, New York, New York (traveling show); *Coast to Coast: A Women of Color National Artist's Book Project*, Jamaica Art Center, New York, New York (traveling show)
1987	*Works on Paper*, Landskrona Art Hall, Landskrona, Sweden; *Masters and Pupils: The Education of the Black Artist in New York 1900–1980*, Jamaica Art Center, New York, New York; *Forward View*, Squibb Gallery, Princeton, New Jersey; *The Afro-American Artist in the Age of Cultural Pluralism*, Montclair Museum of Art, Montclair, New Jersey; *Connection Project*, Museum of Contemporary Hispanic Art, New York, New York
1986	*Progressions, A Cultural Legacy*, The Clocktower, New York, New York
1985	*The Handworked Image*, Associated American Artists, New York, New York
1984	*Art in Print: A Tribute to Robert Blackburn*, The Schomburg Center for Research in Black Culture, New York, New York; *Celebrations: Eight Afro-American Artists Selected by Romare Bearden*, Henry Street Settlement, New York, New York
1983	*Jus' Jass: Correlations of Painting and Afro-American Classical Music*, Kenkeleba House, New York, New York
1982	*The Wild Art Show*, P.S. 1, Long Island City, New York
1980	*Fragments of Myself/The Women*, Douglass College Art Gallery, Rutgers University, New Brunswick, New Jersey; *International Collection*, Associated American Artists, New York, New York
1979	*Black Artists/South*, Huntsville Museum, Alabama; *Impressions/Expressions*, The Studio Museum in Harlem, New York (traveling show)
1970	*Afro-American Artists: New York and Boston*, Boston Museum of Fine Arts, Massachusetts
1968	*30 Contemporary Black Artists*, Minneapolis Institute of Art, Minnesota (traveling show)
1964	*The Spiral*, Christopher Street Gallery, New York, New York

PERMANENT COLLECTIONS

Colgate-Palmolive Collection, New York, New York; The Columbia Museum, Columbia, South Carolina; Dade County Museum of Art, Florida; Franklin Furnace, New York,

New York; Jane Voorhees Zimmerli Art Museum, New Brunswick, New Jersey; Johnson and Johnson Inc., New Brunswick, New Jersey; Lang Communications, New York, New York; Library of Congress, Washington, D.C.; Minnesota Museum of Art, Minneapolis, Minnesota; Museum of African Art, Washington, D.C.; Museum of Modern Art, New York, New York; Newark Museum, Newark, New Jersey; New Jersey State Museum, Trenton, New Jersey; Schomburg Collection, New York Public Library, New York, New York; Skandinaviska Enskilda Bankn, Stockholm, Sweden; Spelman College, Atlanta, Georgia; The Studio Museum in Harlem, New York; Tougaloo College, Tougaloo, Mississippi; Tulsa Civic Center, Tulsa, Oklahoma; United States Embassy, London, England; West Virginia State College, Institute, West Virginia

PUBLICATIONS

The Afro-American Artist in the Age of Cultural Pluralism. Montclair, N.J.: Montclair Museum of Art, 1987. Exhbn cat.

"Album: Committed to Print." *Arts Magazine* (March 1988), pp. 104–105.

Amos, Emma. "The Art of Education." *Heresies* 25 (1990).

Amos, Emma. "Contemporary Art Issues." *M/E/A/N/I/N/G: Contemporary Art Issues* 12 (1992).

Amos, Emma. "Contemporary Views on Racism in the Arts." *M/E/A/N/I/N/G: Contemporary Art Issues* 7 (May 1990).

Amos, Emma. "Do's and Don'ts for Art Students." *Heresies* 25 (1990).

Amos, Emma. "Forum 1989." *M/E/A/N/I/N/G: Contemporary Art Issues* 5 (May 1989).

Amos, Emma. "Juicy Overflowing Studios: Questions Too Rude to Ask Older Artists." *Art and Artists* (November 1982).

Amos, Emma. "Letters: Invisible Woman." *New York Times*, April 23, 1989.

Amos, Emma. "Satire." *Heresies* 19 (1986).

Amos, Emma. "Some Do's and Don'ts for Black Women Artists." *Heresies* 15 (1982).

Amos, Emma. "You Must Remember This." Guest curator, Jersey City Museum, N.J., 1992.

At the Heart of Change: Women Artists Explore Color and Culture. Kennesaw, Ga.: Kennesaw State College Library Art Gallery, 1993. Exhbn cat.

Autobiography: In Her Own Image. New York: INTAR Gallery, 1988. Exhbn cat.

Bearing Witness: Contemporary Works by African American Women Artists. Atlanta, Ga.: Spelman College Museum of Fine Art, 1996. Exhbn cat.

Colby, Joy Hakanson. "Exhibits: Through Women's Eyes." *The Detroit News*, February 15, 1991.

The Decade Show: Frameworks of Identity in the 1980s. New York: The New Museum, 1990. Exhbn cat.

Emma Amos: Paintings and Prints 1982–92. Wooster, Ohio: College of Wooster Art Museum, 1993. Exhbn cat.

Glueck, Grace. "Art News: Art Power." *New York Times*, March 10, 1968.

Hess, Elizabeth. "Breaking and Entering." *Village Voice*, June 5, 1990.

Langer, Cassandra. "Women at the Cutting Edge . . ." *Women Artists' News* (Fall 1988), pp. 26–27.

Lippard, Lucy. "Floating Falling Landing: An Interview with Emma Amos." *Art Papers* (November–December 1991), pp. 13–16.

Lippard, Lucy. *Mixed Blessings: New Art in a Multicultural America.* New York: Pantheon, 1990.

Odyssey. Atlanta, Ga.: Atlanta Arts Festival, 1988. Exhbn cat.

Raven, Arlene. "Colored." *Village Voice*, May 31, 1988.

Raven, Arlene. "Laws of Falling Bodies: Emma Amos, 'The Falling Series.' " *Village Voice*, May 7, 1991, p. 86.

Raynor, Vivien. " 'Forward View at the Squibb': An Abundance of Ethnicity." *New York Times*, April 5, 1987.

Ringgold, Faith. *The Wild Art Show*. Long Island City, N.Y.: P.S. 1, 1982. Exhbn cat.

Rowe, Claudia. "Emma Amos." *Cover* (Summer 1989), p. 15.

Shepard, Joan. "The Arts Community." *The Daily News*, March 6, 1987.

Siegel, Jeanne. "Why Spiral?" *Art News* (September 1966), pp. 48–51, 67–68.

Smith, Roberta. "Art: 'Committed to Print.' " *New York Times*, February 5, 1988.

"TV Craft Series Gets Big Hand from Boston Viewers . . ." *Craft Horizons* (December 1977).

Watkins, Eileen. "Black Artists Link Talents into 'Circle.' " *Star Ledger*, February 7, 1992.

Yalkut, Jud. "The Medium and the Message: 'Committed to Print.' " *Dialogue* (January–February 1989), p. 13.

Zimmer, William. "A Catalyst for Sophistication." *New York Times*, February 9, 1992.

Zimmer, William. "When Deep Memories Are Unshakeable." *New York Times*, April 12, 1992.

BIOGRAPHICAL ESSAY

As a child Emma Amos always wanted to be an artist, and she taught herself to draw by copying pictures from books and magazines. She was encouraged by her parents, and her talents were confirmed when she won poster contests in elementary school. At the age of 11 she received special permission to take an oil painting course at Morris Brown College. Later, she majored in art at Antioch College in Ohio. It was there that she began to experience a heightened race awareness. The mostly white student body contrasted sharply with her upbringing in Atlanta, where she went to all-black schools and was raised in an all-black community surrounded by African American colleges such as Spelman and Morehouse. Amos was well aware of the existence of a black intelligentsia since her father, who worked in the family drugstore, knew and read many works by African American scholars and writers. Zora Neale Hurston often visited with her father on her trips through Atlanta, and even W.E.B. Du Bois once came to the house.

When Amos was 19 she moved to London for a year and a half to study. It was there that she experienced a different kind of awareness because the English had an aversion to all foreigners, regardless of race. With that came a certain kind of freedom that she had not experienced in the United States. She returned to Antioch to graduate and then went back to London and later graduated from the Central School of Art, where she majored in printmaking. After London, Amos moved back to Atlanta, and in 1960, at the age of 23, she moved to New York. There she met Sylvan Cole, director of Associated American Artists Gal-

lery, who began to show some of her prints. After working as an assistant teacher at the Dalton School, she got a job as a weaver/designer with Dorothy Liebs, creating rugs, upholstery, blinds, and dress fabrics. She worked with her from 1961 to 1973 and while working returned to school in 1964 at New York University, where she met Hale Woodruff, whom her mother had known in Atlanta. Amos's mother had asked Woodruff, who was then teaching at Atlanta University, to instruct her young daughter, but he had not at the time taken her seriously. Now he remembered Amos and became her mentor, although she did not take any classes with him. He introduced her to the Spiral Group, which was founded by Romare Bearden and Norman Lewis in 1963 and included other artists such as Merton Simpson, Charles Alston, and Al Hollingsworth. She was invited to join and became their youngest member and first female member. They met regularly once a week to talk about their work and other pertinent topics such as Negritude. She continued to exhibit with them until their last meetings in 1967.

For a time in the late 1960s Amos protested what she saw as a trend toward separatism by declining her own inclusion in all-black shows, but she soon realized that this meant she would have little opportunity to show at all. In 1974 she began teaching textile design at the Newark School of Fine and Industrial Art. Since she was teaching weaving during the crafts craze of the 1970s, she came up with the idea for a television show called *Show of Hands*, which she co-hosted with a quiltmaker. The program, which ran for 13 half-hour episodes, was aired in 1977 and 1978 by WGBH Educational Television, Boston, and covered a range of techniques including weaving, woodworking, stained glass, ceramics, and jewelry.

In 1980 Amos became Assistant Professor of Art at the Mason Gross School of Art, Rutgers University. In 1982 she began to use acrylic paint and started painting male athletes paired with wild animals, then turned to images of women runners also combined with powerful animals as symbols of independence and strength. Her work clearly references African American culture and reinforces the importance of cultural heritage and the need for self-definition. In 1985–1986 Amos began *The Water Series*. Inspired by the absence of black swimmers in the 1984 Olympics, she began to paint images of African American men and women swimming and diving. There is an undercurrent of anxiety in these works similar to the *The Falling Series* of 1988–1992, which expresses her concerns about helplessness and the loss of history. However, many of the works are about retrieving history. In the work *Thurgood and Thelonius—Some Names to Name Your Children* (1989), she has painted falling figures with no apparent safe place on which to land. However, names such as *Thurgood, Thelonius, Bessie, Langston, Duke*, amd *Miles* flank the bodies, referencing important historical figures and reinforcing a strong and solid African American history that grounds the young people hurtling through space. Also, she incorporates an important aesthetic device that she began in the early 1980s. She borders her paintings with strips of her own hand weaving or African cloth. This technique

began as an act of cutting up her own work to recreate her identity and to secure her narratives. By later using African cloth, she makes reference to heritage and gives the falling figures a cultural and historical foundation. She also questions differences between art and craft.

Amos is both a painter and a printmaker. When she had small children, she joined the Printmaking Workshop and was encouraged by Bob Blackburn to continue working. Her monoprints and collagraphs bring together her interest in printmaking and the abstract expressionist quality she could achieve with paint. In 1988 Amos applied the monoprint technique to an autobiographical series called *Odyssey*. These works are acts of self-recovery and celebration. Another important series is *The Gift*, begun in 1990, which is a group of portraits of her women artist friends that she gave to her daughter India for her twentieth birthday. They portray the power of women artists and the support network Amos had from them. Amos came late to feminism because she did not have any female role models. But she is committed to political activism and to art. For a time she joined the editorial board of *Heresies*, a feminist journal on art, and has curated several shows including *Hanging Loose at the Port Authority* for Port Authority Bus Terminal (1984).

Amos's works are a mixture of figurative, surreal, and abstract expressionism. She is interested in portraying African American issues and in investigating notions of race and gender. Her work depicts movement and color, both important elements because they relate to transition, ethnicity, and history. Her figures often drift or float amidst her expressionist backgrounds. Ultimately, her work suggests the possibility of change and the hopes of the future as well as the past.

BILLOPS, CAMILLE

Born: 1934, Los Angeles, California. *Education*: B.A., California State College, 1960. M.F.A., City College of New York, 1973. *Career*: Filmmaker, sculptor, ceramist, painter, archivist, publisher. *Awards*: Huntington Hartford Foundation Fellowship, 1963. MacDowell Colony Fellowship, 1975. International Women's Year Award, 1975–1976. Best Documentary, Sundance Film Festival, 1992. National Endowment for the Arts—Artists Fellowship in Filmmaking, 1994. The James VanDerZee Award, 1994. Village Voice Off-Broadway (OBIE) Award, Special Citation for Distinguished Contributions to Off-Broadway Theatre, 1997.

SELECTED EXHIBITIONS

1997 *Inside the Minstrel Mask*, Noel Fine Art Acquisitions, Charlotte, North Carolina

1991 Black Filmmakers Hall of Fame, Oakland, California

1990 Clark College, Atlanta, Georgia

1986 Calkins Gallery, Hofstra University, Hempstead, New York

1983 American Center, Karachi, Pakistan; Pescadores Hsien Library, Makung, Republic of China

1980 Buchandlung Welt, Hamburg, Germany

1977 Rutgers University, Newark, New Jersey

1973 Ornette Coleman's Artist House, New York, New York

1965 Gallerie Akhenaton, Cairo, Egypt

SELECTED GROUP EXHIBITIONS

1997 *Women in Full Effect*, Rush Arts Gallery, New York, New York

1992 *Prized Pieces: International Video and Film Festival*, National Black Program Consortium, Columbus, Ohio

1988 *1938–1988: The Work of Five Black Women Artists*, Atlanta College of Art, Atlanta, Georgia; McIntosh Gallery, Atlanta, Georgia; *Through a Master Printer: Robert Blackburn and the Printmaking Workshop*, Columbia Museum of Art, Columbia, South Carolina

1987 *The Black Women Independent: Representing Race and Gender*, Whitney Museum of American Art, New York, New York

1983 *New Directors/New Films*, The Film Society of Lincoln Center and the Museum of Modern Art, New York, New York

1976 *Jubilee: Afro-American Artists on Afro-America*, Museum of Fine Arts, Boston, Massachusetts

SELECTED COLLECTIONS

The Cochran Collection, LaGrange, Georgia; Museum of Drawers, Bern, Switzerland; Paul R. Jones Collection, Atlanta, Georgia; Photographers Gallery, London, England; Studio Museum of Harlem, New York

PUBLICATIONS

Bontemps, Arna Alexander, ed. *Forever Free: Art by African-American Women 1862–1980*. Normal, Ill.: The Center for the Visual Arts Gallery, Illinois State University, 1980.

Boyle, Donald. *Black Arts Annual 1987/1988*. New York: Garland Publishing, 1989.

Foster, Gwendolyn Audrey. *Women Filmmakers of the African and Asian Diaspora*. Carbondale and Edwardsville: Southern Illinois University Press, 1997.

hooks, bell. "An Interview with Camille Billops." In *Reel to Real: Race, Sex, and Class at the Movies*. London: Routledge, 1996.

King-Hammond, Leslie, ed. *Gumbo Ya Ya: Anthology of Contemporary African-American Women Artists*. New York: Midmarch Arts Press, 1995.

Lekatsas, Barbara. "Encounters: The Film Odyssey of Camille Billops." *Black American Literature Forum* (Summer 1991).

Lewis, Samella. *African-American Art and Artists*. Berkeley: University of California Press, 1978, 1990.

Powell, Richard J. *Black Art and Culture in the 20th Century*. London: Thames and Hudson, 1997.

Robinson, Jontyle Theresa. *Bearing Witness: Contemporary Works by African American Women Artists*. Atlanta, Ga.: Spelman Museum of Fine Art, 1996.

ARTIST STATEMENT (1996)[1]

I don't know if I am that conscious of it, but some people say that our films have a tendency toward dirty laundry. The films say it like it is, rather than how people want it to be. Maybe it is my character that tends to want to do that, because I think the visual arts [artist?] in me wants to say the same kind of thing. So I don't know if I consciously did it; I think it is just my own spirit.

Note

1. From bell hooks, "An Interview with Camille Billops," in *Reel to Real: Race, Sex, and Class at the Movies* (London: Routledge, 1996), p. 141.

BIOGRAPHICAL ESSAY

Although she began her career as a sculptor, ceramist, and painter, Billops is best known as a filmmaker of the black diaspora. In recent years Billops has collaborated with her husband James Hatch, an English professor and expert in African American theater history, on a series of films marked for their brutally frank depiction of her life and the life of her family (*Suzanne, Suzanne*, 1981; *Older Women and Love*, 1987; *Finding Christa*, 1991). Gwendolyn Foster has aptly described Billops's work as "film therapy," but such terminology does not imply that these films are forms of self-indulgent autobiography. On the contrary, they blend objective and subjective perspectives through a mixture of archival footage from her parents' home movies, her own interviews of family members, and scripted dramatizations, resulting in portrayals both intimate and dispassionate. For example, the award-winning *Finding Christa* (1991) is a wrenching, unadulterated account of Billops's search for and reunion with the daughter whom she gave up for adoption at the age of four. The bare outline of this broken-home scenario is the paradigmatic stuff of stereotypical black family life, but Billops's self-presentation in the film as a middle-class, educated artist who after mature consideration decides to pursue career over motherhood interferes with any programmed expectation of black-single-mother-as-victim. Instead, *Finding Christa* challenges the viewer to rethink not only the nature of

black female subjectivity but also the nature of motherhood itself. Billops is currently working on another one of her signature hybrid "documentaries of self-knowledge," *String of Pearls*, which will probe the life of her stepfather. In *The KKK Boutique Ain't Just Rednecks* (1994), Billops departed from her family as subject to examine with typical straightforwardness the ways in which "political correctness" has caused racism to adapt and to mutate.

The spirit of collaboration and giving that characterizes her filmmaking also marks Billops's social commitment to black visual and literary arts. Her generous gifts of herself and her art enrich and expand the contemporary art world. She mentors and supports black, particularly female, artists, an activity painter Emma Amos commemorated by including Billops in her series of 40 portraits of women artists and supporters of the arts entitled *The Gift* (acrylic on paper, 1990). With her husband, James V. Hatch, Billops founded the Hatch-Billops Collection: Archives of Black American Cultural History in New York City. The Hatch-Billops Collection comprises slides, photographs, oral histories, and books on black artists and art history; it is an invaluable resource and, as bell hooks describes it, "an alternative cultural space, which [Billops shares] with everybody." The Collection also publishes *Artist and Influence*, an annual selection of the oral histories in its archives. Billops has served as the coeditor (with Kellie Jones, curator/critic) for an important anthology of writings on black artists by poets, novelists, art critics, and art historians (special issue of *Black American Literature Forum*, 1985) and as an adviser (with Robert Blackburn, printmaker) in the formation of important collections of black art such as the Wes and Missy Cochran Collection (LaGrange, Georgia).

BURKE, SELMA HORTENSE

Born: 1900, Mooresville, North Carolina. *Education*: M.F.A., Columbia University, 1941. Ph.D., Livingstone College, North Carolina, 1970. *Career*: Sculptor, ceramist, arts administrator, educator. *Awards*: Julius Rosenwald Foundation Fellowship, 1935. Boehler Foundation Fellowship, 1936. Yaddo Foundation Fellowship, 1955. Honorary Doctorate, Livingstone College, Salisbury, North Carolina, 1955. Honorary Doctorate of Fine Arts, University of North Carolina, Chapel Hill, 1977. Honorary Doctorate in Fine Arts, Moore College of Art, Philadelphia, Pennsylvania, 1979. Honorary Doctorate of Humane Letters, Winston-Salem State University, North Carolina, 1979. Ambassador of Bucks County, Central Bucks County Chamber of Commerce, 1979. Award for Outstanding Achievement in the Visual Arts, Women's Caucus for Art, presented

by President Jimmy Carter, Washington, D.C., 1979. Pearl S. Buck Foundation Woman's Award, 1987. Essence Award, 1989. *Died*: 1995, New Hope, Pennsylvania.

SELECTED EXHIBITIONS

1996	Austin Museum of Art, Austin, Texas
1992	Kingsley Center, Pittsburgh, Pennsylvania
1990	Lyndon Baines Johnson Memorial Library, Austin, Texas
1958	Avant-Garde Gallery, New York, New York
1952	Artists Gallery, New York, New York
1945	Carlem Galleries, Philadelphia, Pennsylvania; Modernage Gallery, New York, New York
1941	McMillan Galleries, New York, New York

SELECTED GROUP EXHIBITIONS

1996	*African-Americans in the Visual Arts: A Historical Perspective*, B. Davis Schwartz Memorial Library, Long Island University, C. W. Post Campus, New York; *Three Generations of African-American Women Sculptors: A Study in Paradox*, The Afro-American Historical and Cultural Museum, Philadelphia, Pennsylvania
1993	*African-American Women Artists Prints*, Brandywine Workshop's Printed Image Gallery, Philadelphia, Pennsylvania
1989	Group Exhibition, Genest Gallery and Sculpture Garden, Lambertville, New Jersey
1985	*Hidden Heritage: Afro-American Art, 1800–1950*, Bellevue Museum of Art, Bellevue, Washington
1940	*Exhibition of the Art of the American Negro*, American Negro Exposition, Chicago, Illinois

SELECTED COLLECTIONS

Atlanta University, Atlanta, Georgia; Bethune-Cookman College, Daytona Beach, Florida; Dry Dock Savings Bank, New York City; Gulf Oil Company, Pittsburgh, Pennsylvania; Howard University Gallery, Washington, D.C.; John Brown Association, Lake Placid, New York; Johnson C. Smith University, Charlotte, North Carolina; Livingston College Library, Salisbury, North Carolina; Metropolitan Museum of Art, New York City; Museum of Modern Art, Miami, Florida; Philadelphia Museum of Art, Philadelphia, Pennsylvania; United States Armory, New York City; Whitney Museum of American Art, New York City; Winston-Salem State University, Winston-Salem, North Carolina

SELECTED PUBLICATIONS

Bontemps, Arna Alexander, ed. *Forever Free: Art by African-American Women 1862–1980*. Normal, Ill.: The Center for the Visual Arts Gallery, Illinois State University, 1980.

Dover, Cedric. *American Negro Art*. Greenwich, Conn.: New York Graphic Society, 1960.

Hine, Darlene Clark, ed. *Black Women in America: An Historical Encyclopedia*. Brooklyn: Carlson Publishing, 1993.

King-Hammond, Leslie, ed. *Gumbo Ya Ya: Anthology of Contemporary African-American Women Artists*. New York: Midmarch Arts Press, 1995.

LeBlanc, Michael L., ed. *Contemporary Black Biography*. Detroit: Gale Research Inc., 1992.

Lenihan, Mary L. "Creating a New Black Image." In Ilene Susan Fort, ed., *The Figure in American Sculpture—A Question of Modernity*. Los Angeles: Los Angeles County Museum of Art, 1995.

Lewis, Samella. *African-American Art and Artists*. Berkeley: University of California Press, 1978, 1990.

Negro Heritage Committee. *Afro-American Women in Art: Their Achievements in Sculpture and Painting*. Greensboro, N.C.: Negro Heritage Committee, Alpha Kappa Alpha Sorority, 1969.

Porter, James. *Modern Negro Art*. 1943. Washington, D.C.: Howard University Press, 1992.

Robinson, Jontyle Theresa. *Bearing Witness: Contemporary Works by African American Women Artists*. Atlanta, Ga.: Spelman Museum of Fine Art and Rizzoli International Publications, Inc., 1996.

Schwalb, Harry. "Without Color." *ARTnews* (September 1994), p. 27.

"Selma Burke." *Ebony* (March 1947), p. 32.

Smith, Jessie Carney, ed. *Notable Black American Women*. Detroit: Gale Research Co., 1992.

Spady, James G. "Three to the Universe: Selma Burke, Roy Decarava, Tom Feelings." In Black History Museum Committee, ed., *9 to the Universe, Black Artists*. 1983.

ARTIST STATEMENT (1994)[1]

Art didn't start black or white, it just started. There have been too many labels in this world: Nigger, Negro, Colored, Black, African-American. . . . Why do we still label people with everything except "children of God"?

Note

1. Harry Schwalb, "Without Color," *ARTnews* (September 1994), p. 27.

BIOGRAPHICAL ESSAY

Burke's biography is the stuff of "artist myth," comprising most of the ingredients so essential to the legendary, such as premonition, eccentricity, brushes with greatness leading to one's own greatness, encounters with royalty and heads of state, reversals of fortune, risky adventure, longevity, and the attainment of magnanimous wisdom. That Burke herself had no small hand in the creation and maintenance of her legend only makes her all the more mythic, placing her

squarely in the firmament of other canny self-promoting artists, including Pablo Picasso and Georgia O'Keeffe. A testament to Burke's mythopoetic prowess is the perpetuation of her myth by others since her death in 1995, most recently by storyteller and poet Shindana Cooper, who presented Burke's personal history through narrative, dance, and drumming in a 1996 performance entitled "Sand Art, Mud Pies, Dimes and a Promise" at the State University of New York, Plattsburgh. There is even a Selma Burke Day celebrated in North Carolina, Burke's home state, and also in Pennsylvania, the adopted state of her late years, in recognition of her distinguished life of achievement in the arts.

Burke often described a youthful preoccupation with the muddy clay her mother collected for whitewash from the local creek, pressing the imprints of her palms in it, making mud pies, working it into little figures. She also recounted childlike delight in the impressions that coins made in the clay. These anecdotes serve as early harbingers of her future career as a sculptor and specifically of her portrait of Franklin Roosevelt, which was adapted for the U.S. dime. Yet her enlightened family background is more likely responsible for her career than any elemental power she may have received from the pliant earth of her childhood. Both of her parents encouraged her interest in the arts, and her maternal grandmother was a painter. Before her father found his vocation in the Methodist ministry, he was a well-traveled chef, serving on several sea lines and collecting art wherever he went. Two paternal uncles had been missionaries in Africa in the late nineteenth century, confiscating native religious figures, masks, and other artifacts in the name of Christianity. When they died, their personal effects were returned to the Burkes in Mooresville, and their African art objects were part of the family's considerable art collection. The young Selma, then, was as immersed in the lessons of African and modern art as she was in North Carolina mud, as much a product of culture as nature and considerably younger than Picasso, who was having a similar immersion experience at around the same moment among the ethnographic collections and avant-garde art world of Paris.

Burke herself would not be able to simulate Picasso's early Parisian experience until she was approaching the age of 40, when she spent a year abroad during 1938–1939 to further her pursuit of a sculpture career. The factual details of her experiences in Europe are vague: She studied with sculptor Aristide Maillol in Paris and with ceramist Michael Powolny in Vienna. The mythic dimensions of Burke's year abroad, however, are vibrant: riding on a motorcycle behind photographer Henri Cartier-Bresson; making a pilgrimage to Montparnasse to seek guidance from Henri Matisse, who lauded her work; fleeing Austria in the wake of Hitler's invasion with a half-million dollars worth of jewels sewn into her clothing destined for the Quaker refugee offices in America.

Between her child's play in the mud and her jewel-laden flight from Nazis, Burke had become a registered nurse (her parents' encouragement of her art appreciation did not extend to an enthusiasm for a career in the arts); gained financial security as a private nurse to a wealthy, eccentric Otis elevator heiress;

and met Claude McKay, a major Harlem Renaissance writer, with whom she had a tempestuous yet inspirational relationship until his death in 1948. Throughout her nursing career and years among the figures of the Harlem Renaissance, Burke tenaciously pursued her sculptural education, often supporting herself as a model. Long-term modeling work at Sarah Lawrence College, posing for Leon Kroll, Paul Manship, Alfred Stieglitz, and Edward Steichen, offered her the opportunity for more systematic art study than she had been able to complete up to this time. The portfolio of work she was able to assemble while at Sarah Lawrence led to the fellowships that would make her European travel possible. In 1941, Burke finally formalized her art education with a Master's of Fine Arts from Columbia University. While at Columbia, she forged a lasting friendship with fellow student Margo Einstein, daughter of Albert Einstein, and the Einstein family became staunch patrons of Burke's career from this point on. Her first solo exhibition was also in 1941.

Burke came into professional maturity during the Works Progress Administration (WPA) era, and she enjoyed its particular fruits in the form of teaching jobs at the Harlem Art Center, a model unit of the Federal Arts Project, and at various sculptural workshops and art clinics. Her work, as well, reflects the public character of WPA-era art, consisting to a great extent of sensitive and powerful portraits of black cultural and political leaders. Her best-known sculptural portrait by far is a bronze plaque bearing the bust profile of Franklin Delano Roosevelt, which would become the model for Roosevelt's likeness on the U.S. dime. Burke won the commission to execute the plaque in a 1943 international competition sponsored by the Fine Arts Commission for the District of Columbia. With the bravado and humor typical of one who is accustomed to hobnobbing with the great and notable, Burke wrote the following to President Roosevelt after she discovered that there were no extant images of him in profile from which to work:

Dear Mr. President:
 During the lifetime of President George Washington, the French sculptor, Houdon, was invited to come to this country. He travelled two months by boat. As you perhaps saw in the newspapers, I won the competition to do your bust. I live one hour by plane, two by railroad, and four by car. May I have a sitting with you?[1]

The president arranged for a sitting with Burke, and the original portrait now resides in the Recorder of Deeds Building in Washington, D.C., where it was originally installed in 1945.

Burke's mature style reflects her modernist training with Maillol and Powolny: It is primarily figurative, characterized by a streamlined idealism combined with her own adaptation of WPA-inspired social realism. She typically employs the direct carving method, working in stone and a variety of hard fruitwoods. Yet her stylistic modernism does not define her role as an artist in

society. Burke was anything but an inhabitant of the realm of modernist auton-
omy, especially in her late years, when she worked tirelessly as an educator and
benefactor of the arts, determined that others would not have to struggle as hard
as she had done for an education and a career in the arts. To this end, Burke
has established art schools, sponsored exhibitions for emerging black artists,
served as a consultant to national and international arts foundations, and con-
ducted art workshops for inner-city children. In her later years, she and her
husband, architect and former candidate for lieutenant governor of New York
Herman Kobbe, were the doyens of the artists' community of New Hope, Penn-
sylvania, where they moved in the 1950s and where Burke died at the age of
94 in 1995.

Note

1. National Archives and Records Administration, Franklin D. Roosevelt Library,
Hyde Park, N.Y.

BURROUGHS, MARGARET TAYLOR

Born: 1917, St. Rose Parish, Louisiana. *Education*: B.F.A., 1944, and M.F.A.,
1948, Art Institute of Chicago. *Career:* Painter, printmaker, writer, educator,
museologist, social activist, humanitarian. *Awards*: National Endowment for the
Humanities Grant, 1968. Honorary Doctorate of Humane Letters, Lewis Uni-
versity, Lockport, Illinois, 1972. Young Women's Christian Association Lead-
ership Award for Excellence in Art, 1973. Citation by President Jimmy Carter
as one of the ten most outstanding black artists in the United States, 1980.
Excellence in Art Award, National Association of Negro Museums, 1982. Hon-
orary Doctorate of Fine Arts, Art Institute of Chicago, 1987. Honorary Doctorate
of Fine Arts, North Central College, Naperville, Illinois, 1988. Progressive Black
Woman's Award, Enverite Charity Club, 1988. Women's Caucus for Art Honor
Award, 1988. Women's History Month Award, John Hope Community Acad-
emy, 1992. Ida B. Wells Celebrated Elders Award, National Council of Black
Studies, 1992. Recognition Award, African-American Cultural Coalition, 1992.
Living Women Legends Award, Wordsongs, 1996. Human Resources Devel-
opment Institute Seeds of Africa Award, 1997. 100 Black Men of Chicago
Award, 1998.

SELECTED EXHIBITIONS

1997 Hemphill Fine Arts, Washington, D.C.

1994	*Margaret Taylor Burroughs*, Krannert Museum and Kinkhead Pavillion, Illinois University, Champaign-Urbana, Illinois
1987	*Margaret Taylor Burroughs: Prints*, South Side Community Art Center, Chicago, Illinois; *Sapphire & Crystals*, South Side Community Center, Chicago, Illinois
1986	*Margaret Taylor Burroughs: 40 Years of Art*, Nicole Gallery, Chicago, Illinois
1945	*Margaret Taylor Burroughs: Exhibition of Oils, Watercolors, Prints, Ceramics*, South Side Community Art Center, Chicago, Illinois

SELECTED GROUP EXHIBITIONS

1997	*Alone in a Crowd: Prints by African-American Artists of the 1930s–1940s from the Collection of Reba and Dave Williams*, The Newark Museum, Newark, New Jersey; Arts and Sciences Center for Southeast Arkansas, Pine Bluff, Arkansas
1988	Museum of Fine Arts, Houston, Texas
1982	Evan-Tibbs Collection, Washington, D.C.
1981	*Ten Outstanding Afro-American Artists*, The White House, Washington, D.C.
1978	*Black Artists, WPA–Chicago–New York*, Studio Museum of Harlem, New York, New York
1976	*Two Centuries of Afro-American Art*, Los Angeles County Museum of Art, Los Angeles, California
1975	*Highlights of the Atlanta University Collection*, High Museum, Atlanta, Georgia
1967	Friendship House, Moscow, United Soviet Socialist Republic
1965	*International House Kook Art Exhibit*, Leipzig, East Germany
1961	*New Vistas in American Art*, Howard University, Washington, D.C.
1952	*Margaret Taylor Burroughs*, Mexico City, Mexico
1949	San Francisco Civic Museum, San Francisco, California
1946	*Atlanta Negro Exhibition*, Atlanta, Georgia
1940	*American Negro Exhibition*, Chicago, Illinois

SELECTED COLLECTIONS

Afrikan American Cultural Center, North Carolina State University, Raleigh, North Carolina; Alabama A&M University Print Collection, Normal, Alabama; Atlanta University Art Collection, Atlanta, Georgia; Evans-Tibbs Collection, Corcoran Gallery, Washington, D.C.; Howard University Art Collection, Washington, D.C.; Jackson State College Art Collection, Jackson, Mississippi

SELECTED PUBLICATIONS

Atkinson, J. Edward. *Black Dimensions in Contemporary American Art*. New York: New American Library, 1971.

Bontemps, Arna Alexander, ed. *Forever Free: Art by African-American Women 1862–1980*. Normal, Ill.: Center for the Visual Arts Gallery, Illinois State University, 1980.

Burroughs, Margaret Taylor. *Africa, My Africa!* Chicago: DuSable Museum Press, 1970.

Burroughs, Margaret Taylor. *Did You Feed My Cow? Rhymes and Games from City Streets and Country Lanes*. New York: Crowell, 1956.

Burroughs, Margaret Taylor. *Jasper, the Drumming Boy*. New York: Viking, 1947 (illustrated by Burroughs).

Burroughs, Margaret Taylor. *Peter, the Crop-Sharer*. New York: Board of Education, City of New York, 1940.

Burroughs, Margaret T. G. "The Four Artists." In William E. Taylor and Harriet G. Warkel, eds., *A Shared Heritage: Art by Four African Americans*. Indianapolis, Ind.: Indianapolis Museum of Art, 1996. pp. 13–15.

Burroughs, Margaret Taylor. *What Shall I Tell My Children Who Are Black?* MAAH Press, 1968.

Burroughs, Margaret Taylor. *Whip Me Whop Me Pudding and Other Stories of Riley Rabbit and His Fabulous Friends*. Praga Press, 1966.

Dover, Cedric. *American Negro Art*. Greenwich, Conn.: New York Graphic Society, 1960.

Hine, Darlene Clark, ed. *Black Women in America: An Historical Encyclopedia*. Brooklyn: Carlson Publishing, 1993.

King-Hammond, Leslie, ed. *Gumbo Ya Ya: Anthology of Contemporary African-American Women Artists*. New York: Midmarch Arts Press, 1995.

"Lasting Impressions; In Margaret Burrough's Linocut Prints, a Lifetime of Art Distilled." *Washington Post*, October 23, 1997, sec. B, pp. 3, 7.

LeBlanc, Michael L., ed. *Contemporary Black Biography*. Detroit: Gale Research Inc., 1992.

Negro Heritage Committee. *Afro-American Women in Art: Their Achievements in Sculpture and Painting*. Greensboro, N.C.: Negro Heritage Committee, Alpha Kappa Alpha Sorority, 1969.

Randall, Dudley, and Margaret T. Burroughs, eds. *For Malcolm: Poems on the Life and Death of Malcolm X*. Detroit: Broadside Press, 1967.

ARTIST STATEMENT (1961)[1]

Every individual wants to leave a legacy, to be remembered for something positive they have done for their community. Long after I'm dead and gone the [DuSable] museum will still be here. A lot of black museums have opened up, but we're the only one that grew out of the indigenous black community. We weren't started by anybody downtown; we were started by ordinary folks.

Note

1. From Michael L. LeBlanc, ed., *Contemporary Black Biography* (Detroit: Gale Research Inc., 1992), p. 23.

BIOGRAPHICAL ESSAY

Margaret Burroughs was born in Louisiana, but her family moved to Chicago when she was three years old. She was among the first wave of southern blacks to immigrate to Chicago, making it one of the liveliest sites in the United States for historical and contemporary African American culture. Her contributions extend not only into the realms of the visual and literary arts but also into a wide spectrum of humanitarian endeavor. As a thoroughly Chicago product whose poetry has been justly read into the *Congressional Record* by Senator Paul Simon of Illinois and whose name now graces a residence hall at the School of the Chicago Art Institute, her alma mater, Burroughs is truly a "Favorite Daughter" of Illinois.

Just as all the other women profiled in this chapter have done, Burroughs has created spaces of representation for art in addition to art itself. Undoubtedly, her most illustrious creation in this regard is the founding, with her husband the poet Charles Gordon Burroughs, of a museum of African American history and culture. In 1961, the couple established the Ebony Museum of African American History in their South Side Chicago home with a $10 charter. The collection of artifacts on display there proved to be such a popular and valued resource of African American heritage that Burroughs soon deemed it necessary to become a full-fledged museum director. Shortly after the museum's establishment, Burroughs found herself raising funds for an ever-growing collection of books, papers, memorabilia, and art as well as an expanding roster of associated educational programs, and finally, for facilities capable of housing what is today the oldest and largest museum dedicated to black American life. In 1968, the Ebony Museum became the DuSable Museum of African-American History, renamed for Jean Baptist Pointe DuSable, a man of African descent who was the first permanent settler in the 1770s in the Chicago region. Today, the DuSable Museum is housed in a building of more than 85,000 square feet and includes a sculpture garden, spacious galleries, a research library and archives, a large auditorium, and a gift shop. More important, the museum houses more than 100,000 art objects and artifacts from African and African American cultures, including original slave documents, Langston Hughes's library, and the photographic collections of Pulitzer Prize–winning photographer John Tweedle and South African photographer Leo Leveson. The museum's collection of paintings, drawings, and sculpture by African American artists is often designated as "among the ten most notable collections of such works in the country."[1]

Burroughs's activities as a public leader were evident long before the establishment of the DuSable Museum. As a high school student, she joined, with her friend Gwendylon Brooks (future Poet Laureate of Illinois), a Youth Chapter of the National Association for the Advancement of Colored People. In 1939, she and her first husband, the artist Bernard Goss, were among the founders of the Chicago South Side Community Art Center. The Center was ahead of its time as an institution that provided both gallery space for artists and teaching

studios for art students, providing a model much emulated over the years. Burroughs also inaugurated the Lake Meadows Art Fair in 1959 as a remedy to the general omission of artists of color by the other large art expositions in the Chicago area. Because of her long-standing high profile as a force in the arts community, Burroughs has served as a very effective member on the boards of many corporations and philanthropic foundations. In 1984, she formed the Burroughs Group for the purpose of providing consulting and other services to the arts community. Most recently, she launched a campaign with other Chicago artists, educators, and community activists and assembled an archive and planned a series of nationwide events that marked the centennial of Paul Robeson on April 9, 1998. An ageless 82, Burroughs currently serves as Chicago's Park District Commissioner. Burroughs's great talents as an art educator are equal to her civic expertise; indeed, they often mesh, as attested to by the full schedule of tours, film and poetry festivals, seminars, symposia, and school outreach programs at the DuSable Museum. An art and art history teacher at the elementary, secondary, and college levels for more than 30 years, she knew all too well from firsthand experience that black history was excluded from textbooks. This realization has informed a lifetime of fervent activism in behalf of constructing historical identity and pride in the American black community. Because of such efforts, Burroughs is often cited as a foremother of the Afrocentric movement that emerged on various fronts in the 1960s as a means to educate and to instill self-respect in people of African descent regarding their social, cultural, historical, and spiritual heritage and development. An important part of her educational activism along Afrocentric lines is her publication of children's books consistent with her educational philosophy and objectives, including *Jasper, the Drumming Boy* (with illustrations by Burroughs), 1947; *Did You Feed My Cow? Rhymes and Games from City Streets and Country Lanes,* 1956; and *Whip Me Whop Me Pudding and Other Stories of Riley Rabbit and His Fabulous Friends,* 1966.

Burroughs's passion for her educational mission especially comes through in her poetry. *What Shall I Tell My Children Who Are Black?* (1968) was Burroughs's first volume of poetry; it draws upon her parents' southern roots, their migration experience, and her own better life in the North. Some poems are subjective evocations of Burroughs's family life; many others develop themes of black awareness and pride, such as "Open Letter to Black Youth of Alabama and Other Places," after an experience as guest lecturer at the Second Negro Writers Conference in 1966. Burroughs is also a compelling performer of her own poetry and continues to give readings at venues all over the world, often accompanying them with slide shows of her artwork.

The themes of Burroughs's art accord with the themes of her life: They speak to, for, and of African Americans. Leslie King-Hammond has described her as working "in the grand tradition of history painting, yet with an unconventionally democratic point of view, focusing on social themes and humanistic concerns. She records landmarks of African-American heritage, history, and culture in

order to democratize art and make it available and accessible to everyone.''[2] In works such as *Birthday Party* (1955) and *Blowing Bubbles* (1968) one recognizes children at play, but there is also a certain monumental solemnity about the paintings in the figures' fairly strict frontal or profile displays as well as their rather earnest expressions. In both works, the high-key colors are joyous, although one does not receive an ironic impression from them as one often does in Jacob Lawrence's combination of bright colors and Harlem scenes. Rather, one gets the feeling that we are witnessing *serious* play, the kind that teaches, binds, and socializes, the kind that Burroughs's educational philosophies no doubt foster. It is the significance of the playful that elevates these works from narrative genre to history painting: They represent hybrid subjects, crosses between, for example, Raphael's *School of Athens* and Brueghel's *Children's Games*. Burroughs's intention to create pictorial social history of African Americans reveals the considerable impact of the Mexican muralists, whom she much admired, on her work. Indeed, during a sabbatical from teaching in 1951–1952, Burroughs worked under Leopold Mendez, a protégé of Rivera, at the Taller de Gráfica Popular in Mexico City, developing a significant body of linocut and woodblock prints that furthered her goals of visual social commentary and activism.

In July 1997, 30 African American poets, musicians, singers, actors, dancers, and chanters paid tribute to Margaret Burroughs's body of work, especially her poetry, in an event at the DuSable Museum advertised as ''A Gathering of Utterers.'' Indeed, ''utterer'' may be the best word to describe this multifaceted and multitalented woman, who would seem to be a living incarnation of Elizabeth Catlett's heads of strong, vital women who sing and shout. Through her civic and humanitarian activities, artwork, poetry, books, essays, and lectures, Margaret Burroughs utters for the people of African descent.

Notes

1. From *History and Mission*, DuSable Museum of African American History; available from http://www.dusable.org/info/index.html

2. Leslie King-Hammond, ed., *Gumbo Ya Ya: Anthology of Contemporary African-American Women Artists* (New York: Midmarch Arts Press, 1995), p. 31.

CATLETT, ELIZABETH

Born: 1919, Washington, D.C. *Education*: B.S., cum laude, Howard University, 1936. M.F.A., University of Iowa, 1940. *Family*: She is married to a Mexican

artist, Francisco Mora. They have three sons, a film maker in Mexico, an artist in Germany, and a musician in the United States. She also has several grandchildren. *Career*: Sculptor, painter, printmaker, educator. *Awards*: First Prize, American Negro Exposition, Chicago, 1940. First Prize in sculpture, Golden Jubilee National Exposition, Chicago, 1941. Julius Rosenwald Foundation Fellowship, 1945, 1946. Second Prize in sculpture, Atlanta University Annual, 1946 and 1956. Tlatilco Prize, First Sculpture Biannual, Mexico, 1962. Xipe Totec Prize, Second Sculpture Biannual, Mexico, 1964. First Prize in sculpture, Atlanta University Annual, 1965. First Purchase Prize, National Print Salon, Mexico, 1969. Intergrafic Exhibition Prize, Berlin, 1970. Women's Caucus for Art Award, National Congress, San Francisco, 1981. Brandywine Workshop Award, Philadelphia Museum of Art, 1982. Purchase Prize, Salon de la Plástica Mexicana, Drawing Salon, Mexico, 1985.

SELECTED EXHIBITIONS

1998 *Elizabeth Catlett*, Neuberger Museum, Purchase, New York

1993 *Elizabeth Catlett, Works on Paper, 1944–1992*, Hampton University Museum, Hampton, Virginia

1973 *Elizabeth Catlett*, Fisk University, Nashville, Tennessee; *An Exhibition of Sculpture and Prints by Elizabeth Catlett*, Jackson State College, Jackson, Mississippi

1972 *Elizabeth Catlett*, Studio Museum in Harlem, New York, New York

1962 *Elizabeth Catlett: Sculpture and Prints*, University of Mexico, Mexico City, Mexico

1948 *Elizabeth Catlett: 1948—The Negro Woman*, Barnett-Aden Gallery, Washington, D.C.

SELECTED GROUP EXHIBITIONS

1998 *African American Works on Paper from the Cochran Collection*, Montgomery Museum of Art, Montgomery, Alabama

1997 *Alone in a Crowd: Prints by African-American Artists of the 1930s–1940s from the Collection of Reba and Dave Williams*, The Newark Museum, Newark, New Jersey; *National Black Fine Art Show*, Puck Building, New York, New York

1996 *African-Americans in the Visual Arts: A Historical Perspective*, B. Davis Schwartz Memorial Library, Long Island University, C. W. Post Campus, New York; *Bearing Witness: Contemporary Works by African-American Artists*, Spelman College Museum of Fine Art, Atlanta, Georgia; *In the Spirit of Resistance: African-American Modernists and the Mexican Muralist School*, American Federation of the Arts and The Studio Museum in Harlem, New York, New York; *Three Generations of African-American Women Sculptors: A Study in Paradox*, The Afro-American Historical and Cultural Museum, Philadelphia, Pennsylvania

1995	*The Listening Sky*, The Studio Museum in Harlem, New York, New York
1992	*Free within Ourselves: African-American Artists in the Collection of the National Museum of American Art*, Smithsonian Institution, Washington, D.C. (traveling exhibition)
1988	*Through a Master Printer: Robert Blackburn and the Printmaking Workshop*, Columbia Museum of Art, Columbia, South Carolina; *African-American Artists 1880–1987: Selections from the Evans-Tibbs Collection*, Smithsonian Institution, Washington, D.C.
1985	*Hidden Heritage: Afro-American Art, 1800–1950*, Bellevue Museum of Art, Bellevue, Washington
1940	American Negro Exposition, Chicago, Illinois

SELECTED COLLECTIONS

Amistad Research Center, Tulane University, New Orleans, Louisiana; California African-American Museum, Los Angeles, California; Baltimore Museum of Art, Baltimore, Maryland; Evans-Tibbs Collection, Washington, D.C.; Metropolitan Museum of Art, New York, New York; Museum of Modern Art, New York, New York; National Museum of American Art, Smithsonian Institution, Washington, D.C.; Studio Museum in Harlem, New York; Wadsworth Atheneum, Hartford, Connecticut

SELECTED PUBLICATIONS

Bearden, Romare, and Harry Henderson. *A History of African-American Artists from 1972 to the Present*. New York: Pantheon Books, 1992.

Bontemps, Arna Alexander, ed. *Forever Free: Art by African-American Women 1862–1980*. Normal, Ill.: Center for the Visual Arts Gallery, Illinois State University, 1980.

Boyle, Donald, ed. *Black Arts Annual 1987/1988*. New York: Garland Publishing, 1989.

Dover, Cedric. *American Negro Art*. Greenwich, Conn.: New York Graphic Society, 1960.

Farris, Phoebe. ''A Visit with Elizabeth Catlett.'' *Art Education* 47, no. 3 (1994), pp. 68–72.

Fax, Elton C. *Seventeen Black Artists*. New York: Dodd, Mead & Company, 1971.

Herzog, Melanie. ''Elizabeth Catlett in Mexico.'' *International Review of African American Art* 11, no. 3 (1994), pp. 229–232.

Hine, Darlene Clark, ed. *Black Women in America: An Historical Encyclopedia*. Brooklyn: Carlson Publishing, 1993.

King-Hammond, Leslie, ed. *Gumbo Ya Ya: Anthology of Contemporary African-American Women Artists*. New York: Midmarch Arts Press, 1995.

Lewis, Samella. *African-American Art and Artists*. Berkeley: University of California Press, 1978, 1990.

Lewis, Samella. *The Art of Elizabeth Catlett*. Los Angeles: Alan S. Lewis Associates, 1991.

Negro Heritage Committee. *Afro-American Women in Art: Their Achievements in Sculpture and Painting*. Greensboro, N.C.: Negro Heritage Committee, Alpha Kappa Alpha Sorority, 1969.

Powell, Richard J. *Black Art and Culture in the 20th Century.* London: Thames and Hudson, 1997.

Tesfagiorgis, Freida High W. "Afrofemcentrism and Its Fruition in the Art of Elizabeth Catlett and Faith Ringgold." In Norma Broude and Mary D. Garrard, eds., *The Expanding Discourse: Feminism and Art History.* New York: Icon Editions, 1992. pp. 475–485.

ARTIST STATEMENT (1973)[1]

No other field is as closed to those who are not white and male as is the visual arts. After I decided to be an artist, the first thing I had to believe was that I, a black woman, could penetrate the art scene, and that, further, I could do so without sacrificing one iota of my blackness or my femaleness or my humanity.

Note

1. Freida High W. Tesfagiorgis, "Afrofemcentrism and Its Fruition in the Art of Elizabeth Catlett and Faith Ringgold," in Norma Broude and Mary D. Garrard, eds., *The Expanding Discourse: Feminism and Art History* (New York: Icon Editions, 1992), p. 478.

BIOGRAPHICAL ESSAY

The "bare bones" version of Catlett's formative years resembles Selma Burke's. Both artists received encouragement in their artistic aspirations from enlightened mothers; both studied sculpture; both received Rosenwald Fellowships that allowed them to travel; both were imprinted by the Works Progress Administration (WPA) era; both created figurative sculpture that combines modernist, social realist, and African strains; both dedicated their lives to art education. Yet Catlett acquired an explicit political consciousness that resolutely informs her aesthetics, whereas Burke just as resolutely maintained the "unpolitical" persona typical of a universalistic modernism. For example, Burke discouraged the designation "African-American artist"; Catlett, on the other hand, once introduced herself at a symposium in the following manner: "I'm Elizabeth Catlett and what's important to me is first that I am black, and secondly that I'm a woman and thirdly that I'm a sculptor."[1] In other words, Catlett is "Afrofemcentric" (a term coined by Freida High Tesfagioris in 1984) and thus shares a sensibility with artists such as Camille Billops and Faith Ringgold, whose works also privilege black female subjectivity.

Catlett's sculpture and prints have featured the emotional and intellectual lives of black women since at least her prize-winning M.F.A. thesis sculpture, *Mother and Child* (a First at the 1941 American Negro Exposition in Chicago). Yet critics and scholars commonly have downplayed the obvious Afrofemcentricity

of her work in favor of its more universal social and political consciousness. Catlett's politicized life as an expatriate artist living in Mexico since 1947, inspired by the Mexican muralists and shaped by her long-standing membership in the populist print workshop Taller de Gráfica Popular, apparently has been irresistible as a rationale for focusing upon her art's social activism in behalf of the colonial downtrodden at the expense of its Afrofemcentric dimensions. It is much easier to cite her affiliations with David Alfaro Siqueiros and Diego Rivera than to account for the impact of the conservative Regionalist Grant Wood, Catlett's instructor at the University of Iowa, whose advice to "make what you know best" encouraged Catlett's predominant subject matter of strong women of color.[2] Such one-sided treatment recalls a similar scholarly myopia regarding the work of Käthe Kollwitz, whose expressionist woodcuts that thematize feminine identity among the suffering masses of Germany are the ancestors of Catlett's own dramatic linocuts of powerful, intrepid black women, particularly *The Negro Women* series (1946–1947, Collection of Samella Lewis), which was her project for the Rosenwald Fellowship. At times, Catlett's own words have served those conventional presentations of her works' political agenda, as in the oft-quoted passage about the practices of the Taller:

We work collectively. I still ask people's opinion while I am working: what they think of what I am doing. And if it is clear to them. We work collectively, though we criticize each other's work from a positive point of view, trying to help, trying to see what would better the work.

We also work together. I remember a poster that Leopold [Mendez] and Pablo [O'Higgins] drew. They gave me the drawing and I developed the design for a silkscreen, but being very pregnant I couldn't do the screening myself, so someone else did that. The thinking of many people on one subject, or a piece of art or creating, can also work very well.[3]

In her self-portrayal as working and pregnant, simultaneously creative and pro-creative, there is a certain implicit Afrofemcentricism in this quote, which otherwise foregrounds a collectivist idealism. Later statements, however, more definitively inscribe an Afrofemcentricity:

I am interested in women's liberation for the fulfillment of women; not just for jobs and equality with men and so on, but for what they can contribute to enrich the world, humanity. Their contributions have been denied them. It's the same thing that happens to black people . . . I think that the male is aggressive and he has a male supremacist idea in his head, at least in the United States and Mexico. We need to know more about women.[4]

Given such pronouncements, therefore, one must recognize not only privation in the gaunt face of the female fieldworker in Catlett's color linocut *The Share-*

cropper (1970, Hampton University Museum) but also a wealth of character strength. *The Sharecropper*, as are all the rest of Catlett's images of women of color, is a "woman warrior," challenging "the stereotypical, non-heroic treatment of black women, which characterized Western art for decades, by portraying them as strong, beautiful, creative, and intelligent."[5] Feminist interpretations of Catlett's work have prevailed in the scholarship of recent years as a new generation of art historians and critics examine Catlett's work from new critical perspectives.[6] Feminist revisionism by no means overrides the social consciousness that so obviously informs Catlett's work; indeed, it makes it more resonant. Her works marked by the civil rights movement, for example, seem to give voice to an all the more inclusive group precisely because of Afrofemcentric critique. The "us" referred to in the linocut *Malcolm X Speaks for Us* (1969, Museum of Modern Art) is truly *all* African Americans; the bronze head set behind a wire configuration resembling the sites of a rifle (*Target*, 1970, Tulane University) represents *all* African Americans as potential targets of violence.

Elizabeth Catlett's biography would politicize even the most inherently unpolitical. In 1919, the year of Catlett's birth, a group of drunken servicemen incited a violent three-day clash by instigating attacks upon black citizens of Washington, D.C., based upon their fierce objections to black men in uniform. By the end of second day, over 300 black victims had been wounded, but the third day saw a victorious counterinsurgency by the black people of Washington, rising up against their attackers, refusing to be massacred. Catlett grew up listening to the story of the Washington "riot," absorbing the lessons it held for growing up black in a white America.[7] As an aspiring art student, Catlett was denied admission to the Carnegie Institute of Technology, despite glowing acclamations from its faculty, because of her race. As an art teacher in the public school system of Durham, North Carolina, she experienced salary discrimination at the hands of the white power structure *and* a cynical black elite class.[8]

After her experience in Durham, Catlett decided to pursue graduate work at the University of Iowa, where she concentrated in sculpture and was the first person to earn an M.F.A. degree from that institution even though the head of the art department attempted to prevent such a first. After leaving Iowa, Catlett continued in art education, landing a position as head of the art department at Dillard University in New Orleans, based upon her excellent academic record and the First Prize won by her M.F.A. thesis sculpture in Chicago. While in New Orleans, Catlett successfully "integrated" the New Orleans Museum of Art in order to take a group of black art students to a Picasso retrospective there. The museum itself was not closed to blacks, but the park that surrounded it was. Catlett arranged to have a bus carrying the students drop them off right at the entrance to the museum so that they would not have to set foot in the park, staging what Elton Fax has called a "cultural coup of sorts in the Crescent City."[9] Despite this small victory, Catlett found her experience at Dillard discouraging, due to an apathetic university administration.

Practicing higher art education in the 1940s South proved too frustrating for

Catlett, and she and her husband, the WPA painter and printmaker Charles White, moved to New York City in 1942. There, Catlett reveled in a typical urban life filled with the visual and performing arts while continuing her teaching career with more gratifying results at the progressive George Washington Carver School in Harlem, an alternative community center dedicated to improving the educational level of working-class people. Catlett's experience at the Carver School undoubtedly primed her for the extraordinarily enriching experience of working at the Taller Gráfica Popular, where she not only worked collectively but also was able to speak to a broad population through her work. Catlett remained in Mexico at the end of the Rosenwald Fellowship, which enabled her to travel there, marrying a fellow cultural worker at the Taller, Francisco Mora, after her divorce from White in 1947. She became a Mexican citizen after experiencing archetypal "red-baiting" at the hands of the U.S. government and its agencies. In 1959, Catlett became the head of the sculpture department in the National School of Fine Arts at the Universidad Nacional Autónoma de México, remaining there until she retired in 1976. She continues to call suburban Mexico City home.

Formally, Catlett's work reveals a high modernism, particularly her sculpture, with its sensuously handled materials, its rounded forms, and its generalized figurative abstraction. One easily recognizes in her sculpture the impact of her year of private study in New York with Russian émigré sculptor Ossip Zadkine in 1943. Catlett and Zadkine share an appetite for extracting sheer beauty from their materials; their most typical works divulge an incipient Cubism, an angular potentiality lying just beneath their smooth, curvaceous surfaces, lending them an expressive "edginess," in both form and content. One can also identify Henry Moore's reductive, open-formed figurative sculpture as an obvious source for Catlett's similar figuration, although one very significant difference must be noted: Where Moore's figures are passive and recumbent, Catlett's are energetic and upright, fists often defiantly raised (e.g., *Homage to My Young Black Sisters*, 1968, Private Collection), both active *and* activist, defying their modernism with political conviction.

Notes

1. Freida High W. Tesfagiorgis, "Afrofemcentrism and Its Fruition in the Art of Elizabeth Catlett and Faith Ringgold," in Norma Broude and Mary D. Garrard, eds., *The Expanding Discourse: Feminism and Art History* (New York: Icon Editions, 1992), p. 475.

2. Lizetta LeFalle-Collins, "Working from the Pacific Rim: Beulah Woodward and Elizabeth Catlett," in Carolyn Shuttlesworth, ed., *Three Generations of African-American Women Sculptors: A Study in Paradox* (Philadelphia, Pa.: The Afro-American Historical and Cultural Museum, 1996), p. 39.

3. Romare Bearden and Harry Henderson, *A History of African-American Artists from 1972 to the Present* (New York: Pantheon Books, 1992), p. 423.

4. Samella Lewis, *The Art of Elizabeth Catlett* (Los Angeles: Alan S. Lewis Associates, 1991), p. 102.

5. Beverly Guy-Sheftall, "Warrior Women: Art as Resistance," in Jontyle Theresa Robinson, ed., *Bearing Witness: Contemporary Works by African-American Artists* (Atlanta Ga.: Spelman College, 1996), p. 39.

6. See, for example, essays by Guy-Sheftall, ibid.; and LeFalle-Collins in Carolyn Shuttlesworth, ed., *Three Generations of African-American Women Sculptors.*

7. Elton C. Fax, *Seventeen Black Artists* (New York: Dodd, Mead & Company, 1971), p. 15.

8. Ibid., p. 19.

9. Ibid., p. 22.

CHASE-RIBOUD, BARBARA

Born: 1939; Philadelphia, Pennsylvania. *Education*: B.F.A., Tyler School of Art, Temple University, 1957. M.F.A., Yale University, 1960. *Career*: Sculptor, author, lecturer. *Awards*: John Hay Whitney Fellowship, 1957. National Endowment for the Arts Fellowship, 1973. First Prize, New York City Subway Competition for Architecture, 1973. United States State Department Traveling Grant, 1975. Named the Academic of Italy with a gold metal for sculpture and drawing, 1978. Janet Heidinger Kafka Prize for best novel (*Sally Hemmings*) written by an American woman, 1980. Honorary Doctorate of Arts and Humanities, Temple University, 1981. Carl Sandberg Prize, 1988. Knighthood in Arts and Letters, French Government, 1996.

SELECTED EXHIBITIONS

1998	Smithsonian Institution, Washington, D.C.; Stella Jones Gallery, New Orleans, Louisiana
1990	Pasadena College Museum, Pasadena, California
1981	Bronx Museum, New York City, New York
1980	Musée Reatu, Artes, France
1979	Kunstmuseum, Baden-Baden, Germany
1974	Museum of Modern Art, Paris, France; Wilhelm Lehmbruck Museum, Duisburg, Germany
1973	Berkeley University Museum, Berkeley, California; Detroit Art Institute, Detroit, Michigan; Richard Fonck Gallery, Ghent, Belgium; Indianapolis Art Museum, Indianapolis, Indiana; Kunstmuseum, Dusseldorf, Germany; The Merian Gallery, Krefeld, Germany

| 1970 | Bertha Schaefer Gallery, New York, New York; Massachusetts Institute of Technology, Boston, Massachusetts |
| 1966 | Cadran Solaire, Paris, France |

SELECTED GROUP EXHIBITIONS

1996	*Bearing Witness: Contemporary Works by African-American Artists*, Spelman College Museum of Fine Art, Atlanta, Georgia; *Explorations in the City of Light: African-Americans in Paris, 1945–1965*, The Studio Museum in Harlem, New York City, New York; *Three Generations of African-American Women Sculptors: A Study in Paradox*, The Afro-American Historical and Cultural Museum, Philadelphia, Pennsylvania
1995	*The Listening Sky*, The Studio Museum in Harlem, New York, New York
1992	*Paris Connections: African-American Artists in Paris*, Bomani Gallery, San Francisco, California
1978	*Barbara Chase-Riboud and Mel Edwards*, Bronx Museum, New York City, New York
1971	Biennial Exhibition, Whitney Museum of American Art, New York City, New York

SELECTED COLLECTIONS

Beaubourg Museum, Paris, France; Geigy Foundation, New York City, New York; Kenton Corporation, New York City, New York; Metropolitan Museum of Art, New York City, New York; Museum of Modern Art, New York City, New York; National Museum of Modern Art, Paris, France; Newark Museum, Newark, New Jersey; Philadelphia Art Alliance, Philadelphia, Pennsylvania; University Museum, Berkeley, California

SELECTED PUBLICATIONS

Baraka, Imamu Amiri. "Counter Statement to the Whitney Ritz Bros." In Tom Lloyd, ed., *Black Art Notes*. Privately published, 1971.

Bearden, Romare, and Harry Henderson. *The History of America's Black Artists*. New York: Doubleday, 1993.

Bontemps, Arna Alexander, ed. *Forever Free: Art by African-American Women 1862–1980*. Normal, Ill.: Center for the Visual Arts Gallery, Illinois State University, 1980.

Chase-Riboud, Barbara. *Echo of Lions*. New York: William Morrow, 1989.

Chase-Riboud, Barbara. *From Memphis to Peking*. New York: Random House, 1974.

Chase-Riboud, Barbara. *Portrait of a Nude Women as Cleopatra*. New York: William Morrow, 1987.

Chase-Riboud, Barbara. *The President's Daughter*. New York: Crown, 1994.

Chase-Riboud, Barbara. *Sally Hemmings*. New York: Viking Press, 1979.

Chase-Riboud, Barbara. *Valide: A Novel of the Harem*. New York: William Morrow, 1986.

Dover, Cedric. *American Negro Art*. Greenwich, Conn.: New York Graphic Society, 1960.

Fine, Elsa Honig. *The Afro-American Artist*. New York: Holt, Rinehart and Winston, 1973.

Fraser, C. Gerald. "African-American Artists in Paris 1945–1965: Studio Museum in Harlem." *New York Amsterdam News*, January 27, 1996, p. 21.

Jones, Virginia W. *Contemporary American Women Sculptors*. Boston: Oryx Press, 1986.

King-Hammond, Leslie, ed. *Gumbo Ya Ya: Anthology of Contemporary African-American Women Artists*. New York: Midmarch Arts Press, 1995.

Lewis, Samella. *African-American Art and Artists*. Berkeley: University of California Press, 1978, 1990.

Munro, Eleanor. *Originals: American Women Artists*. New York: Simon and Schuster, 1979.

Negro Heritage Committee. *Afro-American Women in Art: Their Achievements in Sculpture and Painting*. Greensboro, N.C.: Negro Heritage Committee, Alpha Kappa Alpha Sorority, 1969.

Newton, Edmond. "Now Showing: The Artist at Work." *Los Angeles Times*, May 3, 1990, p. J9.

Nora, Françoise. "From Another Country." *Art News* 69 (March 1970), p. 62.

Perry, Regina. *A History of Afro-American Art*. New York: Holt, Rinehart and Winston, 1973.

Powell, Richard J. *Black Art and Culture in the 20th Century*. London: Thames and Hudson, 1997.

Rubinstein, Charlotte Striefer. *American Women Sculptors*. Boston: G. K. Hall, 1990.

ARTIST STATEMENT (1994)[1]

My mother was famous in Albermarle County, and had been ever since I was born. People as far away as Richmond knew her as my father's concubine, mistress of his wardrobe, mother of his children. I was one of those children and my father, a celebrated and powerful man, had hidden us away here for twenty years because of a scandal they called "the troubles with Callendar."

I was never told any more about it then, except that it made my mother the most famous bondswoman in America and put me in double jeopardy. For despite my green eyes and red hair and white skin, I was black.

Note

1. From Barbara Chase-Riboud, *The President's Daughter* (New York: Crown, 1994), p. 21.

BIOGRAPHICAL ESSAY

Just as her fictional character, Thomas Jefferson's illegitimate daughter Harriet Hemmings, whose words are quoted above, Barbara Chase-Riboud has existed astride black and white worlds for most of her life. As an African American from Philadelphia who has lived in Paris since the early 1960s, Chase-Riboud knows firsthand how fraught with contradictions coexistence, however conge-

nial, can be. Indeed, her sculptural practices reflect this experience: She works in cast bronze, a material conventionally "masculinized," which she combines with unlikely materials of traditionally feminine affiliation: silk, wool, and a variety of other braided and knotted fibers. She conceives of her combinatory sculptures as symbols of unity, bringing together male and female, western and nonwestern, art and craft, "the burnished and the mat, the hard and the soft, the forceful and the tender, what resists and what submits."[1]

Chase-Riboud's ecumenical vision has been nurtured by extensive world travel since her first trip to Rome on a John Hay Whitney Foundation Fellowship in 1958. It was while on her Roman sojourn that she also began her comparative examination of world cultures. After a side trip to Egypt, she returned to Rome in awe of the monumentality of Egyptian architecture, characterizing Greek and Roman art as "pastry"[2] in comparison, an evocative association of buildings and food that not only presaged the dualist aesthetic that would dominate her artwork but also the lyrical imagism that would dominate her poetry. In 1961, Chase-Riboud married her first husband, French photographer and journalist Marc Riboud, and during the next five years traveled with him all over the world. Their visit to China in 1965 made her one of the first American women to visit that country since the 1940s.

Chase-Riboud did not engage in much art making during her travels with Riboud. When she did return to work in the late 1960s, it was quite evident that her newly acquired worldliness had inculcated her Yale-derived modernism with a marked multicultural awareness. Her sculpture of the late 1950s (see, for example, *Adam and Eve*, 1958) draws upon the resurgent figuration bordering on abstraction that prevailed over European visual expression in the immediate postwar period, particularly that of Germaine Richier and Alberto Giacometti. Her sculpture from the late 1960s and beyond, on the other hand, is much less figurative but now takes on a powerful totemistic quality, primarily due to the strange variety of its materials. Chase-Riboud herself called attention in a 1970 interview to the "African connotations" of her work's aggregations of metal and fibers, "especially if one considers how the African dancing mask (wood) is always combined with other materials: raffia, hemp, leather, feathers, cord, metal chains or bells. Each element has an aesthetic as well as a symbolic and spiritual function. My idea is to reinterpret the aesthetic function in contemporary terms, using modern materials (bronze and silk, bronze and wool, steel and synthetics, aluminum and synthetics)."[3]

Chase-Riboud's first solo exhibition, at the Bertha Schaefer Gallery in New York in 1970, showcased her new "Africanizing" work. The accompanying catalog was full of references to the contemporary politics of Afrocentrism, with quotations from Eldridge Cleaver's *Soul on Ice* (1968), among others. Despite the obvious African ancestralism of the sculpture presented, it also very much partook of a European polish, a kind of "belle sculpture." Four works in the show dedicated to Malcolm X (*Monuments to Malcolm X, Nos. 1–4*), for example, were elegant relief constructions of hammered yet gleaming ribbons of

bronze from which hung cords of knotted silk or braided wool. Their lack of any overt symbolism that could be related directly to Malcolm X's life or ideology was problematic and even offensive to some in her audience, who felt that the works in the exhibition should have lived up to the radical tone of the catalog and addressed directly the contemporary African American struggle.

The overall abstraction and internationalism of Chase-Riboud's work opened it up for a critique that was heard often during this high-octane era of polemicism on behalf of Black Power (and is still a common enough refrain today), perhaps best stated by poet Amiri Baraka's commentary on a Whitney Museum Biennial that included some African American artists (among them Chase-Riboud) but only those whose work was oriented toward a Eurocentricism. These artists, he felt, do not "actually exist in the black world at all. They are within the tradition of white art, blackface or not. And to try to force them on black people, as examples of what we are at our best, is nonsensical and ugly."[4] Considering Chase-Riboud's life outside of the American racist miasma of the 1960s, this criticism is unfair, especially when one appreciates the obvious construction of African identity in her work. It is also undeniable that her work exists squarely in the tradition of "unpolitical" postwar lyrical abstraction, a tradition she reveres and that she refuses to submit to a sociopolitical revisionism, as one gathers from her paean to Mark Rothko:

> Have it . . .
> For if anyone has earned it,
> You have . . . [5]

Additionally, Chase-Riboud's work matured in the aesthetic context of postminimalism, when there was an emphasis on using nontraditional materials and allowing them to behave according to their unique properties, whether those may be hanging, draping, leaning, or splattering. It is much more enlightening to view Chase-Riboud's work in the context of Eva Hesse's, rather than Elizabeth Catlett's, oeuvre.

If one must, perhaps it would be appropriate to label Chase-Riboud, in the words of Cornel West—who originally coined the term to refer to James Baldwin, yet another habitué of the relatively nonracist Parisian arts milieu—as "a race-transcending prophet," someone who "never forgets about the significance of race but refuses to be confined to race."[6] Although there is no need to justify a diversity of cultural production, some of it political, some of it not, Chase-Riboud is presently working on a proposal for a monument to the African diaspora that should satisfy a public's desire for direct sociological relevance. This proposed 52-foot-high bronze structure is to be erected over the site of an African cemetery in Manhattan and is entitled *Harrar or Monument to the 11 Million Victims of the Middle Passage* after the east African city of her ancestors, which has a personal resonance for her, well expressed in her poem of the same name. One line reads: "Out of the womb of the world we came."[7] The

public sculpture, like her poem, commemorates the 11 million lives lost in the Middle Passage. A chain of 11 million links will connect two bronze obelisks, forming an "H," to signify the ancient African capital. The bronze surfaces will be inscribed with the names of every African place that suffered at the hands of the slave traders. It is hoped that *Harrar or Monument to the 11 Million Victims of the Middle Passage* will be completed by the year 2000.

The medium in which Barbara Chase-Riboud most directly addresses the racial problems produced by colonialism is historical fiction. Since the late 1970s, Chase-Riboud has written four novels, *Sally Hemmings* and *The President's Daughter*, about Thomas Jefferson's alleged patrimony of a daughter, Harriet, by his mistress Sally; *Echo of Lions*, about the events surrounding the revolt on the slave ship *Amistad*; and *Valide: A Novel of the Harem*, about the conditions of slavery during the Ottoman Empire. *Sally Hemmings* won the Kafka Prize for best novel written by an American woman in 1979. In the multiplicity of art forms that she practices, Chase-Riboud is like Margaret Burroughs. They are, however, two very different souls, and a brief comparison of their attitudes bears witness to the greater opportunities afforded the generation of African American women artists who came after Burroughs's trailblazing generation. In 1997, Burroughs delivered the L. M. Clark Lecture at North Carolina State University in which she said, "It strengthens one to constantly be around people who look just like you."[8] Contrast this statement with Chase-Riboud's from 1996, on the occasion of the opening of the *African-American Artists in Paris 1945–1965* exhibition at the Studio Museum in Harlem: "[T]o travel anywhere outside your own culture, outside your country, is essential to evolve as an artist. To discover your own culture from the outside is essential."[9] *Vive la différence.*

Notes

1. Françoise Nora, "From Another Country," *Art News* 69 (March 1970), p. 62.

2. Edmond Newton, "Now Showing: The Artist at Work," *Los Angeles Times*, May 3, 1990, p. J9.

3. Nora, "From Another Country," p. 62.

4. Imamu Amiri Baraka, "Counter Statement to the Whitney Ritz Bros.," in Tom Lloyd, ed., *Black Art Notes* (privately published, 1971), p. 10.

5. Barbara Chase-Riboud, "For Marc Rothko," in Mara R. Witzling, ed., *Voicing Today's Visions: Writings by Contemporary Women Artists* (New York: Universe, 1994), pp. 180–181.

6. bell hooks and Cornel West, *Breaking Bread: Insurgent Black Intellectual Life* (Boston: South End Press, 1991), p. 49.

7. "Harrar," in Mara R. Witzling, ed., *Voicing Today's Visions: Writings by Contemporary Women Artists* (New York: Universe, 1994), pp. 183–185.

8. Cassandra Lester, "Dr. Margaret Burroughs Speaks on Behalf of the L. M. Clark Lecture," *Nubia* (Spring 1997), pp. 1–2.

9. C. Gerald Fraser, "African-American Artists in Paris 1945–1965: Studio Museum in Harlem," *New York Amsterdam News*, January 27, 1996, p. 21.

COCHRAN, MARIE T.

Born: 1962, Toccoa, Georgia. *Education*: B.F.A., University of Georgia, 1985. M.F.A., School of the Art Institute, Chicago, Illinois, 1992. *Career*: Site-specific sculptor, installation artist, educator, art writer. *Awards*: National Endowment of the Arts Summer Internship, 1992. Georgia Council for the Arts, Individual Artist's Grant, 1994–1995. Cultural Olympiad Regional Designation Award, 1995. National Endowment for the Arts/Southern Federation Fellowship, Sculpture, 1995–1996. Achievement by Georgia Women in the Visual Arts Award, 1997.

SELECTED EXHIBITIONS

1996	*Talking with Benny*, site-specific installation, Chattahooche Valley Art Museum, LaGrange, Georgia
1995	*Blood Sweat and the Basic Rules of Survival (for Emanuel)*, site-specific installation, Emanuel Arts Center, Swainsboro, Georgia; *notes of an educated woman*, Nexus Contemporary Arts Center, Atlanta, Georgia
1993	*Vessels and Shadows*, Emanuel Arts Center, Swainsboro, Georgia
1987	*The Field*, site-specific installation, Seven Stages Theater, Atlanta, Georgia
1986	*A Will . . . A Way*, Tate Center Gallery, University of Georgia, Athens, Georgia; *Sapelo Sketchbook*, Macon Museum of Arts and Sciences, Macon, Georgia

SELECTED GROUP EXHIBITIONS

1997	*Joy of the Journey: Women Artists in Georgia*, Spelman College, Camille Hanks Cosby Museum, Atlanta, Georgia; *Big*, Georgia Museum of Art, Athens, Georgia; *Joy of the Journey: Women Artists*, Spelman College Museum of Fine Art, Atlanta, Georgia; *SAGE*, site-specific installation, *Big*, Georgia Museum of Art, Athens, Georgia
1995–1996	*Freedom School*, site-specific installation, Equal Rights and Justice on tour from the High Museum of Art, Atlanta, Georgia, Center for African American History and Culture, Smithsonian Institution, Washington, D.C.
1995	*NEA/Southern Arts Federation Grant Fellows Exhibition*, South Florida Arts Center, Miami Beach, Florida

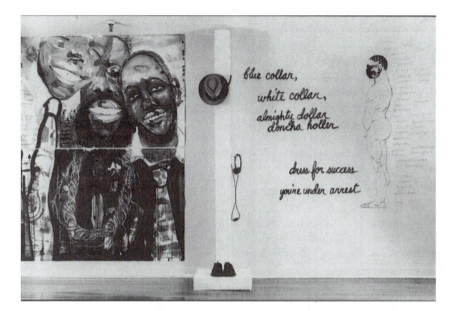

Bluesong for My Brothers by Marie T. Cochran, installation piece. Photographer Becket Logan. Courtesy of Marie T. Cochran

1994	*Hale Woodruff Memorial Exhibition: Curator's Choice*, Studio Museum in Harlem, New York, New York; *Equal Rights and Justice, Reflections on Rights*, The Center for African American History & Culture, Smithsonian Institution, Washington, D.C.
1992	*The Next Generation: Impact of Race, Class and Sexuality on Family Life*, Gallery 2, Chicago, Illinois
1990	*NOURISHMENT*, site-specific installation, *Rethinking the Sacred Image*, exhibition/symposium, New Visions Gallery, Atlanta, Georgia
1989	*VOICES*, site-specific installation, Nexus Contemporary Arts Center, Atlanta, Georgia
1987	*All Work & No Play*, Nexus Gallery, Atlanta, Georgia; *SING/SONG*, site-specific installation, Atlanta Biennial, Nexus Contemporary Arts Center, Atlanta, Georgia
1985	*International Dogwood Arts Festival*, Georgia Technical Institute Art Gallery, Atlanta, Georgia; *5th Annual Afro-American National Juried Show*, Atlanta Life Insurance Company, Atlanta, Georgia

SELECTED PUBLICATIONS

Cochran, Marie. "Carrie Mae Weems: At the Table." *Georgia Review* 48, no. 4 (Summer 1995), pp. 711–712.
Cochran, Marie. "Letter from Home." *The Womanist* 1, no. 2 (1995), pp. 10–13.

Cochran, Marie. "Love on Film Across Color Lines." *High Performance: A Quarterly Magazine for the New Arts* 62 (Summer 1993), pp. 12–13.

Cochran, Marie. "The Year of Which Woman?" *High Performance: A Quarterly Magazine for the New Arts* (Fall 1992), p. 21.

Cotter, Holland. "Objects in Accord with Ideas behind Them." *New York Times*, December 9, 1994, p. B8.

Fox, Catherine. "Exhibit's Innovative Works Reflect the Civil Rights Years." *Atlanta Journal/Constitution*, May 24, 1994.

Fox, Catherine. "Past and Present to Be Embedded in Mechanicsville Public Art Project." *The Atlanta Journal/The Atlanta Constitution* (City Life Atlanta edition), April 11, 1996.

Hale Woodruff Memorial Exhibition: Curator's Choice. Artist's profile by Consultant Curator Helen Shannon and Associate Curator of Exhibition Jorge Daniel Veneciano. New York: The Studio Museum in Harlem, 1994. Exhbn cat.

Howell, Esther. "Artist Reclaims Pieces of Her Past." *Black Issues in Higher Education* 11, no. 12 (August 11, 1994).

Hudson, Tom. "Athens' Olympic Artists." *Athens Magazine* 8, no. 3 (August 1996), pp. 48–49.

King-Hammond, Leslie, ed. *Gumbo Ya Ya: Anthology of Contemporary African-American Women Artists.* New York: Midmarch Arts Press, 1995.

Montgomery, Anne. "GSU Art Teacher Finds Work Reaching Wider Audience." *Statesboro Herald*, February 8, 1994.

Przybilla, Carrie. *Equal Rights and Justice.* Atlanta, Ga.: High Museum of Art, 1987.

Wasserman, Nadine. "Artists' Profiles, NEA/Southern Arts Federation Fellowship, Sculpture." *Sculpture Magazine* (December 1995).

ARTIST STATEMENT (1994)[1]

My philosophy is that art is a tool. I think artworks borrow a small fraction of what exists in the physical world and then shape it into a new reality, and new challenges which could not be found in other forms of communication. With the philosophy that art is a tool, I strive to make my work a willing conduit for interdisciplinary investigation. An integral part of my process is the belief that each image or simple pairing of images is created with the realization that it will transform. The images become part of a repertoire of symbols. Most of my work is closely linked with themes dealing with African-American history.

My artistic evolution began with an interest in college—the whole idea of drawing an image and tearing it apart, finding other materials to incorporate, reassembling them into a different form. I feel that this is analogous to African-American culture, especially when we consider the period of the American Reconstruction or contemporary trends toward revisionist history. The format I use is site-specific installation—making use of the walls, corners, ceiling, and floors. Many of the materials which I incorporate into the works are found objects: objects with a history, with an integrity of their own . . . to active space, to raise questions.

Finally by choosing my own personal subject matter, I want to present codes

and gestures that become a part of a greater dialogue about human experience. I want to react to culture and identification, recognize memory, acknowledge ancestry. These are the things I attempt to capture in my work as an artist.

Note

1. From *Hale Woodruff Memorial Exhibition: Curator's Choice*, artist's profile by Consultant Curator Helen Shannon and Associate Curator Jorge Daniel Veneciano (New York: The Studio Museum in Harlem, 1994), p. 11.

BIOGRAPHICAL ESSAY

Marie Cochran received her B.F.A. from the University of Georgia, Athens, in 1985 with an emphasis in drawing and painting. After active participation in the Atlanta/Arts community, in 1987 she took a position as a visiting artist at Georgia Southern University, Statesboro, Georgia. Cochran later continued her studies with a Ford Foundation scholarship to the School of the Art Institute in Chicago. After earning an M.F.A. in 1992 in Fiber and Drawing/Painting, Cochran was awarded an NEA summer fellowship in museum education.

Cochran's work has been exhibited at the High Museum of Atlanta, the South Florida Arts Center in Miami Beach, the Studio Museum in Harlem, New York, and the Smithsonian Institution in Washington, D.C. She has also been awarded numerous public art commissions, awards, and honors such as the 1994 Individual Artist's Grant from the Georgia Council for the Arts and a 1995 Southern Arts Federation/NEA Sculpture Fellowship. Currently Marie Cochran is a faculty member of the University of Georgia's Lamar Dodd School of Art in Athens, Georgia.

As an artist, writer, professor, and video/theater set designer, Marie Cochran engages in visual/verbal dialogues centering on issues of race and gender from an African American cultural/historical/political perspective. Functioning as an interdisciplinary artist, Cochran utilizes found objects, constructed objects, and personal artifacts in her installations, performance pieces, and public art commissions. Cochran also highlights the achievements of other black women artists in critiques focusing on artists such as Carrie Mae Weems and Lorna Simpson.

A native Georgian, Cochran's southern roots and themes from the 1950s–1960s civil rights movement feature prominently in her work, which is politically charged, often incorporating community participation or consultation. *Freedom School*, Cochran's installation in the touring "Equal Rights and Justice" exhibit, commemorated the 1960s Mississippi civil rights freedom schools for black children. To give voice to those 1960s children who risked their lives by attending freedom schools, Cochran enlisted local Atlanta elementary school students to draw along the top of the walls in the installation after participating in discussions on race and African American culture. The installation also included a desk, globe, tattered books to represent the used textbooks black chil-

dren were given in segregated school systems, and stenciled racist/stereotypical words and imagery from 1950s textbooks.

Praisesong: For My Brothers, an NEA/Southern Arts Federation exhibit, is an homage to African American men in general and to specific black men in Cochran's life. It is her response to the negative media portrayals of black men as rapists, drug dealers, and murderers. Using personal effects of her father, brothers, uncles, and other significant men, the installation honors the male dynamic in African American culture and accentuates the positive male/female relationships that do exist, despite the excessive public discourse on the allegedly "dysfunctional" black family.

In *notes of an educated woman*, a 1995 solo exhibit at Atlanta's Nexus Contemporary Arts Center, Cochran reflected on the intellectual and emotional experiences of the African American women in her family, her hometown, and in her own life. Consisting of computer illustrations, audiotapes, and texts from the writings of black intellectuals such as bell hooks and playwright Lorraine Hansbury, all arranged in a circular room, *notes of an educated woman* informed viewers about the type of black women who are often ignored in the media's and the government's sweeping generalizations about "welfare queens" and "crack-addict mothers."

The author was introduced to Marie Cochran and her work through the University of Georgia's Womanist Studies Consortium (WSC), an interracial, intergenerational, regional affiliation of scholars that supports and facilitates research on women of color in all disciplines. As a charter member of WSC, Marie uses her art to facilitate WSC goals of coalition building to overcome problems of racial, sexual, class, and power-based conflict.

FULLER, META VAUX WARRICK

Born: 1877, Philadelphia, Pennsylvania. *Education*: B.A., Pennsylvania Museum School for the Industrial Arts, 1897. Postgraduate study, Pennsylvania Museum School for the Industrial Arts, 1897–1899. Postgraduate study, Académie des Beaux-Arts, Paris, France, 1899–1900. *Career*: Sculptor, social and civil rights activist. *Awards*: Crozer Prize for Sculpture, Pennsylvania Museum School for the Industrial Arts, 1899. Commission for set of tableaux for the Negro pavilion at the Jamestown Tercentennial Exposition, 1907. Gold Medal, Jamestown Tercentennial Exposition, 1907. Commission for the Emancipation Proclamation's 50th Anniversary, 1913. Commission for medallion, Framingham Equal Suf-

frage League, 1915. Commission for ten dolls representing notable black women, National Council of Negro Women, Washington, D.C., 1957. Commission for plaque depicting working doctors and nurses, Framingham Union Hospital, Framingham, Massachusetts, 1964. Commission for sculpture, Framingham Center Library, 1964. *Died*: 1968.

SELECTED EXHIBITIONS

1930–1968	Frequent exhibitions throughout the Boston area, particularly at local libraries and churches and the Boston Art Club
1921	Pennsylvania Academy of Fine Arts, Philadelphia, Pennsylvania
1908	Pennsylvania Academy of Fine Arts, Philadelphia, Pennsylvania
1906	Pennsylvania Academy of Fine Arts, Philadelphia, Pennsylvania
1902	*Meta Vaux Warrick*, L'Art Nouveau, Paris, France
1901–1902	Series of private exhibitions under sponsorship of Auguste Rodin, Paris, France

SELECTED GROUP EXHIBITIONS

1998	*Rhapodies in Black: Art of the Harlem Renaissance*, Legion of Honor, San Francisco, California
1996	*Three Generations of African-American Women Sculptors: A Study in Paradox*, The Afro-American Historical and Cultural Museum, Philadelphia, Pennsylvania
1988	*Trail Blazers in Harlem*, E. B. Crocker Art Museum, Sacramento, California
1986	*Harlem Renaissance: Art of Black America*, The Studio Museum in Harlem, New York, New York
1984	*Hidden Heritage: Afro-American Art, 1800–1950*, Bellevue Museum of Art, Bellevue, Washington
1961	*New Vistas in American Art*, Howard University Gallery, Washington, D.C.
1921	*Making of America Festival*, New York, New York
1903	Société Nationale des Beaux-Arts Salon, Paris, France

SELECTED COLLECTIONS

Frank Hale Black Cultural Center, Ohio State University, Columbus, Ohio; Hampton University Museum, Hampton, Virginia; James Weldon Johnson Collection, Yale University, New Haven, Connecticut; Museum of Afro-American History, Boston, Massachusetts; National Museum of American Art, Smithsonian Institution, Washington, D.C.; Schomburg Center for Research in Black Culture, New York, New York

SELECTED PUBLICATIONS

Bomani, Asaki, and Belvie Rooks, eds. *Paris Connections: African American Artists in Paris*. San Francisco: Q.E.D. Press, 1992.

Bontemps, Arna Alexander, ed. *Forever Free: Art by African-American Women 1862–1980*. Normal, Ill.: Center for the Visual Arts Gallery, Illinois State University, 1980.

Dannett, Sylvia G. *Profiles of Negro Womanhood*. Vol. 2. Yonkers, N.Y.: Educational Heritage, 1966.

Fine, Elsa Honig. *The Afro-American Artist*. New York: Holt, Rinehart and Winston, 1973.

King-Hammond, Leslie, ed. *Gumbo Ya Ya: Anthology of Contemporary African-American Women Artists*. New York: Midmarch Arts Press, 1995.

Lewis, Samella. *African-American Art and Artists*. Berkeley: University of California Press, 1978, 1990.

Negro Heritage Committee. *Afro-American Women in Art: Their Achievements in Sculpture and Painting*. Greensboro, N.C.: Negro Heritage Committee, Alpha Kappa Alpha Sorority, 1969.

Powell, Richard J. *Black Art and Culture in the 20th Century*. London: Thames and Hudson, 1997.

Robinson, Jontyle Theresa. *Bearing Witness: Contemporary Works by African-American Women Artists*. Atlanta, Ga.: Spelman Museum of Fine Art, 1996.

Smith, Jessie Carney, ed. *Notable Black American Women*. Detroit: Gale Research, 1992.

ARTIST STATEMENT (1966)[1]

Art must be the quintessence of meaning. Creative art means you create for yourself. Inspirations can come from most anything. Tell the world how you feel . . . take the chances . . . try, try!

Note

1. From Sylvia Dannett, *Profiles of Negro Womanhood*, vol. 2 (Yonkers, N.Y.: Educational Heritage, 1966), p. 46.

BIOGRAPHICAL ESSAY

Meta Warrick Fuller is known for her subjects drawn from African culture. Her most famous work, *The Awakening of Ethiopia (ca. 1914–1921)*, which mixes ancient Egyptian and African referents, could be considered an important antecedent to contemporary works such as Lorraine O'Grady's photographs juxtaposing portraits of her family members with portraits of ancient Egyptian women (for example, *Sisters #11: Nefertiti's Daughter Merytaten; Devonia's Daughter Candace*, 1988). As such, it is appropriate to weigh *Ethiopia* in the context of art world debates surrounding the representation of ethnic identity, raging since the early 1990s. This bronze sculpture of an African woman depicted according to Egyptian conventions could be hailed today as a positive statement regarding the confluence of Egyptian and African cultural heritages, which has been substantiated somewhat through archaeological and anthropo-

logical research. Fuller's sculpture might also be decried as pandering to the uncritical wing of identity politics, which seeks merely to redefine the dominant and the subaltern, oftentimes resorting to nothing more than fanciful mythification, in this case that African culture supplied the mystical origins of ancient Egyptian civilization. It is the mythologizing promotion of the Egyptian/African axis that Fred Wilson gently parodies in his 1993 installation *Re-claiming Egypt*, showing Africanizing Egyptian kitsch that one might discover as decor in a typical African American household as if installed in a museum exhibition. However one might induct *Ethiopia* into the pantheon, of African art in the Egyptian tradition, which also includes works by Edmonia Lewis and Barbara Chase-Riboud, it is a tribute to Fuller's indelible classic sense that her work finds itself squarely in the midst of critical currency.

In his recent *Black Art and Culture in the 20th Century*, Richard J. Powell places *Ethiopia* in its proper historical context:

> *The Awakening of Ethiopia* . . . reflects a major step in the history of African American art. *The Awakening of Ethiopia* breaks away from European artistic traditions and represents one of the first examples of "ethnic" African consciousness. In the eighteenth century, African American artists attempted to make their mark in American art and adopted European aesthetic conventions in their work. Faced with discrimination at home, Fuller, along with many other African American artists, studied in Europe in hopes of becoming internationally known. Many of these artists who escaped racial prejudice did not deal with racial subject matter in their work. *The Awakening of Ethiopia* is a notable exception among the works produced in the neoclassic period.[1]

Ethiopia may also have autobiographical significance for Fuller, who was the great-granddaughter of an Ethiopian princess, brought to the United States in slavery.

At any rate, *The Awakening of Ethiopia* is atypical of the majority of Fuller's sculpture, both in form and content. While this sculpture does reflect her life-long affinity for the figurative tradition, its serene demeanor, neoclassical geometricization, and closed form do not at all reflect her much more romantic and emotionally resonant signature work with roots in the late 19th-century Symbolism. Fuller's early work displayed a highly sensitive and expressive surface *and* structural realism and was often described as "macabre and gruesome."[2] Her clay model of *Man Eating His Heart* caught the eye of Auguste Rodin, who proclaimed after examining it minutely that Fuller was a born sculptor with an innate sense of form.[3] Throughout the time that Fuller studied and exhibited in Paris, Rodin functioned as her mentor and sponsor, and her work mirrored his romantic realism. Of Fuller's time in Paris, Fuller scholar Judith Kerr states:

Warrick's creations become more daring in theme and execution. One of her aims had always been to explore the psychology of human emotions, a belief in the function of art she shared with Rodin. Under his tutelage, she learned to execute such ideas with greater force. She refused to limit herself to subjects that were merely aesthetically pleasing, never avoiding portrayals because they were ugly or abhorrent.[4]

Fuller studied art in Paris from 1899 to 1902, thanks to her parents' enlightenment, resources, and connections (W.E.B. Du Bois convinced her parents to let her go; the painter Henry Ossawa Tanner kept an eye on her while she was there). While there, she enjoyed the patronage not only of Rodin and Augustus Saint-Gaudens but also of Samuel Bing, art dealer, promoter of Symbolism in Paris, and director of the gallery L'Art Nouveau. Bing presented 22 of Fuller's sculptures at his gallery in 1902. One sculptural group displayed in this exhibition, *The Wretched*, comprising seven figures in various states of physical and mental misery, earned Fuller the designation "delicate sculptor of horrors" from the French press.[5] Another equally morbid piece in the Bing exhibition, *The Impenitent Thief*, eventually found its way, courtesy of Rodin's sponsorship, into the Société Nationale des Beaux-Arts Salon in 1903.

Unfortunately, Fuller was not able to see her entry as it appeared in the Salon, because she was called home in 1902 by an anxious mother, who had decided that Fuller had "finished" herself sufficiently and was now due, if not overdue, for marriage and family. Fuller always considered her time in Paris to have been fundamental to her career success and encouraged many others in the African American arts community to pursue studies there if at all possible. In doing so, Fuller no doubt helped to trailblaze what would eventually become the fabled "The Negro Colony" of the 1920s and 1930s, which included Aaron Douglas, Palmer Hayden, Nancy Elizabeth Prophet, Augusta Savage, and Laura Wheeler Waring, among many others.

Fuller married the Liberian neurologist Solomon C. Fuller in 1909 and became absorbed in married life. Her subsequent professional career never fully realized the promise of the heady early years in Paris, although she worked steadily throughout the rest of her life, receiving numerous prestigious public commissions. While some of the failure to reach the heights of artistic fame may be ascribed to the demands of her roles as doctor's wife and mother of three, most of the blame must lie with the rampant and institutionalized racism that effectively barred her from gallery and museum representation in the United States (and made life very uncomfortable for her when the Fullers became one of the first black families to settle in Framingham, Massachusetts).

It was only after she experienced the virulence of racist America, as well as strong encouragement from W.E.B. Du Bois to resort more to subjects of African cultural heritage, that Fuller added a heightened race consciousness to the romantic modernism of her sculpture, finding in the process a significant black audience for her work. In this new vein, she created works commemorating the

Middle Passage, the Emancipation, and the civil rights movement; the afore-mentioned *The Awakening of Ethiopia*; and the powerful *Talking Skull* (bronze, 1937). *Talking Skull* visually recounts an African folktale that tells of a young boy who encounters a sort of oracular skull in the African desert and who implores it to speak wisdom to the chief and people of his troubled village.[6] Light flickers across the bronze's Rodinesque surface, adding to the drama one senses in the interaction of the boy and the skull, accenting the tense grace of the anxious youth's kneeling body.

Fuller's raised social consciousness also resulted in her work on behalf of Framingham's equal suffrage movement and later, when she saw how little universal suffrage had extended into the African American community, on be-half of the voter registration campaign in the American South. She died in 1968, at the height of the African American struggle for equal rights, justice, and power, after a long life in which she pioneered African American achievement in the arts and during which her sculpture became powerful visual symbols of Pan-Africanism.

Notes

1. Richard J. Powell, *Black Art and Culture in the 20th Century* (New York: Thames & Hudson, 1997), p. 37.

2. Jontyle Theresa Robinson, *Bearing Witness: Contemporary Works by African American Women Artists* (Atlanta, Ga.: Spelman Museum of Fine Art, 1996), p. 56.

3. Ibid.

4. Judith Kerr, quoted in Robinson, *Bearing Witness*, p. 56.

5. Theresa Leininger, "The Transatlantic Tradition: African American Artists in Paris, 1830–1940," in Asake Bomani and Belvie Rooks, eds., *Paris Connections: African American Artists in Paris* (Fort Bragg, Cal.: Q.E.D. Press, 1992), p. 12.

6. Robinson, *Bearing Witness*, p. 58.

HOARD, ADRIENNE W.

Born: 1949, Jefferson City, Missouri. *Education*: B.S., Fine Art/Art Education, cum laude, Lincoln University, Jefferson City, Missouri, 1970. M.F.A., Paint-ing/Two-Dimensional Design, minoring in Museum Studies, University of Michigan, Ann Arbor, 1972. Ed.D., Art Education, University of Illinois, Urbana-Champaign, 1985. *Family*: Daughter of Charles M. and Yvonne W. Hoard (both deceased), former educators at Lincoln University in Missouri. *Ca-reer*: Assistant Professor of Art at the University of Arkansas, Pine Bluff, 1972.

Instructor of Drawing at the New York–Phoenix School of Design and Researcher-Cataloguer for African Art at the Brooklyn Museum in New York, 1973. Assistant Professor of Art and Black Studies, Ohio State University, Columbus, Ohio, 1975–1980. Visiting Professor at Hong-Ik University, Department of Western Oil Painting and Visiting Professor at Ewha Women's University, Department of Decorative Arts, both in Korea, 1980. Art Teacher, University of Illinois Laboratory High School for Gifted and Talented Students, 1982–1985. Visiting Associate Professor, Department of Art Theory and Practice, Northwestern University, 1985. Associate Professor of Art Education, Louisiana State University, Baton Rouge, 1986–1988. Associate Professor of Fine Art and Art Education, University of Missouri, Columbia, 1988–1998. *Awards*: CAPS Grant in Painting, New York State Council on the Arts, 1975. Fulbright-Hays International to Seoul, South Korea, 1980. Ford Foundation Postdoctoral Fellowship in Creative Arts, 1985. Multiethnic Award for Research, National Art Education Association and Louisiana State Department of Education VERY SPECIAL ARTS/Louisiana Grant, 1987. New Initiatives Faculty Grant from the Missouri University International Center (research travel to South Africa), 1998.

SELECTED EXHIBITIONS

1998	*Two Decades of Float Shapes: A Retrospective of 22 Years of Shaped Canvas Painting*, Bruce R. Watkins Cultural Heritage Center, Kansas City, Missouri (traveling to Atrium Gallery at Lombardi Georgetown University Medical Center, Washington, D.C.); *Juried One Woman Exhibition*, Lombardi Center Gallery, Georgetown University, Washington, D.C.
1996	*Soweto to Salvador: Painting and Photography*, Lincoln University Memorial Hall Gallery, Jefferson City, Missouri
1995	*Not Your Typical Tuscan: An African American Perspective on Italy*, Missouri University Ellis Library Galleries, Columbia, Missouri
1994	*Etruscan Voyage*, Hotel Park Palace, Florence, Italy; *Cosmic Movements: Shapes and Planets*, Elizabeth Rozier Gallery, Jefferson City, Missouri
1991	*Cosmic Movements*, Fontbonne College Gallery, St. Louis, Missouri
1981	*Korean Impressions: Painting and Photography*, International Communication Agency Exhibition Hall, United States Embassy, Seoul, Korea
1980	*One Woman Exhibition*, Shelton Gallery, New York, New York
1979	*Middle Passage*, Ohio State University, Newark Gallery, Columbus, Ohio
1977	*One Woman Exhibition*, The Studio Museum in Harlem, New York, New York
1976	*Sunbirds*, Artforce Artists Co-op Gallery, Columbus, Ohio

SELECTED GROUP EXHIBITIONS

1997 *African Odyssey*, Margaret Hartwell Art Museum, Polar Bluff, Missouri, Mythmaker Gallery, Columbia, Missouri

1996 *Black Creativity*, Museum of Science and Industry, Chicago, Illinois

1993 *Annual Women's Art Exhibition*, UMC Brady Commons Gallery, Columbia, Missouri; *African American Art*, UMC Brady Commons Gallery, Columbia, Missouri

1992 *People, Places and Things: An African American Perspective*, Columbus Museum of Art, Columbus, Ohio; *Visions 1992*, Portfolio Gallery, St. Louis, Missouri; *Survey of African American Art*, St. Louis Art Gould, St. Louis, Missouri

1991 *Purim Mask Invitational*, The Jewish Community Museum, San Francisco, California

1989 *Women in Color*, Manhattan East Gallery of Fine Art, New York, New York

1986 *Roots: A Contemporary Inspiration*, Evanston Art Center, Evanston, Illinois

1982 *Recent Acquisitions*, The Schomburg Center for Research in Black Culture, New York, New York

1981 *Forever Free: Art by African-American Women, 1862–1980*, Illinois State University Gallery, Normal, Illinois; Joslyn Art Museum, Omaha, Nebraska, Montgomery Museum of Fine Art, Montgomery, Alabama, Gibbs Art Gallery, Charleston, South Carolina, University of Maryland College Park Art Gallery, Indianapolis Museum of Art, Indianapolis, Indiana (traveling exhibit)

1976 Butler Institute of American Art, Butler Ohio; 17 Wendell Street Gallery, Cambridge, Massachusetts

1975 *CAPS Grantees in Painting*, Michael C. Rockefeller Arts Center Gallery, State University College, Fredonia, New York; *Hard Edge '75*, Aames Gallery, Soho, New York, New York

1974 Brooklyn Museum, New York; Acts of Art Gallery, New York, New York; Cinque Gallery, New York, New York

SELECTED COLLECTIONS

Columbus Museum, Columbus, Ohio; Compulink International, Inc., Rollings Meadows, Illinois; Gourmet Services, Inc., Atlanta, Georgia; Korea National Museum of Modern Art, Seoul, Korea; Korean Educational Development Institute, Seoul, Korea; Kyungbok Palace, Museum of Contemporary Art, Seoul, South Korea; MCA Record Corporation, Los Angeles, California; The Schomburg Center for Research in Black Culture, New York City, New York; University of Arkansas at Pine Bluff, Department of Music

SELECTED PUBLICATIONS

"Abstractionist Busy in Korea" (review). *The Korea Times*, January 30, 1981.

"Black Studies Mark Gains But Seek Wider Role" (review). *New York Times*, June 19, 1977.

Hoard, Adrienne. "The Black Aesthetic: An Empirical Feeling." In Bernard Young, ed., *Art, Culture and Ethnicity: An Anthology*. Reston, Va.: National Art Education Association, 1990. pp. 155–168.

Hoard, Adrienne. "Frederick D. Bell, Black Classical Composer." *Black Creation Magazine* 6, no. 4 (December), pp. 42–43.

Hoard, Adrienne. "Review of Farris's (ed.), 'Voices of Color: Art and Society in the Americas.' " *Journal of Multicultural and Cross-Cultural Research in Art Education* 15 (1998), pp. 120–126.

Hoard, Adrienne. "Treatise on Creativity." *Gifted and Talented Digest* vol. 15, no. 1, p. 14–15.

Hoard, Adrienne. "The Vision That Was Once a Reality—The Art of Brenda Lynn Robinson." *Mahogany Magazine* 2, no. 25 (May 6, 1979), p. 16.

Igoe, Lynn Moody, and James Igoe. *250 Years of Afro-American Art*. New York: R. R. Bowker, 1981.

Kelly, June. "Adrienne W. Hoard, Artist/Teacher." *Black Art and International Quarterly* 2, no. 2 (Winter 1978), pp. 48–53.

King-Hammond, Leslie, ed. *Gumbo Ya Ya: Anthology of Contemporary African-American Women Artists*. New York: Midmarch Arts Press, 1995.

Lewis, Samella. *Art: African American*. Los Angeles, Calif.: Hancraft Studios, 1978, 1980, 1990.

"Painting Their Lot in Black and White" (review). *News Day*, August 28, 1975, p. 10.

Review. *St. Louis Post/Dispatch*, December 8, 1991, p. 8E.

Self, Dana, ed. *Two Decades of Float Shapes: A Retrospective of 22 Years of Shaped Canvas Paintings*. Kansas City, Mo.: Homegirl, Inc., 1998. Exhbn cat.

ARTIST STATEMENT (1998)[1]

The life of an artist is lived on the edge. The edge of creativity, the edge of a new color mixture, the wing's edge of a new culture uncovered and discovered through direct experience. There is always the thrill of risk, the invitation of the feeling of the next unknown adventure, waiting to be accomplished, then brought from artistic subconscious into tangible form, for the emotive pleasure of the form, for the viewing of sojourning spirits, for pleasure. Peace, Joy, Love and security.

Note

1. Adrienne W. Hoard, "Artists' Statement," in Dana Self, ed., *Two Decades of Float Shapes: A Retrospective of 22 Years of Shaped Canvas Paintings* (Kansas City, Mo.: Homegirl, Inc., 1998), p. 11.

BIOGRAPHICAL ESSAY

Adrienne Hoard, acclaimed painter and photographer, has exhibited and lectured internationally as a former Fulbright Scholar and former Ford Foundation Postdoctoral Fellow. Known for her shaped canvases, which have progressed from hard-edged geometric perimeters to free-form organic shapes, which Hoard refers to as "float shapes," her viewers over the years have been consistently mesmerized by her world of brilliant saturated color with sources from African and Native American histories of abstraction, Cubism, and universal spiritual cosmologies. Also an educator and scholar, Hoard's research into the psychology of visual perception of color and shape and linkages between visual abstraction and various indigenous aesthetics has had a profound impact on her development as a painter and her career in photography and design.

Hoard's intuitive feel for color can be traced to childhood experiences with her grandparents and parents in homes where abundant color, clay figures, artifacts, and musical sounds dominated the atmosphere. Her paternal grandfather of African descent who arrived in the United States in the late 1890s from the Caribbean and his wife, her paternal grandmother who was Blackfoot Indian/ Siksika, shared an oral storytelling tradition in which inanimate objects become animate and animals could speak, especially the turtle. Their spirituality included her grandfather's Christian ministry and her grandmother's memories of pre-Christian Siksika religion based on solar ceremonies and colorfully patterned religious paraphernalia—influences that later impacted Hoard's cosmology-enriched paintings. Both of Hoard's parents, who taught at Lincoln University, a historically black institution, undoubtedly influenced Hoard's decision to obtain a doctorate and combine an art teaching career with her drive to be an artist.

In phone interviews with the author and written communication, Hoard relayed her fine art career narrative as one in which manipulation of the perimeter frame of the canvas stretcher has been a passion in her paintings. Developing a functional technique for the building and stretching of free-form-shaped canvas constructions was helped through a 1994–1995 CAPS grant from the New York State Council on the Arts and the support of fellow black artists working with shaped canvases such as Betty Blayton-Taylor (founder of the Children's Art Carnival); Al Loving, who painted hexagons; and Ed Clark, who painted ovals. Acrylics on canvas from the 1970s were exhibited in one-woman shows at the Studio Museum in Harlem and Artforce Gallery in Ohio, with written commentary by black art historians David C. Driskell and Rosalind R. Jeffries and black artists Lois Mailou Jones and Mel Edwards.

The 1980s marked a transition in Hoard's work involving heavy textured oil paint with more painterly gestures—a transition that originated while a Fulbright Scholar (1980–1981) in Seoul, South Korea. Hoard describes Korea as a peninsula where life is ruled by the rhythms of nature, water, rocks, and wind. Hoard's new natural surroundings led to organically shaped perimeter forms with thick impasto layers of high-key colors.

Upon returning to the United States, Hoard pursued graduate research in the psychology of visual perception, focusing on the psychophysical literature of color theory perception and nonobjective art. Her doctoral dissertation, "Perception of Visual Structure in Abstract Painting," became the focus of later writings on black aesthetics.

A Ford Foundation Postdoctoral Senior-Level Fellowship in Painting (1985–1986) allowed more time for in-depth studio concentration. Working with oil pastel, opaque and metallic pigment, and Korean watercolors on rag paper and linen, Hoard moved into an amorphous, expressive handling of color and materials. In one year she completed 23 works on paper and two acrylic-shaped canvas paintings in a series titled *Tribal Birds*. Five paintings from the *Tribal Birds* series were featured on Compact Disc cover booklets for Centaur Records' CD recordings of synchronic computer music. Booklets printed in English, French, and German were distributed internationally from 1988 to 1992.

A summer spent traveling/painting in Brazil and Peru (1989) was the beginning of Adrienne's *Cosmic Movements* series with works in oil and acrylic on heavy rag paper. While in Brazil, Adrienne presented a paper, "The Black Aesthetic: An Empirical Feeling," at the Third International Symposium on Art Teaching and Its History at City University in São Paulo, Brazil. The *Cosmic Movements* series was temporarily interrupted by the death of both her parents within an 11-month time span. Resuming her creative work to aid in her grief and recovery, Adrienne went on to produce 15 works in this series. *Meteor Shower* and *Jupiter* were reviewed in the *St. Louis Dispatch* with references to the work of Jean Arp, Jean Miro, and Henry Moore because of their "undulating primordial forms." Two pieces from this series were also featured on cover booklets for Centaur Records.

Using travel again as sources for inspiration, Adrienne spent her university sabbatical in Florence, Italy (1993–1994) studying Etruscan symbology, culture, dance forms, and cosmology. The *Etruscan Voyage*, 8 works on paper and 12 shaped canvases, culminated in a one-women exhibit in Florence, Italy. Images such as *The Duet* (oil on shaped canvas, 100" × 50", 1994) and *Smiling Butterfly* are dual-shaped canvas forms that appear as one continuous image with designs and colors transported from one painting to the other—but still maintaining an individual identity. The paired images are based on Adrienne Hoard's research into Etruscan dance and ritual customs in which couples danced a public duet without touching and then were permitted to mate after completing the dance. Both the *Etruscan Voyage* and the *Cosmic Movements* provided solace and a sense of peace in dealing with personal tragedy.

The summer of 1996 was an opportunity to return to Brazil to present a paper entitled "Soul Aesthetic: A Cross-Cultural Event" at the Afro-Latin American Research Association and to meet "mai de santos" (mothers of spirit), Bahian, Brazilian priestesses, and also to visit Pretoria, South Africa, to observe and interact with Ndebele women artists. Both groups of women create abstract, colorful altar art forms to represent visual and spiritual traditions relevant to female deities and guardian spirits. Photographs and watercolor studies of the

Brazilian and South African altar forms resulted in several oil paintings such as *Bahia IV: Birdwomen, Trumpet-Dancer, Dark Lady Dance, The Dance of Innocence,* and *The Dance Weavers,* all part of the *Gate Mothers* series. Technically the *Gate Mothers* series is an exploration of heavy oil paint, applied with a small "cat's tail" brush as opposed to the palette knife used in the Korean series and a color shift from high-key, brilliant to more tonal, less intense chroma assemblages. Spiritually, Adrienne Hoard describes the series as a salute to divine guardian spirits, her "altar offering" to black female healers/artists in Brazil, South Africa, and the entire black diaspora.

Adrienne Hoard's lifelong commitment to using psychology research, photography, design, and painting to study how colors interact with each other to create harmony and her continual body of series using abstraction to transmit universal cultural, spiritual, and historical traditions attests to Hoard's individuality and independence from contemporary art movements. In *Two Decades of Float Shapes,* Adrienne states that abstraction allows her freedom of total emotional expression while keeping her secrets. "Only the colors, authentic and bold, give any indication of the depth of my feelings, the intensity of my Truth, or the Joy in my passion."[1]

Note

1. Adrienne W. Hoard, "Artists' Statement," in Dana Self, ed., *Two Decades of Float Shapes: A Retrospective of 22 Years of Shaped Canvas Paintings* (Kansas City, Mo.: Homegirl, Inc., 1998), p. 11.

JACKSON-JARVIS, MARTHA

Born: 1952, Lynchburg, Virginia. *Education:* B.F.A., Ceramics/Sculpture, Temple University, Tyler School of Art, Philadelphia, Pennsylvania, 1975. M.F.A., Sculpture/Ceramics, Antioch University, Columbia, Maryland, 1981. *Family:* Married and the mother of four children. *Career:* Artist-in-Residence, Howard University, Washington, D.C., 1979–1981. Artist-in-Residence, Guilford College, Greensboro, North Carolina, 1987. Artist-in-Residence, University of Delaware, Newark, Delaware, 1988. University of the District of Columbia, 1986–1989. The Corcoran School of Art, Washington, D.C., 1986–1991. Maryland Institute College of Art, Baltimore, Maryland, 1992–1994. Independent Artist, Jackson-Jarvis Studio, 1995–present. *Awards:* D.C. Commission on the Arts and Humanities Individual Artist Grant in Sculpture, 1979–1980. Mayor's Art Award, Washington, D.C., Emerging Artist Award, 1982. D.C. Commission on the Arts Individual Artist Grant in Sculpture, 1986. National Endowment for the

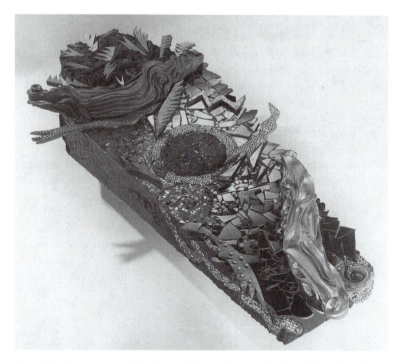

Last Rites Sarcophag I (Earth) by Martha Jackson-Jarvis, 1993, Clay, Glass, Cement, Wood, 4' × 5' × 2½'. Photograph by Harlee Little. Courtesy of Martha Jackson-Jarvis

Arts National Sculpture Grant, 1986. Penny McCall Foundation Grant Award in Sculpture, 1988. Virginia Groot Fellowship Grant in Sculpture, 1992. Arts International Lila Wallace–Readers Digest Grant, Travel Grant to Italy: The American Academy in Rome, 1992.

SELECTED EXHIBITIONS

1996	*Structuring Energy*, Corcoran Gallery of Art, Washington, D.C.; *Boxes for OCHUM*, Swarthmore College, Swarthmore, Pennsylvania; Maryland Art Place, Baltimore, Maryland
1991	BR Kornblatt Gallery, Washington, D.C.
1990	SUNY College at Brockport Tower Fine Arts Gallery, Brockport, New York
1989	BR Kornblatt Gallery, Washington, D.C.
1988	University of Delaware, Museum Gallery, Newark, Delaware
1983	Franz Bader Gallery, Washington, D.C.
1981	Howard University, Gallery of Art, Washington, D.C.
1980	Washington Project for the Arts (WPA), Washington, D.C.
1977	African American Historical Museum, Philadelphia, Pennsylvania

SELECTED GROUP EXHIBITIONS

1997 SPOLETO Festival USA, *Human/Nature: Art and Landscape in Charleston and the Low Country*, Charleston, South Carolina

1996 *My Magic Pours Secret Libations*, Florida State University Museum of Fine Arts, Tampa, Florida; *Contained and Uncontained*, African-American Museum, Dallas, Texas; *Actively Physical*, Main Line Art Center, Haverford, Pennsylvania

1995 *Three Dimensions: Women Sculptors of the 90's*, Snug Harbor Cultural Center, Staten Island, New York

1994 *Across Borders/Sin Fronteras*, The Art Museum of the Americas, Organization of American States, Washington, D.C.; *Sources*, University of Maryland Art Gallery, College Park, Maryland

1993 *Artists Respond/New World Question*, Studio Museum of Harlem, New York, New York; *Connected Passages*, Philadelphia African American Historical Museum, Philadelphia, Pennsylvania

1992 *Picturing Paradise: The Rain Forest at Risk*, The Fernbank Museum of Natural History, Atlanta, Georgia; Invitational: *"Arts of Grace*," Peninsula Fine Arts Center, Newport News, Virginia

1991 Invitational: *Recent Acquisitions and Loaned Works*, National Museum of Women in the Arts, Washington, D.C.; *Washington/Moscow Exchange*, Tretyakov Gallery, Moscow, USSR

1990 Invitational: *The Decade Show*, Museum of Contemporary Hispanic Art, New York, New York; Invitational: *Next Generation: Southern Black Aesthetic*, South Eastern Center for Contemporary Art (SECCA), Winston-Salem, North Carolina; Invitational: *Legacies*, New Jersey Center for Visual Arts, Summit, New Jersey

1989 Invitational: *The Blues Aesthetic*, The Washington Projects for the Arts, Washington, D.C.; *Introspective Contemporary Art by Americans and Brazilians*, California African American Museum, Los Angeles, California

1988 Invitational: *Art as a Verb*, Maryland Art Institute College of Art, Myerhoff Gallery, Baltimore, Maryland

1987 Invitational: *Contemporary Visual Experiences*, Smithsonian Institution–Anacostia Museum, Washington, D.C.

1986 Invitational: *The Other Gods*, The Everson Museum, Syracuse, New York; Invitational: *Generations in Transition*, Chicago Museum of Science and Industry, Chicago, Illinois

1985 Invitational: *Evocative Abstractions*, Nexus Foundation for Contemporary Art, Philadelphia, Pennsylvania

1984 Invitational: *National Contemporary Art East/West*, California African American Museum, Los Angeles, California; Invitational: *Washington Sculpture*, Georgetown Court Artist Space, Washington, D.C.

1980 Juried Exhibition: *Sculpture 80*, National Sculpture Conference, Bal-
 timore, Maryland

1979 Invitational: Brooks Memorial Museum, Memphis, Tennessee

SELECTED COMMISSIONS

Arco Chemical Company, Newton Square Corporate Campus II, Newton Square, Penn-
sylvania; LaGuardia Community College, Long Island, New York; New York Transit
Authority, Mount Vernon Station—Metro North, New York, New York; Prince George's
County Courthouse, Upper Marlboro, Maryland; SPOLETO Festival USA 1997, Sculp-
tural Garden, Charleston, South Carolina

SELECTED COLLECTIONS

Arco Chemical Company; Artery Organization; Howery and Simon Law Firm; KPMG
Peat Marwick; LaGuardia Community College; Lenkin Company; Merck Company; New
York Transit Authority; Philip Morris Corporation; Sallie Mae

SELECTED PUBLICATIONS

Chapp, Belena. *Martha Jackson-Jarvis*. Newark: University Gallery, University of Del-
 aware, 1988.
Didach Anne S. "University Gallery, University of Delaware, Newark; Exhibit." *New
 Art Examiner* 16 (October 1988), pp. 54–55.
Driskell, David C., ed. *African-American Visual Aesthetics: A Postmodernist View*.
 Washington, D.C.: Smithsonian Institution Press, 1995.
Howell, George. "Martha Jackson-Jarvis." *Art Papers* 20 (November–December 1996),
 p. 46.
"Interview with Joyce Scott, Winnie R. Owens-Hart, Martha Jackson-Jarvis, and Pat
 Ward Williams." In *Next Generation: Southern Black Aesthetic*. Winston-Salem,
 N.C.: Southeastern Center for Contemporary Art, 1990. Exhbn cat.
King-Hammond, Leslie, ed. *Gumbo Ya Ya: Anthology of Contemporary African-
 American Women Artists*. New York: Midmarch Arts Press, 1995.
Lewis, Samella. *African-American Art and Artists*. Berkeley: University of California
 Press, 1978, 1990.
Lippard, Lucy. *Mixed Blessings*. New York: Pantheon Books, 1990.
Powell, Richard J. *Black Art and Culture in the 20th Century*. London: Thames & Hud-
 son, 1997.
Robinson, Jontyle Theresa. *Bearing Witness: Contemporary Works by African-American
 Women Artists*. Atlanta, Ga.: Spelman College; New York, Rizzoli International
 Publ., 1996. Exbhn cat.
Weaver, A. M. "Suspended Metaphors." *International Review of African-American Art*
 13, no. 3 (1996), pp. 32–41.

ARTIST STATEMENT (1990)[1]

I want to go to the beginning and search through those very basic things that
work for me as an artist. These are probably things that don't get addressed
publicly that often, but they go into the work. I can only hope that once I've

produced the work, once I've laid it bare, that I'll indeed begin to communicate some of these things. I have to search within myself, my existence, for a functioning definition of what I believe art to be. For art is that thing that has carried me from being a student to making my way in the real world.

Note

1. From Samella Lewis, *African-American Art and Artists* (Berkeley: University of California Press, 1978, 1990), p. 282.

BIOGRAPHICAL ESSAY

Martha Jackson-Jarvis is most noted for her mixed-media installations that explore aspects of African, African American, and Native American spirituality, ecological concerns, and the roles of women in preserving indigenous cultures. Composed of terra-cotta, sand, copper, wood, plexiglass, glazed clay fragments, architectural tile, and coal, her floor/freestanding/wall relief ceramic sculptures are both abstract and representational in form, with abstraction dominating. Jackson-Jarvis's seemingly abstract shapes and forms, often made from recycled pottery shards, possess a subtle symbolism that may not be obvious to the casual observer. But Jackson-Jarvis refers to their connection with West African spirituality, especially in issues concerning death and the afterlife.

As a child growing up in Lynchburg, Virginia, Martha accompanied her grandmother to a local spring to gather white clay. Making clay dolls and other objects inspired Martha at an early age to want to be an artist. Her idea to use broken pottery shards and other objects strewn on the floor in site-specific installations is inspired by her grandmother's custom of placing crockery and pottery shards on family grave sites. This southern black burial tradition is based on African concepts of preparing souls for the afterlife. Other southern traditions that impacted on her later art development are associations with the use of clay by Native Americans and the belief that Native American spirits are ever present in what is now the United States.

In addition to the African and Native American cultural influences, Martha's 1980s pieces also contain biological symbolism based on beliefs about life originating from what some consider "inanimate" objects but what other cultures consider "alive." Jackson-Jarvis considers her clay pieces "power objects." Pieces resembling skeletons of underwater life are arranged in environments of sand, natural substances, and wood, covering the floor in a circular formation and extending to the walls.

Martha's best-known work from this period is the 1988 *Gathering* installation at the University Gallery of the University of Delaware. Forty feet in diameter, the circular gathering on the floor and the pieces on the surrounding wall consist of irregular shaped forms of fired and glazed clay, broken plates, cups, and saucers, and architectural tiles—links to her grandmother's African-derived rit-

ual of laying broken pottery shards on funeral grounds. Other installations from this period use the word *gather* in the title—*The Time Gathers* and *The Gathering and Arc of the Southern Sun.*

Since the 1990s Martha Jackson-Jarvis has moved away from concentrating on installations to create freestanding sculptural forms and wall relief sculptures—but maintaining her earlier African and Native American cultural referents. Most noted in her early 1990s work is *Last Rites Sarcophagi II* (1993, clay, slate, venetian glass, copper, cement, wood)—a series of seven coffin-shaped tables titled *Plants, Earth, Air, Water, Healing, Blood*, and *Ancestor Spirits*, the tallest being eight feet. Its environmental theme of earth's potential destruction, life cycles, and the interrelatedness of humans, animals, and nature is a continuation of Jackson-Jarvis's respect for indigenous cultures. Also from this period is another sarcophagi series—*Table of Plenty*, altarlike structures of sarcophagi elevated on wrought iron legs. The eight tables in the series have detailed mosaic surfaces consisting of clay cast collard greens, slate, coal, and metal.

Martha's recent works are bas reliefs of boxed shapes hung on walls created with inlays of venetian glass, clay fish, encrusted silver, gold and silver paint, tiles, and clay cast collard greens. *Blue Fish* (1985, clay, glass, coal, paper, 41" × 19" × 12" in diameter) and *Collard Box* (1995, clay, glass, cement, wood, 36" × 33" × 16" in diameter) cross the boundaries between painting, sculpture, and crafts.

Like many women artists of her generation, Martha Jackson-Jarvis is eschewing the traditional dichotomies between "high art" versus crafts and utilitarian art objects versus "art for art's sake." Her respect for pottery, an earth-based art form that is usually created by women in indigenous societies, is taken out of its usual practical applications and applied to intellectual formats such as conceptual art/installations. However, the spiritual component of Martha's art links it back to indigenous African and Native American cultures that do not separate art and religion. Also, the theoretical basis of installation art that demands a temporary location and eventual destruction and/or recycling has parallels with Native American practices such as Navajo sandpaintings. Martha's 1980s installations have certain affinities with Sara Bates's Native American *Honorings* installations. It is interesting to note some of the similarities between both traditional African and Native American art and contemporary similarities expressed by artists such as Martha Jackson-Jarvis. It reinforces the need for the type of research that investigates cross-cultural links among "peoples of color."

JONES, LOIS MAILOU

Born: 1905, Boston, Massachusetts. *Education*: Diploma in Design, School of the Museum of Fine Arts, Boston, 1927. Certificate, Boston Normal Art School, 1927. Diploma, Designers Art School of Boston, 1928. A.B., art education, Howard University, 1945. *Family*: Parents Thomas Vreeland Jones and Carolyn Dorinda Adams. Brother John Wesley Jones. Married Haitian graphic artist and designer Louis Vergniaud Pierre-Noël in 1953. *Career*: Freelance textile and fabric designer. Head of art department, Palmer Memorial Institute Junior College, Sedalia, North Carolina, 1928–1930. Professor of art, Howard University, 1930–1977. Freelance illustrator for Associated Publishers of Washington, 1936–1965. *Awards*: Honorable Mention, Harmon Foundation Exhibition, 1930. General Education Board Fellowship to study at Académie Julian, Paris, 1937. Robert Woods Bliss Prize for Landscape, The Society of Washington Artists, 1941. Women of 1946 Award, National Council of Negro Women, 1946. John Hope Prize for Landscape, Atlanta University Annual Exhibition, 1949. Oil Painting Award, Corcoran Gallery of Art, Washington, D.C., 1949. National Printing Award, Mead Papers, Dayton, Ohio, 1950. Oil Painting Award, Corcoran Gallery of Art, Washington, D.C., 1953. Diplôme et Décoration de L'Ordre National "Honneur et Mérite au Grade de Chevalier," Government of Haiti, 1954. Popular Prize, Atlanta University Annual Exhibition, 1955. Pyramid Club Meritorious Award for Achievement in Art, Philadelphia, Pennsylvania, 1957. Award for Oil Painting, National Museum of Art, Washington, D.C., 1960. Franz Bader Award for Oil Painting, Washington Society for Artists, National Museum of Art, Washington, D.C., 1962. Howard University Research Grant, "The Black Visual Arts," Haiti, 1968. Howard University Research Grant, "The Black Visual Arts," Africa and United States, 1969. Alain Locke Award, Cleveland University, 1972. Howard University Research Grant, "Women Artists of the Caribbean and Afro-American Artists," 1973. Honorary Doctorate, Colorado State Christian College, 1973. Diploma Award, The World's Who's Who of Women, Cambridge, England, 1973. Howard University Fine Arts Faculty Award for Excellence in Teaching, 1975. Edward Mitchell Bannister Award for Great Contribution to American and Afro-American Art, National Center of Afro-American Artists, Boston, 1976. Award of Appreciation, Association for the Study of Negro Life and History, Washington, D.C., 1978. Alumni Achievement Award, Howard University, 1978. President Jimmy Carter Award for Outstanding Achievement in the Arts, 1980. Honorary Doc-

torate, Suffolk University, Boston, 1981. Candace Award, National Coalition of 100 Black Women, Metropolitan Museum of Art, New York, 1983. Mayor's Third Annual Art Awards, Washington, D.C., 1983. July 29 declared Lois Jones Day in Washington, D.C., 1984. Outstanding Achievement in the Visual Arts Award, Women's Caucus for Art, Cooper Union, New York, 1986. Honorary Doctorate, Massachusetts College of Art, Boston, 1986. Honorary Doctorate, Howard University, Washington, D.C., 1987. *Died*: 1998, Martha's Vineyard, Oak Bluffs, Massachusetts.

EXHIBITIONS

1994	Red Barn Gallery, Martha's Vineyard, Massachusetts
1990	*The World of Lois Mailou Jones*, Meridian House International, Washington, D.C. (traveling show)
1989	St. Mary's College of Maryland, St. Mary's City, Maryland
1988	Brody Gallery of Art, Washington, D.C.; Armour J. Blackburn Gallery of Art, Washington, D.C.
1987	Howard University, Washington, D.C.
1986	Musée d'Art Haïtien, Port-au-Prince, Haiti
1985	Harbor Gallery, University of Massachusetts, Boston
1984	Bethune Museum and Archives, Washington, D.C.; Reynolds House Museum of American Art, Winston-Salem, North Carolina
1979	Phillips Collection, Washington, D.C.
1973	*Reflective Moments*, Museum of Fine Arts, Boston, Massachusetts
1972	*40 Years of Painting*, Howard University Gallery of Art, Washington, D.C.
1968	Galerie International, New York, New York; Smith-Mason Gallery of Art, Washington, D.C.; Association for the Presentation and Preservation of the Arts, Washington, D.C.
1967	Cornell University, Ithaca, New York
1966	Galerie Soulanges, Paris, France
1961	Galerie International, New York, New York
1955	Pan American Union Building, Washington, D.C.
1954	Centre d'Art, Port-au-Prince, Haiti
1948	Whyte Gallery; Howard University Gallery of Art, Washington, D.C.
1947	Lincoln University, Lincoln, Pennsylvania
1946	Barnett-Aden Gallery, Washington, D.C.
1940	Morgan State College, Baltimore, Maryland
1939	Robert C. Vose Galleries, Boston, Massachusetts
1937	Howard University Gallery of Art, Washington, D.C.
1935	Hampton University Founder's Day, Hampton, Virginia

| 1929 | Martha's Vineyard, Oak Bluffs, Massachusetts |

SELECTED GROUP EXHIBITIONS

1996	*Bearing Witness: Contemporary Works by African American Women Artists*, Spelman College Museum of Fine Art, Atlanta, Georgia
1988	Hong Kong Museum of Art, Hong Kong, China
1987	*The Art of Black America in Japan*, Tokyo and Chiba, Japan
1985	*Hidden Heritage*, Bellevue Art Museum, Bellevue, Washington (traveling show); *Tradition and Conflict*, Studio Museum in Harlem, New York (traveling show)
1984	Emily Lowe Gallery, Hempstead, New York; Jamaica Arts Center, New York, New York; Museum of African Art, Los Angeles, California; Bucknell University, Lewisburg, Pennsylvania
1983	The Granary Gallery of Art, Martha's Vineyard, Massachusetts
1977	High Museum, Atlanta, Georgia; San Jose Museum of Art, San Jose, California
1976	*Six Distinguished Women Artists*, Brooklyn Museum, New York; *Two Centuries of Black American Art*, Los Angeles County Museum of Art, Los Angeles, California (traveling show)
1975	Corcoran Gallery of Art, Washington, D.C.
1974	Dartmouth College, Hanover, New Hampshire
1972	Carnegie Institute, Pittsburgh, Pennsylvania; Scripps College, Claremont, California; Southern Illinois University, Carbondale, Illinois; Studio Museum in Harlem, New York; National Portrait Gallery, Washington, D.C.
1971	New Jersey State Museum, Trenton, New Jersey; Museum of Fine Arts, Boston, Massachusetts
1968	The Art Club, Washington, D.C.
1967	Oakland Museum, Oakland, California; City University of New York, New York, New York
1966	Société des Artistes Français, Grand-Palais, Paris, France
1962	Rhodes National Gallery, Zimbabwe
1952	American University, Washington, D.C.
1951	Corcoran Gallery of Art Biennial Exhibition, Washington, D.C.
1950	ACA Gallery, New York, New York; Grand Central Art Galleries, New York, New York
1942	National Academy of Design, New York, New York
1941	Philips Collection, Washington, D.C.; Seattle Museum of Art, Seattle, Washington
1940	American Negro Exhibition, Chicago, Illinois; National Museum of Art, Washington, D.C.

1938 Société des Artistes Français, Grand-Palais, Paris, France; Galerie de
 Paris, Paris, France; Galerie Jean Charpentier, Paris, France

1936 Washington, D.C., Public Library, Washington, D.C.; Texas Centen-
 nial, Hall of Negro Life, Houston, Texas

1931 Biennial Exhibition, Corcoran Gallery of Art, Washington, D.C.

PERMANENT COLLECTIONS

American Embassy, Luxembourg; Andrew Rankin Chapel, Howard University, Wash-
ington, D.C.; Atlanta University, Atlanta, Georgia; The Brooklyn Museum, New York;
The Corcoran Gallery of Art, Washington, D.C.; Carl Van Vechten Gallery of Art, Fisk
University, Nashville, Tennessee; Galerie International, New York, New York; Hirshhorn
Museum and Sculpture Garden, Washington, D.C.; Howard University Gallery of Art,
Washington, D.C.; International Fair Gallery, Ismir, Turkey; Johnson Publishing Co.,
Chicago, Illinois; Milwaukee Art Museum, Milwaukee, Wisconsin; Museum of African-
American Art, Tampa, Florida; Museum of Fine Arts, Boston, Massachusetts; National
Museum of American Art, Washington, D.C.; The National Museum of Women in the
Arts, Washington, D.C.; National Portrait Gallery, Washington, D.C.; Palais National,
Port-au-Prince, Haiti; The Phillips Collection, Washington, D.C.; The Rosenwald Foun-
dation, Chicago, Illinois; Schomburg Center for Research in Black Culture, New York
Public Library, New York; The Studio Museum in Harlem, New York; Taylor Gallery,
North Carolina Agricultural and Technical State University, Greensboro, North Carolina;
University of Panjab, Pakistan; University of the District of Columbia, Washington, D.C.;
Wadsworth Atheneum, Hartford, Connecticut; Walker Art Museum, Bowdoin College,
Brunswick, Maine; Walter Reed Army Medical Center Museum, Washington, D.C.

PUBLICATIONS

Afro-American Women in Art: Their Achievements in Sculpture and Painting. Greens-
 boro, N.C.: Negro Heritage Committee, Beta Iota Omega Chapter, Alpha Kappa
 Alpha, 1969. Exhbn cat.
Bearden, Romare, and Harry Henderson. *A History of African-American Artists from
 1792 to the Present.* New York: Pantheon, 1993.
Bearing Witness: Contemporary Works by African American Women Artists. Atlanta,
 Ga.: Spelman College Museum of Fine Art, 1996. Exhbn cat.
Benjamin, Tritobia H. *The Life and Art of Lois Mailou Jones.* San Francisco: Pome-
 granate Artbooks, 1994.
Benjamin, Tritobia H. *The World of Lois Mailou Jones.* Washington, D.C.: Meridian
 House International, 1990.
Black Women in the Visual Arts: A Tribute to Lois Mailou Jones. Washington, D.C.:
 Martin Luther King Memorial Library, 1979.
Bontemps, Arna, ed. *Forever Free: Art by African-American Women 1962–1980.* Al-
 exandria, Va.: Stephenson, 1980.
Dover, Cedric. *American Negro Art.* New York: Graphic Society, 1960.
Driskell, David. *Hidden Heritage: Afro-American Art, 1800–1950.* Bellevue, Wash.:
 Bellevue Museum, 1985.
Driskell, David. *Two Centuries of Black American Art.* New York: Knopf, 1976.

Fax, E. C. *Seventeen Black Artists*. New York: Dodd, Mead, 1971.

Fifteen Afro-American Women. Greensboro, N.C.: North Carolina Agricultural and Technical State University, 1970.

Fine, Elsa Honig. *The Afro-American Artist*. New York: Holt, Rinehart & Winston, 1973.

Haitian Ceramics from the Centre Céramique, Port-au-Prince, and Paintings of Haiti by Lois M. Jones. Washington, D.C.: Howard University Gallery of Art, 1965.

"In the Galleries: Lois Mailou Jones." *Arts* 35 (March 1961), p. 52.

Jones, Lois Mailou. *Contemporary African Art*. Washington, D.C.: Association for the Study of Negro Life and History, 1970.

Jones, Lois Mailou. *Lois Mailou Jones: Peintures 1937–51*. Tourcoing, France: Presses Georges Frère, 1952.

LaDuke, Betty. *Africa through the Eyes of Women Artists*. Trenton, N.J.: Africa World Press, 1991.

Lewis, Samella. *Art: African-American*. San Diego, Calif.: Harcourt Brace Jovanovich, 1978.

Locke, Alain. *Negro Art: Past and Present*. New York: Hacker, 1968.

Lois and Pierre: Two Master Artists. Boston: Museum of the National Center of Afro-American Artists, 1983.

Lois Mailou Jones: Retrospective Exhibition. Forty Years of Painting, 1932–72. Washington, D.C.: Howard University Gallery of Art, 1972.

Morrison, Keith. *Art in Washington and Its Afro-American Presence: 1940–1970*. Washington, D.C.: Washington Project for the Arts, 1985.

Porter, James A. *Modern Negro Art*. New York: Arno Press, 1969.

Schmidt-Campbell, Mary, and David C. Driskell. *Harlem Renaissance: Art of Black America*. New York: Studio Museum and Harry N. Abrams, 1987.

Tradition and Conflict: Images of a Turbulent Decade, 1963–1973. New York: The Studio Museum in Harlem, 1985. Exhbn cat.

Wardlaw, Alvia, Barry Gaither, Regina Perry, and Robert Farris Thompson. *Black Arts, Ancestral Legacy: The African Impulse in African-American Art*. New York: Abrams, 1990.

Wright, Beryl J., and G. A. Reynolds. *Against the Odds: African-American Artists and the Harmon Foundation*. Newark, N.J.: Newark Museum of Art, 1989. Exhbn cat.

BIOGRAPHICAL ESSAY

When she was young Lois Mailou Jones remembers drawing all the time and making storybooks that she could illustrate. Her parents sent her to the High School of Practical Arts, and she won four consecutive scholarships to attend after-school drawing classes at the Museum of Fine Arts, Boston (1919–1923). In high school she apprenticed with Grace Ripley, a costume designer at the Rhode Island School of Design. Afterward she attended the School of the Museum of Fine Arts (MFA), Boston, and was awarded the Susan Minot Lane Scholarship in Design for four consecutive years. In her senior year she received the Nathaniel Thayer Prize for excellence in design. While she was at the MFA, she took evening classes at the Boston Normal Art School. Afterward, she began

graduate studies at the Designers Art School of Boston. She began a career as a freelance fabric designer for department stores and manufacturers.

In 1928 Jones met Charlotte Hawkins Brown from the Palmer Memorial Institute Junior College, and she moved to Sedalia, North Carolina, to create an art department there. In 1930 she was recruited by James Vernon Herring to join the Department of Art at Howard University, Washington, D.C. There she worked with James A. Porter, an important scholar, and taught classes in design. In 1934 she took a summer session course at Columbia University to study masks of non-Western cultures. In 1937 she was awarded a General Education Board Fellowship to study at the Académie Julian in Paris for one year. It was there that she began to develop her own style and started to think of herself as a painter rather than a teacher and designer.

Upon her return Jones met Alain Locke, who encouraged her to move away from her impressionistic style so influenced by European painters and to introduce into her work subject matter that related to her own heritage and ancestral legacy. Like many other African American artists of the time, she began to depict a black consciousness and focused on the dignity of her subjects. Jones made frequent trips to New York, where she met many key figures in the "New Negro Movement." While many of her works from this period used African American subject matter, she continued to paint landscapes and portraits in Cubist and Postimpressionist fashion, and she traveled to France every summer from 1946 through 1953. Two works made in 1938 demonstrate her styles very well. *Rue St. Michel* is a Cezanne-like depiction of a Paris street, and *Les Fétiches* emphasizes the geometric patterns of a group of African masks. While the influence of Cubism is clear, she also uses the masks as an extension of her own cultural heritage. In later work she makes direct reference to African American experience. In her pivotal work *Meditation (Mob Victim)* 1944, Jones paints an image of both power and resignation. The lynch victim, with eyes turned upward, stands erect and dignified even in his anguish.

In 1953, Jones married Louis Vergniaud Pierre-Noël, whom she had met at Columbia University in 1934 when they were both taking summer courses. Pierre-Noël was from Haiti, and although they lived in Washington, D.C., they visited the island every year for over three decades. Even after Pierre-Noël's death in 1982, Jones continued to travel there. On her very first visit Jones was invited by Haitian President Paul E. Magliore to paint a series of works that would show the peoples and landscapes of his nation and to teach at the Centre d'Art and the Foyer des Arts Plástiques. On September 17, 1954, she was awarded the Diplôme et Décoration de L'Ordre National "Honneur et Mérite au Grade de Chevalier." The experience of Haiti significantly changed her work, and she began to incorporate Haitian life, culture, and religion in colorful, abstract, and decorative style. She depicted the markets, the rhythms, and colors and used symbols from voodoo rituals. In her work *Vendeuses de Tissus* (1961), Jones shows the bright colors worn by the vendors and the rhythms of their bodies. The clear connections to Africa in Haiti also greatly impressed Jones,

and she began to include more African imagery such as masks, sculpture, and patterns into her paintings.

In 1970 Jones visited 11 African countries in order to conduct research on the art and artists there. Through a grant from Howard University, she gathered information and interviewed artists in Ethiopia, Sudan, Kenya, Zaire, Nigeria, Dahomey, Ghana, Ivory Coast, Liberia, Sierra Leone, and Senegal. On her tour she gave lectures on African American art for the U.S. Information Service. Similar to her experiences in Haiti, the whole trip made a lasting impression on her and influenced her work. She was able to see clearly the relationship between African art and African American art. Her work of the 1970s and 1980s reflects her interest in African sculpture, textile patterns, and masks. In *Ubi Girl from the Tai Region* (1972) Jones combines new and old, painting and design, realism and symbolism.

In 1989 Jones returned to France to complete a series of Impressionist and Postimpressionist paintings in an effort to revisit the style of her early career. Later that year she suffered a heart attack but was back on her feet for the opening of her retrospective *The World of Lois Mailou Jones*. In her later years she never slowed down and continued to travel, lecture, and show her work: She was commissioned to design the movie poster for *Cry the Beloved Country*, and she gave President Bill Clinton and Hillary Rodham Clinton a watercolor for the White House when they attended her exhibit at the Red Barn Gallery, Martha's Vineyard, in 1994. She had a long and prolific career, and she was adamant that she would paint until the end. She adapted to the times and retained a strong interest in depicting the "black experience" and in producing work of the highest standards. While she was innovative throughout her career, in recent years she waited for the creative spirit to move her and remained interested in her early styles. She demonstrated her great passion for making art and is remembered by her students as having imbued in them that same passion. Jones died in the summer of 1998 at Martha's Vineyard, Oak Bluffs, in Massachusetts.

MOUTOUSSAMY-ASHE, JEANNE

Born: 1951, Chicago, Illinois. *Education*: B.F.A., Photography, The Cooper Union, New York, New York, 1975. *Family*: Widow of tennis star Arthur Ashe. Mother of one daughter, Camera. *Career*: Freelance photographer for magazines, news associations, and private and public organizations since the 1970s. Photography and graphic design for NBC, New York City, New York, 1974–1977. Photography Editor, *PM Magazine*, WNEW-TV, New York City, New York,

1982–1983. Appointed by President Clinton to serve as an Alternate Representative of the United States to the Fiftieth Session of the United General Assembly. Currently Photography Instructor at the Dalton School, New York City, New York. *Awards*: CEBA Award for IBM Advertisement, 1979. City of Chicago Mayoral Citation for *Viewfinders*, 1986. Distinguished Alumni Citation, The Cooper Union, 1990. Featured "Style Maker," Book Fair Organizer, *New York Times*, 1991. Inwood House, Iphigene Ochs Sulzberger Award for Contributions to Family Life, 1994. Mother's Voices, Care Giver Award, 1994. Catholic Big Sisters Award, 1995. National Mother's Day Committee, Outstanding Mother Award, 1996.

SELECTED EXHIBITIONS

1999	Leica Gallery, New York, New York
1996–1997	Leica Gallery, New York, New York
1993	*Daddy and Me*, Marymount School, New York, New York
1992	*DAUFUSKIE ISLAND*, Savannah College of Art and Design, Savannah, Georgia
1989	*DAUFUSKIE ISLAND*, The Elbow Room, London, England
1983	Suttons Black Heritage Gallery, Houston, Texas; Chicago Public Library Cultural Center, Chicago, Illinois
1982	Simmons College Art Gallery, Boston, Massachusetts; *Image and Imagination*, Jazzonia Gallery, Detroit, Michigan; *DAUFUSKIE ISLAND: A Photographic Essay*, The Columbia Museum of Art, Columbia, South Carolina
1979	*A Mind Is a Terrible Thing to Waste*, Art Salon, New York, New York; *Light Images*, Excelsior Hotel, Florence, Italy
1978	*South Africa: Impressions*, Just Above Midtown Gallery, New York, New York

SELECTED GROUP EXHIBITIONS

1998	*Weddings*, Leica Gallery, New York, New York
1993–1994	*The African Americans* (traveling exhibit)
1992–1994	*Songs of My People* (traveling exhibit)
1988	*Photographs*, Isobel Neal Gallery, Chicago, Illinois
1986	*Art against Apartheid: 3 Perspectives*, Schomburg Center, New York, New York; *America: Another Perspective*, New York University, New York, New York
1984	*A Group Show*, Gallery Castillo, New York, New York; *14 Photographers*, Schomburg Center, New York, New York
1982	*Group Exhibition*, Jazzonia Gallery, Detroit, Michigan
1981	*Products of the Seventies*, Cooper Union Houghton Gallery, New York

1980	*Port Authority Celebrates Black History*, World Trade Center, New York, New York
1979	*Official Portraits: Photographs of the Carter Administration*, National Portrait Gallery, Washington, D.C.; *Self-Portrait*, Black Enterprise, New York, New York
1978	*Black Photographers Annual* (traveling exhibition for the Soviet Union)
1977	*The Black Photographer*, Corcoran Gallery, Washington, D.C.
1976	*Sun People*, Benin Gallery, New York, New York

SELECTED COLLECTIONS

Columbia Museum of Art and Science, Columbia, South Carolina; National Portrait Gallery, Washington, D.C,; Schomburg Center for Research in Black Culture/New York Public Library, New York; Studio Museum of Harlem, New York, New York

SELECTED PUBLICATIONS

Ashe, Arthur. *Days of Grace*. New York: Knopf, 1993.

Ashe, Arthur. *Getting Started in Tennis*. Photographs by Jeanne Moutoussamy. New York: Atheneum, 1977.

Ashe, Arthur. *Off the Court*. New York: New American Libraries, 1981.

Black Photographers Annual. Vols. 2 and 4. Brooklyn, N.Y.: Another View, Inc., 1972, 1975.

Champions and Challengers Series. *Tracy Austin, Bjorn Borg, Franco Harris, Reggie Jackson*. EMC Publishers, 1977.

Essence. May 1986, pp. 120–121.

Essence. March 1994, p. 67.

Harper's Baazar. February 1990, p. 146.

Jet. May 8, 1980.

King-Hammond, Leslie, ed. *Gumbo Ya Ya: Anthology of Contemporary African-American Women Artists*. New York: Midmarch Arts Press, 1995.

Life. November 1993, pp. 61–68.

Mathabane, Mark. *Kaffir Boy*. New York: Random House, 1983.

Moutoussamy-Ashe, Jeanne. *Daufuskie Island: A Photography Essay*. (Foreword by Alex Haley.) Columbia: University of South Carolina Press, 1982.

Moutoussamy-Ashe, Jeanne. *Viewfinders: Black Women Photographers, 1839–1985*. New York: Dodd, Mead and Company, 1986.

Moutoussamy-Ashe, Jeanne, and Camera Ashe. *Daddy and Me: A Photo Story of Arthur Ashe and His Daughter*. New York: Knopf, 1993.

New York Times. March 3, 1991, p. 46.

Randolph, Laura B. "Jeanne Moutoussamy-Ashe: On Love, Loss and Life after Arthur." *Ebony* 48, no. 12 (October 1993), pp. 27–32.

Reynolds, Pamela. "The Black Experience in Pictures." *Boston Globe*, April 12, 1986.

Sepia. December 1981.

Songs of My People. New York: Little Brown, 1992.

Time. April 12, 1993, p. 81.

BIOGRAPHICAL ESSAY

Jeanne Moutoussamy-Ashe, photojournalist and social activist, has been working professionally since the 1970s for public/private corporations and independently. During the early stages of her career, Jeanne Moutoussamy-Ashe worked as a photographer/graphic designer for NBC News Center 4, as a contributing editor for *Self* magazine, photo commentator for television's *PM Magazine*, and photographer for the Associated Press. She has freelanced for *Life, Smithsonian, New York Times, Detroit News*, and *Sports Illustrated*. Other projects Moutoussamy-Ashe has been involved with include producing and directing *The Sun*, a film on children for the United Nations International Year of the Child, 1979; an eight-month research project in West Africa, *West African Polyrhythms and Lifestyles*, 1974; and a three-year photo documentation of African Americans on Daufuskie Island, South Carolina, 1977–1980. Jeanne Moutoussamy-Ashe also serves on several boards, serving as the Chairperson of The Arthur Ashe Endowment for the Defeat of AIDS. In 1995 she was appointed by President Clinton to serve as an Alternate Representative of the United Nations General Assembly. During her career as a photographer she has also exhibited her work in solo/group shows in New York, Chicago, Washington, D.C., and Europe.

Born and raised in Chicago, Illinois, Jeanne Moutoussamy-Ashe is the daughter of an architect father and interior designer mother. Growing up in an environment that encouraged creativity, she attended her first art classes at the Art Institute of Chicago when she was eight years old. As a teenager, exposure to the work of African American photographer Roy DeCarava inspired Jeanne to pursue that medium as a career. Upon completion of a B.F.A. in 1975 from New York's Cooper Union School of Art Jeanne began to work at NBC and met her future husband, tennis star Arthur Ashe, on a shooting assignment. After leaving NBC in 1977, Jeanne had more time to devote to artistic projects, exhibitions, public lectures, and freelance assignments.

A committed social activist, Jeanne uses her photography to visually communicate pressing issues. Her travels to South Africa in the 1980s to document black life under apartheid culminated in the 1984 exhibit *Art against Apartheid: 3 Perspectives* at the Schomburg Center for Research in Black Culture, New York Public Library. Her documentary work on black descendants of slaves living on the South Carolina island Dafuskie gave greater public exposure to these Gullah-speaking inhabitants who have retained much of their ancestors' African traditions. Jeanne's 1982 book *Daufuskie Island: A Photographic Essay* evolved into three exhibits in 1982, 1989, and 1992.

Widely acclaimed by historians, social scientists, and feminists as well as a photography audience, *Viewfinders: Black Women Photographers, 1839–1985* is Jeanne's historical survey of women who have often been unrecognized by the photography establishment. It chronicles nineteenth-century black women

working in portraiture up to contemporary photographers in the 1980s, utilizing a variety of styles and formats.

After the 1993 death of her husband Arthur Ashe from AIDS induced by a tainted blood transfusion, Jeanne took on another cause and once again used photography to relay her message. In collaboration with her daughter Camera, who provided the text, *Daddy and Me: A Photo Story of Arthur Ashe and His Daughter* is a children's book that demystifies AIDS for children, showing them how families can lead relatively normal lives when a loved one has AIDS, helping them to understand how to live with the illness and help the sick loved one and how to cope with the impending mortality. The photos portray Camera and Arthur Ashe enjoying each other's company despite impending death. The book can also be applicable to other situations in which a young child has to face the death of a parent.

Moutoussamy-Ashe continues to be involved in photographic projects, community issues, and social activism as she adjusts to the responsibilities of single parenthood. As a founding member of the Black Family Cultural Exchange, her latest efforts involve organizing book fairs for and about black children, proceeds of which go to scholarship funds and book funds for local community organizations.

MUSASAMA, SANA

Born: 1953, Queens, New York. *Education*: B.A., Ceramics/Education, City College, City University of New York, 1974. M.F.A., Ceramics, Alfred State College of Ceramics, New York, 1987. Also studied at the Archie Bray Foundation in Helena, Montana; Gakium Designer College in Tokyo, Japan; Tuscarora International School of Ceramics, Tuscarora, Nevada; and Mende Pottery, Mende Sierra Leone, West Africa. *Career*: Research Assistant, The Schomberg Center, New York, 1989. The Dalton School, New York, 1989–1994. Adjunct Professor, City College, City University of New York, 1991–present. Visiting Professor, Maryland Institute, College of Art, Baltimore, Maryland, 1994–1995. Adjunct Professor, Hunter College, City University of New York, 1995–present. *Awards*: Atlanta Life Insurance Company, 1987–1988. Empire State Craft Alliance Grant, 1989. Mid-Atlantic Grant, Baltimore, Maryland, 1990. Mid-Atlantic Grant, Manchester Guild, Pittsburgh, Pennsylvania, 1992. Pollack-Krasner Foundation, 1992. Empire State Craft Alliance Grant, 1992. Dalton School Summer Research Grant to Thailand, 1993. New York Foundation Fel-

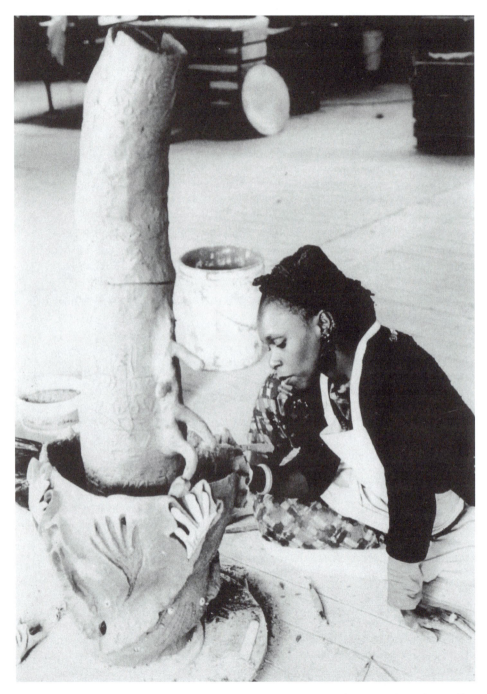

Artist Sana Musasama with *Maple Tree Series* by Sana Musasama, 1995, ceramic sculpture. Photograph by B. Vincent. Courtesy of Sana Musasama

lowship, 1995. Perspectives in African American Art, Seagrams Award, 1995–1996.

SELECTED EXHIBITIONS

1998	*Maple Tree Series*, Fine Arts Gallery, Long Island University, Southampton, New York
1997	*Maple Tree Series II*, June Kelly Gallery, New York, New York
1995	June Kelly Gallery, New York, New York
1994	*Legacy*, Sewickley Academy, Pittsburgh, Pennsylvania
1992	*Ceramic Sculpture*, Manchester Craftsman Guild, Pittsburgh, Pennsylvania
1989	*Echoes & Excavations*, Soho 20 Gallery, New York, New York
1987	*The Garden Series*, Cinque Gallery, New York, New York
1986	*Artist-in-Residence Exhibit*, Jamaica Arts Center, Jamaica, New York
1985	*Montana Series*, The Studio Museum in Harlem, New York, New York

SELECTED GROUP EXHIBITIONS

1998	*Constructions in Multiple Hues*, Painted Bride Gallery, Philadelphia, Pennsylvania; *National Conference on the Education of Ceramic Art*, Irving Arts Center, Irving, Texas
1997	*Women in Full Effect*, Rush Art Gallery, New York; *Forms and Transformations in Ceramics from Art to Industry*, Queens Borough Public Library, New York; *The Next Mill*, Cincinnati Contemporary Art Center, Cincinnati, Ohio; *Voices of Color*, Union Gallery, Purdue University, West Lafayette, Indiana
1996	*A Love of Labor*, The New Museum of Contemporary Art, New York, New York
1995–1996	*In Three Dimensions: Women Sculptors of the 90's*, Staten Island, New York; *Exploring a Movement: Feminist Visions in Clay*, Wignall Museum, Chaffey College, Rancho Cucamonga, California; *New York Clay*, Gallery BKF, Oslo, Norway
1994	American Craft Museum, New York, New York
1993	Nancy Margolis Gallery, New York, New York; Kingsborough Community College, Brooklyn, New York
1992	*Material Evidence*, Baltimore School for the Arts, Baltimore, Maryland
1991	The French Consulate, New York, New York; *Residence Show*, Greenwich House Pottery, New York, New York; June Kelly Gallery, New York, New York
1990	*The Residence Show*, Baltimore Clay Works, Baltimore, Maryland; *Box Works*, Art in General, New York, New York; *Shapeshifters*, Triplex Gallery, New York, New York

| 1988 | Cité des Arts, Paris, France; *Introductions*, June Kelly Gallery, New York, New York |
| 1987 | *Wellspring Series*, Ken Keleba Gallery, New York, New York |

SELECTED COMMISSIONS

1997	Woodburn Center, Baltimore, Maryland
1996	Stateway Gardens House, Chicago, Illinois
1992	Manchester Craftsman Guild, Pittsburgh, Pennsylvania
1985	Art Park, Lewistown, New York
1983	Art Park, Lewistown, New York

SELECTED COLLECTIONS

Archie Bray Foundation, Helena, Montana; Atlanta Life Insurance Company Atlanta, Georgia; European Ceramic Center, Hertogenbosch, Holland; Jingdezhen Ceramic Institute, China; Sande Webster Gallery, Philadelphia, Pennsylvania; The Schomburg Center for Research in Black Culture, New York, New York; The Studio Museum, New York, New York; Tuscarora Historical Museum, Tuscarora, Nevada

SELECTED PUBLICATIONS

"Adventurous Women." *Essence*, July 1995.

"African-American Artists," *Westchester Times*, November 1992, p. 11.

"Against All Odds: African-American Women Artists." *Essence*, September 1992, p. 103.

Ancient Inspirations/Contemporary Interpretations. Robertson Center for the Arts and Sciences, August 1982. Cat.

"Art Guide." *New York Times*, January 16, 1998.

Baltimore City Sun. July 9, 1997.

Bobrowski, Gina. "Simultaneous Demonstrations: Toby Buonagurio, Sana Musasama and Matt Nolan." *N.C.E.C.A. Journal* (1997), p. 52–54.

Boyle, Donald, ed. *Black Arts Annual*. New York: Garland Publishing, 1989, p. 36.

"Interview with Sana Musasama." In Phoebe Farris, ed., *Voices of Color: Art and Society in the Americas*. Atlantic Highland, N.J.: Humanities Press, 1997.

King-Hammond, Leslie, ed. *Gumbo Ya Ya: Anthology of African-American Women Artists*. New York: Midmarch Arts Press, 1995.

"Maine Coasts Artists/Rockport Watershed: The Historical Present." *Art New England 0Review* (October–November 1994), p. 31.

"The Maple Tree Series." *Cover Magazine*, May 1995, p. 10.

Modern/Post Modern Sculpture. Kenkelaba Gallery, October 1984. Cat.

Poetic License. New York: Saller Center for the Arts, SUNY/Stony Brook, December 1990. Cat.

"Sana Musasama: Maple Tree Series." *Long Island Times*, March 6, 1998.

Schlesinger, Toni. "Shelter." *The Village Voice*, January 21, 1998.

"The Stars of Today Pick the Stars of Tomorrow." *Art News* (March 1997), p. 99.

Studio Potter. Vol. 26, no. 1 (December 1997).

ARTIST STATEMENT (1998)

My development as an artist has been animated by an impulse to explore the world. In my course of inquiry into the clay cultures of the world, I have mastered various techniques, firing atmospheres, and surfaces. Enriched by this exploration, my work emerges from and exists in a domain of imaginative *freedom* that is deeply hospitable to diverse influences, concepts, and techniques. The work that has dominated my career is a series of large ceramic pieces known as the *Maple Tree Series.* These sculptures were inspired by the Maple Tree Abolitionist Movement in the late eighteenth century in New York and Holland. Dutch colonists, Native Americans, and free indentured African servants joined together in protest against slave labor on sugarcane plantations in the West Indies. They took as their symbol the maple tree—a source of sugar without exploiting slave labor. At once trees and aspects of the human body, these sculptures explore links between trees and human sexuality, between trees and human agency.

BIOGRAPHICAL ESSAY

Sana Musasama, an artist who uses the medium of clay to create sculptural and architectural structures, has been exhibiting her work and teaching ceramics since the 1980s. Sana's research into the uses of clay in other countries began in the 1970s with a trip to West Africa and accelerated in the 1980s and 1990s with research trips to China, Japan, Korea, France, Italy, Greece, Thailand, India, Vietnam, and Holland. Her work reflects her incorporation of styles she has encountered in Africa, Asia, and Europe as well as the technical background she was exposed to at Alfred State College of Ceramics, City College of New York, and the Tuscarora International School of Ceramics. Sana is a hand builder who does multiple firing, mostly at low temperature range, uses inlay, underglaze painting, "sgraffito" (pushing fired clay objects into wet clay), and is proficient in crank case oil firing, kiln building, and Raku (a Japanese ceramic technique).

Like many artists, Sana attributes much of her success to a supportive family environment. Her black working-class parents made many sacrifices to enable Sana and her sisters to attend art, piano, violin, dance, and singing lessons. Another family influence was an aunt who worked as a fashion designer after attending the New York Art and Design High School in the 1950s, an unusual school and career choice for black women in the segregated 1950s. In an interview with the author, Sana stated, "My love of my family, community, ancestry, and racial identity has empowered me and made me a survivor. It allows me to travel all over the world fearless and to mingle with all people. It is my wellspring, my reservoir."

During the 1980s Sana exhibited in solo shows in New York, many at galleries/museums that highlighted African American artists such as the Studio

Museum in Harlem, the Cinque Gallery, also in Manhattan, and the Jamaica Arts Center in Queens, which showcases emerging and mainstream artists from diverse backgrounds. Experimenting with Raku at this time, Sana worked on a series titled *Echoes & Excavations* that dealt with the bird icon as an important symbol, a metaphor for herself. The series reflected Sana's personal journey in clay during the 1970s and 1980s.

The 1990s have been especially significant for Sana's growth as an artist with solo/group shows in New York, Philadelphia, California, Cincinnati, Ohio, and Norway and write-ups in periodicals like the *New York Times*, the *Village Voice, Art News, Essence*, and *Black Arts Annual* and books such as *Gumbo Ya Ya: Anthology of African-American Women Artists* and *Voices of Color: Art and Society in the Americas*. Most of this notoriety is attributed to the success of Sana's *Maple Tree Series*, which began in 1991. Constructed of trunklike ceramic structures, usually the height of a person, the series is inspired by Sana's research into the Maple Tree Movement, an effort by the colonial Dutch, free blacks, and Native Americans to protest the importation of sugarcane and its role in the African slave trade, advocating instead the use of maple syrup as an alternative to sugarcane and its enormous toll on human life. The Dutch, free blacks, and Native Americans would march with tree branches, espousing the benefits of maple syrup tapping as opposed to using slaves in the West Indies and the southern United States to harvest sugarcane.

Reinterpreting this history in the form of ceramic sculptures also led to Sana's studying trees and their mythologies and the concept of the maple tree as a female tree, causing gender and environmental issues to surface in her work. For Sana, the trees are a fusion of symbols relevant to Native Americans, Africans, and Europeans, the sugarcane process, and gender issues. These handbuilt, heavily textured forms have been made in the United States, Holland, and Mexico, with each piece titled the *Maple Tree Series* as well as the name of the location where it was created. Over the years the trees have gone through many visual transformations—at times, branches seeming to emerge from a single root; stalks sprouting leaves, flowers, and human hands; ceramic shards and leaves covering the floor like roots; and the mixing of clay with liquid porcelain and beads.

Sana shares her love of ceramics and world travel with students at Hunter College and City College, students with class backgrounds similar to hers who often have to work their way through college. For Sana the ceramic studio functions as a community in which participants are encouraged to take risks, change, and grow in a supportive environment where Sana functions as a guide, exposing them to the richness and diversity of clay and the cultural contexts in which it is used worldwide.

In addition to functioning as an artist and educator, Sana Musasama is a businesswoman with an import/export business involving women basket makers in Vietnam. Working with women artists from other cultures that are involved

in small-scale, family-run cottage industries is one way that Sana expresses female solidarity and embraces global feminism, stating, "Feminism provides me with a personal map, a global plan, a past and future. Feminism is love of our female selves."

In Sana Musasama's art, teaching, international artist residencies, public lectures, and interviews with this author, the essence that permeates her life seems to be an openness to new surroundings, diverse peoples, and divergent sources of knowledge. In her own words, "In all the places I have lived, worked, and traveled, I have arrived open . . . leave full, . . . in a constant state of questioning, giving, creating, and reinventing. That is why I make my art."

O'GRADY, LORRAINE

Born: 1940, Boston, Massachusetts. *Education*: B.A., Wellesley College, 1961. M.F.A., Iowa Writers Workshop, University of Iowa, 1967. Bunting Institute, Radcliffe Research and Study Center, Harvard University. *Family*: Two ex-husbands, one son, and three granddaughters. *Career*: School of Visual Arts, New York, 1974–present. Senior Fellow, Vera List Center for Art and Politics, New School for Social Reasearch, New York, 1997–present. *Awards*: Project grant, New York State Council on the Arts, 1982. Fellowship, CAPS, New York State Council on the Arts, 1983. Emerging Artist Fellowship, National Endowment for the Arts, 1983. Residency, Millay Colony for the Arts, 1990. Project Grant, Art Matters, Inc., 1990. Residency, Space Program, Marie Walsh Sharpe Art Foundation, 1993. Residency, Virginia Center for the Creative Arts, 1995. Residency, The MacDowell Colony, 1995. Residency, Yaddo, 1995. Fellowship in Visual Art, Bunting Institute, Radcliffe Research and Study Center, Harvard University, 1995.

EXHIBITIONS

1996	*The Secret History: Work in Progress*, The Bunting Institute of Radcliffe College, Harvard University, Cambridge, Massachusetts
1995	*Lorraine O'Grady/Matrix 127*, Wadsworth Atheneum, Hartford, Connecticut
1993	*Photo Images: 1980–91*, Thomas Erben Gallery, New York, New York
1991	*Critical Interventions: Photomontages*, INTAR Gallery, New York, New York

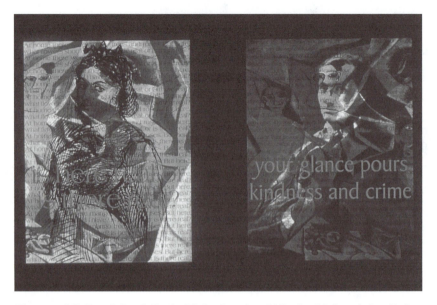

Flowers of Evil and Good (Study #1) by Lorraine O'Grady, 16-diptych installation, digital cibachrome, 36⅜" × 28¼" (ea pan). Courtesy of Lorraine O'Grady

SELECTED GROUP EXHIBITIONS

1997 *Eye of the Beholder: Photographs from the Avon Collection*, International Center of Photography, New York, New York; *Identity Crisis: Self Portraiture at the End of the Century*, Milwaukee Art Museum, Milwaukee, Wisconsin; *Vraiment: Féminisme et Art*, Centre National d'Art Contemporain de Grenoble, France; *The Gaze*, Momenta Art, Brooklyn, New York; *Composite Persona*, Fullerton Museum Center, Fullerton, California, University Art Gallery, San Diego State University, San Diego, California

1996 *New Histories*, Institute of Contemporary Art, Boston, Massachusetts; *NowHere*, Louisiana Museum of Modern Art, Humlebaek, Denmark; *Sexual Politics: Judy Chicago's Dinner Party in Feminist History*, Armand Hammer Museum at UCLA, Los Angeles, California

1995 *Laughter Ten Years After*, Zilkha Gallery, Wesleyan University, Middletown, Connecticut; *A Range of Views: New Bunting Fellows in the Visual Arts*, The Bunting Institute of Radcliffe College, Harvard University, Cambridge, Massachusetts; *Face Forward: Contemporary Self-Portraiture*, John Michael Kohler Arts Center, Sheboygan, Wisconsin

1994 *The Body as Measure*, Davis Museum and Cultural Center, Wellesley College, Wellesley, Massachusetts; *Face-Off: The Portrait in Recent Art*, Institute of Contemporary Art, Philadelphia, Pennsylvania (traveling show); *Nor Here Neither There*, Los Angeles Contemporary

Exhibitions, Los Angeles, California; *Outside the Frame: Perform-
ance & the Object*, Cleveland Center for Contemporary Art, Cleve-
land, Ohio, Snug Harbor Cultural Center, Staten Island, New York

1993 *Exquisite Corpses*, The Drawing Center, New York, New York; *Blue-
beard: The Exhibition*, The Palace Theatre, Stamford, Connecticut;
Personal Narratives: Women Photographers of Color, Southeastern
Center for Contemporary Art, Winston-Salem, North Carolina (trav-
eling show); *International Critics' Choice*, Mitchell Museum, South-
ern Illinois University, Cedarhurst, Illinois; *Color*, DIA Center for
the Arts, New York, New York; *The Nude: Return to the Source*,
Westbeth Gallery, New York, New York; *Coming to Power: 25 Years
of Sexually X-Plicit Art by Women*, David Zwirner Gallery and Simon
Watson/The Contemporary, New York, and Real Art Ways, Hartford,
Connecticut; *Songs of Retribution*, Richard Anderson Gallery, New
York, New York

1992 *Revealing the Self: Portraits by Twelve Contemporary Artists*, Bronx
Museum/PaineWebber Art Gallery, New York, New York

1988 *Art as a Verb: The Evolving Continuum*, Maryland Institute, College
of Art, Baltimore, Maryland, Met Life Gallery, New York, New York

PERMANENT COLLECTIONS

The Avon Collection, New York, New York; The Davis Museum, Wellesley College,
Massachusetts; Peter and Eileen Norton, Santa Monica, California; The Wadsworth Ath-
eneum, Hartford, Connecticut

PUBLICATIONS

Appler, Jacki. "Performance Art Is Dead! Long Live Performance Art." *High Perfor-
mance* 66 (Summer 1994), pp. 54–59.
Aukeman, Anastasia. "Lorraine O'Grady at Thomas Erben." *Art in America* (July 1994),
pp. 93–94.
Broude, Norma, and Mary Garrard, eds. *The Power of Feminist Art*. New York: Harry
N. Abrams, 1994.
Cottingham, Laura. "Lorraine O'Grady: Artist and Art Critic." *Artist and Influence*. Vol.
15. New York: Hatch-Billops Collection, Inc., 1996.
Davis, Theo. "Artist as Art Critic: An Interview with Conceptualist Lorraine O'Grady."
Sojourner: The Women's Forum (November 1996), pp. 25–28.
Feldman, Melissa. *Face-Off: The Portrait in Recent Art*. Philadelphia, Pa.: Institute of
Contemporary Art, 1994.
Fusco, Coco. "The Bodies That Were Not Ours: Black Performers, Black Performance."
Nka: Journal of Contemporary African Art 5 (Fall 1996), pp. 29–33.
Hess, Elizabeth. "The Women." *Village Voice*, November 8, 1994, pp. 91–93.
Isaak, Jo Anna. *Feminism and Contemporary Art: The Revolutionary Power of Women's
Laughter*. New York: Routledge, 1996.
Isaak, Jo Anna. *Laughter after Ten Years*. New York: Hobart and William Smith College
Press, 1995.
Lippard, Lucy. *Mixed Blessings*. New York: Pantheon, 1990.

Lippard, Lucy. *The Pink Glass Swan: Selected Feminist Essays on Art*. New York: New Press, 1995.

"Lorraine O'Grady" (Biographical artist statement). In Susan Cahan and Zoya Kocur, eds., *Contemporary Art and Multicultural Education*. New York: New Museum of Contemporary Art and Routledge, 1996.

Meyers, Terry. " 'NowHere,' Louisiana Museum of Modern Art, Humlebaek, Denmark." *World Art* 4 (1996), pp. 94–95.

Miller-Keller, Andrea. "Lorraine O'Grady: The Space Between." In *Lorraine O'Grady/ Matrix 127*. Hartford, Conn.: Wadsworth Atheneum, 1995. Exhbn brochure.

New Histories. Boston: Institute of Contemporary Art, 1996. Exhbn cat.

NowHere. Humlebaek, Denmark: Louisiana Museum of Modern Art, 1996.

O'Grady, Lorraine. "Black Dreams." *Heresies* 15 (1982), pp. 42–43.

O'Grady, Lorraine. "The Cave: Lorraine O'Grady on Black Women Film Directors." *Artforum* 30, no. 5 (January 1992), pp. 22–24.

O'Grady, Lorraine. "Dada Meets Mama: Lorraine O'Grady on WAC." *Artforum* 31, no. 2 (October 1992), pp. 11–12.

O'Grady, Lorraine. "A Day at the Races: Lorraine O'Grady on Basquiat and the Black Art World." *Artforum* 31, no. 8 (April 1993), pp. 10–12.

O'Grady, Lorraine. "Maren Hassinger: Visual Artist." In *Artist and Influence*. Vol. 12. New York: Hatch-Billops Collection, Inc., 1993, pp. 21–32.

O'Grady, Lorraine. "Mlle Bourgeoise Noire." *High Performance #13* 4, no. 2 (Summer 1981), p. 56.

O'Grady, Lorraine. "Mlle Bourgeoise Noire Goes to the New Museum." *Heresies* 14 (1982), p. 21.

O'Grady, Lorraine. "Nefertiti/Devonia Evangeline." *Art Journal* (Winter 1998).

O'Grady, Lorraine. "Nefertiti/Devonia Evangeline." *High Performance #17/18* 5, no. 1 (Spring–Summer 1982), p. 133.

O'Grady, Lorraine. "Olympia's Maid: Reclaiming Black Female Subjectivity." *After-image* 20, no. 1 (Summer 1992), pp. 14–15.

O'Grady, Lorraine. "Olympia's Maid: Reclaiming Black Female Subjectivity." In Joanna Frueh, Cassandra Langer, and Arlene Raven, eds., *New Feminist Criticism: Art/Identity/Action*. New York: Icon Editions, HarperCollins, 1994.

O'Grady, Lorraine. "SWM." *Artforum* 32, no. 8 (April 1994), pp. 65–66.

Outside the Frame/Performance and the Object: A Survey History of Performance Art in the USA since 1950. Cleveland, Ohio: Cleveland Center for Contemporary Art, 1994. Exhbn cat.

Parnes, Laura, and Jan Avgikos. *The Gaze*. Brooklyn, N.Y.: Momenta Art, 1997. Exhbn cat.

Personal Narratives: Women Photographers of Color. Winston-Salem, N.C.: SECCA, 1995. Exhbn cat.

Powell, Richard J. *Black Art in the 20th Century*. New York: Thames and Hudson, 1997.

Reid, Calvin. "A West Indian Yankee in Queen Nefertiti's Court." *New Observations: COLOR* 97 (September–October 1993), pp. 5–9.

Rosoff, Patricia. "Shadow Boxing with the Status Quo: Artist Lorraine O'Grady Refuses to Treat the Art World with Kid Gloves." *Hartford Advocate*, June 29, 1995, pp. 21–22.

Rrose Is a Rose Is a Rose: Gender Performance in Photography. New York: Solomon R. Guggenheim Museum, 1997. Exhbn cat.

Sexual Politics: Judy Chicago's Dinner Party in Feminist Art History. Los Angeles: Armand Hammer Museum of Art, University of California Press, 1996. Exhbn cat.

Temin, Christine. "ICA Creates 'New Histories' with Global Perspective." *Boston Globe*, October 25, 1996, pp. C1, C18.

Unger, Miles. "New Histories." *Flash Art* 30, no. 192 (January–February 1997), p. 61.

Vine, Richard. "Report from Denmark, Part I: Louisiana Techno-Rave." *Art in America* (October 1996), pp. 40–47.

Wilson, Judith. *Lorraine O'Grady: Photomontages*. New York: INTAR Gallery, 1991. Exhbn cat.

ARTIST STATEMENT (1995)[1]

Like many cross-cultural artists, I have been drawn to the diptych or multiple image, in which much of the important information occurs *in the space between*. And like many, I have done performance and installation work where traces of the process are left behind. In my work, "miscegenation," the pejorative legal word for the mixing of races, functions as a metaphor both for the mixed media I employ and for the difficulties and potentialities of cultural reconciliation.

Note

1. In "Lorraine O'Grady/Matrix 127," exhibition brochure, Wadsworth Atheneum, Hartford, Conn., 1995, p. 9.

BIOGRAPHICAL ESSAY

Having been raised in Boston by Jamaican parents, Lorraine O'Grady, like many children of immigrant parents, has always felt that she is negotiating between worlds. In addition, she is very aware of the effects of race, gender, and class on her life. She came late to art as a career and began as a professional, majoring in economics and working for the Bureau of Labor Statistics and the Department of State. She was the only African American at her jobs and experienced tremendous alienation, which led her to search for a method to express who she was. So, at the age of 25, she made a radical shift in her life. She quit her job, took out her retirement fund, and went to Denmark and Norway to write a novel. After completing 50 pages, she was accepted to the Iowa Writer's Workshop. In the early 1970s she became a pop culture and rock critic for the *Village Voice* and *Rolling Stone* but later began teaching at the School of Visual Arts, where she was exposed to performance art, body art, and earthworks. At the time the combination of text and image was an important method in conceptual art.

In 1979 O'Grady saw a performance by Eleanor Antin in which she dressed up as a black ballerina. O'Grady realized that she could do a better job of expressing her own experience, and having been aware of the performance work

of Adrian Piper, she decided to use this method as well. In 1980 she emerged onto the art scene with her character Mlle Bourgeoise Noire, who would appear, guerrilla-style, at art openings dressed in a gown and cape painstakingly made from 180 pairs of white gloves. She would pass out white chrysanthemums, lash herself with a cat-o'-nine-tails, throw it down, and recite a militant poem with calls to action such as "No more Boot-licking. . . . No more ass-kissing. . . . BLACK ART MUST TAKE MORE RISKS!!!" or "Wait in your alternate/ alternate spaces . . . stay in your place. . . . THAT'S ENOUGH! . . . Now is the time for an INVASION!" She first appeared at Just Above Midtown and later at the New Museum of Contemporary Art, New York, as a critique of the internalized repression she saw in black aesthetics as well as the external oppression and exclusion of the mainstream culture. O'Grady considers her work to be "high culture warfare."

Her following work, *Nefertiti/Devonia Evangeline* (1980), was a formal performance at Just Above Midtown. While this work was also critical, it took a more personal tone. Her older sister Devonia had died suddenly at the age of 38 shortly after O'Grady and her sister had had a reconciliation after years of sibling rivalry. A couple years after Devonia's death, O'Grady had traveled to Egypt and for the first time found mixed-blood people that she felt she looked like. She began to conduct extensive research on the Amarna period of Akhenaton and Nefertiti. She had always thought her sister looked like Nefertiti, and in this work she explored the family resemblances by combining visuals with storytelling. The piece examined the relationship between sisters by comparing her family relationships to those of Queen Nefertiti, who died at age 37. Included in this performance was a ritual reenacted from the Egyptian book of the dead. Not only was this a way to insure her sister's immortality, but it was a critique of pseudo-African religious practices in the United States. This work also looked at ancient Egypt's African heritage, and at the same time, O'Grady was making comparisons to her own upbringing by status-conscious immigrants. While O'Grady performed this work a number of times, she eventually turned the piece into an installation with 65 sets of images called *Miscegenated Family Album*.

The use of the diptych is common in O'Grady's work as an expression of her bicultural condition. She is interested also in critiquing the dualism of Western culture where everything is oppositional rather than hybrid. She prefers to think in terms of Both/And rather than Either/Or, and the diptych is an effective method for expressing a negotiation between both sides as well as the integration of the space between. In 1983 she curated *The Black and White Show* at Kenkeleba Gallery in New York. It displayed work in black and white by 14 African American artists and 14 Euro-American artists but received no critical response. A short time afterward O'Grady, responding to a black poet's assertion that "black people don't relate to avant-garde art," created a float for the Afro-American Day Parade in Harlem called *Art is . . .* in order to prove that unconventional work was relevant to the community.

O'Grady began to feel frustrated and discouraged by the lack of reception to

her work, and so she dropped out for five years in order to take care of her mother who had been diagnosed with Alzheimer's. She resumed her work in 1989 but moved away from performance and began working more in photography and installation. Because she felt that people were not often ready to hear her messages, she began to publish writings that would complement her work and create a theoretical context for what she was doing. In many of her pieces, she explores black female self-reclamation and subjectification rather than objectification. After she produced the work *The Clearing: Or Cortez and La Malinche, Thomas Jefferson and Sally Hemings, N. and Me* (1991), she wrote "Olympia's Maid" in order to discuss the predominant absence of the black female nude outside of her own work. She felt that many people were uncomfortable with the theme of the work and her imagery, which presented the sexual and exploitative dimensions of interracial relationships and their by-product—mixed-race children. Another work, *Flowers of Evil and Good* (1996), deals with the relationship between Baudelaire and his black common-law wife, Jeanne Duval. While Duval has historically been silenced and demonized, O'Grady attempts to introduce her as an equal participant in a complex relationship. In all of her work, O'Grady acts as a cultural critic, challenging her audience to confront difficult and often uncomfortable issues. She is confident of her intellectual prowess and is never afraid of being too demonstrative or cutting-edge.

PINDELL, HOWARDENA

Born: 1943, Philadelphia, Pennsylvania. *Education*: B.F.A., cum laude, Boston University, 1965. M.F.A., Yale University, 1967. *Career*: Exhibition assistant, 1967; Curatorial assistant, Department of Prints and Drawings, 1969; Assistant curator, Department of Prints and Illustrated Books, 1971; Associate curator, Department of Prints and Illustrated Books, 1977 at the Museum of Modern Art, New York. Associate Professor, State University of New York at Stony Brook, 1979–1984. Full Professor of Art, 1984–present. *Awards*: National Endowment for the Arts Painting Fellowship, 1972. U.S./Japan Friendship Commission Creative Artists Fellowship Exchange Program, 1981. National Endowment for the Arts Painting Fellowship, 1983. Boston University Alumni Award for Distinguished Service to the Profession, 1983. Ariana Foundation for the Arts, 1984. Guggenheim Fellowship in Painting, 1987. The College Art Association Artist Award for Distinguished Body of Work, 1990. The Studio

Museum in Harlem Artist Award, 1994. The Joan Mitchell Award, 1994. Women's Caucus for Art Honor Award for Outstanding Achievement, 1996.

EXHIBITIONS

1996	*Howardena Pindell*, N'Namdi Gallery, Chicago, Illinois, Suffolk Community College, New York
1995	*Howardena Pindell*, Arting Gallery, Cologne, Germany, N'Namdi Gallery, Birmingham, Michigan
1993	*Howardena Pindell: A Retrospective*, Roland Gibson Gallery, Potsdam College of the State University of New York (traveling show)
1991	*Howardena Pindell*, N'Namdi Gallery, Birmingham, Michigan, David Heath Gallery, Atlanta, Georgia
1989	*Howardena Pindell: Autobiography*, Cyrus Gallery, New York, New York, Liz Harris Gallery, Boston, Massachusetts; *Howardena Pindell/Matrix 105*, Wadsworth Atheneum, Hartford, Connecticut
1987	*Howardena Pindell*, N'Namdi Gallery, Detroit, Michigan
1986	*Howardena Pindell*, Grand Rapids Art Museum, Grand Rapids, Michigan, Harris/Brown Gallery, Boston, Massachusetts; *Howardena Pindell: Odyssey*, The Studio Museum in Harlem, New York
1985	*Howardena Pindell, Travelers Memories: India*, David Heath Gallery, Atlanta, Georgia
1983	*Howardena Pindell, Memory Series: Japan*, A.I.R. Gallery, New York, New York
1981	*Howardena Pindell: Works on Canvas*, Lerner-Heller Gallery, New York, New York; *Howardena Pindell: Free, White, and 21*, Videotape performance, Franklin Furnace, New York, New York
1980	*Howardena Pindell: Free, White, and 21*, Videotape performance, A.I.R. Gallery, New York, New York, University of Iowa, Iowa City, Iowa, State University of New York at Stony Brook; *Howardena Pindell*, Lerner-Heller Gallery, New York, New York; *Howardena Pindell and Jack Witten*, Trenton State College, Trenton, New Jersey

SELECTED GROUP EXHIBITIONS

1996	*WCA Honor Awards*, Rose Art Museum, Brandeis University, Waltham, Massachusetts
1995	*Language/Text/Imagery: Narratives*, Painted Bride, Philadelphia, Pennsylvania; *Western Artists/African Art*, Museum for African Art, New York (traveling show); *Land*, Terrain Gallery, San Francisco, California; *Chess*, Exit Art, New York, New York; *Ancestors*, Kenkeleba House Gallery, New York, New York; *The Emblem*, Yale University, New Haven, Connecticut
1993	*Empowering the Viewer: Art, Politics, and the Community*, Benton Museum of Art, University of Connecticut, Storrs; *The Sporting Life, 1878–1991*, High Museum of Art, Atlanta, Georgia (traveling show);

Artists Respond: The New World Question, Studio Museum in Harlem, New York; *Forms of Abstraction*, G. R. N'Namdi Gallery, Birmingham, Michigan, N'Namdi Gallery, Columbus, Ohio

1991 *The Search for Freedom: African-American Abstract Painting*, Kenkelaba House Gallery, New York, New York (traveling show); *Collage: New Applications*, Lehman College Art Gallery, New York, New York; *Art of Resistance*, Galería El Bohio, New York, New York; *In King's Image*, University of California, San Diego, California, Grove Gallery, La Jolla, California; *Gender and Representation*, Zoller Gallery, School of Visual Arts, Penn State University, University Park, Philadelphia; *Figuring the Body*, Boston Museum of Fine Arts, Boston, Massachusetts

1990 *Prophets and Translators*, The Chrysler Museum, Richmond, Virginia; *American Resources II African American Artists*, Delaware Museum, Delaware (traveling show)

1989 *Renaissance: Art of Black America*, Cheekwood Museum, Nashville, Tennessee; *Projects and Portfolios*, Brooklyn Museum, New York; *Bookworks*, Akron Museum, Akron, Ohio; *The Cutting Edge*, Fine Arts Museum of Long Island, New York; *Lines of Vision: Drawings of Contemporary Women*, Blum-Hellman Gallery, New York, New York (traveling show); *Making Their Mark: Women Artists Move into the Mainstream*, Cincinnati Art Museum, Cincinnati, Ohio (traveling show); *Traditions and Transformations: Contemporary Afro-American Sculpture*, Bronx Museum, New York; *Art as a Verb*, The Maryland Institute College of Art, Baltimore, Maryland, The Studio Museum in Harlem, New York

1988 *From the Campus to the Community*, African-American Museum, Hempstead, New York; *Opening Exhibition*, Cyrus Gallery, New York, New York; *Alice and Look Who Else Through the Looking Glass*, Bernice Steinbaum Gallery, New York, New York (traveling show); *Turning Point, Art and Politics in 1968*, Lehman College Art Gallery, Bronx, New York (traveling show); *Black Women Artists*, Museum of the National Center of Afro-American Artists, Boston, Massachusetts; *Connection Project/Conexus*, Museum of Contemporary Hispanic Art, New York, New York

1987 *Diamonds Are Forever: Artists and Writers on Baseball*, New York State Museum, Albany, New York (traveling show); *The Afro-American Artist in the Age of Cultural Pluralism*, Montclair Art Museum, Montclair, New Jersey; *Black America in Japan: Afro-American Modernism, 1937–87*, Terada Warehouse Gallery, Tokyo, Japan; *Outrageous Women*, Ceres Gallery, New York, New York

1986 *Television's Impact on Contemporary Art*, Queens Museum, New York; *Choosing*, The College of Fine Arts, Howard University, Washington, D.C.; *Howardena Pindell and Al Loving*, The Studio Museum in Harlem, New York

1985 *Since the Harlem Renaissance*, directed by SUNY at Old Westbury,

New York (traveling show); *American Women in Art: Works on Paper*, United Nations International, Women's Conference, Nairobi, Kenya; *Generations in Transition: An Exhibition of Changing Perspectives in Recent Art and Art Criticism by Black Americans 1970–84*, Hampton Institute, Hampton, Virginia

1984 *American Women Artists, Part II: The Recent Generation*, Sidney Janis Gallery, New York, New York; *East-West*, California Museum of Afro-American History and Culture, Los Angeles, California

1983 *Modernist Trends*, 22 Wooster Gallery, New York, New York

1982 *Afro American Abstraction*, Los Angeles Municipal Art Gallery, Los Angeles, California (traveling show)

1981 *Stay Tuned*, The New Museum, New York, New York

1980 *Fire and Water: Paper as Art*, Rockland Center for the Arts, West Nyack, New York

PERMANENT COLLECTIONS

ARCO, Philadelphia, Philadelphia; Brooklyn Museum, New York; Citibank, New York, New York; The Corcoran Museum, Washington, D.C.; Fogg Art Museum, Harvard University, Cambridge, Massachusetts; High Museum, Atlanta, Georgia; IBM, New York, New York; Louisiana Museum, Copenhagen, Denmark; Maryland Art Institute, Baltimore, Maryland; Metropolitan Museum, New York, New York; Museum of Contemporary Art, Chicago, Illinois; Museum of Fine Arts, Houston, Texas; Museum of Modern Art, New York, New York; National Gallery, Washington, D.C.; Newark Museum, New Jersey; New Museum of Art, New York, New York; New York Public Library, New York; Philadelphia Museum of Art, Pennsylvania; Sonja Henie Onstad Foundation, Oslo, Norway; The Studio Museum in Harlem, New York; Toledo Museum of Art, Ohio; Tranegarden Gentofte Kunstbibliotek, Hellerup, Denmark; Udine Museum, Udine, Italy; Wadsworth Atheneum, Hartford, Connecticut; Walker Art Center, Minneapolis, Minnesota; Whitney Museum of American Art, New York, New York; Yale University Art Gallery, New Haven, Connecticut; Zurich Kunsthalle, Zurich, Switzerland

PUBLICATIONS

Berger, Maurice, Lowery Sims, Tilden LeMelle, Margaret LeMelle, and David Goldberg. *Race and Representation*. New York: Hunter College Art Gallery, 1987. Exhbn cat.

Coast to Coast. Radford, Va.: Flossie Martin Gallery, Radford University, 1990. Exhbn cat.

The Decade Show. New York: New Museum; Museum of Contemporary Hispanic Art; Studio Museum in Harlem, 1990. Exhbn cat.

Failing, Patricia. "A Case of Exclusion." *Art News* 88, no. 3 (March 1989), pp. 124–131.

Fonvielle-Bontemps, Jacqueline. *Choosing: An Exhibit of Changing Perspectives in Modern Art*. Hampton, Va.: Hampton Institute, 1986. Exhbn cat.

Goode-Bryant, Linda, and Marcy S. Philips. *Contextures*. New York: Just Above Midtown, Inc., 1978.

Howardena Pindell: Paintings and Drawings: A Retrospective Exhibition, 1972–92. Roland Gibson Gallery at Potsdam College, State University of New York. Kansas City, Mo.: Mid-America Arts Alliance, 1992. Exhbn cat.

Howardena Pindell: Traveler's Memories. Birmingham, Ala.: Birmingham Museum of Art, 1985.

Lippard, Lucy. *From the Center: Feminist Essays on Women's Art.* New York: E. P. Dutton, 1976.

Lippard, Lucy. *Mixed Blessings: New Art in a Multicultural America.* New York: Pantheon, 1990.

Lippard, Lucy. *Por Encima del Blogrieo.* Havana, Cuba: Centro Wifredo Lam. Exhbn cat.

McNeil, Wendy, and Clement Price. *The Afro-American Artist in the Age of Cultural Pluralism.* Montclair, N.J.: Montclair Art Museum, 1987. Exhbn cat.

Miller, Lynn F., and Sally S. Swenson. *Lives and Works: Talks with Women Artists.* Metuchen, N.J.: Scarecrow Press, 1981.

Miyamoto, Michiko, and Makoto Nagasawa. *Americans' Point of View about Japanese People.* Tokyo: Soshisha Publishing Company, 1982.

Odyssey: Howardena Pindell. New York: The Studio Museum in Harlem, 1986. Exhbn cat.

Pindell, Howardena. "Art World Racism: A Documentation." *New Art Examiner* 16, no. 7 (March 1989), pp. 32–36.

Pindell, Howardena. *Autobiography: In Her Own Image.* New York: INTAR Latin American Gallery, 1988. Exhbn cat.

Pindell, Howardena. "Breaking the Silence." *New Art Examiner* 18, no. 2 (October 1990), pp. 18–23.

Pindell, Howardena. "Criticism/Or/Between the Lines." *Heresies* 2, no. 4 (February 1979), pp. 2–4.

Pindell, Howardena. "From Sea to Shining Sea." *Heresies* 6, no. 4 (1989), p. 79.

Pindell, Howardena. "Untitled." *Issue: A Journal for Artists* (Spring 1986), p. 42.

Pindell, Howardena. *The Writings and Paintings of Howardena Pindell.* New York: Midmarch Arts Press, 1996.

Robbins, Corrine. *The Pluralist Era: American Art, 1968–1981.* New York: HarperCollins, 1984.

Rosen, Randy. *Making Their Mark: Women Artists Move into the Mainstream, 1970–1985.* New York: Abbeville Press, 1989.

Rubenstein, Charlotte Streifer. *American Women Artists.* Boston: G. K. Hall, 1982.

Sims, Lowery Stokes. "The Mirror/The Other." *Artforum* 28, no. 7 (March 1990), pp. 111–115.

White, Clarence. "Howardena Pindell." *Art Papers* (July–August 1991), pp. 34–37.

Wilson, Judith. "Howardena Pindell Makes Art That Winks at You." *Ms.* 8, no. 5 (May 1980), pp. 66–70.

ARTIST STATEMENT[1]

The goal of my work is to share knowledge. This is the reason I have also been writing as well as painting, teaching, and giving some public lectures. I

do not feel very much part of the art world because of the restrictive environment that is brought to it by people who are pathologically indifferent. I do not see art and life as separate.

Note

1. In "Howardena Pindell: Paintings and Drawings, 1972–92," exhibition catalogue, Exhibits USA, p. 21.

BIOGRAPHICAL ESSAY

After her third-grade teacher recognized her special talent for art, Howardena Pindell's parents enrolled her in free Saturday morning classes at the Fleischer School. She went on to major in art in college and graduate school but felt very isolated because she was one of only a few African American students and was constantly aware of being treated differently. After school Pindell had trouble finding a job teaching but lucked into a position at the Museum of Modern Art as an exhibition assistant in the Department of National and International Circulating Exhibitions. In 1969 she became Curatorial Assistant in the Department of Prints and Drawings, in 1971, Assistant Curator of Prints and Illustrated Books, and in 1977, Associate Curator in the same department. She left the Museum in 1979 to become Associate Professor at the State University of New York at Stony Brook, where she is currently a Full Professor.

Pindell was trained as a figurative painter, but when she moved to New York and started working, she could no longer paint during the day. Without access to daylight she began to experiment with color and light, which led to her abstract dot and grid work of the 1970s. By punching holes, she made stencils or templates that she could use to spray paint through. The punched holes accumulated, and she ended up with bags and bags of tiny dots. Since she was fascinated with numbers, she began to number some of the dots and remembered from her childhood that her father had worked with numbers and that he used to keep track of mileage on road trips. She equated numbers with distance, size, mass, quantity, and identification but ultimately used them in grids as a visual concern and not as a conceptual tool. The unnumbered dot works became studies in accumulation of color, space, and surface texture. The effects were very sculptural, and the body of work explored contrasts such as planned or accidental and confinement or overflow. But underneath the seemingly random surfaces was always the grid that reflected her thoughts about a technological society. As Pindell began to move away from rigid forms, she started to introduce sewing into her canvases, thereby lending a different form of physicality and geometry. Her work from this early period was a form of meditation for Pindell and a way of escaping and dealing with the rage and frustration she felt as a result of racism, sexism, and discrimination.

Since abstraction was not considered a valid form of expression for African

American artists at this time, Pindell turned to the women's movement and helped found a collective called A.I.R. Gallery. As the only black woman in this organization, Pindell began to feel like a token and further felt that issues specific to her existence as an African American woman artist were not being addressed. By the late 1970s Pindell became more involved in political activism. The main instigator was a show at Artist's Space in 1979 called *Nigger Drawings*. This show outraged the black community, and a protest ensued. Pindell began to feel tensions at work, and because of this and her frustration that she was still powerless to help other African American and women artists, she decided to leave.

In 1980 Pindell made the work *Free, White, and 21*, a video that was inspired by her experience with the women's movement. With the camera pointed directly at her, Pindell recounts incidents of prejudice in her own life. She plays herself as well as a white character who tells her she must be paranoid. It is a particularly personal piece that testifies to her own experience while exposing racism in the art world. It signified a turning point in Pindell's work because she was becoming increasingly dissatisfied with the lack of explicit political imagery in her work. In addition, memory plays a big part after this point because Pindell was in a serious car accident in 1979, from which she experienced memory loss. As an exercise, she began to use postcards and photographs from her extensive travels in order to recreate her impressions of different places. Each new country profoundly influenced the style and content of her work.

In 1982 Pindell traveled to Japan on a U.S.-Japan Friendship Commission Creative Artist Grant. She was there for eight months, and the body of work that emerged from her experience was more circular and organic in shape than earlier work. She was inspired by Mount Fuji and by the Zen gardens as well as by a visit to the Peace Museum. In 1984 she traveled to India on a National Endowment for the Arts Painting Fellowship. Her work became more sinuous and S-shaped like coiled snakes or flowing rivers. She was inspired by the meditative quality of India's cultures and the spirituality of the religions. The series of works that came out of these experiences were like travelogues or personal narratives. Not all of her experiences were positive, however. She found Japan to be quite rigid and very rascist, and in India there was so much poverty and suffering.

The series of work that came out of the late 1980s was much more about autobiography, and Pindell often used her own image. This series brought together a number of key personal and aesthetic issues in her work. Some of the issues she wanted to address were definition of self, miscegenation, mixed heritage, appearance, images of people of color in the media, omission and appropriation, criticism, and stereotyping. The *Autobiography* series is made up of two types of work. One type is unstretched canvas; the other is photocollage, but they are often mixed together. Both styles reflect Pindell's interest in discovering things under intense scrutiny that blend into a whole when viewed from far away. Her large-scale work, when viewed up close, is filled with in-

tricate and obsessive details. While many works emerge out of her own personal experiences, they also reflect public concerns. In the work *Autobiography: Water/Ancestors/Middle Passage/Family Ghosts* (1988) Pindell uses a silhouette of her own body, cut out of the canvas and sewn back in, as the central image while surrounding it are symbols of her multicultural heritage, African American experience, and a narrative about unspoken histories. This body of work represents both rupture and healing, and Pindell continues to work in this mode, combining aesthetics with politics and testimony. While Pindell continues to create work, she perseveres in exposing racism in the art world through her persistent research.

PIPER, ADRIAN MARGARET SMITH

Born: 1948, New York City, New York. *Education*: A.A. School of Visual Arts, New York, 1969. B.A., City College of New York, 1974, M.A., 1977, and Ph.D., Harvard University, Cambridge, Massachusetts, 1981. Advanced studies, University of Heidelberg, Germany. *Family*: Parents are deceased. She is divorced and has no children. *Career*: Professor of Philosophy, Wellesley College. Non-Resident Fellow of the New York Institute for the Humanities at New York University. Has taught at Harvard, Stanford, University of Michigan, University of California at San Diego, and Georgetown University. *Awards*: Visual Artists Fellowship, National Endowment for the Arts, 1979. Visual Artists Fellowship, National Endowment for the Arts, 1982. Art Matters, Inc., 1987. John Simon Guggenheim Memorial Fellowship, 1989. New York State Council on the Arts, 1989. Awards in the Visual Arts, 1990.

SELECTED EXHIBITIONS

1994	*The Hypothesis Series 1968–70*, Paula Cooper Gallery, New York, New York
1992	*Ur-Madonna, Expo '92*, Monasterio de Santa Clara, Moguer (Huelva), Spain; *Decide Who You Are*, Grey Art Gallery, John Weber Gallery, Paula Cooper Gallery, New York, New York
1991	*What It's Like, What It Is, #2*, Hirshhorn Museum, Directions Gallery, Washington, D.C.; *Adrian Piper: European Retrospective*, Ikon Gallery, Birmingham, England (traveling show); *Space, Time, and Reference 1967–1970*, John Weber Gallery, New York, New York
1990	*Pretend*, John Weber Gallery, New York, New York; *Out of the*

Corner, Whitney Museum of American Art, Film and Video Gallery, New York, New York

1989 *Cornered*, John Weber Gallery, New York, New York

1987 *Adrian Piper: Reflections, 1967–1987*, The Alternative Museum, New York, New York (traveling show)

1980 *Adrian Piper at Matrix 56*, Wadsworth Atheneum, Hartford, Connecticut; *Adrian Piper*, Real Artways, Hartford, Connecticut

1976 *Adrian Piper*, Gallery One, Montclair State College, Montclair, New Jersey

1969 *Three Untitled Projects*, postal art exhibition, New York, New York

SELECTED GROUP EXHIBITIONS

1996 *NowHere*, Louisiana Museum of Modern Art, Humlebaek, Denmark; *Devant l'Histoire*, Centre Georges Pompidou, Paris, France

1995 *Public/Private: ARS 95*, Museum of Contemporary Art, Finnish National Gallery, Helsinki, Finland; *Africus: South Africa Bienniale*, Johannesburg, South Africa; *Reconsidering the Object of Art: 1965–1975*, Museum of Contemporary Art, Los Angeles, California

1994 *L'Hiver de l'Amour*, Musee d'Art Moderne de Ville de Paris, France; *Mappings*, The Museum of Modern Art, New York, New York; *Gewalt/Geschäfte*, Neue Gesellschaft für bildende Kunst e.V., Berlin, Germany

1993 *The Boundary Rider: 9th Biennale of Sydney*, Gallery of New South Wales, Australia; *Kontext Kunst*, Neue Galerie, Graz, Austria

1992 *Dream Singers, Story Tellers: An African American Presence*, Fukyui Fine Arts Museum, Fukyui-ken, Japan

1991 *What It's Like, What It Is, #3*, Dislocations, Museum of Modern Art, New York, New York

1989 *L'Art Conceptuel: Une Perspective*, Musee d'Art Moderne, Paris, France (traveling show)

1985 *Kunst mit Eigen-Sinn*, Museum Moderner Kunst, Vienna, Austria

1977 *Paris Biennale*, Musee d'Art Moderne, Paris, France

1975 *Bodyworks*, Museum of Contemporary Art, Chicago, Illinois

1971 *Paris Biennale*, Musee d'Art Moderne, Paris, France

1970 *Conceptual Art and Conceptual Aspects*, New York Cultural Center, New York, New York; *Information*, Museum of Modern Art, New York, New York

1969 *Number Seven*, Paula Cooper Gallery, New York, New York; *Language III*, Dwan Gallery, New York, New York; *Concept Art*, Stadisches Museum, Leverkusden, West Germany; *Plans and Projects as Art*, Kunsthalle, Bern, Switzerland

PERMANENT COLLECTIONS

Museum of Contemporary Art, Chicago; Museum of Fine Arts, Houston; University of California at Berkeley Art Museum; Wadsworth Atheneum, Hartford, Connecticut; Wexner Center of Ohio State University, Columbus, Ohio; Whitney Museum of American Art, New York; Williams College Museum of Art, Williamstown, Massachusetts

PUBLICATIONS

Appiah, Anthony. "Art Beat." *Village Voice Supplement* (October 1992), p. 12.

Baldauf, Anette. "Rassismus und Fremdenangst: Gesprach mit der Konzeptkunstlerin und Philosophin Adrian Piper." *Wiener Zeitung Kulturmagazin*, 1993, p. 16.

Barrow, Claudia. "Adrian Piper: Space, Time, and Reference 1967–1970." In *Adrian Piper*. Birmingham, England: Ikon Gallery, 1991. Exhbn cat.

Berger, Maurice. "The Critique of Pure Racism: An Interview with Adrian Piper." *Afterimage* 18, no. 3 (October 1990), pp. 5–9.

Blase, Christophe. "Sezierte Angst—Eine politische Kunstlerin: Adrian Piper in Munchen." *Frankfurter Allgemeine Zeitung*, November 3, 1992.

Brenson, Michael. "Adrian Piper's Head-on Confrontation of Racism." *New York Times*, October 26, 1990, p. C36.

Cottingham, Laura. "Adrian Piper." *Journal of Contemporary Art* 5, no. 1 (Spring 1992), pp. 88–136.

Hayt-Atkins, Elizabeth. "The Indexical Present: A Conversation with Adrian Piper." *Arts Magazine* (March 1991), pp. 48–51.

Johnson, Ken. "The Artist as Intellectual Warrior." *Art in America* 85, no. 1 (January 1997), pp. 29–30.

Johnson, Ken. "Being and Politics." *Art in America* 78, no. 9 (September 1990), pp. 154–161.

Lewis, Jo Ann. "Images That Get under the Skin." *Washington Post*, June 27, 1991, pp. G1, G5–G6.

McWilliams, Martha. "Gallery Panel Discussion." *Washington City Paper*, February 19, 1993, p. 44.

Perree, Rob. "Adrian Piper: Plaatst de waarheid boven de schoonheid." *Kunst Beeld Nr. 11* 15 (November 1991), pp. 32–34.

Piper, Adrian. *Colored People*. London: Bookworks, 1991.

Piper, Adrian. *Decide Who You Are*. New York: Paula Cooper Gallery, 1992.

Piper, Adrian. *Here and Now*. Independently published by the artist, 1968.

Piper, Adrian. *Out of Order, Out of Sight*. Vol. 1, *Selected Writings on Meta-Art 1968–1992*. Cambridge, Mass.: MIT Press, 1996.

Piper, Adrian. *Out of Order, Out of Sight*. Vol. 2, *Selected Writings in Art Criticism 1967–1992*. Cambridge, Mass.: MIT Press, 1996.

Piper, Adrian. *Talking to Myself: The Ongoing Autobiography of an Art Object*. Brussels, Belgium: Fernand Spillemaeckers, 1974.

Quatman, Christian. "Mittlerin zwischen Mainstream und Marginalitat." *Kunstforum International* 118 pp. 221; 229–232.

Raven, Arlene. "Civil Disobedience." *Village Voice*, September 25, 1990, Arts Section, cover, pp. 55, 94.

Thompson, Mildred. "Interview: Adrian Piper." *Art Papers* 12, no. 2 (March–April 1988), pp. 27–30.

Van Tuyl, Laura. "Artist Adrian Piper Mounts Urgent Challenge to Racism in Society." *Christian Science Monitor*, July 19, 1991, p. 10.
Weil, Benjamin. "Interview with Adrian Piper." *Purple Prose* 3 (Paris: Summer 1993), pp. 74–79.
Wilson, Judith. "In Memory of the News and of Ourselves: The Art of Adrian Piper." *Third Text* 16–17 (Autumn–Winter 1991), pp. 39–62.

ARTIST STATEMENT[1]

Blacks like me are unwilling observers of the forms racism takes when racists believe there are no blacks present. Sometimes what we observe hurts so much we want to disappear, disembody, disinherit ourselves from our blackness. Our experiences in this society manifest themselves in neuroses, demoralization, anger, and in art.

Note

1. In Lucy R. Lippard, *Mixed Blessings: New Art in a Multicultural America* (New York: Pantheon Books, 1990), p. 43.

BIOGRAPHICAL ESSAY

As both philosopher and artist, Adrian Piper deftly combines politics, art, and theory. Working in a variety of mediums including performance and video, she has confronted issues surrounding racism, stereotyping, xenophobia, and race relations throughout the span of her career. Her education has encompassed degrees both in Fine Arts and in Philosophy, and the written and spoken word are particularly important to her work. The daughter of a secretary at City College and a real estate lawyer, she grew up in Harlem where her light skin made her a target for taunting and nicknames such as "paleface." She attended the New Lincoln School on scholarship, which made her feel distinctly separate from the children in her own community. At the same time, she was exposed to racism at this private white school and therefore felt a keen sense of difference and alienation. When she was a teenager she took classes at the Art Students League, and when she entered the School of Visual Arts, she was very committed to art.

While Piper had been making figurative, mildly surrealist work since grade school, in her second year at the School of Visual Arts she was exposed to a wide variety of contemporary art. She was particularly influenced by Sol LeWitt and his ideas about Conceptual art. Piper explains that this and the political activism of the art world in the 1970s really had an impact on her life and work. It is important to note that simultaneous to her art making is her extensive writing, which clarifies and explains what she is doing. She initiated this practice in part because she felt at a loss to define any of her work by the aesthetic

principles that she had been taught. Her first major work was a series of street performances called *Catalysis* (1970). In these pieces, she altered her physical appearance and demonstrated antisocial behavior in order to explore gender and body issues and to examine the roots of prejudice and bias. For example, she appeared in public in clothes that smelled or were sticky with white paint, or she attached balloons to her ears, nose, teeth, and hair, or she concealed a tape recorder on her body that played loud belching noises at five-minute intervals. During each performance, she would study people's reactions.

In 1974 Piper developed a male alter ego called the *Mythic Being*. Playing a black or Latino street kid, she would appear on the street and swagger, stride, or lope accordingly. This work developed into posters and ads where the visual image of the *Mythic Being* appeared monthly in the *Village Voice* gallery page with a cartoonlike thought balloon containing statements statement such as "I embody everything you most hate and fear." She continued to combine text and image in her *Political Self Portraits* (1978–1980) in which she superimposed an image of herself with text relating to a personal experience. In 1981 she made the work *Exaggerating My Negroid Features*, and in 1983 she started conducting lecture demonstrations called *Funk Lessons*. Not only did she want to challenge the preconceived notion that all African Americans have rhythm, but she wanted to confront white cultural discomfort with black popular music and its African sources. Around this time she was also conducting guerrilla performances in social settings where she heard racist comments that were made in her presence by someone who did not know she was black. As an unwilling observer of racism, she developed *My Calling (Card) #1 (for Dinners and Cocktail Parties)* (April 1986–1990) and *My Calling (Card) #2 (for Bars and Discos)* (June 1986–1990). If she heard a remark or experienced unwanted attention, she would hand the offender one of the cards that read either "Dear Friend, I am black. I am sure you did not realize this when you made/laughed at/agreed with that racist remark . . ." or "Dear Friend, I am not here to pick anyone up. . . . Thank you for respecting my privacy." In this way she forced people to confront their racism and sexism and to accept their own responsibility to do something about it.

Piper's later work is more image and text based and less performative. She began to use more advertisements, video, and photographs. In her *Vanilla Nightmare Series* (1986–1990) she took pages from the *New York Times* with loaded imagery or text and drew on them with charcoal or oil crayon. The images she added relate to the deep fears, anxieties, and fantasies about African Americans that exist deep down in a racist society. The black figures are animalistic, lascivious, violent, and forceful as they surround the white models in advertisements or crowd out logos. The images confront fears about sexuality, miscegenation, and loss of self through invasion by the "other." In her video installation *Cornered* (1988), Piper speaks directly to a white audience about the intermingling of white and black blood that has occurred for 400 years in

this country. She reasons with her audience, in the tone of a teacher talking to her students, that many white Americans have some black blood in their lineage.

As a conceptual artist, Piper uses her experiences of marginalization and alienation to re-form herself in constructive ways as a form of self-defense. She is interested in pursuing a society of tolerance, empathy, and acceptance, free of racism and racial stereotyping. She does not consider her work to be directly autobiographical but rather uses her personal experiences to comment upon what she sees as the social diseases of racism and xenophobia. She uses art as a tool for consciousness raising, provocation, confrontation, and profound thought about deep-seated racist attitudes. She prefers to work on a personal level with her audience in order to promote their self-awareness and to influence political change by reflection upon their own racism or experience of racism. She relies on immediacy and the direct relationship to the viewer's own experiences in life to get people to reflect upon their own reality and to accept accountability rather than to express doubt at their own complicity in racism. Conceptual art not only allows her to present the priority of the message over the aesthetics of the image, but it offers her great flexibility of medium so that she can choose the appropriate method for the missive, whether drawing, audiotape, performance, text, video, installation, film, or choreography.

RINGGOLD, FAITH

Born: 1930, Harlem, New York. *Education*: B.S., Fine Art, City College of New York, 1955. M.A., Art, City College of New York, 1959. *Family*: Daughter of Willi Posey Jones, a fashion designer. Mother of Michele Wallace, a cultural arts critic, and Barbara Wallace, a linguist. *Career*: New York City Public School art teacher, 1955–1973. Part-time instructor at Bank Street College, Pratt Institute, and Wagner College, 1970. Visiting Associate Professor at University of California, San Diego, 1984. Appointed tenured Full Professor in Visual Arts at University of California, San Diego, 1985. *Awards*: American Association of University Women Travel Award to Africa, 1976. National Endowment for the Arts, 1978. MacDowell Colony Grant, 1982. Award for Sculpture, 1982. Wonder Woman Award from Warner Communications, 1983. CAPS Grant from New York State Council of the Arts, 1984. Honorary Doctorate from Moore College of Art in Philadelphia, Pennsylvania, 1986. Candace Award from One Hundred Black Women, 1986. Guggenheim Fellowship, 1987. Public Art Fund from the New York and New Jersey Port Authority, 1987. Honorary Doctorate from the College of Wooster, Wooster, Ohio, 1987. New York Foundation for

the Arts Award for Painting, 1988. LaNapoule Artist Residency in France, 1988. Mid-Atlantic Arts Foundation Award, 1988. Honorary Doctorate from City College of New York, 1988. Henry Clews Foundation Award for painting in the South of France, 1990. New York Times Children's Book Award, 1992. Caldecott Honor for the best illustrated children's book of 1991, 1992. Coretta Scott King Award for the best illustrated book by an African American, 1992. Metropolitan Transit Authority Mural Commission, 1992. National Endowment for the Arts Travel Award, 1993. Honorary Doctorate from the California College of Arts and Crafts, 1993. Honorary Doctorate from Rhode Island School of Design, 1994. Townshend Harris Medal from the City College of New York Alumni Association, 1995. Honorary Doctorate from Russell Sage College, 1996. Honorary Doctorate from Wheelock College in Boston, 1997. Honorary Doctorate from Molloy College in New York, 1997. New Jersey Artist of the Year from the New Jersey Center for the Arts, 1997.

SELECTED EXHIBITIONS

1998	*Dancing at the Louvre: Faith Ringgold's French Collection and Other Story Quilts*, Berkeley Art Museum, University of California, Berkeley, Berkeley, California
1996	*Faith Ringgold: Story Quilts*, Bowling Green State University, Bowling Green, Ohio
1995	*Faith Ringgold: Masks and Dolls*, Indiana University of Pennsylvania, Indiana, Pennsylvania; *Faith Ringgold: Paintings and Drawings Spanning Four Decades*, ACA Galleries, New York, New York; *Children's Stories by Faith Ringgold*, Athenaum: Music and Arts Library, LaJolla, California
1994	*Currents 57: Faith Ringgold*, St. Louis Art Museum, St. Louis, Missouri; *Dinner at Aunt Connie's House* and *Aunt Harriet's Underground Railroad in the Sky*, Hewlett-Woodmere Public Library, Hewlett, New York
1993	*Tar Beach*, Children's Museum of Manhattan, New York, New York; *Inspirations: Exploring the Art of Faith Ringgold*, Textile Museum, Washington, D.C.
1990	*Faith Ringgold: A Twenty-five Year Survey*, Fine Arts Museum of Long Island, Hempstead, New York (traveling exhibit)
1987	*Faith Ringgold: Painting, Sculpture, Performance*, College of Wooster Art Museum, Wooster, Ohio
1984	*Faith Ringgold: Twenty Years of Painting, Sculpture and Performance (1963–1983)*, Studio Museum in Harlem, New York
1977	*Festac 77*, Lagos, Nigeria, Africa
1973	*Ten Year Retrospective*, Voorhees Gallery at Rutgers University, New Jersey
1970	*America Black*, Spectrum Gallery, New York, New York

1967 Spectrum Gallery, New York, New York

SELECTED GROUP EXHIBITIONS

1997 *American and European Painting and Sculpture and Contemporary
 Art*, ACA Galleries, New York, New York; *Community of Creativity:
 A Century of MacDowell Colony Artists*, National Academy Museum,
 New York, New York (traveling exhibition); *Threads: Fiber Art in
 the 90's*, New Jersey Center for the Arts, Summit, New Jersey; *Face
 à l'Histoire*, Centre Georges Pompidou, Paris, France

1996 *Bearing Witness: Contemporary Works by African-American Artists*,
 Spelman College Museum of Fine Art, Atlanta, Georgia; *Heralding
 the 21st Century: Contemporary African American Women Artists*,
 Spelman College Museum of Fine Art, Atlanta, Georgia; *The
 Oklahoma City Children's Memorial Art Quilts*, Oklahoma City,
 Oklahoma; *Labor of Love*, The New Museum of Contemporary Art,
 New York, New York; *Quilts and Oral Traditions in Black Culture*,
 Museum for Textiles, Toronto, Canada; *Art, Design and Barbie: The
 Evolution of a Cultural Icon*, World Financial Center, New York,
 New York (traveling exhibition)

1995–1996 *"Rainbow" Bob Blackburn's Printmaking Workshop Exhibition*, La-
 gos, Nigeria (traveling exhibit)

1995 *Artists on Artists*, Gallery Swan, New York, New York; *The Recon-
 structed Figure: The Human Image in Contemporary Art*, Katonah
 Museum of Art, Katonah, New York; *Women's Work*, White House,
 Washington, D.C.; *Illustrations from Caldecott Books*, Art Institute
 of Chicago, Chicago, Illinois; *UCSD Faculty Exhibition*, UCSD Uni-
 versity Art Gallery, San Diego, California; *Ancestors*, Asian Ameri-
 can Arts Center, New York, New York; *10 × 10: Ten Women, Ten
 Prints, a Portfolio of Silkscreen Prints*, Berkeley Arts Center, Berke-
 ley, California; *Division of Labor "Women's Work" in Contempo-
 rary Art*, Bronx Museum, Bronx, New York; *Fashion Is a Verb*,
 Fashion Institute of Technology, New York, New York; *(In) Forming
 the Visual: (Re) Presenting Women of African Descent*, Montgomery
 Gallery, Pomona College, Pomona, California; *Cocido y Crudo*, Mu-
 seo National Centro de Arte Reina Sofía, Madrid, Spain

1994 *Strategies of Narration: The Fifth International Cairo Biennial 1994*,
 Aknaton Gallery, Cairo, Egypt; *The Impact of Slavery: "It's More
 Than Just Another Art Show,"* Firehouse Art Gallery, Garden City,
 New York; *Girls and Girlhood: A Perilous Path*, UNICEF, United
 Nations, New York, New York (traveling exhibit); *Odun de- Odeun
 de-*, California College of Arts and Crafts, Oakland, California; *Po-
 litical Imagery from the Black Arts Movement of the 1960's and
 1970's: Black Power: Black Art . . . and the Struggle Continues,* San
 Francisco State University Art Department Gallery, San Francisco,
 California; *Old Glory: The American Flag in Contemporary Art*,
 Cleveland Center for Contemporary Art, Cleveland, Ohio; *Women's*

Caucus for the Arts Honor Awards, Queens Museum of Fine Art, Flushing, New York

1993 *Interior Vision: The Illustrator's Eye*, Cinque Gallery, New York, New York; *The Definitive Contemporary American Quilt*, Southern Ohio Museum, Portsmouth, Ohio; *New Developments in American Fiber Art: USA Today*, Museum of the Applied Arts, Helsinki, Finland; *USA Today: In Fiber Art,* Netherlands Textile Museum, Tilburg, Netherlands; *Reflections of a King*, National Civil Rights Museum, Memphis, Tennessee; *Fiber Art*, National Institute of Art and Disabilities, Richmond, California

1992 *Dream Singers: Story Tellers: An African American Presence*, New Jersey State Museum, Trenton, New Jersey (traveling exhibit); *Ancestors Known and Unknown: Boxworks by Coast to Coast National Women Artists of Color*, Women and Their Work Center, Austin, Texas (traveling exhibit)

1988 *Through a Master Printer: Robert Blackburn and the Printmaking Workshop*, Columbia Museum of Art, Columbia, South Carolina; *1938–1988: The Work of Five Black Women Artists*, Atlanta College of Art, Atlanta, Georgia

1968 *Martin Luther King Jr. Benefit*, Museum of Modern Art, New York, New York

SELECTED FILMS AND VIDEOS

1995 *Faith Ringgold Paints Crown Heights*, color video, sound, 28 min., distributed by Home Visions, Las Video Enterprises, Chappaqua, New York

1994 *Tar Beach with Faith Ringgold*, color video, sound, 15 min., distributed by Scholastic, New York

1991 *Portrait of an Artist: Faith Ringgold: The Last Story Quilt*, color video, sound, 28 min., distributed by Home Visions, Las Video Enterprises, Chappaqua, New York

1990 *Faith Ringgold*, color video, sound, 6 min., distributed by Random House, New York

1983 *No Name Masked Performance #2*, color film, sound, 16 mm, distributed by San Antonio College, Texas

1975 *Sexual Imagery and Censorship*, color film, sound, 16mm, distributed by Art Documentation, Queens College Library, New York; *Faith Ringgold*, black and white film, sound, 16mm, distributed by Women's Archive, Women's Institute Center, New York

1970, 1974 *Black Artists in America, Part III*, color film, sound, 16mm, and *Black Artists in America, Part IV*, color film, sound, 16mm, produced and directed by Oakley Holmes, Jr.

SELECTED COLLECTIONS

ACA Galleries, New York, New York; David Rockefeller/Chase Manhattan Bank Art Collection, New York, New York; Guggenheim, Museum, New York, New York; The High Museum of Atlanta, Atlanta, Georgia; The Metropolitan Museum of Art, New York, New York; Phillip Morris Co., North Carolina; St. Louis Art Museum, St. Louis, Missouri

SELECTED PUBLICATIONS

Baraka, Amiri. "Faith." *Black American Literature Forum* (Spring 1985) p. 12.

Bontemps, Arna Alexander, ed. *Forever Free: Art by African-American Women 1862–1980.* Normal, Ill.: Center for the Visual Arts Gallery, Illinois State University, 1980.

Broude, Norma, and Mary Garrard, eds. *The Power of Feminist Art.* New York: Harry N. Abrams, 1994.

Cameron, Dan, ed. *Dancing at the Louvre: Faith Ringgold's French Collection and Other Story Quilts.* Berkeley and Los Angeles: University of California Press, 1998.

Damsker, Matt. "Performance Art Creates a Tableau." *Los Angeles Times*, February, 1984.

Davis, Marianna W. *Contributions of Black Women to America: The Arts.* Columbia, S.C.: Kenday Press, 1982.

Faith Ringgold: A Twenty-five Year Survey. Hempstead, N.Y.: Fine Arts Museum of Long Island, 1990. Exhbn cat.

Faith Ringgold, Change: Painted Story Quilts. New York: Bernice Steinbaum Gallery, 1987. Exhbn cat.

Fax, Elton C. *Seventeen Black Artists.* New York: Dodd, Mead & Co., 1971.

Fine, Elsa Honig. *Afro-American Artist.* New York: Holt, Rinehart and Winston, 1973.

Glueck, Grace. "An Artist Who Turns Cloth into Social Commentary." *New York Times*, July 29, 1984.

Hine, Darlene Clark, ed. *Black Women in America: An Historical Encyclopedia.* Brooklyn: Carlson Publishing, 1993.

King-Hammond, Leslie, ed. *Gumbo Ya Ya: Anthology of Contemporary African-American Women Artists.* New York: Midmarch Arts Press, 1995.

Lewis, Samella. *African-American Art and Artists.* Berkeley: University of California Press, 1978, 1990.

Miller, Lynn, and Sally Swenson. *Lives and Works: Talks with Women Artists.* New York: Simon and Schuster, 1979.

Munro, Eleanor. *Originals: American Women Artists.* New York: Simon and Schuster, 1979.

Powell, Richard J. *Black Art and Culture in the 20th Century.* London: Thames and Hudson, 1997.

Ringgold, Faith. "An Open Show in Every Museum." *Feminist Art Journal* (April 1972), p. 10.

Ringgold, Faith. *Aunt Harriet's Underground Railroad in the Sky.* New York: Crown, 1992.

Ringgold, Faith. "Being My Own Woman." In Amiri and Amina Baraka, compilers, *Confirmation: An Anthology of African American Women.* New York: William Morrow, 1983.

Ringgold, Faith. *Dinner at Aunt Connie's House.* New York: Hyperion Books for Children, 1993.

Ringgold, Faith. *Faith Ringgold's Talking Book*. New York: Crown Books for Young Readers, 1995.

Ringgold, Faith. *Tar Beach*. New York: Crown, 1991.

Ringgold, Faith. *We Flew over the Bridge: The Memoirs of Faith Ringgold*. Boston: Little, Brown, 1995.

Roth, Moira, Thalia Gouma-Peterson, Alice Walker, and Faith Ringgold. *Change: Painted Story Quilts*. New York: Bernice Steinbaum Gallery, 1987.

Sims, Lowery. "Aspects of Performance in the Works of Black American Women Artists." In Arlene Raven, Cassandra Langer, and Joanna Frueh, eds., *Feminist Art Criticism*. Ann Arbor, Mich.: UMI Research Press, 1988. pp. 207–225.

Sims, Lowery S. "Black Women Artists." *Art Forum* (April 1973), p. 68.

Tesfagiorgis, Freida High W. "Afrofemcentrism and Its Fruition in the Art of Elizabeth Catlett and Faith Ringgold." *SAGE* 4, no. 1 (Spring 1987), pp. 25–32.

Trescott, Jacqueline. "Black Artists: Role and Responsibility." *Washington Post*, March 12, 1975.

Unseld, Teresa. *S. Portfolios: African-American Artists*. Palo Alto, Calif.: Dale Seymore, 1994.

Wallace, Michele. "And What Happened . . ." *Esquire*, May 1976, pp. 80–81.

Wallace, Michele. "Black Macho and the Myth of the Superwoman." *Ms.*, January 1979, pp. 45–91.

Wallace, Michele, Moira Roth, and Faith Ringgold. *The French Collection, Part I*. New York: Being My Own Woman Press, 1992.

Wallace, Michele, and Lowery Sims, eds. *Faith Ringgold: Twenty Years of Painting, Sculpture and Performance (1963–1983)*. New York: Studio Museum in Harlem, 1984. Exhbn cat.

Witzling, Mara R., ed. *Voicing Our Visions*. New York: Universe, 1991.

ARTIST STATEMENT (1991)[1]

Should I paint some of the great and tragic issues of our world? A black man toting a heavy load that has pinned him to the ground? Or a black woman nursing the world's population of children? Or the two of them together as slaves, building a beautiful world for others to live free? Non! I want to paint something that will inspire—liberate. I want to do some of the WOMEN ART. Magnifique!

Note

1. Faith Ringgold, *We Flew over the Bridge: The Memoirs of Faith Ringgold* (Boston: Little, Brown, 1995), p. 124.

BIOGRAPHICAL ESSAY

Faith Ringgold, visual artist, writer, feminist, political activist, educator, and performance artist, is truly a "Renaissance Woman." In her career, which spans

more than a quarter of a century, Ringgold has reached an international audience that includes adults and children, men and women, all races and all classes. Creator of over 85 story quilts, author and illustrator of children's books, recipient of nine honorary doctorates to date, winner of numerous prestigious awards such as National Endowment for the Arts (NEA) grants and Guggenheim Fellowships, and champion of civil rights and women's liberation, one must ask, Where does she get her energy? Does this woman ever sleep?

Growing up in Harlem in a family where her father was able to support them during the economic crisis of the depression and where her mother eventually achieved financial independence as a dressmaker and fashion designer, Ringgold knew early on that being a working woman was not a lifestyle option but a survival necessity. Heavily influenced by the colors, flair, drama, and style of her mother's fashion shows and model/photographer/entertainer associates, Ringgold caught the creativity bug and pursued degrees in art at City College, eventually becoming an art teacher in the New York public school system and a struggling artist.

Frustrated with the Eurocentric art education she received at City College, where painting professors could not teach her how to mix colors for dark skin tones, Ringgold embarked on her own search for black aesthetics by reading the literature of Amiri Baraka (Le Roi Jones) and James Baldwin and the aesthetic philosophy of Alain Locke, studying African art, and embracing the 1960s concept of "Black is Beautiful." Ringgold's newfound consciousness inspired the creation of works like *The Flag Is Bleeding, U.S. Postage Stamp Commemorating the Advent of Black Power*, and *Die*. Like many other black artists of that era, such as Cliff Joseph and Benny Andrews, Ringgold was active in the movement to bring art to the prisons. Her 1971–1972 mural at the Women's House of Detention at Rikers Island in New York City depicted women of all races engaged in constructive work that challenged gender stereotypes. Ringgold's commitment to women's issues, especially black women's increased, leading to the creation of African-inspired portrait masks constructed of beads, fabric, and embroidery with opened mouths to represent black women speaking out. The 1970s also saw Ringgold in the center of protests against the art establishment's racism/sexism at marches in front of the Whitney Museum of American Art, protests against the so-called alternative anti-Venice Biennial exhibit in which no black or women artists were represented, her joining the Ad Hoc Committee on Women Artists and Students for Black Liberation, involvement in activities that led to the New York Museum of Modern Art's hiring two black members to their board of trustees and staging two major African American exhibits, and her cofounding, with Kay Brown and Dinga McGannon, the black women artist group "Where We At." Ringgold's political and art activism reached new heights in 1972 with her participation in the *American Women Artists Show* in Hamburg, Germany—the beginning of much deserved recognition and critical analysis.

Ringgold's art has provided an impetus and catalyst for black women art

critics/historians such as Lowery S. Sims, Judith Wilson, Ringgold's daughter Michele Wallace, and Freida High Tesfagiorgis. In 1984, Tesfagiorgis introduced the concept "Afrofemcentrism" to "designate an Afro-female centered worldview and its artistic manifestation,"[1] which was initially applied to Ringgold's art and ideology and later embraced other black women artists such as Elizabeth Catlett. "Afrofemcentrism" described Ringgold's imagery and other like-minded artists as projecting the black woman as subject as opposed to object, active rather than passive, and embracing an African-derived aesthetic that includes both realism and abstraction in its color, texture, and rhythms.[2]

For Tesfagiorgis, Ringgold's adaptation of mixed-media soft sculpture into her art repertoire and its reliance on sewing/embroidery (traditionally women's occupations) is an affirmation of women's creativity. Ringgold's portrait masks and soft sculptures initiated a new phase in her art career—performance art—in which Ringgold created stories and characters that voiced the black American experience from a woman's perspective. One of the most famous installation/performance pieces from the mid-1970s was *The Wake and Resurrection of the Bicentennial Negro*, which combined storytelling, performance art, and visual art, setting a "precedent and model for the tone and themes of Ringgold's subsequent story quilts."[3]

Ringgold's incorporation of quilting was inspired by her fashion designer mother, Willi Posey, with whom she collaborated on many fiber projects, and the African American quilt-making tradition that has origins in the rural South. Other fiber influences were the Tibetan cloth paintings, *Tankas*, whose cloth borders/frames made storage/transportation easier. The quilts *Who's Afraid of Aunt Jemima* and *Slave Rape Story Quilt* include written narratives about black women's lives. *Change: Faith Ringgold's Over 100 Pounds Weight Loss Performance Story Quilt* (1986, photoetching on silk, 57" × 70"), incorporating performance and video, is Faith's own story and also the story of all women's lives affected by imposed standards of physical "beauty."

The 1988 story quilt *Tar Beach* evolved into a children's book about an eight-year-old Harlem heroine whose power of flight involves fantasies of solving family problems like denial of union membership for her Afro-Indian construction-worker father. *Tar Beach* and other Ringgold written/illustrated books like *Aunt Harriet's Underground Railroad in the Sky, Dinner at Aunt Connie's House, My Dream of Martin Luther King*, and *Bonjour, Lonnie* have won numerous awards for their themes on African American history and race relations.

Ringgold's *French Collection* and *American Collection* pointed quilt series (1991–1997) move "back and forth in time, from past to future, from fact to fiction, in order to redress history, both political and artistic, and to create a more prominent place in this new history for African-American women."[4] With narrative titles such as *Picnic at Giverny* (1991), *Dinner at Gertrude Stein's* (1991), *Le Café des Artistes* (1994), and *Bessie's Blues* (1997), Ringgold's alter ego Willia Marie Simone interacts with historical figures such as Sojourner

Truth, Rosa Parks, Harriet Tubman, James Baldwin, Langston Hughes, Richard Wright, Picasso, Van Gogh, Gauguin, Archibold Motley, and Edmonia Lesis. Also in the 1990s, *Marlon Riggs: Tongues Untied*, a quilt commemorating the life and career of the black gay filmmaker who died of AIDS, is a further testimony of Ringgold's lifelong commitment to social/political issues. Proceeds from the quilt benefit AIDS research and care.

Perhaps the best way to summarize Ringgold's contributions to the art world and to life in general is to emphasize her democracy in the true sense of what democracy is supposed to entail. A Ringgold work of art appeals to a wide audience, disregards the dominant culture's dichotomies between art and crafts, embraces postmodern discourse without rejecting modernism, blurs fact and fiction in narratives based on herstory and history, embraces both feminism and black nationalism, is accessible to a less affluent population through affordable children's books and posters, and finally, connects black art and culture to the United States, Europe, and Africa, making it a significant player in the global art arena.

Notes

1. Freida High W. Tesfagiorgis, "Afrofemcentrism and Its Fruition in the Art of Elizabeth Catlett and Faith Ringgold," *SAGE* 4, no. 1 (Spring 1987), pp. 25–32.

2. Ibid.

3. Thalis Gouma-Peterson, "Faith Ringgold's Journey," in Dan Cameron, ed., *Dancing at the Louvre: Faith Ringgold's French Collection and Other Story Quilts* (Berkeley and Los Angeles: University of California Press, 1998), p. 45.

4. Moira Roth, "Of Cotton and Sunflower Fields: The Makings of the French and the American Collection," in Cameron, *Dancing at the Louvre*, p. 59.

SAAR, ALISON

Born: 1956, Los Angeles, California. *Education*: B.A., Scripps College, Claremont, California, 1978. M.F.A., Otis Art Institute, Los Angeles, 1981. *Family*: Her mother Betye Saar, father Richard, and older sister Lezley are all artists. She is married to Tom Lesser, a filmmaker, and has two children, son Kyle and daughter Maddy. *Career*: Assistant to her father, a conservator and art restorer, for eleven years through graduate school and beginning in high school. Artist-in-Residence at the Studio Museum in Harlem, 1984. Artist-in-Residence at Roswell Museum, New Mexico, 1985. Artist-in-Residence at Washington Pro-

ject for the Arts, 1986. Taught at School of the Visual Arts, 1991–1994. Taught at Banff Art Center, the State University of New York at Purchase, and Yale University, New Haven, Connecticut. *Awards*: Sculpture Installation, Art on the Beach, Creative Time, New York, 1984. Artist-in-Residence, The Studio Museum in Harlem, New York, 1984. Artist Fellowship, National Endowment for the Arts, 1984. Sculpture Installation, Artpark, Niagara Falls, New York, 1985. Artist-in-Residence, Roswell Museum of Art, New Mexico, 1985. Engelhard Award, Institute of Contemporary Art, Boston, 1985. Artist-in-Residence, Washington Project for the Arts, 1986. Artist Fellowship, National Endowment for the Arts, 1988. John Simon Guggenheim Memorial Foundation Fellowship, 1989.

EXHIBITIONS

1997	*Alison Saar*, List Gallery, Swarthmore College, Pennsylvania, Laumeier Sculpture Park, St. Louis, Missouri, Jan Baum Gallery, Los Angeles, California; *Alison Saar: Hairesies*, Phyllis Kind Gallery, New York, New York
1996	*Alison Saar: The Woods Within*, The Brooklyn Museum, New York; *Alison Saar: Strange Fruit*, Phyllis Kind Gallery, New York, New York
1994	*Fertile Ground: Art at the Edge*, High Museum, Atlanta, Georgia (traveling show); *Catfish Dreamin'*, The Contemporary, Baltimore, Maryland (traveling show); *Directions*, Hirshorn Museum, Washington, D.C.; *Myth, Magic, and Ritual: Figurative Work by Alison Saar*, Freedman Gallery, Albright College, Reading, Pennsylvania; *Alison Saar: Sculptural Portraits, Wall Works and Artists's Books*, Addison Gallery of American Art, Phillips Academy, Andover, Massachusetts
1992	*Alison Saar: Allegorical Sculpture*, Cleveland Center for Contemporary Art, Cleveland, Ohio; *Alison Saar: Inside Looking In*, Neuberger Museum, Purchase, New York, The Nelson-Atkins Museum of Art, Kansas City, Missouri; *Slow Boat*, Whitney Museum of American Art at Philip Morris, New York
1991	*Dreamin's*, Jan Baum Gallery, Los Angeles, California
1990	*Alison Saar: Milagros Pequeños*, Jan Baum Gallery, Los Angeles, California
1988	*Figures: Zombies, Totems, Rootmen and Others*, Jan Baum Gallery, Los Angeles, California, The New Gallery, Calgary, British Columbia, Canada, Thomas Barry Fine Art, Minneapolis, Minnesota
1986	*New Icons*, Monique Knowlton Gallery, New York, New York; *Soul Service Station*, Roswell Museum of Art, Roswell, New Mexico
1985	*Alison Saar: Shamen, Saints, and Sinners*, Jan Baum Gallery, Los Angeles, California
1984	*Alison Saar: Relief Paintings and Sculpture*, Monique Knowlton Gallery, New York, New York

1983 *Alison Saar: Icons of the Street*, Jan Baum Gallery, Los Angeles, California; *Alison Saar*, Peppers Art Gallery, Redlands University, Redlands, California

1982 *Alison Saar: Sculpture*, Jan Baum Gallery, Los Angeles, California

SELECTED GROUP EXHIBITIONS

1997 *American Stories*, Setagaya Art Museum, Japan (traveling show)

1996 *Bearing Witness: Contemporary Works by African American Women Artists*, Spelman College Museum of Fine Art, Atlanta, Georgia (traveling show); *Myth and Magic*, California Center for the Arts Museum, Escondido, California; *Subjective Vision*, Kipp Gallery, Indiana University of Pennsylvania, Indiana, Pennsylvania; *A Labor of Love*, The New Museum of Contemporary Art, New York, New York

1995 *Imaginary Beings*, Exit Art, New York, New York; *Art with Conscience*, The Newark Museum, Newark, New Jersey; *Twentieth Century American Sculpture at the White House*, Washington, D.C.

1994 *Black Male: Representation of Masculinity in Contemporary Art*, Whitney Museum of American Art, New York, New York; *The Landscape as Metaphor*, Denver Museum of Art, Denver, Colorado, Columbus Museum of Art, Columbus, Ohio

1993 Biennial Exhibition, Whitney Museum of American Art, New York, New York

1992 *Horizons*, Nelson-Atkins Museum of Art, Kansas City, Missouri; *Beyond Glory: Re-Presenting Terrorism*, Maryland Institute of Art, Baltimore

1991 *Sophisticated Innocence*, Palos Verdes Art Center, Palos Verdes, California; *The Art of Advocacy*, The Aldrich Museum, Ridgefield, Connecticut

1990 *Secrets, Dialogues, Revelations: The Art of Betye and Alison Saar*, Wight Art Gallery, University of California, Los Angeles; *Celebrations: Sights and Sounds of Being*, Fisher Gallery, University of Southern California, Los Angeles; *The Decade Show: Frameworks of Identity in 1980s*, New Museum, Studio Museum, Museum of Contemporary Hispanic Art, New York, New York

1989 *Currents*, Santa Barbara Museum of Art, Santa Barbara, California

1988 *New Visions*, The Queens Museum, New York, New York; *Acts of Faith: Politics and the Spirit*, Cleveland State University, Cleveland, Ohio

1987 *Mind's I*, Asian Arts Institute, New York, New York; *Passages: A Survey of California Women Artists*, Fresno Art Center, Fresno, California

1986 *Other Gods: Containers of Belief*, The Everson Museum, Syracuse, New York (traveling show); *Correspondance*, Lafayette Museum,

Tokyo, Japan; *Contemporary Screens*, Contemporary Arts Center, Cincinnati, Ohio

1985 *Messangers*, University of Virginia, Charlottsville; *Carnival: Ritual and Reversal*, Kenkeleba House, New York, New York

1984 *American Women Artists: The Recent Generation*, Sidney Janis Gallery, New York, New York; *Precious Objects*, University Art Gallery, University of Southern Florida, Tampa, Florida

PERMANENT COLLECTIONS

Baltimore Art Museum, Baltimore, Maryland; Harold Washington Library, Chicago, Illinois; High Museum, Atlanta, Georgia; Hirshorn Museum and Sculpture Garden, Smithsonian Institution, Washington, D.C.; Metropolitan Museum of Art, New York, New York; Nelson-Atkins Museum of Art, Kansas City, Missouri; Newark Art Museum, Newark, New Jersey; Peter Norton Foundation, Los Angeles, California; Philip Morris, New York, New York; Santa Barbara Museum of Art, Santa Barbara, California; Studio Museum in Harlem, New York; Trenton Museum, Trenton, New Jersey; Virginia Museum of Fine Art, Richmond; Walker Art Center, Minneapolis, Minnesota; Whitney Museum of American Art, New York, New York

PUBLICATIONS

Acts of Faith: Politics and the Spirit. Cleveland, Ohio: The Art Gallery, Cleveland State University, 1988. Exhbn cat.

Brown, Betty-Ann. "Reviews: Alison Saar: Theatrical Imagery." *Arts Magazine* 57 (October 1982), p. 27.

Cohen, Ronny. "Alison Saar." *Artforum* 33 (November 1984), p. 105.

Curtis, Cathy. "Radical Differences in Two Black Artists." *Los Angeles Times*, June 29, 1989, sec. 6, p. 1.

Curtis, James. "Alison Saar: Fertile Ground/Crossroads." *Art Papers* 18 (November–December 1994), p. 54.

Diehl, Carol. "Review." *Art News* 94 (December 1995), pp. 140–141.

Gardner, Colin. "The Art Galleries: Wilshire Center." *Los Angeles Times*, February 20, 1987, sec. 6, p. 17.

Harrison, Helen. "In the Realm of 2 1/2 Dimensions." *New York Times*, April 21, 1985, sec. 21, p. 20.

Hugo, Joan. "Dreams of Games and Figures." *Artweek* 18 (October 17, 1987), p. 1.

Hugo, Joan. "Pandora and the Rattle." *Artweek* 18 (May 23, 1987), p. 1.

Hugo, Joan. "Sophisticated Ladies." *Artweek* 14 (January 8, 1983), p. 16.

Jones, Kellie. "New Visions and Continuing Traditions." In *New Visions*. New York: The Queens County Art and Cultural Center, 1988. Exhbn cat.

Klein, Ellen Lee. "Alison Saar." *Arts Magazine* 60 (April 1986), p. 132.

Kuspit, Donald. "Alison Saar." *Artforum* 24 (April 1986), p. 111.

Powell, Richard. *The Blues Aesthetic: Black Culture and Modernism*. Washington, D.C.: Washington Project for the Arts, 1989, p. 102. Exhbn cat.

Schipper, Merle. "Alison Saar." *Art News* 85 (January 1986), pp. 109–110.

Smucker, Ronica Sanders. "Interview." *Art Papers* 18 (July–August 1994), pp. 15–19.

Soul Service Station. Roswell, N.M.: Roswell Museum and Art Center, 1986. Exhbn cat.

White, Patrick. "Enigmatic Inquiry: The Search for Meaning." *New Art Examiner* 15 (June 1988), pp. 48–49.

Wilson, Judith. "Hexes, Totems, and Necessary Saints: A Conversation with Alison Saar." *Real Life Magazine* (Winter 1988–1989), pp. 36–41.

Word, Terrence. "Figures and Frescoes: Alison Saar." *Visions* 1 (Summer 1987), p. 31.

BIOGRAPHICAL ESSAY

Growing up with two parents who were artists was an important influence on Alison Saar. Because creativity was shared and encouraged in her household, her early experiences have clearly had an impact on her art making as well as her subject matter. Saar remembers trips to Watts Towers with her mother, Betye Saar, and working on projects while in her mother's studio so that she and her sisters would not go near the etching acids. Just like her mother did as a child, Saar would unearth small treasures from the ground near her house that were buried there from the Bel Air fire of 1958 and wonder at their histories. While her work has close affinities to her mother's, Saar remembers that her father exposed her to a lot of art when she was young. He gave her drawing lessons and took Alison and her two sisters to museums. He was an art conservator, and Saar started working for him when she was 13 and continued through high school, college, and graduate school for a total of 11 years. During this time she was introduced to a wide variety of objects from all over the world, and she attributes her technical skills and interest in process to this apprenticeship. She taught herself to carve so that she could repair parts of icons and pre-Columbian and African objects. Her father taught her to clean and retouch work.

When Saar was in high school her mother began to gain recognition, and Alison felt that her own work was overshadowed by her mother's and she wasn't getting the attention she needed. She did, however, work with her mother on a project-by-project basis and helped her with assembling things and by using her skills with tools. It was not until she attended graduate school that Alison began to see the advantages of being her mother's daughter, especially since Betye Saar was teaching at the Otis Art Institute.

As an undergraduate Saar studied art history and took classes in Afro-Caribbean art from Dr. Samella Lewis. She wrote her thesis on black American folk art, and it is clear that she is greatly influenced by it in her own work. In graduate school, however, Saar was more interested in color and abstraction until a few months before her M.F.A. show when she began to carve and decided to create a whole new body of work. She found that she was drawn to materials that were more palpable and physical than paint. In addition, she was attracted to found objects, like metal and wood, because they had a past history. At that time she was offered her first show at Jan Baum Gallery, where she was working, and it took place a year later in 1982. With this new body of work there was a relationship to her mother's work because both artists prefer recycled objects and the power that emerges from them due to their previous functions.

While both artists use forms of collage and mixed media, Alison's work is distinctly different in that it is usually manifested in a single image or figure, and the works are predominantly carved. She often focuses on a social type or character, and different pieces appear to be part of a greater narrative. Alison's work is also more about the physical process and has a look that is tough and gritty.

Saar has a keen interest in spiritualism and the African diaspora. She credits her interest in spiritualism to her mother. As a child of an interracial marriage she often focuses on multiracial or hybrid themes as an exploration of the experience of the "outsider." She is inspired by her own feelings of existing between two worlds. Most of her characters emerge from an African American experience, and they project aspects of duality. Some of them are inspired by historical figures, whereas others are people Saar has encountered or thought of. She culls her ideas from a variety of eclectic sources and often uses religious imagery. Perhaps her most common references are to African and African-inspired religions, such as Vodun and Santería, which arise from her strong interest in the confluence of cultures. She has also been inspired by other non-Western cultural practices and objects such as Mexican altars and *retablos* and Inuit totem poles. Saar was raised a Unitarian and feels that this inspired her to see a spiritual element in everything and a universal mythology that crosses many cultures.

Many of Saar's characters are inspired by ordinary individuals or types that she has seen or encountered, but she attempts to show their power by incorporating materials with memory. She enhances their image through assemblage or the combination of elements such as wood, paint, metal, or other cast-offs such as wood floor beams or tin ceilings from old buildings. These materials are wiser and have seen more than new materials. In a way her individuals become modern-day saints and fetishes. Tattooed ladies, preachers, sweet young things, Sapphire, and Sweet Dady Good Life people her world, emerging from her profound ability to reflect the spirituality emanating from everyday lives. Oftentimes her figures display open hearts, chests, and wounds embedded with shards of glass, ceramic, or charms. The cavities provide insight and resemble Congolese Minkisi. These works evoke powerful feelings of love, pain, joy, fear, and passion. After Saar's pregnancy, however, she found that she was more interested in spirituality and less in the individuals or materiality, and she paid less attention to detail.

By transforming the ordinary into something extraordinary, Saar mixes the sacred and the profane. She works with duality as two sides of a necessary whole and seeks to sanctify everyday experiences. Not only does she mix often oppositional categories, but she is adept at merging imagery and beliefs of many cultures in order to tap into the mystical potential of the resultant combinations. She begins with her own experiences and broadens them to include both ancestral memory and syncretic assimilation. She explains that her work explores the tension between the primal and the rational. Her work depicts the good with

the bad in order to acknowledge their coexistence. She is intrigued by how things blend together and has a strong affinity with self-taught, visionary, and folk artists because they also use found materials. While she is influenced by the notion that most non-Western cultures believe that everything has a spirit, she also feels that found materials are less precious and more down to earth.

Aside from individual pieces, Saar is interested in the environment of the work and creates installations that include her figures as well as other objects. By changing or creating a real environment inside a gallery, she helps her audience feel a closer affinity with the works because the viewer shares the space and is integrated within it. Like her mother, Saar often invites viewer participation. Ultimately, her work plays with preconceptions about race and explores the boundaries between Western and non-Western, male and female, and nature and culture.

SAAR, BETYE

Born: 1926, Pasadena, California. *Education*: B.A., University of California, Los Angeles, 1949. Graduate studies at California State University, Long Beach, 1958–1962. University of Southern California, 1962. California State University, Northridge, 1966. American Film Institute, Los Angeles, 1972. *Family:* Three daughters, two of whom are artists, Alison and Lezley. *Career*: Subject of film *Spirit Catcher: The Art of Betye Saar*, produced as part of the series *The Originals: Women in Art* for WNET, New York, 1978. Featured in *Six L.A. Artists*, KHJ-TV, Los Angeles, 1980. Public commission mural, 5th Street, Downtown Los Angeles. Public commission *L.A. Energy*, National Endowment for the Arts, Brockman Galleries Productions, Cultural Affairs Commission, Los Angeles, 1983. Public commission mural *Fast Trax*, Newark Station, New Jersey, 1984. Public commission *On Our Way*, Metrorail Station, Miami, 1986. *Awards*: National Endowment for the Arts Fellowship, 1974. National Endowment for the Arts Fellowship, 1984. Womens Caucus for Art Honor Award for Outstanding Achievement, 1989. J. Paul Getty Foundation for the Visual Arts Fellowship, 1990. John Simon Guggenheim Memorial Foundation, 1991. Honorary Doctorate Degree, College of Arts and Crafts, Oakland, California, 1991. Massachusetts College of Art, Boston, 1992. James Van Der Zee Award, Brandywine Workshop, Philadelphia, Pennsylvania, 1992.

SELECTED EXHIBITIONS

1993 *Realm of the Spirits*, University of Colorado, Boulder; *Betye Saar: The Secret Heart*, Fresno Art Museum, California

1991	*The Ritual Journey*, Joseloff Gallery, Chicago, Illinois
1990	*Sanctified Visions*, Museum of Contemporary Art, Los Angeles, California
1989	*Illusions*, Wellington City Art Gallery, New Zealand
1988	Saxon-Lee Gallery, Los Angeles; Taichung, Taiwan; *Shadow Song*, Kuala Lumpur, Malaysia; Manila, Philippines
1987	*Sentimental Sojourn: Strangers and Souvenirs*, The Pennsylvania Academy of the Fine Arts, Philadelphia; *Mojotech*, The Albert and Vera List Visual Arts Center, Massachusetts Institute of Technology, Cambridge
1986	Southwest Craft Center, San Antonio, Texas
1985	Lang Gallery, Scripps College, Claremont, California
1984	Matrix Gallery, Sacramento, California; Minneapolis College of Art and Design, Minnesota
1983	Women's Art Movement, Adelaide, Australia; Canberra School of Art, Australia; Smith Art Gallery, University of California, Santa Cruz
1982	Quay Gallery, San Francisco, California
1981	Monique Knowlton Gallery, New York, New York; Baum-Silverman Gallery, Los Angeles, California
1980	Linda Ferris Gallery, Seattle, Washington
1979	Baum-Silverman Gallery, Los Angeles, California; Gallery 62, National Urban League, New York, New York; University of North Dakota, Grand Forks; Mandeville Art Gallery, University of California, San Diego
1977	Baum-Silverman Gallery, Los Angeles, California; San Francisco Museum of Modern Art, California
1976	Wadsworth Atheneum, Hartford, Connecticut; Monique Knowlton Gallery, New York, New York; Douglas College, Rutgers University, New Brunswick, New Jersey
1973	The Art Gallery, California State University, Los Angeles; Berkeley Art Center, California

SELECTED GROUP EXHIBITIONS

1996	*Bearing Witness: Contemporary Work by African American Women Artists*, Spelman College, Atlanta, Georgia
1994	5th Biennale of Havana, Cuba
1993	*USA Today*, Netherlands Textile Museum, Tilburg, Netherlands; *In Out of the Cold for the Arts*, Yerba Buena Gardens, San Francisco, California
1992	*500 Years: With the Breath of Our Ancestors*, Municipal Art Gallery, Los Angeles, California

1991	*Professor's Choice*, Montgomery Art Gallery, Pomona College, Claremont, California
1990	*The Decade Show*, The New Museum, New York, New York: *Secrets, Dialogues, Revelations: The Art of Betye and Alison Saar*, Wight Art Gallery, University of California, Los Angeles
1989	*Forty Years of California Assemblage*, Wight Art Gallery, University of California, Los Angeles; *Art as a Verb*, The Decker Gallery, Maryland Institute College of Art, Baltimore
1988	*The Poetic Object*, San Antonio Museum, Texas; *Cultural Currents*, The San Diego Museum of Art, California; *Frontiers in Fiber: The Americans*, organized by the North Dakota Museum of Art to travel in Asia; *Lost and Found in California: Four Decades of Assemblage Art*, Shoshana Wayne Gallery, Santa Monica, California
1987	*The Afro-American Artist in the Age of Pluralism*, Montclair Art Museum, New Jersey
1986	*Art Expressions in Paper*, Security Pacific National Bank, Los Angeles, California; *Gentlemen's Choice*, Women's Building, Los Angeles, California
1985	*Tradition and Conflict: Images of a Turbulent Decade 1963–1973*, Studio Museum in Harlem, New York
1984	*Return of the Narrative*, Palm Springs Desert Museum, California
1983	*On and Off the Wall: Shaped and Colored*, Oakland Museum, California; *Visions: Margaret Omar and Betye Saar*, St. Mary's College, Los Angeles, California
1982	*The Book as Art*, Artworks, Los Angeles, California
1977	*Object as Poet*, Museum of Contemporary Crafts, New York, Renwick Gallery, Smithsonian Institution, Washington, D.C.; *Miniature*, California State University, Los Angeles; *Painting and Sculpture in California: The Modern Era*, National Gallery of Art, Washington, D.C.
1975	*Collage and Assemblage*, Los Angeles Institute of Contemporary Art, California
1973	*The Drawing Show*, Womanspace, Los Angeles, California; *Dimensional Prints*, Los Angeles County Museum of Art, California
1972	*Small Environments*, University Galleries, Southern Illinois University, Edwardsville
1970	Whitney Museum Sculpture Annual, New York, New York
1968	*25 California Women Artists*, Lytton Center of Visual Arts, Los Angeles, California

PERMANENT COLLECTIONS

The High Museum, Atlanta, Georgia; Montclair Art Museum, Montclair, New Jersey; New Jersey State Museum, Trenton; Philadelphia Museum of Art, Pennsylvania; San

Francisco Museum of Modern Art, California; Santa Barbara Museum of Art, California; Seattle Arts Commission, Washington; The Studio Museum in Harlem, New York; University Art Museum, Berkeley, California

PUBLICATIONS

The Afro-American Artist in the Age of Cultural Pluralism. Montclair, N.J.: Montclair Art Museum, 1987. Exhbn cat.

Albright, Thomas. "A Wild Mixture of Media." *San Francisco Chronicle*, December 25, 1972, p. 68.

Andrews, Benny. "Jemimas, Mysticism, Mojos: The Art of Betye Saar." *Encore American and Worldwide News* 4 (March 17, 1975), p. 30.

Art as a Verb: The Evolving Continuum. Baltimore: Maryland Institute, College of Art, 1989. Exhbn cat.

Ballatore, Sandy. "Betye Saar at Baum/Silverman and the Mandeville Art Gallery." *Art in America* 67 (October 1979), p. 130.

Betye Saar: Selected Works 1964–1973. Los Angeles: California State University, 1973. Exhbn cat.

Brenson, Michael. "Split Show of Black Artists Using Nontraditional Media." *New York Times*, April 7, 1989, p. 23.

Britton, Crystal. "Betye Saar." *Art Papers* 8 (1984), p. 4.

Britton, Crystal. "Interview: Betye Saar." *Art Papers* 5 (September–October 1981), pp. 8–9.

Burke, Carolyn. "Images from Dream and Memory." *Artweek* 15 (January 14, 1984), p. 4.

Campbell, Mary Schmidt. *Rituals: The Art of Betye Saar.* New York: The Studio Museum in Harlem, 1980. Exhbn cat.

Canavier, Elena Karina. "Betye Saar: Nine Years of Work." *Artweek* 4 (October 20, 1973), p. 16.

Clothier, Peter. *Betye Saar.* Los Angeles: The Museum of Contemporary Art, 1984. Exhbn cat.

Conwill, Houston. "Interview with Betye Saar." *Black Art: An International Quarterly* 3 (1980), pp. 4–15.

East/West: Contemporary American Art. Los Angeles: California Afro-American Museum, 1984. Exhbn cat.

"15 Leading Black Artists: A Jury of Experts Picks Outstanding Talents." *Ebony*, May 1986, p. 46.

Glueck, Grace. "Art: Betye Saar Gives Spirits Form." *New York Times*, April 18, 1980, sec. C, p. 22.

Hershman, Lynn. "Reflections on Saar's Windows." *Artweek* 4 (January 13, 1973), p. 4.

Jaar, Alfredo. "The Peripatetic Artist: 14 Statements." *Art in America* 77 (July 1989), pp. 131–155.

King-Hammond, Leslie. *Ritual and Myth.* New York: Studio Museum in Harlem, 1982.

Knight, Christopher. "A '19 Sixties' Look Back at Black Nationalism: 'Watts Riot' Could Be Signature Work." *Los Angeles Herald Examiner*, April 21, 1989, p. 5.

Kramer, Hilton. "Art: 'Blacks: USA 1973' Is Eclectic." *New York Times*, September 29, 1973, p. 27.

Lewis, Samella S., and Ruth G. Waddy. *Black Artists on Art.* Vol. 1. Los Angeles: Contemporary Crafts Publishers, 1969.

Liss, Andrea. "Power and Gentle Force." *Artweek* 19 (February 27, 1988), p. 3.

Muchnic, Suzanne. "Saar: Assembling a Positive Vision." *Los Angeles Times*, July 22, 1984, Calendar sec., p. 88.

Munro, Eleanor. *Originals: American Women Artists.* New York: Simon and Schuster, 1979.

Nemser, Cindy. "Conversations with Betye Saar." *Feminist Art Journal* 4 (Winter 1975–1976), pp. 19–24.

19 Sixties: A Cultural Awakening Re-evaluated 1965–1975. Los Angeles: California Afro-American Museum Foundation, 1989. Exhbn cat.

The Poetic Object. San Antonio, Tex.: San Antonio Museum Association, 1988. Exhbn cat.

Reed, Ishmael, *Shrovetide in Old New Orleans.* Garden City, N.Y.: Doubleday and Company, Inc., 1978.

Rosen, Randy. *Making Their Mark: Women Artists Move into the Mainstream, 1970–85.* New York: Abbeville Press, 1989.

Rosing, Larry. "Betye Saar." *Arts Magazine* 50 (June 1976), p. 7.

Saar, Betye. "Installation as Sculpture." *International Review of African American Art* 6, no. 1 (1984), pp. 44–48.

Sculpture of the Eighties. New York: The Queens Museum, 1987. Exhbn cat.

Shepherd, Elizabeth, ed. *Secrets, Dialogues, Revelations: The Art of Betye and Alison Saar.* Los Angeles: Wight Art Gallery, University of California, 1990. Exhbn cat.

Sims, Lowery. "Betye Saar: A Primer for Installation Work." In *Resurrection: Site Installations, 1977 to 1987.* Fullerton: Visual Arts Center, California State University, 1988. pp. 9–17. Exhbn cat.

Tradition and Conflict: Images of a Turbulent Decade 1963–1973. New York: The Studio Museum in Harlem, 1985. Exhbn cat.

Tucker, Marcia. *Betye Saar.* New York: Whitney Museum of American Art, 1975. Exhbn cat.

Woelfle, Gretchen Erskine. "On the Edge: Betye Saar, Personal Time Travels." *Fiberarts Magazine* 9 (July–August 1982), pp. 56–60.

Wooster, Ann-Sargent. "Betye Saar (Monique Knowlton Gallery)." *Art News* 75 (October 1976), p. 125.

Wright, Beryl. *The Appropriate Object.* Buffalo, N.Y.: Albright-Knox Art Gallery, 1989.

BIOGRAPHICAL ESSAY

As a child, Betye Saar, who was born in Pasadena, used to spend her summers with her grandmother who lived in the rural Watts area of Los Angeles. She would play in the backyard where she would find glass, beads, and stones, and she would collect shells at the beach and discarded objects along the railroad tracks. It was at her grandmother's that she began her lifelong activity of collecting. Inspired by the Watts towers, built by Simon Rodia and adorned with mosaics of broken glass, shells, pottery, and tiles, Saar would later become strongly associated with the art of assemblage. The arts were encouraged in Saar's household, where every summer she and her siblings would take recreation and craft classes through the park district.

Later Saar studied design in college because few African Americans were encouraged to pursue fine arts degrees. In her graduate studies she focused on printmaking and took classes with Dick Swift at California State, Long Beach, and later with Don Leveer at the University of Southern California. As her prints gained recognition and her children grew older, Saar had more time to devote to her career as an artist. While she began as a printmaker, by the mid-1960s she began to combine mediums. After seeing a show on the works of Joseph Cornell, she realized the potential of assemblage as an art of metaphor and juxtaposition. Her work moved away from realism and began to reflect her interest in nostalgia, cultural memory, cross-cultural rituals, spirituality, and magic. Many sources intersect in her work, and by combining a variety of elements, she relies on the recycled energy to create an emotional impact.

In an early work, *Black Girl's Window* (1969), Saar began to mix graphics, collage, and found objects. This work revolves around the theme of death and refers to the death of her father as well as to the cycle of life. The small central panel depicts death as a white skeleton. The color white represents the spiritual realm in African culture. Other symbols in this work come from Saar's interest in different religions and philosophies such as astrology, palmistry, tarot, voodoo, and shamanism. Additional objects such as a tintype of a woman relate to Saar's personal history. Saar began to rely on the combination of objects to tap into a collective energy or vital force. The act of renewal contributes to the strong impact of her work, and Saar believes that art is not merely an object but an object of power.

In the early 1970s Saar visited the Field Museum of Natural History in Chicago and saw traditional ritual objects from Africa and Oceania. She felt overwhelmed by their spiritual intensity. Her own work tends to be inspired by a deep-rooted intuition in which she is not entirely aware of what she is doing and something in her takes over. She acts as a type of shaman who creates charms by combining mystical symbols with natural objects. After reading an essay by Arnold Rubin called ''Accumulation: Power and Display in African Sculpture,'' Saar understood that her work was an extension of an African cultural heritage and a tie to cultures that are related to the earth and nature. Many influences intermingle in her work, and she combines materials and symbols that work together from a variety of sources. She gleans special ingredients and objects from the environment around her. She recycles and regenerates found objects into assemblages, altars, and installations.

Saar's work strives to capture the essence of human spirit and emotion. By using objects charged with memory and nostalgia, she creates a vehicle for her audience to become personally involved in her work and to realize a collective experience of being human. Saar uses the power of human emotion to draw her audience into her world and to ultimately show common experience and shared pasts. She exposes a collective consciousness that emerges from human memory. In addition, her work seeks to expose the connectedness and mystical, almost indistinguishable boundaries between the realms of time and space. It attempts

to exceed beyond barriers to expose a common thread between history, culture, memory, and emotion while emerging from her own history as an African American woman.

Many of Saar's works deal with the commonality of religions through the combination of elements and the use of common symbology. Although not all of her symbols can be pinned down to an exact cultural inspiration, she strives for a sense of ritual inspired by mysticism, nostalgia, and dreams. The act of making art is also a ritual that follows through the imprint of ideas, the search, the collecting and gathering, the recycling and transformation, and finally the release or sharing of the object. Her emphasis on ritual demonstrates the similarities that exist between cultures and religions. Her major sources are Africa, Asia, and Latin America as well as rummage sales, thrift shops, and her travels. She combines found objects, each with their own personal history, in order to capture the resultant energy. The mixture of forces results in a powerful object.

Saar's early work of the 1960s focused on the use of derogatory and racist images but later became more introspective and related to events in her life. In 1974 Saar's Aunt Hattie died and triggered in Saar the emotions she had felt with the death of her father. She inherited drawers and closets full of her great aunt's belongings, and this sparked a new body of work. Many of these works were boxes filled with Aunt Hattie's personal belongings such as gloves and calling cards, and they act as evidence of her existence. After her box works, Saar began to create altars as a way to invite her audience to interact by leaving an offering or exchanging something. Many of Saar's more recent works are installations. Although larger, they still maintain the intimacy and energy of her boxes and altars, and they invite the viewer in. They also continue to evolve as ritual and often contain elements of nature. Saar's work, in all its forms, taps into nostalgia in order to attest to the lives of ordinary people. She chooses objects for their symbolic value and their energy. Her philosophical content is consistent throughout her body of work as she exposes a collective unconscious.

SAVAGE, AUGUSTA

Born: 1900, Green Cove Springs, Florida. *Education*: Tallahassee State Normal School, Cooper Union, 1924. Academie de la Grande Chaumière, Paris, 1927. *Career*: Sculptor, educator, arts administrator, activist. *Awards*: Rosenwald Fellowship, 1929–1932. Citation, Salon d'Automne, Paris, 1931. Citation, Salon Printemps at the Grande Palais, Paris, 1931. Medallion, French Government Colonial Exposition, 1931. Carnegie Foundation Travel Grant, 1931. Carnegie

Foundation Grant to open an art gallery in Harlem, 1932. Commission, New York World's Fair, 1939. Silver Medal, Women's Service League, Brooklyn, 1939. *Died*: 1962.

SELECTED EXHIBITIONS

1988	*Augusta Savage and the Art Schools of Harlem*, Schomburg Center for Research in Black Culture, New York, New York
1930–1931	Harmon Foundation, New York, New York

SELECTED GROUP EXHIBITIONS

1997	*National Black Fine Art Show*, Puck Building, New York, New York; *Revisiting American Art: Works from the Collections of Historically Black Colleges*, Katonah Museum of Art, Katonah, New York
1996	*Three Generations of African-American Women Sculptors: A Study in Paradox*, The Afro-American Historical and Cultural Museum, Philadelphia, Pennsylvania
1992	*Free within Ourselves: African-American Artists in the Collection of the National Museum of American Art*, Smithsonian Institution, Washington, D.C. (traveling exhibition)
1989	*Against the Odds: African-American Artists and the Harmon Foundation*, Newark Museum, Newark, New Jersey
1985	*Hidden Heritage: Afro-American Art, 1800–1950*, Bellevue Museum of Art, Bellevue, Washington
1970	James A. Porter Gallery, Howard University, Washington, D.C.
1967	City College of New York, New York
1940	*American Negro Exhibition*, Chicago, Illinois
1938	Harmon Foundation, New York, New York
1935	Argent Galleries, New York, New York
1934	National Association of Women Painters, New York, New York
1929–1935	Various group exhibitions in Paris, Belgium, and Germany
1926	Group Exhibition, Baltimore Federation of the Parent Teachers Club, Baltimore, Maryland

SELECTED COLLECTIONS

Morgan State College, Baltimore, Maryland; National Archives, Washington, D.C.; National Museum of American Art, Smithsonian Institution, Washington, D.C.; Schomburg Center for Research in Black Culture, New York, New York

SELECTED PUBLICATIONS

"Augusta Savage: An Autobiography." *Crisis* 36 (August 1929), p. 269.

Bearden, Romare, and Harry Henderson. *A History of African-American Artists: From 1972 to the Present*. New York: Pantheon Books, 1992.

Bearden, Romare, and Harry Henderson. *6 Black Masters of American Art*. New York: Zenith Books, 1972.

Bontemps, Arna Alexander, ed. *Forever Free: Art by African-American Women 1862– 1980*. Normal, Ill.: Center for the Visual Arts Gallery, Illinois State University, 1980.

Dover, Cedric. *American Negro Art*. Greenwich, Conn.: New York Graphic Society, 1960.

Hine, Darlene Clark, ed. *Black Women in America: An Historical Encyclopedia*. Brooklyn, N.Y.: Carlson Publishing, 1993.

Lewis, Samella. *African-American Art and Artists*. Berkeley: University of California Press, 1978, 1990.

Locke, Alain. *The New Negro*. New York, 1925.

Negro Heritage Committee, Alpha Kappa Alpha Sorority. *Afro-American Women in Art: Their Achievements in Sculpture and Painting*. Greensboro, N.C. 1969.

Reynolds, Gary, Beryl Wright, and David Driskell. *Against the Odds: African-American Artists and the Harmon Foundation*. Newark, N.J.: The Newark Museum, 1989.

Roth, Moira, ed. *Bridging Horizons: Flying through History*. Oakland, Calif.: Visibility Press, 1996.

ARTIST STATEMENT (1929)[1]

I have created nothing really beautiful, really lasting. But if I can inspire one of these youngsters to develop the talent I know they possess, then my monument will be in their work. No one could ask more than that.

Note

1. Romare Bearden and Harry Henderson, *6 Black Masters of American Art* (New York: Zenith Books, 1972), pp. 96–970.

BIOGRAPHICAL ESSAY

In many ways, Augusta Savage's life was quite typical of the lives of many of the African American women artists born in the early part of the twentieth century, a life marked by struggle and, as a result, by clearing spaces so that others would not have to struggle as much. However, Savage's life also diverged in significant ways from lives of many of the artists outlined in this chapter: It was both triumphant and tragic, lived first in the limelight and then in obscurity, initially charged with activism and subsequently muted by complacency. Like Selma Burke, Savage was drawn to the sculptural potential of the muddy clay of her native Florida, "[making] 'things' instead of mud pies," she has recalled, while still "at the mud pie age."[1] Unlike Selma Burke's, Savage's early childhood creativity went unrewarded by her religious parents, who thought of her "things" as graven images. Like Margaret Taylor Burroughs, Savage founded

and headed institutions in behalf of African American art. Unlike Burroughs, Savage did not continue to hone her museological skills to eventually become the philanthropic pillar of art and society in the manner that Burroughs has become. Like Elizabeth Catlett, Savage was politicized early when she was denied admission to a prestigious art school because of her race and further cut her "political teeth" during the Works Progress Administration (WPA) era. Unlike Catlett, Savage did not persevere with her political and social idealism into old age but settled into a rather self-absorbed isolation, living near her daughter in Saugerties, New York, supporting herself with odds jobs, teaching art in children's summer camps, and creating portrait sculptures for the Catskill tourists. Before she became a virtual recluse, however, Augusta Savage helped to shape twentieth-century African American art, particularly in terms of her active participation in the Harlem Renaissance, as a sculptor, educator, and social activist.

Despite the lack of parental support, Savage continued to make sculpture, scavenging clay from a pottery factory after she moved from northern Florida to West Palm Beach, where the geology did not favor clay's natural abundance. From her high school days, Savage acquired renown and modest earnings as a local artist, exhibiting at county fairs, executing portraits of the locals. She moved to New York City in 1920 with a letter of introduction from a West Palm Beach County official and $4.60, determined to make it as an artist within a year.

Savage's tenacious determination paid off: By 1921, she was studying sculpture under George Brewster at Cooper Union and was soon supported by scholarship funding. Even before she completed her four-year course of study at Cooper Union, Savage had gained fame for a portrait of W.E.B. Du Bois, after which she received numerous other commissions for portraits of notable black Americans, including Marcus Garvey, who sat for her over a series of Sundays in his Harlem apartment. By 1923, her esteem among the black community of Harlem and especially among the figures of the Harlem Renaissance helped secure Savage a scholarship for summer study at the Palace of Fountainbleau art school in France. When it was learned that she was black, the scholarship money was withdrawn. Savage's fame turned to notoriety when the news of the French art school's withdrawal of its offer became front-page, cause célèbre material in the black and radical press of New York City. Although she did receive another offer for summer study in College Point, New York, and eventually did get to Paris by means of the Julius Rosenwald Fellowship, Savage also received an undeserved reputation as a troublesome agitator because of the press coverage, resulting in a generalized rebuff from the white art world that effectively shut Savage out of museum and gallery representation for the rest of her life.

The denial of Savage's Fountainbleau scholarship and the ensuing furor was one of the first of many professional disappointments experienced by Savage, usually attributable to racism and lack of funding. Another disappointment in-

volved her inability to secure sufficient income to support a scholarship to study at the American Academy in Rome, which led her to refuse the award. Perhaps one of the biggest setbacks of her life as an artist was the destruction of one of her most celebrated sculptures, *Harp*, a large public work commissioned for the 1939 New York World's Fair and installed on the fairgrounds in the courtyard of the Contemporary Arts Building.

Savage was the only black woman to receive a sculptural commission from the Fair Corporation (and one of only four women). With the $1,200 award, she produced *Harp*, a sixteen-foot plaster cast with black basalt finish of a singing choir supported by the hand and arm of God, with the entire grouping resembling an anthropomorphic harp. A figure kneeling in front of the choir held a bar of musical notation with inscribed lyrics taken from James Weldon Johnson's poem "Lift Every Voice and Sing," which had become an unofficial national anthem of African America. Formally, Savage's dazzling sculptural invention reflected an Art Deco quality in the figures'/harp strings' rather streamlined, monumental quality, as well as a quality of the social realism typical of the WPA era in the strength, humanity, and passion of the vigorously singing heads of the choral figures, loudly proclaiming faith in God, in their identity, in their traditions, and in their self-determination. Tragically and typically, there were no funds available at the end of the Fair for *Harp* to be cast in bronze, and it was bulldozed. Nevertheless, *Harp* remained a potent symbol of and for the African American community, living on in replicas cast in pot metal and in photographic reproduction. It is tempting and probably not inaccurate to designate the singing heads of *Harp* as possible sources for Elizabeth Catlett's later series of powerful female heads, mouths wide open in intonation and proclamation, demanding to be heard.

Savage persisted despite her disappointments. European study in sculpture would prove personally and professionally rewarding for her. She felt that she greatly improved her technique during her European sojourns of the early to mid-1930s. Savage also received as much recognition in Europe—and almost as quickly—as when she first appeared on the Harlem scene, with her European work enjoying exhibition, awards, and critical acclaim.

Savage's efforts on behalf of promoting African American art were as dedicated as those on behalf of her own art education and art making. In 1932, she founded the Savage Studio of Arts and Crafts in Harlem. Many future luminaries of African American modernism would attend, including Ernest Crichlow, Norman Lewis, and William Artis. In a savvy move, Savage affiliated her school with the State University of New York, which resulted in its becoming the largest art school of its kind in New York, thus attracting the attention and support of the Carnegie Foundation and the Federal Art Project of the WPA. This affiliation led to Savage's close consultation with the Federal Art Project and to her successful promotion on the national level of the arts of the African American community.

In 1937, Savage became the first director of the innovative WPA-sponsored

Harlem Community Center, dedicated to fostering artistic ability and art appreciation among the working classes, while also training serious art students. After organizing a rigorous and celebrated program of recreation, education, and art at the Center, she took a leave of absence to work on the commission for the 1939 New York World's Fair but never returned to her post there. Savage's activist life making and promoting art is a list of "firsts":

> She was the first Black member of the National Association of Women Painters and Sculptors, the first director of one of the most important art centers in the nation, the only Black artist to receive a commission for the World's Fair, and the first and only director of the first Black-owned corporation to open a gallery devoted to the work of Black artists.[2]

Unfortunately and somewhat mysteriously, Savage did not choose to continue her highly effective public life in the arts. Throughout the 1940s, Savage's reputation grew while her public profile diminished as she retired to a much more private life in upstate New York.

Notes

1. "Augusta Savage: An Autobiography," *Crisis* 36 (August 1929), p. 269.
2. Darlene Clark Hine, ed., *Black Women in America: An Historical Encyclopedia* (Brooklyn, New York: Carlson, 1993), p. 1013.

SCOTT, JOYCE J.

Born: 1948, Baltimore, Maryland. *Education*: B.F.A., Maryland Institute College of Art, Baltimore, 1970. M.F.A., Instituto Allende, San Miguel Allende, Mexico, 1971. Haystack Mountain School of Crafts, Deer Isle, Maine, 1976. Rochester Institute of Technology, New York, 1979. *Family*: Daughter of quilter Elizabeth Scott, four generations of Scott quilters. *Career*: Lecturer at various colleges and museums, 1975–1992. Artist-in-Residence, University of Delaware, Newark, Delaware, 1990. Artist-in-Residence, Contemporary Arts Center, Cincinnati, Ohio, 1992. Currently, self-employed. *Awards*: Maryland State Arts Council Fellowship, 1981. Maryland State Arts Council Fellowship, 1988. National Endowment for the Arts Craftsmen Fellowship, 1988. Art Matters Inc., New York, New York, 1992. National Printmaking Fellowship, Rutgers Center for Innovative Printmaking, 1992.

SELECTED EXHIBITIONS

1995 *Images Concealed*, Walter McBean Gallery, San Francisco Art Institute, San Francisco, California

1992 Drew University Art Gallery, Madison, New Jersey; Brooklyn College Art Gallery, New York; Esther Saks Fine Art Ltd., Chicago, Illinois; Diggs Gallery, Winston-Salem State University, North Carolina; Visual Arts Center, North Carolina State University, Raleigh, North Carolina; Eubie Blake Cultural Center, Baltimore, Maryland

1990 *I-con-no-body/I-con-o-graphy*, Corcoran Gallery of Art, Washington, D.C.

1985 *Dreamweaver*, Cultural Center, Chicago, Illinois

SELECTED GROUP EXHIBITIONS

1997 *The Teapot Redefined*, Mobilia Gallery, Cambridge, Massachusetts, SOFA CHICAGO Gallery, Chicago, Illinois

1996 *Bearing Witness: Contemporary Works by African American Women Artists*, Camille Olivia Hanks Cosby Academic Center, Spelman College, Atlanta, Georgia (traveling exhibit through 1999); *my magic pours secret libations*, Museum of Fine Arts, Florida State University, Gainesville, Florida

1990 Renwick Gallery, Washington, D.C.

1989–1990 *Crafts Today, USA*, American Crafts Museum, New York, New York (international tour traveled throughout Europe)

1989 *Elizabeth T. Scott/Joyce J. Scott: Family Traditions, Recent Works*, Pennsylvania Academy of the Fine Arts, Philadelphia

1988–1989 *Art as a Verb*, Maryland Institute College of Art, Baltimore; *Beads*, John Michael Kohler Arts Center, Sheboygan, Wisconsin; *6th International Triennial of Tapestry*, Central Museum of Textiles, Lodz, Poland

1988 *Eloquent Object*, organized by Philbrook Art Center, Tulsa, Oklahoma, traveled to Museum of Fine Arts, Boston, Massachusetts, Chicago Public Library Cultural Center, Illinois, Orlando Museum of Art, Florida, Virginia Museum of Fine Arts, Richmond, Oakland Museum, Art Division, California, The National Museum of Modern Art, Kyoto, Japan, Crafts Gallery, The National Museum of Modern Art, Tokyo, Japan

1987 *Art Black America*, Terada Warehouse Gallery, Tokyo, Japan; *Three Voices in 3D*, University of Chicago, Illinois

1986 *Other Gods: Containers of Belief*, Everson Museum, Syracuse, New York

1984 *Art against Apartheid*, The Henry Street Settlement, New York, New York

1981–1982 *Good as Gold*, Renwick Gallery, Smithsonian Institution, Washington, D.C.

PERFORMANCES

1993 *Generic Interference/Genetic Engineering*
1988 *Women of Substance, Thunder Thigh Revue* series

COLLECTIONS

Baltimore Museum of Art, Baltimore, Maryland; Bannecker-Douglas Museum, Annapolis, Maryland; Montreal Museum of Fine Arts, Montreal, Quebec, Canada; Morgan State University, Baltimore, Maryland; Philadelphia Museum of Art, Philadelphia, Pennsylvania; Westfield State College, Westfield, Massachusetts

SELECTED PUBLICATIONS

Benesh, Carolyn L. E. "Message through Veil: Joyce Scott's Beaded Jewelry." *Ornament* 10 (Winter 1986), pp. 32–33.

Cabeen, Lou. "Contemporary Political Fiber: Criticizing the Social Fabric." *Fiber Arts* 17 (Summer 1990), pp. 32–35.

Douglas, Diane. "Textile Arts Centre, Chicago Exhibit." *New Art Examiner* 15 (Summer 1988), pp. 42–43.

Floden, Roberta. "Joyce Scott: Beaded Jewelry and Small Sculpture." *Metalsmith* 10 (Summer 1990), p. 45.

Gips, Terry. "Joyce Scott's Mammy/Nanny Series." *Feminist Studies* 22 (Summer 1996), pp. 310–311.

Hamaker, Barbara. "Joyce Scott, I-con-no-body/I-con-o-graphy." *Ornament* 15 (Winter 1991), p. 33.

"Interview with Joyce Scott, Winnie R. Owens-Hart, Pat Ward Williams, and Martha Jackson-Jarvis." In *Next Generations: Southern Black Aesthetic*. Winston-Salem, N.C.: Southeastern Center for Contemporary Art, 1990. Exhbn cat.

Kangas, Matthew. "Common Ground, Separate Choices." *Art in America* 80 (March 1992), pp. 57–59.

King-Hammond, Leslie, ed. *Gumbo Ya Ya: Anthology of Contemporary African-American Women Artists*. New York: Midmarch Arts Press, 1995.

"Passages: A Curatorial Viewpoint." In Robinson, Jontyle Theresa, ed., *Bearing Witness: Contemporary Works by African American Women Artists*. Atlanta, Ga.: Spelman College, 1996. Exhbn cat.

Searle, Karen. "Joyce Scott: Migrant Worker for the Arts." *Ornament* 15 (Summer 1992), pp. 46–51.

BIOGRAPHICAL ESSAY

Joyce Scott, multimedia artists, employs blown glass, beadwork, quilting, weaving, photocollage, knitting, crocheting, jewelry design, and fabric art into her sculptural designs, which may hang on a wall or be freestanding in gallery/museum exhibits/installations or adorn the body in her live performance pieces. Often using humor to address social issues such as racism, sexism, and envi-

ronmental destruction, Scott dialogues with gallery viewers and performance audiences with craft materials that are "accessible" to a wide gamut of people. Crossing the boundaries of sculpture and jewelry, Scott's necklaces and other sculptural forms are composed of thousands of beads threaded into abstract and representational shapes.

Scott's interest and expertise in various craft techniques can be partly attributed to a family tradition that includes collaboration with her mother in quilt making, the quilting experiences of both her grandmothers and one great-grandfather, the sweetgrass basketry and blacksmith work of one grandfather, and the woodworking (carving and decorating canoes) of another grandfather. In addition to family influences, Scott studied traditional arts at the Instituto Allende in San Miguel Allende, earning an M.F.A. in 1971, and subsequently traveled through Central America, the U.S. Southwest, and Africa, incorporating other indigenous art forms into her repertoire.

As a performance artist Scott collaborated with actress Kay Lawal in the 1988 piece *Women of Substance*, part of an ongoing series titled *Thunder Thigh Revue* that affirmed the beauty of a variety of body images and celebrated the voluptuousness of black women, challenging the mainstream obsession with thinness. In 1993 Scott performed the solo piece *Generic Interference/Genetic Engineering*, which dealt with the social ramifications of genetic engineering.

During the mid-1980s and early 1990s Joyce Scott embarked on a *Nanny* series that portrayed the continuing use and abuse of women of color, the neglect suffered by their biological children, and future issues about their roles as caretakers. *Nuclear Nanny* (1983–1984, 32 ½" × 23 ½", Mola with embroidered fabric, beads, and sequins) is a skeleton of white leather bones on a background of layered cloth, symbolizing the misuse of nuclear power and its damaging effect on future generations—generations without human caretakers/nannies, an earth without caretakers. Scott's adaptation of Molas, appliqued shirts of layered cloth created by Cuna Indians from the Panamanian San Blas Islands, can be interpreted as signifying the United States' new nannies, Latin American women, "undocumeted" and underpaid.

Scott's *Mammy/Nanny* exhibit depicted African American women caring for white children and their conflicting feelings of love and prejudice as well as the feelings of neglect experienced by the nannies' children. *No Mommy Me* is a black figure holding a white baby of pearl beads as a black child clings to her skirt; *No Mommy Me, II* depicts a black girl sitting on a floor screaming for attention; and *Madonna and Child* consists of a black woman with a beaded halo holding a black child in one arm and a white child in the other. *Chainsaw Mammy, Out to Dry*, and Scott's performance art confront the potential for violence by mammies/nannies.

In the recent (1996–1999) touring exhibit entitled *Bearing Witness: Contemporary Works by African American Women Artists*, Joyce Scott explored social conflicts centering around race, gender, and eroticism in *P-Melon*, a blown glass and beadwork sculpture, and *Jar Woman #4*, a mixed-media standing figure. In

P-Melon (11" × 14" × 8"), *P* represents the derogatory term for female sexual organs, the objectification of the African American female body, and its inter-relationship with the equally objectifying and stereotypical image of the African American male body. *Jar Woman #4* (49" × 15" × 15") carries collective memories in a stomach filled with jars of amulets, dolls, plastic embryos, bones, photos, vessels, and other paraphernalia collected for Joyce by her mother, Elizabeth Scott. *Jar Woman* is flanked by two *calaveras*, Mexican pre-Columbian skeletal figures.

Both *P-Melon* and *Jar Woman #4* attest to Scott's versatility in utilizing African, African American, and Latin American imagery to connect the common experiences of peoples of color. Whether working in sculpture, jewelry, bead-work, blown glass, installation, weaving, quilting, or performance, Joyce Scott uses her creativity and sensitivity to world cultures in a continual public engagement with contemporary issues.

SIMPSON, LORNA

Born: 1960, Brooklyn, New York. *Education*: B.F.A, School of Visual Arts, New York, 1982. M.F.A., University of California, San Diego, 1985. *Family*: Only child of Elian, a social worker, and Eleanor, a medical secretary. *Awards*: National Endowment for the Arts, Arts Management Fellowship, Washington, D.C., 1985. National Studio Program, P.S.1, New York, 1986. Artists Advisory Board, The New Museum of Contemporary Art, New York, 1986. Workspace Grant, Jamaica Arts Center, Queens, New York, 1987. Polaroid Corporation, 20 × 24 Camera, New York, 1988. AVA 9, Awards in the Visual Arts, Winston-Salem, North Carolina, 1989. Artists Space Board of Directors, New York, 1989. Louis Comfort Tiffany Award, Louis Comfort Tiffany Foundation, New York, 1990. The Christian A. Johnson Endeavor Foundation, Distinguished Artist-in-Residence, Colgate University, Hamilton, New York, 1991. College Art Association, 1994.

EXHIBITIONS

1997	*Recent Work*, Rhona Hoffman Gallery, Chicago, Illinois; *Lorna Simpson*, Miami Art Museum, Florida
1996	*Details*, Karen McReady Fine Art, New York, New York; *The Body and Deception*, Galerie Wohn Maschine, Berlin, Germany
1995	*Lorna Simpson*, Sean Kelly, New York, New York, Cohen/Berkowitz

She by Lorna Simpson, 1992, color Polaroids and plastic plaque edition of 4, 29 ×
85¼". Photo by Michael Tropea. Courtesy of Rhona Hoffman Gallery, Chicago

	Gallery, Kansas City, Missouri, *Lorna Simpson, "Wigs,"* Albracht Kemper Museum of Art, St. Joseph, Missouri
1994	*Standing in the Water*, The Whitney Museum of American Art at Phillip Morris, New York, The Fabric Workshop, Philadelphia, Pennsylvania; *Lorna Simpson: New Works*, Rhona Hoffman Gallery, Chicago, Illinois
1993	*Lorna Simpson: Recent Work*, John Berggruen Gallery, San Francisco, California; *Lorna Simpson*, Shoshana Wayne Gallery, Santa Monica, California, Josh Baer Gallery, New York, New York; *Works by Lorna Simpson*, Contemporary Arts Museum, Houston, Texas
1991	Josh Baer Gallery, New York, New York; *Lorna Simpson*, Center for Exploratory and Perceptual Art, Buffalo, New York
1990	*Lorna Simpson: Recent Phototexts, 1989–90*, Denver Art Museum, Colorado; *Perspectives 15: Lorna Simpson*, The Portland Art Museum, Oregon; *Lorna Simpson: Projects 23*, Museum of Modern Art, New York, New York; *Centric 38: Lorna Simpson*, University Art Museum, California State University, Long Beach, University Art Museum, Berkeley, California
1989	*Matrix Gallery Show*, Wadsworth Atheneum, Hartford, Connecticut
1988	Jamaica Arts Center, Queens, New York; Mercer Union, Toronto, Canada
1986	*Screens*, Just Above Midtown, New York, New York
1985	*Gestures/Reenactments*, 5th Street Market, Alternative Gallery, San Diego, California

SELECTED GROUP EXHIBITIONS

1996	*Thinking Print*, The Museum of Modern Art, New York, New York; *Bearing Witness*, The Spelman College Museum of Fine Art, Atlanta, Georgia (traveling show); *Inclusion/Exclusion*, Steirischer Herbst, Austria; *To Live Is to Leave Traces*, Expoarte Guadalajara, Mexico;

Silence, Lawing Gallery, Houston, Texas; *Urban Evidence*, The Cleveland Center for Contemporary Art, Ohio

1995 *Fact & Fiction: Photographs from the Permanent Collection*, Whitney Museum of American Art, New York, New York

1993 *Personal Narratives: Women Photographers of Color*, Southeastern Center for Contemporary Art, Winston-Salem, North Carolina; *Object Bodies*, Emison Art Center, DePauw University, Greencastle, Indiana (traveling show); *Disorderly Conduct*, P.P.O.W., New York, New York; *Extravagant: The Economy of Elegance*, Russisches Kulturzentrum, Berlin, Germany; *Vivid: Intense Images by American Photographers*, Raab Galerie, Berlin, Germany; *The Seventh Wave*, John Hansard Gallery, The University of Southampton, Great Britain; *Transit*, The New Museum, New York, New York; *The Theatre of Refusal: Black Art and Mainstream Criticism*, University of California, Irvine; *PROSPECT 93*, Frankfurt Kunstverein, Schirn Kunsthalle, Germany; *Photoplay*, Chase Manhattan Collection, New York, New York (traveling show)

1992 *The Fortune Teller*, Rochdale Art Gallery, Lancashire, England (traveling show); *Dirt and Domesticity: Constructions of the Feminine*, The Whitney Museum of American Art at Equitable Center, New York, New York; *Dream Singers, Story Tellers: An African-American Presence*, Fukai Fine Arts Museum, Fukai City, Japan (traveling show); *Mistaken Identities*, University Art Museum, University of California, Santa Barbara (traveling show); *Images Matisses*, Intitut du Monde Arabe, Paris, France

1991 *The Sibylline Eye*, Munich Kunsthalle, Germany; *Biennial Exhibition*, Whitney Museum of American Art, New York, New York; *Places with a Past: Site-Specific Art in Charleston*, Spoleto Festival, South Carolina; *Desplazamientos*, Centro Atlántico de Arte Moderno, Canary Islands, Spain; *Beyond the Frame*, Setagaya Art Museum, Tokyo, Japan (traveling show); *Altrove*, Museo D'Arte Contemporanea Luigi Pecci, Prato, Italy; *American Artists of the 80's*, Museo D'Arte Contemporanea, Trento, Italy; *Artists of Conscience: Sixteen Years of Social and Political Commentary*, Alternative Museum, New York, New York

1990 *Aperto '90*, The Venice Bienale, Arsenale Corderie, Italy; *The Decade Show*, The New Museum of Contemporary Art, New York, New York; *All Quiet on the Western Front?*, Galerie Antoine Candau, Paris, France; *Art That Happens to Be Photography*, Texas Gallery, Houston

1989 *Image World: Art and Media Culture*, Whitney Museum of American Art, New York, New York; *The Cutting Edge*, Fine Arts Museum of Long Island, New York; *Constructed Images: New Photography*, Studio Museum in Harlem, New York (traveling show); *Bridges and Boundaries*, Snug Harbor Cultural Center, Staten Island, New York

1988 *Transatlantic Traditions*, Camerawork, Bethnal Gree, London, Eng-

land (traveling show); *Autobiography: In Her Own Image*, INTAR Gallery, New York, New York (traveling show); *Utopia Post Utopia*, Institute of Contemporary Art, Boston, Massachusetts

1987	*The Body*, The New Museum of Contemporary Art, New York, New York; *In the Tropics, P.S.* 39/Longwood Arts Project, Bronx, New York
1985	*Seeing Is Believing*, Alternative Museum, New York, New York
1984	*Contemporary Afro-American Photography*, Allen Memorial Art Museum, Oberlin College, Ohio
1983	*Our Point of View*, William Grant Still Community Center, Los Angeles, California

PERMANENT COLLECTIONS

The Baltimore Museum of Art, Maryland; The Brooklyn Museum of Art, New York; Chase Manhattan Bank, New York, New York; The Corcoran Gallery of Art, Washington, D.C.; The Denver Art Museum, Colorado; Department of Cultural Affairs, Chicago, Illinois; The High Museum of Art, Atlanta, Georgia; The Israel Museum, Jerusalem; Milwaukee Art Museum, Wisconsin; Museum of Contemporary Art, Chicago, Illinois; Museum of Contemporary Art, San Diego, California; Museum of Modern Art, New York, New York; The Progressive Corporation, Mayfield Heights, Ohio; Reader's Digest Corporation, Pleasantville, New York; University of New Mexico, Albuquerque; Wadsworth Atheneum, Hartford, Connecticut; Walker Art Center, Minneapolis, Minnesota; The Whitney Museum of American Art, New York, New York

PUBLICATIONS

Artner, Alan G. "Simpson Photoworks Speak Through Body Language." *Chicago Tribune*, March 27, 1993.
Avgikos, Jan. "Lorna Simpson." *Artforum* (October 1992), p. 104.
Beyond the Frame: American Art 1966–1990. Tokyo, Japan: Setagaya Art Museum, 1991. Exhbn cat.
Bridges and Boundaries. New York: Snug Harbor Cultural Center, 1989. Exhbn cat.
Canning, Susan. "Lorna Simpson/Barbara Bloom." *Art Papers* (January–February 1991), p. 67.
Centric 38: Lorna Simpson. Long Beach: University Art Museum, California State University, 1990. Exhbn cat.
The Devil on the Stairs: Looking Back on the Eighties. Philadelphia, Pa.: Institute of Contemporary Art, University of Pennsylvania, 1991. Exhbn cat.
Fall from Fashion. Roslyn Harbor, N.Y.: The Aldrich Museum of Art, 1993. Exhbn cat.
Faust, Gretchen. "Lorna Simpson." *Arts Magazine* (September 1991), p. 80.
Gray, Alice. "Lorna Simpson." *Art News* (October 1992), pp. 124, 126.
Harrison, Helen A. "Putting the Blame on Adam and Eve." *New York Times*, February 10, 1991.
hooks, bell. "Lorna Simpson: Waterbearer." *Artforum* (September 1993), pp. 136–137.
Johnson, Ken. "Generational Saga." *Art in America* (June 1991), pp. 45–51.
Jones, Kellie. "Lorna Simpson, Conceptual Artist." *Emerge* 2, no. 3 (January 1991), p. 40.

Joseph, Regina. "Lorna Simpson Interview." *Balcon* 5–6 (1990), pp. 35–39.

Lamb, Yanick Rice. "Sister Art." *Essence* (September 1992), p. 100.

Levin, Kim. "Lorna Simpson." *Village Voice* (October 5, 1993), p. 75.

Lorna Simpson: For the Sake of the Viewer. Chicago: The Museum of Contemporary Art, 1992. Exhbn cat.

"Lorna Simpson: Stop and Think." *Ms.*, May–June 1991, pp. 48–53.

Mifflin, Margot. "Feminism's New Face." *Art News* (November 1992), pp. 120–125.

Mistaken Identities. Santa Barbara: University Art Museum, University of California, 1992. Exhbn cat.

O'Grady, Lorraine. "Olympia's Maid: Reclaiming Black Female Subjectivity." *Afterimage* (Summer 1993), pp. 14–15, 23.

Places with a Past: New Site-Specific Art at Charleston's Spoleto Festival. New York: Rizzoli International, 1991.

PROSPECT 93. Frankfurter Kunstverein, Schirn Kunsthalle, Germany, 1993. Exhbn cat.

Sanconie, Maica. "Noire Amérique." *Beaux Arts* 105 (October 1992), pp. 54–64.

Sims, Lowery Stokes. "The Mirror, the Other: The Politics of Esthetics." *Artforum* 28 (March 1990), pp. 111–115.

Slowinski, Dolores S. "Lorna Simpson: Words and Images." *Michigan Photography Journal* 5.

Willis, Deborah. *Lorna Simpson: Untitled 54.* San Francisco: The Friends of Photography, 1992.

BIOGRAPHICAL ESSAY

Raised by parents who were politicized in the 1960s, Lorna Simpson brings to her work a keen awareness of issues relating to sexuality, gender, race, violence, and identity. She is interested in challenging assumptions and confronting stereotypes through the use of photography. Simpson got her first camera when she was young from an offer on the back of a tissue box. She took her first formal photography class at the High School for Art and Design in New York City and studied photography in college. As an undergraduate she interned in the education department at the Studio Museum in Harlem. During this time Simpson considered herself a documentary photographer, and she was taking pictures in the United States, Europe, and Africa. But she quickly became disenchanted with straight photography because it seemed so invasive of people's privacy. Therefore, in graduate school she moved away from street photography and changed her style by experimenting with the combination of imagery and language. She wanted to ask questions about African American experience, her own identity as a black woman, and the existence of objective truth.

Simpson was interested in using theory to examine the authority of the camera as well as the role of the photographer. She began to combine text and image in order to subvert and alter traditional roles and question stereotypes about race, beauty, subordination, and gender. Her work questions the objectivity of the photograph and the way the image is manipulated by the photographer and then received by the viewer. Ultimately, she is interested in the way identity is

constructed, particularly in terms of how African American women are portrayed by others and how they in turn define themselves. Using her own experience as a starting point, Simpson reclaims the traditionally hidden voices of black women by presenting imagery that both undermines stereotypes and reclaims histories. She deconstructs the authority behind documentary photography by staging her own photographs and adding texts. The texts themselves may be one word or a sentence, and they relate to the images but never fully narrate them so that the viewer must participate in interpreting the message. The words do not serve as captions but rather as clues to multiple readings. In this way, Simpson encourages the viewer to question what he or she is seeing and to reevaluate preconceived notions.

The often ambiguous narratives mimick documentary style but force the viewer to accept that they only tell part of the message. Simpson manipulates both the text and the image in order to confront us with the notion that we cannot accept everything that is fed to us as objective truth. She works in large format, and the addition of text is usually on engraved plastic or bronze plaques. Along with enigmatic language, Simpson presents an image that disrupts our expectations. Her models, most often female, are usually presented with their backs to the camera and with any identifying attributes either cropped out of the picture or fractured. She uses this technique of removing individual char-acteristics as a way to disrupt any preconceptions about that individual. Since we all make assumptions about people because of the way they look, Simpson forces us to reevaluate our judgments, particularly when it comes to race and gender. She also makes us confront our voyeuristic complicity. Her subjects become allegorical, and they appear in generic clothing—plain white shifts, black dresses, or brown suits. In later works, the figure is completely removed and replaced with a symbolic stand-in for the body such as shoes or gloves.

Simpson interjects a feminist critique into the debate surrounding racial iden-tity. She focuses on the black female body and interjects her own thoughts to encourage us to consider our role as spectator. By disrupting our invasive gaze, she forces us to confront our voyeurism and at the same time invites us to collaborate on redefining the realities of African American female experience. In the work *Same* (1991), Simpson addresses many of her underlying themes such as identity, common history, and individuality. This piece is made up of four similar yet subtly different images displayed one above the next. Each group of four photographs depicts the heads and shoulders of two African Amer-ican women, photographed from behind. Connecting these women is a long braid that runs across four panels. Hair is a recurring image in Simpson's work and represents cultural practice and ethnicity. In each pair some women wear white T-shirts, whereas others are bare-shouldered. The texts underneath the groups attest to both the similarities and differences between each woman. While the piece affirms that each woman is an individual with her own personal ex-perience, it also demonstrates that black women are simultaneously linked by their shared experiences. The image of the women linked by a braid also appears

in Simpson's installation *Five Rooms* (1991) made for the Spoleto Festival in South Carolina. This piece was a departure from her purely photographic and conceptual work and was more straightforward. Collaborating with vocalist and composer Alva Rogers, Simpson explored themes relating to slavery in Charleston including the Middle Passage, insurrections, economic justifications, and lynching.

Overall, Simpson uses the body as the site for exploring issues relating to gender, race, sexuality, objectification, oppression, and power. She explores the complexity of these issues and the need to decode as well as repudiate dominant definitions. She reclaims the terrain of the body as spectacle and location of violence and manipulation. By questioning the authority of the photograph to depict the truth and by subverting the gaze, she encourages a reevaluation of power structures and reinforces the need for multiple readings of identity.

STOUT, RENÉE

Born: 1958, Junction City, Kansas. *Education*: B.F.A., Carnegie-Mellon University, Pittsburgh, Pennsylvania, 1980. *Career*: Independent artist. Taught painting at the University of Georgia at Athens (spring semester 1995). *Awards*: Afro-American Master Artists in Residency Program, Northeastern University, Boston, Massachusetts, 1984.

EXHIBITIONS

1997	*Renée Stout: Dueling Dualities*, Steinbaum Krauss Gallery, New York, New York.
1995	*Dear Robert, I'll See You at the Crossroads*, University Art Museum, University of California, Santa Barbara
1992	*Recent Sculpture*, Pittsburgh Center for the Arts, Pennsylvania
1991	*Recent Sculpture*, B. R. Kornblatt Gallery, Washington, D.C.
1987	Chapel Gallery, Mount Vernon College, Washington, D.C.

SELECTED GROUP EXHIBITIONS

1996	*American Kaleidoscope: Themes and Perspectives in Recent Art*, National Museum of American Art, Smithsonian Institution, Washington, D.C.
1992	*The Migrations of Meaning*, INTAR Gallery, New York (traveling show); *Sites of Recollection: Four Altars and a Rap Opera*, Williams

College Museum of Art, Williamstown, Massachusetts (traveling show); *Houses of Spirit/Memories of Ancestors*, Bronx Council on the Arts at Woodlawn Cemetery, Bronx, New York; Lewallen-Butler Gallery, Santa Fe, New Mexico; *Homeplace*, Henry Street Settlement, New York, New York; *Touch: Beyond the Visual*, Handworkshop, Richmond, Virginia

1991 *Power and Spirit (Renée Stout: Spirit House #2; Fred Wilson: The Other Museum)*, Washington Project for the Arts, Washington, D.C.

1990 *Gathered Visions: Selected Works by African American Women Artists*, Anacostia Museum, Smithsonian Institution, Washington, D.C.

1989 *Black Art—Ancestral Legacy: The African Impulse in African-American Art*, Dallas Museum of Art, Texas (traveling show)

1988 *New Directions*, Marie Martin Gallery, Washington, D.C.

1987 Bloomers Gallery, Pittsburgh, Pennsylvania; Carlow Gallery, Pittsburgh, Pennsylvania

1986 California University of Pennsylvania, California, Pennsylvania; The Undercroft Gallery, Pittsburgh, Pennsylvania; Martin Luther King Public Library, Washington, D.C.; AT&T Building, Pittsburgh, Pennsylvania

1985 Allegheny County Courthouse Gallery, Pittsburgh, Pennsylvania; Massachusetts College of Art, Boston; Fitchburg State College, Fitchburg, Massachusetts; *Black Creativity*, Museum of Science and Industry, Chicago, Illinois

1984 The Joan Velar Gallery, Carnegie-Mellon University, Pittsburgh, Pennsylvania; Sewickley Academy, Sewickley, Pennsylvania; The Undercroft Gallery, Pittsburgh, Pennsylvania; The Paul Robeson Cultural Center, Pennsylvania State University, State College, Pennsylvania

1983 H. M. Neal Galleries, Pittsburgh, Pennsylvania

1982 The Paul Robeson Cultural Center, Pennsylvania State University, State College, Pennsylvania

1981 Duquesne University, Pittsburgh, Pennsylvania

PERMANENT COLLECTIONS

Allegheny Community College, Pittsburgh, Pennsylvania; Columbia Hospital, Pittsburgh, Pennsylvania; Coraopolis Health Center, Pittsburgh, Pennsylvania; Dallas Museum of Art, Texas; National Museum of American Art, Washington, D.C.; The Virginia Museum of Fine Arts, Richmond

PUBLICATIONS

American Kaleidoscope: Themes and Perspectives in Recent Art. Washington, D.C.: National Museum of American Art, 1996. Exhbn cat.

Astonishment and Power: Kongo Minkisi & the Art of Renée Stout. Washington, D.C.: National Museum of African Art, 1993. Exhbn cat.

Berns, Marla. *Dear Robert, I'll See You at the Crossroads*. Santa Barbara: University Art Museum, University of California, Santa Barbara, 1995.

Fleming, Lee. "Casting Spells." *Museum & Arts Washington* (March–April 1990), p. 35.

Hall, Robert L. *Gathered Visions: Selected Works by African American Women Artists.* Washington, D.C.: Smithsonian Institution Press for the Anacostia Museum, 1992.

James, Curtia. "Astonishment and Power: Kongo Minkisi & the Art of Renée Stout." *Art News* (October 1993), p. 171.

Mandle, Julia Barnes, and Deborah Menaker Rothschild, eds. *Sites of Recollection: Four Altars and a Rap Opera.* Williamstown, Mass.: Williams College Museum of Art, 1992. Exhbn cat.

Prokop, Alan, ed. *Power and Spirit (Renée Stout: Spirit House #2; Fred Wilson: The Other Museum).* Washington, D.C.: Washington Project for the Arts, 1991. Exhbn brochure.

Rozelle, Robert, Alvia Wardlaw, and Maureen McKenna, eds. *Black Art—Ancestral Legacy: The African Impulse in African-American Art.* Dallas, Tex.: Dallas Museum of Art, 1989. Exhbn cat.

Rubenfeld, Florence. "Renée Stout." *Arts Magazine* (May 1991), p. 79.

Tanguy, Sarah. "Renée Stout." *Sculpture* (July–August 1991), p. 55.

Thompson, Robert Farris. "Betye and Renée: Priestesses of Chance and Medicine." In *The Migrations of Meaning.* New York: INTAR Gallery, 1992. Exhbn cat.

BIOGRAPHICAL ESSAY

Renée Stout was born in Kansas, where her father was stationed in the army, but when she was one year old her family returned to Pittsburgh, and she remained there until 1984 when she moved to Boston for a six-month residency. There were creative individuals around her when she was growing up. Her grandfather played several instruments and carved toys, her mother sewed, and her uncle was a painter. In school and immediately after, Stout was painting in a realist style influenced by Edward Hopper, and her work depicted the outside world. But during her stay in Boston, her style changed quite radically. Her studio had no windows, and for the first time she was away from Pittsburgh and her family. She found the new city cold and unfriendly, so she kept to herself and her work turned inward, becoming more personal and introspective. She stopped painting altogether and began to work with sculpture, particularly box formats, and started scavenging for found materials. After her residency, she moved to Washington in 1985 and found that it was also an impersonal city.

In Washington, however, she discovered her interest in spiritualism. She began to explore some of the root stores and to learn about spiritualists, palm readers, and folk medicine. Intrigued by the mystery behind these things, she tapped into her imagination and pursued a newfound interest in African art, culture, and religion. This led to further research into African resonances in African American culture and to piecing together her cultural heritage. While she was not aware of them as a child, there were some things in her upbringing that may have stimulated her later interests. For instance, Stout remembers a house near hers where a woman lived who put all sorts of dolls and stuffed

animals on staffs in her yard as well as a scarecrow made with an overcoat and a hat on a pole. There were other strange and wonderful things like a sign in the window of a house that read ''Madam Ching'' with no other information or the fact that she was told to never throw her hair away and instead to burn it. Her grandmother never talked about cultural practices that conflicted with her Christian beliefs, but there were remnants that would sometimes show up. For example, she would never touch a spoon that had fallen a certain way. Stout also remembers going to the Carnegie Museum when she was ten to take art classes and finding a Nkisi Nkondi figure on display. She was automatically drawn to it and awed by all of the nails.

The influence of Kongo Minkisi is clearly evident in Stout's work. Two years after she moved to Washington, she began work on her fetish series. Her interest was in the ability of fetishes to mediate between positive and negative forces. At the time she was working with very young children and felt that their innocence functioned in a similar manner. She started making medicine bundles or charms similar to the objects used in Kongo and in voodoo rituals. Many of these pieces are small, but one of her key pieces, *Fetish no. 2* (1988), is life size. This work functions as a psychic self-portrait of the artist that also doubles as a power figure or charm. The figure is a female nude with medicine pouches resting around her shoulders and other medicines encased in her belly. Stout becomes a Nkisi as an expression of self-empowerment and a link between her present, past, and future. Minkisi represent the connection between the material world and the spiritual world of the ancestors.

After the death of her grandmother in 1989 Stout's work began to build more upon her family relationships as well as her personal experiences and fascination with mystery and magic. In her family, however, there was little discussion of personal history or memory, perhaps because the past was so painful that they wanted only to remember the time since they first moved to Pittsburgh. Stout's interest is to explore the past and to construct for herself a cultural identity. She works with blending the past and the present as well as reality and fiction. One of her methods is to include objects from her life or the lives of her friends and family, and occasionally she incorporates actual sepia photographs into her work. She uses the method of assemblage to create powerful objects and installations, and the influence of voodoo and Kongo religious practices are clearly evident in her work.

Her interest in accumulation may also relate to her father, who was a mechanic and never threw anything away, and her interest in magic may relate to her grandmother's feather duster, which Stout used to play with as a child. The feather duster had a gold-painted handle and was studded with rhinestones and fake pearls and crowned by bright red feathers, and Stout used to pretend it was a magic wand. These memories coupled with her trips to New Orleans and further exposure to African art have fueled her imagination. In many of her works, Stout constructs fictional narratives and mythic personalities. Part of her interest in formulating these elaborate narratives is to reconstruct her own family

history as well as a cultural heritage. In her work *She Kept Her Conjuring Table Very Neat* (1990), Stout has constructed a fictional narrative around a man who lived near her named Frank Davis. She has created a story about a woman named Dorothy and her love for Colonel Frank, who is always traveling to far-off lands. The low table is covered with roots, herbs, bones, and a photograph of Colonel Frank. Alongside the table are Dorothy's slippers, which Stout made and beaded by hand. Other individual pieces such as *Womba Doll* (1990) also relate to these characters and their story.

In more recent work, Stout continues to grapple with issues of identity and power. Having witnessed two murders from her studio window, she created one installation in which she displayed guns, each with a tag containing names of important figures in African American history. She explains that she uses her art as a weapon of resistance and a means to express her rage. These works function in a similar way to the medicine pieces and carry on her search for spiritual transformation and intervention.

THOMAS, ALMA

Born: 1891, Columbus, Georgia. *Education*: B.S., Fine Arts, Howard University, 1924. M.A., Teachers College, Columbia University, 1934. *Career*: Painter, educator, arts administrator, civic leader. *Awards*: First Prize in Oils, Outdoor Art Fair, Commerce Department, 1939. Third Prize, Howard University Gallery of Art, 1961. First Prize, Capitol Hill Community Art Show, 1962. Purchase Prize, Howard University, 1963–1973. Honorable Mention, Society of Washington Artists, 1963, 1968, 1970. Honorable Mention, American-Austrian Society Art Exhibition, 1968. Honorable Mention, United States Art in Embassies Program. Mayor Walter Washington proclaimed September 9, on the opening of the Corcoran Art Gallery solo exhibition, Alma W. Thomas Day in Washington D.C., 1972. Two Thousand Woman of Achievement Award, 1972. International Women's Year Award, 1976. Invited to the White House by President Jimmy Carter, 1977. *Died*: 1978, Washington, D.C.

SELECTED EXHIBITIONS

1981	*A Life in Art: Alma Thomas, 1891–1978*, National Museum of American Art, Smithsonian Institution, Washington, D.C.
1976	H. C. Taylor Art Gallery, North Carolina Agricultural and Technical State University, Greensboro, North Carolina
1975	Howard University Gallery of Art, Washington, D.C.

1973	Martha Jackson Art Gallery, New York, New York
1972	Corcoran Gallery of Art, Washington, D.C.; Whitney Museum of American Art, New York, New York
1968–1974	Franz Bader Gallery, Washington, D.C.
1968	Whitney Museum of American Art, New York, New York; Corcoran Gallery of Art, Washington, D.C.
1967	Margaret Dickey Gallery, Washington, D.C.
1962	College Arts Traveling Service
1960–1962	Dupont Theater Art Gallery, Washington, D.C.

SELECTED GROUP EXHIBITIONS

1992	*Free within Ourselves: African-American Artists in the Collection of the National Museum of American Art*, Smithsonian Institution, Washington, D.C. (traveling exhibition)
1989	*African-American Artists 1880–1987: Selections from the Evans-Tibbs Collection*, Smithsonian Institution, Washington, D.C.
1985	*Art in Washington and Its Afro-American Presence: 1940–1970*, Washington Project for the Arts, Washington, D.C.
1981	*Forever Free: Art by African-American Women 1862–1980*, The Center for the Visual Arts Gallery, Illinois State University, Normal, Illinois
1979	*Black Artists/South*, Huntsville Museum of Art, Alabama
1975	*Eleven in New York*, Women's Interart Center Inc., New York, New York
1974	*Painting and Sculpture Today*, Indianapolis Museum of Art, Indianapolis, Indiana
1952	*Eleventh Annual Exhibition: Paintings, Sculpture, Prints by Negro Artists*, Trevor Arnett Library, Atlanta University, Atlanta, Georgia
1951–1981	Frequent group exhibitions at the Barnett-Aden Gallery, Dupont Theatre Art Gallery, Howard University Gallery of Art, Smithsonian Institution, and many other art groups and societies local to the Washington, D.C., metropolitan area

SELECTED COLLECTIONS

American University Gallery of Art, Washington, D.C.; Barnett-Aden Collection, Washington, D.C.; Corcoran Gallery of Art, Washington, D.C.; Evans-Tibbs Collection, Washington, D.C.; Fort Wayne Museum of Art, Fort Wayne, Indiana; Hirshhorn Museum and Sculpture Garden, Washington, D.C.; Howard University Gallery of Art, Washington, D.C.; Museum of Art, University of Iowa, Iowa City, Iowa; National Museum of American Art, Smithsonian Institution, Washington, D.C.; Wadsworth Atheneum, Hartford, Connecticut; Whitney Museum of American Art, New York, New York

SELECTED PUBLICATIONS

Atkinson, Edward J., ed. *Black Dimensions in Contemporary American Art*. New York: New American Library, 1971.

Black Bourgeosie: The Rise of a New Middle Class in the United States. Collier Books: New York, 1969.

Dover, Cedric. *American Negro Art*. Greenwich, Conn.: New York Graphic Society, 1960.

Fine, Elsa Honig. *The Afro-American Artist*. New York: Holt, Rinehart and Winston, Inc., 1973.

LeBlanc, Michael L., ed. *Contemporary Black Biography*. Detroit: Gale Research Inc., 1992.

Munro, Eleanor. *Originals: American Women Artists*. New York: Simon and Schuster, 1979.

Negro Heritage Committee. *Afro-American Women in Art: Their Achievements in Sculpture and Painting*. Greensboro, N.C.: Alpha Kappa Alpha Sorority, 1969.

Porter, James. *Modern Negro Art*. Washington, D.C.: Howard University Press, 1992 (1943).

Sterling Brown/Alma Thomas. Profiles of Black Achievement Series. Pleasantville, N.Y.: Harcourt Brace Jovanovich, 1973.

ARTIST STATEMENT (1982)[1]

I guess I always wanted to succeed on my own terms, as a woman, an individual. Maybe I would have become an artist sooner if I'd grown up in Harlem instead of Washington. You know how reserved the black community here was in the old days, how it admired successful black people. Well, my family succeeded in Georgia, right in the heart of the South, and they did better than most after we came to Washington. I was proud of them and I still am. But for educated young black people there were so many expectations then, so many pressures to conform. I don't know why I never lost this need to create something original, something all my own.

Note

1. Merry A. Foresta, *A Life in Art: Alma Thomas, 1891–1978* (Washington, D.C.: National Museum of American Art, 1982), exhbn cat.

BIOGRAPHICAL ESSAY

By all accounts, Alma Thomas was imperious. Creative, intelligent, and volatile, she was also raised to be a well-bred gentlewoman in the old-fashioned sense. Apparently, her innate temperament opposed her upbringing to the extent that a personality was constructed that inspired no ambivalent emotions in others but either love or hate. The very sight of Thomas at her exhibition openings wielding a gold-headed cane, bedecked in jewels and satin, apparently evoked

both derision and devotion. However difficult it may have been for Thomas to negotiate her life inasmuch as her disposition was fraught with contradiction, one cannot avoid presuming that her antithetical nature also resulted in an iconoclasm sufficient to create the transcendent beauty of her signature luminous abstractions, an iconoclasm that led as well to Thomas's blunt descriptions of her paintings as abject "cracks and color."[1] Certainly, Thomas's paintings appear to give off the same kind of supernatural glow associated with the Byzantine mosaics that she much admired. However, so many of her works could suggest also the accidental beauty of the laboratory, in which case their "tesserae" transmute into particles floating in some kind of a radioactive suspension. As such, Thomas's work (for example, her *Space Painting* series inspired by the pre-Moonwalk circumlunar-module spacecraft) anticipates the postmodern abstraction of artists like Peter Halley and Jack Goldstein, whose works representing electronic circuitry or molecular structures seek, according to Hal Foster, "to picture abstractive tendencies in late-capitalist life: in science, technology, telecommunications, image and commodity production."[2]

It is remarkable that this complicated artist—at once straitlaced and bohemian, haughty and warmhearted, whose complicated art is at once sacred and secular, evocative of a distant past and a postmodern future—would succeed at all in an art world at a time when "difficult" art, especially abstraction, was considered to be a white male province. Consider, for example, Ann Gibson's account of the black Abstract Expressionist Norman Lewis's strained reception by the New York School:

> Was Lewis ejected from the canonical group of Abstract Expressionists because he was black? Well, yes and no. The white artists in the school were conflicted about the politics that his very presence evoked. On the one hand, most white critics, curators, even fellow artists did at some level, either positively or negatively, connect his absence to his identity as an African American. At the Club, for instance, a late-forties gathering place for the New York School, "they liked Norman; they were glad he was there," remembered his partner in those years, Joan Murray. "But it was a strange attitude: what was he doing there? He should be painting lynchings."[3]

It is all the more remarkable that Alma Thomas, a female *and* an African American, knew success in her lifetime as an acknowledged member of the Washington Color School's second generation. No doubt, the Color School's receipt of Clement Greenberg's stamp of approval elevated the visibility of everyone associated with it. Nonetheless, Thomas's notices from the predominantly white critical press were consistently superlative, referring to her as "the Signac of current color painters" and as a "gifted, ebullient abstractionist."[4] One must also credit Thomas's success to her legendary indomitable vivacity and tenacity,

which Adolphus Ealey, the director of the Barnett-Aden Gallery who knew
Thomas well, recognizes embedded in the works themselves as

> her iconoclastic spirit moving through her canvases when I view them in
> various prestigious museums and galleries. It is as if she has reincarnated
> herself in her canvases; I sense her aura vibrating through them. Alma
> used to say to me: "Do you see that painting? Look at it move. That's
> energy and I'm the one who put it there. You know what the scientists
> say, 'Energy can't be created or destroyed.' Well, maybe I transform en-
> ergy from these old limbs of mine."[5]

Yet in the end, it is the powerful effulgence of Thomas's painted mosaics—
phosphorescent, vibrating, humming even—that account for her acclaim.

As with so many African American women artists, success did not come until
relatively late in life, after she retired from a long career as an art educator
(another common career choice amongst many of the other artists considered in
this chapter). As a high school student at Armstrong Technical High School in
Washington, she showed great promise in art, design, and architecture but de-
cided it would be more practical to pursue a career in teaching. After graduating
from Miner Teachers Normal School, Thomas moved to Wilmington, Delaware,
where she excelled in teaching kindergarten at the Thomas Garrett Settlement
House. She drew upon her architectural and design abilities by creating stage
sets—painted by her students—for puppet shows, carnivals, and circuses, for
which her students would also design the costumes.

Inspired by her positive teaching experiences in staging theatrical extrava-
ganzas for children, Thomas decided to further her own education and enrolled
in Howard University in 1921 to study costume design. While there, she met
James V. Herring with whom she would co-found in 1943 the Barnett-Aden
Gallery, the first private collection of African American art chartered in the
United States and one of the first galleries to mount exhibitions of contemporary
art, routinely featuring artists regardless of race or sex. At the time of their
meeting, Herring was attempting to establish a fine arts department at Howard.
He convinced Thomas to drop her plans for a career as a costume designer and
to enroll in his nascent program. Over the next four years, Herring was Thomas's
mentor, giving her access to his private library, introducing her to the study of
art history, and encouraging her emerging desire to be a professional artist. In
1924, Thomas became the first graduate of Howard's new Fine Arts Department.

Over the next ten years, Thomas taught art at Shaw Junior High School in
Washington, D.C. and painted in her spare time. In 1930, Thomas began sum-
mering in New York City, extending her own art education through museum
and gallery visits and eventually, matriculating at Columbia University in edu-
cation. After receiving her Master of Arts from Columbia in 1934, Thomas
returned to Washington, D.C. and continued teaching at Shaw Junior High until
her retirement in 1960. Throughout her teaching career, Thomas always main-

tained a high profile on the Washington arts scene. As vice-president of the Barnett-Aden Gallery, Thomas not only gained experience in fundraising and arts management but also met virtually all of the East Coast luminaries in the visual arts.

Undoubtedly, the skills and contacts Thomas acquired through her work at the Barnett-Aden Gallery served her very well in terms of her famous ability to negotiate the art world successfully. In addition, Thomas studied art and art history throughout the 1950s at American University, meeting in the process many of the artists of the Washington Color Field Group with whom she would be later associated. Throughout the 1960s and 1970s, Thomas simultaneously honed her craft *and* was celebrated for her accomplishments in a series of solo and group exhibitions mounted by some of the most prestigious art institutions in the United States. In 1972, The Whitney Museum of American Art presented a retrospective of Thomas's work in the first one-person exhibition of an African American woman ever organized by the Museum. Considering the Whitney's terrible track record for showing women at all, Thomas's retrospective there was no mean feat. During that same year, the Corcoran Gallery in Washington, D.C., also gave Thomas a major solo retrospective, which incorporated ''Alma Thomas Day'' on September 9, 1972, a fitting tribute to her unwavering ambition for and dedication to her art. During an interview three years before, Thomas had stated in her typically starchy fashion, ''Do you have any idea of what it's like to be caged in a 78 year-old body and to have the mind and energy of a 25 year-old? If I could only turn the clock back 60 years I'd show them. I'll show them anyway.''[6] She certainly did.

Notes

1. Adolphus Ealey, ''Remembering Alma,'' in *A Life in Art: Alma Thomas, 1891–1978* by Merry A. Foresta (Washington, D.C.: Smithsonian Institution Press, 1981), p. 13.

2. Hal Foster, ''Signs Taken for Wonders,'' in Howard Risatti, ed., *Postmodern Perspectives: Issues in Contemporary Art* (Upper Saddle River, N.J.: Prentice-Hall, 1990), p. 159.

3. Ann Gibson, ''Recasting the Canon: Norman Lewis and Jackson Pollock,'' in Maurice Berger, ed., *Modern Art and Society* (New York: HarperCollins, 1994), pp. 225–226.

4. ''Critics' Tributes to the Artist,'' in *Alma W. Thomas: Recent Paintings* (Washington, D.C.: Howard University Gallery of Art, 1975), exhbn cat.

5. Ealey, ''Remembering Alma,'' p. 13.

6. Michael L. LeBlanc, ed., *Contemporary Black Biography* (Detroit: Gale Research Inc., 1992), p. 208.

WEEMS, CARRIE MAE

Born: 1953, Portland, Oregon. *Education*: B.A., California Institute of the Arts, Valencia, 1981. M.F.A., University of California, San Diego, 1984. Graduate Program in Folklore, University of California, Berkeley, 1984–1987. *Career*: Assistant Professor, Hampshire College, Amherst, Massachusetts, 1987–1991. Visiting Professor, Hunter College, New York, 1988–1989. Assistant Professor, California College of Arts and Crafts, Oakland, 1991. "Behind the Scenes," television program for PBS in association with Learning Designs, New York, 1992. *Awards*: Los Angeles Women's Building Poster Award, 1981. University of California Fellowship Award, 1981–1985. University of California Chancellor's Grant, 1982. California Arts Council Grant, 1983. Artist-in-Residence, Visual Studies Workshop, Rochester, New York, 1986. Artist-in-Residence, Light Work, Syracuse, New York, 1988. Massachusetts Artists Fellowship (finalist), 1988, 1989. Artist-in-Residence, Art Institute of Chicago, 1990. Artist-in-Residence, Rhode Island School of Design, 1990. Louis Comfort Tiffany Award, 1992. Adeline Kent Award, San Francisco Art Institute, 1992. Friends of Photography, Photographer of the Year, 1994. National Endowment for the Arts Visual Arts Grant, 1994.

EXHIBITIONS

1997	Moderna Museet, Stockholm, Sweden; Virginia Museum of Fine Arts, Richmond
1996	*From Here I Saw What Happened and I Cried*, P.P.O.W., New York, New York; Contemporary Arts Museum, Houston, Texas; Rhona Hoffman Gallery, Chicago, Illinois; Krannert Art Museum, University of Illinois at Urbana-Champaign
1995	*Carrie Mae Weems Reacts to Hidden Witness*, J. Paul Getty Museum of Art, Malibu, California; *Projects 52*, Museum of Modern Art, New York, New York
1994	Sarah Moody Gallery of Art, University of Alabama, Tuscaloosa (traveling exhibition); Hood Museum of Art, Dartmouth College, Hanover, New Hampshire
1993	The National Museum of Women in the Arts, Washington, D.C. (traveling exhibition); *Sea Islands*, Linda Cathcart Gallery, Santa

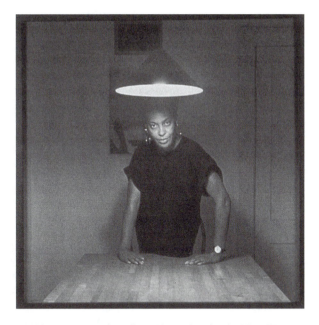

Untitled (Woman Standing Alone) by Carrie Mae Weems, 1990, gelatin silver print, edition of 5, 28¼" × 28¼". Courtesy of Rhona Hoffman Gallery, Chicago

Monica, California, Rhona Hoffman Gallery, Chicago, Illinois; New Langton Arts, San Francisco, California; The Fabric Workshop, Philadelphia, Pennsylvania; *States of Loss*, Jersey City, New Jersey

1992 Greenville County Museum of Art, Greenville, South Carolina; *And 22 Million Very Tired and Angry People*, San Francisco Art Institute, California; *Sea Islands*, P.P.O.W., New York, New York

1991 Trustman Gallery, Simmons College, Boston, Massachusetts; *And 22 Million Very Tired and Angry People*, The New Museum of Contemporary Art, New York; Wadsworth Atheneum, Hartford, Connecticut; *Currents*, Institute of Contemporary Art, Boston, Massachusetts; *Family Pictures and Stories*, Albright College, Reading, Pennsylvania, Art Complex Museum, Duxbury, Massachusetts; University of Southern California at Irvine

1990 *Calling Out My Name*, CEPA Gallery, Buffalo, New York; P.P.O.W., New York, New York

1989 Rhode Island School of Design, Providence

1987 Hampshire College Art Gallery, Amherst, Massachusetts

1984 *Family Pictures and Stories*, Multi-Cultural Gallery, San Diego, California

SELECTED GROUP EXHIBITIONS

1996 *Inside the Visible*, Institute of Contemporary Art, Boston, Massachu-
 setts (traveling show); *Herkunft*, Winterthur Fotomuseum, Winter-
 thur, Switzerland; *Gender-Beyond Memory*, Tokyo Metropolitan
 Museum of Photography, Japan

1995 *Art about Life: Contemporary American Culture*, Fine Arts Gallery,
 Indiana University, Bloomington, Indiana; *'95 Kwangju Bienniale*,
 Seoul, Korea

1994 *Gesture and Pose*, Museum of Modern Art, New York, New York;
 Bad Girls, Part I, The New Museum of Contemporary Art, New
 York, New York; *Women's Representation of Women*, Sapporo
 American Center Gallery, Japan (traveling show); *Who's Looking at
 Family?* Barbican Art Gallery, Barbican Centre, London, England;
 Imagining Families: Images and Voices, Smithsonian Institution,
 Washington, D.C.; *Black Male: Representations of Masculinity in
 Contemporary American Art*, The Whitney Museum of American Art,
 New York, Armand Hammer Museum of Art, Santa Monica, Cali-
 fornia

1993 *Contemporary Women Artists and the Issue of Identity. My/Self:
 Your/Other*, Castle Gallery, College of New Rochelle, New York;
 Personal Narratives, SECCA, Winston-Salem, North Carolina; *Fic-
 tions of the Self: The Portrait in Contemporary Photography*, Weath-
 erspoon Art Gallery, University of North Carolina, Greensboro,
 Herter Art Gallery, University of Massachusetts, Amherst; *The The-
 atre of Refusal: Black Art and Mainstream Criticism*, Fine Arts Gal-
 lery, University of California, Irvine (traveling show)

1992 *Disclosing the Myth of Family*, The Betty Rhymer Gallery, The
 School of the Art Institute of Chicago, Illinois; *Schwarze Kunst: Kon-
 zepte zur Politik und Identitat*, Neue Gesellschaft fur bildende Kunst,
 Berlin, Germany; *Dirt and Domesticity: Constructions of the Femi-
 nine*, Whitney Museum of American Art at Equitable Center, New
 York, New York; *Family Pictures and Stories*, Cleveland Center for
 Contemporary Art, Ohio; *Mis/Taken Identities*, University Art Mu-
 seum, University of California, Santa Barbara (traveling show)

1991 *Whitney Biennial*, The Whitney Museum of American Art, New
 York, New York; *Of Light and Language*, Pittsburgh Center for the
 Arts, Pennsylvania; *The Art of Advocacy*, The Aldrich Museum,
 Ridgefield, Connecticut; *Pleasures and Terrors of Domestic Comfort*,
 The Museum of Modern Art, New York, New York (traveling show);
 1992: Conquests Do Not Belong Only to the Past, INTAR Gallery,
 New York, New York; *No Laughing Matter*, University of North
 Texas, Denton, Texas (traveling show); *Artists of Conscience: 16
 Years of Social and Political Commentary*, Alternative Museum, New
 York, New York

1990	*Black Women Photographers*, Ten-8, London, England; *Trouble in Paradise*, MIT List Visual Arts Center, Boston; *The Power of Words: An Aspect of Recent Documentary Photography*, P.P.O.W., New York, New York; *Urban Home*, The Studio Museum in Harlem, New York; *The Empire's New Clothes*, Camerwork, London, England
1989	*A Century of Protest*, Williams College, Williamstown, Massachusetts; *Black Women Photographers*, LeMois de la Photo a Montreal, Canada
1988	*Herstory: Black Women Photographers*, Firehouse Gallery, Houston, Texas; *Prisoners of Image, 1800–1988*, Alternative Museum, New York, New York
1987	*Documenta 8*, The Castle, Kassel, Germany; *Edict and Episode: Image as Meaning*, Installation Gallery, San Diego, California
1986	*America: Another Perspective*, New York University, New York; *Social Concerns*, Maryland Institute of Art, Baltimore; *Past, Present, Future*, The New Museum, New York, New York
1985	*Analysis and Passion: Photography Engages Social and Political Issues*, Eye Gallery, San Francisco, California
1983	*Four West Coast Photographers*, Vanderbilt University Art Gallery, Nashville, Tennessee
1981	*Women in Photography*, Cityscape Photo Gallery, Pasadena, California
1980	*Contemporary Black Photographers*, San Francisco State University, California

PERMANENT COLLECTIONS

Akron Art Museum, Ohio; The Art Institute of Chicago, Illinois; The Bowen Foundation, California; The Brooklyn Museum, Brooklyn, New York; Cincinnati Art Museum, Ohio; Des Moines Museum of Art, Iowa; General Mills, Minneapolis, Minnesota; Greenville County Museum of Art, South Carolina; Hood Museum of Art, Dartmouth College, Hanover, New Hampshire; Johnson Enterprises, Chicago, Illinois; Los Angeles County Museum of Art, California; Museum of Fine Arts, Houston, Texas; Museum of Modern Art, New York, New York; Museum of Modern Art, San Francisco, California; The New School for Social Research, New York, New York; The Norton Gallery, Florida; Reader's Digest, New York, New York; Refco, Inc., Chicago, Illinois; The Santa Barbara Museum of Art, California; Southwestern Bell, Texas; St. Louis Museum of Art, Missouri; The Wadsworth Atheneum, Hartford, Connecticut; Walker Art Center, Minneapolis, Minnesota; The Whitney Museum of American Art, New York, New York

PUBLICATIONS

And 22 Million Very Tired and Very Angry People. San Francisco, Calif.: Walter/McBean Gallery, San Francisco Art Institute, 1992. Exhbn cat.
Benner, Susan. "A Conversation with Carrie Mae Weems." *Art Week* 23 (May 7, 1992), pp. 4–5.

Bonetti, David. "Looking Truth in the Face, Carrie Mae Weems Delivers Political Messages with Human Spirit." *San Francisco Examiner*, June 18, 1993, p. E7.

Carrie Mae Weems. Philadelphia, Pa.: The Fabric Workshop, 1996.

"Carrie Mae Weems/Matrix 115, Wadsworth Atheneum." *Journal of the Print World* 14, no. 2 (Spring 1991), p. 49.

Doniger, Sidney, Sandra Mathews, and Gillian Brown, eds. "Personal Perspectives on the Evolution of American Black Photography: A Talk with Carrie Mae Weems." *Obscura* 2, no. 4 (Spring 1982), pp. 8–17.

Family Pictures and Stories: A Photographic Installation. Reading, Pa.: Albright College Freedman Gallery, Center for the Arts, 1991. Exhbn brochure.

Felshin, Nina. *No Laughing Matter*. New York: Independent Curators Inc., 1991. Exhbn cat.

Heartney, Eleanor. "Carrie Mae Weems." *Art News* 90, no. 1 (January 1991), pp. 154–155.

In These Islands: South Carolina, Georgia. Birmingham: University of Alabama, 1995.

Jones, Kellie. "In Their Own Image." *Artforum* 29, no. 3 (November 1990), pp. 133–138.

Kelley, Jeff. "The Isms Brothers: Carrie Mae Weems at SFAI." *Art Week* 23 (May 7, 1992), p. 4.

Kirsh, Andrea, and Susan Fisher Sterling. *Carrie Mae Weems*. Washington, D.C.: The National Museum of Women in the Arts, 1993. Exhbn cat.

Mellor, Carl. "No Joke: Photographer Carrie Mae Weems Blasts Away Stereotypes." *Syracuse New Times*, August 31–September 7, 1988, p. 1f.

Personal Narrative: Women Photographers of Color. Winston-Salem, N.C.: SECCA, 1994. Exhbn cat.

A Portrait Is Not a Likeness. Tucson: Center for Creative Photography, University of Arizona, 1991. Exhbn cat.

Princethal, Nancy. "Carrie Mae Weems at P.P.O.W." *Art in America* 79, no. 1 (January 1991), p. 129.

Reid, Calvin. "Carrie Mae Weems." *Arts Magazine* 65, no. 5 (January 1991), p. 79.

Rodriquez, Geno. *Artists of Conscience: 16 Years of Social and Political Commentary*. New York: Alternative Museum, 1991. Exhbn cat.

Smith, Roberta. "A Photographer Upstages Herself." *New York Times*, December 22, 1995, p. C31.

States of Loss: Migration, Displacement, Colonialism, and Power. Jersey City, N.J.: Jersey City Museum, 1993.

Tarlow, Lois. "Carrie Mae Weems." *Art New England* 12 (August–September 1991), cover, pp. 10–12.

Trippi, Laura. *And 22 Million Very Tired and Very Angry People*. New York: New Museum of Contemporary Art, 1991. Exhbn brochure.

Trouble in Paradise. Cambridge, Mass.: List Visual Arts Center, MIT, 1989. Exhbn cat.

Weems, Carrie Mae. *Blues & Pinks*. 1982. Artist's book.

Weems, Carrie Mae. *Family Pictures and Stories: A Photographic Installation*. San Diego, Calif.: Alternative Space Gallery, 1984. Artist's book.

Weems, Carrie Mae. "Family Stories." In Brian Wallis, ed., *Blasted Allegories: An Anthology of Writings by Contemporary Artists*. Cambridge, Mass.: MIT Press, 1987.

Weems, Carrie Mae. *Then What? Photographs and Folklore.* Buffalo, N.Y.: CEPA Gallery, 1990. Artist's book.
Weems, Carrie Mae. *Stories.* 1982. Artist's book.
Weems, Carrie Mae. *Vanishing Cream.* 1982. Artist's book.
Willis-Thomas, Deborah. *An Illustrated Bio-Bibliography of Black Photographers, 1940–1988.* New York: Garland Publishing, 1989.

BIOGRAPHICAL ESSAY

When a friend gave Carrie Mae Weems a camera in 1976 she began to record the world around her. She entered a B.F.A. program at the California Institute of the Arts in 1979 at the age of 27. Prior to this she had been a dancer with Anna Halpern in San Francisco and had worked a variety of jobs. She was active in grassroots political organizing and attributes her return to school to what she saw as a crisis in left-wing politics. As an undergraduate she focused on African American subject matter and found that few of her professors or classmates could respond to the imagery. It was not until graduate school that she found a sympathetic professor. He offered criticism that helped her to address some important issues about documentary photography.

Weems was interested in recording her own environment and in using photography as a political tool to capture the human condition. She wanted to present her own culture as portrayed by an insider and to use black subjects to represent universal concerns. She came to realize that her chosen genre had a history in the black community that was different than traditional documentary, which was most often used to study the "other." Artists like James Van Der Zee and Roy DeCarava were important influences. Her first works were in the tradition of street photographers and captured images from her hometown as well as her travels. Her following works were taken from the inner-city black neighborhood of southeast San Diego. This series demonstrates an interest in narrative that would develop further in her later work. But with these photographs Weems realized that she was still an outsider, and so she turned to subject matter that came directly out of her own personal experience. The series *Family Pictures and Stories* (1978–1984) depicts Weems's own family accompanied by narratives, both audio and text based. Her family histories and migrations are recounted through four generations, and they tell of poverty, racism, and violence as well as affection, strength, and support. This series is a form of testifying and claiming both the good and the bad within the multiplicity of black experience. By relying on a first-person account, Weems subverts the traditional method of "objective" documentary recording. As a student of folklore she was interested in storytelling and in getting closer to the anecdotes of real people.

Weems's next series of works was called *Ain't Jokin* and was based on racist humor. The pieces in this series force the viewer to confront stereotypes. The following series, *American Icons*, depicts racist knicknacks and decorative objects such as cookie jars and salt and pepper shakers in household settings.

Perhaps her most well-known body of work is the *Kitchen Table Series*. In these works, Weems uses a large format camera to explore an African American woman's life from the activities around her kitchen table. The camera is placed at the same vantage point, and each individual image acts as a storyboard in a narrative where objects and people move in and out of the space. The images are coupled with texts in third person, and the central female figure of the story occasionally looks directly out at the viewer. This series attests to African American female experience and undermines the objectification of black women. It challenges the notion of the passive subject and the dominant gaze.

Weems believes in an African American aesthetic. Her work grapples with the way images shape our perceptions of race, class, and gender. By using photographic conventions, she can manipulate the look of documentary while resisting its inequities. She exploits European aesthetics and standards to her own ends, creating a conceptual format that questions the authenticity and authority of the camera, photographer, and image. She asks important questions about who is constructing history, identity, and space, as well as who her audience is, who is looking, and who is being looked at. She asserts her own voice by introducing text, thereby manipulating viewer response.

In her first color work, *And 22 Million Very Tired and Very Angry People* (1990), Weems used a 20 × 24 Polaroid camera to photograph single objects or subjects such as a rolling pin, globe, or armed man. She installed these in a group of 15 images, each with captions, around the periphery of a space. Above the symbolic images were banners with quotes by various notables such as Malcolm X and Rosa Luxemburg. The installation can be read as an acknowledgment of oppression and a call to political action. Around this same time, she was working on a series called *Colored People*. The photographic prints themselves are hand-dyed and reflect the politics of skin color. Weems places her subjects in traditional scientific pose with captions such as *Blue Black Boy* and *Golden Yella Girl* and colors the image in the appropriate tone. These works reference the social implications of color in the African American community while at the same time celebrating the multiplicity of appearance.

The whole of Weems's work centers around the complexity of black identity and the status of African Americans in the United States. Her *Sea Islands Series* brings her back to a search for her roots and an exploration of migration in her own family as they moved from Mississippi to Portland. She uses the South as a symbol for African American heritage and a place of return and memory. There is a mystical and haunting quality to these images. In these works, Weems continues to search for identity and looks to the Sea Islands off the coast of South Carolina and Georgia. It is here that the Gullah culture exists and where there are still strong associations to Africa, the Middle Passage, and slavery. She photographs slave quarters, homes, churches, landscapes, shops, and graveyards and pairs the images with texts that recount some of the folklore, magic spells, and history of the place. Included in this series is a set of dinner plates

on which are sentences that begin "Went looking for Africa . . ." and end with such phrases as "found it lurking quietly along the shores of the Carolinas." The objects and photographs come together in an installation that is both poetic and powerful. Weems employs a documentary style that exploits both the beauty of the place and its mythic and symbolic quality. This series adds a rich and complex dimension to Weems's efforts to capture the complexity of African American experience in the photographic medium.

4

ASIAN PACIFIC AMERICAN WOMEN ARTISTS

Reena Jana, Melinda L. de Jesús,
Kristine C. Kuramitsu, William W. Lew,
and Mary-Ann Milford-Lutzker

Innovative in vision, honest in expression, strong in technique, brave in voice—
these words naturally come to mind when describing the work of the artists
featured in this chapter, from the Realist paintings of Lenore Chinn to the Surreal
performances of Yoko Ono, from the minimalist photographic-based installa-
tions of Young Kim to the figurative paintings of Pacita Abad. Innovative, hon-
est, strong, brave—these words, in fact, perhaps more accurately reflect the
shared attributes of these artists and their work than the blunt fact that they are
all women of Asian descent who have launched their careers in the twentieth
century. Still, we must never forget that they—and no one else—can escape
their ethnicity, their gender, their primary place of residence, or the era in which
they live. But at the same time, we must always remember that it is only lucid
visual communication that defines enduring quality in art. And this is why it is
important to recognize these artists: because their work, seen individually, is
work of quality and, seen collectively, is work that helps us understand what it
means to live in the twentieth century—from a voice that is outside the main-
stream and burdened by both sexual and racial stereotypes. It is work with a
distinct focal point: the simultaneously complex, dynamic, and sensitive per-
spective of women of Asian descent living and working in the United States.

As this ethnically diverse group of artists working in varied media illustrates,
the categories of "Asian" and "Asian American" refer to a broad spectrum of
art histories and cultures. These classifications refer not only to Chinese Amer-
ican or Japanese American or Indian American or Korean American societal
legacies and aesthetic concerns. Thus, by nature, the grouping of "Asian" and
"Asian American" artists can only reflect the omniculturalism of the United
States and its "melting pot" identity in the microcosmic sense—as well as the
universal nightmare of alienation and displacement experienced when pursuing
the myth of the American Dream or, perhaps more fairly, the personal freedom
it symbolizes. In general, the artists included in this chapter tend to explore

issues of identity, utilizing thematic and technical means that both directly or indirectly refer to their Asian roots and the Western influences that have shaped their aesthetic and personal visions. The result of such cultural hybridity: work that is as multifaceted as the Asian American identity itself.

Because it is work that bridges both East and West, work created by Asian American women artists is work of both national and international significance. Through the collective eyes of these artists, we can comprehend the pains and the triumphs of confronting one's own identity in the context of society—in Eastern, Western, and even global terms. It is a particularly grueling sense of confrontation of identity, as women and artists of color have, throughout the world's history, shared the sad legacy of widespread discrimination. As women artists of color in America, these artists have had to endure layers of prejudice, seen as "outsiders" not only in the traditionally male and Eurocentric U.S. art world but also in their Asian motherlands—as emigrants or children or grand-children of emigrants.

Thus, displacement is a common theme in the work of contemporary Asian American female artists. While at the time of this writing the conceit of "identity politics" and its pet theme of displacement are no longer as chic as they were in the late 1980s and early 1990s, the notion of displacement will forever be a natural theme for any American-based artist who chooses to address his or her roots, since America is, for the most part, a nation of immigrants. Besides, displacement is a common sense of alienation felt by anyone who has left the boundaries of their childhood home, even to move to another neighborhood, city, state, or province for school, work, or with a spouse. As travel and long-distance communications become more and more efficient and effective, as people continue to shift their places of existence more readily and more easily than ever, the work by Asian American women artists that deals with displacement as a common human experience will achieve more widespread resonance.

While there was once a lacuna of high-profile exhibitions of contemporary Asian and Asian American artists, there is, at the end of this decade, century, and millennium, a welcome steady stream of shows in galleries large and small across the United States, from alternative spaces and universities to commercial, mainstream galleries. In the late 1990s, major institutions such as the Asia Society, the SoHo branch of the Guggenheim Museum, and San Francisco's Asian Art Museum have consistently shown commitment to displaying work created by modernists and today's artists of Asian descent, an honor once reserved only for centuries-old traditional arts of Asia, such as a Ming vase or a statue of the goddess Kali culled from a Hindu temple.

There is no question that the visibility of the dual existence of the Asian American is gaining momentum in the nation's eye—and this is thanks, in part, to the passion, dedication, and outspokenness of contemporary Asian American artists themselves. Many have a dual identity not only ethnically but also professionally, an identity that reaches beyond "Asian American artist." They are more often than not artists-activists-writers-educators-curators-performers-

critics. Often they work a parallel career in one of the professions, such as architecture or nursing. Rarely do they wear a single hat; and thanks to their remarkable ability and willingness to make known their identities is the understanding of what it means to be of Asian descent and living in America. Their creativity and desire to communicate their experiences, thoughts, and observations reach beyond the white cube of the gallery into various levels of media and society, helping the world become more familiar with Asian American history and art history, thus widening—slowly, yes, but nonetheless, steadily—the context of the lives of each and every member of their widespread audiences, no matter what their ethnicity.

<div align="right">Reena Jana</div>

ABAD, PACITA

Nationality: Filipina-Americana. *Born*: 1946, Basco, Batanes, Philippines. *Education*: B.A., University of the Philippines, Quezon City, 1968. M.A., University of San Francisco, 1972. Corcoran School of Art, Washington, D.C., 1975–1977. The Art Students League of New York, 1978. *Career*: Printmaker, painter, mixed-media visual artist; lecture and workshop leader at many universities, museums, and arts organizations, 1980–1994. Cultural Alliance, Washington, D.C., 1981–1993. Board Member, Arlington Arts Center, Virginia, 1989–1993. Alternative Museum, New York, 1990–1993. *Awards*: Excellence 2000 Award for Artists, U.S.-Pan Asian Chamber of Commerce. NEA Individual Artist Grant. TOYM for Most Outstanding Artist in the Philippines. Residency Fellowship, Virginia Center for the Creative Arts, 1992, 1994. Artist Workshop Program, Virginia Museum of Fine Art, 1993–1994. Visual Artist Fellowship, Brandywine Workshop, Philadelphia, Pennsylvania, 1994–1995.

SELECTED EXHIBITIONS

1994	*Artist+Community: People of Color: The Immigrant Experience*, National Museum of Women Artists, Washington, D.C.; *Images of Indonesia*, National Museum of Jakarta, Indonesia; *Assaulting the Deep Sea*, Peninsula Fine Arts Center, Newport News, Virginia
1993	*Flower Paintings*, Philippine Center, New York, New York
1992	*Abstract Emotions*, Philippine Center, New York, New York
1991	*Pacita Abad and Edgar Sorrells-Adewale*, Pyramid, Atlantic, Mary-

land; *Wild at Art*, Ayala Museum, Makati, Philippines; *Small Paint-ings*, Luz Gallery, Makati, Philippines

SELECTED GROUP EXHIBITIONS

1998 *At Home and Abroad: 20 Contemporary Filipino Artists*, Asian Art Museum of San Francisco, California

1997 *Memories of Overdevelopment: Philippines Diaspora in Contempo-rary Art*, University College, Irvine

1994 *Asia/America: Identities in Asian American Art*, Asia Society Gallery, New York, New York; *Beyond the Border: Art by Recent Immigrants*, Bronx Museum of Arts, New York

1993–1994 *Touch: Beyond the Visual* (traveling)

1993 *Dress Forms*, D.C. Arts Center, Washington, D.C.; *A Common Thread*, Bomani Gallery, San Francisco, California, CRT Craft Guild, Hartford, Connecticut

1992–1993 *Circle of Friendship*, Sumner School Museum, Washington, D.C.

1992 *Washington Project for the Arts at the Hemicycle*, Corcoran Gallery of Art, Washington, D.C.; *Crossing Over/Changing Places*, Print Club of Philadelphia, Pennsylvania (circulated by the USIA in the United States and Europe)

1991 *Fiber: The State of the Art*, Meyerhoff Gallery, Maryland Institute and College of Art, Baltimore; *Nine Paths to a Journey: The Immi-grant Experience*, Ellipse Gallery, Arlington, Virginia

1990 *Day of the Dead*, Alternative Museum, New York, New York

SELECTED PUBLICATIONS

Asian Women United. *Art to Art: Expressions by Asian American Women Artists*. Author, 1993. Videotape.
Driscoll, Arabela. "The Art of Abad." *Filipinas Magazine* (San Francisco), January 1993, pp. 13–14.
Findlay, Ian. "Assailing the Senses." *Asian Art News* (March–April 1994).
Friis-Hansen, Dana, Jeff Baysa, Alice Guillermo, and Patrick Flores. *At Home and Abroad: 20 Contemporary Filipino Artists*. San Francisco, Calif.: Asian Art Mu-seum, 1998. Exhbn cat.
James, Curtia. "Eight Paths to a Journey: Cultural Identity and the Immigration Expe-rience." *New Art Examiner* (October 1991).
Machida, Margo. "Out of Asia: Negotiating Asian Identities in America." In *Asia/Amer-ica: Identities in Asian American Art*. New York: New Press, 1994.
McCoy, M. "Asian Artists Drawn into Circle." *Washington Post*, December 3, 1993.
Pagano, Peggy. "Hot House." *Washington Post*, August 12, 1994.
Raynor, Vivien. "The Immigrant Experience in the 1990s." *New York Times*, 1994.

ARTIST STATEMENT (1993)[1]

Abad: Art is for other people—it's not just for yourself, you know. Especially for people like us . . . if you want to be included, you know, you don't have any choice, you got to go out there and tell them. . . .

Interviewer: Tell me, what have you contributed to this country . . . as an artist?

Abad: Color! I have given it color! I remember when I was a student at the Art Students League in New York and we were painting still lifes. It was a grew November, the teacher came next to me and he said to me, "Pacita! These colors are wild!" And I said, "Well, these are the colors I grew up with, you know, Chinese red, yellows, and orange, and I can't help it—I have to paint with these colors!"

Note

1. From Asian Women United, *Art to Art: Expressions by Asian American Women Artists* (Author, 1993), videotape.

BIOGRAPHICAL ESSAY

Pacita Abad was born in 1946 on the island of Batanes in the northernmost part of the Philippines. Raised in a politically prominent family, Abad studied political science and attended law school in Manila; she was forced to leave the country in 1970 due to her involvement in anti-Marcos activism. En route to Madrid to continue law school, Abad stopped off in San Francisco and became involved in the arts community. Turning down a scholarship to law school at the University of California at Berkeley, Abad studied art at the Art Students League in New York and the Corcoran School of Art in Washington, D.C. She returned to the Philippines in 1982, witnessing the end of the Marcos era and the election of Corazon Aquino. Now a U.S. citizen, Abad maintains a studio in Jakarta, Indonesia, and divides her time between Asia and Washington, D.C.

Abad's distinctive, boldly colored work combines silk screen, tie-dye, painting, and collage with trapunto, "a form of collaged tapestry" wherein fabric is embellished with stuffing, stitching, embroidery, and decorative elements such as ribbon, buttons, and other found items.[1] Moreover, Abad's exposure to many different cultures greatly influences her art. Incorporating indigenous and found materials gathered from her extensive traveling and living among Third World peoples in over 50 countries throughout Latin America, Asia, and Africa, her work proffers an eclectic personal and yet communal, global worldview. Recurrent themes in Abad's work (identity, displacement, assimilation) reflect a compassionate rendering of the realities of immigrants' lives as contrasted to the myth of the American Dream; certainly her own experience of physical danger and economic difficulty as a Filipina in the diaspora has had a profound

impact upon her art.[2] She notes, "The dreams of immigration hold myriad hopes; the reality holds an abundance of deceptions."[3]

Two of Abad's best-known works, *I Thought the Streets Were Paved with Gold* (1991) and *How Mali Lost Her Accent* (1991), incorporate incisive renderings of the immigrant experience and its effect on people of color. *I Thought the Streets Were Paved with Gold*, mixed-media painting on padded canvas, depicts interwoven portraits of Asian, Latino, and Filipino[4] immigrants whom Abad came to know in the United States. Surrounding each immigrant's portrait is a personalized inscription as well as clothes and tools representing his/her livelihood—cannery work, painting, child care, food service, nursing, domestic work. Through these images, Abad underscores the reality of immigrant over-representation in the secondary labor market; she depicts the service industry occupations that many immigrants (even those with professional degrees) are forced to take in order to survive in America.[5]

Similarly, *How Mali Lost Her Accent* (1991), mixed media on stitched and padded canvas, explores the complex negotiations that characterize the assimilation process for immigrants and refugees. Abad notes: "When Mali came here she didn't speak English, but when I saw her recently I said, 'Mali, how come you lost your accent?' She replied, 'This is how the kids talk in school.' She has to do it because she has to blend in."[6] Here Mali, a young Laotian and Vietnamese girl wearing a Benetton purse, is depicted in the center of the work; surrounding her are computers and the banners and facades of renowned American universities such as Harvard, University of California at Berkeley, and Yale. Mali clearly has "made it" in America; nevertheless, Abad underscores that the educational opportunities offered her have a steep price: Mali's loss of her language and culture.

Pacita Abad maintains that she is "drawn to [her] medium [trapunto]" for "its accessibility and lack of pretense"; similarly, she is credited with "[bringing] into the mainstream a hitherto marginalized and non-canonical art form associated with women's painstaking needlework."[7] Rooted in the traditions of many cultures and committed to documenting the lives of the marginalized—women, people of color, immigrants, and refugees—Abad's provocative work melds unique forms with a distinct political vision.

Notes

1. Dana Friis-Hansen, Jeff Baysa, Alice Guillermo, and Patrick Flores, *At Home and Abroad: 20 Contemporary Filipino Artists* (San Francisco, Calif.: Asian Art Museum, 1998), p. 53, exhbn cat.

2. Abad's art reflects the Filipino diasporan experience through allusions to transnationalism, labor immigration under capitalism, and the issues of identity, language, cultural maintenance, identity, and assimilation. See E. San Juan, Jr., "The Predicament of Filipinos in the United States: 'Where Are You From? When Are You Going Back?' "

in Karin Aguilar-San Juan, ed., *The State of Asian America* (Boston: South End Press, 1993), Sucheng Chan, *Asian Americans: An Interpretive History* (Boston: Twayne Publishers, 1992), and Yen Le Espiritu, *Filipino American Lives* (Philadelphia, Pa.: Temple University Press, 1995), for more information about the Filipino American experience.

3. Friis-Hansen et al., *At Home*, p. 54.

4. Here Abad makes a specific allusion to Filipino immigration history by including references to Filipino workers in the canning and fishery industries of Alaska and the Pacific Northwest and to the more recent influx of Filipina nurses.

5. Margo Machida, "Out of Asia: Negotiating Asian Identities in America," in *Asia/America: Identities in Asian American Art* (New York: New Press, 1994), p. 83.

6. Ibid., p. 98.

7. Friis-Hansen et al., *At Home*, pp. 53, 41.

ACEBO DAVIS, TERRY

Nationality: Filipina American. *Born*: 1953, Oakland, California. *Education*: B.S., California State University, Hayward, 1976. Graduate coursework, University of California, San Francisco, Graduate School of Nursing, 1985. B.F.A., San Jose State University, 1991. M.F.A., San Jose State University, 1993. *Career*: Printmaker, mixed-media artist, curator, lecturer, nurse. *Awards*: James D. Phelan Award, Kala Institute, Palo Alto, California, 1997. Radius Award, Palo Alto Cultural Center, Palo Alto, California, 1997. Residency, Franz Masreel Center, Kasterlee, Belgium, 1998.

SELECTED EXHIBITIONS

1998	*New Work*, Washington Square Gallery, San Francisco, California
1996	*Of the Body*, Boom Gallery, Honolulu, Hawaii
1995	*Cantho into Haarlem: New Works*, Richard Sumner Gallery, Palo Alto, California
1993	*Redefining Self: The Flip Side*, San Jose State University, San Jose, California

SELECTED GROUP EXHIBITIONS

1998	*San Francisco Babaylan*, Museo Ng Maynila, Manila, Philippines; *Balikbayan Box: Tracing a Strain with DIWA Arts*, Bronx Museum, New York; *Sino Ka? ano Ka?* Fine Art Gallery, San Francisco State University, California

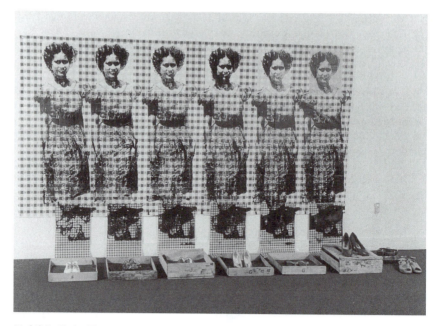

Dahil Sa Yo by Terry Acebo Davis, 1996, screened imagery 66" × 84" × 18". Courtesy of Terry Acebo Davis

1997	*Respect Diversity*, Mountain View City Hall, Mountain View, California; *Families: Rebuilding, Reinventing, Recreating*, Euphrat Museum, Cupertino, California; *Multicultural Perspectives*, Koret Gallery, Palo Alto, California; *Bay Area's Diversity in Art*, Synopsis, Inc. Office, Mountain View, California
1996	Alexander Gerbode Foundation, Capp Street Project, San Francisco, California; *Memories of Overdevelopment: Philippine Diaspora in Contemporary Visual Art*, University of California at Irvine; *Kayumanggi Presence '96*, East-West Gallery, University of Hawaii, Honolulu, Hawaii
1995	*Biennial Print Competition and Exhibition*, Triton Art Museum, Santa Clara, California; *13th Annual National Juried Exhibition*, Los Angeles Printmaking Society, Loyola Marymount University, Los Angeles, California; *Filipinas in Hawaii*, The Philippine Consulate General, Honolulu, Hawaii; *Artists Respond to Proposition 187*, San Jose Center for Latino Arts, San Jose, California
1994	*Yellow Forest*, SOMAR Gallery, San Francisco, California; *Making Women Artists Visible*, Galería Tonantzin, San Juan Bautista, California; *Bay Area Artists*, Galerie Adlergasse, Dresden, Germany; *Día de Los Muertos*, Yerba Buena Center for the Arts, San Francisco, California
1993	*Works on Paper*, Berkeley Art Center, Berkeley, California; *Object*

as Identity, 1078 Gallery, Chico, California; *Printmakers*, Walter Bischoff Gallery–Amerikahaus, Stuttgart, Germany; *American Exhibition*, Stuttgart International Airport, Stuttgart, Germany; *Kayumanggi Presence*, Academy Art Center at Linekona, Honolulu, Hawaii; *Time Echoes*, C. N. Norman Gallery, University of California, Davis

1992	*Harmony of Cultures*, Bingham Gallery, San Jose, California
1991	*New Printmakers Invitational*, California State University, Long Beach
1990	*Prints*, Washington Square Editions, Masters Gallery, San Jose State University, California
1989	*Letter Home: Photographs of China*, Gallery Two, San Jose State University Lithography Prints, Gallery Eight, San Jose State University, California
1988	*Monotypes*, Pacific Art League, Palo Alto, California
1979	*Printmaking*, Foothill College, Los Altos, California

SELECTED COLLECTIONS

Dr. & Mrs. Alan Bergano, United States; Dr. Gary Hartman, Washington, D.C.; Leland Whitney Ltd. International, San Francisco, California; Ralph and Sheila Pickett, Saratoga, California; Coby Prins and Tom Kroener, Amsterdam, The Netherlands; Dr. Ernesto Salazar, Iquitos, Peru

SELECTED PUBLICATIONS

Jana, Reena. "Terry Acebo Davis." *Asian Art News* (July–August 1995), p. 63.
Pimental, Ben. "A Balance between Art and Nursing." *San Francisco Chronicle*, April 28, 1995.
Santiago, Chiori. "Sunday Art Review." *San Jose Mercury News*, December 17, 1995.
Santiago, Chiori. "Urban Concerns Cross Borders in Dresden Exchange." *San Jose Mercury News*, March 19, 1994.

ARTIST STATEMENT (1998)

I draw upon my identity as a woman of Filipina American extraction as a source for my art. That identity was forged by growing up the eldest child of working-class Filipino parents who immigrated after the war. . . . Though my education and upbringing are strongly influenced by Euro-American contemporary thought and practices, I find that by delving into my dominant Filipina psyche I find issues that are unsettling. Plaguing me are the questions of diversity, gender, discrimination, and racial injustices that continue to pervade society today. These thoughts serve as catalysts for my work, and the ideas manifest themselves from subtle to blatant understandings.

BIOGRAPHICAL ESSAY

"The marks she makes chronicle her many journeys—as an Asian-American woman, a caregiver and an artist," wrote *San Francisco Chronicle* reporter Benjamin Pimentel of Terry Acebo Davis in 1995. Indeed, it is Acebo Davis's ability to not only manage but lucidly express her complex identity of Filipina American printmaker/mixed-media artist/lecturer/nurse that fuels her highly meditative work. From the figurative oil painting *Ideology Is Pernicious*, a commentary on war and racism that features images of a crying child, handcuffs, and a masked surgeon, to the abstract lithograph print *Ancient Tagalog*, a sense of balance pervades. Acebo Davis presents to her viewers visual mantras, simultaneously pleasing in their careful compositions yet hauntingly thought-provoking in their subject matter.

Dahil Sa Yo, a multimedia installation featuring wooden boxes of shoes set in front of multiple images of the artist's mother screened on red and white tablecloth material, is arguably Acebo Davis's seminal work. The repetitive images recall Andy Warhol's silkscreens of Elvis and Marilyn; the shoes spark the immediate association of the Philippines' notorious Imelda Marcos and her many pairs of shoes. The artist's mother is iconized as a figure from American pop culture or international political headlines, yet she is simultaneously robbed of her uniqueness, as she appears in multiple. The piece is an interplay between the subjective and the objective, the personal and the shared, East and West. The palette that Acebo Davis utilizes in this piece represents her signature color symbolism: red, which is "equivalent to life's blood," as she states in an artist's credo, and yellow, which is "equated with the sun's heat of fearful emotions." Thus, despite its streamlined aesthetic, *Dahil Sa Yo* exemplifies Acebo Davis's ability to express the complexity of human relationships on both the intimate and intercultural levels.

In general, Acebo Davis creates expressive, strong lines formed in neat patterns. In her prints, paintings, and mixed-media work, a sense of movement is achieved by the use of black lines or strokes juxtaposed with collage elements, from tickets to book pages. The recurrent elements in her visual language consist of mathematical and scientific symbols, foreign language characters as well as English text, the cross, and depictions of her family, from portraits of her grandparents to arresting images from her father's CAT scan. Such recurrent imagery addresses the topics not only of history, both public and private, but of spirituality, order, and ritual.

The eldest of six children of Filipino immigrants, Acebo Davis grew up in a predominantly white middle-class suburb of San Francisco in the 1960s. "Though my education was typically 'American' and fairly well-assimilated, an edge of racial strife shadowed me as I was first labeled 'Mexican' or 'Chink' by young classmates who had seen few if any Filipinos and whose parents felt best we weren't friends," she recalls in her credo. "Incidents like these, vividly

recalled, split me from the majority and toward a firmer bedrock, my own ethnic identity. It is this identity that spurs my art."

Her identity as a Filipina American has also spurred her to collaborate with other artists with the same ethnic background. She has participated in various projects with Diwa, a collective of Filipino American artists (past and current members have included Carlos Villa, Rene de Guzman, Joanna Poethig, among others) who have named themselves after the Tagalog word for "consciousness." The group has shown around the United States, ranging from the Bronx Museum to the University of California, Irvine.

Acebo Davis has also dedicated much of her time to educating others about the Filipino identity in lectures she has presented at high-profile venues ranging from the Smithsonian Institution in Washington, D.C., where she presented "Peasants, Rebels, and Sojourners: The Impact of History on Filipino Arts and Letters" in 1996, to the University of Pennsylvania, where she gave a talk entitled "The Evolution of Contemporary Filipino American Art," also in 1996. Other public lectures given by Acebo Davis include "Asian American Women's Representation in the Arts," presented at Mills College in 1996, and "Filipino History through Art," presented in 1997 at San Francisco's Washington Square Gallery.

This is not to say that Acebo Davis has anything less than a broad worldview either. Her *Cantho into Haarlem* series of mixed-media "drawings" illustrate her ability to apply her intensely focused style to subject matter other than her immediate ethnicity. The *Cantho into Haarlem* pieces (the title inspired by Acebo Davis's travels to both Vietnam and the Netherlands while on duty as a nurse) are collages that intrigue the eye and tease the mind, suggesting stories. In these works, the artist utilizes both found elements such as Vietnamese stamps, fragments from a map, and pages torn from a German book, as well as hand-rendered diagrams and sketches of a child's whimsical origami, delicate handmade paper boats, and airplanes. In this series, Acebo Davis has created a crazy-quilt of widely eclectic elements, gathered in neat, textural compositions that are simultaneously mysterious yet accessible.

Looking at the individual works of Acebo Davis, one realizes that many of the allusions used seem highly personal; observing them collectively, however, leaves the viewer with the impression that each piece shares a common identity, mimicking the fragmentation of personal memory as well as the universal desire to catalog and preserve experiences. Acebo Davis's methodical and meticulous approach to her work—evident in her meticulous, cross-referential body of work—reflects the symmetry of the artist's duty as a "professional" recorder of experience and memory and the basic human desire to do so.

Acebo Davis's identity as a professional nurse (most recently, she has been named Pediatric Critical Care Transport Specialist at Stanford Medical Center) has also played a role in the shaping of her identity as an artist. As a pediatric nurse, each day on the job forces her to deal more immediately with the drama

of life and death than most. The impact of her emotion-filled workdays directly influence her in the studio. As she told the *San Francisco Chronicle*, ''I think it gives me greater insight as an artist.''

Perhaps from her formal training as a printmaker, Acebo Davis has adopted and applied a theory of serialism, of the power of working with a sense of collectiveness. Each piece she creates seems to be one stage in the evolution of her oeuvre, related, in some physical or philosophical context, to both its precedent and predecessor.

CHINN, LENORE

Nationality: Chinese American. *Born*: 1951, San Francisco, California. *Education*: Studied advertising art and design, City College of San Francisco. Studied sociology, San Francisco State College. *Career*: Painter, graphic artist, lecturer, writer, cultural activist. *Awards*: Purchase Award, San Francisco International Airport Competition, 1977. Ligoa Duncan Award, Paris, France, 1981. First Award, Painting, Westwood Center for the Arts, Los Angeles, California, 1982. First Place, Painting, Art in the Park, San Francisco, California, 1982. *Art Search, Mom . . . Guess What! Newspaper*, Sacramento, California, 1988. Bronze Award, Art of California Discovery Awards, 1993.

EXHIBITIONS

1991	Rasmussen Gallery, San Francisco, California; The Michael Himovitz Gallery, Sacramento, California
1985	U.C. Extension Gallery, San Francisco, California
1980	Lucien Labaudt Art Gallery, San Francisco, California

SELECTED GROUP EXHIBITIONS

1995	Esperanza Peace and Justice Center, San Antonio, Texas; *No More Scapegoats* (Companion Exhibit to *Anne Frank and the World Today*), Corte Madera, California
1994	SOMAR Gallery, Asian American Women Artists' Association, San Francisco, California; *Family Album*, The Luggage Store Gallery, San Francisco, California
1993	Levi Strauss & Co., San Francisco, California; Gallery Route One, Pt. Reyes Station, California; SOMAR Gallery, HIV Healing Arts Project, Project Open Hand, San Francisco, California

1992	San Francisco State University, Artists Equity, Northern California Chapter
1991	*Visible for a Change*, Harvard University, Cambridge, Massachusetts; Pro-Arts Gallery (cosponsored by Guerrilla Girls West), Oakland, California
1990	SOMAR Gallery, Artists Equity, Northern California Chapter, San Francisco; *Lesbian & Gay Fine Art Exhibit*, City Hall Rotunda, San Francisco, California; Women's Building Arts & Crafts Fair, Fort Mason, San Francisco, California
1988	*Mom . . . Guess What! Newspaper*, San Francisco, California; *Artists against AIDS—Phase IV*, San Francisco, California
1987	*Beyond Power—A Celebration*, Women's Art Caucus for Art and Southern Exposure Gallery, Belmont, California, and Redwood City, California; Images . . . A Gallery, San Francisco, California
1986	*La Grange National XI*, Chattahoochee Valley Art Association, La Grange, Georgia
1983	72nd American Annual Exhibition at Newport, Newport, Rhode Island
1982	Hayward Area Forum for the Arts, Hayward, California; Westwood Center of the Arts, Los Angeles, California; Art in the Park, San Francisco, California; National Arts Club, Allied Artists of America, New York, New York
1980	*Capricorn Asunder*, San Francisco Arts Commission, San Francisco, California; Richmond Art Center, Richmond, California
1977–1982	San Francisco Arts Festival, San Francisco, California

SELECTED PUBLICATIONS

Fisher, Barbara. "United Front: 'Family Album' at the Luggage Store Gallery." *Artweek* (July 7, 1994).

FitzSimons, Casey. " 'Families: Rebuilding, Reinventing, Recreating' at the Euphrat Museum of Art." *Artweek* (February 1997).

Gunsaulus, Michael. "Artist's Profile." *San Francisco Sentinel*, December 16, 1988.

Hammond, Harmony. *Making Out: A Contemporary History of Lesbian Art* (forthcoming).

Kelly, Caffyn. *Forbidden Subjects: Self Portraits by Lesbian Artists*. North Vancouver, Canada: Gallerie Publications, 1992.

Lee, Elisa. "Asian Pacific American Artists Flip Through 'Family Album.' " *Asian Week* (June 17, 1994). Exhibition curated by Lenore Chinn and Steven Compton.

Lee, Kris. "I Was a Baby Dyke." *DYKE TV* (1995).

Oakley-Melvin, Deborah. "Lesbian and Gay Center for Art and Culture Opens." *San Francisco Sentinal*, November 24, 1993.

Oakley-Melvin, Deborah. "Levi Strauss's Queer Art Exhibit." *Deneuve* (November–December 1993).

Stein, Peter. "The Castro . . ." KQED TV (radio show).

Szajko, Lidia. *They Can't All Have Come from That Island in Greece*. Documentary film

presented by San Francisco Cinemateque at Yerbe Buena Center for the Arts, San Francisco, Calif. October 9, 1997.

ARTIST STATEMENT (1997)

I am a painter of great intimacy, and in many of my works, I explore domestic interiors and the people or objects associated with them. Through character studies in contemporary themes, I restore cultural difference to center stage, creating a presence that resonates in its luminosity, texture, color, and light.

BIOGRAPHICAL ESSAY

To look at a painting by Lenore Chinn is to step into another world. Her carefully composed canvases create the sensation of physical closeness to the painting's subject or subjects, generally women, gay men, lesbians, and people of color. Although she represents minorities and the marginalized, Chinn's style reflects those of American and European genre painters living and working in the late 1800s, namely, Mary Cassatt, Edouard Manet, and Berthe Morisot. Her hyperrealist technique and understanding of light and color also call to mind work by Vermeer and Van Eyck, as well as twentieth-century figures such as Richard Estes and Lucian Freud.

Chinn's paintings, although easily linked to traditional genre painting, have a distinctly contemporary edge in that the figures she chooses to represent are usually presented as isolated or alone, thus emphasizing their "outsider" status. *Walt Whitman's Recital*, for example, depicts a woman lying on a couch, feet propped up, reading a book. She is presented close to the picture plane and thus is highly accessible to the viewer's sight; however, as her gaze is planted firmly on the pages that she reads, the viewer feels isolated from her. It is a highly intimate moment—but the sensation of looking at the painting is voyeuristic, as if we are spying, unnoticed, at the subject.

Composition in Color and Light conveys the same sense of voyeurism. Its subject is a lone woman standing in front of a building, reading. As in *Walt Whitman's Recital*, the subject is absorbed in her reading material, and although she is placed basically on the picture plane, she is removed.

Both of these canvases exemplify Chinn's eye for acute detail and meticulous use of light. Although set in a room devoid of any decoration, save for a ficus plant and a reading lamp, *Walt Whitman's Recital* is a study in the richness of textures, as every fold in the subject's simple army-style cargo pants are as carefully rendered as any cascade of velvet robe found in a masterpiece by a Flemish master. *Composition in Color and Light* shows off Chinn's ability to depict even the most minute decorative detail, including precise rendering of mosaic tile.

Not all of Chinn's paintings feature people alone, although those paintings that do feature more than one subject depict homosexual couples presented in

"center stage" as well, isolated from others. *Break from Pulp* features an African American lesbian couple relaxing together, playing with their dog and sitting on the floor, a newspaper strewn on the floor beside them, as if taking a reprieve from reading. Chinn renders her subjects immediately on the painting's surface, so the viewer has no choice but to confront and accept this quiet and loving moment; still, the subjects do not look the viewer in the eye but instead are both fixated on the dog.

Occasionally, Chinn does present her subjects in positions that engage the viewer directly, but in these pieces, there is a lack of interaction between the subjects, as if they must hide their relationship when observed. In *Domestic Partners*, the composition is a departure from Chinn's signature style of arrangement: The central figures, a gay male couple, face the viewer eye-to-eye, smiling, but they stand with hands at their sides or in pockets, careful not to touch each other or imply in any physical way that they are or might be lovers. In the remarkable *Déjà vu*, the subjects, another gay couple, stand apart, although the viewer is completely incorporated into the scene—one subject, closest to the picture plane, holds up a camera as if shooting a photograph of the viewer; a mirror, hung on the wall, reflects "out" into the world of the viewer. This painting recalls the wit and visual clarity of Van Eyck's classic *Giovanni Arnolfini and His Bride*, although, sadly, in *Déjà vu*, the couple choose not to proudly display their intimacy by holding hands or engaging in any public display of affection.

"My signature paintings, with their super realistic, crisply rendered compositions, convey a subtle message of visibility for the socially and politically disenfranchised peoples in my personal social landscape," wrote Chinn in 1998. "I explore a genre that is largely invisible in the fine arts." Via the visual accessibility of her paintings, she opens the door to understanding of those outside the mainstream.

Since childhood, Chinn herself has dealt with the challenges of being an outsider. Born into a Chinese American family that was the first of Asian descent to settle in an all-Caucasian, middle-class neighborhood in San Francisco, Chinn had to cope with a dual alienation—from both her Chinese roots and the culture of mainstream America.

"This set the stage for a complex layering of cultural encounter and a personal odyssey which defied many of the labels, mores, and social limitations imposed on the 'cultural others' or my particular post-war baby boom generation," wrote Chinn in 1997. "These early explorations gave me the foundation for a more global perspective in the way I identified with others, prompting an insatiable appetite for understanding the rituals and traditions of people from very diverse backgrounds. Ultimately, this also became a part of my growth and development as a visual artist."

As a little girl, Chinn created her own toys and showed an early interest in drawing and painting. She studied advertising art and design and sociology in college and discovered, after spending a short period working at an advertising

agency, that commercial art was unappealing to her. As she developed her fine art skills, Chinn also began to nurture her interest in human rights and social justice. It is these interests that fuel the content of her body of paintings.

Chinn, who has gained visibility as a lesbian in San Francisco electoral politics, is also recognized as a cultural activist, writing about and lecturing about the importance of developing strong communities of otherwise "marginalized" artists and thinkers. Through her work as an artist and activist, Chinn promotes the concept of a cultural framework that includes symposia and forums as well as courting of collectors, educators, and historians dedicated specifically to work created by artists outside the mainstream.

ITAMI, MICHI

Nationality: Japanese American. *Born*: 1938, Los Angeles, California. *Education*: Attended the University of California, Los Angeles, where she received her B.A. degree in 1959. Shortly thereafter she moved to New York City, where she attended Columbia University from 1959 to 1962. Eventually returning to the West Coast, Michi Itami continued her education at the University of California, Berkeley, where she received her M.A. degree in 1971. *Career*: Michi Itami has had a long and fruitful career as an artist, having taught and exhibited her works on both the East and West Coasts of the United States. She is currently an active artist in New York and a faculty member at the City College of New York of the City University of New York where she serves as the director of the M.F.A. Program. *Awards*: National Defense Foreign Language Fellowship, 1961. National Endowment for the Arts Artist's Grant, 1981. Printmaking Fellowship, Festival of the Arts, Asilah, Morocco, 1984. Cleveland Print Club of the Cleveland Museum—Print commission published, Ohio, 1986. ACM Siggraph Educator's Grant, Las Vegas, Nevada, 1991. Cash Prize, "Twenty Fourth Annual Works on Paper," Southwest Texas State University Gallery, San Marcos, Texas, 1994. Travel Grant, The City College of New York, 1995. Eisner Grant, The City College of New York, 1995. New York Foundation for the Arts Artist's Grant, 1995. Brandywine Press Residency, Philadelphia, Pennsylvania, 1996. Visual Arts Residency, Mid Atlantic Arts Foundation, Rutgers Center for Innovative Printmaking at Rutgers University, New Brunswick, New Jersey, 1996. Brandywine Press Residency, Philadelphia, Pennsylvania, 1997.

RECENT EXHIBITIONS

1999 Atelier 221, New Delhi, India

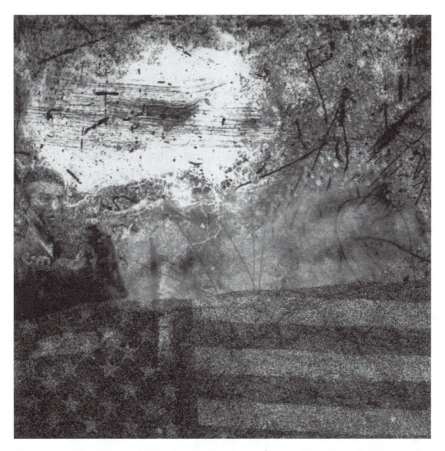

Tsuioku by Michi Itami, 1997, 4 color lithograph, 20" × 30". Photo by Brandywine Press. Courtesy of Michi Itami

1998	Rutgers University, New Brunswick, New Jersey; A.I.R. Gallery, New York, New York
1994	San Francisco Museum of Modern Art Rental Gallery, San Francisco, California; *The Irony of Being American*, Art Gallery of Long Island University at Southampton, Southampton, New York
1993	One-Person Show, Art House Odeon, Sag Harbor, New York
1992	Shinsegae Dongbang Plaza Art Gallery, Seoul, Korea
1991	A.I.R. Gallery, New York, New York; 55 Mercer Gallery, New York, New York

SELECTED GROUP EXHIBITIONS

| 1998 | *Faculty Exhibition*, Compton-Goethals Gallery, City College, New York, New York; *Honolulu Printmakers 70th Annual Exhibition*, Honolulu, Hawaii; *Memory Walking*, Wellington City Gallery, New |

Zealand; *Urban Encounters*, A Public Access exhibit, Downstairs at the New Museum: Godzilla, Asian American Art Network, New York, New York; *Mythologies*, Jonkonnu Gallery, Sag Harbor, New York; *PIECES 2*, Gallery 128, New York, New York; *A.I.R. Gallery Group Show*, Canessa Gallery, San Francisco, California; *25 Years of A.I.R., The First Women Artists Cooperative in America*, Kingsborough Community College, Brooklyn, New York; *The Digital Print, Exhibition/Workshop*, A.I.R. Gallery, New York, New York

1997 *Faculty Exhibition*, Compton-Goethals Gallery, City College, New York, New York; *Fermented*, Parsons School of Design, New York, New York; *Immigrant Strategies*, Raritan Valley Community College Gallery, Somerville, New Jersey; *Voices of Color*, in conjunction with the publication of *Voices of Color*, Purdue University Galleries, West Lafayette, Indiana; *Contemporary Asian Artists in America*, Mills Pond Gallery, Smithtown Township Arts Council, St. James, New York; *Kim Chee Extravaganza*, Korean American Museum, Los Angeles, California; *Inside/Out: Japanese and Japanese American Artist Prints*, The Printed Image Gallery, Brandywine Workshop, Philadelphia, Pennsylvania; *New Dialogues: Women Printmakers Invitational 1997*, Trustman Art Gallery, Simmons College, Boston, Massachusetts; *Benefit for Robert Blackburn's Printmaking Workshop*, Leo Castilli Gallery, New York, New York; *Arcade II*, University of Brighton Gallery, Brighton, England, U.K. Traveling exhibit, University of Derby, The Atrium, Kensington & Chelsea College Art Gallery, London, Stoke City Museum & Gallery; *Exhibition of New Works*, Rutgers Center for Innovative Print and Paper, Mason Gross School of the Arts Galleries, New Brunswick, New Jersey

1996 *Cultural Economies*, Drawing Center, New York, New York (included in ongoing slide show); *Women's Work*, sponsored by A.I.R. at the Arsenal Gallery, New York, New York; *The 3rd Kochi International Triennial Exhibition of Prints*, Ino-cho Paper Museum, Kochi, Japan; Honolulu Printmakers 68th Annual Exhibition, Honolulu, Hawaii; *Picture Element*, Valencia Community College, Orlando, Florida; *Eleven at A.I.R.*, 1996 Group Show, New York, New York; *Women of Color in Art: National Juried Exhibition*, Women's Caucus for Art, Federal Reserve Bank Gallery, Boston, Massachusetts

1995 *Artist as Citizen*, American Council for the Arts Exhibition Space, New York, New York; *CODE*, Ricco-Maresca Gallery, New York, New York

COLLECTIONS

Achenbach Foundation of the Legion of Honor Museum, San Francisco, California; Brooklyn Museum, Brooklyn, New York; Cincinnati Art Museum, Cincinnati, Ohio; KTVU, Channel 2, Oakland, California; National Museum of Modern Art, Kyoto, Japan; Neuberger Museum, Newark, New Jersey; New Booneville Hotel, Booneville, California;

Oakland Museum, Oakland, California; Queens College Library, Queens, New York; Rutgers Center for Innovative Paper and Printmaking, New Brunswick, New Jersey; San Francisco Museum of Modern Art, San Francisco, California; State of Hawaii, Honolulu, Hawaii; University Art Museum, Berkeley, California; University of Colorado, Boulder, Colorado; Zimmerlie Museum of Newark, Newark, New Jersey

PUBLICATIONS

Braff, Phyllis. "Uses of Paper and National Identities." *New York Times* (Long Island edition), March 27, 1994.

Harrison, Helen A. "Some Luminous Surfaces and 2 Asian Survey Shows." *New York Times* (Long Island edition), October 12, 1997.

Itami, Michi. "The Irony of Being American." In Phoebe Farris-Dufrene, ed., *Voices of Color: Art and Society in the Americas*. Atlantic Highlands, N.J.: Humanities Press International, 1997. pp. 20–28.

Itami, Michi. "The Irony of Being American." *M/E/A/N/I/N/G* no. 19–20 (1996).

Print Collector's Newsletter xxv, no. 2 (May–June 1994). p. 68.

Slivka, Rose C. S. "From the Studio." *East Hampton Star*, April 7, 1994.

"Voices of Choices." *Village Voice*, March 30, 1993.

Weiss, Marion Wolberg. "Art Commentary." *Dan's Papers*, April 1, 1994.

ARTIST STATEMENT (1997)[1]

What is truly "American" is to adapt an attitude of activism to ensure the ideals of fair play and equal opportunity for everyone. This is the responsibility of everyone, regardless of color or ethnic background. Part of that activism is to relate our own personal stories and histories through our different media and inform one another of the complexity of our nation. Multiculturalism encompasses *everyone*; all of us have a story to tell, and understanding and empathy are increased when we share our stories.

Note

1. Michi Itami, "The Irony of Being American," in Phoebe Farris-Dufrene, ed., *Voices of Color: Art and Society in the Americas* (Atlantic Highlands, N.J.: Humanities Press International, 1997), p. 26.

BIOGRAPHICAL ESSAY

For Michi Itami, art and family history become inextricably intertwined. However, Itami uses her art not only to explore her background as a Japanese American but also to affirm her strongly felt attitudes about the multicultural nature of this country. Her current artistic involvement with her ethnic background was influenced to a great degree by a number of events, perhaps the most significant of which had to do with a collection of photographs bequeathed her by her father. The subject matter of these photographs had to do with her father's family

and his past. In Itami's own words, she "felt compelled to tell his story visually."[1] In doing so Itami also presents to her viewing audience a facet of her own history. For Itami, and many other Japanese Americans of her generation, that history includes to one degree or another the internment experience endured by the Japanese American population during World War II.

A Californian by birth, Michi Itami and her family were sequestered in Manzanar, one of ten "relocation" camps intended for the internment of persons of Japanese ancestry that resulted from President Franklin D. Roosevelt's signing of Executive Order 9066. A work that references this experience in Itami's attempts to give visual form to this history is a large computer-generated collage photograph entitled *The Irony of Being American*. This piece, which dates from 1994, presents images of Itami's father at three different stages of his life superimposed over a photographic image of Manzanar that was taken by Ansel Adams. As a youth of 16, the father is shown in the background in Japanese dress; as a young man of 23 he is shown in the middleground in a business suit. Finally, at age 27 the father is presented in the foreground, occupying almost one half of the work's surface, in his U.S. Army uniform. The three images of Itami's father superimposed over Ansel Adam's photograph of Manzanar does not go unnoticed.

As previously mentioned, Michi Itami's artistic involvement with her ethnic background was influenced by a number of different events. In addition to the photographs that were passed on to her from her father, another of these was her purchase of a high-end computer. By training, Itami is a printmaker. And as a printmaker, she incorporated images from her father's photographs into her work through photo-etching processes. Finding these processes to be rather restrictive for what she wanted to do, she sought another avenue to enhance both the size and scope of her works. Her solution was to be found in computer-generated images. Access to a high-end computer was absolutely essential for the making of these works that proved to be an expression not only of her father's history but of her own as well.

Michi Itami's purchase of such a computer, while peripheral to the aforementioned work, proves not only to be a fascinating story in and of itself but provides a context for a more profound understanding of the work's content and, especially, its title. On August 10, 1988, then-President Reagan signed into law the Redress Bill, also known as The Civil Liberties Act of 1988. This law assured reparation payments to persons of Japanese ancestry who were interned during World War II as a means of redress for what this country now publicly recognizes as an illegal and immoral act that it had perpetrated on them. As a result of this law, the Attorney General's Office established the Office of Redress Administration to locate eligible individuals and to administer reparation payments to them. In due time, Itami was informed that she was a beneficiary of this law. Itami's initial response to the reparation payment was one of ambivalence; however, the thought of larger-scale works that focused on both her

father and her family's internment at Manzanar prompted her to use a portion of the monies for the purchase of the computer.[2] Interestingly enough, the reparation payment becomes an important aspect of *The Irony of Being American*. The letter from President George Bush that accompanied the reparation payment making possible her purchase of the computer is placed next to this work, serving not merely as an explanatory note but as an important component of its content and the raison d'être for its title.

While one might view the work's content to be merely biographical and personal, the artist fully intended for it and for her current body of works to present a more complete picture of the multicultural fabric of American society. Itami fully subscribes to the idea that an individual artist can use her or his art to inform that society and, therefore, to enhance the multicultural dimensions of our history.

> In the United States we share a common history in that we all came from other places. Because of this, we all have much to contribute to the storehouse of shared experience; we need to investigate our own pasts, the history of our mothers and fathers and their parents, to fully appreciate and understand how we have shared similar tribulations. At the same time, we need to acknowledge the differences of our various backgrounds.[3]

This position was not arrived at overnight. In fact, Itami's past works were primarily of an abstract nature. However, her move to an "objective" and representational art emerged with her need to re-create her personal ethnic history in visual form and to have that history both enhance the multicultural dimensions of our society and serve as an agent for social change. It might do us well to underscore this latter concern, for Itami's commitment to it extends well beyond the confines of her own art and manifests itself in many other aspects of her professional life.

Michi Itami's commitment to social change has caused her to press her concern about multicultural issues before a number of other venues within the profession. Within the College Art Association, for example, she proved to be an instrumental working member of the Committee on Cultural Diversity, which compiled and distributed a 19-page bibliography of books and videos on cultural diversity and which attempted to establish a forum for the compilation of multicultural curricula in the visual arts. Michi Itami will serve as vice-president of the College Art Association until 2000 and assume the presidency subsequently. She has participated on boards and steering committees of other arts organizations and groups not only to broaden her own perspective and sense of reality but to educate others and to broaden their perspectives, as well as to open up opportunities for other artists of color.

For Michi Itami, it is of paramount importance for artists of color to become involved with issues of a multicultural nature. Itami's commitment is to be seen not only in her creative works, which focus on her personal history, but also

and to a large extent through her active involvement with these issues in different forums within the profession as well.

Notes

1. Michi Itami, "The Irony of Being American," in Phoebe Farris-Durfene, ed., *Voices of Color: Art and Society in the Americas* (Atlantic Heights, N.J.: Humanities Press International, 1997), p. 20. This essay borrows heavily from Itami's article.
2. Ibid.
3. Ibid., p. 23.

KANG-ENGLES, SUK JA

Nationality: Korean American. *Born*: Korea. *Education*: Attended Sung Shin Women's University in Seoul, Korea, where she earned her B.A. degree in Korean Literature. Moving to the United States about nine years ago, Suk Ja Kang-Engles pursued and completed her B.F.A. degree in painting and drawing from the University of Georgia in Athens. *Career*: As an artist Suk Ja Kang-Engles is in the early stages of what appears to be a promising career. She is beginning to establish a regional reputation in the Southeast and especially, Atlanta, Georgia. *Awards*: Selected for NASAD Art Exhibition, University of Georgia, 1994. Selected for Art Place Student Art Competition, Atlanta, Georgia, 1995. Juror's Award, Yensen Student Art Exhibition, University of Georgia, 1995. Representative for Students of the School of Art, Lamar Dodd School of Art Dedication Ceremony, University of Georgia, 1996. USA Today All-American Academic Team, Honorable Mention, 1996. American Scholar Award, 1996. Lamar Dodd School of Arts Scholarship Award, 1996.

RECENT EXHIBITIONS

1998	Lowe Gallery, Atlanta, Georgia
1996	*Traced Crossings*, African American Cultural Center, University of Georgia, Athens
1995	The Big A Art Show, Atlanta, Georgia; Visual Arts Building, University of Georgia, Athens; Last Resort, Athens, Georgia

SELECTED GROUP EXHIBITIONS

1997	*Athens Underground*, Fay Gold Galleries, Atlanta, Georgia; Gallery B, Atlanta, Georgia; *Multiple Identities*, Nexus Contemporary Art

Center, Atlanta, Georgia; Dual show with Katie Bauman, Suil Art Gallery, Athens, Georgia; Emory University Law Library, Atlanta, Georgia

1996 Clayton Street Galleries, Athens, Georgia; Student Print Competition, Visual Arts Building, University of Georgia, Athens

1995 The Art Place, Hollywood, Florida; Kiang Galleries, Atlanta, Georgia; Yensen's Student Art Exhibition, Athens, Georgia; WSSO Art Expo, Tate Center, Athens, Georgia

1994 NASAD Exhibition, Athens, Georgia; Art Place Annual Student Exhibition, Marietta, Georgia; Visual Arts Building, University of Georgia, Athens, Georgia

PUBLICATIONS

"Artist's Corner" (feature/review). *The Red and Black* (April 1996).

Cochran, Rebecca Dimling. "Atlanta: Suk Ja Kang-Engles at Lowe." *Art in America*, October 1998.

[Feature photo]. *Atlanta Journal Constitution*, July 1997.

[Feature photo]. *Suburban Review*, February 1996.

McCord, Patrick. "Suk Ja Kang-Engles." *Art Papers* (September–October 1998), p. 42.

ARTIST STATEMENT (1997)[1]

I think of myself, first of all, as a woman still in the process of escaping from a stridently patriarchal culture. While America has often seemed to offer less restrictions on my selfhood than Korea did, I continue to find myself subject to forces that try to define who and what I am. I think the ongoing struggle between these past and present impositions and my instinctual resistance to them has been the central animating tension through the many stages of my art.

Note

1. Quoted from an unpublished statement by the author, 1997.

BIOGRAPHICAL ESSAY

Born and raised in Korea, Suk Ja Kang-Engles has lived in the United States now for almost a decade. Having immigrated to this country about nine years ago, Kang-Engles thought she was escaping one culture that she describes as "stridently patriarchal" only to find another that attempted in other ways to "pigeonhole" and to define her in terms of race and gender. A strong-willed and outspoken person by nature, Kang-Engles finds herself constantly reacting to those social forces in both cultures that she feels attempt to define her being— who and what she is not only as a person of Asian ancestry but as a woman.

As her awareness of those social forces grows, so too does the reconstruction in her art of her personal identity. It is the tension created by her reactions to these forces that attempt to impose on her a definition of her being that gives a resonant and biting edge to the content of her works.

Suk Ja Kang-Engles credits her grandfather for her rebellious nature. According to the artist, her grandfather passed away when she was 23. Much of him, however, is still with her. One's impression of Kang-Engles's grandfather is that of a high-spirited individualist. As related by the artist, the grandfather was a former Buddhist monk who was cast out of his temple because he fell in love with one of the regular temple goers (Kang-Engles's eventual grandmother). A person of many appetites, stories of his drunken exploits abound in his village.[1]

One series of Kang-Engles's works is based on her childhood memories of her grandfather. Each of the works in this series plays on Confucian texts that Kang-Engles once found buried in her grandfather's clothing. Torn fragments of these Confucian texts, which for Kang-Engles symbolize the ''moral blueprints'' of her Korean ancestry, overlap actual blueprints of the art building at the University of Georgia in Athens, Georgia, where she earned her B.F.A. degree in painting and drawing. For the artist, the overlapping and juxtapositioning of these two very different kinds of blueprints ''represent the conflation of our stubborn energies.''[2] The process of making also becomes significant in this series of works. Employing both an additive and a subtractive process, Kang-Engles in certain instances collaged the fragments of Confucian texts onto the surfaces of these paintings and in other instances tore the texts and sanded them away. While she feels that the resulting swirling shapes and potential images suggest various memories of her grandfather, the effacement of the blueprints perhaps also serves as a symbolic response to those social forces that the artist is reacting to.

In yet an earlier series of paintings, maps serve a function similar to that of the fragments of Confucian texts and blueprints in the works based on Kang-Engles's memories of her grandfather. The maps, which overlay each other in these paintings, identify locations in Korea that have special significance to the artist in that they proved to be shaping influences in important junctures of her early life. Of particular significance are the maps of her hometown and especially the town of the prison in which she was once incarcerated because she expressed too strongly and clearly in writing her political beliefs.[3] In one particular work an imaginary blueprint of the prison in which she was held captive is superimposed over a map of Korea. In other images she overlays maps of the American town in which she currently resides, thus expressing more completely the multicultural nature of the social forces that are now acting upon her and to which she reacts.

Although Suk Ja Kang-Engles references the town in this country where she now lives, nevertheless, the focus of these two series of works is overwhelmingly her reaction to her native culture of Korea. She, however, is not

insensitive to those forces in this country that attempt to stereotype and define her. In large part her involvement with the visual arts had much to do with her reaction to those forces. Arriving in the United States she found the language barrier to be much greater than initially had been anticipated. The visual arts provided her with the necessary expressive outlet by which she could deal with her reactions. Within the new environment, she found herself reacting to and having to deal with a preconceived notion of an "Oriental" or "Asian" woman. She has worked tirelessly to dispel that notion relative to herself and to her art. Accordingly, she commented in an interview conducted by Phoebe Farris, "I work hard to avoid catering to latent mainstream ideas of exotic Asian femininity, and I hope the straightforward and sometimes aggressive nature of my work encounters such expectations and fantasies."[4] In one of her more recent works, which seems to find its cue more so from Joseph Cornell than from sources in painting, Kang-Engles presents the viewer with a box on its side and in which are to be found an array of objects. Among these objects are six spice jars placed neatly in a row, each having at one time contained a different spice. Within each of the different spice jars is to be found a portrait image of the artist, a different spice for different occasions, but, according to the artist, the concept remains the same.

Suk Ja Kang-Engles professes that she has little interest in creating "beautiful" objects and concepts. Her works, whether they be paintings or constructions, exhibit an uneasy and sometimes raw tension that would support this notion. This tension, the result of her own reaction and "instinctual resistance" to defining social forces—both Korean and American—might suggest a personality in a perpetual state of anger. To the contrary, the artist is of a belief that her art can draw attention to these cultural impositions, whether they derive from her former culture or from the one in which she now exists.

Notes

1. Suk Ja Kang-Engles, "Artist's Statement."
2. Ibid.
3. Ibid.
4. Quoted from an unpublished interview with Phoebe Farris, Athens, Ga., 1997. p. 2.

KANO, BETTY NOBUE

Nationality: Japanese American. *Born*: 1944, Sendai, Japan. *Education*: B.A., San Francisco State College, 1967. M.A., University of California, Berkeley,

Touch by Betty Kano, 1995, Acrylic on paper, 14" × 11".
Courtesy of Betty Kano

1977. M.F.A., University of California, Berkeley, 1978. *Career*: Painter, print-maker, curator, lecturer, educator, activist. Program Director, Pro-Arts, Inc. *Awards*: Exhibition Award, San Francisco Arts Festival, 1977. California Arts Council Artist-in-Residence Grant, 1985–1986. Artist-in-Residence, ''Mixing It Up'' Symposium, University of Colorado at Boulder. Society for the Encouragement of Contemporary Art (SECA) Finalist, San Francisco Museum of Modern Art, 1991, 1992. Rockefeller Foundation Residency Fellowship in the Humanities, Asian American Center, Queens College, New York, 1991–1992. California Arts Council, Museum of Children's Art, Artist-in-Residence, Oakland, California, 1995–1996.

EXHIBITIONS

1996 Visual Arts Gallery, University of Illinois, Springfield

1994	Plaza Gallery, Bank of America World Headquarters, San Francisco, California
1993	Mary Porter Sesnon Gallery, University of California, Santa Cruz
1984	Solo Exhibition, UPB Gallery, Berkeley, California
1982	Ron Sagaldo/Downtown Gallery, Los Angeles, California
1980	Allrich Gallery, San Francisco, California
1978	Richmond Art Center, Richmond, California

SELECTED GROUP EXHIBITIONS

1998	*In the Wind: Betty Kano and Kamoko Murakami*, Asia Resource Gallery, Oakland, California
1997	*Impressions: Contemporary Asian Artist Prints*, Brandywine Workshop, Center for the Visual Arts, Philadelphia, Pennsylvania; *Estardantes*, Tijuana Cultural Center, Tijuana, Mexico
1996	*Face of Home*, Oliver Art Center, Oakland, California
1995	*Birds in Paradise*, Mary Porter Sesnon Gallery, University of California, Santa Cruz
1994	*Painting: Asian American Perceptions*, Marjorie Barrick Museum, University of Nevada, Las Vegas, Nevada Museum of Art, Reno, Nevada; *Odun de Odun de*, Oliver Art Center, Oakland, California
1993	*The Art We Love to Hate*, Chicano Humanities & Art Council, Denver, Colorado; Zoller Gallery, Pennsylvania State University, University Park, Pennsylvania
1992	*Betty Kano/Brian Tripp*, Berkeley Store Gallery, Berkeley, California
1988	*Echoes through Times*, EPCOT Center, Orlando, Florida (was on view through 1992)
1987	*Betty Kano and Enrique Chayoga—Societal Narratives: An Exploration in Content*, Berkeley Art Center, Berkeley, California; *Emerging Asian Artists*, Triton Museum of Art, Santa Clara, California
1985	*Traditions Transformed*, Oakland Museum of Art and Japanese American Community Cultural Center, Los Angeles, California
1984	*Japan Ima Festival*, Mary Porter Sesnon Gallery, University of California, Santa Cruz
1983	*Elegant Miniatures from San Francisco and Kyoto*, San Francisco Museum of Modern Art, San Francisco, California, Belco House, Kyoto, Japan
1981	*Beyond Words*, San Jose Institute of Contemporary Art, San Jose, California; *Betty Kano/Cornelia Schultz*, Falkirk Community Cultural Center, San Rafael, California
1980	*American Artists*, Fukuoka Municipal Art Museum, Fukuoka, Japan
1979	*Bay Area Artists*, Oakland Museum of Art, Oakland, California

1978 *Aesthetics of Graffiti*, San Francisco Museum of Modern Art, San Francisco, California

1977 *Six East Bay Painters*, Oakland Museum of Art, Oakland, California

SELECTED COLLECTIONS

American Telephone and Telegraph, New York, New York; Charles Schwab, New York, New York; Rene di Rosa; IBM, New York, New York; Jerry Magnin; Tom Mazzolini; NEA Associates, Washington, D.C.; San Francisco Arts Commission; University of Colorado Art Museum, Boubler, Colorado

SELECTED PUBLICATIONS

Albright, Thomas. *Art in the San Francisco Bay Area 1945–1980.* Berkeley: University of California Press, 1985.

Boettger, Suzaan. "Fresh Paint." *San Francisco Chronicle*, June 27, 1982.

Heath, Jennifer. *Black Velvet, the Art We Love to Hate.* San Francisco: Pomegranate Artbooks, 1994.

Lim, Shirley, and Mayumi Tstakawa, eds. *The Forbidden Stitch.* Calyx Books, 1989.

Lippard, Lucy. *Mixed Blessings: New Art in a Multicultural America.* Pantheon, N.Y.: Pantheon Books, 1990.

MacDonald, Robert. "Manifestations of Graffiti." *Artweek*, June 3, 1978.

Mimura, Glen. "Betty Kano: All the Earth Is Red in Cuba, Todo la tierra es roja en Cuba." *Asian America: Journal of Culture and the Arts* (1993).

Roth, Moira, and Carlos Villa. "Coming Together." *Artweek*, November 9, 1989.

Shere, Charles. "Emotional Depth Is Fully Realized." *Oakland Tribune*, September 28, 1983.

ARTIST STATEMENT (1997)

Painting is for me a way to interact with certain forces, natural, spiritual, physical, and intuitive. The images one creates speak to more than strictly conscious motives; one also directs one's consciousness in certain ways, to unearth further meanings and relationships; the effort is a kind of prayer.

BIOGRAPHICAL ESSAY

Distinctly piquant, highly emotional, intensely meaningful, the art of Betty Kano packs a visceral punch. Schooled in the traditions of abstract expressionism and color field painting, her formal approach to visual communication utilizes a decidedly modernist approach. Kano brings together a vibrant palette (of predominantly primary colors) and adventurous experiments in composition to convey powerful comments on the personal, political, spiritual, and natural worlds with an effective terseness of vision, a balanced sense of lucidity, no matter what theme she focuses on. "Even when the subject matter is horrific, her paintings maintain a balance, even a harmony, that transcends the social

tumult in which the artist is a daily participant,'' wrote Lucy Lippard of Kano's work in 1992.[1]

Kano was born in Japan during a tumultuous era of war and loss: the 1940s. At the age of three, Kano relocated with her parents to the United States. She was reunited with her extended family in the San Francisco Bay Area, who were held along with other Americans of Japanese descent in wartime internment camps. Kano studied painting in the Bay Area as a young adult, while a student at the University of California (UC) at Berkeley, where R. B. Kitaj was on faculty. Kano attended university during the 1960s, when the free speech movement was in full swing. Her early artwork commented on civil rights.

Kano attended UC Berkeley for graduate school as well. While a grad student, Kano joined a student movement that staged a strike in promotion of an ethnic studies college. The movement didn't receive much campus support, and Kano decided to move to her native Japan in 1969. There, the focus of her work shifted to less political themes. After three years, she returned to the United States, and after a few years spent employed as a glassblower and silkscreener, Kano returned to graduate school, garnering a pair of higher degrees: an M.A. and M.F.A. in Fine Arts. She celebrated the completion of graduate school with a museum show of her spiritually themed, abstract paintings.

As the decade turned over into the 1980s, Kano's work centered around poetic expressionist pieces that celebrated the power of color, evident in pieces like *White Maize* or *Deep Crimson*. By 1982, she began consistently creating paintings on a large scale. Her *Grief Up/Rising*, a series of four 9' × 5'6" canvases, exemplifies the raw drama that characterizes this period in Kano's career. In a style that calls to mind the emotional theatrics of an Anself Kiefer or Clyfford Styll painting, *Grief Up/Rising* conveys a sense of mourning in the deep brown, black, and maroon tones that Kano uses to depict ''different stages in the process of grieving, something I felt we don't know enough about in our contemporary culture.'' In an attempt to generalize the human condition, Kano's dramatic interplay of both thick and undetectable brush strokes combined with the overwhelmingly monumental size of the canvas express a pure, unadulterated feeling of loss and detachment, translated to defy any cultural or ethnic boundary of language or difference.

But after coproducing an event in San Francisco entitled ''Art Works for the People,'' Kano resumed her interest in politically charged work. While organizing the event, she became acquainted with other activists who used art as their voice to speak out against prejudice, namely, apartheid, an issue that deeply bothered Kano. In 1985, Kano visited Cuba with a political group, fueled by a notion ''that we had very little sense of Cuba, one of the few places in the world at the time with active resistance to apartheid.''

The trip to Cuba proved to be a pivotal event in Kano's development as an artist. After returning from Cuba, not only did she shift away from her oversized canvases, but she also began to consistently address political themes. In 1986, Kano made the last of her large paintings, *South Africa*, which depicts a black

inverted triangle surrounded on both sides by fiery red. This piece shares the same dark lyricism of the *Grief* series, yet also can be seen as a transitional work. Around the same time, she completed the triptych *Havana/New York*, a work seen as controversial by critics and curators alike, for iconography that includes a colorful rendering of Che Guevara in a panel depicting a carefree, sunny Cuba in one panel and a black and white image of Ronald Reagan juxtaposed with African masks and distraught faces of a child and the Statue of Liberty. This seminal work is admittedly didactic, concentrating on "the implements of the spiritually animated fullness of life," explains Kano.

Kano made repeat visits to Cuba, including appearances at the Havana Bienale, and began to identify with the country, realizing that Cuba, like Japan, is an island nation. As her exploration of Cuba deepened, so did her appreciation of African influences on that culture. "I am drawn to the strong visual language of African imagery, such as masks, somethings unseen in the European culture I had been exposed to," states Kano. "The African imagery is reflected only in form in Western art, such as in Picasso's work, but there is no presence of the content."

Throughout the 1980s, the content of a majority of Kano's work continued to be political. Her canvases commented on many of the headlines of the decade, using color and abstraction to make her points clear, from 1987's *Iran-Contra Connection* to 1989's *Tiananmen Square*, both of which use blood red and black hues as elements of her visually expressive language. *Promise*, a 1991 representational work that depicted a realistic rendition of a cowrie shell (seen as a symbol of fecundity and wealth), also served as a means for political statement, as it addressed the Gulf War and the threat it posed to the area of the world that Kano calls "the cradle of civilization."

Around this time, Kano also started experimenting with real shells—as well as real leaves, feathers, branches, and other elements from the natural world—incorporating them into her canvases and works on paper by stitching them by hand onto the surface, in the body of work collectively entitled the *Initiation* series, or arranging them in complex installations such as *All the Earth Is Red in Cuba/Todo la tierra es roja en Cuba*. The complexity of these works, from the presence of the universally feminine ritual of sewing to the use of the red feather from an African parrot, to the reemergence of Che Guevara as icon, reflect a rich and rare sense of cross-cultural harmony.

Throughout the late 1980s, Kano began working more and more with diptychs and triptychs, as if symbolic of her bi- and multicultural identity as an artist. The physical complexity of these more conceptual pieces is balanced with a fluidity of color and form that exudes an instinctual reading. *In/can/descent*, for example, is a late 1990s work that exemplifies this period. Using the primary color blue, balanced with its complement orange, Kano creates a shorthand to illustrate the dynamics of love. We see coolly hued abstract forms juxtaposed with those depicted in warm tones and immediately understand that there are two very different parts to the composition—two parts that might be polarities

or extremes, brought together, made whole. It is this remarkable sense of wholeness that pervades all of Kano's work, despite its many different forms and phases, a wholeness that is achieved from Kano's profound understanding of raw humanness and pure humanity, which each work in her oeuvre shares.

Note

1. Lucy R. Lippard, *Mixed Blessings: New Art in a Multicultural America* (New York: Pantheon-Random House, 1990, reprinted 1992), p. 232.

KIM, MIMI D.

Nationality: Korean American. *Born*: 1973, Knoxville, Tennessee. *Education*: Attended Smith College in Northampton, Massachusetts, where she received her B.A. degree in 1994 with a major in fine arts (painting) and a minor in Chinese. Pursued graduate study at the University of Pennsylvania in Philadelphia, where she received her M.F.A. degree in 1997 with a major in painting. *Career*: A recent graduate of the University of Pennsylvania, Kim joined the faculty of the University of Northern Iowa in 1997 on a temporary appointment as a Visiting Assistant Professor of Art. Having completed her appointment at Northern Iowa, she recently returned to the East Coast to establish her studio in New York City. *Awards*: Foreign Education Abroad, Smith College, 1993. Teaching Assistant Award, University of Pennsylvania, 1996. CGS Teaching Award, University of Pennsylvania, 1996. Overseers Scholarship, University of Pennsylvania, 1996. Arthur Ross Gallery Prize, 1997. Charles Addams Memorial Prize, University of Pennsylvania, 1997.

RECENT EXHIBITION

1998 Recent Paintings, Waterloo Museum of Art, Waterloo, Iowa

SELECTED GROUP EXHIBITIONS

1998 Group Exhibition, Gallery of Art, University of Northern Iowa, Cedar Falls, Iowa; Young Talent Show, Washington Art Association, Washington, Connecticut

1997 *PENNART*, Kohn Pedersen Fox Gallery, New York, New York; Mount Carmel Guild Invitational, Princeton, New Jersey; Invitational Exhibition, Hearst Center for the Arts, Cedar Falls, Iowa; Folio '97 Print Exhibition, Burrison Art Gallery, Philadelphia, Pennsylvania;

	East/West: Visions in Between, Arthur Ross Gallery; MFA Exhibition, University of Pennsylvania, Philadelphia, Pennsylvania
1996	Large Print Show, Meyerson Gallery, Philadelphia, Pennsylvania; University Art Auction, University of Pennsylvania, Philadelphia, Pennsylvania; Small Art Works Show, T-Square Gallery, Philadelphia, Pennsylvania; Critical Issues Show, Morgan Gallery, Philadelphia, Pennsylvania; MFA Exhibition, University of Pennsylvania, Philadelphia, Pennsylvania
1995	Drawing Show, Morgan Gallery, Philadelphia, Pennsylvania; Large Works on Paper Show, Meyerson Gallery, Philadelphia, Pennsylvania; Recent Paintings Exhibition, Red Mill Gallery, Johnson, Vermont; MFA Exhibition, University of Pennsylvania, Philadelphia, Pennsylvania
1994	Drawing Exhibition, New York Studio School Gallery, New York, New York; Juried Figurative Painting Show, Smith College, Northampton, Massachusetts; Juried Drawing Show, Smith College, Northampton, Massachusetts; Recent Paintings Exhibition, Smith College, Northampton, Massachusetts

ARTIST STATEMENT (1997)[1]

I find explaining my work uncomfortable and awkward because it seems to put a label on what I do. My work changes with every evaluation of my ideas. What I believe in today may change tomorrow. In my view, a static mind-set is the death of an artist.

Note

1. Quoted from an unpublished statement by the artist, Philadelphia, Pa., 1997.

BIOGRAPHICAL ESSAY

Having received her M.F.A. in May 1997, Mimi Kim is currently making the transition from art student to artist and attempting to establish her own foothold in the profession. For her and her parents, however, being an artist and considering a career as a practitioner in the fine arts were not choices. While they both held strongly to this position, parents and offspring viewed these choices from very different perspectives. From her parents' perspective a proper profession provided one with a ''foundation for security,'' and in their eyes, being an artist did not meet this particular prerequisite. On the other hand, from an early age Kim saw no other viable alternative or direction in life. ''As presumptuous as it may sound, I believe that being an artist was *not a choice*. There were and are no other possibilities.''[1] She was determined and committed from the outset.

Kim's interest in the fine arts developed at an early age. As the artist recalls,

she began attending art academies from the eighth grade on. There was never any doubt in her mind that she would become an artist. Also, because of this, Kim never entered into any serious discussions with her parents about her chosen path. Her parents, exhibiting a typically Asian response in regard to the matter, insisted upon other career choices that would afford financial security together with "honorable" status. The disagreements that inevitably developed between offspring and parents over her future profession have in recent years subsided. According to the artist, her parents have arrived at a greater understanding of who she is and now go out of their way to be supportive of her.

Of mixed Asian parents (her father is Korean and her mother is Chinese), Kim was born in Knoxville, Tennessee, spent her early years in the Bay Area and Korea, lived for short periods of time in Hong Kong, Beijing, and Nanjing, and was educated in both Korea and the United States. Believing at one time that her varied cultural background and mixed cultural experiences had no relevance whatsoever to her work, she now realizes that it is impossible for them not to have had some impact since they influence greatly who she is as a person. However, she is also quick to point out that her Asian heritage does not surface in her work: "I feel no reason to stress my roots because I am comfortable with my heritage and fully participate in it. . . . I have no urge to regurgitate my identity. I would rather digest it."[2]

Mimi Kim's current approach to painting is very direct and immediate. She attacks the surface of her canvases in an extremely physical and aggressive manner, treating the subject matter of her work in similar fashion. This is not to suggest or imply that the creative process for Kim is without its moments of reflection. She will often sit in front of her canvas and ponder the work for long periods of time before applying the paint or pencil marks to its surface. This reflective and more meditative aspect of her work, however, does not manifest itself, or is it easily seen, in the final product. It is the immediate mark of the brush, the sometimes rawness of the color, and the confrontational presentation of the images that first catch our eye. The gestural character of her paint strokes does justice to the aesthetics of Abstract Expressionism, whereas the presentation of her subject matter appears to run the gamut from Surrealism to Jean-Michel Basquiat to the drawings of children.

While Kim might begin with a general idea in mind at the outset of a painting, she has absolutely no preconceived notion as to the outcome of the finished product. For her, much stress is given to the activities associated with the act of making, the process itself. An important aspect of this process is her need to explore and to reexamine both the general idea that served as the initial source of inspiration for the painting and her ideas about art in general. The finished painting, therefore, can be thought of as the by-product of this investigation; as Kim aptly describes it, the work itself is "the residue of the digestive process and thought" that goes into its making.[3]

In responding to the influences of past artistic traditions that might have had an impact on her own development as an artist, Kim states the following:

My work, like many others', has "gone through" stages of movements through imitation, in chronological order. As informative as those historical "truths" were, I realized that those movements/ideas were conceived by the great thinkers who risked pushing the limits of Form. I have been greatly influenced by many artists of the past, but I believe they were great only in reference to their time. I have no desire to imitate Form of the past. I will continuously search for Form of the future.[4]

She also holds strong views about art with a political agenda. While acknowledging the merits of some political art, she generally appears to be quite judgmental in her responses to this kind of work and to galleries that specifically cater to or support this kind of agenda:

In the past, I was extremely prejudiced against political art and political movements. They are often one liners filled with an agenda. The most successful political art works are those that are self reflective and not judgements made on morals. Currently, I am fascinated and humored by them (possibly for the wrong reasons). Art that tries desperately to be serious, profound, or self reassuring is often the most dishonest.[5]

On the other hand, and perhaps to the contrary, Kim also admits to certain issues with political overtones that recently have surfaced in her own paintings. As an undergraduate student, Kim attended an all-women's college where concerns about race, gender, and sexual orientation proved to be extremely sensitive issues. She, herself, was deeply affected by these issues, though she admits they had no great impact on her work until quite recently. A painting completed in the past year references her recent involvement with these issues. The subject matter in this work is composed of two almost cartoonlike animals: one is a large black cat, the other a bowling ball–shaped rooster with a bright red cockscomb and beak. It is difficult to tell whether the cat is rearing backward on its hind legs away from the rooster or lunging forward toward it. On the other hand, it is quite evident that the relationship between the two is an adversarial one. The title of the work, *The Pussy and the Cock*, provides us with an appropriate context for understanding.

Admittedly, Mimi Kim is not a creator of beautiful objects. For Kim, the significance of her art is not to be found in the finished product but in its making. And inherent in that process of making is her search for a reality and a truth that she feels is constantly changing.

Notes

1. Excerpt from a statement prepared by the artist in response to a series of questions posed to her in a questionnaire, Cedar Falls, Iowa, 1998.

2. Ibid.

3. Ibid.
4. Ibid.
5. Ibid.

KIM, YOUNG

Nationality: Korean American. *Born*: 1955, Incheon, Korea. *Education*: B.A., San Francisco State University, San Francisco, California, 1986. M.F.A., California College of Arts and Crafts, Oakland, California, 1992. *Career*: Photographer, educator. *Awards*: San Francisco Bay Guardian Photography Award, San Francisco, California, 1986. Ford Foundation Fellowship, 1989. California College of Arts and Crafts Fellowship, 1989. American Photography Institute Grant, 1992. WESTAF/National Endowment for the Arts Regional Fellowship for Visual Artists, 1993. Lace/New Langton Arts Artists' Projects Grant, 1994. National Endowment for the Arts/Arts International Travel Grant for Artists, 1994. The Wallace Alexander Gerbode Foundation Grant, 1997.

SELECTED EXHIBITIONS

1998	The Friends of Photography, Ansel Adams Center, San Francisco, California
1997	CEPA Gallery, Buffalo, New York
1996	San Francisco Arts Commission Gallery, San Francisco, California

GROUP EXHIBITIONS

1997	*On the Rim*, Transamerica Pyramid, San Francisco, California
1996	*Who's Afraid of Freedom*, Newport Harbor Art Museum, Newport Beach, California; *CCAC: Past, Present, Future*, Oliver Art Center, Oakland, California; *When Two or More: New Typologies*, Houston Center for Photography, Houston, Texas
1995	*Points of Entry: Tracing Cultures*, The Friends of Photography at Ansel Adams Center, San Francisco (traveled to Center for Creative Photography, Tuscon, Arizona, Museum of Photographic Arts, San Diego, California, International Museum of Photography at George Eastman House, Rochester, New York, Smithsonian Institution, Washington, D.C., Center for the Fine Arts, Miami, Florida)
1994	*Seven Contemporary Korean-American Artists from California*, Wiegand Art Gallery, College of Notre Dame, Belmont, California; *Cultural Identities and Immigration: Changing Images of America in the*

90s, Oliver Art Center, Oakland, California; *Across the Pacific: Contemporary Korean and Korean-American Art*, Kumho Art Museum, Seoul, Korea

1993 *Interior Dialogues*, International Festival of the Image, Rochester, New York; *Across the Pacific: Contemporary Korean and Korean American Art*, Queens Museum of Art, Queens, New York

1992 *A Woman's Vision*, SOMAR Gallery, San Francisco, California; MFA Exhibition, Oliver Art Center, Oakland, California; Fellowship Award Exhibition, New York University Gallery, New York, New York

PUBLICATIONS

Appleford, Steve. "Images of Immigration." *Los Angeles Times*, September 10, 1995.

Bonetti, David. "Photos Focus on Cultural Viewpoints of 'Displacement.' " *San Francisco Examiner*, September 15, 1995.

Carter, Holland. "Korean Works Coming to Terms with the West." *New York Times*, December 10, 1993.

Cohn, Terri. "An American Dilemma." *Afterimage* (November–December 1995).

Corn, Alfred. "Across the Pacific." *ARTnews* (January 1994).

Ehmke, Ronald. "Images of the Link between Two Worlds." *Buffalo (N.Y.) News*, September 25, 1997.

Gerard, Alice E. "Uncommon Traits: Re/Locating Asia." *Buffalo (N.Y.) Alternative Press*, October 9–23, 1997.

Holt, Patricia. "Immigration's Hardships Made Bearable by Freedom." *San Francisco Chronicle*, September 29, 1995.

Jana, Reena. "Young Kim at Arts Commission Gallery." *Asian Art News* (May–June 1996).

Kahn, Robert. "Tracing Cultures." *California Life*, November 23, 1995.

Levin, Kim. "Seoul Searching." *Village Voice* (November 1993).

O'Sullivan, Shawn. "Coming into the Country." *New York Daily News*, May 17, 1997.

Pincus, Robert L. "Artists Turn Their Focus to Concepts of Self-Identity." *San Diego Union Tribune*, November 26, 1995.

Portwood, Pamela. "Photo Exhibit Crosses Cultures." *Arizona Daily Star*, February 2, 1996.

Soe, Valerie. "Points of Entry: Tracing Cultures." *Godzilla West* (September 1995).

Strickland, Carol. "The Boon and Burden of Uprooting Oneself." *Christian Science Monitor*, January 8, 1996.

Yang, Alice. "Searching for Identity in Korean-American Art." *Art Monthly* (Seoul, Korea) (September 10, 1995).

ARTIST STATEMENT (1997)

The direction of my artistic interests has gradually evolved with each body of work, from a meditation on the personal experience of migration, involving memory and loss, to a desire to transcend differences of language, culture, and identity.

BIOGRAPHICAL ESSAY

Utilizing photography's power to present an object subjectively as well as convey a subject in a more "objective" manner than in other artistic media, Young Kim explores the broad issue of cultural definition with an intensely personal approach. The result: not only a bravely intimate perspective to the universal quest for identity but also a lucid reflection on the ever-evolving concept of "home" in both the larger societal and individual arenas. Her projects include such diverse photographic elements as instant Polaroids and illuminated light boxes, as well as familiar objects such as tables, benches, and soup bowls, incorporated in elegant installations—visually accessible means used to help us explore the general ideas of lineage and history as each of us struggles to locate and identify ourselves as individuals. It is a life's quest that all of us embark on, a psychic journey that transcends location, language, and race.

Take, for example, her haunting installation *Interval*. A meditation on ritual, remembrance, preservation, identity, aging, the piece consists of Kim's daily Polaroid self-portraits, taken over a span of more than 2,000 days—a practice she intends on repeating until the year 2000. Not all are neat "mug shots" of the artist's visage. Some reveal a specific day's definition of the artist's personality or mood as perceived by the artist herself. We witness Kim's likeness to travel to different quadrants of the Polaroid's rectangular frame: Sometimes Kim is sitting at the center of the shot's composition, sometimes not. On other days, the artist's image is absent altogether, resulting in blacked-out or blank white frames. We see Kim with makeup and without. Her hairstyles change over time. The landscape of her face, presented consistently in an expressionless state, seems as still and yet malleable by the natural order of time as a stone, in turn untouched, ravaged, and polished as the days and their environmental challenges pass.

The effect of witnessing the neat rows of Kim's bluntly revealing photographs, side by side, is similar to watching an intricately staged set of dominos being toppled in a rhythmic drama. Each singular self-portrait is a carefully chosen word in Kim's visual life story, knotted together tightly, like pearls on a string. It is a visual exploration of the inevitability of change over time, as well as the uncertainty of identity, which, like time, is as fluid in its evolution as time itself, no matter what nation is home.

Kim was born in Korea and moved to the United States in 1974. "It is ironic and humorous that I feel so close and yet so distant to Korea," wrote Kim in 1995 in the catalog for the traveling exhibition *Tracing Cultures*. "With each visit, as I see my parents aging and sense time passing, I'm aware of an increasing distance. We know each other and yet we don't know each other."[1] Her work addresses the dramatic and emotional push-pull dynamics between national identities that are ever present in an era of hybrid characteristics of self-definition.

Her installation *Distances* perhaps best conveys such a dialogue. Composed

of 12 panels, black and white gelatin silver prints of images from Kim's own family album are combined with confessional text, such as "As my English gets better, my Korean gets worse" and "I thought getting away from my family would change my life but I realized I had been wrong all along. One can never leave one's family," on sculptural, dark-hued rectangular framed wooden structures that bring to mind the form of traditional Asian scroll paintings. Like scroll paintings, the individual pieces serve as narratives; the reference to the Eastern genre is so subtle that it registers in the viewer's mind like a specter from the past.

"Young Kim poignantly [sums] up the pull of two worlds which underlies every immigrant story," wrote critic Shawn O'Sullivan in the *New York Daily News*.[2] Because the world is such a mobile place, and because the United States is a nation solely populated by immigrants, no matter how early they set foot on North American soil, Kim's consistent theme of the notion of alienation is one that is highly accessible, one that transcends ethnicity and era. In fact, as dictionary definitions of *home* have evolved from "a family's place of residence" to "one's place of residence," such feelings of displacement can even be felt on many levels, whenever a migration occurs, be it country to country, state to state, city to city, house to house.

"The experience of migration has a way of 'intensifying' memory because the act of remembering brings back the past," wrote Kim in the catalog for *Uncommon Traits: Re/Locating Asia*, which was on view at Buffalo, New York's CEPA Gallery in 1997. "I am a Korean-American, the hyphenated identity that is neither Korean nor American."[3] This complex sensation of losing a past self, gaining a new self, and being caught somewhere in a void in between the two is expressed poetically in her installation. *Attachment/Detachment*. The work brings together dissolving projected texts featuring quotes from *The Poetics of Space* by Gaston Bachelard as well as definitions of "home" culled from lexicons old and new, transparencies depicting juxtaposed images of various places in both Korea and America, and sculptural objects—all arranged in a floor pattern based on the graphics found on the Korean flag. The "walls" of the installation space consist of hanging panels of fabric; the mobility of the "walls" as well as the constantly shifting text projection convey an unsettling sense, whereas the structure of the installation, an homage to Kim's Korean background, remains as the foundation.

As cultural currents shift away from the late 1980s/early 1990s emphasis on identity politics in the late 1990s, so has Kim's work. In the installation *Dispersion*, for example, Kim presents photograms of silhouettes of countries, from Australia to Canada, from India to Japan, all shrunken to the same small scale. Kim arranges them in systems similar to the patterns of island atolls, and they appear to float on a background of black. The series of 24 photographs are hung on the gallery wall and surround a series of light boxes that house a thick sheet of glass sandblasted with authentically sized renditions of the ancient skeleton named "Lucy" by scientists. The bones are depicted in disarray, as if her ribs

and coccyx are individual islands. The overall effect communicates the focus that is the signature theme of Kim's oeuvre: the essentially human ache of displacement and its eventual counterpart, isolation.

Notes

1. *Points of Entry: Tracing Cultures* (San Francisco: Friends of Photography, Ansel Adams Center, 1995), exhbn cat.
2. Shawn O'Sullivan, "Coming into the Country," *New York Daily News*, May 17, 1997.
3. *Uncommon Traits: Re/Locating Asia* (1997), exhbn cat.

LIN, MAYA

Nationality: Chinese American. *Born*: 1959, Athens, Ohio. *Education*: B.A., Architecture, Yale University, 1981. M.A., Architecture, Yale University, 1987. *Career*: Architect, sculptor. *Selected awards*: American Institute of Architects Honor Award. Brunner Prize, American Academy of Arts and Letters. Presidential Design Award.

SELECTED EXHIBITIONS/PUBLIC ART WORK

1999	Des Moines Art Center, Des Moines, Iowa
1998	Southeastern Center for Contemporary Art, Winston-Salem, North Carolina; Cleveland Center for Contemporary Art, Cleveland, Ohio; Grey Art Gallery and Study Center of New York University, New York, New York
1995	University of Michigan, Ann Arbor
1994	Pennsylvania Station, New York, New York
1993	Wexner Center for the Arts, Columbus, Ohio
1989	Charlotte Coliseum, Charlotte, North Carolina

SELECTED GROUP EXHIBITIONS

1997	*Stung by Splendor*, Arthur A. Houghton Gallery, Cooper Union, New York, New York
1996	*Extended Minimalism*, Max Protech Gallery, New York, New York
1994	*Critical Mass*, Yale University, New Haven, Connecticut
1992	*Ornament*, John Post Lee Gallery, New York, New York

1991	*Working with Wax*, Tibor di Nagy Gallery, New York, New York
1988	*Sculpture Parallels*, Sidney Janis Gallery, New York, New York
1987	*Avant Garde in the Eighties*, Los Angeles County Museum of Art, Los Angeles, California

SELECTED ARCHITECTURAL WORKS AND MONUMENTS

1993	The Women's Table, Yale University, New Haven, Connecticut
1989	Civil Rights Memorial, Mobile, Alabama
1980	Vietnam Veterans Memorial, Washington, D.C.

SELECTED PUBLICATIONS

Brown, Patricia Leigh. "Making History on a Human Scale." *New York Times*, May 21, 1998.

Donnelly, Judith. *A Wall of Names: The Story of the Vietnam Veterans Memorial*. New York: Random House, 1991.

Finkelpearl, Tom. "The Anti-Monumental Work of Maya Lin." *Public Art Review* (Fall–Winter 1996).

Ling, Bettina. *Maya Lin*. Raintree/Steck Vaughn, 1997.

McCombs, Phil. "Maya Lin and the Great Wall of China." *Washington Post*, January 3, 1982.

Mock, Frieda Lee, director. *Maya Lin: A Strong, Clear Vision*. Documentary film, 1994.

Sexton, Jim. "Making Art That Heals." *USA Today*, November 1–3, 1996.

ARTIST STATEMENT (1993)[1]

I've always felt my work should be extremely site sensitive, site aware. It deals with the notion that when you place something in the landscape, do you fight the landscape and try to conquer it or do you try to work with it and interact with it? [This] has brought me to a very firm respect and devotion to protecting the environment and preserving the environment. When I'm not doing artwork I also volunteer—I'm on a couple different boards that are focusing really on energy efficiency and environmental issues. And I think this piece comes out of that desire on my part to use recycled materials, to conserve resources, to really tell people it can be done, we can consume much less in this world and we actually have to, and it's very important to me.

Note

1. In conversation with Sara Rogers, Director of Exhibitions, Wexner Center for the Arts, Columbus, Ohio, October 18, 1993.

BIOGRAPHICAL ESSAY

She is ingrained in our collective consciousness as the bright, girlish, 20-year-old Yale undergraduate who, in 1980, singlehandedly created one of this century's most moving architectural constructions, Washington's Vietnam Veterans Memorial. Bravely, she withstood the harsh comments of veterans and skeptics who believed the irony too great that an Asian American was to design a monument dedicated to those who died at the hand of Asian troops. She proved that her sleek stone memorial, carefully crafted and positioned environmentally to provide an astonishing blend of both private and public emotional catharsis, featuring rows and rows of engraved names of U.S. soldiers who had died listed in chronological order, could stir a nation's soul.

Despite the high profile that Lin's architectural work has achieved—it has been the subject of countless newspaper and magazine articles; a 1994 documentary film entitled *Maya Lin: A Strong, Clear Vision* won critical raves and an Academy Award—she has remained remarkably private and able to manage a tandem career as a sculptor of elegant, environmentally aware artwork. "To the world at large, she has seemed something of a distant figure," wrote Patricia Leigh Brown in the *New York Times*. "A sober, somber wisp, unyielding as a monolith."[1] While her name and her public identity have become synonymous with the elegiac constructions that bear her signature, from the Vietnam Veterans Memorial to the Civil Rights Memorial in Mobile, Alabama, which pays homage to Martin Luther King, Jr., and other brave voices in the tumultuous civil rights movement, in the years following her meteoric rise in the national and international limelight, her career as a sculptor has begun to flower and blossom simultaneously.

Her studio-based sculpture, public art, drawings, and prints share the same sensitivity of her architectural projects, continuously exploring the relationship between human beings and the natural environment. Topography, technology and science, primitive architecture, and a distinctly Asian aesthetic are consistent thematic elements; wax, water, glass, stone, and earth recur as Lin's media. Contemplative, these works speak with physical eloquence that is at once lyrical and streamlined, monumental yet accessible.

Take, for example, her public artwork *The Wave Field* (1995), on view at the University of Michigan, Ann Arbor. This 10,000-square-foot construction consists of rows of sand and soil, sculpted in undulating patterns to recall a chaotic sea. Lin worked from the aerial perspective of waves as seen from planes to achieve the look and feel of the sculpture. Due to its nature and outdoor location, it is constantly in flux. Rain, snow, and sunlight—not to mention the students and other passersby who walk through or sit within the organic structure—share Lin's role as sculptor. Reminiscent of work by Robert Smithson and other earth artists of the 1960s and 1970s—as well as a Japanese minimalist aesthetic—*The Wave Field* is a dynamic example of the sculptor's power to alter spaces and our reactions and experiences within that space.

Lin's fascination with the power of sculpted objects and profound understanding of Eastern aesthetic concerns can be traced back to her childhood and family background. Her father, Henry H. Lin, was the dean of the College of Fine Arts at Ohio University in Athens, Ohio, and achieved recognition as a ceramicist; her mother, Julia C. Lin, is a poet and scholar of both American and Chinese literature. Lin's brother Tan is a poet and professor of English at the University of Virginia (they have collaborated creatively in the past). Lin's parents left China in 1949, right before Mao Tse-tung's regime took hold, eventually settling in a suburban home near the Ohio University campus. The house was decorated with a Japanese sense of austere beauty, furnished with items created by Lin's father, including screens used as room dividers; the family even ate from bowls that he created. Lin played with her brother in the woods and stream that surrounded the home, building small stone dams. Mysteriously beautiful mounds of earth, which dotted the landscape of southeastern Ohio, created by Native American tribes who had once settled in the area, grabbed her eye and imagination.

In 1986, Lin accompanied her brother and mother to the Fujian Province in China to see the house that her father was raised in, a home that overlooked a river, with "rooms" created by screens. It was a journey to Lin's own creative roots, where she consciously recognized the source of the clean lines of her signature aesthetic and her natural kinship with nature.

Lin's visual vocabulary also brings to mind a hybridity of modern and contemporary sculptural strategies from both East and West. Beyond the references to Smithson in her work, also evident is the influence of Japanese sculptor Isamu Noguchi's characteristic simplicity and clarity of surface and form. Lin has also consistently mentioned Richard Serra's aggressively site-specific work as a source of inspiration. Jeff Fleming, Chief Curator at the Southeastern Center for Contemporary Art, has likened Lin's vision to those of nineteenth-century Hudson River School painters such as Frederic Edwin Church and Luminist painter Martin Johnson Heade in an essay in the accompanying brochure to Lin's first exhibition of large-scale environmental sculpture, entitled *Topologies*.[2] This major solo exhibition, which has toured several venues across the United States, juxtaposed Lin's installations in wood, glass, and wax; drawings; models for landscape projects that were exhibited as sculptures in their own right; and prints.

Regardless of her choice of media, Lin's reverential, meditative approach to nature shines through. Her *Flatlands* series of monoprints, created with shards of glass and ink, recall the raw beauty of ice cracking and separating on the surface of a thawing body of water. Her *Glass Rocks*, an installation of 43 "stones" created from blown glass, bring to mind bubbles in a babbling stream or pebbles found at the seashore, rendered translucent. Her installation *Groundswell*, featuring countless pieces of broken glass dumped and shaped in wavelike mounds, at once reminds the viewer of a series of ocean swells. As her oeuvre as both artist and architect continues to develop, she continues to be not only

an interpreter of landscape but a powerful creator of environments that speak to body, mind, and soul.

Notes

1. Patricia Leigh Brown, "Making History on a Human Scale," *New York Times*, May 21, 1998.
2. Jeff Fleming, "Maya Lin," *Topologies* (Winston-Salem, N.C.: Southeastern Center for Contemporary Art, 1998).

LIU, HUNG

Nationality: Chinese American. *Born*: 1948, Changchun, China. *Education*: B.F.A., Beijing Teachers College, Beijing, China, 1975. Graduate Student (M.F.A. equivalent), Central Academy of Fine Art, Beijing, China, 1981. M.F.A., University of California, San Diego, 1986. *Career*: Painter, educator, writer. *Awards*: National Endowment for the Arts Painting Fellowship, 1989. Contemporary Art by Women of Color Artists' Award, Guadalupe Cultural Center, San Antonio, Texas, 1990. National Endowment for the Arts Painting Fellowship, 1991. Society for the Encouragement of Contemporary Art Award, San Francisco, California, 1992. The Fleishbacker Foundation Eureka Fellowship, San Francisco, California, 1993. International Association of Art Critics Award, 1994. Artist-in-Residence, Anderson Ranch Arts Center, Snowmass Village, Colorado, 1995. Hometown Hero, Oakland Artist Who Has Made a Difference proclamation by Elihu M. Harris, Mayor of the City of Oakland, 1996. San Francisco Women's Center Humanities Award, 1996.

SELECTED EXHIBITIONS

1998	Rena Bransten Gallery, San Francisco, California; College of Charleston, Charleston, South Carolina; College of Wooster Art Museum, Wooster, Ohio
1997	Bard College Center for Curatorial Studies Museum, Annendale-on-Hudson, New York; Golden Gate University, San Francisco, California; Steinbaum Krauss Gallery, New York, New York.
1996	Horwitch Lew Allen Gallery, Santa Fe, New Mexico; Donna Beam Fine Art Gallery, University of Las Vegas, Nevada; Fort Wayne Museum of Art, Fort Wayne, Indiana; Rena Bransten Gallery, San Francisco, California; Joy Pratt Markham Gallery, Walton Arts Center, Fayetteville, Arkansas

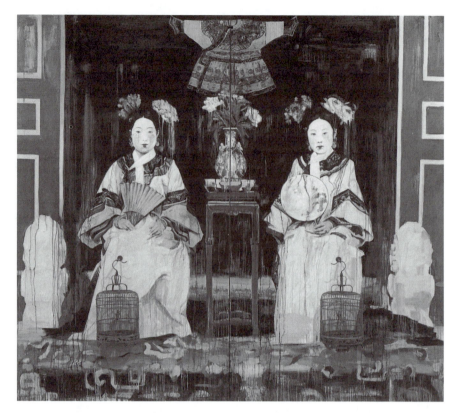

Two Fujin by Hung Liu, 1996, oil on canvas, wood birdcages, 96" × 110" × 12". Courtesy of Hung Liu

1995	The Contemporary, Baltimore, Maryland; Ohlone College, Fremont, California; The Chrysler Museum of Art, Norfolk, Virginia; Mills College, Oakland, California; Steinbaum Krauss Gallery, New York, New York
1994	Fine Arts Gallery, University of California, Irvine; University of California, Santa Cruz; M. H. de Young Museum, San Francisco, California; John Michael Kohler Arts Center, Sheboygan, Wisconsin; Steinbaum Krauss Gallery, New York, New York
1993	Rena Bransten Gallery, San Francisco, California; Churchill County Library, Fallon, Nevada
1992	Bernice Steinbaum Gallery, New York, New York
1991	Rena Bransten Gallery, San Francisco, California
1990	Diverseworks, Houston, Texas
1989	The Women's Building, Los Angeles, California; Nahan Contemporary, New York, New York

1988	Capp Street Project, San Francisco, California; Southwestern College Art Gallery, Chula Vista, California
1987	D-Art Visual Art Center, South Dallas Cultural Center, Dallas, Texas; Bath House Cultural Center, Dallas, Texas
1986	University of California, San Diego
1985	Sheppard Fine Arts Gallery, University of Nevada, Reno
1981	Central Academy of Fine Arts, Beijing, China

SELECTED GROUP EXHIBITIONS

1998	*East Meets East in the West*, Limn Gallery, San Francisco, California
1997	*Traditions/Innovations: Four Northern California Artists*, Crocker Art Museum, Sacramento, California; *On the Rim*, Transamerica Building, San Francisco, California; *American Stories—Amidst Displacement and Transformation*, Setagaya Art Museum, Tokyo, Japan (traveling)
1995	*Garden Variety*, Rena Bransten Gallery, San Francisco, California; *10 × 10, Ten Contemporary Women Artists*, Berkeley Art Center, Berkeley, California; *Dis-Oriented: Shifting Identities of Asian Women in America*, Steinbaum Krauss Gallery, New York, New York; *About Faces*, Santa Barbara Museum of Art, Santa Barbara, California; *Making Faces: American Portraits*, Hudson River Museum of Westchester, New York; *Reinventing the Emblem: Contemporary Artists Recreate a Renaissance Idea*, Yale University Art Gallery, New Haven, Connecticut; *Setting the Stage: A Contemporary View of the West*, Eiteljorg Museum, Indianapolis, Indiana; *Microsoft ArtWalk 12*, Microsoft Corporate Campus, Redmond, Washington; *Excavating Culture*, Brattleboro Museum and Art Center, Brattleboro, Vermont; *Family in Focus: Cultural Diversity and the Family*, The Noyes Museum, Oceanville, New Jersey; *Objects of Personal Significance*, Exhibits USA and Eastern Illinois University, Charleston, Illinois (national tour); *Gender . . . Beyond Memory*, Tokyo Metropolitan Museum of Photography, Tokyo, Japan; *American Kaleidoscope: Art at the Close of This Century*, The National Museum of American Art, Smithsonian Institution, Washington, D.C.
1994	*Identities in Contemporary Asian American Art*, Tacoma Art Museum, Tacoma, Washington; *Evolution of the Print: Fourteen Years of Collaboration at Pyramid Atlantic*, Addison Ripley Gallery, Washington, D.C.; *Women's Spirit*, Bomani Gallery, San Francisco, California; *New Voices 1994*, Oberlin College, Oberlin, Ohio; *Plural America Singular Journey*, The Art Guild, Farmington, Connecticut; *Painting: An Asian American Perception*, University of Nevada, Las Vegas; *Asia/America: Identities in Contemporary Asian American Art*, Asia Society, New York, New York; *Memories of Childhood: So We're Not the Cleavers or the Brady Bunch*, Steinbaum Krauss Gallery, New York, New York

1993 *Redefining Self: 6 Asian Americans*, San Jose State University, San Jose, California; *Backtalk*, Santa Barbara Contemporary Arts Forum, Santa Barbara, California; *Multicultural Americana*, Florida Community College, Jacksonville, Florida; *In Transit*, New Museum, New York, New York; *Women's Art, Women's Lives, Women's Issues*, Tweed Gallery, New York, New York; *Self-Portrait: The Changing Self*, New Jersey Center for Visual Arts, Summit, New Jersey; *Narratives of Loss: The Displaced Body*, University of Wisconsin, Milwaukee; *Picasso to Christo, the Evolution of a Collection*, Santa Barbara Museum of Art, Santa Barbara, California; The 43rd Biennial Exhibition of Contemporary Painting, Corcoran Gallery of Art, Washington, D.C.

1992 *Why Painting—Part I*, Susan Cummins Gallery, Mill Valley, California; *Decoding Gender*, School 33 Art Center, Baltimore, Maryland; *Voices*, Shea & Bornstein Gallery, Santa Monica, California; *Virgin Territories*, Long Beach Museum of Art, Long Beach, California; *Counterweight: Alienation, Assimilation, Resistance*, Santa Barbara Contemporary Arts Forum, Santa Barbara, California; *In Plural America: Contemporary Journeys, Voices and Identities*, Hudson River Museum, Yonkers, New York

1991 *Viewpoints*, Richmond Art Center, Richmond, California; *Selected Bay Area Drawings*, The Drawing Center, New York, New York; *Diverse Directions*, TransAmerica Pyramid Lobby, San Francisco, California; *Mito y Magia en America*, Museo de Arte Contemporáneo de Monterrey, Monterrey, Mexico; *Counter Colon-Iaslísmo*, Centro Cultural de la Raza, San Diego, California

1990 *Memory/Reality*, Ceres Gallery, New York, New York; *Contemporary Art by Women of Color*, Hemisfair Plaza, San Antonio, Texas; *Precarious Links*, San Antonio Museum of Art, San Antonio, Texas; *Narrative Constructs—Contemporary Trends by Women of Color*, Women and Their Work Gallery, Austin, Texas; *Implosion*, San Francisco Arts Commission Gallery, San Francisco, California; *Official Language*, Walter McBean Gallery, San Francisco Art Institute, San Francisco, California

1988 *Four Corners in Coast to Coast*, Diverseworks, Houston, Texas, The Kitchen, New York, New York; *15 in the AIR*, Sheppard Gallery, University of Nevada, Reno

1987 Texas Sculpture Symposium, San Antonio, Texas; *Art in the Metroplex*, Texas Christian University, Fort Worth, Texas

1980 National Fine Arts Colleges Exhibition, Beijing, China

1979 Graduate Student Works, Central Academy of Fine Arts, Beijing, China

1978 Portraiture Exhibition, Winter Palace Gallery, Beijing, China

SELECTED COLLECTIONS

AT&T Corporation, New York, New York; Baruch College, William & Anita Newman Library, CUNY, New York, New York; City of San Francisco Public Art Program, California; City of San Jose, California; Dallas Museum of Art, Texas; Fort Wayne Museum of Art, Indiana; Mills College, Oakland, California; Muscarelle Museum of Art, College of William & Mary, Williamsburg, Virginia; National Museum of American Art, Smithsonian Institute, Washington, D.C.; Rutgers Archives for Printmaking Studios at the Jane Voorhees Zimmerli Art Museum, New Brunswick, New Jersey; San Jose Museum of Art, California; Santa Barbara Museum of Art, California; Spencer Museum of Art, University of Kansas, Lawrence; University of Arizona Art Museum, Tucson.

PUBLICATIONS

Allen, Sarah. "Hung Liu." *The Oakland Tribune*, February 13, 1996.
Antenorcruz, Maria. "Hung Liu: Year of the Dog." *Asian American Arts* III, no. 4 (Winter 1993), pp. 3, 9.
Binstock, Jonathan P. "Hung Liu." In Jacquelyn Days Serwer, ed., *American Kaleidoscope: Themes and Perspectives in Recent Art*. Washington, D.C.: Smithsonian Institution, 1996. pp. 120–131.
Edelman, Robert G. "The Figure Returns." *Art in America* 82, no. 3 (March 1994), pp. 39–43.
Jan, Alfred. "Hung Liu." *New Art Examiner* 21, no. 8 (April 1994), p. 45.
Lewis, JoAnn. "Kaleidoscope, Pieces of a Dream." *Washington Post*, October 10, 1996, pp. D1, D8.
Lippard, Lucy R. *Mixed Blessings: New Art in a Multicultural America*. New York: Pantheon Books, 1990. pp. 102, 137, 144.
Poshyananda, Apinana. "Yellow Face, White Gaze." *Art and Asia Pacific* 2, no. 1 (January 1995), pp. 30–31.
Robinson, Hilary. "Hung Liu." *Women's Art* no. 58 (May/June 1994), p. 25.
Walker, Bill. "Filling Williamsburg's Art Gap." *William and Mary News* XXVI, no. 15 (March 26, 1997).

ARTIST STATEMENT (1995)

My work is about the preservation and loss of memory. As a painter (primarily) I know that the painting process equalizes all subjects the way time equalizes all stories. Saturated with oils and mediums, my paintings sort of perform themselves—they drip, stain, and wash the images in a way that opens them to time, the literal time of gravity pulling oil to the bottom edge of the canvas. I never know what my paintings are going to look like the next morning. They create and destroy themselves at the same time.

BIOGRAPHICAL ESSAY

Complex and multifaceted, the extensive oeuvre of Hung Liu in many ways represents a trajectory through time and space, across cultural and societal

boundaries of East and West. Her rich body of work conveys, in many ways, the definitive Chinese American perspective. It is a perspective that the artist has cultivated over time, developed from years of experience, observation, analyzation, and interpretation.

Liu was born in Changchun, a city that was once Manchuria's imperial capital, in 1948. This was a year before the People's Republic of China was established. Raised in Beijing, Liu experienced the Cultural Revolution as a youth. At the age of 20, she was sent, along with many of her peers, to work in the fields of the Chinese countryside when universities were shut down. While harvesting crops, Liu taught herself how to use a camera and occupied her time shooting photographs of nearby villagers; she also sketched scenes from country life—which she had to hide from supervisors. Four years later, she was allowed to enter the Revolutionary Entertainment Department at Beijing Teachers College. Upon graduating, she served the Communist Party in the role of art educator.

In 1979, Liu was accepted to the Central Academy of Fine Arts in Beijing. There, she studied mural painting; after receiving the equivalent of an M.F.A., Liu joined the faculty. Her passion for education fueled her to immigrate to the United States, where she matriculated as a graduate student at the University of California at San Diego.

As she adjusted to life in the United States, her work began to evolve. "I shifted my art work from socialist realism, the style in which I had been trained, to social realism," stated Liu in a lecture given in Chicago in the late 1980s. "And it transformed my personal identity crisis to a crisis of cultural collision."

Indeed, looking at the work of this prolific artist, certain themes resonate: the vertigo of dramatic cross-cultural adjustment, a confrontation of both the glories and the tragedies in Chinese history, a hybridization of traditional Eastern imagery and Western perceptions of China and her people. Observes Trinkett Clark, Curator of Twentieth Century Art at the Chrysler Museum of Art, Norfolk, Virginia, "An eloquent social historian, Liu regards each work as a vehicle in which she simultaneously captures and comments on historical milestones, as well as sociopolitical and autobiographical issues."[1] Her iconography is simultaneously accessible and exotic, from images of Chinese prostitutes to references to figures from Western art history, such as Manet's *Olympia*. Although primarily a painter, Liu has also consistently incorporated sculptural elements into her work, from attaching a real, three-dimensional empty bird cage to a canvas, as in 1989's *Family*, which incorporates porcelain tea sets set on shelves, to the custom-built oversize canvases of 1993's *Tai Chi*, in which the painting takes the literal shape of its subjects. Another signature element of Liu's visual vocabulary is the use of tearlike drips of thinned paint, running seemingly haphazardly down the surfaces of portraits or narrative paintings. The drips, often created with dark pigment, bring to mind rain tracks running down dirty windows, exposing the eye to a sudden view once hidden by layers of the soot and filth of many years.

Through this visual language, Liu exhibits a permeating and highly effective sense of history. We read her paintings as glimpses into China's past. In fact, Liu is clearly a thorough researcher; in general, old photographs that accurately document life in China are the source for her work. For example, the paintings that she created in the early 1990s are based upon pictures taken by Westerners. The disturbing bloody visions of the severed heads of Chinese soldiers killed during the Boxer Rebellion, seen in the *Boxer Rebellion* series, and the arresting images of women with bound feet in *Sepia 1900* are based on these photographs, taken from the observant yet extremely distant viewpoint of the Westerner. The fact that these images are captured by observers removed from the Chinese experience adds a thought-provoking layer: Were the original images representative of a possibly sensationalist or exploitative point of view?

Liu has utilized other photographs as starting points for her canvases. After a 1991 return visit to Beijing, she encountered portraits of Chinese prostitutes posing amidst stylized backdrops and props. These pictures spurred a highly dramatic series of paintings in which Liu fused both the kitschy images of the prostitutes along with easily recognizable female figures from the canon of Western art history, such as the *Madonna* or Leonardo's *Mona Lisa*. The result was not only a set of hybridized Eurasian ''portraits'' but also a powerful exploration of the subjugation of women throughout time—unfortunately, a widespread issue in both East and West.

As an individual who must deal with the polarity of her past in Communist China and her present as an American citizen and internationally known artist, Liu's work in many ways ultimately conveys an underlying quest for identity. Whether taking a more tongue-in-cheek approach, such as in 1988's *Resident Alien* (a giant 75" × 90" rendition of the I.D. card required by the U.S. Department of Justice—Immigration and Naturalization Service for resident aliens, issued in the painting to a fictional character named ''Fortune Cookie'') to her more subtle commentaries, such as *Imperial Garden* (in which the central figure's face is lucidly, realistically rendered, although her traditionally costumed body is faded and blurred, as if to suggest the past or the traditional is abstract or ephemeral), Liu achieves a sense of displacement. It is a displacement that is much deeper than an inability to find comfort in a physical location but an unsettling feeling of cultural alienation—the price, perhaps, of managing more than one identity, caught between worlds.

Liu's stylistic, tehnical, and thematic quest, it seems, is to explore, not unlike an archeologist, the myriad layers of experience that have overlapped to culminate in her own perspective not only as an artist but as a person. Through her elegant and elegiac work, she achieves a truly complex expression of the challenges of confronting history, both personal and political.

Note

1. Trinkett Clark, ''Hung Liu'' (Norfolk, Va.: Chrysler Museum of Art, 1995).

MACHIDA, MARGO

Nationality: Japanese American. *Born*: 1951, Hilo, Hawaii. *Education*: B.A., New York University, 1976. M.A., Hunter College, City University of New York, 1978. Ph.D. candidate, State University of New York, Buffalo. *Career*: Painter, independent curator, writer, educator. *Awards*: National Endowment for the Arts Visual Artists Fellowship, 1983–1984. Artist-in-Residence, New York State Council on the Arts, 1984–1985. Critic-in-Residence, November 1987, February 1988. National Endowment for the Arts, Arts Administration Fellow, 1988. Rockefeller Foundation Residency Fellowship in the Humanities, 1989. Artist-in-Residence, Henry Street Settlement/Louis Abrons Arts for Living Center, New York State Council on the Arts, 1990–1991. Artist Fellowship, New York Foundation for the Arts, 1991–1992. Artists Fellowship, Rutgers Center for Innovative Printmaking, Rutgers University, 1994. Presidential Fellowship, State University of New York, 1995–1996.

EXHIBITIONS

1990	The New Arts Program, Kutztown, Pennsylvania
1987	Bronx Museum of the Arts, New York, New York
1985	Catherine Gallery, New York, New York
1983	55 Mercer Gallery, New York, New York
1982	Merrill Lynch Commodities, Inc., New York, New York
1981	Alternative Museum, New York, New York; Andrea Olitsky Gallery, Millerton, New York; Semaphore Gallery, New York, New York

SELECTED GROUP EXHIBITIONS

1996	*naked truths*, University of Hawaii Art Gallery, Honolulu, Hawaii
1995	*In and Out of Character*, The Roger Smith Gallery, New York, New York
1994	*Five Women Artists*, Nexus Contemporary Art Center, Atlanta, Georgia; Group Show, Rutgers Center for Innovative Printmaking, Rutgers University, New Brunswick, New Jersey
1993	*Race, Sexuality, and Gender: Realities of the Asian American Artist*, Painted Art Center, Philadelphia, Pennsylvania; *Continuum: Culture and Consciousness*, Japan Information and Culture Center, Washington, D.C.

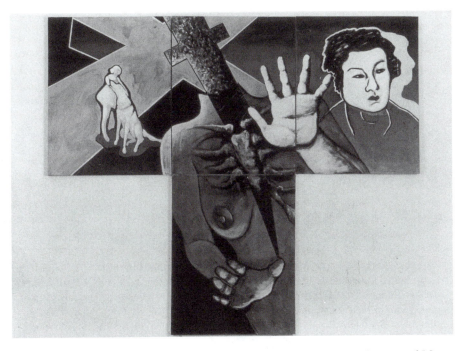

Mama's Girl by Margo Machida, 1986, acrylic on canvas, 60" × 72". Courtesy of Margo Machida

1991	*Artists of Conscience*, The Alternative Museum, New York, New York
1990	*The Decade Show*, The New Museum of Contemporary Art/Studio Museum of Harlem at the Museum of Contemporary Hispanic Art, New York, New York; *Post-Boys & Girls*, Artists Space, New York, New York
1989	*Bridges and Boundaries*, The New Center for Contemporary Art, New York, New York; *Autobiography: In Her Own Image*, INTAR Gallery, New York, New York; *Three Painters*, University Art Museum, Binghampton, New York
1988	*Cultural Currents*, The San Diego Museum of Art, San Diego, California
1987	*MIND's I*, Asian Arts Institute, New York, New York
1986	*Asian Artists of Brooklyn*, Brooklyn Museum, New York, New York; *Transculture/Transmedia*, Exit Art, New York, New York
1985	Office of Governor Mario Cuomo, World Trade Center, New York, New York; *The Figure: Symbol and Allegory*, Rotunda Gallery, New York, New York
1984	*Affirmations of Life*, Kenkeleba Gallery, New York, New York

1981 *Voice Expressing What Is*, Westbeth Galleries, New York, New York;
 Painting, Touchstone Gallery, New York, New York

1980 Central Park, New York, New York; Lever House Gallery, New
 York, New York

1979 *New York Artists: New Sensibilities*, 22 Wooster Gallery, New York,
 New York; Diane Brewer Gallery, New York, New York; Institute
 for Contemporary Art, PS1 Museum, New York, New York

1978 Oenophilia Gallery, New York, New York; Downstairs Gallery, New
 York, New York; Arte Fiera, Bologna, Italy; Tim Blackburn Gallery,
 New York, New York

1977 Hunter Art Gallery, New York, New York; Women's Workspace,
 New York, New York; Art in Public Places, New York, New York

1975 Acabonic Exhibition, East Hampton, New York

SELECTED COLLECTIONS

Chemical Bank, New York, New York; Connecticut General Life Insurance Company,
New Haven, Connecticut; The Continental Group; Home Industries, Inc.; Merrill Lynch
Commodities, Inc., New York, New York; New York City Health & Hospitals Corpo-
ration; Phillip Morris Corporation, Salem, North Carolina; Singer Corporation, Chicago,
Illinois; SOSA International (Saudi Arabia); Sun Oil Corporation, New York, New York;
Sydney Lewis Foundation

SELECTED PUBLICATIONS

Chadwick, Whitney. "New Directions: A Partial Overview." In *Women, Art, and So-
 ciety*. New York: Thames and Hudson, 1996.
Karmel, Pepe. "Expressing the Hyphen in 'Asian-American.' " *New York Times*, April
 23, 1995.
Lippard, Lucy. *Mixed Blessings: New Art in a Multicultural America*. New York: Pan-
 theon Books, 1990.
O'Neill, Eileen. "The Re-Imaging of Eros: Women Construct Their Own Sexuality."
 IKON, no. 7 (1987).
O'Neill, Eileen. "(Re)presentations of Eros: Exploring Female Sexual Agency." In
 Bordo and Jagger, eds., *Gender/Body/Knowledge: Feminist Reconstructions of
 Being and Knowing*. New Brunswick, NJ: Rutgers University Press, 1989.
Raven, Arlene. "Beyond Survival: Old Frontiers/New Visions—Artists Speak Out." In
 Positions: Reflections on Multi-racial Issues in the Visual Arts. New York: The
 New York Feminist Art Institute/Women's Center for Learning, 1989.
Raven, Arlene. "Colored." *Washington Post*, November 9, 1997.
Raven, Arlene. "Women in Command." *Village Voice* (January 1990).
Sims, Lowery. "The Mirror, the Other." *Artforum* (March 1990).

ARTIST STATEMENT (1998)

Over the last two decades, my art has become more private, diaristic, and
autobiographical, reflecting a deep impulse to come to grips with some of the

contradictory currents inherent in what it has meant for me to grow up as a Japanese American woman in contemporary America. My imagery is self-referential, fragmentary, and mutable. It is intended to embody difficult psychological states by giving concrete form to inchoate internal conflicts—and, in the process, to recognize and more fully come to "own" the diverse aspects of a multilayered and evolving identity. To mediate among these constantly shifting inner conceptions, I draw upon and intermingle images based on photographs of my childhood in Hawaii, elements of East Asian iconography, and depictions of my body, as well as a range of contrary personae: female/male, child/woman, animal/human.

BIOGRAPHICAL ESSAY

Throughout her wide and varied career, Margo Machida has helped us on the postmodernist's quest of understanding what it means to possess a multiplicity of identities. On one level, her hyphenated self is artist-educator-curator; she is a daring painter who also divides her time out of the studio between lecturing university students on Asian American art with curating breakthrough shows, such as 1994's *Asia/America*. On another level, she grapples with a vertiginous cultural tightrope walk when attempting to find balance between an Asian history and American citizenry. In all areas of her work, her passion remains clear; hers is a powerful voice dedicated to communicating the challenges of clear self-definition in the postmodern age.

Born and raised in Hilo, Hawaii, Machida was exposed to her Japanese roots while growing up. She learned about Buddhism, bonsai trees, and brush painting as a child. (Visual icons drawn from traditional Japanese culture are evident in her paintings, from her rendering of the head of a Buddha sculpture in 1985's *The Buddha's Asleep* to images of white-faced geishas in 1988's *Geisha Girl × 4*.) At the age of 12, Machida read *Confessions of a Mask*, a story about a sensitive, introverted child, by the renowned Japanese novelist Yukio Mishima, who became a major influence and inspiration. Mishima, known for his right-wing militarist views, lived a life of conflict as he confronted homosexuality and the dichotomies of creativity and war. He became a role model for Machida.

"Like Mishima, I have also sought to define myself through shifting guises— whether posing as a geisha; merging my image with animal alter egos; or drawing upon snapshots of myself as an infant and young girl to suggest a unity between past and present," Machida explained in a 1991 interview with Hanford Yang, a curator at The Rockland Center for the Arts in West Nyack, New York.

Machida's 1986 work *Self Portrait as Yukio Mishima* not only illustrates the creative kinship she feels toward the novelist but also visually articulates the anguish and anxiety of a segmental identity. On the purely physical level, the piece is composed of three separate panels. The flesh of the figures is represented in pallid tones, simultaneously calling to mind the eeriness of complexion possessed by both the geisha and the dead. Their eyes meet neither each other nor

the viewer; the effect is unsettling, alienating. The abdomens of both figures are pierced, and they bleed; it is a visual nod to Mantegna's painting of St. Sebastian. The panel featuring the central figure of Machida, arms grasped at the elbows and raised above her head, slices through the separate panels that feature Mishima's head and abdomen, respectively, a reference, perhaps to Mishima's ritualistic suicide—death by disembowelment and decapitation. It is a haunting depiction of a discomforting journey into the core of the self.

The presence of nightmarish imagery and multiple panels recur in other notable paintings by Machida. For example, 1986's *Mama's Girl* echoes the three-panel, decapitated cross structure of *Self Portrait as Yukio Mishima* and features cross imagery, a headless female figure with visible bones erupting from its torso, a Kabuki-white face, a disembodied hand held up as if to signal ''stop,'' and a pair of pale silhouettes that appear to be a canine and human.

Noli Me Tangere (1986) includes geishi-white central panels featuring a face and female body, juxtaposed with colorful panels of what appears to be a volcanic eruption and an angry baby, arranged in a square cross shape. The painting's title is translated as ''Do not touch me''—a reference to both an eponymous book by Filipino writer José Rizal as well as words spoken to Jesus by Mary Magdalen, lending this work the added dimensions of concurrent awareness of both Asian and Christian culture and spirituality.

Altered Fates (1990) represents an evolution of Machida's signature crosslike structure; the central panel is thin and elongated, depicting in blood red tones a biomorphic figure that recalls a dissected body atop skeletallike language symbols painted in white on a black background, flanked with two square panels on which Machida has rendered two faces in ghostly white, one, which appears to be decapitated, juxtaposed with images of bones.

The dramatic anguish conveyed through use of symbolism, reference, color, and form lends to a dark and disturbing vision. The paintings exude a rawness of emotion above all else. ''The ruptures in Machida's paintings are not keyed to an aesthetic ideal, but to her perception of the self as fragmented, provisional, and multiple,'' wrote the critic John Yau in 1996 of the artist's concern with substance over style.

A key thematic element in Machida's work is also her consistent exploration of the outer perceptions and inner emotions of the Asian American woman, evident in her repetitive use of the female figure presented in the context of visual clues ranging from the artist's own likeness to generic Japanese figures, as in 1988's *Like a True Samurai*. In this provocative painting, a woman attempts to break free from the violent hold of a soldier; Machida appears in the left-hand panel, eyes hidden behind sunglasses as she witnesses the act of sexual aggression. An intriguing interplay of past and present views of Asian and Asian American women, the two scenes are crowned with a third panel depicting a lily-white duck, presumably an alter ego for the women, floating serenely on a background of black.

Animal forms reappear throughout Machida's work. In *The Buddha's Asleep*, a beast bearing its fangs is superimposed onto a nude female figure. In 1985's *First Bird*, Machida merges an image of the skeletal remains of a prehistoric bird with that of a squatting woman (portrayed with face painted geisha white). The combined presence of females and animals conveys a sense of instinctual power either hidden beneath the fragile surface of skin or transcendent of mere physical space.

Machida's career has been as fluid and mutable as the images that appear in her paintings. She has curated innovative exhibitions such as 1995's *(Dis)Oriented: Shifting Identities of Asian Women in America*, which was on view at New York City's Henry Street Settlement Abrons Arts Center and Steinbaum Krauss Gallery, featuring the work of key artists ranging from Pacita Abad to Tomie Arai to Hung Liu. An established specialist, Machida has written extensively on Asian American visual art and related cultural criticism, including essays for the major anthology on Asian American identity, *Fresh Talk/Daring Gazes: Asian American Issues in the Contemporary Visual Arts* (University of California Press, 1998). In addition, Machida served as the Director of the Cultural Dialogue Project, Asian/American Center, Queens College, City University of New York, from 1994 to 1996. Hers is a creative, curious voice that continues to evolve, manifesting itself in a potent inner vision made public, urging us to confront, analyze, and understand the intricacies of identity.

MIN, YONG SOON

Nationality: Korean American. *Born*: 1953, Korea. Lives and works in Los Angeles. *Education*: B.A., University of California, Berkeley, 1975. M.A., University of California, Berkeley, 1977. M.F.A., University of California, Berkeley, 1979. Whitney Museum Independent Study Program, New York, 1981. *Career*: Visiting Faculty, Rhode Island School of Design, Providence, 1992. Assistant Professor, School of Arts, University of California, Irvine, 1993–present. *Selected Awards*. Residency, Yaddo, 1985. Artist-in-Residence Grant, New York State Council on the Arts, 1988–1989. Visual Artists Fellowship Grant in New Genre, National Endowment for the Arts, 1989–1990. National Printmaking Fellowship (funded by National Endowment for the Arts), The Rutgers Center for Innovative Printmaking Workshop, 1990. Residency, Blue Mountain Center, New York, 1991. National Studio Program Residency, The Institute for Contemporary Art (PS1), 1991–1992. Brandywine Workshop Visiting Artist

Fellowship, 1992. Artist-in-Residence Grant, Light Work, New York, 1992. Artist-in-Residence Grant, The New York Experimental Glass Workshop, 1993. "RAW Specifics" Project Grant, Real Art Ways/Hartford, Connecticut, 1993. Warren Tanner Memorial Fund, award for sculptor, Organization of Independent Artists, 1993. Travel Grants Pilot (to Philippines), a joint project of the National Endowment for the Arts and Arts International, 1993. Arts Research Grant, University of California, Irvine, 1994. Percent for Art Commission for Queens Regional Public Library, New York, 1994. Arts Research Grant, University of California, Irvine, 1995. University of California, Irvine, Faculty Career Development Program Award, 1995. Intercampus Arts of University of California Award as principal organizer of Philippine Diaspora Exhibition and Symposium, 1995. Arts Research Grant, University of California, Irvine, 1996. Director, University of California Intercampus Arts Special Projects Grant, 1996. The Bus Shelter Project Commission and University of Washington, 1996. Artist-in-the-Community Program Grant, City of Los Angeles Cultural Affairs Department, 1996. Bellagio Residency, The Rockefeller Foundation, 1997.

SELECTED EXHIBITIONS AND COMMISSIONS

1997	*Yong Soon Min: Bridge of No Return*, Krannert Art Museum, Champaign, Illinois (traveling to Tyler School of Art, Temple Gallery, Philadelphia, Pennsylvania, and Art in General, New York, New York); *AlterNatives*, with Allan deSouza, Robert B. Menschel Photography Gallery, Syracuse, New York; *Memory Matters*, public art commissioned by Korean American Museum, Los Angeles, California, distributed in grocery stores; *Belly Talk*, The Bus Shelter Project commission, Washington State Arts Commission and University of Washington, Seattle.
1994	*alter idem/performing personae*, collaborative installation with Allan deSouza, Camerawork, London, England; *DMZ XING*, a Real Art Ways "RAW" Specific commissioned project, University of Connecticut at Storrs (traveling to Hartford Civic Center, Hartford, Connecticut, and the Smith College Museum of Art, Northampton, Massachusetts)
1992	*Home Be Coming*, commissioned sculpture, University of Southern Maine, Gorham, Maine
1991	*deCOLONIZATION*, The Bronx Museum of the Arts, New York
1990	*Goodwill Games Arts Festival*, commissioned project, 911 Contemporary Arts Center, Seattle, Washington
1989	Window installation curated by Lucy Lippard, Printed Matter, New York, New York
1988	*City Hall Park Group Sculpture Show*, commissioned project, Public Art Fund, New York, New York
1987	Untitled room installation, Jamaica Art Center, New York, New York

SELECTED GROUP EXHIBITIONS

1997 *Kimchi Xtranvaganza!* Korean American Museum, Los Angeles, Cal-
 ifornia; *Safari: Far Bazaar at the Old Zoo*, installation with Allan
 deSouza, Griffith Park, Los Angeles, California

1996 *Thinking Print: Books to Billboards, 1980–1995*, Museum of Modern
 Art, New York, New York; *Korean American Artists in California*,
 Newport Harbor Art Museum, Newport Beach, California; *Family in
 Focus*, The Noyes Museum, Trenton, New Jersey; *Projections*, AMC
 Old Pasadena 8 Theaters, Pasadena, California, and Sony Magic
 Johnson Theaters, Los Angeles, California

1995 *A Dress (States of Being)*, Winnipeg Art Gallery, Winnipeg, Mani-
 toba, Canada; *Finding Family Stories*, Japanese American National
 Museum, Los Angeles, California, and Korean American Museum,
 Los Angeles, California; *Photography Los Angeles Now*, Los Angeles
 County Museum of Art, Los Angeles, California; *Semblances*, Mu-
 seum of Modern Art, New York, New York; *Fire without Gold*, Yan-
 kee Stadium subway station, New York, New York

1994 *Across the Pacific*, Kumho Museum, Seoul, Korea; *Art, Society, Re-
 flection*, Fifth Havana Biennial, Havana, Cuba; *Asia/America: Iden-
 tities in Contemporary Asian American Art*, The Asia Society
 Galleries, New York, New York (traveling to the Tacoma Art Mu-
 seum, Tacoma, Washington; Walker Art Center, Minneapolis, Min-
 nesota; Honolulu Academy of Fine Arts, Honolulu, Hawaii; Center
 for the Arts at Yerba Buena Gardens, San Francisco, California; MIT
 List Visual Arts Center, Cambridge, Massachusetts; Blaffer Gallery,
 University of Houston, Houston, Texas); *Picturing Asia America:
 Communities, Culture, Difference*, Houston Center for Photography,
 Houston, Texas

1993 *Geography of Desire*, collaborative installation with Allan deSouza
 and Luis Fancia, Fourth Baguio Arts Festival, Manila, Philippines;
 Across the Pacific, Queens Museum, New York, New York (traveling
 exhibition); *International Critics' Choice*, Mitchell Museum, Illinois;
 Discursive Dress, John Michael Kohler Arts Center, Madison, Wis-
 consin; *The Return of the Cadavre Exquis*, The Drawing Center, New
 York, New York; *1993 Whitney Biennial*, The Whitney Museum of
 American Art, New York, New York, segment in Shu Lea Cheang's
 collaborative video installation *Those Fluttering Objects of Desire*

1992 *Mistaken Identities*, University Art Museum, University of California,
 Santa Barbara, Santa Barbara, California (traveling to Museum Folk-
 wang, Essen, Germany; Forum Stadtpark, Sydney, Australia; Neues
 Museum Weserburg im Forum Langenstrasse, Bremen, Germany;
 Louisiana Museum of Modern Art, Humlebæk, Denmark); *This Is
 My Body, This Is My Blood*, Herter Art Gallery, University of Mas-
 sachusetts, Amherst, Massachusetts; *Remerica/America: 1492–1992*,
 Hunter Galleries, Hunter College, New York, New York; *Those Flut-*

tering Objects of Desire, segment in Shu Lea Cheang's collaborative video installation, Exit Art, New York, New York

1991 *Artists of Conscience: 16 Years of Social and Political Commentary*, Alternative Museum, New York, New York; *1992: Conquests Do Not Belong Only to the Past*, INTAR Gallery, New York, New York

1990 *Disputed Identities, U.K./U.S.*, Camerawork, San Francisco, California (traveling exhibition); *The Decade Show*, Museum of Contemporary Hispanic Art/The New Museum/Studio Museum of Harlem, New York, New York; *Art against Apartheid*, Jamaica Art Center, New York, New York; *Occupation and Resistance: American Impressions of the Intifada*, Alternative Museum, New York, New York; *Irrational Fullness*, collaborative performance/installation with Barbara Chang and Elliott Sharp, Dia Art Foundation, New York, New York

1989 *Land and the Elements*, Luise Ross Gallery, New York, New York

1988 *Autobiography: In Her Own Image*, INTAR Gallery, New York, New York; *Committed to Print*, Museum of Modern Art, New York, New York (traveling exhibition)

SELECTED PUBLICATIONS

Allan deSouza/Yong Soon Min: AlterNatives. Syracuse, New York: Robert B. Menschel Photography Gallery, Syracuse University, 1997. Exhbn cat.

Art Journal 54, no. 1 (Spring 1995), pp. 71, 82–83.

Asia/America: Issues of Identity in Asian American Art. New York: The Asia Society and New Press, 1994.

Frontiers, a Journal of Women's Studies 18, no. 1 (1997), pp. 134–141.

Kim, Elaine H. " 'Bad Women': Asian American Visual Artists Hahn Thi Pham, Hung Liu, and Yong Soon Min." In Elaine H. Kim, Lilia V. Villanueva and Asian Women United of California, eds., *Making More Waves: New Writing by Asian American Women*. Boston: Beacon Press, 1997. pp. 191–194.

Kino Review 28 (1997), pp. 30–33.

"Mapping Difference." *Third Text* (1996), pp. 19–32.

Min, Yong Soon. "Allan deSouza." In Allan deSouza and Shaheen Merali, eds., *Crossing Black Waters*. London: Working Press, 1992.

Min, Yong Soon. "Comparing the Contemporary Experiences of Asian American, South Korean and Cuban Artists." In Shirley Hune, ed., *Asian Americans: Comparative and Global Perspectives*. Seattle: Washington State University Press, 1991. pp. 277–287.

Neumaier, Diane, ed. *Reframings: New Feminist Photographies*. Philadelphia: Temple University Press, 1995.

Positions, East Asia Culture Critique 5, no. 1 (Spring 1997), cover, pp. 283–284.

Rogoff, Irit. "The Politics of Vision." In Teresa Berman and Martin Jay, eds., *Vision in Context: Historical and Contemporary Perspectives on Sight*. New York: Routledge, 1996. pp. 198–202.

"Sexual Hybrids, from Oriental to Post-colonial Grotesque." *Parachute* 70 (1993), pp. 22–29.

Yong Soon Min: Bridge of No Return. Champaign, Ill.: Krannert Art Museum, 1997. Exhbn cat.

Yong Soon Min: DMZ XING. Hartford, Conn.: Real Art Ways, 1993.

BIOGRAPHICAL ESSAY

Yong Soon Min came to southern California from Korea with her parents at the age of seven. Min's multilayered installation work draws from the transcultural, expanding on her own negotiations of a Korean American identity and the attendant issues of immigration, exile, resettlement, and translation. Broadly speaking, Min highlights the role of international politics and military aggressions in shaping individual lives, as well as the role of the mass media and other institutional forces in constructing our views of ourselves and the world around us.

Politics and the body, particularly the female body, are important themes for Min. In a six-part photo piece entitled *Defining Moments* (1992), Min overlays photographs of her body with texts and images relating to personal and political events that have helped to shape her identity. Some of the images that comprise/ obscure her body in this series include a Seoul street rally during President Rhee's overthrow in 1960, the military breaking up a student protest in Kwangju in 1980, a photo of the 1992 L.A. uprising taken from a newspaper for the Korean American community in L.A., and a picture of Mount Baektu, the mythical birthplace of all Koreans. In the first image, Min inscribes her naked body with the words "occupied territory" on either arm, "heartland" over her chest, and a spiral of dates radiating from her bellybutton: the year of her birth, the date of the student uprising that unseated President Rhee, the Kwangju student uprising (and the year her family immigrated to the United States), and the date of the Los Angeles uprising. This combination of personal and collective histories aligns her female body with the fragmented and colonized Korean nation; the photo is overlaid with the text: "My body lies over the ocean/My body lies over the sea/My body lies over the DMZ/Oh bring back my body to me." As in her other works, her position is as a diasporic subject who simultaneously desires an embodied unity (for herself and for both of her countries) and acknowledges the complexity and ultimate impossibility of such unification. In discussing one of Min's installations, Elaine Kim writes: "Min is exploring the metaphorical possibilities of magnetic attraction and repulsion. . . . Division and difference can excite desire, and tragedy is inextricably plaited with hope."[1]

Expanding upon the themes of *Defining Moments*, Min created *DMZ XING* (1994), in which she interwove stories of several Southeast Asian immigrants into a broader history of immigration to the United States and U.S. militarism as well as her own experiences as a 1.5 generation Korean American.[2] The circular room installation weaves together the personal and national through vertical text and photo panels leaning against the walls; in the center, an octagonal mirror reflects and refracts the panels, visualizing the complex, unfixable, and ultimately multiple nature of diasporic experiences.

In *Belly Talk* (1997), a series of photo transparencies done for bus shelters in Seattle, she asks others to map their defining stories onto their bodies. These personal anecdotes, assessments, and musings are handwritten in spirals radi-

ating around the individuals' belly buttons, once their literal lifelines. They are touching personal statements made public and almost monumental.

In *Bridge of No Return* (1997), Min has symbolically recreated the divide between North and South Korea in our physical space. The snaking wall is tangible yet transparent; each side of the wall represents one side of the 38th parallel, and both sides taken together represent a 24-hour time period. A single string of reproductions of official government tourist industry images that market the countries around the world as well as newspaper images crosses each side of the wall. Min here invokes the issues of mass media and commerce as mediating forces between the North and South and between South Korea and the rest of the world that she explored in her photo/text work *Kindred Distance* (1996). The North Korean side is represented by pale blue photographs, the South Korean, by pink photographs. The installation speaks to the role of both time and space in the division between South and North Korea and the artificiality of the means to maintain that distance.

Min has also engaged in the critique of anthropology as a discipline in the installation *alter idem*, created in collaboration with photographer and cultural critic Allan deSouza. This work deals with the history of anthropology, a lens through which Western cultures have viewed the rest of the world. The artists donned T-shirts reading "Native" and "Informant" and photographed themselves in ethnically charged locations around Los Angeles (tourist sites such as Watts Towers, the Cantínflas handprints at the Mann's Chinese Theater in Hollywood, etc.). The installation also featured classic texts of anthropology and ethnography, excerpted and highlighted to emphasize the framing and colonizing role of these disciplines since their inception, and photographs of ethnographic subjects printed in negative as a literal commentary and ghostly presence. The critical investigation of colonial and "native" desires and the role of images and texts as technologies for the negotiation of power relations are also important elements in Min's work.

Min has been a professor at the University of California at Irvine since 1993 and exhibits actively at institutions around the world. Through her artwork and teaching, Min encourages personal reflection on the political and social constitution of identities and the poetry that is possible in the midst of this complicated matrix.

Notes

1. Elaine H. Kim, "On Yong Soon Min's *Bridge of No Return*," in *Yong Soon Min: Bridge of No Return* (Champaign, Ill.: Krannert Art Museum, 1997), p. 7, exhbn cat.

2. This generational designation is specific to Korean Americans, indicating immigration from Korea while still a young child.

ONO, YOKO

Nationality: Japanese American. *Born*: 1933, Tokyo, Japan. *Career*: Artist, performer, activist, author, singer, songwriter, filmmaker.

SELECTED ONE-PERSON EXHIBITIONS/PERFORMANCES

1998	Museum of Modern Art, Oxford, England; Deitch Projects, New York, New York
1997	Royal Festival Hall, London, England
1996	Anderson Gallery, Virginia Commonwealth University, Richmond, Virginia
1993	Galeria 56, Budapest, Hungary; Cranbrook Academy of Art Museum, Bloomfield Hills, Minnesota
1991	Centre d'art Contemporain, Geneva, Switzerland
1990	Sogetsu-kai Foundation, Tokyo, Japan; Fondazione Mudima, Milan, Italy
1989	Cranbrook Academy of Art Museum, Bloomfield Hills, Minnesota
1971	Everson Museum of Art, Syracuse, New York
1964	Yamaichi Concert Hall, Tokyo, Japan
1962	Sogetsu Art Center, Tokyo, Japan

SELECTED GROUP EXHIBITIONS/PERFORMANCES

1995	*Scream against the Sky*, Guggenheim Museum SoHo, New York, New York, San Francisco Museum of Modern Art/Yerba Buena Center for the Arts, San Francisco, California
1994	*Scream against the Sky*, Yokohama Museum of Art, Yokohama, Japan
1993	*In the Spirit of Fluxus*, Walker Art Center, Minneapolis, Minnesota
1992	*Fluxus: A Conceptual Country*, Franklin Furnace, New York, New York
1988	*Fluxus: Selections from the Gilbert and Lila Silverman Fluxus Collection*, The Museum of Modern Art, New York, New York
1983	*Fluxus etc./Addenda I: The Gilbert and Lila Silverman Collection,*

Baxter Art Gallery, California Institute of Technology, Pasadena, California

1964 Hi Red Center (at various venues), Tokyo, Japan

1962 Sogetsu Art Center, Tokyo, Japan

SELECTED PUBLICATIONS

Haskell, Barbara, and John G. Handardt. *Yoko Ono: Arias and Objects.* Salt Lake City, Utah: Gibbs Smith, Publisher, 1990.

Hendricks, John. *Instructions for Paintings by Yoko Ono.* Budapest: Galeria 56, 1993. Exhbn cat.

Hendricks, John. *Paintings and Drawings by Yoko Ono.* Budapest: Galeria 56, 1993. Exhbn cat.

Hendricks, John. *Yoko Ono: To See the Skies.* Milan: Fondazione Mudima, 1990. Exhbn cat.

Ono, Yoko. *Grapefruit: A Book of Instructions + Drawings by Yoko Ono.* New York: Simon and Schuster, 1971.

Ono, Yoko. *Onobox.* Salem, Mass.: Rykodisk, 1992. Set of 6 CDs.

ARTIST STATEMENT (1971)[1]

Among my instruction paintings, my interest is mainly in "painting to construct in your head." In your head, for instance, it is possible for a straight line to exist—not as a segment of a curve but as a straight line. Also, a line can be straight, curved, and something else at the same time. A dot can exist as a 1,2,3,4,5,6 dimensional object all at the same time or at various times in different combinations as you wish to perceive. The movement of the molecule can be continuum and discontinuum at the same time. It can be with colour and/or without. There is no visual object that does not exist in comparison to or simultaneously with other objects, but these characteristics can be eliminated if you wish. A sunset can go on for days. You can eat up all the clouds in the sky. You can assemble a great painting with a person in the North Pole over a phone, like playing chess. The painting method derives from as far back as the time of the Second World War when we had no food to eat, and my brother and I exchanged menus in the air.

There may be a dream that two dream together, but there is no chair that we two see together.

Note

1. Excerpted from Yoko Ono, *Grapefruit: A Book of Instructions + Drawings* (New York: Simon and Schuster, 1971), in Alexandra Munroe, ed., *Scream against the Sky: Japanese Art after 1945* (New York: Harry N. Abrams, 1994) p. 376.

BIOGRAPHICAL ESSAY

Straddling the often dissonant worlds of Western pop culture and the Asian avant-garde, Yoko Ono is an artist whose innovative ideas and high-profile personal life have made her one of the most influential and recognized names in twentieth-century creative circles. While most people in the West might recognize her as the widow of ex-Beatle and rock icon John Lennon (who was murdered in 1980), Ono has gained canonical status in the history of Japanese and Asian American art. Her daring, experimental performances, either as a solo artist, with the Japanese artists group Fluxus, or in collaboration with musicians such as composer John Cage, have helped establish Ono as a globally renowned performance artist. Her thought-provoking installations, sculptures, and paintings have also gained consistent attention from critics, collectors, curators, and scholars alike, drawn to her work, which is seen as some of the most important of the post–World War II era—work that helps us understand the profundity of life in Japan after the war's climax, the bombing of Hiroshima.

Perhaps some of the most direct and honest artistic confrontation of the postwar sense of fear and destruction is evident in some of Ono's more recent work, completed in 1993: the large installation *Endangered Species: 2319–2322*. This installation depicts sculpted bronzed figures of a seated family, whose bodies have been melted down after a nuclear war, who represent the last human beings left on earth. The father figure reaches futilely to protect his wife and children; the mother figure grasps the daughter's hand. Each of the figures wear numbered body tags and are rendered as if their bodies have been discovered in an archaeological excavation in the years after the fictional nuclear holocaust. Photo collages juxtaposed with the statues indicate the individual thoughts of each of the family members at the time of their deaths. Inspired by a trip to Pompeii, in this haunting work, Ono is able to present the human side of the victims of war, even if they might be "the enemy."

Ono's identity as a significant postwar artist began to emerge during the early 1960s, when she was living and working in her native Tokyo. At the time, she composed conceptual music and created her well-known *Instructions for Paintings* ink-on-paper works. These dreamlike text compositions, written in Japanese characters, read like poems and bloom in the mind's eye as mental images.

Ono also began to collaborate with groundbreaking artists of the day, including Nam Jun Paik, who associated, along with Ono, with the group Fluxus. Ironically, Fluxus artists didn't recognize themselves as members of a formal collective or artistic movement but saw commonalities in terms of their "alternative" stance to art making. While in art history texts Fluxus is generally most associated with New York and West Germany, the group (founded in 1961 by artist George Maciunas) exchanged ideas with artist, writer, and composer peers in Tokyo. Ono was one of Tokyo's most active participants in this dynamic— and highly unusual for its time—exchange between East and West and drew upon Zen, existentialist, and absurdist thoughts to incorporate the notion of

randomness as the operative force behind art. During her involvement with Fluxus, Ono participated in happenings such as "The Imperial Hotel Physical (Shelter Plan)," held at the Imperial Hotel in Tokyo from January 26–27, 1964, in which guests were invited to have their bodies measured individually for custom-tailored bomb shelters. That same year, Ono performed one of her most legendary solo pieces, *Cut Piece*, at Kyoto's Yamaichi Concert Hall, in which she invited audience members to approach her on stage, and each cut a piece of clothing from her body, an unnerving exercise in trust.

At the same time, Ono was creating work at the Sogetsu Art Center, a hotbed of international creativity and research, as well as leading demonstrations along with the likes of Robert Rauschenberg and John Cage, calling for an integration of Western modernism and Japanese cultural notions to formulate a truly global art with "world relevance," or *sekai-sei* as it was labeled in Japanese. The main credo that Ono shared with her counterparts was the idea that modern abstract art conveyed an international vision that transcended any sense of specific national aesthetic.

In the mid-1960s, Ono's work grew even more minimalist and conceptual, stripped more and more of any reference to her Japanese identity. Some clear examples of her work during this period: *Pointedness*, created between 1964 and 1966, features a crystal ball encased on a plexiglass pedestal and enclosed with a plexiglass vitrine. The pedestal is engraved with the text "The sphere will be a sharp point when it gets to the far corners of the room in your mind." *A Box of Smile*, created between 1965 and 1971, consists of a small stainless steel and mirror glass, engraved teasingly, whimsically, with the piece's eponymous title.

Some of Ono's more recent artwork carries on the same imaginative spirit and stripped-down aesthetic of *A Box of Smile* and the *Instructions for Paintings* series, namely, 1996's *Cleaning Piece*, in which Ono places stones culled from a river in the middle of a gallery, with a large white canvas on one of the gallery's walls, a large black canvas on the opposite wall, and a wall bearing instructions for gallery visitors. Those visiting the gallery are asked to write their sorrows on the black canvas and their recollections of happiness on the white canvas with writing devices supplied by Ono. After recording either a sorrow or a happiness, the gallery visitor must remove a river rock from the pile and place it on the side of the gallery that corresponds to either sorrow or happiness, depending on which emotion was recorded.

Ono is also known for her book *Grapefruit: A Book of Instructions + Drawings by Yoko Ono*, first published in 1964 by Wunternam Press, Tokyo, in a limited run of 500, and later published in expanded form in 1971 by Simon and Schuster. Always outspoken, Ono also achieved international recognition as an activist for peace in the 1960s and 1970s. Her films and popular songs have also added further dimension to the multifaceted career of this dynamic artist.

SIKANDER, SHAHZIA

Nationality: Pakistani American. *Born*: 1969, Lahore, Pakistan. *Education*: B.F.A., National College of Arts, Lahore, Pakistan, 1992. M.F.A., Rhode Island School of Design, Providence, Rhode Island, 1995. *Career*: Freelance artist. *Awards*: Distinction Award, National College of Arts, Lahore, Pakistan, 1992. Haji Sharif Award, Excellence in Miniature Painting, National College of Arts, Lahore, Pakistan, 1993. Shakir Ali Award/Rudyard Kipling Award, highest merit award in Pakistan, 1993. Graduate Fellowship Award, Rhode Island School of Design, 1993–1995. Core Fellowship, Glassell School of Art, Houston, 1995–1997. Tiffany Foundation Grant, 1997.

SELECTED INDIVIDUAL EXHIBITIONS

1998	The Renaissance Society, University of Chicago, Chicago, Illinois; The Kemper Museum of Contemporary Art & Design, Kansas City, Missouri
1997	Hosfelt Gallery, San Francisco, California; Deitch Projects, New York, New York; Yerba Buena Gardens Center for the Arts, San Francisco, California
1996	Artist Installation, Project Row Houses, Houston, Texas; Barbara Davis Gallery, Houston, Texas

SELECTED GROUP EXHIBITIONS

1998	Forum for Contemporary Art, St. Louis, Missouri
1997	Biennial Exhibition, The Whitney Museum of American Art, New York, New York; Caldas da Rainha Biennial, Portugal; The Drawing Center, New York, New York; *Out of India*, Queens Museum of Art, Flushing Meadows, New York; Core: 1997 Exhibition, Glassell School of Art, Houston Fine Arts Museum, Houston, Texas; *Eastern Edge*, Laing Gallery, Newcastle, England
1996	Core: 1996 Exhibition, Glassell School of Art, Houston Fine Arts Museum, Houston, Texas; *An Intelligent Rebellion, Women Artists of Pakistan*, Bradford City Museum, Bradford, England
1995	*A Selection of Contemporary Paintings from Pakistan*, Pacific Asia Museum, Pasadena, California

SELECTED PUBLICATIONS

Baker, Kenneth. *San Francisco Chronicle*, May 22, 1997.

Camhi, Leslie. "Xtra Small." *Village Voice*, November 25, 1997.

Colpitt, Frances. *Core: 1997 Exhibition*. Houston: Glassell School of Art, 1997. Exhbn cat.

Cotter, Holland. *New York Times*, December 26, 1997.

Goodman, Jonathan. "Small Pleasures." *World Art*, no. 15 (1997), pp. 28–31.

Helfand, Glen. *San Francisco Focus* (May 1997).

Jana, Reena. *Asian Art News* (March–April 1997).

Jana, Reena. *Flash Art International* (January–February 1997).

Jana, Reena. "Shahzia Sikander: Celebration of Femaleness." *Flash Art* (March–April 1998), pp. 98–101.

Johnson, Patricia C. "Art Notes." *Houston Chronicle*, February 2, 1997.

Johnson, Patricia Covo. *ARTnews* (February 1998), pp. 86–88.

Klein, Gudrun. "Beyond Surfaces" (interview) *Art Lies* (Winter 1997).

Knowles, Susan W. "Shahzia Sikander: A Kind of Slight and Pleasing Dislocation." *Art Papers* (November–December 1997).

Lufty, Carol. "Asian Artists in American: Shahzia Sikander." *Atelier* (December 1996).

Pagel David. *Core: 1996 Exhibition*. Houston: Glassell School of Art, 1996. Exhbn cat.

Porges, Maria. *Art Issues* (January–February 1998), pp. 32–33.

Saltz, Jerry. *Time Out New York*, November 27–December 4, 1997.

Smith, Roberta. "Drawing That Pushes Beyond the Boundaries." *New York Times*, March 21, 1997.

Smith, Roberta. *New York Times*, December 5, 1997.

Varghese, Rachel. "Pushing the Limits." *Indo-American News*, April 8, 1996.

BIOGRAPHICAL ESSAY

The debate concerning naming works of art is stillborn in the miniature paintings and collaged murals of Shahzia Sikander, who was born in Lahore, Pakistan, and now lives in Houston, Texas. *Uprooted Order, Series III; A Kind of Slight and Pleasing Dislocation; Apparatus of Power; Separate Working Things; Beyond Surfaces; Somewhere beyond the Cultural and Personal; Ready to Leave*—Sikander's titles are provocative, curious, and most important, an invitation to explore and investigate her paintings beyond the surfaces. The names and the paintings allude to a heightened feminist sensibility whereby situations are hinted at and a veiled dance of Hindu and Near Eastern iconography is performed to the rhythm of Western deconstructionism.

Sikander is a woman of two worlds, both of which play an integral role in her art. She was born and grew up in Lahore, Pakistan, where she studied the methods of traditional miniature painting. She was interested in reinventing traditions instead of working solely in the Western idiom. The eighteenth-century art of the Pahari masters of Basholi, Guler, and Kangra has provided Sikander with a strong intuitive foundation upon which to develop her own aesthetic vocabulary, which draws also upon recurring images from Hindu my-

thology. Sikander sketches and paints on thin sheets of *wasli*, strong tissue paper. This is the type of paper that has been used throughout the ages by traditional miniature artists to trace and copy paintings. Using this same paper for spontaneous drawings and paintings is a liberating experience, which at the same time calls into question the conservative nature of the traditional culture of which Sikander is a part, particularly as miniature painting was the preserve of male painters in India and Pakistan. Working in a small format seems natural to Sikander, who often makes her own squirrel-tail hairbrushes, grinds her own pigments from roots and minerals, and prepares *wasli* by staining it with tea and burnishing it. Sikander brought these skills and techniques with her when she came to the United States to study at the Rhode Island School of Design (RISD). At RISD she was challenged to break through the conventional approach of traditional painting and encouraged to experiment with new ways of making art. The result for Sikander was a truly liberating experience. Her *wasli* drawings and paintings floated onto walls in layered collages. From the defining contours of the miniature tradition, and the enclosed and protected world of a South Asian Muslim woman, Sikander extended her paintings and her personal world, with bold, gestural brush strokes that encompassed a seeming infinity of space beholden to no restrictive borders. Acknowledgment of Sikander's art was her invitation to participate in the 1997 Whitney Biennial, where she received much critical attention as one of the most promising young artists in the United States.

Looking at Sikander's work, one has the sense of Indian painting that is not only unwired but also miswired. Objects are attached by sinuous, ropy lines that often spin into centrifugal circles; winged griffinlike animals and women are crowned with long, fringed *chadors*, veils; and feet have strings attached. Hindu iconic and literary references resonate throughout Sikander's work. Her small painting *Apparatus of Power* (1995) is a masterful reinterpretation of a Basohli painting, circa 1700, of Krishna stealing the *gopis'* (cow herdesses') clothes, an incident that is recounted in the *Bhagavata Purana*. The tree in which Krishna hid the clothes has been transformed into a winged female figure wearing a long skirt and *chador*, whose stringlike fringes become lotus stems, a symbol of spiritual purity and fertility. Within her body is one of the seated *gopis*, and to either side are two fallopian tubes that bear incipient figures in their ovaries. Suspended before this extraordinary female figure is a lotus medallion that emits a five-pointed star. Rising above her head like a halo is the Mughal solar disc enclosing a uterus, and above that, the moon. Wherein the original painting the *gopis* were embarrassed and tried in vain to conceal their nudity, using the same figures in almost identical postures, Sikander has filled them with a sense of awe as they respond to this truly miraculous matriarch.

In her painting *A Kind of Slight and Pleasing Dislocation* (1995), Sikander has depicted Durga, one of the most powerful manifestations of Devi *sakti*, the feminine principal in India. In an iconic presentation, Durga floats upon a neutral sand-colored ground. Her head and torso are covered by a long, fringed, white

chador. All that can be seen of her body are her legs and multiple hands. Her legs, painted in the *xie-hua*, boneless style, are attached by four intestinal ropes, which is a contradiction to the open, splayed-leg stance Durga usually assumes, as is the concealing of her normally beautiful head and sensual body. All the gods of the Hindu pantheon bestowed their weapons upon Durga to help her destroy a demon that was more powerful than all of them put together. The arms of Sikander's Durga are bristling with daggers, swords, axes, *khatars*, knives, and elephant goads. Ironically, a pair of mendicant's wooden sandals dangle from her waist, perhaps a reference to Gandhian *ahimsa*, pacifist policies.

Sikander reinterprets stereotypical notions of the feminine, using not only South Asian prototypes but also Rapunzel, Red Riding Hood, and Botticelli's Venus, among others. Her work addresses the strength of women and role models for independence. But the unraveling qualities that pervade her paintings suggest the responsibilities that women can never shed. Umbilical cords float out from her figures bearing a continual succession of womblike bubbles. They are the ties that bind. The intestinal entrails suggest constant entrapment. Rarely are her women anchored. They float in space, before frames, in front of buildings. Their transparency adds to their weightlessness and sense of dislocation. Their environment has become unstable.

Sikander brings together East and West, the traditional and the nontraditional, in innovative ways. She questions the aesthetic and gender stereotypes of South Asia and challenges her viewers to follow her visual dance through a complex and highly inventive personal iconography.

TANAKA, JANICE D.

Nationality: Japanese American. *Born*: California. *Education*: B.A., Cinema and Television, magna cum laude, University of Southern California, 1977. M.F.A., Cinema and Television, University of Southern California, Los Angeles, 1979. Advanced Performance and Teaching Credentials, Miyagi Koto Music School, Tokyo, Japan, 1985. Communication, Postgraduate work, University of California, Los Angeles, 1990. English, Postgraduate work, Indiana University, Bloomington, 1992. English, Postgraduate work, Purdue University, West Layfatte, Indiana, 1995. *Career*: Owner, Tanaka Video Productions, producing industrial videos for nonprofit organizations and corporations, 1987–present. Adjunct Professor, Cinema/Television, University of Southern California, Los Angeles, California, 1989–1990. Programming Assistant, Visual Communications, Los Angeles, California, 1992. Visiting Professor, Telecommunications, Indiana

University, Bloomington, Indiana, 1992–1993. Assistant Professor, Communication/Telecommunications, Purdue University, West Lafayette, Indiana, 1993–1995. Assistant Professor, Telecommunications Department, University of Florida School of Journalism, 1995–present. *Selected Awards*: Gold Award, Visual Communicators Department of the Year Award, The Associations of Visual Communicators, 1988. Certificate of Merit for *New Employee Orientation Video, City National Bank*, International Television Association, 1993. Golden Angel for Japanese American National Museum *Welcome Video*, International Television Association, 1993. Faculty Incentive Grant, Purdue University School of Liberal Arts, 1994. Regional fellowships, The Center of New Television, 1994.

SELECTED FILMOGRAPHY

1997–present	*When You're Smiling* (Documentary); *The Barracks Project* (Documentary)
1995	*At Face Value: Asian Immigrants in the Midwest* (segment on Tony Yamasaki) (Documentary)
1980	*Bachan* (Documentary); *Hilto Hata Raise the Banner* (key crew member) (Documentary)
1976	*Ohakamairi: A Visit to the Graves* (Documentary)

BIOGRAPHICAL ESSAY

Janice Tanaka, a Sansei (third-generation) Japanese American filmmaker and educator, explores the complicated relation between community and personal stories through a series of film and installation projects. These pieces grapple with the cultural memory of the internment of Japanese Americans during World War II and the long-term effects of this social atrocity on individual families and the wider community.

In the documentary *Bachan* (1980), made toward the end of her film school education at the University of Southern California, Tanaka traces the story of her grandmothers' lives as immigrants to the United States from Japan in the early 1900s. The importance of reconstituting such family histories, especially through the eyes of the matriarchs, is particularly crucial for the Japanese American community. There is a general reluctance to talk about the internment experience on the part of the Issei (first-generation immigrants) and Nisei (second-generation Japanese Americans) who experienced the internment; yet this event left an indelible impression on the shape and form of the community since the postwar era. Tanaka sites the scholarship of Donna Nagata, who has studied the sociological and psychological impact of the internment on the children of internees, as one of the few sources of information about this important aspect of the camps. The story of her grandmothers, who were interned at Gila River, Arizona, and Amache, Colorado, became windows through which Tanaka could reconstitute her family's silenced history as well as a wider communal

history. She has also documented her personal search for historical connections in her first film, *Ohakamairi: A Visit to the Graves* (1976). Tanaka chronicles her pilgrimage to Manzanar, site of one of the largest internment camps and the most prominent annual gathering point for the remembrance of the internment. Efforts such as Tanaka's to record an unwritten history of collective struggle by means of very personal stories are crucial to forging a community history.

In her current project, *When You're Smiling* (forthcoming), Tanaka creates a room installation that features video, music, drawing, and photographs. The title refers to the popular song ("When you're smiling, the whole world smiles with you . . ."), reflecting what Tanaka sees as the philosophy of her parents toward their extremely difficult wartime experiences. Their desire to disguise the damage, personal and financial, wrought by the war was particularly strong on the part of the Nisei. The effects of internment, however, lasted long after the government closed the camps, manifesting themselves in community-wide problems such as domestic violence and alcohol and drug abuse. And although some ethnic tensions were exacerbated by the war, the internment also managed to strengthen ties between other ethnic communities and the Japanese Americans as African Americans, Latinos, and Jewish Americans, for example, helped during resettlement, creating ties that would last through the next generation.

By focusing specifically on the very complicated and little-discussed postinternment era, Tanaka turns the spotlight on the moment when forming Japanese American identity was most complicated and precarious. Tanaka uses voiceover narratives from her family members, who speculate about their family's past while photos, video footage of their old neighborhood, and Tanaka's own drawings of family photographs are collaged into a dreamlike sequence that calls to mind the process of remembering. Tanaka employs a technique called "blind contour drawing," in which she does not look at the image she reproduces, but she remembers and tries to reproduce it as a sense experience. This experimental technique and the multifaceted collage of images in the film, combined with the overall installation, which will feature sound and sculptural/spatial elements, extends Tanaka's cultural memory project into exciting new territory.

Tanaka asserts that "the story specifically draws the parallels of the common experience of class struggle, alcoholism and discrimination shared by some Japanese American, African American and Latinos in urban Los Angeles. I believe this project can be instrumental in tearing down stereotypes by sharing our commonalities during this turbulent time in history."

Tanaka's video works poetically evoke the complicated processes of memory and history. While teaching at the university level and working with such organizations as Visual Communications (an Asian American film cooperative organization in Los Angeles), she is also the proprietor of her own video production company, which produces films for corporations and nonprofit institutions such as the Japanese American National Museum in Los Angeles.

TRINH T. MINH-HA

Nationality: Vietnamese American. *Born*: Vietnam. Came to the United States in 1970. *Education*: B.A., cum laude, French Literature and Music, Wilmington College, 1972. Certificat C1, in both Langue, litterature et culture d'Oc and Ethnomusicology, Université de Paris IV–Sorbonne, 1974–1975. Master of Music, Composition, University of Illinois, Urbana-Champaign, 1976. Ph.D., French and Francophone Literatures, University of Illinois, Urbana-Champaign, 1977. *Career*: Associate Professor, Department of Cinema, San Francisco State University, San Francisco, California, 1985–1993. Editorial Board member, *Amerasia*, Asian American Studies Center, University of California, Los Angeles, 1989–present. Board of Directors, National Asian American Telecommunication Association, 1990–1993. Chancellor's Distinguished Professor, Women's Studies, University of California, Berkeley, 1991. Research Fellow and Visiting Professor, The Society for the Humanities, Cornell University, Ithaca, New York, 1991. Professor, Departments of Women's Studies, Film Studies, and Rhetoric, University of California, Berkeley, 1992–present. Visiting Professor, Women's Studies and Visual and Environmental Studies, Harvard University, Cambridge, Massachusetts, 1993. Neilson Distinguished Professor, Women's Studies Program, Smith College, Northampton, Massachusetts, 1994. Regular Visiting Faculty, The London Consortium (Architectural Association School of Architecture; Birkbeck College; University of London; British Film Institute; Tate Gallery), 1994–present. Editorial Board member, *Discourse, a Journal for Theoretical Studies in Media and Culture*, 1996–present. *Awards*: National Endowment for the Arts, Film Production, 1987–1988, 1990–1991, 1993–1994. Honorary Doctor of Fine Arts, Oberlin College, 1990. Blue Ribbon Award, Best Film as Art Feature at the American Film and Video Festival, 1990. First Prize, Film as Art Award, The Society for the Encouragement of Contemporary Art, San Francisco Museum of Modern Art, 1990. Merit Award, Bombay International Film Festival, India, 1990. The Guggenheim Fellowship, 1990–1991. The American Film Institute Independent Film Award, 1991. Maya Deren Award, American Film Institute, 1991. Best Cinematography Award, Sundance Film Festival, 1992. Best Experimental Feature Documentary, Athens International Film Festival, 1992. The Rockefeller Foundation Intercultural Film Fellowship, 1993–1994.

FILMOGRAPHY

1995–1996	*A Tale of Love*, 108 mins., 35mm
1991	*Shoot for the Contents*, 102 mins.
1989	*Surname Viet Given Name Nam*, 108 mins.
1985	*Naked Spaces—Living Is Round*, 135 mins.
1982	*Reassemblage*, 40 mins.

SELECTED SCREENINGS AND FESTIVAL APPEARANCES

1997 Maori Women's Film Hui, Auckland, New Zealand; Festival Internazionale Cinema delle Donne, Turin, Italy; Asian Art Museum, San Francisco, California; Brooklyn Museum of Art, New York; Image Film & Video Center, Atlanta, Georgia; Wexner Center, Columbus, Ohio; Harvard Film Archive, Cambridge, Massachusetts; Museum of Modern Art, New York, New York; Mini-Cine, Los Angeles, California; Film Center, Art Institute of Chicago, Chicago, Illinois

1996 Feminale Women's Film Festival, Köln, Germany; Tokyo Metropolitan Museum of Photography, Tokyo, Japan; Frauenkino Xenia, Zurich, Switzerland; Cinematrix, London, England; 3rd Seoul Short Film Festival, Seoul, Korea; Berlin International Film Festival, Film Forum, Berlin, Germany; Mostra Internacional de Films de Dones, Barcelona, Spain; Taipei Golden Horse Film Festival, Taipei, Taiwan; RoxieCinema, San Francisco, California; UC Theater, Berkeley, California; Los Angeles Asian Pacific Film Festival, Los Angeles, California

1995 Hong Kong Arts Centre, Wanchai, Hong Kong; Filmhaus, Vienna, Austria; Shedhalle, Zurich, Switzerland; Filmmusem & Kunstverein München, Munich, Germany; Kino fsk, Berlin, Germany; American Center, Paris, France; Toronto International Film Festival, Toronto, Ontario, Canada; Virginia Festival of American Film, Charlottesville

1994 Colgate University, Hamilton, New York; Women's International Film Festival, Rock Hill, South Carolina; Multicultural Film Festival, Amherst, Massachusetts

1993 Eldorado, Centrum Voor Beeldcultuur, Antwerp, Belgium; The Banff Center, Alberta, Canada; Theater Hoogt, Utrecht, Netherlands; Filmtheater Desmet, Amsterdam, Netherlands; STUC, Lewen, Belgium

1992 Madrid International Film Festival, Madrid, Spain; Mannheim International Film Festival, Mannheim, Germany; Bombay International Film Festival, Bombay, India; Institute of Contemporary Art, London, England; The Cinematograph, New York, New York; Roxie Theater, San Francisco, California; Wexner Center for Visual Arts, Columbus, Ohio; UCLA Film and Television Archive, Melnitz Theater, Los Angeles, California; Walker Arts Center, Minneapolis, Min-

	nesota; Brattle Theater, Boston, Massachusetts; Chicago Filmmakers, Chicago, Illinois; Sundance Film Festival, Park City, Utah
1991	San Francisco Cinematheque, San Francisco, California; Cornell Cinema, Ithaca, New York; Kabuki Theater, San Francisco, California
1990	National Gallery of Canada, Ottowa, Ontario, Canada; Athens International Film Festival, Athens, Greece; Museum of Kyoto, Kyoto, Japan; Osaka American Center, Osaka, Japan; Sapporo American Center, Sapporo, Japan; Hong Kong Arts Center, Hong Kong; Wexner Center for the Visual Arts, Columbus, Ohio
1989	São Paulo International Film Festival, São Paulo, Brazil; Jerusalem International Film Festival, Jerusalem, Israel; Sheldon Film Theater, Lincoln, Nebraska; Rainbow Film Festival, Portland, Oregon; The Collective for Living Cinema, New York, New York; Northwest Film and Video Center, Portland, Oregon
1988	Cornell Cinema, Ithaca, New York; Yale University, New Haven, Connecticut
1987	Anteneo de Caracas Film Festival, Caracas, Venezuela; Third Cinema Festival, London, Ontario; American Film Festival, New York, New York; Biennial, Whitney Museum of American Art, New York, New York; Carnegie Museum of Art, Pittsburgh, Pennsylvania

PUBLICATIONS

Clough, Patricia T. *Feminist Thought*. Cambridge: Blackwell, 1994. pp. 114–128.

Ditta, Susan. "In-Between Spaces: The Films of Trinh T. Minh-ha." In *The Film & Video by Artists Series*. Ottawa: The National Gallery of Canada, 1990.

Foster, Gwendolyn. "*A Tale of Love*: A Dialogue with Trinh T. Minh-ha." *Film Criticism* 21, no. 3 (Spring 1997), pp. 89–113.

Kaplan, E. Ann. *Looking for the Other. Feminism, Film, and the Imperial Gaze*. London: Routledge, 1997. pp. 195–217.

Long, Renee. "Trinh T. Minh-ha: An Approach to Contemporary Experimental Film." *Harbour* 2, no. 4 (Fall 1993), pp. 34–38.

MacDonald, Scott. *Trinh T. Minh-ha—Film Retrospective*. New York: Colgate University, 1994.

Rist, Peter. "Teaching Trinh T. Minh-ha: An Approach to Contemporary Experimental Film." *Harbour* 2, no. 2 (1992), pp. 57–65.

Trinh T. Minh-ha. "An Acoustic Journey." In J. Welchman, ed., *Rethinking Borders*. London: Macmillan Press Ltd., 1996. pp. 1–17.

Trinh T. Minh-ha. *En minuscules* (A book of poems). Paris: Le Méridien éditeur (formerly Les Editions Saint-Germain des Près), 1987.

Trinh T. Minh-ha. *Framer/Framed*. New York: Routledge, 1992. German edition published by Munich: Kunstverein München, SYNEMA-Gesellschaft für Film und Medien, Blickpilotin e.V., 1995.

Trinh T. Minh-ha. "It Went by Me." In Elaine Kim et al., eds., *Making More Waves*. Boston: Beacon Press, 1997. pp. 242–257.

Trinh T. Minh-ha, "Know by Heart." In Barbara Tran, ed., *Watermark*. New York: The Asian American Writers' Workshop, 1997.

Trinh T. Minh-ha. "Mother's Talk." In Obioma Nnaemeka, ed., *The Politics of M(Othering): Womanhood, Identity and Resistance in African Literature*. London: Routledge, 1997. pp. 26–32.

Trinh T. Minh-ha. "Nature's r: A Musical Swoon." In George Robertson et al., eds., *Futurenatural*. London: Routledge, 1996. pp. 86–104.

Trinh T. Minh-ha. "Other Than MYself/My Other Self." In G. Robertson et al., eds., *Traveller's Tales*. London: Routledge, 1994.

Trinh T. Minh-ha. *Un Art sans oeuvre*. Troy, Mich.: International Book Publishers, 1981.

Trinh T. Minh-ha. *When the Moon Waxes Red. Representation, Gender & Cultural Politics*. New York: Routledge, 1991. Japanese edition translated by Fukuko Kobayashi. Tokyo: Misuzu Publisher, 1996.

Trinh T. Minh-ha. "With Curse, or Love." In Rodney Sappington and Tyler Stalling, eds., *Uncontrollable Bodies: Testimonies of Identity and Culture*. Seattle, Wash.: Bay Press, 1994.

Trinh T. Minh-ha. *Woman, Native, Other. Writing, Postcoloniality and Feminism*. Bloomington: Indiana University Press, 1989. Japanese edition translated by Kazuko Takemura. Tokyo: Iwanami Shoten Publishers, 1995.

Trinh T. Minh-ha, in collaboration with Jean-Paul Bourdier. *African Spaces. Designs for Living in Upper Volta*. New York: Holmes & Meier, 1985.

Trinh T. Minh-ha, in collaboration with Jean-Paul Bourdier. *Drawn from African Dwellings*. Bloomington: Indiana University Press, 1996.

Trinh T. Minh-ha, Isaac Julien, and Laura Mulvey. " 'Who Is Speaking?': Of Nation, Community and First Person Interviews." In Peg Brand and Carolyn Korsmeyer, eds., *Feminism and Tradition in Aesthetics*. University Park: Pennsylvania State University Press, 1994. pp. 193–214.

Trinh T. Minh-ha, Cornwell West, Russell Ferguson, and Martha Gever, eds. *Out There: Marginalization in Contemporary Culture*. New York: New Museum of Contemporary Art and MIT Press, 1990.

Trong Minh. "Trinh T. Minh-ha." In R. Murphy, ed., *The Pride of the Vietnamese*. Trans. Nguyen V. Giai. Irvine, Calif.: Vu Trong Chat, 1991. pp. 169–178.

Verhoeven, Deb. "Interview with Trinh T. Minh-ha on the Language of Love and Cinema." *World Art* 14 (Fall 1997), pp. 36–41.

Wheal, Nigel. *The Postmodern Arts*. London: Routledge, 1995.

BIOGRAPHICAL ESSAY

Trinh T. Minh-ha came to the United States from Saigon in 1970 to obtain a doctorate in French literature; after completing her studies at the University of Illinois at Urbana-Champaign, Trinh studied at the Sorbonne in Paris and lived for several years in Dakar (Senegal, West Africa), teaching and doing fieldwork in social anthropology. This international background has significantly informed her views on the irreducible multiplicity of diasporic experiences. Her politically challenging, poetic work insists on the complexity of our subjectivity by rigorously questioning those uneasy spaces between monolithic definitions of identity and culture. Her oeuvre defies disciplinary boundaries, combining poetry, film, philosophy and cultural theory, art and architectural history, and

music. One of the foundational figures in postcolonial studies and Third World feminist studies, Trinh has published widely, receiving international acclaim for her three pivotal volumes of cultural theory: *Framer/Framed* (1992), *When the Moon Waxes Red* (1991), and *Woman, Native, Other* (1989). Her films combine documentary and fictional narrative with a distinctive lyricism; of particular note are *Shoot for the Contents* (1991), which earned Best Cinematography at the Sundance Film Festival in 1992; *Surname Viet Given Name Nam* (1989), which won the Blue Ribbon Award for Best Film-as-Art Feature in 1990 at the American International Film Festival and at the SECA Festival; and her most recent piece, *A Tale of Love* (1995–1996). It is particularly useful to consider her writing and her films in relation to each other, since they share so many formal similarities and goals.

As a diasporic artist and writer informed by French literature and literary theory, Trinh explores the fluidity of culture, memory, history, identity, and truth, actively contesting easy legibility. The strength in her work lies in its willingness to allow for the unresolvable, avoiding all-too-easy political reductivism by maintaining spaces of conflicting desires while calling for a constant awareness of how power relations are formulated and maintained at any given moment. In her films, Trinh has confounded traditional audience expectations for narrative, documentary, or even experimental film by constantly shifting modes of address, filming techniques, and even film genres themselves. Both her films and textual works revel in culturally, visually, and narratively ambiguous spaces. She explains: "The films I've been making confront people in their normalized need to categorize, to make sense and to know all."[1]

Her earliest films directly engage with the history of anthropology and the relations between First and Third World nations. *Reassemblage* (1982) is less a documentary of the rural Senegalese than a meditation on the process of ethnographic documentation itself. Trinh addresses the anthropologist's obsessive faith in the observable as truth, bringing into play the function of anthropology as a science of Othering whose primary function is to create the identity of the anthropologists and their culture. Similarly, *Naked Spaces—Living Is Round* (1985) explores the relationships between a poetics of space, home, and spirituality among women in West Africa. In perhaps one of her best-known films, *Surname Viet Given Name Nam*, Trinh films the stories of women of the Vietnamese diaspora as they resist internal and external oppression. *Shoot for the Contents* addresses the effects of shifting power structures in contemporary (post-Tiananmen Square massacre) China.

A Tale of Love, her most recent film and first 35mm project, is inspired by "The Tale of Kieu," the unofficial national poem of Vietnam that tells the tragic story of a woman (symbolically seen as Vietnam itself) who becomes a prostitute to save her family. In the film, Kieu is a writer in the United States who makes money to send her family in Vietnam as a photographer's model. The intertwining themes of the film (desire, voyeurism, sensory excess, and deprivation) are played out in the interaction of the characters and in the visual and audial

experience of the film itself. Trinh asserts that the film focuses on ''an altered state of the mind and body, the state of being in love.''[2]

While writing and making films, Trinh has also been an active teacher in the United States and elsewhere. She holds a professorship at the University of California at Berkeley in Women's Studies, Film Studies, and Rhetoric and has guest taught at The London Consortium of institutions, Colgate University, Smith College, and Harvard University, to name but a few posts. She is also an editor of the cultural theory journal *Discourse* and recently coedited the fall 1997 issue, which focused on African American and women poets in the Beat movement. She is also an active member of the film community, having served on boards and juries for groups such as the National Asian American Telecommunication Association (NAATA), The Rockefeller Foundation, and the American Film Institute. Trinh's ability to move between media, disciplines, and nations gives her the ability to illuminate with particular clarity those particularly complicated spaces in-between.

Notes

1. Gwendolyn Foster, ''*A Tale of Love*: A Dialogue with Trinh T. Minh-ha,'' *Film Criticism* 21, no. 3 (Spring 1997), p. 91.

2. Deb Verhoeven, ''Interview with Trinh T. Minh-ha on the Language of Love and Cinema,'' *World Art* 14 (Fall 1997), p. 39.

WONG, FLO OY

Nationality: Chinese American. *Born*: 1938, Oakland, California. *Education*: Received her B.A. degree in English from the University of California, Berkeley, in 1960 and her California teaching credentials from California State University, Hayward, in 1961. Returned to school and continued her education in art at DeAnza College, Cupertino, from 1978 to 1980, and at Foothill College, Los Altos Hills, in 1978 and from 1980 to 1982. *Career*. Having seriously entertained the arts since 1978, Flo Oy Wong has established her presence as both an artist and an activist in the Asian American art circles of the Bay Area. She has proven herself to be a prolific artist in northern California. In recent years her artistic activities have drawn the attention of those in the Midwest, Texas, and other regions of the United States. *Awards*: Certificate of Recognition, Leadership Sunnyvale, Sunnyvale, California, 1990. The Fourth R: Art and the Needs of Children and Youth Award, Euphrat Museum of Art, DeAnza College, Cu-

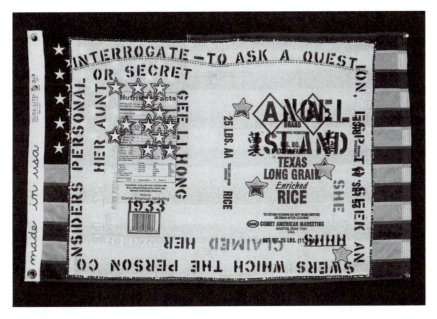

Made in USA: Angel Island Shhh by Flo Oy Wong, 1998, sack, flag, sequins, beads, 2' × 3'.

pertino, California, 1992. Best artist in Sunnyvale, *SUNNYVALE SUN* Survey, November 30, 1994. President's Award, Women's Caucus for Art, San Antonio, Texas, 1995.

EXHIBITIONS

1997–1998	*Baby Jack Rice Story*, African American Museum of History, Detroit, Michigan, Wallace/Muscat Gallery, San Antonio, Texas, University of Nebraska, Lincoln, Nebraska
1996	Bemis Center for Contemporary Arts, Open House Exhibition, Omaha, Nebraska
1995	*Flo Oy Wong: Essences*, Montalvo Center for the Arts, Saratoga, California
1994	*"My Tongue Speaks," Eye of the Rice: Yu Mai Gee Fon* Installation, San Jose City College, San Jose, California
1993	*"Rice Story," Eye of the Rice: Yu Mai Gee Fon* Installation, IDEA Gallery, Sacramento, California
1992	*Kaleidoscope*, Prieto Gallery, Mills College, Oakland, California
1991	*Long Grain, Extra Fancy*, 1078 Gallery, Chico, California
1989	*Chinatown, Et. Al*, Mid-Peninsula YWCA, Palo Alto, California
1988	*New Works*, Mission College, Santa Clara, California

| 1986 | *Artworks*, Fellowship Gallery, Los Gatos, California |
| 1985 | *723 Webster Street*, Asian Resource Gallery, Oakland, California |

SELECTED GROUP EXHIBITIONS

1998	*Cultures in Contact*, Lawrence University, Appleton, Wisconsin
1997–2000	*Pure Vision: American Bead Artists*, Exhibits USA, United States Embassy, United States Department of State Artists in Embassies Program, Sambia, Africa
1997	Sesnon Art Gallery, Porter College, University of California, Santa Cruz, California; Multicultural Art Exhibition, Synospsy, Mountain View, Network General Corporation, Menlo Park, Lifescan Incorporated, Milpitas, California; Alumni Printmakers, California State University, Hayward, Hayward, California
1996	*Families: Rebuilding, Reinventing, Recreating*, Euphrat Museum of Art, DeAnza College, Cupertino, California; *Building Bridges, Crossing Cultures*, St. Mary's College, Moraga, California; *(Inside) Out*, WORKS Gallery, San Jose, California; *Subversive Domesticity*, Edwin A. Ulrich Museum of Art, Wichita State University, Wichita, Kansas; *A Case for Art*, Richmond Art Center, Richmond, California; *Women's Leadership for a New Century: Beyond Beijing-Oakland*, Mills College, Oakland, California; *Cooking the World*, Gallery Route One, Port Reyes Station, California; *Transforming Tradition*, Women's Caucus for Art national juried exhibition, Boston, Massachusetts; *Family Matters: Traditional and Contemporary Depictions of Home Life*, Bedford Gallery, Regional Center for the Arts, Walnut Creek, California
1995	*Ancestors*, Asian American Arts Centre, New York, New York; RICE, Asian American Women Artists Association/WORKS San Jose Art and Performance Space, San Jose, California; *Asians Now: Americans in the Making*, Intercultural Center, Sonoma State University, Sonoma, California; *Teenage Mutant Ninja Turtles . . . NOT*, Reed College/Godzilla Collaboration, Reed College, Portland, Oregon; *Family Matters—Make Yourself at Home: Race, Ethnicity and the American Family*, Atlanta College of Art–Woodruff Art Center, Atlanta, Georgia
1994	*Stories*, Chico State University, Chico, California; *Domestic Landscapes*, Falkirk Gallery, San Rafael, California; *Imagining Families: Image & Voices*, National African American Museum Project, Arts & Industries Building, Smithsonian Institution, Washington, D.C.; *Family Album*, Luggage Store Gallery, San Francisco, California; *Mirror, Mirror: Gender Roles and the Historical Significance of Beauty*, California College of Arts and Crafts Gallery, Oakland, California; *Narratives*, Painted Bride Art Center, Philadelphia, Pennsylvania; *Struggles against Racism*, Cambridge Multicultural Art Center, Cambridge, Massachusetts
1993	*Redefining Self: Six Asian American Artists*, San Jose State University, San Jose, California; *Local Color*, Raynor Studio Artists Exhibition,

Creative Arts Center Gallery, Sunnyvale, California; *Open Houses*, Headlands Center for the Arts, Sausalito, California; *Diversity-Influences*, Creative Growth Center Gallery, Oakland, California

1992 *Food for Thought*, Berkeley Art Center Association, Berkeley, California; *deFORMATION transFORMATION*, Hilda Shum, Florence Wong, Capp Street Project, San Francisco, California; *Face of the Soul*, 1978 Gallery, Chico, California; *Spirit as Source*, Bade Museum, Pacific School of Religion, Berkeley, California; *Different Voices*, University of California at Santa Barbara Women's Center, Santa Barbara, California; *Gathering*, Lite Rail Gallery, California State University at Sacramento, Sacramento, California; *Internal Visions*, San Jose Art League, San Jose, California

1991 *Men by Women*, Gallery Concord, Concord, California; *Awaken*, Asian American Women Artists Association Exhibit, ART WORKS Galleries, Fair Oaks, California; Asian American Women Artists Association at the Chinatown Neighborhood Arts Program, San Francisco, California; *Out of the Classroom into the Gallery*, Museum of Children's Art, Oakland, California; *Expressions of Sociometry*, ARTLINK, Fort Wayne, Indiana; *Spirit of East and West*, Asian American Women Artists Association, Berkeley Store Gallery, Berkeley, California; *Freedom Views 1991*, Euphrat Museum of Art, DeAnza College, Cupertino, California; *Our History, Our Rituals*, a SALAD BAR Exhibition, Intercultural Gallery Sonoma State University, Sonoma, California, Bayview Opera House, San Francisco, California, Alameda County Administration Building, Oakland, California; *Her Story: Narrative Art by Contemporary California Artists*, Oakland Museum, Oakland, California

1990 Dito Gallery, Sacramento, California; *Art as Social Comment*, Brockman Gallery, Los Angeles, California; *3 Universes in the Atomic Cafe*, I.D.E.A. Gallery, Sacramento, California; ARTISTS' EQUITY Northern California Members Exhibition, San Francisco, California; *Perspectives*, Creative Art Center Gallery, Sunnyvale, California

1989–1990 Salon Show at the Art League Downtown Gallery, San Jose, California; Artists' Open Studio, Santa Clara County, California

1989 State of the City Celebrates The ARTS, Sunnyvale, California

1987 *Back in Touch*, Euphrat Museum of Art, DeAnza College, Cupertino, California; *Contemporary Voices: The Asian American Aesthetic*, Triton Museum of Art, Santa Clara, California

1986 *Asian Seeds/Western Soil*, Berkeley Art Center Association, Berkeley Foothills College, Los Altos Hills, California; *The Green Wagon*, Creative Art Center Gallery, Sunnyvale, California

COMMISSIONS

1997 California Arts Council/Arts Council of Santa Clara County Multi-Residency Grant Team Artist, Almaden Community Schools, San Jose, California

1996 NEA/California Arts Council/Santa Clara County Arts Council Multi-
 Residency Grant Team Artist, Calero School, San Jose, California

SELECTED PUBLICATIONS

Bethel, Amy. "1995 WCA President's Awards." *National Update* (Spring 1995).
Bethel, Amy. "A Test of Self: Flo Oy Wong Telling a Hot Flash Blue Streak." *National Update* (Fall 1995).
Biggar, Alison. "A Family Affair." *Diablo Arts* (January–March 1996).
Cheng, Baolin. "Guest of an American Family." *New Continent* (1995).
Gelhaus, Anne. "East Meets West in 'Essences.' " *Los Gatos Weekly*, July 19–25, 1995.
Holman, Rhonda. "Artwork Shows That Identity Begins at Home." *Wichita Eagle*, May 19, 1996.
Huynh, Danthanh. "Family MATTERS: Euphrat Exhibit Reveals Artists' Kindred Spirits." *Sun*, January 22, 1997.
Jana, Reena M. *Asian Pacific Sculpture News* 1, no. 3 (Summer 1995).
Jana, Reena M. " 'Rice' at Works Gallery." *Asian Pacific Sculpture News* 1, no. 3 (Summer 1995), p. 51.
Lange-Kubick, Cindy. "An American Story." *Lincoln Journal Star Focus Magazine*, January 12, 1997.
Lewallen, Constance. *1991–1993 CAPP Street Project Catalog.* 1995.
Sherman, Ann Elliot. "Family Affairs: Plugging into Personal Pasts at Euphrat Museum." *Metro*, January 16–22, 1997.
Wong, William. "View from Huairou." *Asianweek*, September 15, 1995.
Wong, William. "Women Exhilarated by China Conference." *Tribune*, September 13, 1995.

ARTIST STATEMENT (1992)[1]

In an art history survey class, I consulted with the instructor, telling him that I specifically wanted to use Asian images in my work. "That's not necessary," he replied. "The fact that you are Asian American makes the art you create Asian American." I wasn't able to tell him how I disagreed, how I hungered to stretch beyond the Western-influenced symbols I was using, how my creativity needed to be satisfied in an ethnic-specific way.

Note

1. Flo Oy Wong quoted in Moira Roth and Diane Tani, "Flo Oy Wong: A Narrative Chronology," in *Kaleidoscope: An Exhibition of Ink Paintings and Drawings by Flo Oy Wong* (Berkeley, Calif.: Visibility Press, 1992), pp. 67–68, exhbn cat.

BIOGRAPHICAL ESSAY

Flo Oy Wong's works are both personal and biographical. They explore the Chinese and American aspects of her background and their interactions. Her

story is one that many Chinese Americans—and by extension, Asian Americans—can relate to and, perhaps, serves as a microcosm of the Chinese American experience in this country. This story might not have been told had she followed the advice of one of her art instructors who did not see the necessity for her to explore visual issues related to her heritage as a Chinese American.

Flo Oy Wong is a first-generation American of Chinese ancestry. Like many offspring of Chinese immigrant families of her generation, Wong's parents emigrated from the Canton area of China to the United States in the third and early fourth decades of this century. The sixth child in this family of six daughters and one son, Wong was born in Oakland, California, approximately five years after her mother arrived in this country. Her early years were greatly influenced and shaped by Oakland's Chinatown, a Chinatown that was overshadowed by San Francisco's Chinatown and that for some proved to be invisible during World War II and the several decades thereafter. As Flo Oy Wong's journalist brother William commented in a 1988 news article for the *Oakland Tribune*, "Some people still don't know Oakland has a Chinatown. Others consider it second-rate, like Oakland itself, because *dai fow* (Cantonese for "big city," meaning San Francisco) casts such a long shadow."[1] Her brother concludes this news article with the following: "Like so many others I fled Chinatown, but it's as if an umbilical cord still links me to it. Though I now live a couple of miles away, I make regular pilgrimages."[2] For Flo Oy Wong, this "umbilical cord" not only links her to her roots but also serves as a source of creative sustenance in her works.

Flo Oy Wong's strong commitment to the visual arts developed when she was in her late thirties, after a short stint of several years as a public school teacher and time out to raise a family. Upon her graduation from high school in Oakland, Wong enrolled at the University of California, Berkeley, where she earned her B.A. degree in English in 1960. In 1961 she married her husband of 38 years. In the same year she received her California teaching credentials and shortly thereafter taught in the Bay Area public school systems until 1966, at which time she devoted her attention to the raising of her family. In 1976 she resumed her education as a fine arts student. In the same year, Judy Chicago's *Dinner Party* was exhibited in San Francisco. So moved by this piece, Wong visited the exhibition twice and professes the strong influence of Chicago's work on her.

The impact of this exhibition may have had something to do with Wong's desire to use her own work as a vehicle to explore her ethnic cultural background and to sustain her through that period of time when this particular direction received less-than-enthusiastic response from some of her art instructors. Her persistence eventually led to the creation of a mixed-media piece in 1978 that initiated her first significant series of work, the *Rice Sack Series*. Although Wong is indebted to Chicago, she credits Filipino artist Lee Tacang as an inspirational source for this series.[3] The only art instructor of color that Wong had while attending a local junior college in the Bay Area, it was his work that triggered

her use of rice sacks in this series. Initially turned off by Tacang's works, which related his farm labor youth in the Philippines through rice sacks and cords of wood, Wong became more cognizant of the potential that his approach to art making and his use of these materials held out for her. Accordingly, she notes, "His use of Chinese rice sacks then triggered the importance of rice as a symbol in my life as a first generation American contemporary artist."[4] Not only did her encounter with Tacang's work prove to be a liberating force for Wong, it also provided her with a visually meaningful vehicle by which to delve both into her family background and into issues of a Chinese American nature.

Flo Oy Wong's *Rice Sack Series* has occupied her attention on and off now for two decades. As rice proves to be the fundamental staple and the cornerstone of the Chinese meal, especially within the context of a Cantonese family, the rice sacks in this series of works serve as both a focus and a point of departure for the artist as she forages into her family's history, broader multicultural concerns, and social issues related to her being an Asian American and a woman of color. The rice sacks and their many attendant associations in Wong's works become even more significant and poignant when one realizes that an important aspect of her family history revolved around the family restaurant in Oakland, which opened in the early 1940s and closed in 1961. "After searching for ways to support the seven of us, my parents opened the Great China Restaurant in 1943. From then on, Great China becomes our window to the world."[5] The restaurant also became a focus for activity in the family's household and gave to it an identity. "Our home life centered on the restaurant where we cohered as a family—eating, studying, working."[6]

A fascinating cycle of works from the *Rice Sack Series* touches upon the relationship between the family of Wong's immediate in-laws and this family's relationship with that of an African American household. Wong's husband grew up in Augusta, Georgia, in the 1930s and the 1940s and, as a child, established a long-standing friendship with members of an African American family. This relationship between the two families serves as the focus for this cycle of works entitled *Baby Jack Rice Story*. The works that comprise the *Baby Jack Rice Story* serve as a vehicle not only by which Wong explores a facet of her husband's family history but also by which the artist explores an interesting facet of cross-cultural relationships in the South.

Flo Oy Wong's commitment to issues of an Asian American and a feminist nature extends well beyond the sphere of her own art. Within the past decade, she has surfaced as a strong and intelligent voice in support of the activities of Asian American women artists both locally, in the Bay Area, and nationally. Rather than detracting from her personal work, her involvement in this other arena, as an advocate and as an activist, seems continually to energize her creative activities. As Moira Roth so astutely noted in an article about Wong, "Activism and art play off one another in the creative process of Flo Oy Wong."[7]

Notes

1. William Wong, "A Place for Oakland Chinatown at Last?" in *Kaleidoscope: An Exhibition of Ink Paintings and Drawings by Flo Oy Wong* (Berkeley, Calif.: Visibility Press, 1992), p. 47, exhbn cat.

2. Ibid., p. 49.

3. Moira Roth and Diane Tani, "Flo Oy Wong: A Narrative Chronology," in *Kaleidoscope*, pp. 69–70.

4. Ibid., p. 70.

5. Ibid., p. 59.

6. Ibid., p. 61.

7. Moira Roth, "Entering Unstable Ground: Chinatown, Oakland/Sunnyvale and Georgetown, Maine," in *Kaleidoscope*, p. 22.

ZARINA

Born: 1937, Aligarh, India. *Education*: B.Sc., Aligarh University, India, 1958. Started making woodcuts in Bangkok, Thailand, 1958–1961. Studied etching with S. W. Hayter at Atelier 17, Paris, France, 1963–1967. Studied at St. Martin's School of Art, London, 1966. Studied papermaking in Rajasthan, India, 1968. Studied silkscreen printmaking in Germany, 1971. Studied woodblock printmaking and papermaking in Japan, 1974. *Career*: New York Feminist Art Institute, New York, 1979–1989. Bennington College, Bennington, Vermont, 1983–1984. Cornell University, Ithaca, New York, 1985–1986. Art Students' League of New York, New York, 1987–1988. Summer Arts Institute, Women's Studio Workshop, Rosendale, New York, 1988. Split Rock Art Program (Summer), Duluth, Minnesota, 1988. University of California at Santa Cruz, 1992–1998. *Awards*: President's Award for Graphics, India, 1969. Japan Foundation Fellowship, 1974. The Printmaking Workshop Fellowship, New York, 1984–1985. International Biennial of Prints, Grand Prize, Bhopal, India, 1989. Adolph and Esther Gothlieb Foundation Grant, 1990. New York Foundation Fellowship, 1990.

SELECTED EXHIBITIONS

1994	*Homes I Made*, Faculty Gallery, University of California at Santa Cruz, California
1993	Chawkandi Gallery, Karachi, Pakistan
1992	*House with Four Walls*, Bronx Museum of the Arts, Bronx, New York

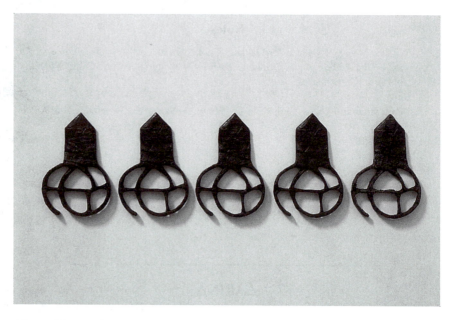

Moving House II by Zarina, 1992, bronze with patina, 6½" × 4½" × ½". Courtesy of Zarina R. Hashmi

1990	Roberta English Gallery, San Francisco, California
1986	Art Heritage, New Delhi, India
1985	Women Artist Series, Rutgers University, New Brunswick, New Jersey
1983	Satori Gallery, San Francisco, California
1981	Herbert F. Johnson Museum of Art, Ithaca, New York; Orion Editions, New York, New York; Gallery Chanakya, New Delhi, India
1977	Gallery Alana, Oslo, Norway
1976	India Ink Gallery, Los Angeles, California
1975	Malvina Miller Gallery, San Francisco, California

SELECTED GROUP EXHIBITIONS

1998	*Out of India: Contemporary Art of the South Asian Diaspora*, Queens Museum of Art, New York, New York
1997	*India and Pakistan Contemporary Prints*, Victoria and Albert Museum, London, United Kingdom; *Gift from India*, Sahmat Lalit Kala Akedemi, New Delhi, India
1996	*25 Years of Feminism/25 Years of Women's Art*, Mason Gross School of Art Gallery, Rutgers University, New Brunswick, New Jersey; *Mini Print*, Gallery Espace, New Delhi, India

1995	*Arts and Letters*, June Kelly Gallery, New York, New York; *International Biennial of Prints*, Bhopal, India
1994	*Asia/America: Identities in Contemporary Asian American Art*, The Asia Society, New York, New York; *International Print Triennial and Intergrafica*, Cracow, Poland
1992	*From Bonnard to Baselitz: From Print Collection*, Bibliotheque Nationale, Paris, France; Norwegian International Print Triennale, Fredrikstad, Norway
1990	*International Biennial of Prints*, Bhopal, India
1988	*The Language of Form: The Form of Language*, Rosa Esman Gallery, New York; *Coast to Coast: Women of Color National Artist Book Project*, traveling exhibition; *Artists Choose Artists*, A.I.R. Gallery, New York, New York; *Art for Art's Sake*, Kala Institute, Berkeley, California
1987	*Heresies 10th Anniversary Benefit*, PPOW Gallery, New York, New York
1986	*The Heroic Female: Images of Power*, Ceres Gallery, New York, New York; *New Art New York*, The Harlem School of the Arts, New York, New York
1985	*Ripe Fruit*, P.S.1, Long Island City, New York; *Reflections: Women in Their Own Image*, Ceres Gallery, New York, New York

SELECTED COLLECTIONS

Bibliotheque Nationale, Paris, France; Gilkey Print Center Collection, Oregon Art Institute, Portland, Oregon; Japan Foundation, Tokyo, Japan; Jordan National Gallery, Amman, Jordan; Museum of Fine Arts, Bhopal, India; Museum of Modern Art, New York, New York; National Gallery of Modern Art, New Delhi, India; The Neurosciences Research Foundation, New York, New York; Schulmberger Ltd., New York, Paris; South East Banking, Florida; U.S. Library of Congress, Washington, D.C.: Victoria and Albert Museum, London, England; World Bank, Washington, D.C.

PUBLICATIONS

Borum, Jenifer P. "Asia/America." *Artforum* 33, no. 1 (September, 1994), p. 108.

Cohen, Ronny. "Paper Routes." *Art News* 82, no. 3 (1983).

Farver, Jane. *Out of India, Contemporary Art of the South Asian Diaspora*. New York: Queens Museum of Art, 1997. Exhbn cat.

Glowen, Ron. "Matters of Survival: Asia/America." *Artweek* 25 (November 3, 1994), p. 14.

Green, Charles. "Zarina." *Artforum* (April 1998), p. 122.

Hirch, Fay. "Zarina Hashmi." *On Paper* 2, no. 2 (November–December 1997), p. 41.

Hussain, Marjorie. "Etched in Mind." *The Herald* (Karachi Pakistan), 1990.

Hussain, Marjorie. "House of Four Walls." *Dawn* (Karachi, Pakistan), 1992.

Lal, Laxshmi. "A Metaphor in Full Bloom." *Times of India* (Bombay), 1986.

Liebmann, Lisa. "Zarina's Balm: Objects of Exchange." *Artforum* 26 (January 1988), pp. 74–76.

Lippard, Lucy. Review. *Village Voice*, 1981.

Machida, Margo. *Asia/America: Identities in Contemporary Asian American Art*. New York: The Asia Society Galleries/The New Press, 1994.

Nadelman, Cynthia. Review. *ArtNEWS* 81, no. 7 (1982), p. 77.

Naqvi, Akbar. "The House That Zarina Built." *The Herald* (Karachi, Pakistan), 1993.

Review. *New Yorker*, May 11, 1992.

Review. *Printmakers' Newsletter* 3 (1984).

Safrani, Shehbaz H. "Zarina at the Bronx Museum of the Arts." *Asian Art News* 2, no. 2 (March–April 1992).

Saint-Gilles, Amaury. Interview. *Mainichi Daily News* (Tokyo), 1983.

Shere, Charles. Review. *The Oakland Tribune*, 1987.

BIOGRAPHICAL ESSAY

Strong white paper punctured with pinpricked designs, paper sculptures saturated with deep red earth tones, bronze and metal objects that seem idiosyncratic yet recognizable. Monochrome prints on textured handmade paper, compositions whose abstract lines evoke formal harmony yet suggest subtle meaning, ambiguous texts that hint of private yet also known worlds. There is a compelling essence about Zarina's work that invites the viewer to investigate it further. In other words, her art stands on its own. It needs no explanations. The aesthetic vocabulary that she uses is readily accessible. The metaphors reflect constancy and change, the reality of twentieth-century mobility at the cost of stability. We are on familiar territory. Her visual messages resonate with our own subconscious longings.

The point that I am making about Zarina's work is that at one level, at the most accessible level, it defies a specific cultural identity. This raises the question of relevance, because the most important aspect of Zarina's work is that it is pure art. She works with different materials in order to express her own creative forces. She does not profess to create an overtly political agenda through her art, yet in subtle and sometimes humorous ways she strikes a cord that alerts our subconscious to the unrelenting pressures that haunt our existence. She plays upon themes of repetition and monotony, of rootlessness and belonging, and of identity and independence. These are themes that are at the heart of every woman's being. The seeming simplicity of objects and the abstraction of her compositions mask the complexities and depth of Zarina's art.

Zarina was born in 1937 in Aligarh, north India. She grew up in a traditional home—a house with four walls—that encompassed the rooms of her extended family and a garden. After graduating from Aligarh University in 1958 she was married to a young diplomat. Thus began her life of wandering as she followed her husband to Southeast Asia, France, Germany, and the United States. While living in Bangkok for three years from 1958 to 1961, she started making woodblock prints, after which she studied for four years, from 1963 to 1967, with Stanley W. Hayter at Atelier 17 in Paris; this included work in 1966 at St. Martin's School of Art in London. In 1971, while in Germany, she studied

silkscreen printing, and in 1974, when she was in Japan, she studied woodblock printing and papermaking. Making art for Zarina was a way for her to achieve some balance in her life. By the time she returned from Paris in 1968, she recognized that she could no longer tolerate *char divari*, the home and husband syndrome expected of South Asian women. She came to the United States from Japan in 1974 and lived in New York. She became involved with *Heresies*, the publication for feminist writings. The first showing of her work in the United States was at the Martha Jackson Gallery in New York, followed by one at the Malvina Miller Gallery in San Francisco in 1975. In 1981 Zarina had a one-person show of paper sculptures at Orion Editions in New York. In 1992 a solo exhibition of her prints and sculptures, *House with Four Walls*, was held at The Bronx Museum of Art in New York. Since coming to the United States, Zarina has been actively teaching art, first for ten years (1979–1989) at the New York Feminist Art Institute, and has held visiting positions at Bennington College, Cornell University, the Art Students' League of New York, and the University of California at Santa Cruz. Her home and studio are in New York.

Zarina is also a sculptor. She makes objects from paper pulp, wax, bronze, and other metals, all of which have an elemental quality to them that appear to be serpentine spirals, segmented fruits, conical seeds, and lapelled buds. In many instances, she has given them evocative terms. Buds become *amulets*, seeds become *tents*, and a segmented fruit is called *Shrine*. There is a potential force within each form: Guardian powers, fertility, shelter, and the means to communicate with the spiritual world are suggested. *Amulets*, small containers made of metal or cloth that hold sacred texts or relics invested with certain spiritual powers, are worn by many in South Asia as protective devices. The segmented *Shrine* recalls an *amalaka*, a round, segmented architectural element, inspired by a fruit of the same name, that adorns the tops of Hindu temple towers. A pear-shaped contour suggests the lines of a Mughal dome. Some of these sculptures are made of caste paper pulp; others such as *Shrine* have been made in both wax and bronze. *Spiral* is four feet in diameter. Caste from gritty paper pulp with fine striations across the coils, it is tensely wound like a sleeping *naga*, serpent. In human scale, it is the counterpoint to Robert Smithson's *Jetry*.

Zarina uses walls like canvases for her most innovative sculptures. The wall thus becomes the foundation for her ideas yet retains its own integrity as a wall, the fundamental structure and enclosure of a house. In the recent exhibition *Out of India: Contemporary Art of the South Asian Diaspora* (1997), held at Queens Museum of Art in New York, Zarina covered a wall with small metal cutouts of houses on wheels. The houses were square in shape with a triangular roof sitting atop two large wheels. They descended the wall like an untidy caravan, or a wave of migrant nomads that recalled the constant movements of people throughout time: rootless, shifting, searching for fertile pastures and hospitable environments. The house on wheels has come to symbolize Zarina's own peripatetic wanderings and her musings on the concepts of home and house. Constantly moving since the age of 21, she has looked back wistfully to her

childhood years where house and home were one and the same, a place of nurture and security. The most enigmatic house is cast from bronze and stands 11 inches tall. It is also placed on wheels. However, there is one wheel aligned under each of the walls, abutting up against each other. It seems like a joke. A mechanical folly, this house can go nowhere. The wheels may spin, but the house will not move. Yet it is the imagined energy of the spinning wheels that makes everything within the house/home work. The visual conundrum continues with *Moving House II* (1993), where multiple boxlike houses caste in bronze parade across the wall. Each house, however, is mounted on a wheel whose spokes are off axis, and an extension of the wheel acts like a brake. The houses are becoming more and more vulnerable, until in *House That Flew Away* (1996), all that remains are two empty wheels joined at their edges. No longer are the wheels supporting a house/home, no longer containing power within them, no longer constantly moving. Perhaps this work is a metaphor for Zarina's and our perpetual quest.

AFTERWORD: PARTS OF A PUZZLE

Moira Roth

Among concerned feminists, the disaffection of many women of color from the mainstream feminist movement has been the focus of much debate. Many black feminist/womanist theorists have been particularly prescient and influential in establishing useful theoretical modes and scholarship for all women of color which offer alternatives to mainstream feminist discourse with its hitherto narrow focus on gender oppression and its inability to sufficiently address the complex realities of women of color.
> —Yong Soon Min, "Our World Within"[1]

If those who have been made invisible by social forces are to represent themselves, white people at the same time must let go of the privilege of representing everybody. . . . Looking for the link that I missed, I see that we the critics and scholars concerned with cross-cultural discourse have not paid enough attention to the development of *white consciousness.*
> —Lucy R. Lippard, "Turning the Mirrors
> Around—The Pre-Face"[2]

In 1994, Yolanda M. López and I argued in our essay "Social Protest: Racism and Sexism" that the very language of "The Feminist Art Movement" (dominated from the start by Euro-American women) suggests an identity prioritized by gender, not race, and that for "women artists of color—despite their concern with women's issues—ethnicity more than gender has shaped their primary identity."[3] In our text, we explored the history and dimensions of this feminist art from the viewpoint of social protest and race, announcing in our first para-

graph, "There is a dramatic inequality of information on women of color as opposed to white women."[4]

This current heroic research project, led by Phoebe Farris, will make a significant contribution to helping right such inequalities. But why has there been this profound inequality between writings on white women artists and women artists of color?

To answer, "racism" is obviously true in so many ways, but to leave it at that basic level is inadequate. Equally the explanation of "sexism," when discussing the inequalities between male and female artists of color within most ethnic-specific art histories, again demands further analysis in order to understand the obstacles and to figure out strategies for change.

Let me suggest that among relevant future studies the following will require extensive investigation: feminist and ethnic-specific art history over the last three decades, the role of theory in art history in the 1980s onward, and its impact on scholarship concerning women artists of color. Behind this is the institution of art history itself and the entrenched nature of art history practice—all of which needs to be examined.

I am a white London-born feminist in my midsixties who since age 24 has lived in California (aside from a couple of early years in New York City). Trained first at the London School of Economics, and later at the University of California, Berkeley (with a Ph.D. in modern European art, 1974), I have shifted increasingly toward U.S. art history with an emphasis on contemporary art, frequently working in intercultural collaborative situations, such as the one with López. When I moved to southern California in 1970, a time of intense activity in Los Angeles among women artists, I became involved for the first time with feminism, primarily in the form of feminist art history. Over the decades between 1970 and now, I have witnessed feminist art history slowly expanding in terms of ethnicity, but in its early stages, it was singularly white—and heterosexual and middle class (something that continues, for the most part, to be true, today).

In the 1970s, I, and many other white feminist art historians with graduate degrees, began to teach and write. In addition to general white feminist publications and demonstrations, we were guided by early histories, catalogs, and contemporary feminist criticism concerning women artists.

This stage culminated in 1976 with Lucy R. Lippard's anthology of writings *From the Center: Feminist Essays on Women's Art* and the huge traveling exhibition of painting (accompanied by a major 368-page catalog) *Women Artists: 1550–1950*, curated by Linda Nochlin and Ann Sutherland Harris.[5] We studied, too, the many articles and images that appeared in women's newsletters and monthly and quarterly publications such as *Feminist Art Journal* (1972–1977), *Women Artists Newsletter* (1975–1991), *womanart* (1976–1978), *Chrysalis* (1977–1980), and *Heresies* (1977–1993) and, a little later, the *Woman's Art Journal* (still flourishing), which started up in 1980. Many of us regularly attended the annual meetings of the Women's Caucus for Art, founded in 1972.[6]

Despite much admirable research throughout the 1970s in terms of scholarly feminist art history surveys and studies, the very concept of *the* woman artist and more generally of woman's art history was frequently, silently, and automatically assumed to be white. Unsurprisingly, the patterns of perception and focus in this early white feminist art history had parallels with the general feminist movement of this period.

It was to take considerable time for me and other white feminists to recognize the specific parameters of this early "women's" art history—in other words, that what we had read comfortably as universal was, in effect, only white. To do so, first, I had to unlearn simple assumptions based on white privilege. Second, I had to teach myself to recognize the primal impact of ethnicity and class on the construction of art history and the reading of images—be they in the wider context of the daily visual culture of media and advertising or in the narrower confines of art.

Obviously, during the 1970s, racism and ethnic divisions were being hashed out in private and public among women of diverse ethnic and class backgrounds in the collective situations of women's galleries and feminist art groups. Simultaneously the decade witnessed the formation of separate groups, composed around shared concerns—ethnicity and sexual orientation being major focal points. Within feminist art history circles, as opposed to contemporary women art circles, however, these arguments were more muted—at least in my experience of the 1970s—given the almost all-white nature of the participants (I remember more arguments about Marxism than ethnicity).

As the decade progressed, there was an increasing public presence of women of color. They loudly, passionately, and often angrily voiced their visions, successes, tribulations, and demands, simultaneously performing the painful juggling acts around conflicting identities, split loyalties, and the harsh prioritizing choices, frequently demanded of them, between race and gender commitments. Faith Ringgold remembers that "in the 1970s, being black and a feminist was equivalent to being a traitor to the cause of black people."[7] In the introduction to her anthology *Chicana Feminist Thought: The Basic Historical Writings*, Alma M. Garcia writes: "Throughout the 1970s, this initial generation of self-proclaimed Chicana feminists viewed the struggle against sexism within the Chicano movement and the struggle against racism in the larger society as central ideological components of their feminist thought."[8]

In 1980, Ana Mendieta curated an important exhibition in New York at A.I.R., a women's gallery, entitled *Dialectics of Isolation: An Exhibition of Third World Artists in the United States*, which included Howardena Pindell's video *Free, White and 21*. Pindell, by this time a prominent black curator at the Museum of Modern Art as well as an established artist, later wrote that her video—in which she plays both the black narrator and a white woman character (whose refrain throughout is "But, of course, I'm free, white, and 21")—had been provoked by "yet another run-in with racism in the art world and the white feminists. I was feeling very isolated."[9]

In retrospect *Dialectics of Isolation* constituted a public pulse-taking moment in the U.S. woman's art movement, at least in New York City.

During the 1980s, dramatic shifts occurred in the balance between scholarship on white and women artists of color.

Between 1980 and 1985, two "firsts" appeared, respectively, in Norman, Illinois, and New York City: the exhibitions of *Forever Free: Art by African-American Women, 1862–1980*[10] and *Women of Sweetgrass, Cedar and Sage: Contemporary Art by Native American Women*[11]—whose catalogs greatly expanded investigations into the history of black and native women artists. In the same time period, a number of women of color published influential anthologies and theoretical texts, which affected artists as well as subsequent writing of art history. All in all, there were highly significant advances on many fronts.

In the second half of the decade, these trends continued, with an increasing emphasis on cross-ethnic/cultural connections between artists of color, including women, and the expansion of cultural studies.[12] Generally this decade witnessed a more systematic emergence of artist-activist-scholars of color who intervened in conventional art history through their writing, organizing, curating, lecturing, and consulting—in addition, of course, to the writings of traditionally trained art historians of color.[13] Prominent among the women artist-activist-scholars are such figures as Margo Machida, Amalia Mesa-Bains, Howardena Pindell, and Jaune Quick-to-See Smith.

By the end of this decade, Barbara Christian, who had earlier published *Black Feminist Criticism: Perspectives on Black Women Writers* (1985), asked a question bluntly—surely one on many minds in one form or the other—when she entitled her essay "But Who Do You Really Belong to—Black Studies or Women's Studies?"[14]

The 1980s was also the decade of coalitions between women artists of color.

A major event in this history was the creation of Coast to Coast: National Women Artists of Color in 1987 by Faith Ringgold, who decided it was "an idea whose time had come . . . [to give women of color] . . . much-needed visibility, support and national attention."[15] In 1988 Coast to Coast had its first exhibition in Houston, Texas: a wonderful exhibition of 120 artists' books. In her autobiography *We Flew over the Bridge*, Ringgold describes the books, which ranged greatly in content, techniques, and materials, as being "about love, hate, food, family, friendship, childbirth, sex, marriage, motherhood, war, rape, incest, music, AIDS, being black, poor, a woman, Native American, Chicana, or Asian. . . . And yet they all seemed to declaim, 'I am a woman of color, making a serious statement about my life and work.' "[16]

A year after the formation of Coast to Coast, Howardena Pindell produced a brilliant selection of 20 artists of color for a traveling exhibition, originating in New York's INTAR Latin American Gallery.[17] She curated this exhibition at the same time as she undertook a massive research project on "Art World

Racism," first presented in lecture form in 1987, then published in various places.[18]

The end of the 1980s witnessed the beginnings of a systematic investigation into Asian American art history, together with the formation of two Asian American art activist groups. In 1988, the Asian American Women Artists Association (AAWAA) was founded in the Bay Area. The next year, in New York City, a group of Asian American artists and critics—among whom women formed a highly visible component—created Godzilla: The Asian American Arts Network. One of the founding members was Margo Machida, an artist-activist-scholar whose work has always included a focus on women. Her scholarship has been central in the development of Asian American art history, as has that of Elaine Kim.[19]

Women have also played major roles in Chicano art history scholarship (and in the larger field of Latino art studies) as well as being central to that narrative.[20] As with Asian American art history, there has been a recent surge of scholarship here within the wider arena of multiculturalism. The complexity of this subject can be sensed from the intriguing recent study (1998) by Alicia Gaspar de Alba[21] about the 1991 CARA survey of contemporary Chicano art.[22] Gaspar de Alba describes this exhibition as "the first major national art show organized and represented by Chicanos and Chicanas in collaboration with a mainstream art institution[;] it . . . marked the large-scale intervention of a marginalized art and culture in the master's house."[23] In her *Chicano Art: Inside/Outside the Master's House: Cultural Politics and the CARA Exhibition* (the subtitle refers to Audre Lorde's famous 1979 conference paper entitled "The Master's Tools Will Never Dismantle the Master's House"),[24] Gaspar de Alba analyzes many of the exhibition's frameworks (internal and external) including the problematic one of multiculturalism, for which she suggests various interpretations—from the dismantling of the "master's house" to merely "a cover for business as usual."[25] She concludes, however, "[T]he response that CARA received from all sides . . . proved that, more than being a transgression into the boundaries of the art world, CARA was decisively a kick in the face of the mainstream cultural cannon."[26]

Cultural cannons?

These are often concealed and operate not only in the shadows but in the unconsciousness of their practitioners. The act of making them conscious is a prerequisite for any change. A second task is for us, as scholars, to do our cultural as well as artistic homework in order to appreciate new arenas of art making. A third task is to study our institutional bases (the academy in its various forms, be it a school, journal, or organization)—so that we actively support the necessary expansion of scholars of color within them—while simultaneously working on the deconstruction of canonized art history and creating freer, more complex narratives.

For me, it is obvious that still lurking in academic shadows is a central component of this puzzle: the entrenched and institutional nature of art history. How does art history work? How can it be changed? Who is traditionally qualified to write and teach "professional" art history? How does one help open up the barriers? How does one read artistic production from within and from outside one's own ethnicity, gender, culture, and class? Finally, if one decides on this kind of intercultural research (which certainly applies, among many other scholars, to myself), how does one acknowledge, critique, and stay aware of inevitable confines without getting politically or intellectually paralyzed?

For me, collaboration and alliances have been essential.

When I was asked in 1993 to contribute to the anthology *The Power of Feminist Art*, it was no accident that I wanted to coauthor such an essay on sexism and racism. What's more, I specifically sought to coauthor it, not only with a woman of color (for the authorship of the book was totally white) but with an artist-activist-scholar—hence, my collaboration with Yolanda M. López.

López is part of a new breed of artist-scholar (especially prevalent among artists of color, both male and female, as well as white women artists) who are doing remarkable and innovative work, which is often more significant than most of us who were trained traditionally. These artists, whose politics and intellectual curiosity have turned them toward art historical research, have become self-trained art historians, much courted as curators and guest speakers but not yet, sadly, as potential tenured members of an art history department. Their work, too, is still somewhat marginalized on the grounds of their lack of "professional" qualifications. Also problematic—if these already established artist-scholars (together with other would-be art historians of color) do decide to attend graduate school—is where they should go to train and in what department.

The training and hiring of art historians are, for the most part, enormous barriers to change. If you do not have a Ph.D. in art history, it is virtually impossible to get a teaching job as an art historian on a university level. Concomitantly, if you do not have an institutional base, it is harder to find support for one's research and establish professional credentials. Graduate programs in art history continue to be, for the most part, surprisingly traditional and powerful in their influences. Not only do I, for example, still experience the lingering constraints of mine, but equally I am surprised when I compare notes with young graduates as to how, in a profound way, there have been insufficient basic changes from the 1960s.

With rare exceptions, art history faculties are still white—although far less male dominated than they used to be. Also, the student body in a typical art history Ph.D. program continues to be primarily white, as does the choice of artists and movements. All in all, this does not make such graduate programs enticing for scholars of color who are interested in visual culture; thus, they more frequently turn to cultural or ethnic studies programs than to art history ones.

And even within revisionist art history circles, there is often a new obstacle concerning research on women artists of color—that of the prevalence of "theory" (despite its many fascinating aspects). Currently, feminist scholars of all ethnicities have become highly (often exclusively) immersed in theoretical discourse—writing texts that are hard for anyone but other scholars to read—and, therefore, are generally not attracted to archival research or interviews with artists. This is highly problematic, as much of this type of work must be done if we are to establish complex and fuller histories of women artists of color, both past and present.

Women Artists of Color: A Bio-Critical Sourcebook to 20th Century Artists in the Americas is thus a rare as well as much-needed publication at this time. Guided by these new cartographers—Phoebe Farris and her contributors—we should be able to travel through a more varied and interesting terrain of art history in the future, one in which many more women artists of color reside. The landscape of American art will look different as a result.

NOTES

Many people have helped me with this text, including Annika Marie, Cheryl Leonard, and Renée Jadushlever. I am deeply grateful to them, as I am to Phoebe Farris, who invited me to write this afterword but challengingly left the specific focus up to me.

This afterword is dedicated affectionately to a group of colleague-friends whose work takes them into these areas of scholarship about women artists of color: Theresa Harlan, Lucy R. Lippard, Yolanda M. López, Margo Machida, and Judith Wilson.

1. Yong Soon Min, "Our World Within," in *Ancestors Known and Unknown: Box Works* (New York: Coast to Coast Publication, 1990), p. 26.

2. Lucy R. Lippard, "Turning the Mirrors Around—The Pre-Face," *American Art* (Winter–Spring 1991), p. 29.

3. Yolanda M. López and Moira Roth, "Social Protest: Racism and Sexism," in Norma Broude and Mary D. Garrard, eds., *The Power of Feminist Art: The American Movement of the 1970s, History and Impact* (New York: H. N. Abrams, 1994), p. 140.

4. Ibid.

5. Ann Sutherland Harris and Linda Nochlin, *Women Artists: 1550–1950* (Los Angeles: Los Angeles County Museum of Art; New York: Alfred A. Knopf, 1976); Lucy R. Lippard, *From the Center: Feminist Essays on Women's Art* (New York: E. P. Dutton, 1976).

6. The important Women of Color Caucus was formed in the 1990s within the Women's Caucus for Art (WoCA), and one of its major achievements has been the production in 1997 of packages of slides by women artists of color. (These WoCA slides can be ordered from Universal Color Slide Company, 8450 South Tamiami Trail, Sarasota, Fla. 34238–2936.)

7. Faith Ringgold, *We Flew over the Bridge: The Memoirs of Faith Ringgold* (Boston: Little, Brown, 1995), p. 175.

8. Alma M. Garcia, ed., *Chicana Feminist Thought: The Basic Historical Writings* (New York: Routledge, 1997), p. 5.

9. Howardena Pindell, "Free, White and 21," *Third Text* (Summer 1992), p. 31.

Reprinted in Pindell, *The Heart of the Question: The Writings and Paintings of Howardena Pindell* (New York: Midmarch Arts Press, 1997), p. 65.

10. Arna Alexander Bontemps, ed., *Forever Free: Art by African-American Women, 1862–1980* (Alexandria, Va.: Stephenson, Incorporated, 1980). Two more recent sources devoted to black women's art are Jontyle Theresa Robinson and Maya Angelou, eds., *Bearing Witness: Contemporary Works by African-American Women Artists* (Atlanta, Ga.: Spelman College; New York: Rizzoli International Publications, Inc., 1996); and Sylvia Moore, ed., *Gumbo Ya Ya: Anthology of Contemporary African-American Women Artists* (New York: Midmarch Arts Press, 1995).

11. Harmony King-Hammond and Jaune Quick-to-See Smith, *Women of Sweetgrass, Cedar and Sage: Contemporary Art by Native American Women* (New York: Gallery of the American Indian Community House, 1985). Also see Theresa Harlan, *Watchful Eyes: Native American Women Artists* (Phoenix, Ariz.: The Heard Museum, 1994).

12. Two significant 1990 publications in the cross-cultural arena were Lucy R. Lippard, *Mixed Blessings: New Art in a Multicultural America* (New York: Pantheon Books, 1990); and *The Decade Show: Frameworks of Identity in the 1980s* (New York: Museum of Contemporary Hispanic Art, The New Museum of Contemporary Art, and The Studio Museum in Harlem, 1990), curated by women curators Nilda Peraza, Marcia Tucker, and Kinshasha Holman Conwill.

13. Among the notable art historians of color are three black women, Leslie King-Hammond, Lowery Sims, and Judith Wilson, all of whom have made substantial contributions to the field.

14. Barbara Christian, "But Who Do You Really Belong to—Black Studies or Women's Studies?" *Women Studies* 17, nos. 1–2 (1989), pp. 17–23.

15. See Ringgold, *We Flew over the Bridge*, pp. 263–265. The 1988 Coast to Coast artists' books exhibition was followed by another in 1990, *Ancestors Known and Unknown: Box Works*, accompanied by a publication (see note 1).

16. Ibid., pp. 264–265.

17. Howardena Pindell, *Autobiography: In Her Own Image* (New York: INTAR Latin American Gallery, 1988).

18. An up-to-date version of this material can be found in Howardena Pindell, "Art World Racism," in Pindell, *The Heart of the Question*, pp. 3–28.

19. Among key recent publications on Asian American art history are Margo Machida's *Asia/America: Identities in Contemporary Asian American Art* (New York: The Asia Society Galleries and The New Press, 1994) and *[dis]Oriented: Shifting Identities of Asian Women in America* (New York: Henry Street Settlement and Steinbaum Krauss Gallery, 1995). Machida and Elaine Kim are in the process of editing the first full-length study of the subject: *Fresh Talk/Daring Gazes: Contemporary Asian American Issues in Visual Arts* (Berkeley: University of California Press, 1999). Also see the writings of Elaine H. Kim including " 'Bad Women': Asian American Visual Artists Hanh Thi Pham, Hung Liu and Yong Min," *Feminist Studies* 23, no. 3 (Fall 1996), pp. 573–602.

20. Among the many fine figures in this field are artist-scholars Amalia Mesa-Bains and Yolanda M. López and art historian Shifra M. Goldman.

21. Alicia Gaspar de Alba, *Chicano Art: Inside/Outside the Master's House: Cultural Politics and the CARA Exhibition* (Austin: University of Texas Press, 1998).

22. Richard Griswold del Castillo, Teresa McKenna, and Yvonne Yarbro-Bejarano, eds., *Chicano Art: Resistance and Affirmation, 1965–1985* (Los Angeles: Wight Museum, University of California, 1991).

23. Gaspar de Alba, *Chicano Art*, p. 7.

24. See Audre Lorde, "The Master's Tools Will Never Dismantle the Master's House" (1979), reprinted in Cherríe Moraga and Gloria Anzaldúa, eds., *This Bridge Called My Back: Writings by Radical Women of Color* (New York: Kitchen Table, Women of Color Press, 1981). This text was a critique of white feminists, as Lorde was arguing—within the context of a woman's conference, dominated by white feminists—that it "is an old and primary tool of all oppressors to keep the oppressed occupied with the master's concerns." For a long time, women had been asked to educate men about their very existence as well as their needs, but, as Lorde pointed out, white women were currently doing the same thing: "Now we hear that it is the task of black and third world women to educate white women . . . as to our existence, our differences, our relative roles in our joint survival. This is a division of energies and a tragic repetition of racist patriarchal thought" (p. 100).

25. See the "conclusion" chapter of Gaspar de Alba in del Castillo, McKenna, and Yarbro-Bejarano, *Chicano Art*, pp. 199–222.

26. Ibid., p. 222.

CULTURAL RESOURCES

Aboriginal Multi-media Society of Alberta, 15001, 112th Avenue, Edmonton, AB T5M 2V6, Canada

Afro-American Historical Museum, 7 & Arch Street, Philadelphia, Pa. 19104, (215) 574–0380

Alianza Nacional de Profesionales Indígenas Rilingues AC, Madero 67–60 piso, Despacho 611, Mexico 1 D. G. CP 06000

American Indian Community House Theater, 404 Lafayette Street, New York, N.Y. 10003

American Indian Contemporary Arts, 23 Grant Avenue, San Francisco, Calif. 98108–5828, (415) 989–7003, fax (415) 989–7205, www.citysearch.com/sfo/indian art

American Indian Culture and Research Journal, American Indian Studies Center, University of California, Los Angeles, Calif. 90095–1548

American Indian Dance Theater, 223 East 61st Street, New York, N.Y. 10021

Asian American Arts Center, 26 Bowery Street, New York, N.Y. 10013, (212) 233–2154

Asian Art Museum, Golden Gate Park, San Francisco, Calif. 94118, (415) 379–8813

Asian Art News, P.O. Box 301388, Escondido, Calif. 92030-9955, (619) 747–8327

Association for Native Development in the Performing and Visual Arts, 2049 St. Joseph Street, Toronto, ON M4Y 1J6, Canada

Association of Hispanic Arts, 173 East 116 Street, New York, N.Y. 10029, (212) 860–5445, fax (212) 427–2787

Atlatl, Inc.—National Service Organization for Native American Arts, P.O. Box 34090, Phoenix, Ariz. 85067–4090, (602) 277–3711, fax (602) 277–3690, e-mail atlatl@artswire.org

Bernice Bing websites, http://www.sla.purdue.edu/waaw/AsianAmerican/ArtistsAB.html (Women Artists of the American West Project, Purdue University, West Lafayette, IN); and http://www.queerculturalcenter.org/Pages/Bingshow/BBSplash.html (Queer Cultural Center, San Francisco)

Black Filmmaker Foundation, Tribeca Film Center, 670 Broadway, New York, N.Y. 10012, (212) 253–1690, fax (212) 253–1689

California Newsreel—African American Perspectives, 149 Ninth Street, #420, San Francisco, Calif. 94103, (415) 621–6196, fax (415) 621–6522

The Canadian Journal of Native Studies, Department of Native Studies, Trent University, Peterborough, Ontario, K9J 7B8, Canada

Caribbean Cultural Center, 408 West 58th Street, New York, N.Y. 10019, (212) 307–7420

Center for Cuban Studies, 124 West 23rd Street, New York, N.Y. 10011, (212) 242–0559, fax (212) 242–1937

Centro Cultural de la Raza, 2130–1 Pan American Plaza, #1, Balboa Park, San Diego, Calif. 92101, (619) 235–6135, fax (619) 595–0034

Consejo Indio de Sur América, Apartado 2054, Correo Central, Lima, Peru

Eiteljorg Museum of American Indian Art, 500 West Washington Street, Indianapolis, Ind. 46204, (317) 636–9378

Four Winds Theater, P.O. Box 912, Hobbema, AB T0C 1N0, Canada

Galería de la Raza/Studio 24, 2857 24th Street, San Francisco, Calif. 94110, (415) 826–8009, fax (415) 826–5128

Heard Museum, 2303 North Central Avenue, Phoenix, Ariz., (602) 257–9164, and 22 East Monte Vista Road, Phoenix, Ariz., (602) 528–0530

Indigenous Women's Network, P.O. Box 174, Lake Elmo, Minn. 55402

Journal of Indigenous Studies, Gabriel Dumont Institute of Native Studies and Applied Research, 121 Broadway Avenue, East Regina, Sask. S4N 026, Canada

Mexican Art Museum, 1852 West 19th Street, Chicago, Ill. 60608, (312) 738–1503

Mexican Museum, Buchanan & Marina Boulevard, San Francisco, Calif., (415) 441–0445 and (415) 441–0404

MEXIC-Arte Museum, P.O. Box 2632, Austin, Tex. 78768, (512) 480–9373, fax (512) 480–8626

El Museo del Barrio, 1230 Fifth Avenue, New York, N.Y. 10029-4496, (212) 831–7272, fax (212) 831–7927

Museum of African American Art, 4005 Crenshaw Boulevard, Los Angeles, Calif. 90008, (213) 294–7071

The National Afro-American Museum and Cultural Center, P.O. Box 578, Wilberforce, Ohio 45384, (513) 376–4944, fax (513) 376–2007

National Asian American Telecommunications Association, 346 Ninth Street, San Francisco, Calif. 94103, (415) 863–0814

National Black Programming Consortium, 929 Harrison Avenue, Suite 101, Columbus, Ohio 43215, (614) 299–5355, fax (614) 299–4761

National Museum of the American Indian, The Film and Video Center, One Bowling Green, New York, N.Y. 10004, (212) 283–2420, fax (212) 694–1970

The Native American Center for the Living Arts, 25 Rainbow Mall, Niagara Falls, N.Y. 14303, (716) 284–2427, fax (716) 282–5138

Native American Public Broadcasting Consortium, P.O. Box 83111, Lincoln, Nebr. 68501

Native Americas, Awe: kon Press, 300 Caldwell Hall, Cornell University, Ithaca, N.Y. 14853

Native Arts Circle, 1433 East Franklin Avenue, Minneapolis, Minn. 55404, (612) 870–7173, fax (612) 870–0327

Native Earth Performing Arts, 37 Spadina Road, Toronto, ON M5R 2S9, Canada

Native Media Network, P.O. Box 848, Portage La Prairie, MB RIN 363, Canada

Native Studies Review, Native Studies Department, 104 McLean Hall, University of Saskatchewan, Saskatoon, Sask. S7N 0W0, Canada

Native Women's Association of Canada, 195a Bank Street, Ottawa, ON K29 1W7, Canada

News from Native California, P.O. Box 9145, Berkeley, Calif. 94709

North Carolina Indian Cultural Center, P.O. Box 2410, Pembroke, N.C. 28372, (919) 521–2433, fax (919) 521–0394

Sacred Circle Gallery of American Indian Art, Discovery Park, P.O. Box 99100, Seattle, Wash. 98199, (206) 285–4425, fax (206) 282–3640

Schomburg Center for Research in Black Culture, The New York Public Library, 515 Malcolm X Boulevard, New York, N.Y. 10037–1801, (212) 491–2200, fax (212) 491–6760

SEORO Korean Cultural Network, 39 Bowery, Box 671, New York, N.Y. 10002

Spiderwoman Theater, 77 Seventh Avenue, Apt. 85, New York, N.Y. 10003

The Studio Museum in Harlem, 144 West 125 Street, New York, N.Y. 10027, (212) 864–4500, fax (212) 666–5753

Third World Newsreel, 335 West 38th Street, New York, N.Y. 10018, (212) 947–9277, fax (212) 594–6417

Turtle Quarterly, Native American Center for the Living Arts, 25 Rainbow Mall, Niagara Falls, N.Y. 14303

Visual Communications/Southern California Asian American Studies Central, 263 South Los Angeles Street, #307, Los Angeles, Calif. 90012, (213) 680–4462, fax (213) 687–4848

Women Make Movies, 462 Broadway, New York, N.Y. 10013, (212) 925–0606, fax (212) 925–2052

Women of Color Slide Resource Series, Universal Slide Co., 8450 South Tamiami Trail, Sarasota, Fla. 34238, (800) 326–1367, fax (800) 487–0250

Women's Caucus for Art, 625 Broadway, New York, N.Y., (212) 634–0007, www.nationalwca.com

INDEX

Page numbers in **bold** refer to artists' biographies.

ABOUT THE EDITOR AND CONTRIBUTORS

PHOEBE FARRIS (Powhatan) is an Associate Professor of Art & Design/ Women's Studies at Purdue University. She is the editor of *Voices of Color: Art and Society in the Americas*. Dr. Farris has been a recipient of a Fulbright grant, a National Endowment for the Humanities grant, and a Rockefeller Scholar-in-Residence. She has published in numerous journals, exhibited nationally and internationally, and is often consulted on issues pertaining to Native American art and culture.

REENA JANA is a Contributing Editor at Hong Kong's *Asian Art News* and *World Sculpture News* magazines, the "Flash Asia" columnist for Milan, Italy's *Flash Art International*, and a regular contributor to the *New York Times Magazine* and *Wired* magazine. She is on the faculty at the University of San Francisco and teaches an Extension writing workshop at the University of California at Berkeley.

MELINDA L. DE JESÚS is Assistant Professor of Asian American Studies at San Francisco State University. Her research interests include womanist/feminist of color literature and theory, multiethnic American literatures, Asian American literature and cultural studies, and feminist theory.

KATHRYN KRAMER is currently an Assistant Professor in the Department of Art and Art History at SUNY Cortland in Cortland, New York. She received the Ph.D. in Art History and Archaeology, Columbia University, in 1993. She is a twentieth century modernist with expertise in German modernism, the institutional history of women's art after 1945, and critical theory.

KRISTINE C. KURAMITSU is a Ph.D. student in the Department of Art History at the University of California, Los Angeles. She has written about issues

of the internment, history, and memory in Japanese American art as well as the 1960s work of Yayoi Kusama.

WILLIAM W. LEW is Professor of Art and Head of the Department of Art at the University of Northern Iowa, where he teaches in the art history area.

MARY-ANN MILFORD-LUTZKER teaches Asian Art History at Mills College, where she holds the Carver Chair in Asian Studies. She has curated several exhibitions including *The Image of Women in Indian Art* in 1985 and has published widely. Dr. Milford-Lutzker is currently on the Board of Directors and Treasurer for the American Council for Southern Asian Art (ACSAA) and serves on the advisory Committee for Rhodes Scholarships. She has a long association with the Asian Art Museum in San Francisco, where she is on the Advisory Committee for the Society for Asian Art.

MOIRA ROTH is Trefethen Professor of Art History at Mills College in Oakland, California. A feminist art historian, critic, activist, and curator, she has received her Ph.D. from the University of California, Berkeley. She is the author and editor of numerous books, art periodicals, and catalogues. Among her recent writings is a two-volume collection, *Difference/Indifference: Musings on Postmodernism, Marcel Duchamp and John Cage* with Jonathan Katz and *Musings on Feminism and Cultural Diversity* with Sutapa Biswas (both 1998).

CYNTHIA A. SÁNCHEZ is the Director of the New Mexico Capitol Art Foundation and the Curator of the New Mexico Capitol Art Collection, Santa Fe. She has a Ph.D. in Performance Studies from New York University. Sánchez is a performance artist and writer whose works focus on the politics of representation and identity in the visual arts and performance.

NADINE WASSERMAN is Curator of Exhibitions at the Samuel Dorsky Museum of Art, State University of New York at New Paltz. She received her M.A. in Afro-American Studies from the University of Wisconsin-Madison. She has previously held positions as Curator of the Wriston Art Center Galleries, Lawrence University, Appleton, Wisconsin, and as Curatorial Assistant at the Museum of Contemporary Art, Chicago.